THE
ETERNAL
SEA

THE ETERNAL SEA

Philip Plisson ⚓

Text by Christian Buchet
Captions by Anne Jankéliowitch

ABRAMS, NEW YORK

TRANSLATED FROM THE FRENCH BY DAVID H. WILSON

Library of Congress Cataloging-in-Publication Data

Plisson, Philip.
 [Mer, avenir de la terre. English]
 The eternal sea / photographs by Philip Plisson ;
text by Christian Buchet.
 p. cm.
 ISBN 10: 0–8109–3091–9 (hardcover with jacket)
 ISBN 13: 9–780–8109–3091–9

1. Ocean—Pictorial works. 2. Marine ecology—Pictorial
works. 3. Ocean. 4. Marine ecology. I. Buchet,
Christian. II. Title.

 GC21.P55 2006
 551.46022'2—dc22
 2006019270

Printed and bound in France
10 9 8 7 6 5 4 3 2 1

HNA ▮▮▯▮▯▯

harry n. abrams, inc.
a subsidiary of La Martiniere Groupe
115 West 18th Street
New York, NY 10011
www.hnabooks.com

Contents

'I really don't know why it is that all of us are so committed to the sea, except I think it is because, in addition to the fact that the sea changes and the light changes, and ships change, it is because we all came from the sea. And it is an interesting biological fact that all of us have, in our veins, the exact same percentage of salt in our blood that exists in the ocean, and therefore, we have salt in our blood, in our sweat, in our tears. We are tied to the ocean. And when we go back to the sea, whether it is to sail or to watch it, we are going back to whence we came.'

In his opening speech for the America's Cup in Newport, Rhode Island, on 14 September 1962, John F. Kennedy answered a question that had obsessed me since my youth: why, ever since the age of four, after my first encounter with sea on the beach at Carnac in northern France, have I felt such a deep-seated need for the sea that over time it has become a fundamental part of my life?

Brought up by the Loire river, I came to the sea at my father's side in the 1950s, at the beginning of the post-war boom in leisure sailing, the pleasure of going out to sea. By the age of eighteen, I had spent two years in a sailor's uniform, travelling the oceans of the world as a curious passenger. At the age of forty-four, the French Navy offered me a new life, as their official artist. Now well-known, recognized and even popular, I nonetheless do not seek honours. It is the sea that I try to honour through my gaze, by sharing it and raising awareness that it is the future of the earth, as Christian Buchet confirms in this book. I hope that my illustrated emotions will take you on a voyage between the sea and the sky and truly become part of the same biological fact: the longing for the sea.

Photographically yours
Philip Plisson

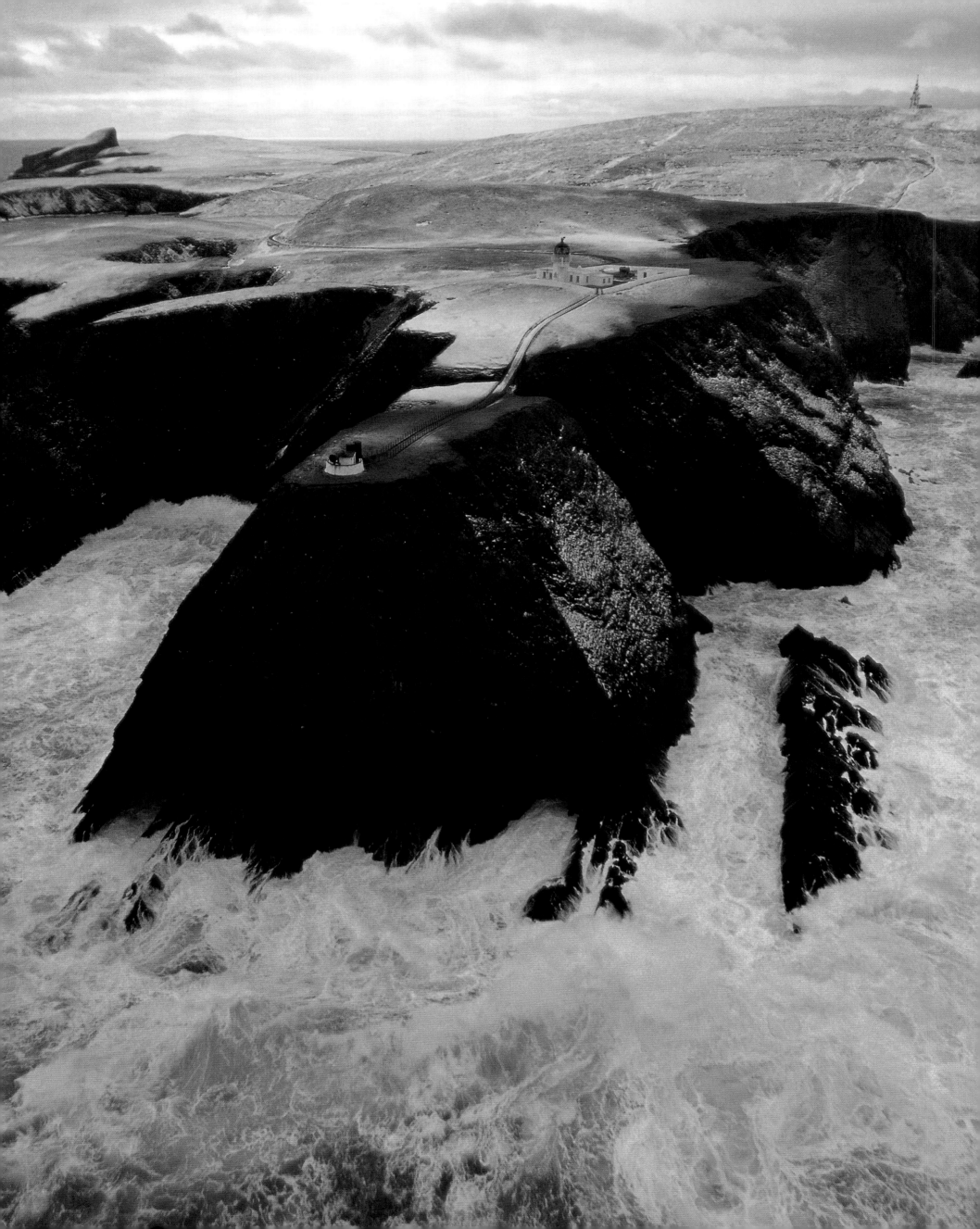

1 The Spirit of the Ocean

'What folly to trust in the sea,' cried Erasmus in the early 16th century, to be echoed later by Sancho Panza, Don Quixote's faithful squire: 'If you wish to learn to pray, go to sea.' A Danish variant on the same theme runs: 'He who cannot pray should go to sea, and he who cannot sleep should go to church.'

It was indeed regarded as folly to launch oneself onto the vast ocean that teemed with monsters such Scylla, Leviathan, the Kraken and all the other beasts who preyed on each other in the dark depths of the sea, but whose common aim was to capture and devour human beings – or at least, like Circe, rob them of their human identity. Here the unleashed elements recall the primeval chaos of the world. What folly, then, to expose oneself to the tempests and the raging winds, as they whip up mountainous waves that rise from the abyss and then crash down, threatening to engulf you and hurl you for ever into an eternity without a grave.

Was not the sea – or so it was long believed – the domain of Satan? How often the Devil himself was sighted at the helm of ghost ships, each a floating hell. Hence the need to exorcise the raging spirits of the ocean, as the sailors of Spain and elsewhere used to do when they threw holy relics into the sea – and hence the long, majestic line of monuments and plaques to give thanks for rescues at sea.

And are not the mariners themselves dangerous men to know? What is it that draws them to the open sea – these irregular churchgoers and legendary womanizers, with a girl in every port and a dusky sweetheart on every tropical island? The ocean is chaos and it causes chaos. St John prophesied no sea in paradise. But is this folly in fact a form of wisdom?

The ocean plumbs the very depths of humanity. In the light of the sun, it mirrors the human soul. It is the long journey to far-off lands, and a call to liberty. Beneath the dome of the starry skies, it invites contemplation and exploration of oneself, of others, and of the wide world. Ulysses' odyssey is the archetypal voyage of discovery and initiation: Circe, the sirens, the kingdom of the dead, abysses and monsters – they are all trials to test the stature of the hero. Setting sail, holding one's course, building character, acquiring experience – this is a school of life for all whom the ocean seduces and holds captive: the pleasure-seekers, the adventurers, the fishermen, the merchants, faces furrowed by the sun refracted in the shimmering salt.

Those who think that going to sea is a challenge that entails danger, defiance of the elements, the ever-present fear of shipwreck, have good reason, but this is only one aspect of the reality. There is another perspective to life at sea: the pleasure of solidarity, being part of a team, believing that whatever the waves may be doing now, they are taking you to those mythical 'Fortunate Isles', long sought by the navigators of old, and situated according to legend somewhere in the eastern Mediterranean.

If you head for the sea, you are committing yourself to new encounters and hence to new opportunities, to adventure and hence to risk – values that have all been promoted by the modern, liberal economy. In Britain's golden age, the navy symbolized the threefold ideal of liberty: it was the force that defended political, religious and entrepreneurial freedom. More than in the Protestant ethic so conducive to the development of the capitalist spirit – to paraphrase the title of Max Weber's famous work, with its diametrically opposed counter-examples – it is in the attraction to land or sea that one finds the true split. There is a striking contrast between 18th-century France, where the physiocrats argued that the land was the sole source of wealth, and England, where in 1776 Adam Smith published

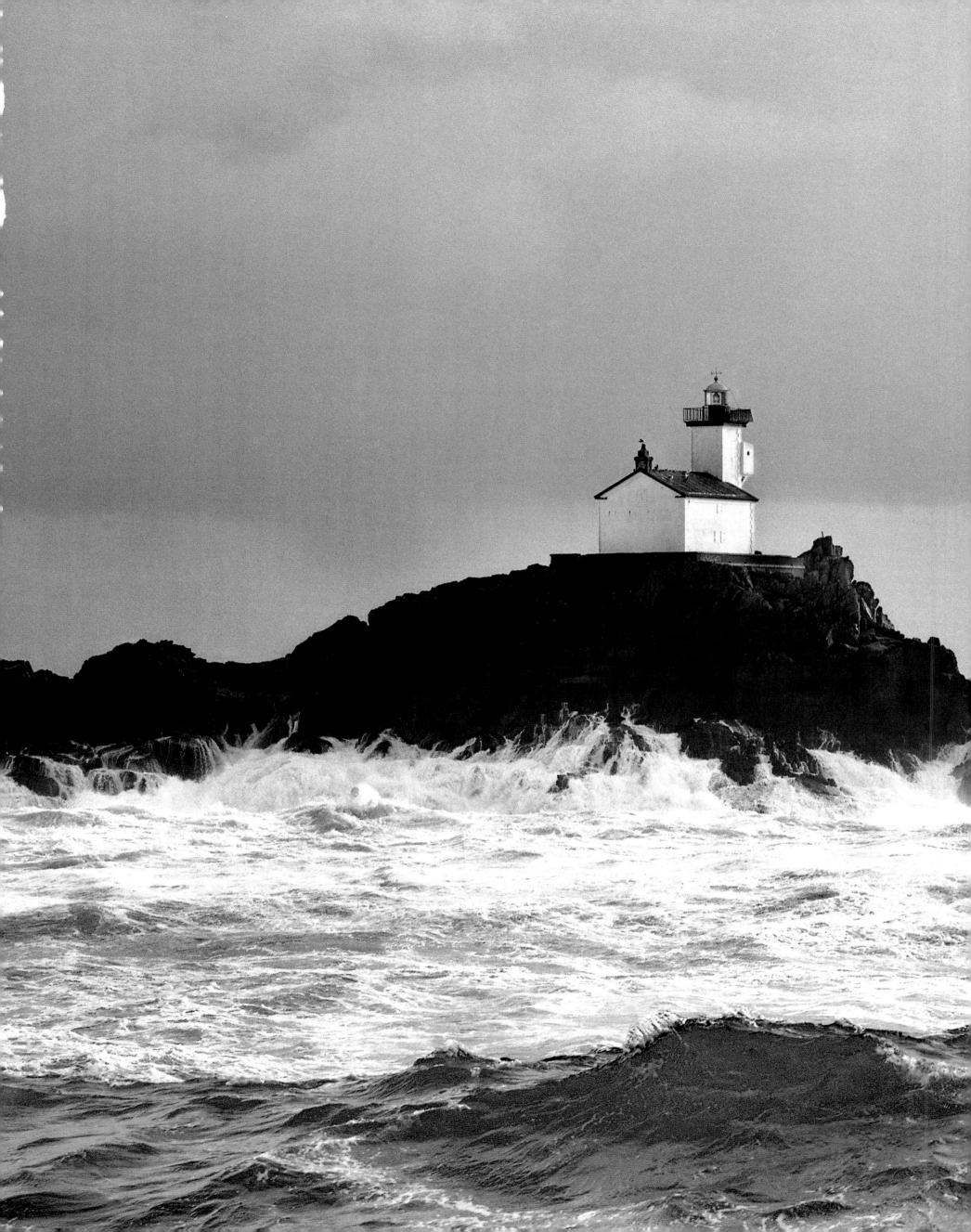

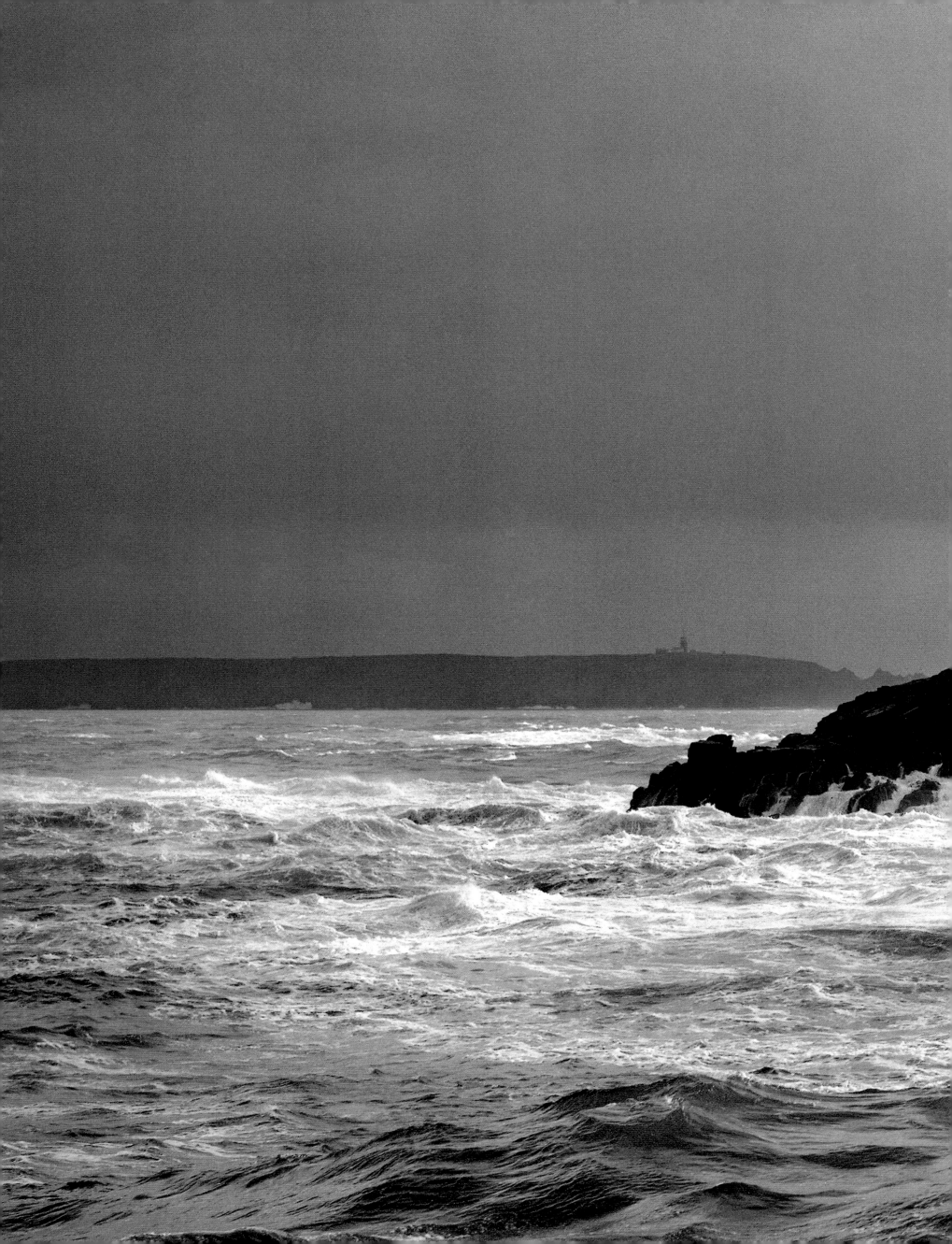

the first paean to industrial philosophy, *The Wealth of Nations*.

In the same vein, the theories of Utopian socialists such as Fourier, Saint-Simon and Cabet were based on the formation of traditional rural communities which all had one feature in common: the fact that they were far away from the sea, unlike Thomas More's island of Utopia. The same tendency was to be seen in Spain, with the Proyectistas, and in Russia, where the rural way of life maintained its dominance, and where despite the efforts of the State, the industrial era was still struggling to establish itself at the end of the 19th century.

Throughout history, the sea has been a source of prosperity, and also source of democracy. One might recall the beginning of the second part of Rousseau's *Discourse on the Origin of Inequality*: 'The first man who, having enclosed a piece of ground, bethought himself of saying "this is mine"…' But the ocean cannot be enclosed and it cannot give birth to tyranny. The absence of constraint in nations with strong naval traditions, like Great Britain or the Netherlands in modern times, or Athens further back in the past, has translated itself into freedom for the individual.

Source of democracy, source of liberty – and also source of relativity. 'Everything flows,' wrote Heraclitus. What lesson does the ocean teach us, if not that shores move, things fall apart, cliffs crumble, and even continents are only islands? The ocean demonstrates endless change, whereas the land nourishes our illusions of permanence. Reality, and therefore true wisdom, resides in the waves, but this very instability is itself a source of wealth.

In an age of mechanical propulsion, not to mention nuclear physics, when the unexpected is little more than an improbable contingency, the seaman's senses have for the most part given way to mathematics, meteorology and other exact sciences that leave nothing to chance. But the sea, as those who know it will confirm, makes a habit of upsetting all predictions, and invalidating even the most precise and scientific calculations. That is why a sailor's job will always contain the element of unknown danger which so attracts both men and women of courage and character.

In the light of this, and other factors too, the true folly lies in the fact that most formal education systems make a point of ignoring the ocean. France is one of the prime and most perverse examples. In a maritime sense, it is one of the most richly endowed of all nations: it is the only country in Europe that borders on four different oceans (the North Sea, the English Channel, the Atlantic and the Mediterranean) and, because of its overseas territories, it has access to every sea route; since the creation of exclusive economic zones in 1994, it has boasted the second largest area of ocean, with 11 milllion km^2 – compared to a land surface of 550,000 km^2. But in schools and colleges, the ocean is virtually a no-go area, except in literature courses. In Victor Hugo's *Oceano Nox* or Pierre Loti's *An Iceland Fisherman*, it presents itself as the cruel sea, enemy of mankind, who are best advised to stay at home. Even in higher education it is conspicuous by its absence: you will find no mention of it in business colleges, although a vast proportion of world trade is carried out by sea; nor does it figure in colleges of engineering, although technologically it offers a vast potential. We should be going out of our way to ensure that a sea breeze blows away the prejudices, to bring a new ocean-going energy, interest, and spirit of adventure to younger generations.

With the cyber-revolution, we have embarked on a new kind of voyage. Perhaps it is worth remembering that 'cybernetics' is derived from the Greek *kubernan*, which means to steer.

Today, the ocean offers us boundless possibilities. It enables new generations to forget the missed appointments of the past. The planet is becoming more and more oceanic. Pangaea, the primordial Earth that split up into five continents, should be viewed now as a base from which to explore the sea that unites them all, for only the sea can provide us with the means to go round our world without leaving it. The land that has emerged is fully occupied, and there is now a significant movement by humanity to engage itself intensively in the zones around the shores. One step further, and we shall be occupying the sea itself. In due course, even the most earthbound of nations will learn to set sail.

FRANCE, TÉVENNEC
LIGHTHOUSE
Exiled in watery isolation, lighthouse keepers had to be strong characters. Cut off amid the foaming tumult of the waves, they needed to be fearless, as they constantly underwent tests of endurance and self-sacrifice. The site of a lighthouse since 1875, three miles from the Île de Sein, the infernal rock of Tévennec typifies the extreme solitude that the keepers had to endure for weeks on end. In thirty-five years, twenty-three Tévennec keepers – male and female, not counting temporary replacements – came and went. This record finally brought about the automation of the lighthouse in 1910, and sealed its reputation as an accursed place – the lighthouse that drove its keepers mad.

The Spirit of the Ocean

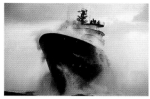

FRANCE, SEA RESCUE
Not all the consequences of the wreck of the *Amoco Cadiz* in 1978 were tragic. The catastrophe led to the French Navy chartering a rescue vessel designed to enhance the safety of the Ouessant route, the most crowded of all Europe's waterways, which is used by 150 ships a day. In 2005, after 26 years of service, the *Abeille Flandre* handed over its guardianship of the waters to the *Abeille Bourbon*, a new generation of rescue ship. Among its most common tasks are fighting fires, floods and pollution, and countering the damage inflicted by a tempestuous sea.

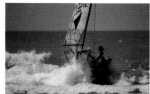

BRAZIL, STATE OF CEARÁ, CAPONGA
Typical of the coast of Ceará, in north-eastern Brazil, the *jangadas* – traditional sailing boats used for fishing – continue to provide a living for some 30,000 families. The only concession to modern times is that instead of logs, the hulls are now made of boards. Precarious though they may seem, these boats fearlessly sail a hundred miles out to sea, staying away for days on end and defying the most violent storms. There is nothing naive about these exploits. On the contrary, the *mestres* (captains) are wise in the ways of the ocean, with a unique mixture of flair and knowledge that has been passed down through the centuries.

INDIA, KERALA, SEINE FISHING
Ignoring the breakers crashing down on the beach at Vilinjam, the fishermen put out to sea in order to cast their net and then drag it swiftly back to the shore. There are millions of boats all over the world practising this traditional method of fishing. Most of the nets measure less than 24 m, and are used by more than 97 per cent of the 15 million fishermen on Earth. This vast fleet, designed for offshore fishing, generally fails to comply with international standards relating to health and safety. Over-exploitation of coastal stocks often forces the crews to go further afield in these unsuitable vessels, and to stay out on the open sea for longer periods, with the result that the risks become higher.

MARTINIQUE, BETWEEN GRAND RIVIÈRE AND LE PRÊCHEUR
The Caribbean, between the Central American isthmus and the Atlantic Ocean, is the dream of the long-distance voyager. To the east it is bordered by the Lesser Antilles, a chain of islands that stretches for 3,500 km from the Virgin Islands to Grenada, via Martinique. Colourful villages, traditional fishing, warm-hearted people, exotic food, idyllic beaches and coral reefs all feed the fantasies of round-the-world yachtsmen and women as they launch themselves across the Atlantic on the final stage before dropping anchor on the golden sands of the fairytale Caribbean.

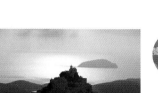

GREECE, ISLAND OF SERIPHOS
Scattered around the waters of the Mediterranean are a multitude of enchanting islands and archipelagos, including the Balearic Islands, Corsica, Sardinia, Sicily and the Aeolian Islands, cradle of the wind god. The Croatian coast has scattered many fragments of land into the Adriatic, and Greece has sown a crop of some 2,000 islands off its own coast, including the Ionians, the Sporades, and the illustrious Cyclades with their villages of dazzling white. These jewels are home to people who have lived off the sea for thousands of years, and off tourism for a few decades, but they still joyfully preserve the traditions and characteristics that have been shaped for so long by island life.

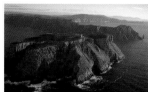

AUSTRALIA, TASMANIA
Off the south-east coast of Australia, the Bass Strait isolates a great chunk of land from the rest of the continent: Tasmania. And south of Tasmania, the rocky citadel of Tasman Island juts out of the Tasman Sea in front of Cape Pillar. Built in 1906 at the top of cliffs that rise to a height of 250 m, the lighthouse is one of the loneliest places in the country. Changes of personnel and the provision of supplies used to be effected by means of a rudimentary cable car, and for twenty years urgent messages were sent by carrier pigeon. Nowadays, everything is done by helicopter, but the three little houses that were once the homes of the former keepers now lie abandoned to the mercy of the elements.

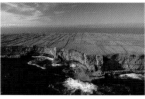

IRELAND, ARAN ISLANDS
Off the west coast of Ireland, the Aran Islands guard the entrance to Galway Bay. Battered by the powerful winds of the Atlantic, these rocky fragments with their steep ramparts rising to a height of 90 m seem anything but hospitable. And yet humans have settled here for some 4,000 years, defying the harshness of the elements. Over the centuries, they have enriched the soil with a mixture of sand and algae to build up the thin layer of humus necessary for agriculture and livestock farming, which they supplement with fishing. To protect their land from the insidious erosion of the winds, the islanders have built almost 12,000 km of windbreaks, which cover the ground in a gigantic mosaic.

IRELAND, SKELLIG MICHAEL
On the cliffs of Skellig Michael, a craggy islet jutting out of the sea some 10 km off the south-west coast of Ireland, the ruins of a lighthouse built in 1826 lie forgotten at the end of a winding path, abandoned to the winds. The impregnable fortress of the ocean guarantees its isolation, all too familiar to the convicts and lighthouse keepers who spent their lives in such desolate places as Skellig Michael. The ocean also gave monks the solitude they needed for their meditations. This remote rock conceals the remains of a 6th-century monastery, perched at a height of 180 m and exemplifying the rigours of monastic Christianity at that time.

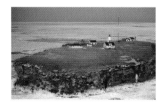

CANADA, GULF OF ST LAWRENCE, BIRD ISLAND
Before joining the Atlantic, the St Lawrence River merges into the vast Gulf of St Lawrence (300 km wide), the largest estuary in the world, from which rises the archipelago of the Magdalen Islands. Its 13,000 inhabitants, most of them French-speaking (Acadian and Québécois), live on fishing – particularly for lobsters. Amid the pounding waves, these fragments of land provide a natural bird reserve, and many migratory birds use them for a stopover. The Micmacs originally named the archipelago *Menagoesenog*, 'the islands swept by the wave' – an apt description in view of the 400 or so ships recorded as wrecked by storms in this region.

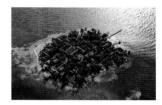

PANAMA, SAN BLAS ISLANDS
Off the Caribbean coast of Panama, some 350 islets are strung out across a crystal sea. These are the San Blas Islands, land of the Kuna people. Life flows along between lagoon and ocean, and in their crude but sharply honed wooden pirogues, the Kuna glide between the splinters of land on which their palm-roofed huts stand crowded together. They earn their living by fishing for crustaceans, cultivating coconuts, and through tourism and the traditional craft of making *molas*, brightly coloured fabrics embroidered by the women. Despite modern influences, this independent nation, which has been politically autonomous since 1925, has succeeded in preserving its ancient maritime culture.

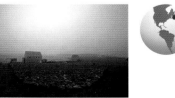

PANAMA, PANAMA CITY
The capital of the Republic of Panama, a country uniquely situated at a junction between two oceans and two continents, nurtures many contrasts and a cosmopolitan culture. On the seafront, a fortress of skyscrapers protects the drab business district with its procession of banks and shops. Light years away from there, the fishing port launches one of its jetties into the bay, not far from the Casco Vieja, one of the historic colonial districts. Here you can eat your fill of ice cream, have long conversations sitting on a mooring post, or lie down and have a siesta on top of the fishing nets, while an old wreck miraculously floating on the other side of the landing stage slowly rusts away.

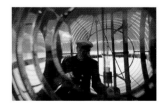

MOROCCO, ESSAOUIRA
In the port of Essaouira, the seine fishermen in their blue boats (painted this colour so as not to frighten away the sardines) fill their nets and crates with sardines, sole and red mullet, which they pile up on the quays amid all the paraphernalia of their industry. Sardines are abundant off the coast of north-west Africa, and Morocco has been a leader in the tinned sardine industry for many decades. Exports have doubled since 1997, reaching 100,000 tonnes. But the migration of the shoals is a cause of concern to the industry, which has already been forced to send its refrigerated lorries southwards in pursuit of the fish.

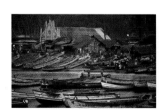

INDIA, KERALA, HARBOUR OF VILINJAM
The state of Kerala takes its name from *kera*, meaning 'coconut palm', and *alam*, meaning 'country'. It is a narrow coastal strip that runs along the south-west of the Indian peninsula. But Kerala's palms share star billing with the omnipresent water. The 'Backwaters', a vast network of lagoons and waterways that link up with the ocean, impose on the inhabitants a way of life that always revolves round the sea. The canals, bordered with lush vegetation, serve as roads, while the villages with their mosques and churches huddle together on narrow strips of land, and flocks of wading birds live in the lily and lotus-covered marshes. In Kerala, people spend as much of their lives on the sea as on the land. Every night, boats set out to fish about a mile from the shore, in the glow of oil lamps, illuminating the horizon in a garland of sparkling lights.

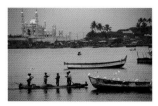

INDIA, KERALA, HARBOUR OF VILINJAM
Two thousand years ago, the Indian region that now constitutes the state of Kerala was already attracting seafarers eager to trade in spices, sandalwood and ivory. Phoenicians, Romans, Arabs and Chinese followed one another, and after the arrival of Vasco da Gama in 1498, trade with Europe brought ships from Portugal, the Netherlands and Britain. Kochi (formerly Cochin) was the final destination of this maritime route, and among other things it offered one of the finest natural harbours in the world. Constructed at the point where Lake Vembanad – a huge coastal lagoon – flows into the Sea of Oman, Kochi guards the entrance to a vast network of canals, islands and man-made lakes that bring the sea into the daily lives of the surrounding villages.

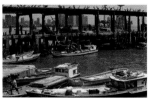

SAINT-PIERRE AND MIQUELON, ÎLE AUX MARINS
Off the east coast of Canada, south of Newfoundland, the little French archipelago of Saint-Pierre and Miquelon comprises 242 km² of rural land, sometimes enveloped in thick banks of fog coming from Newfoundland. For more than 180 years, the economy was driven by cod-fishing, with the cod being laid out to dry on these great stone platforms. But the crisis in the fishing industry has been an economic catastrophe, and since then the islands have depended on subsidies from France. The 7,000 inhabitants include many descendants of Breton, Basque and Norman fishermen who settled on the islands back in the 16th century. The traditions and folklore of these three seafaring peoples formed the original culture of Saint-Pierre and Miquelon.

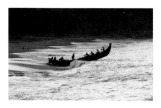

IRELAND, TORY ISLAND, JOHN JOSEPH DOHERTY
In the 6th century, a sailor monk landed on Tory Island, north-west of Ireland, and prophesied that this tiny islet would never be deserted. With the exception of a period during the Middle Ages, when the inhabitants prospered on piracy, life has always been hard on this, the poorest of all Ireland's islands. Despite the efforts of the government to make them leave, the people have clung to their rocky home, living on fishing, market gardening and subsidies. Art too may have helped to save them from disappearing completely. However, unemployment and emigration are a threat to the precarious balance of this community. Fifteen centuries later, the prophecy is still holding, but for how much longer?

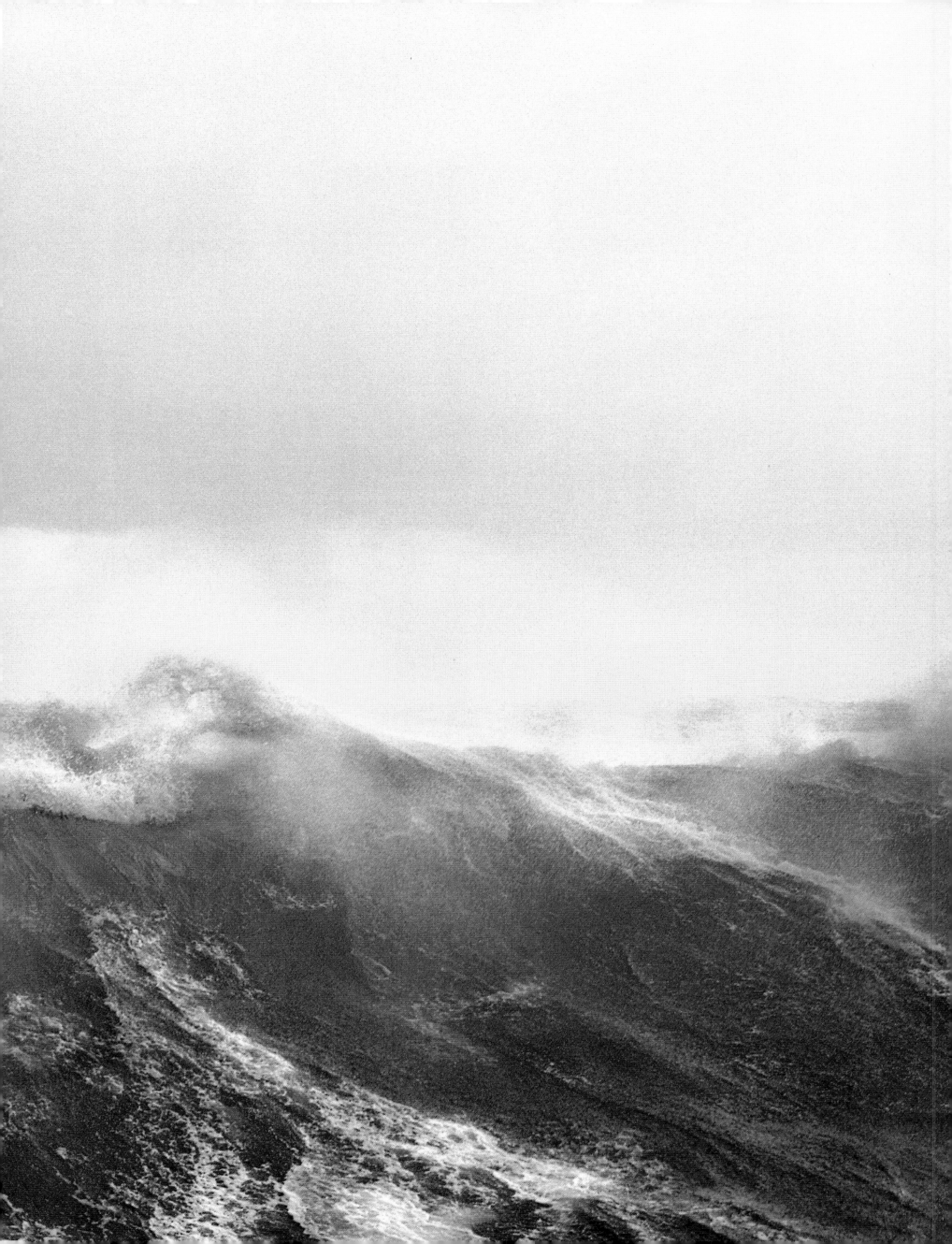

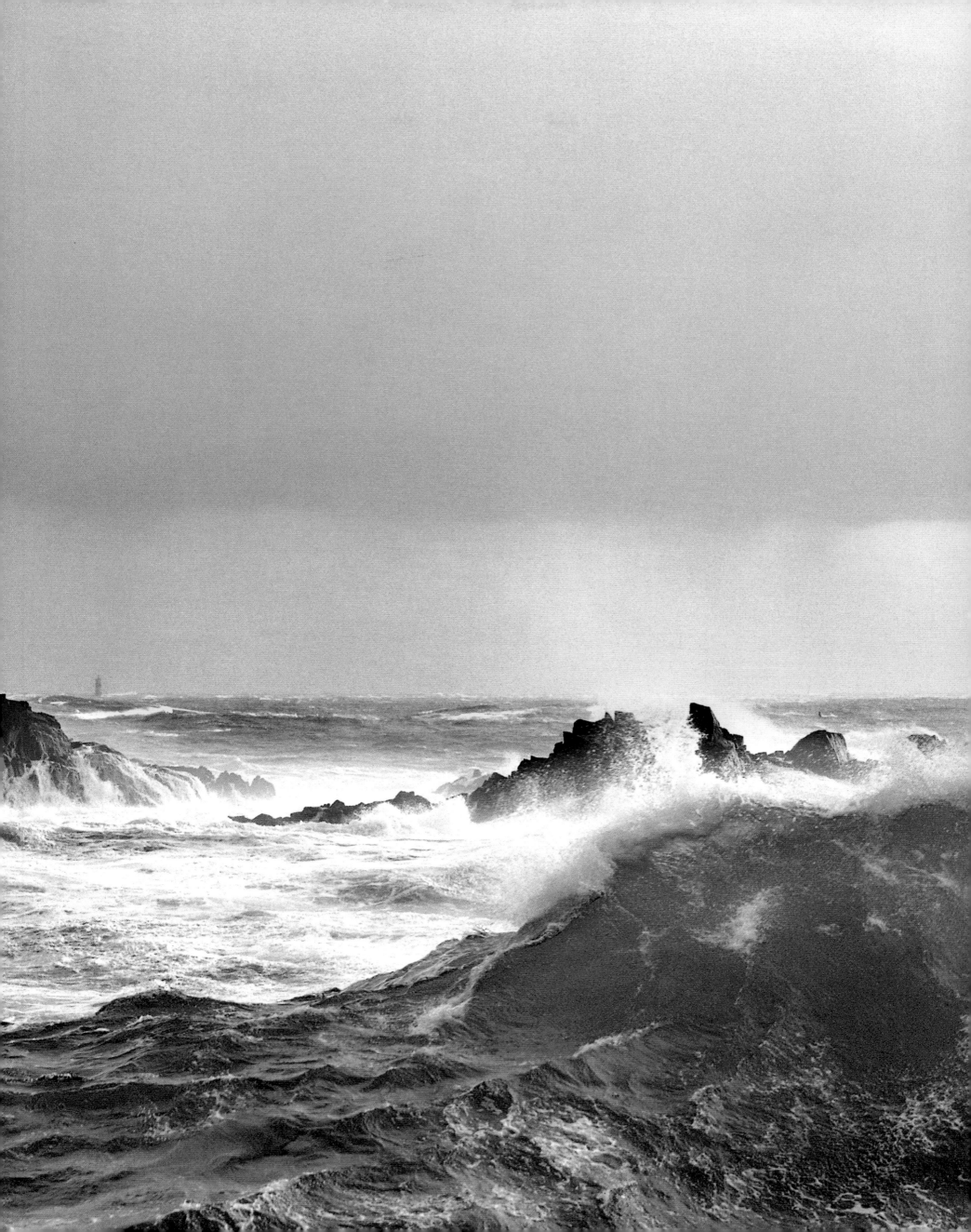

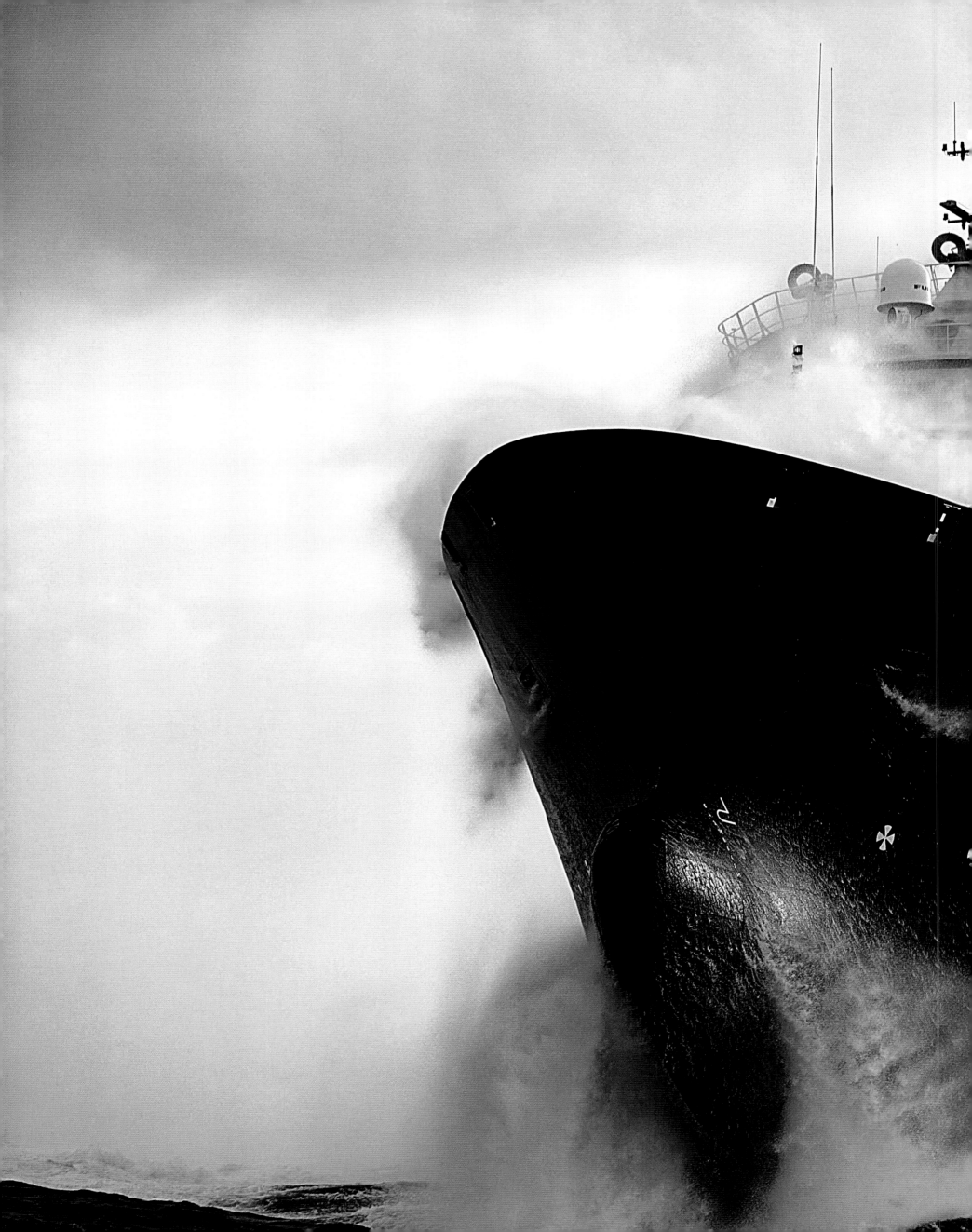

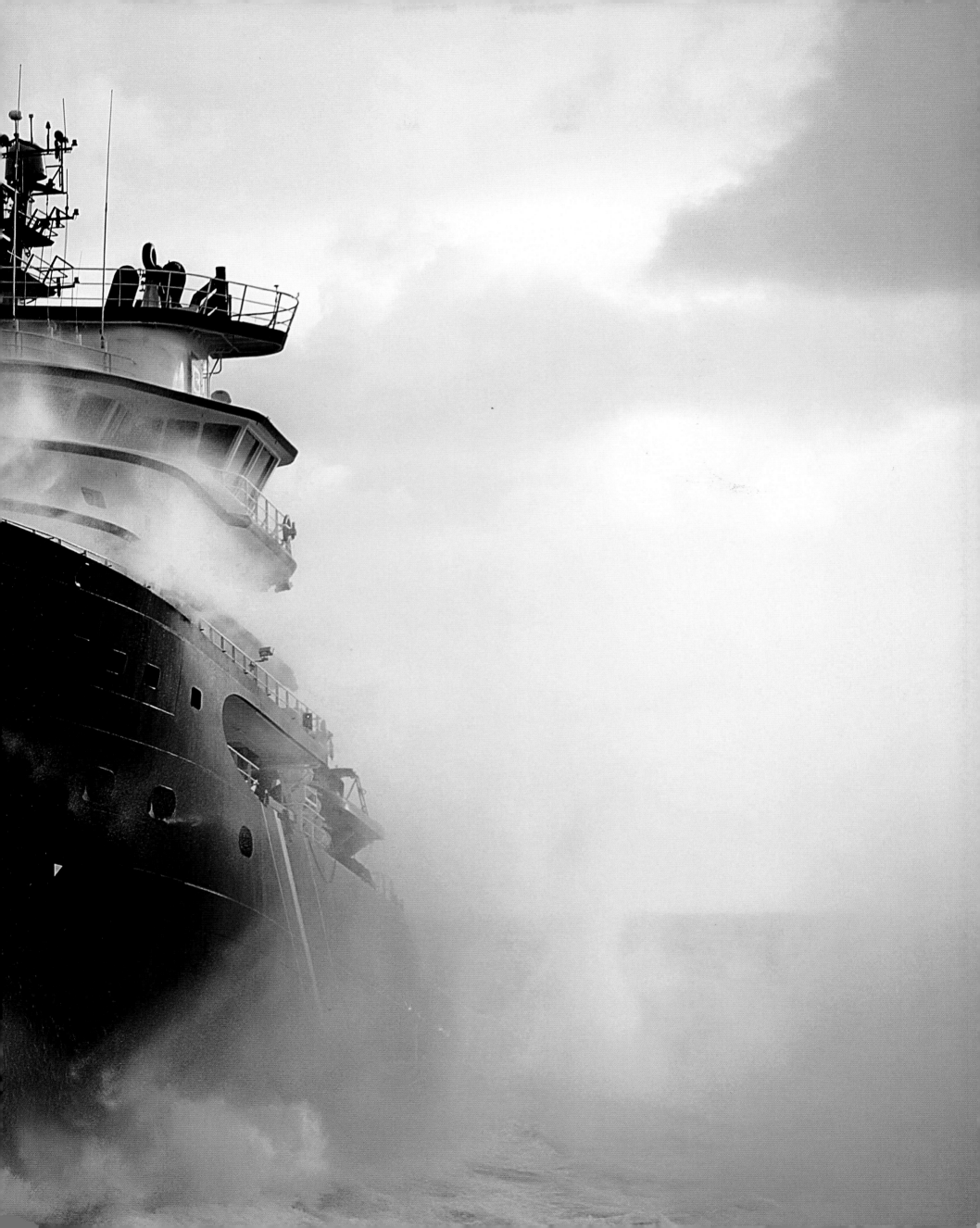

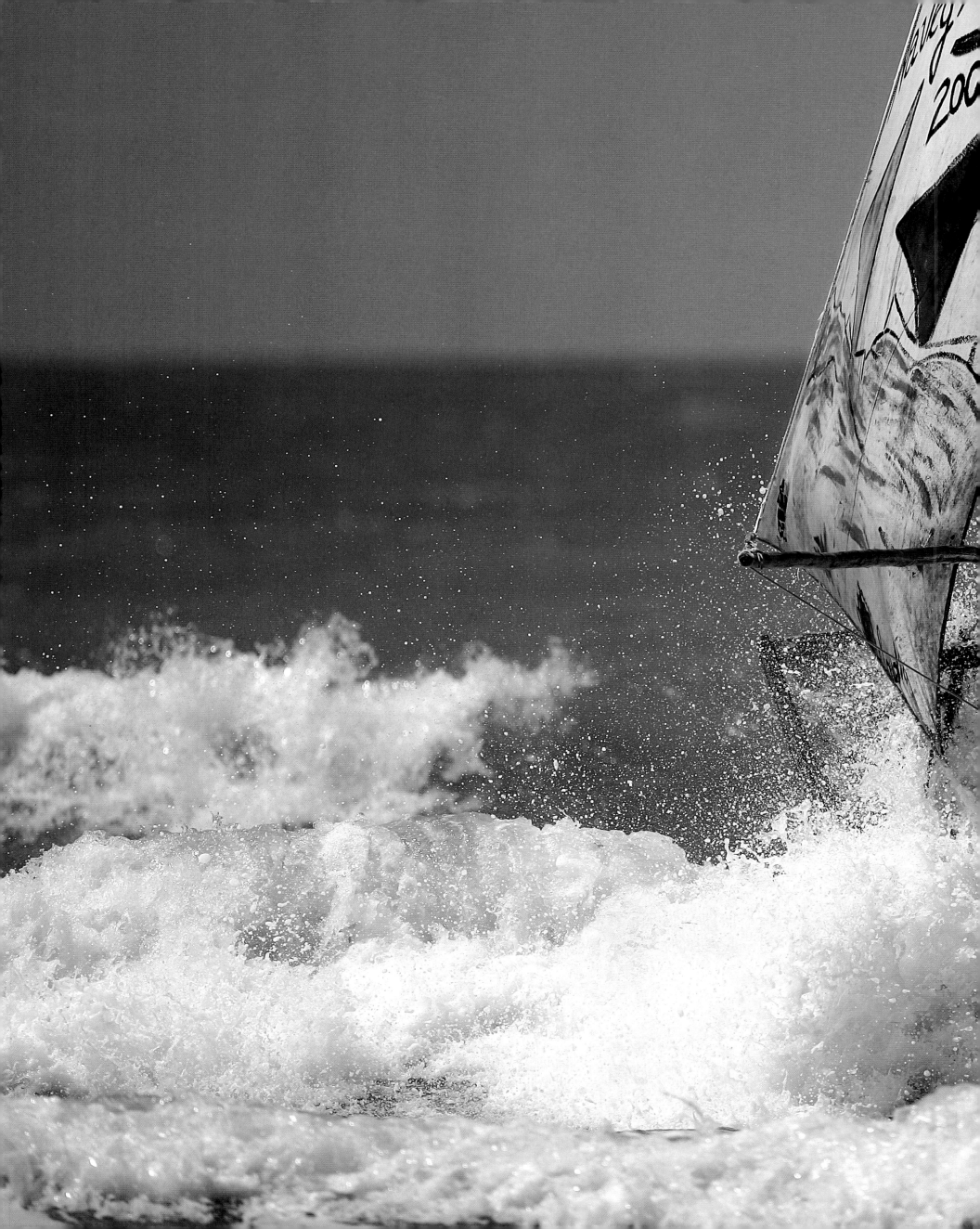

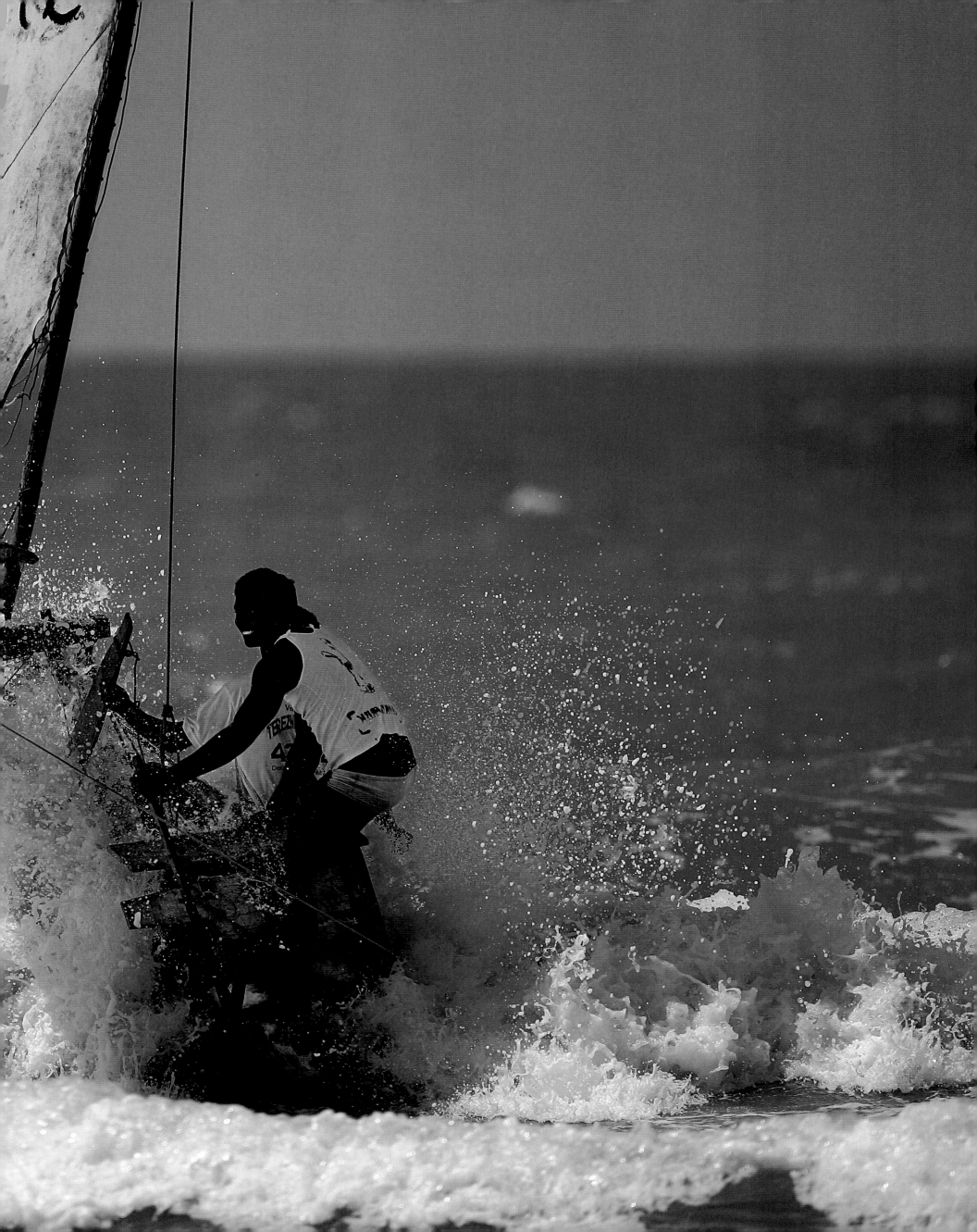

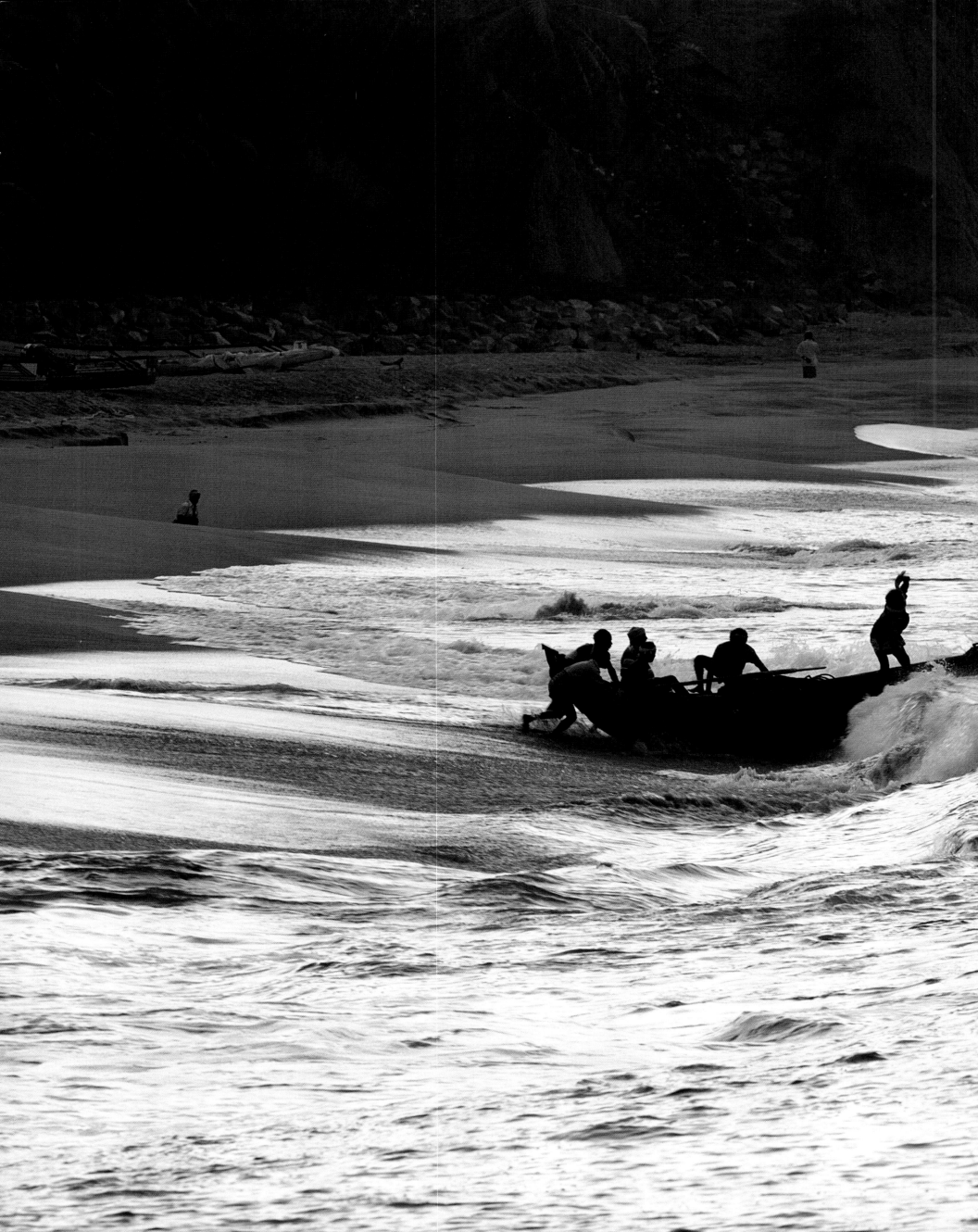

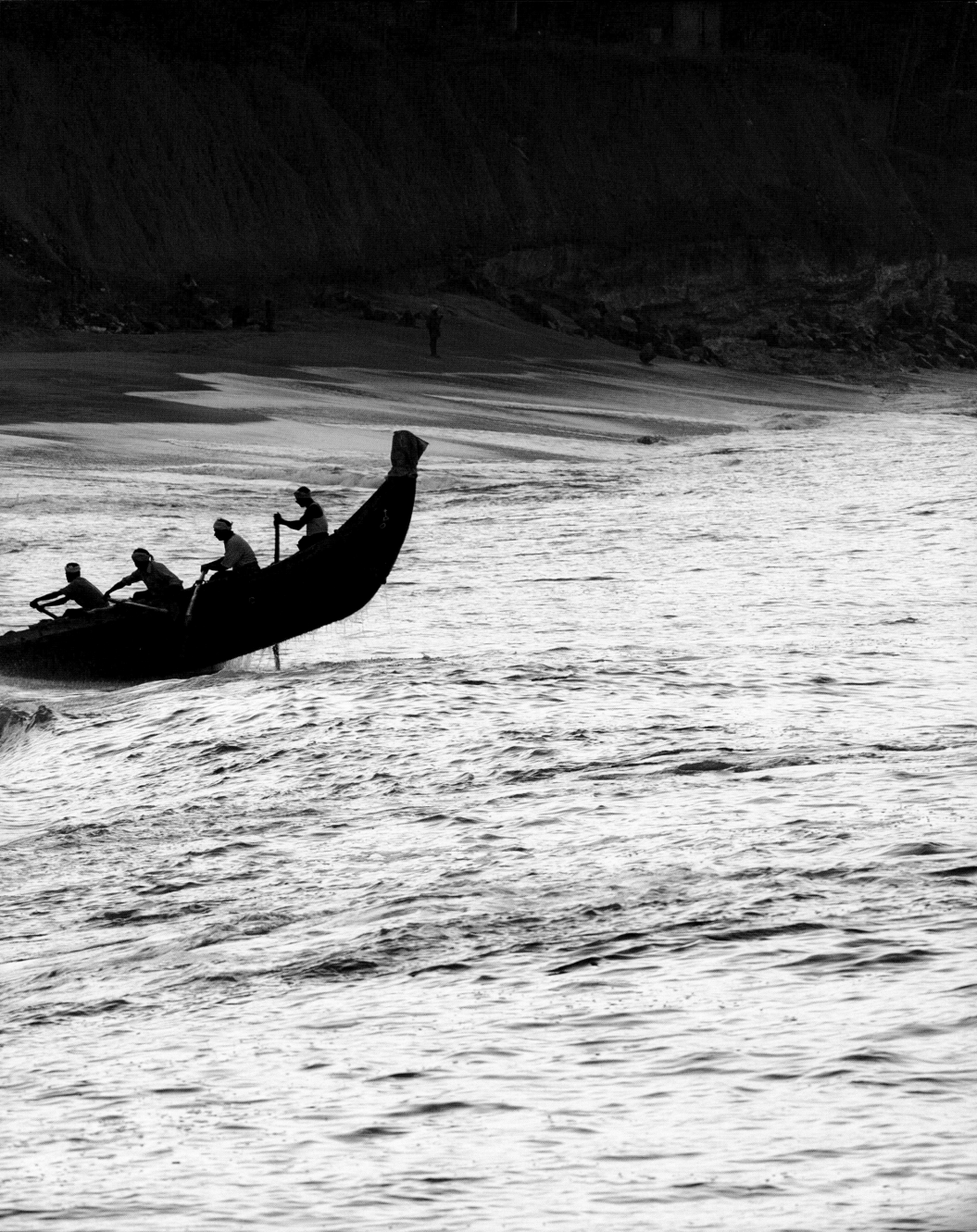

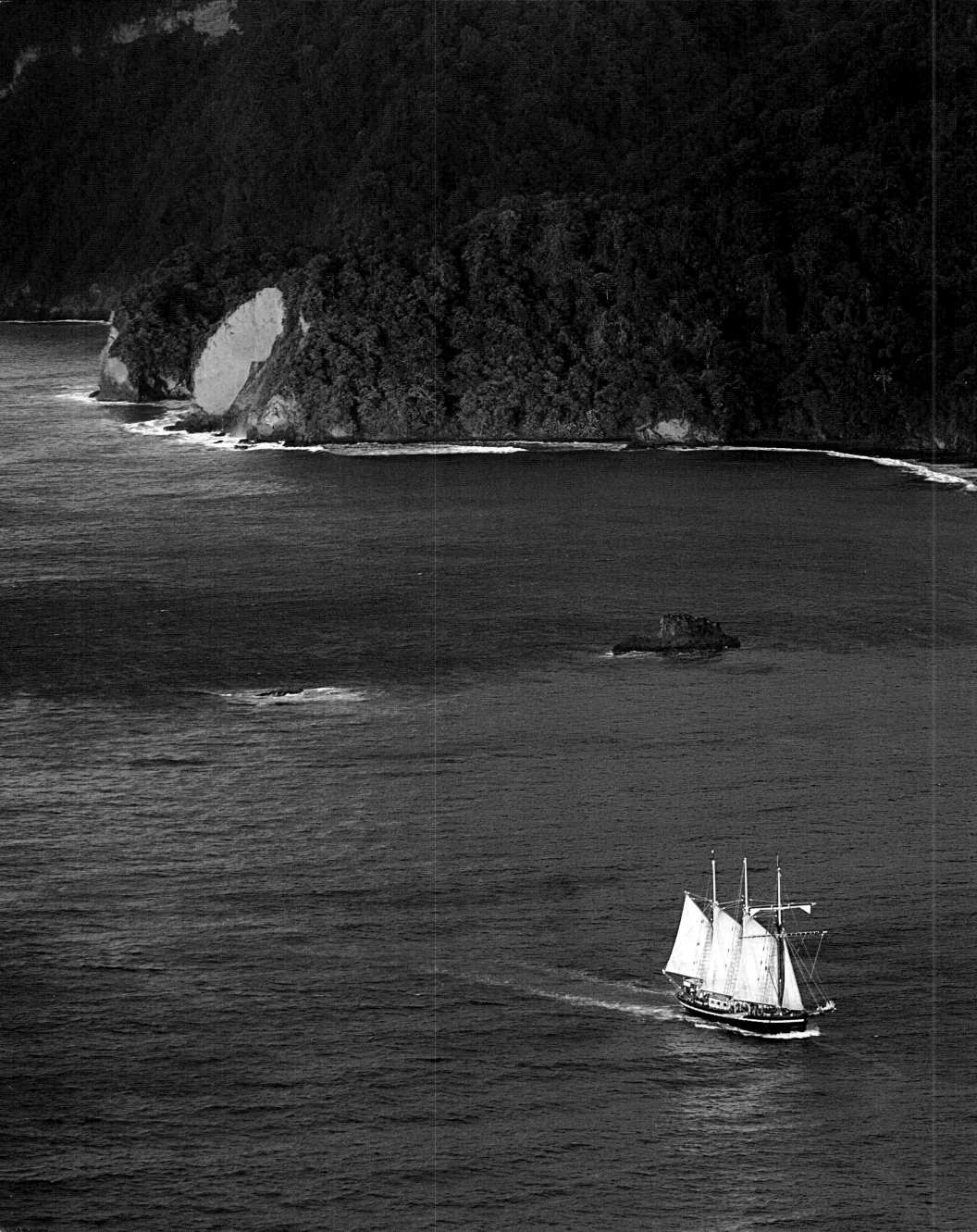

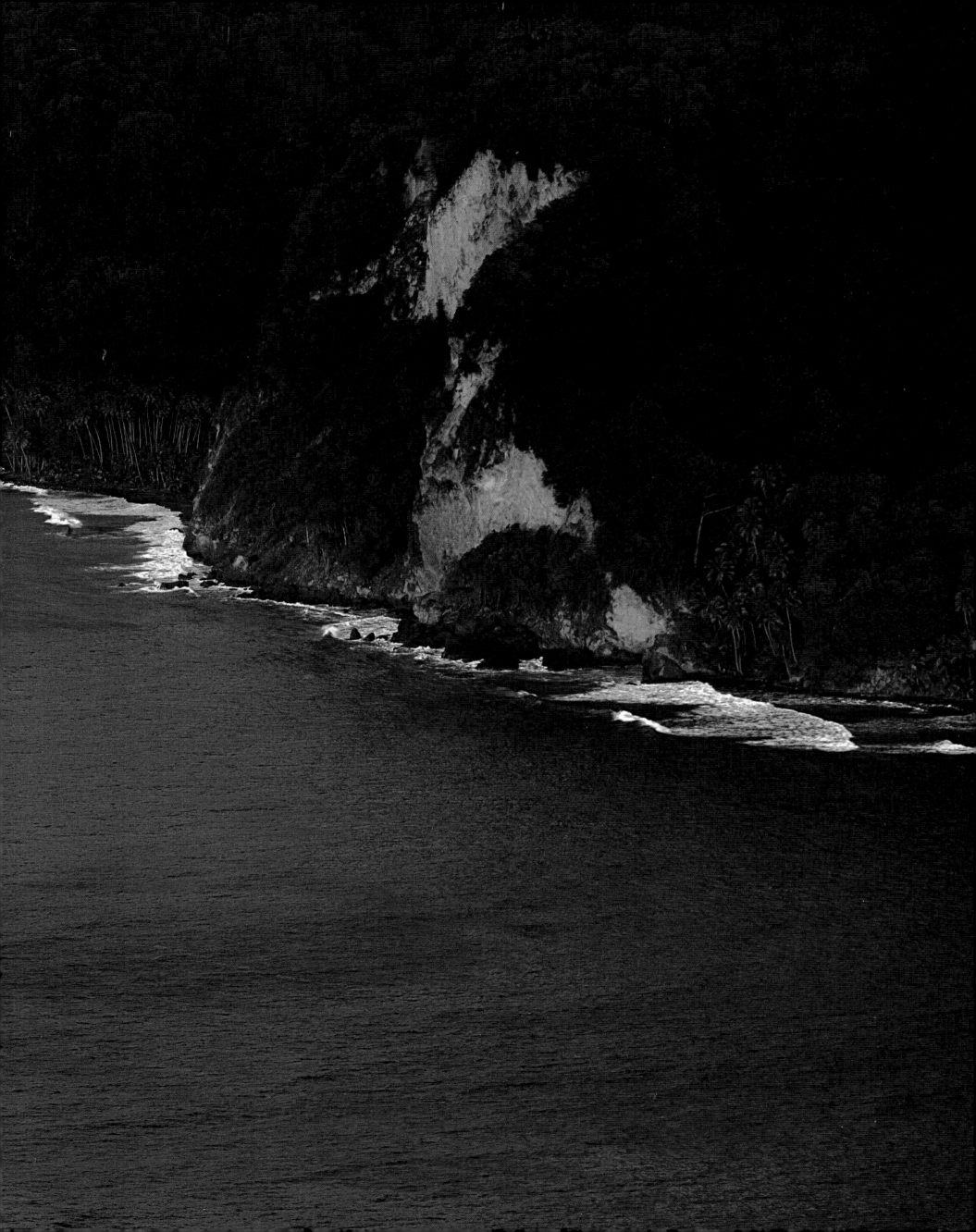

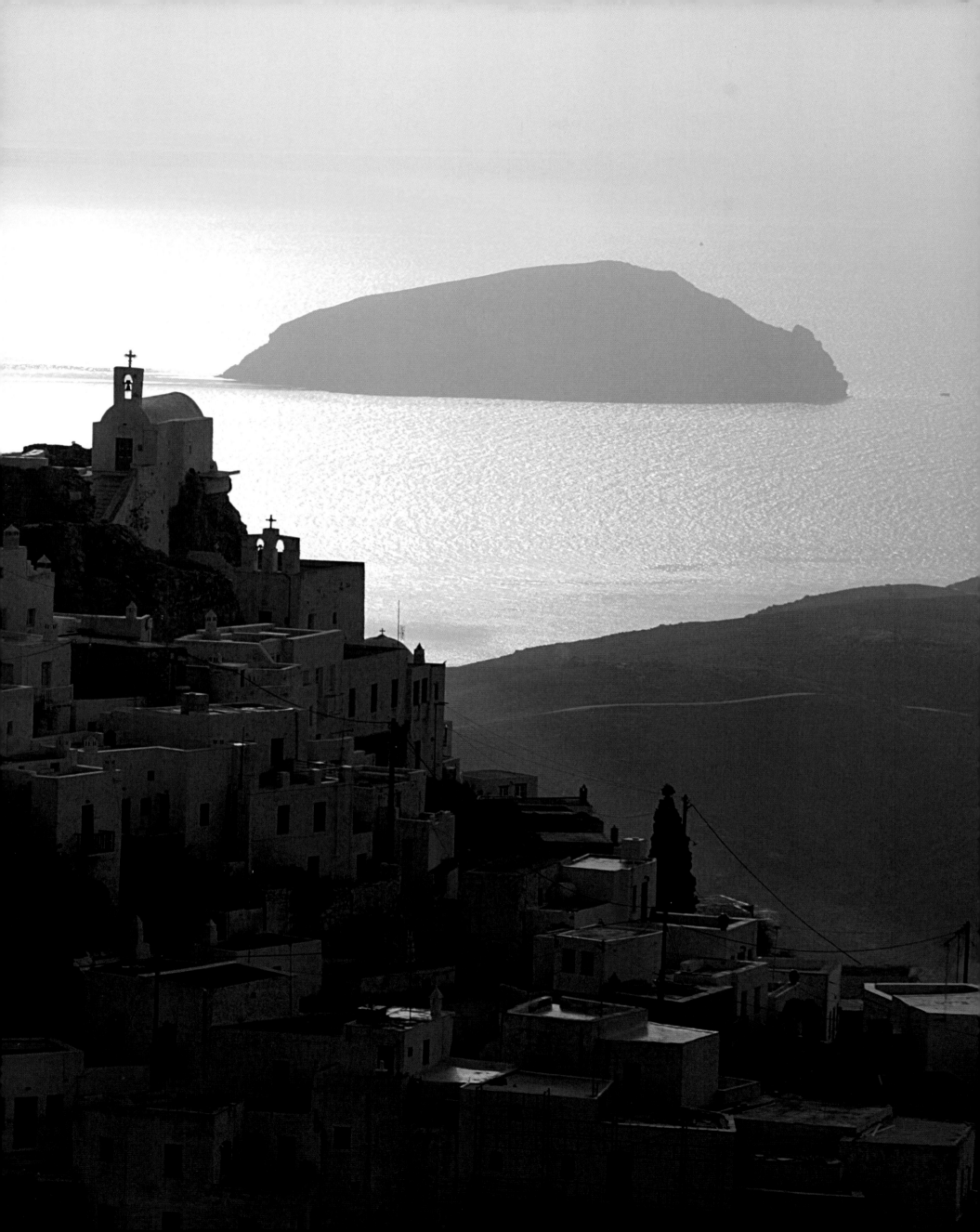

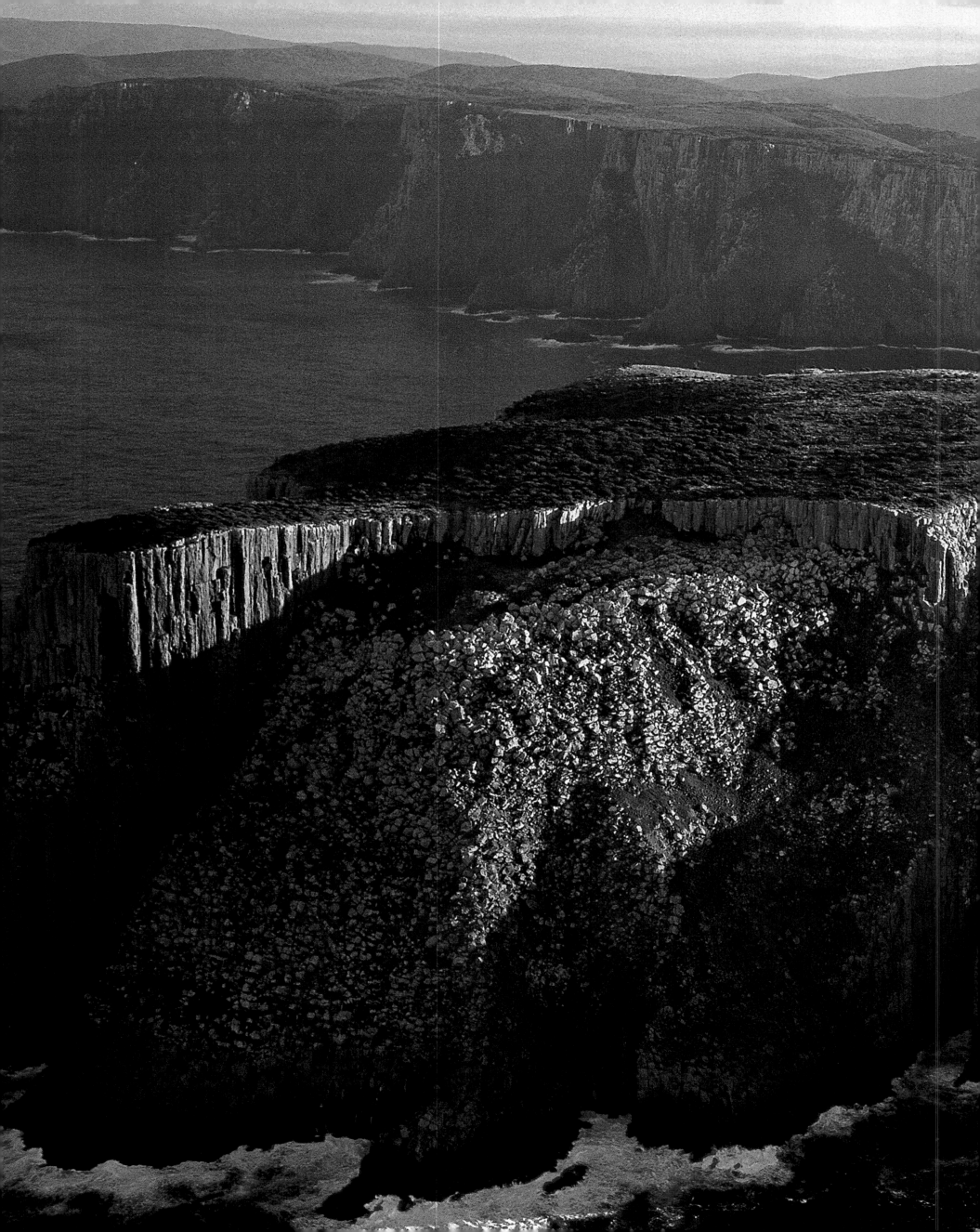

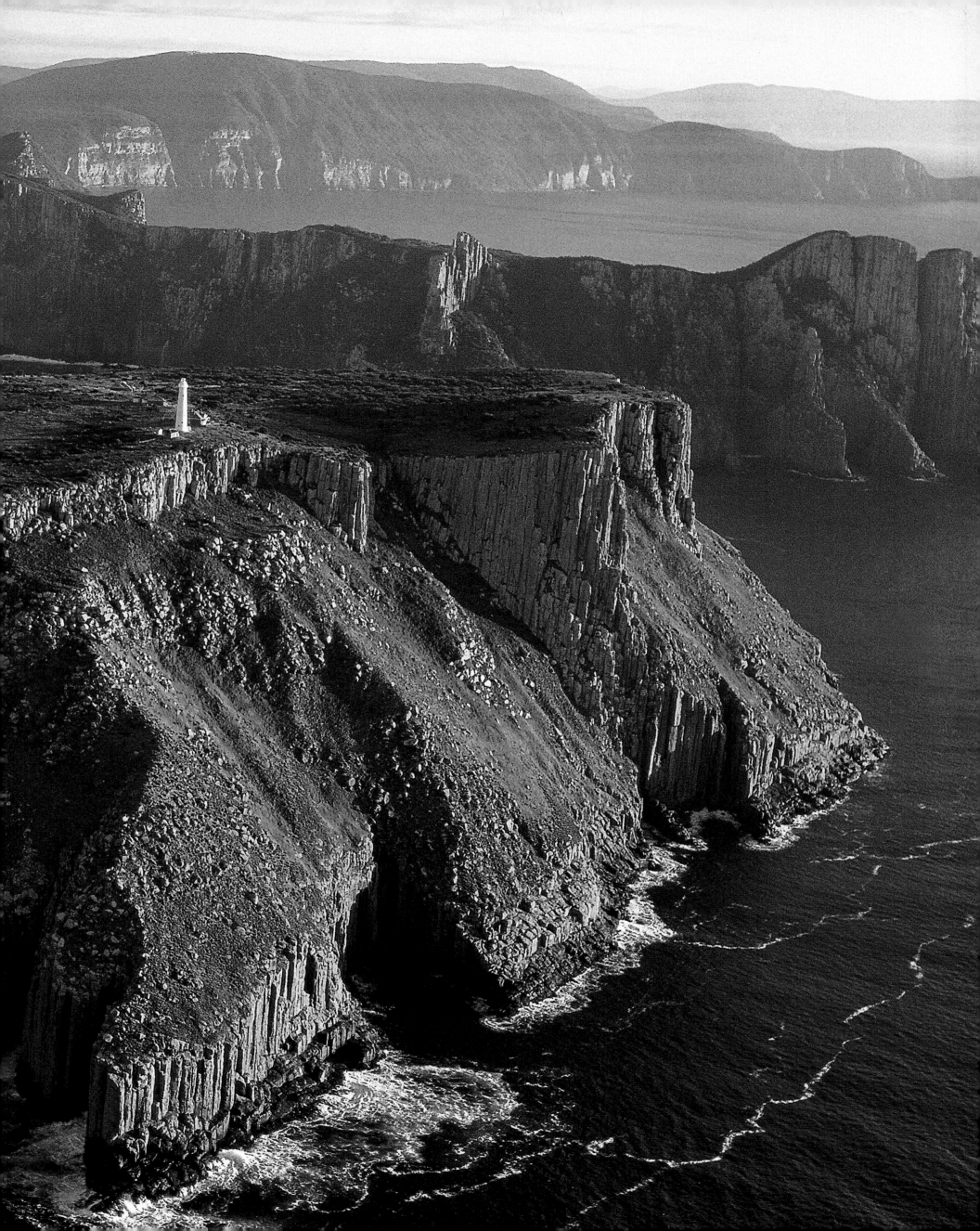

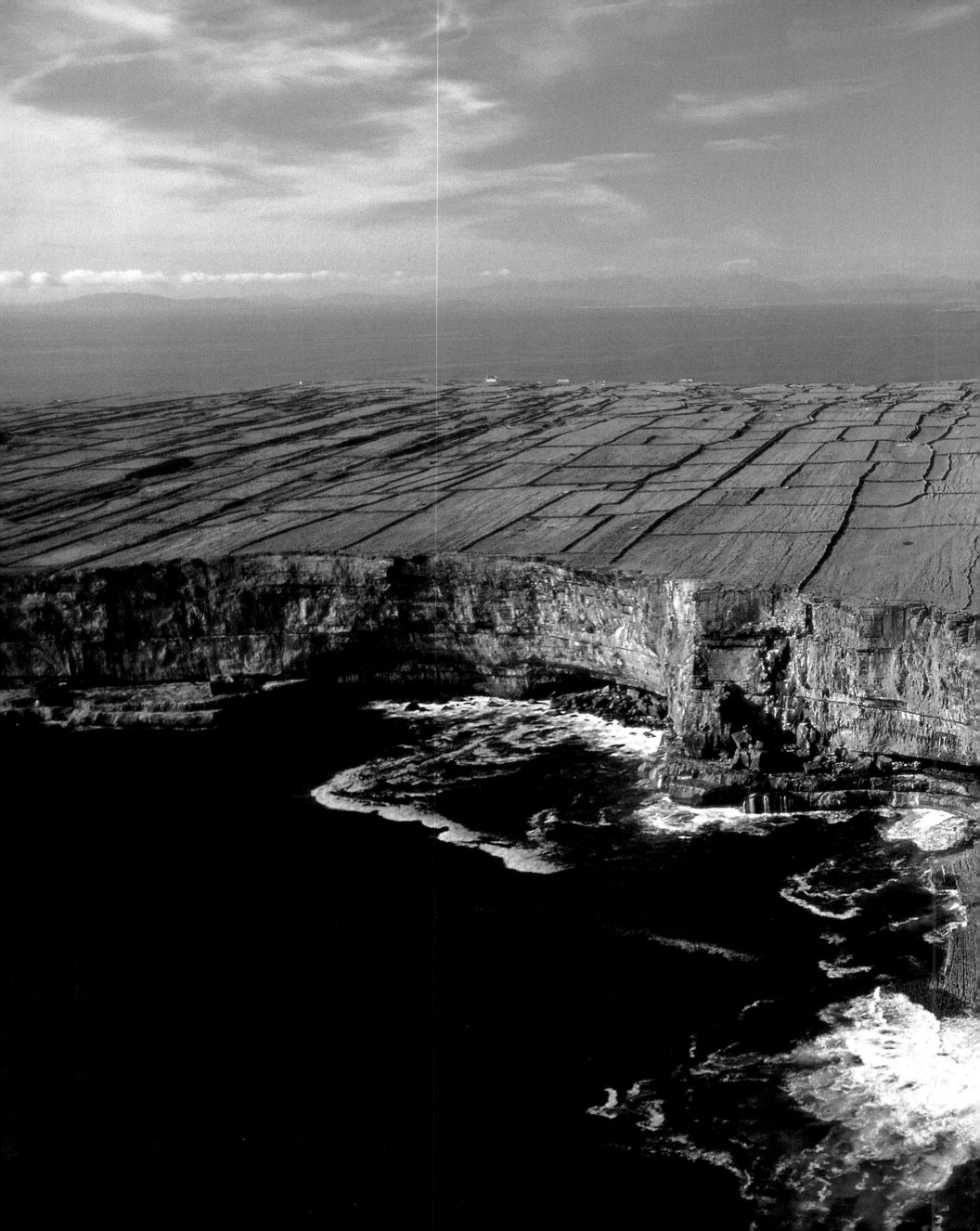

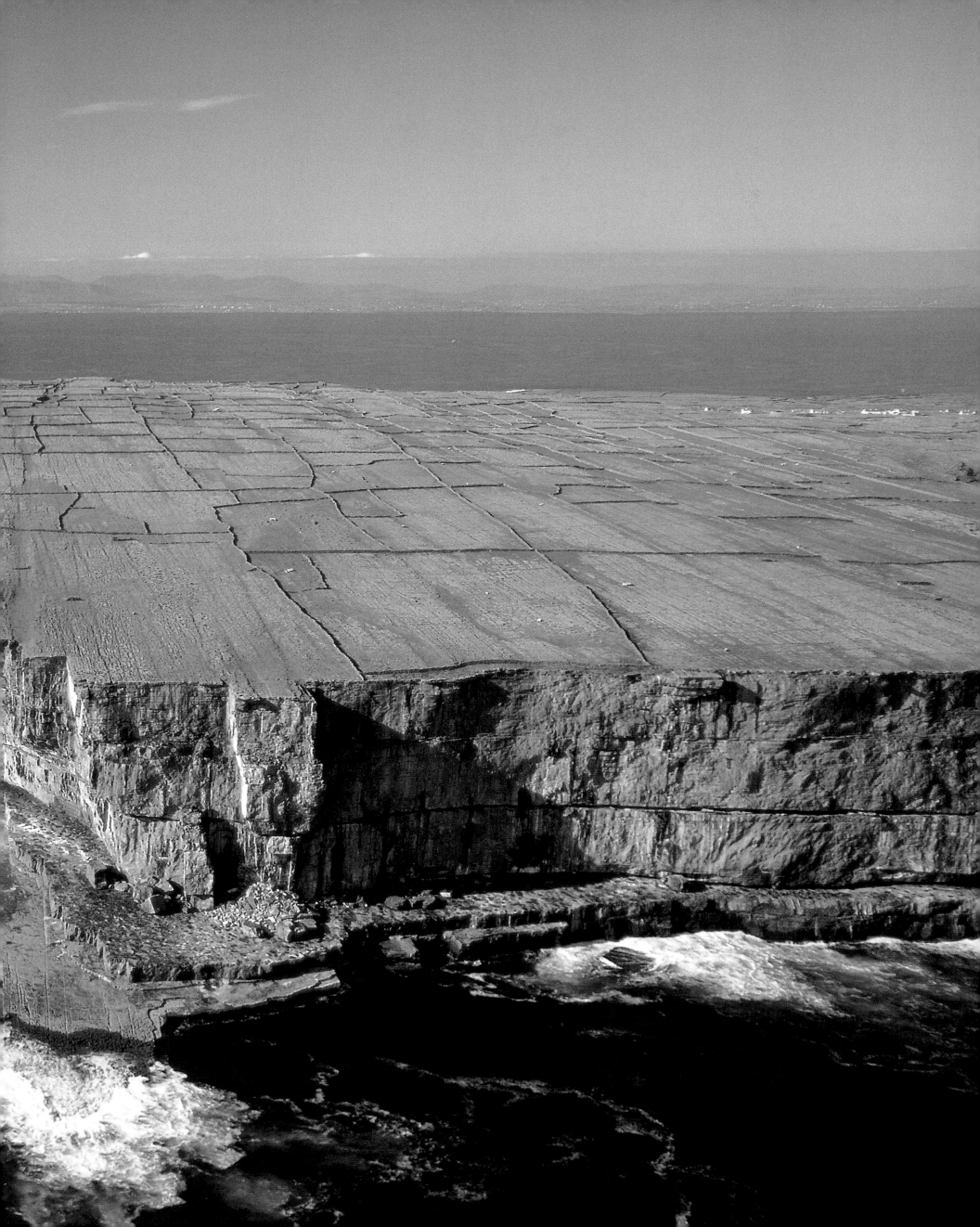

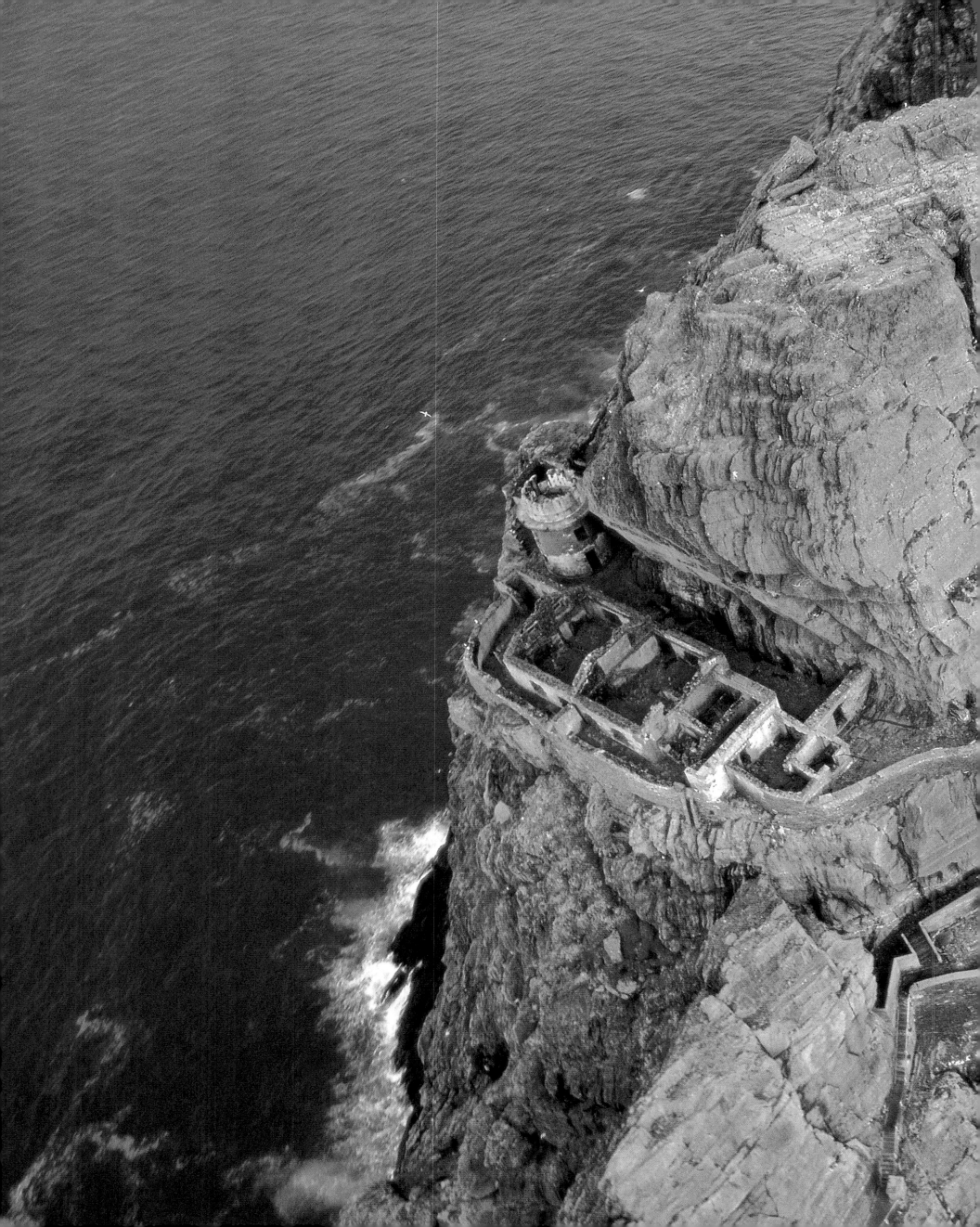

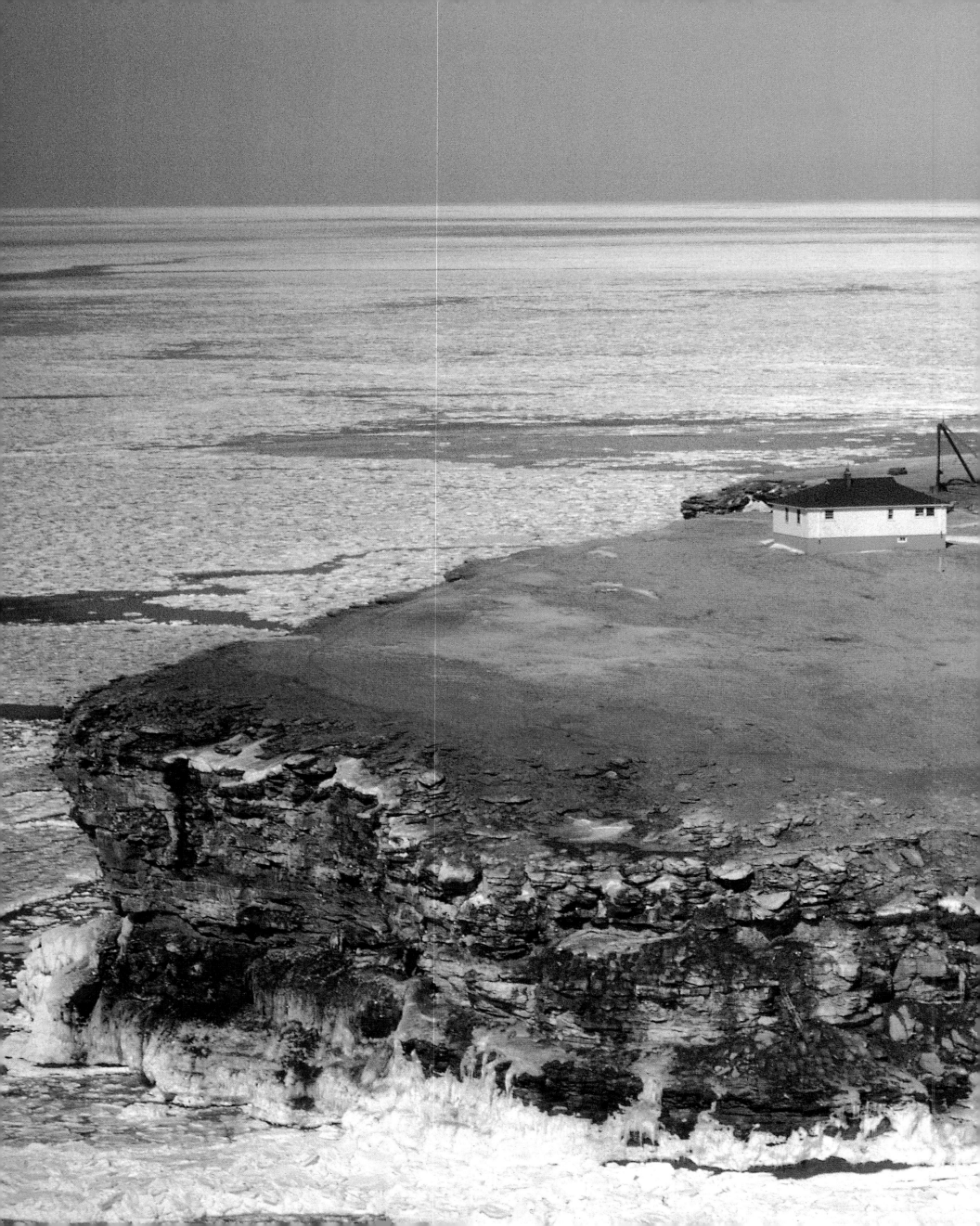

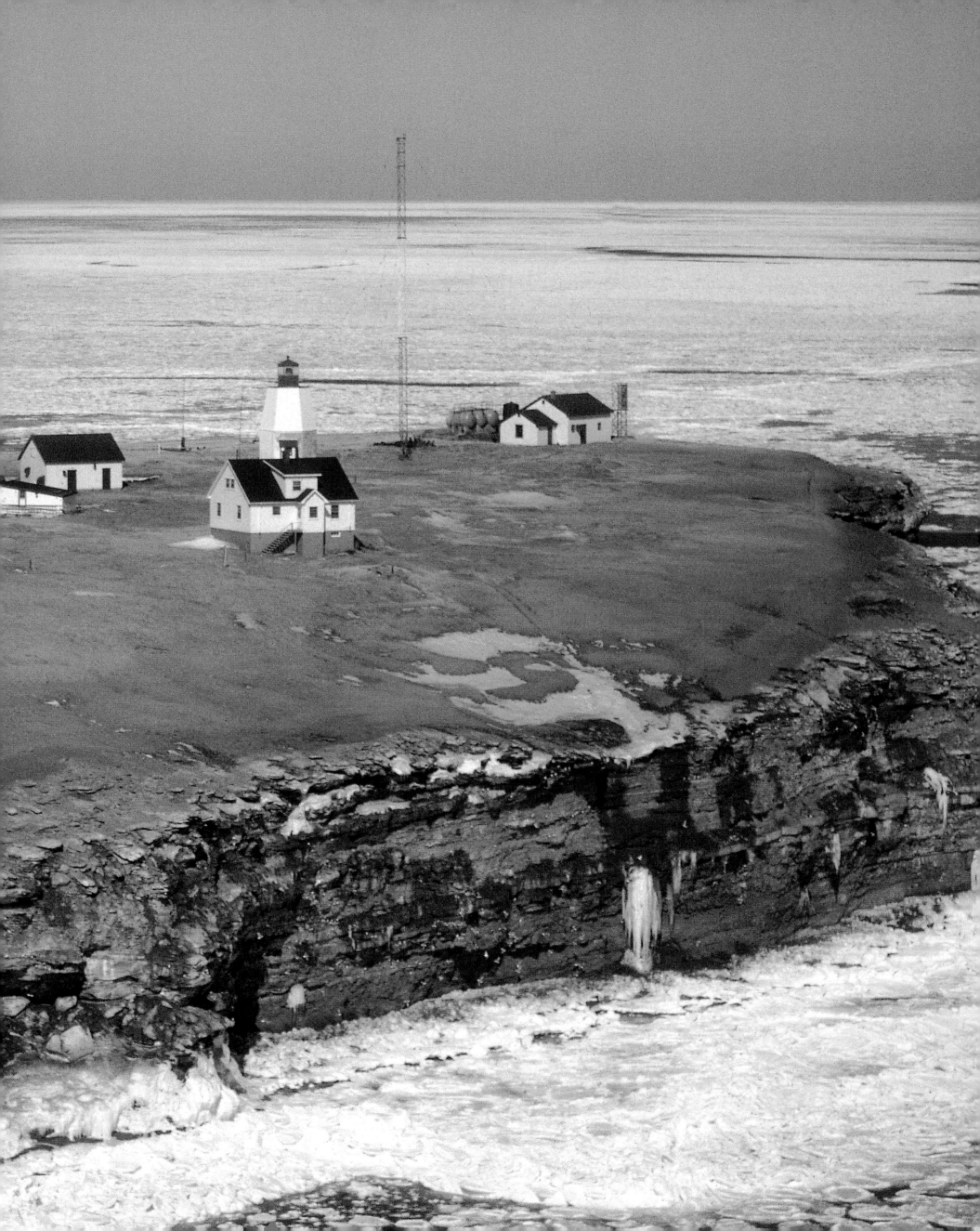

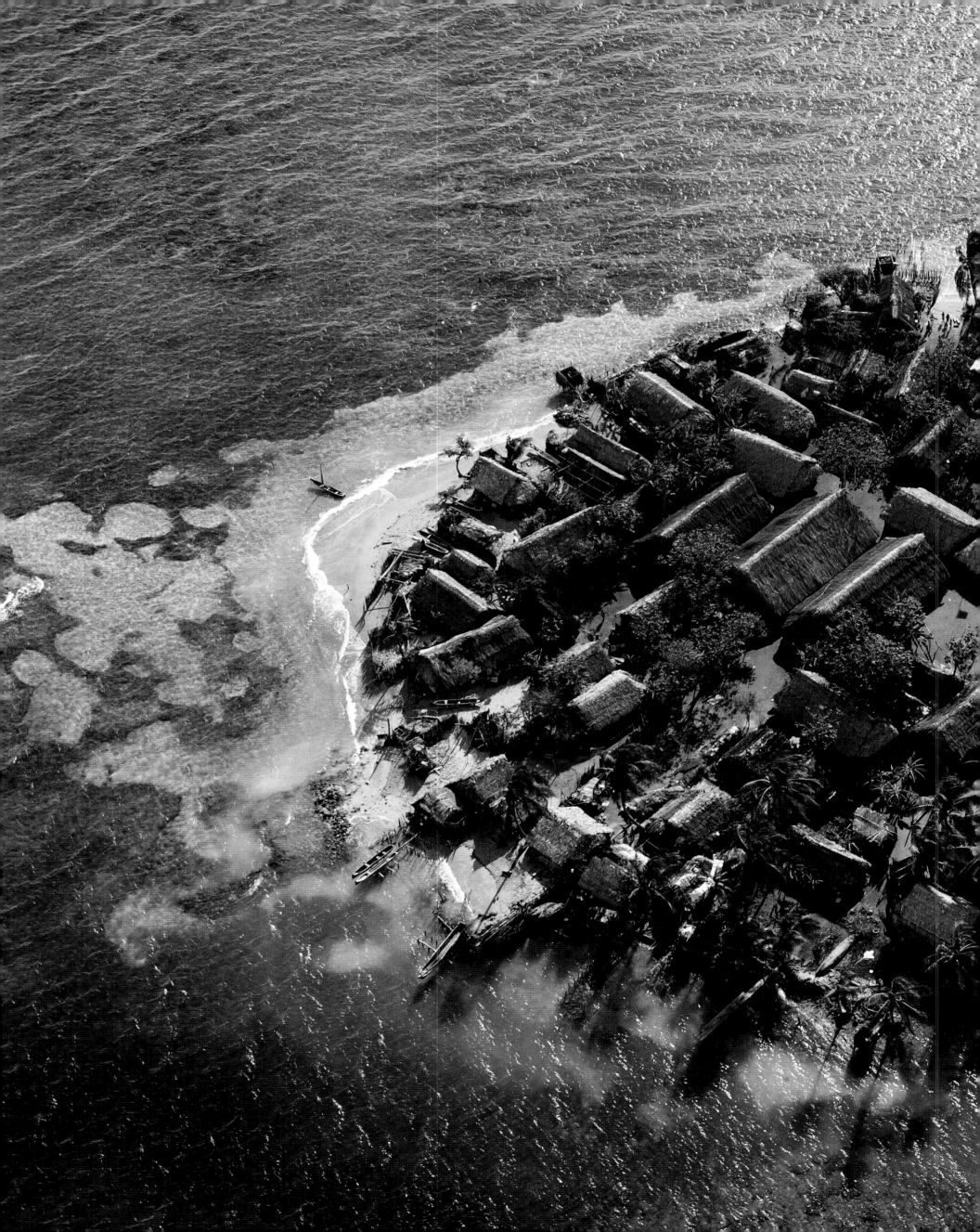

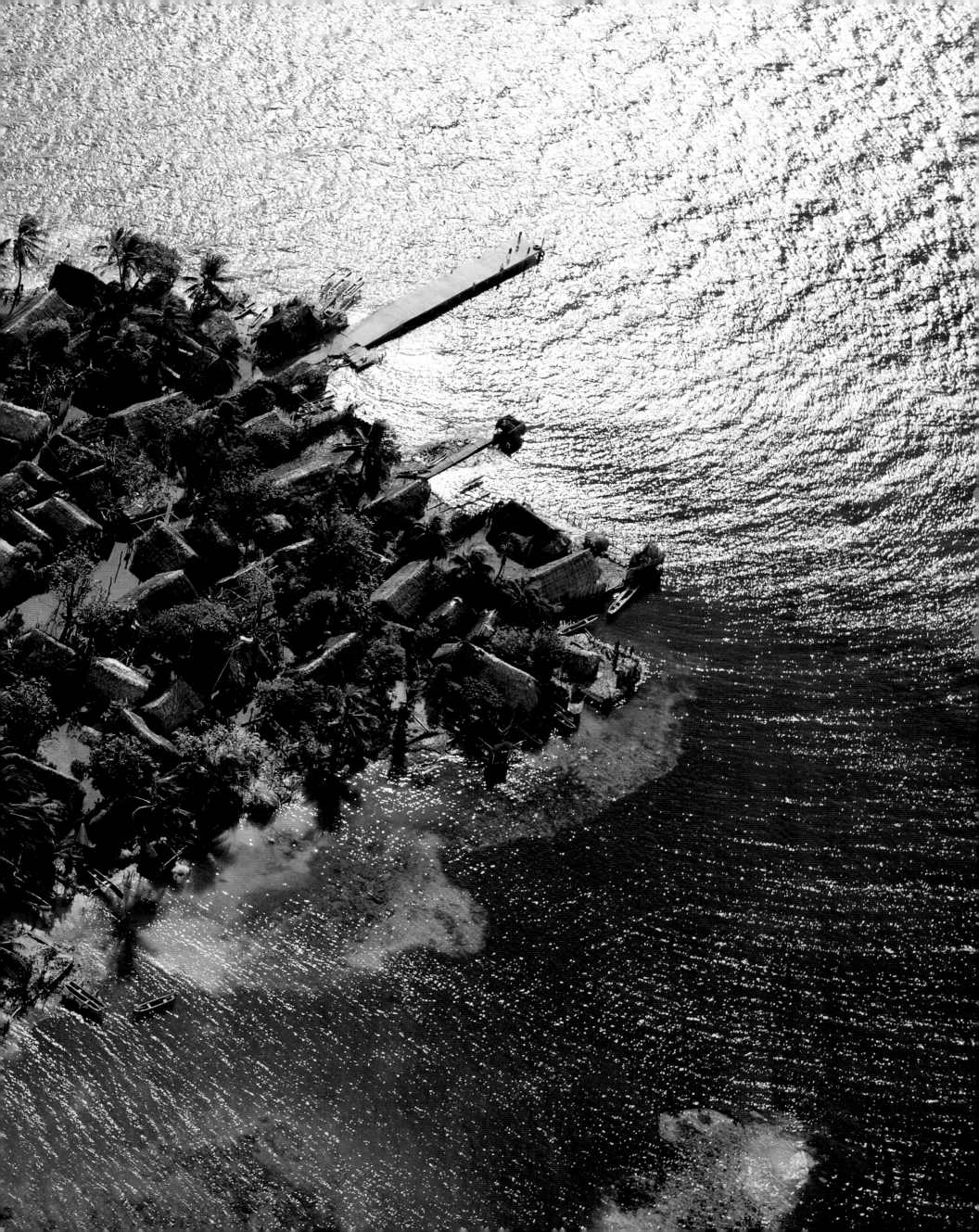

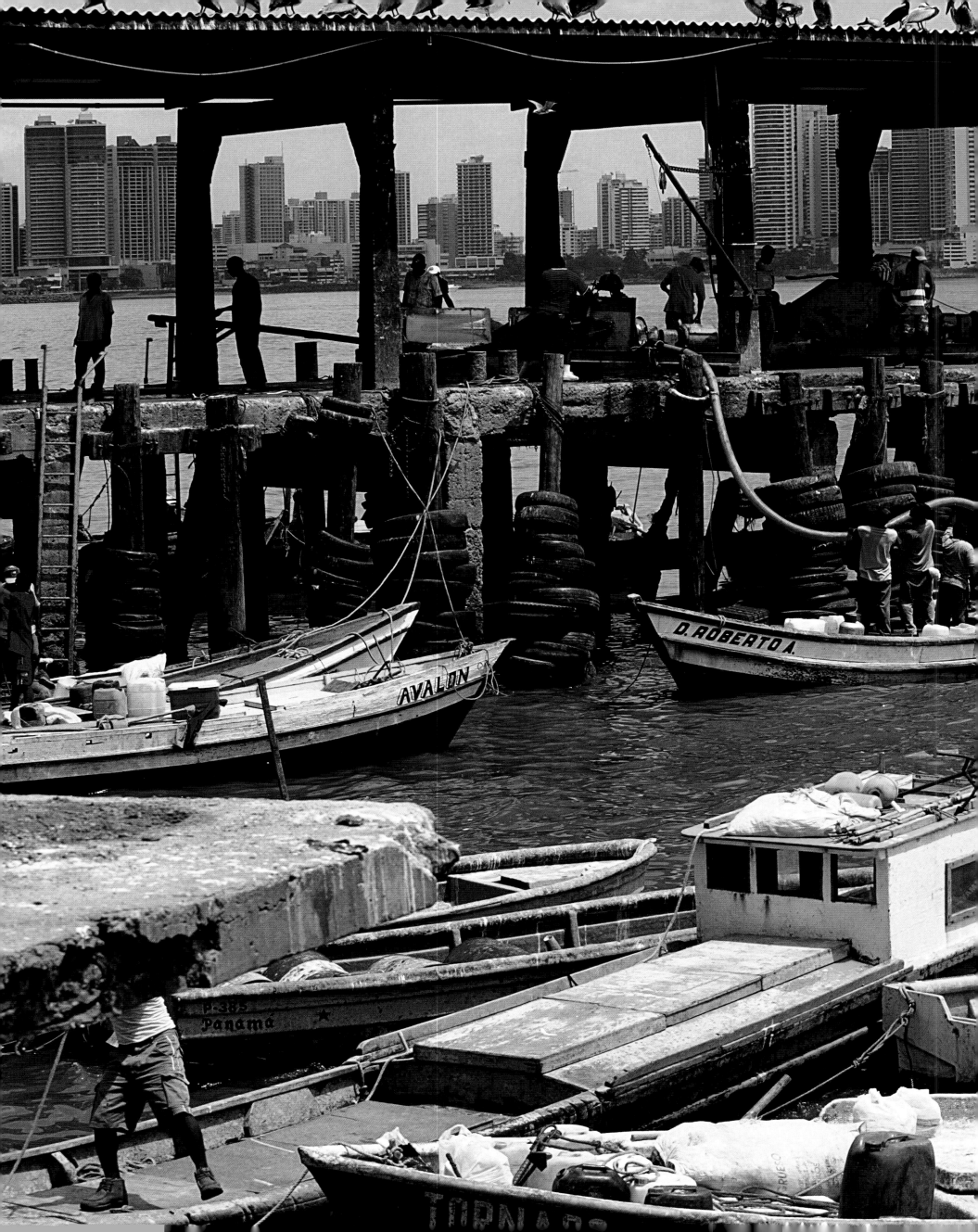

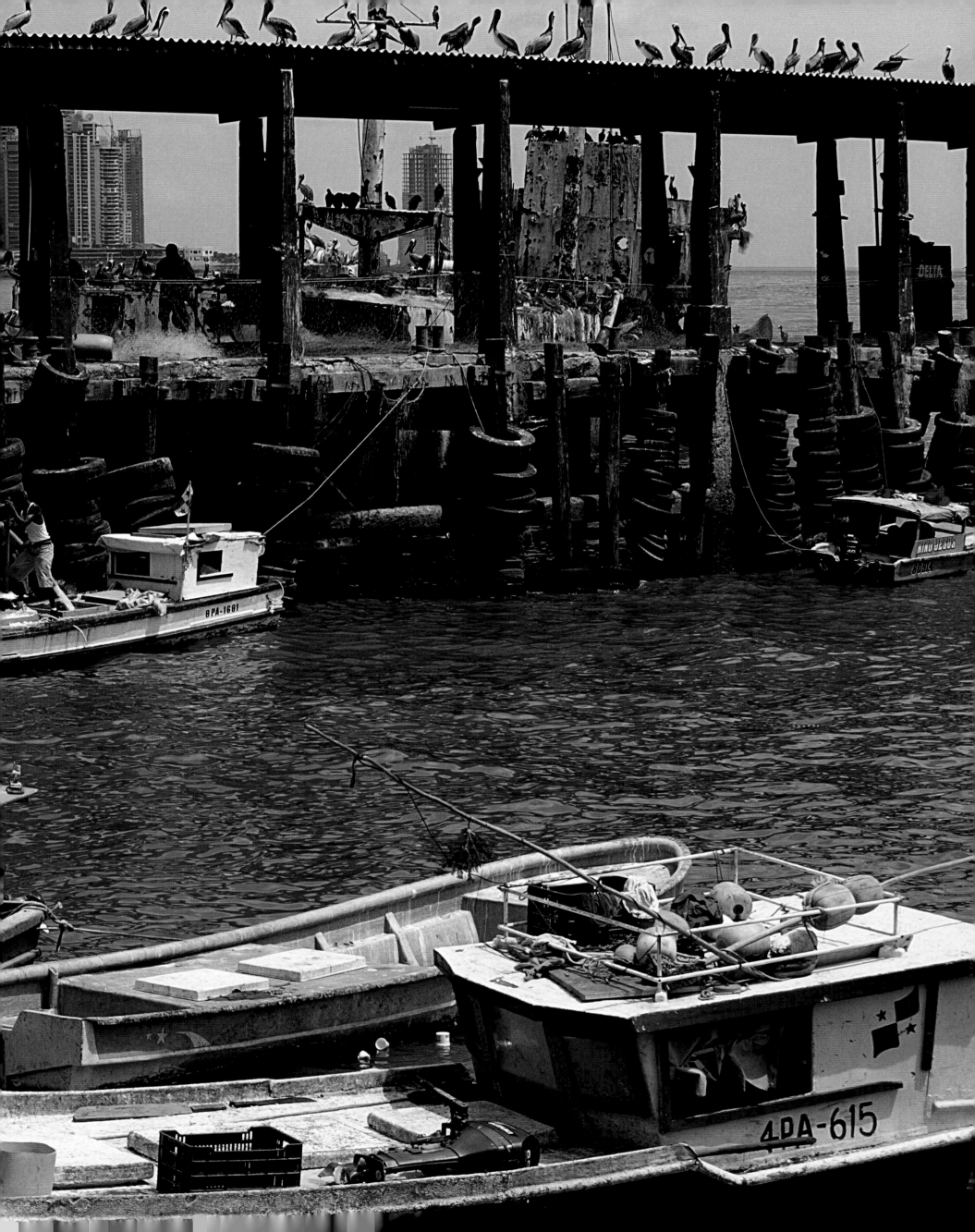

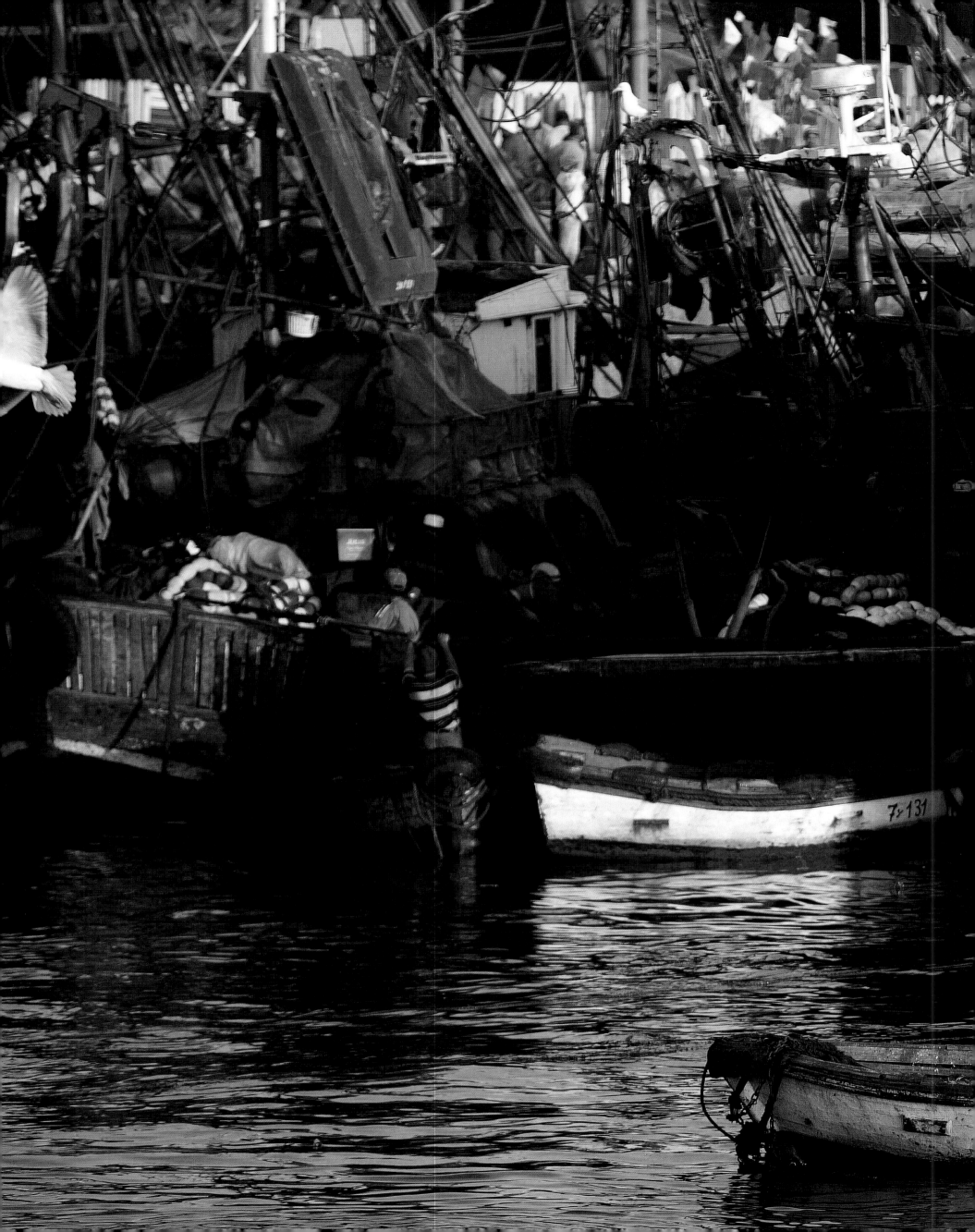

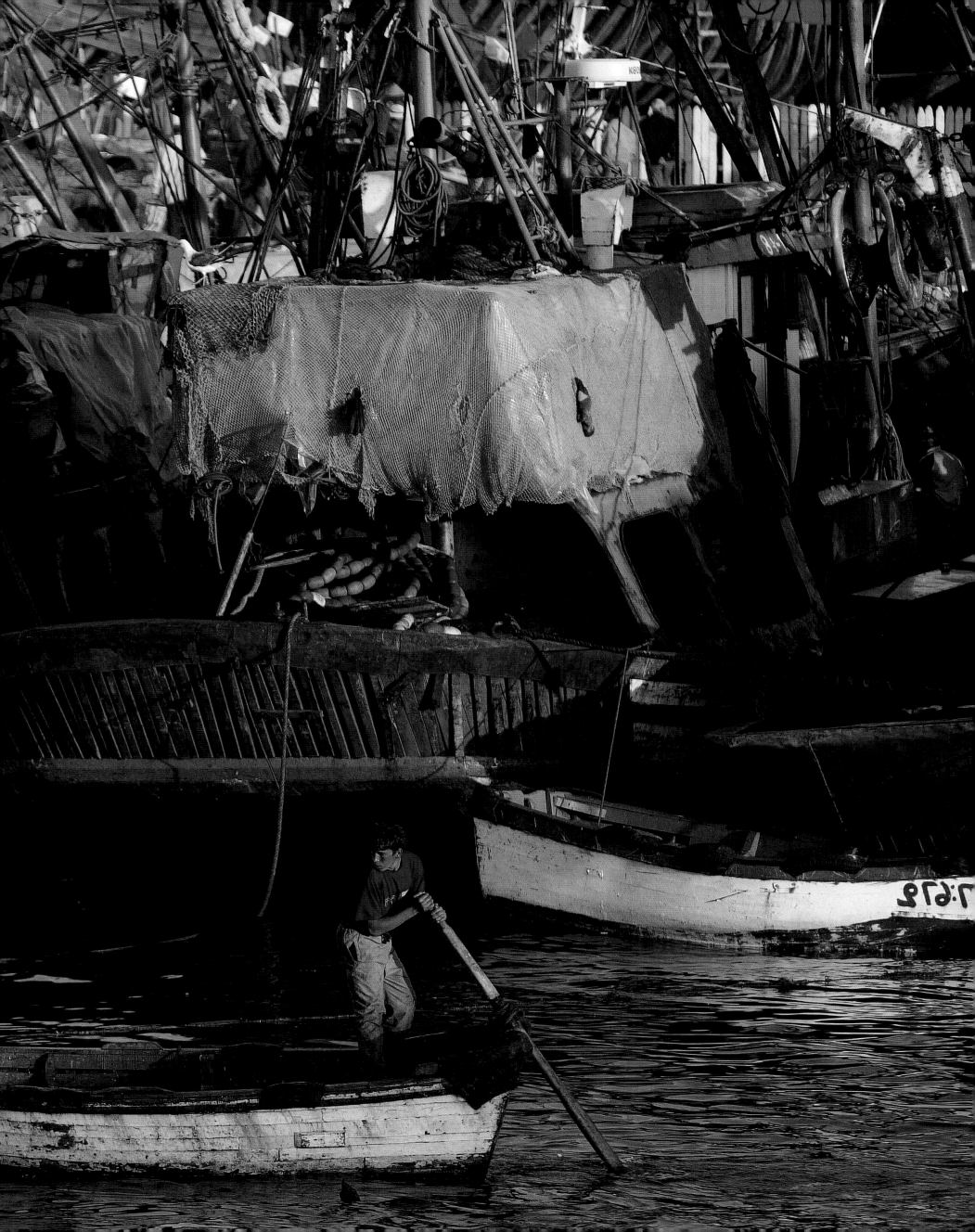

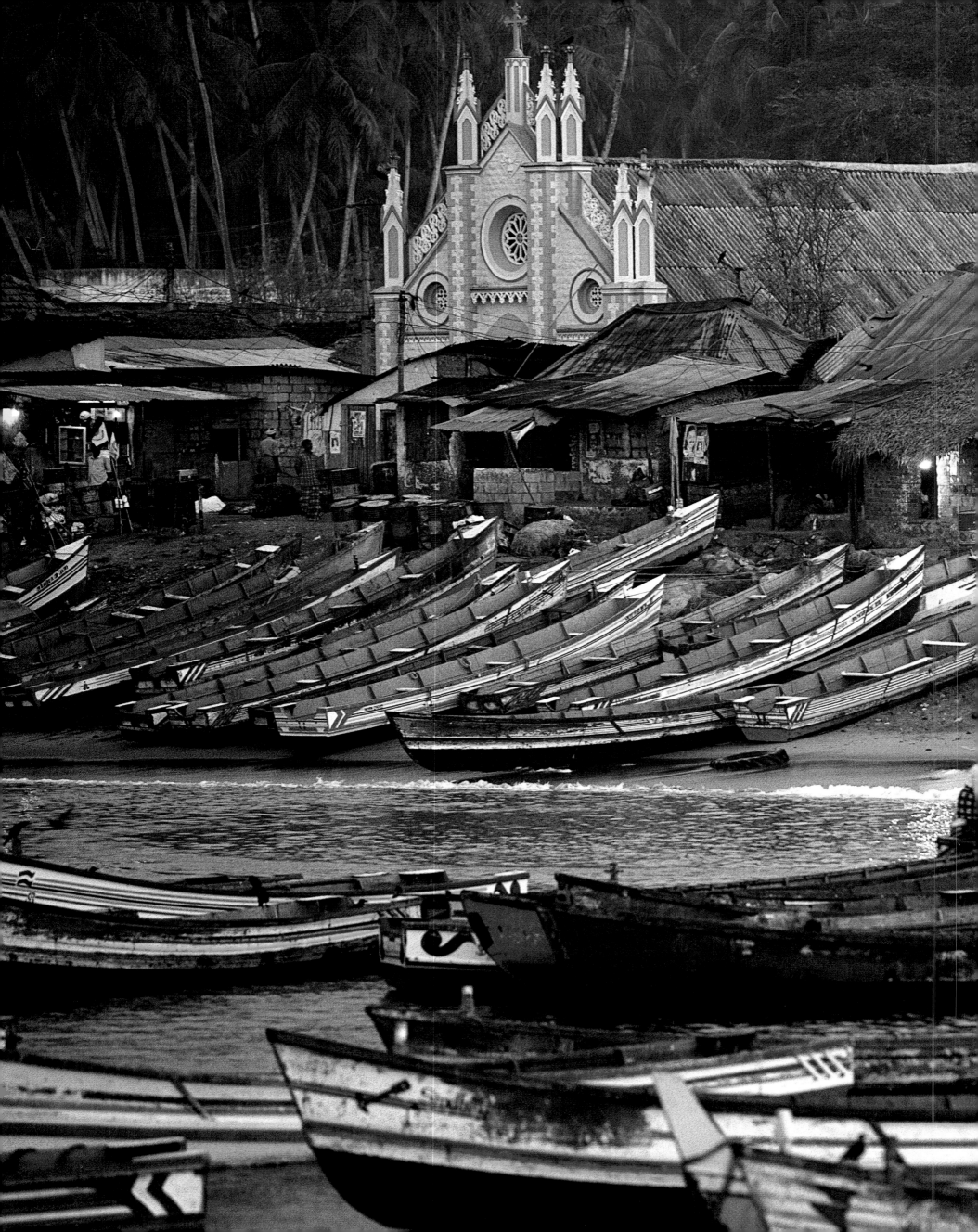

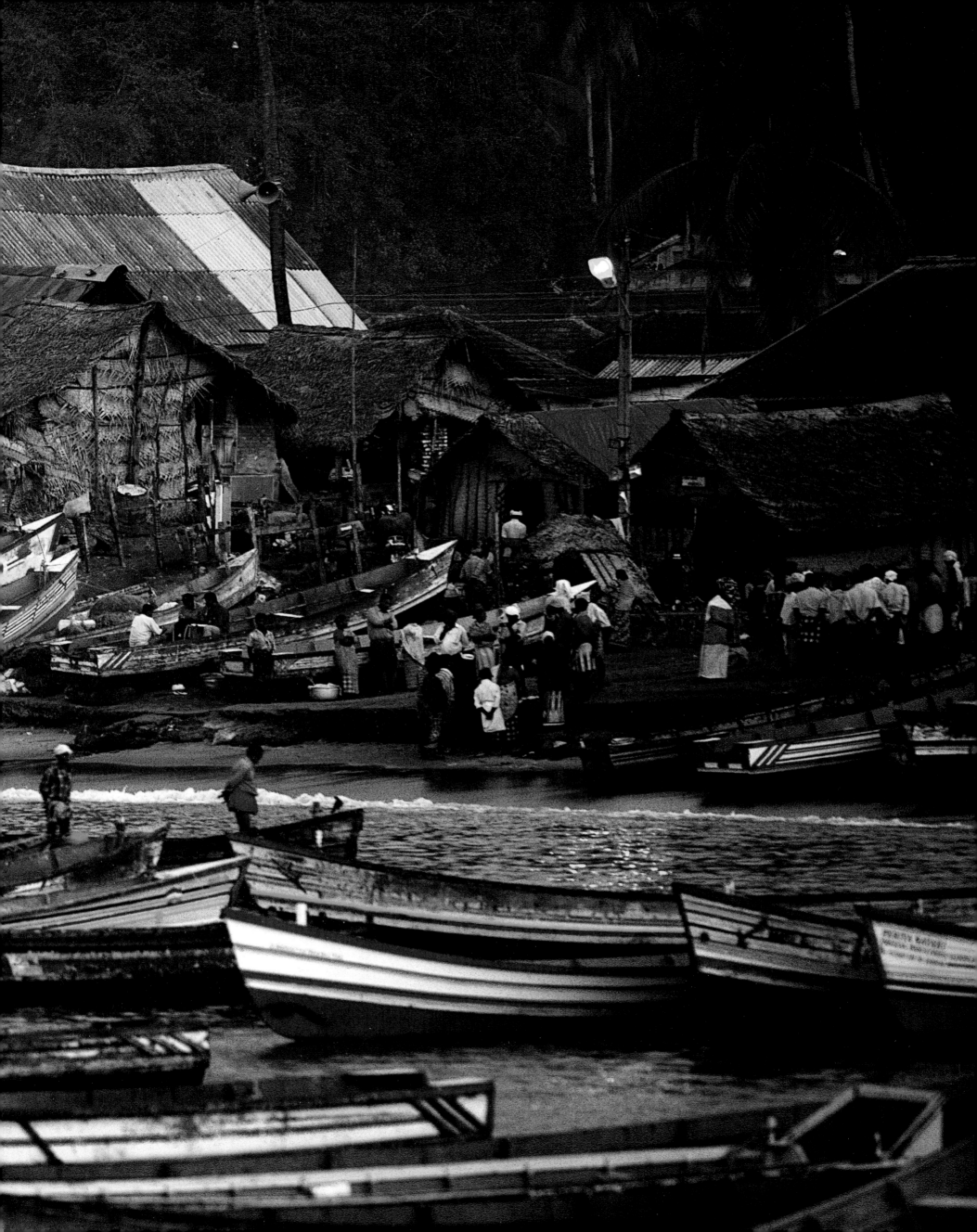

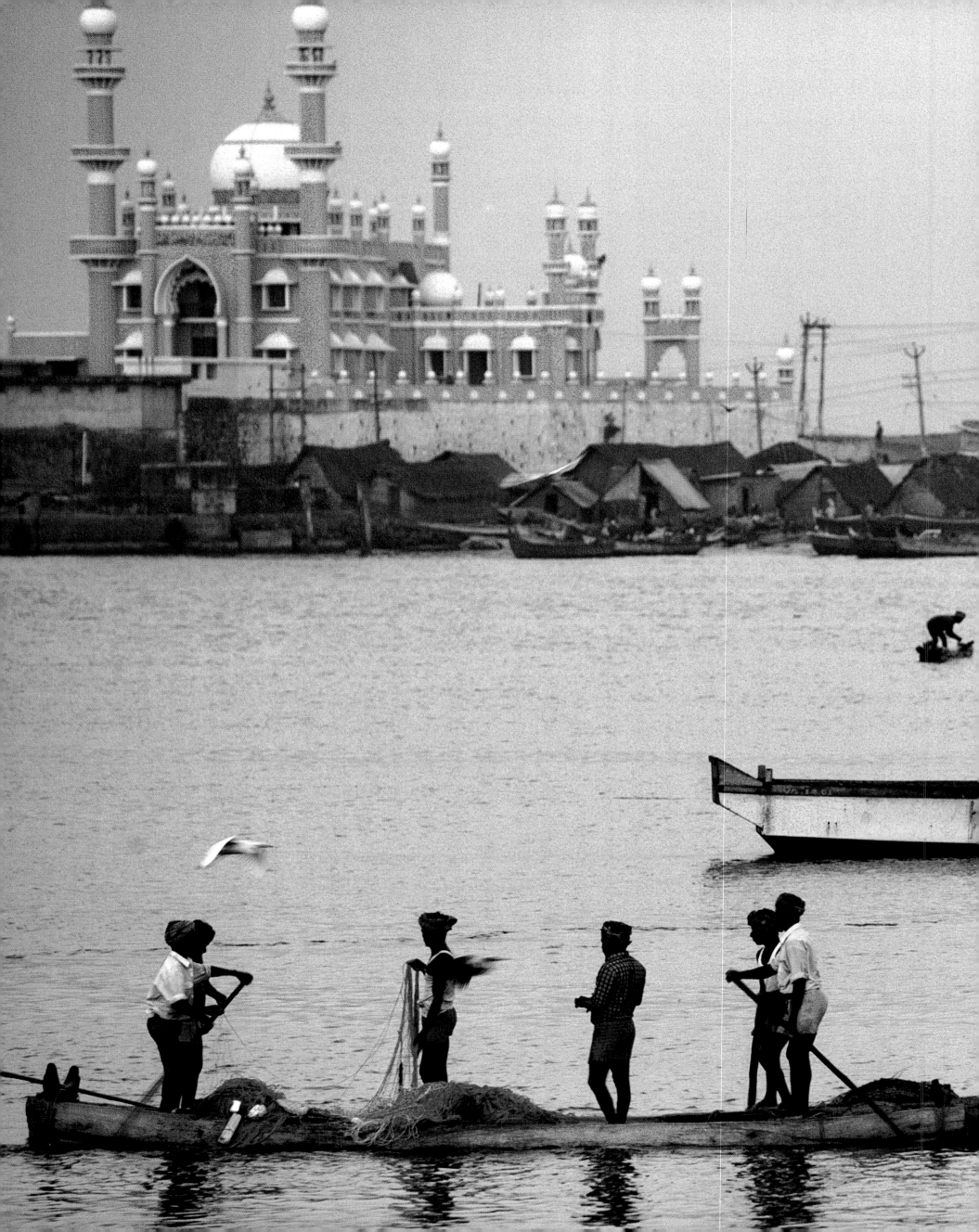

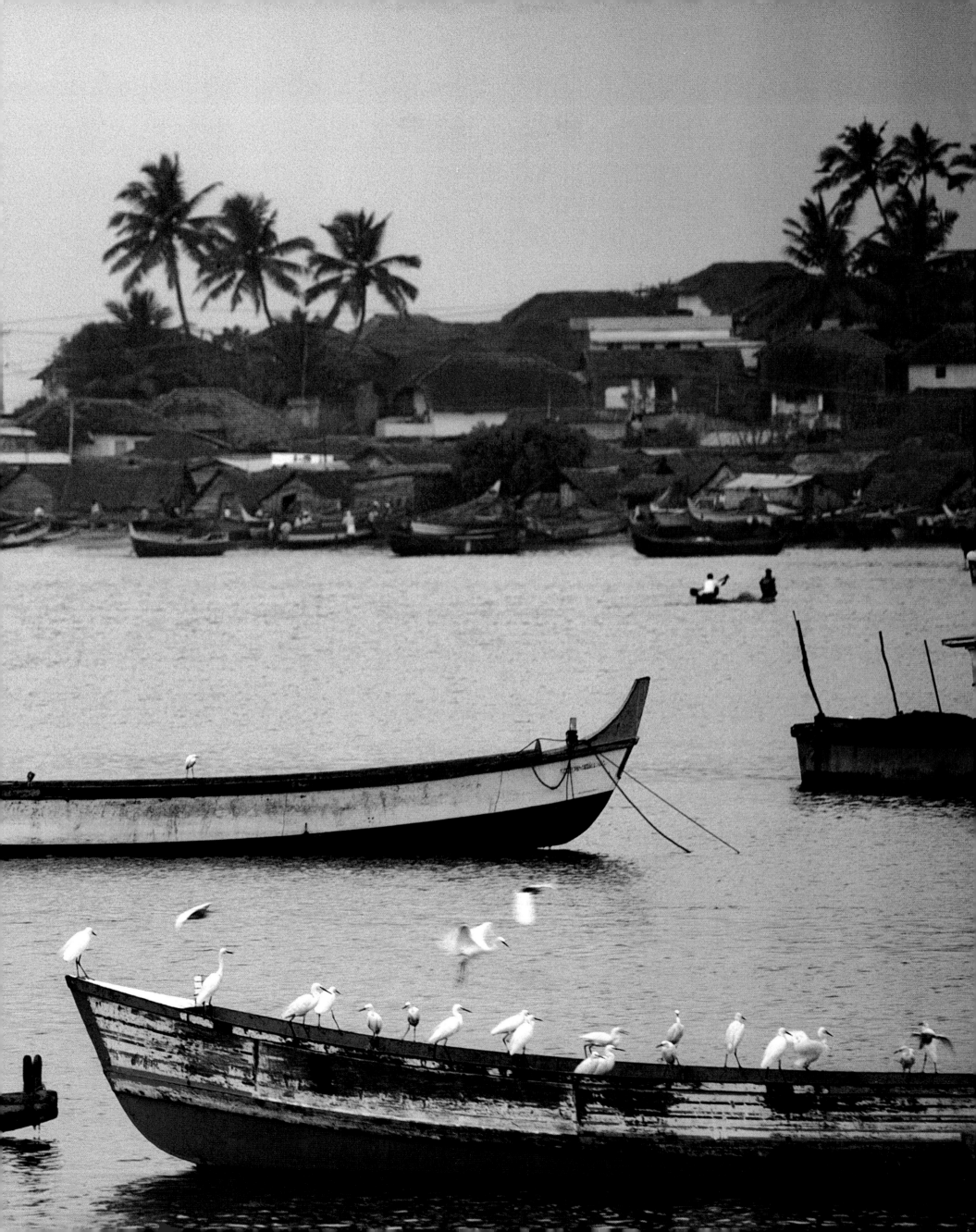

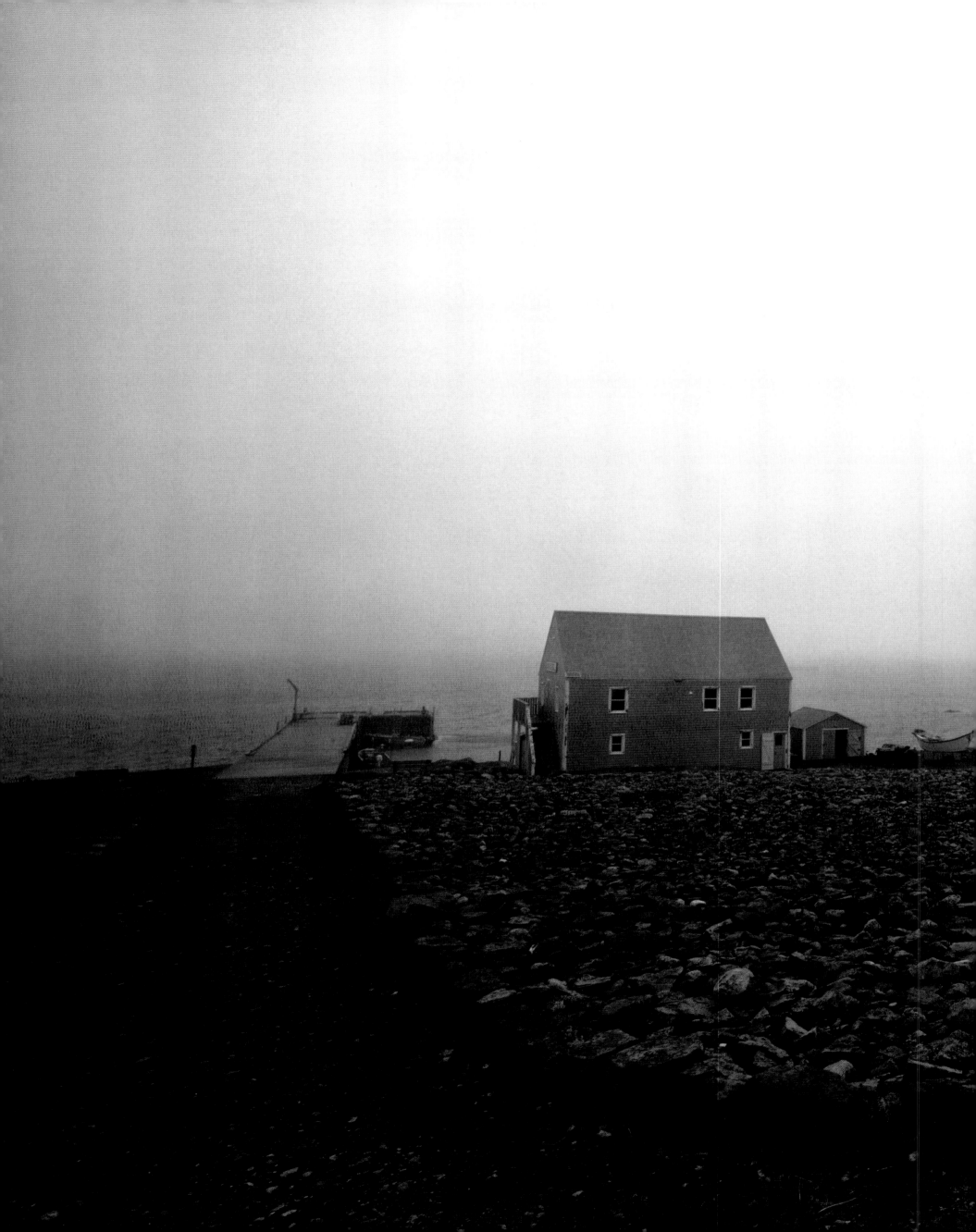

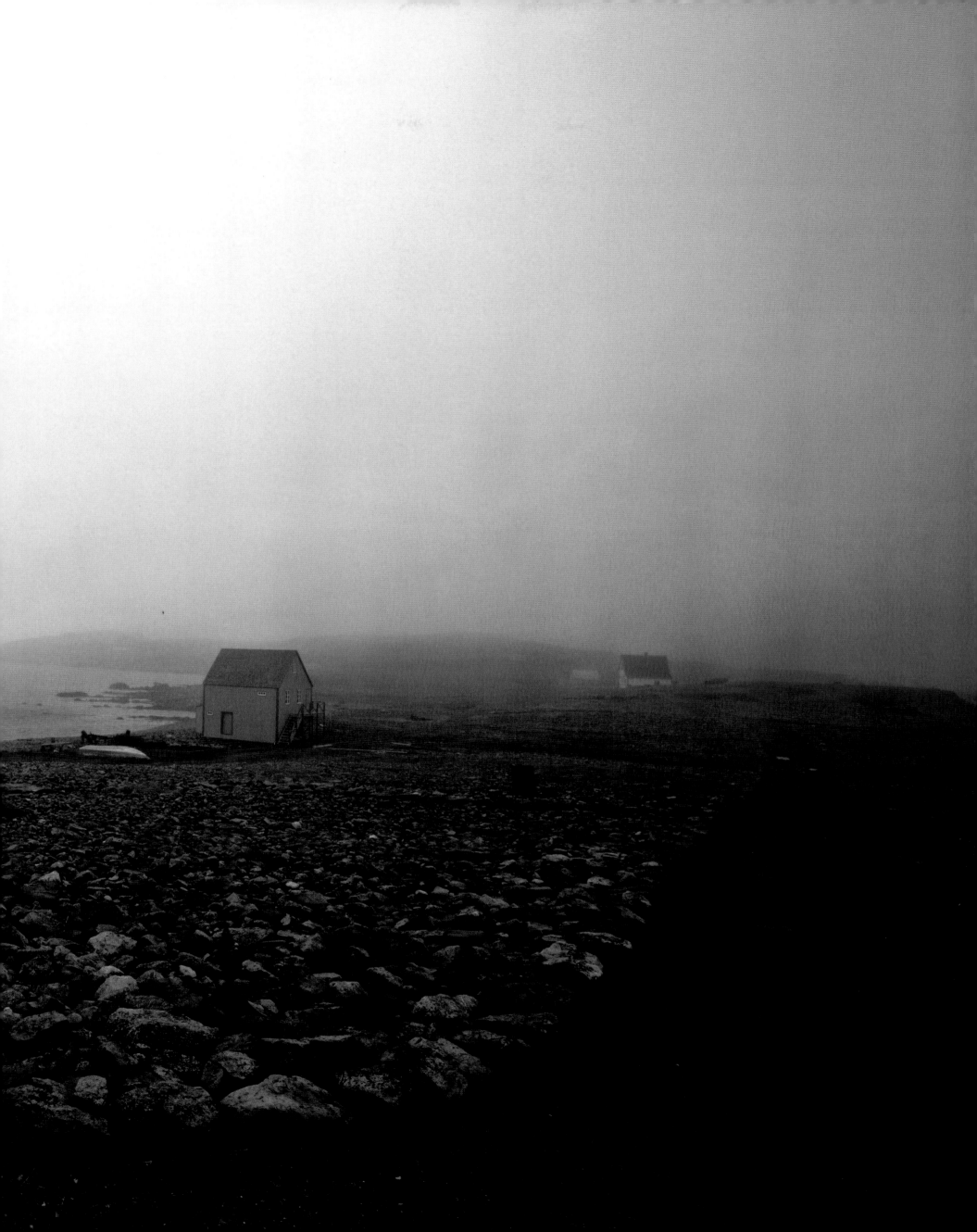

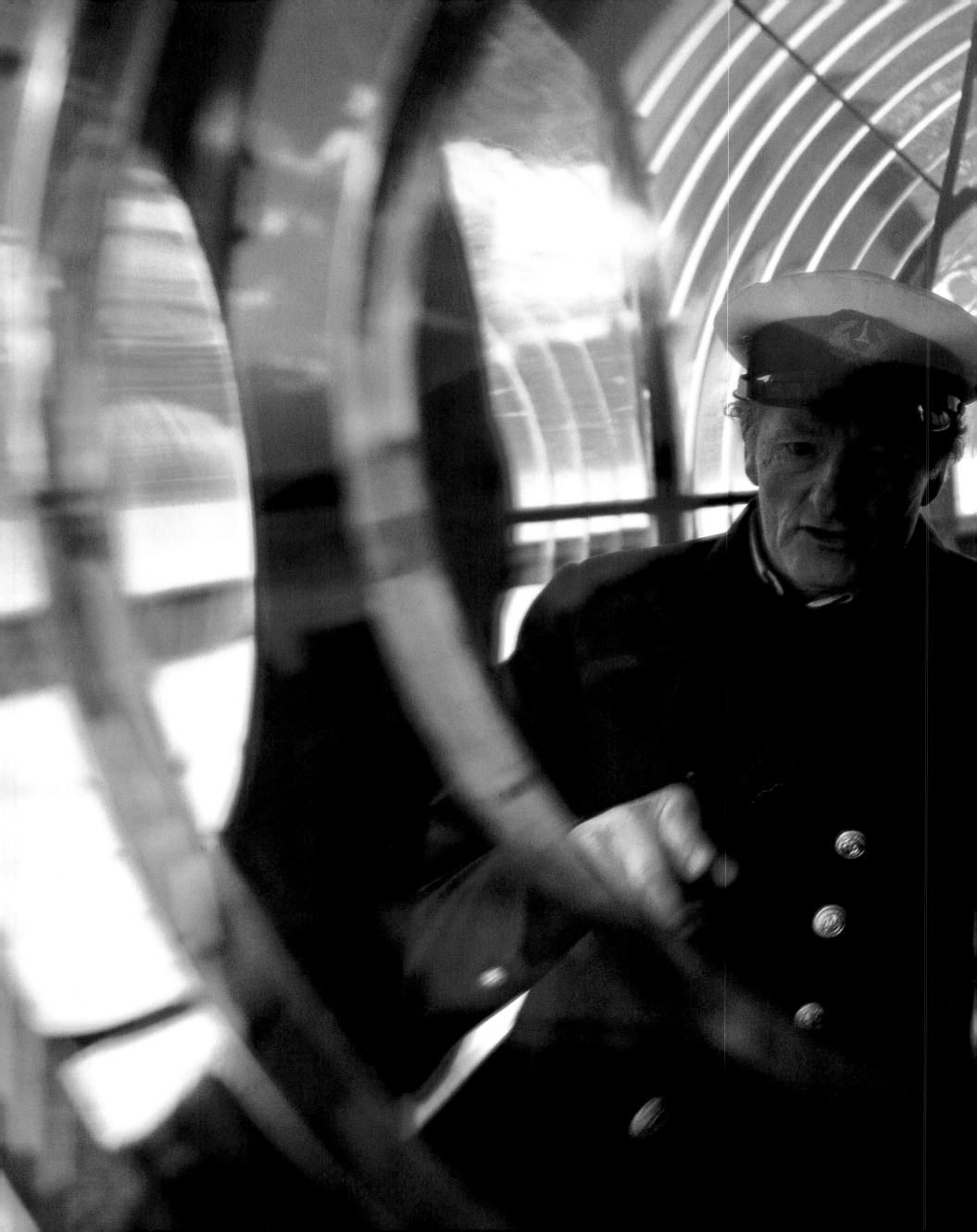

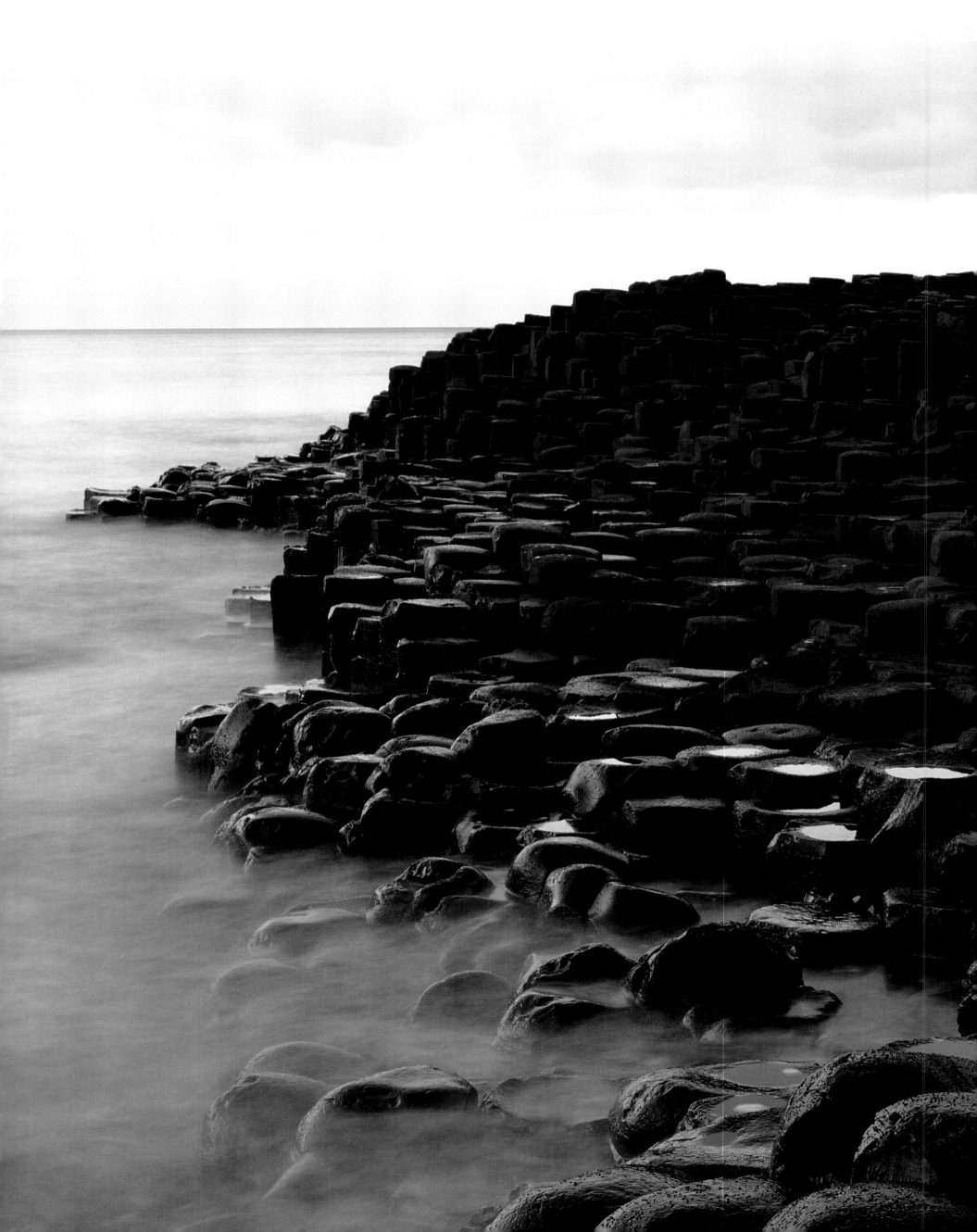

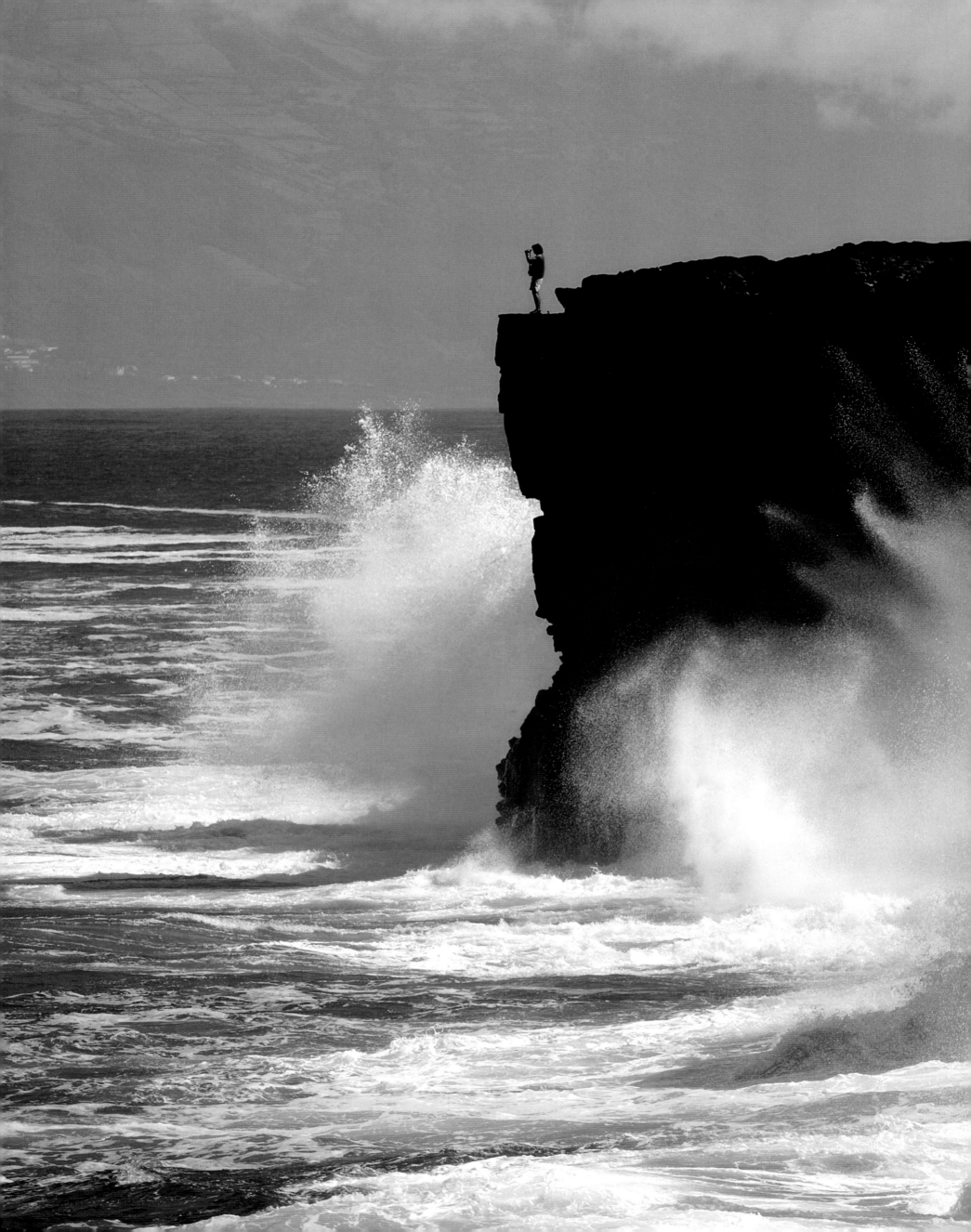

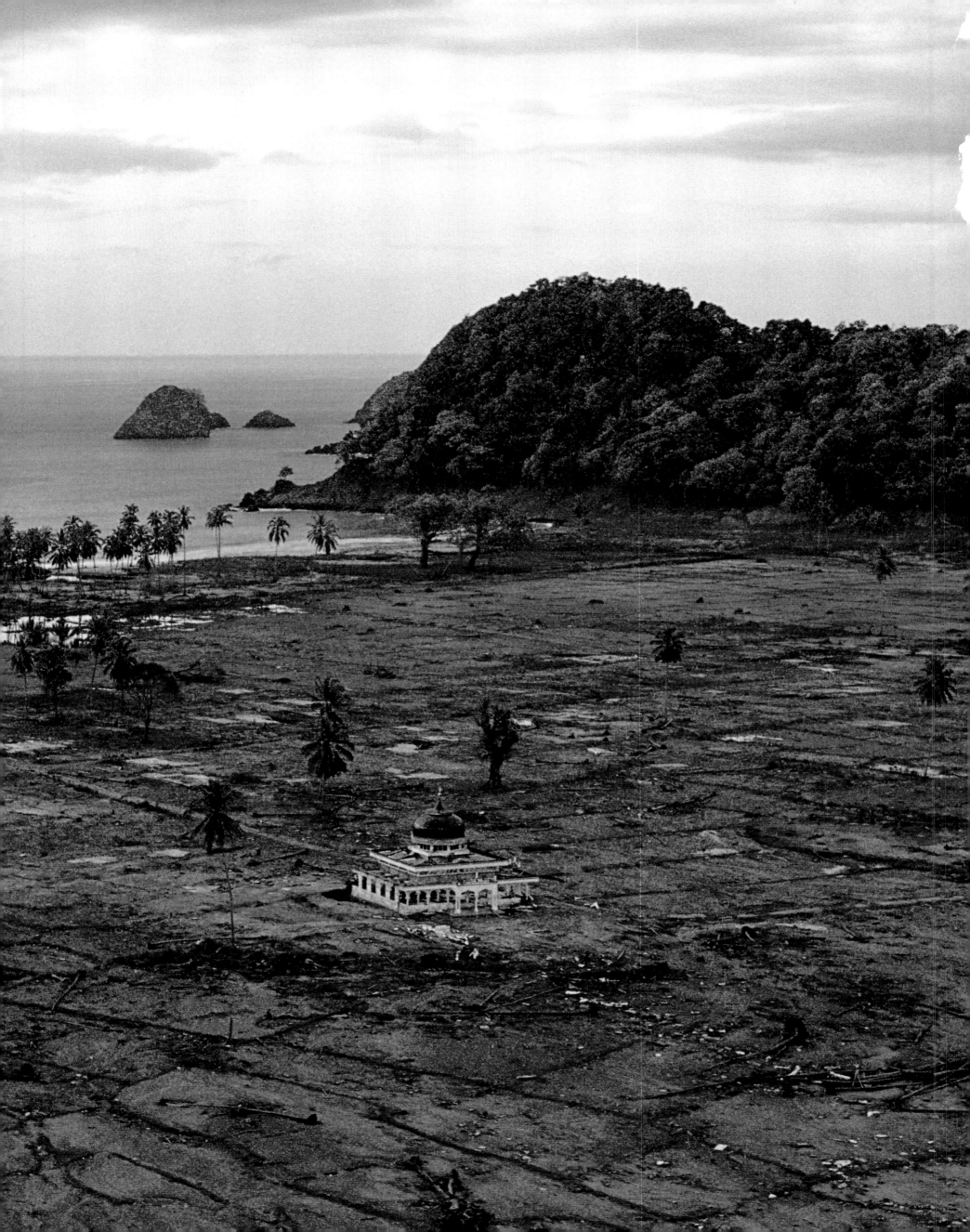

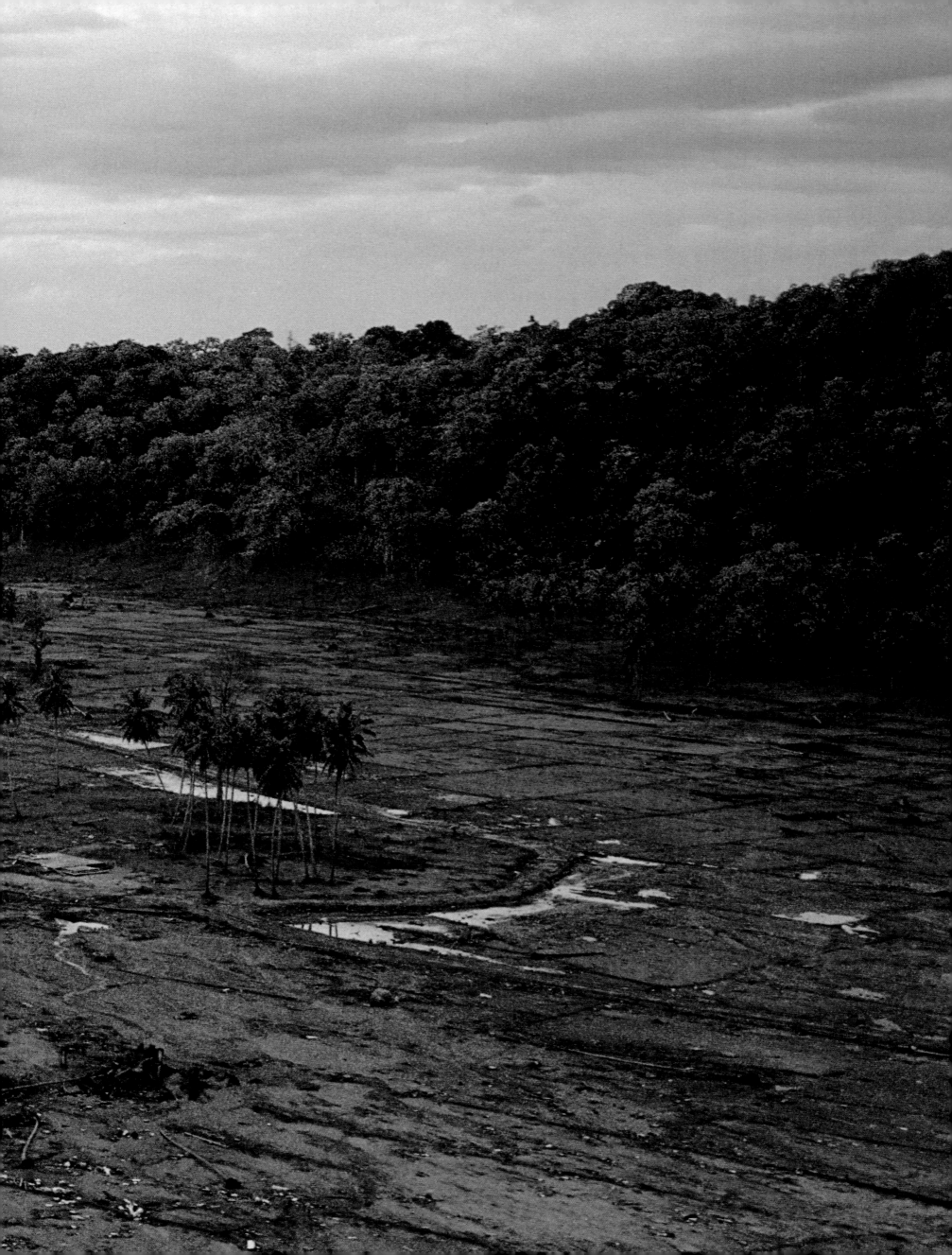

2 The Ocean Shapes the Land

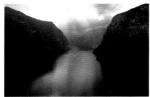

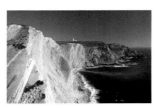

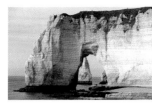

PORTUGAL, AZORES, THE PICO ISLANDS
The ocean is strewn with islands of volcanic origin, such as the Azores. Erupting below the water, a volcano spews out its molten innards, which cool to form rocks and then land. Some islands, like Hawaii and Réunion, have not yet finished growing, and they expand with every new flow of lava. But the ocean does not allow itself to be invaded without fighting back: molten lava pouring through the water at 1,140° C creates a violent reaction. Explosions of gas, noxious vapours, rocks fired like cannonballs, jets of molten lava, and scarlet foam create an oceanic hell on a Dantean scale, but all to no avail, for the land continues to expand.

NORWAY, FJORD
Meetings between land and sea can swing from perfect harmony to violent disputes. Where the marriage works, there are rich estuaries, deltas, lagoons and salt marshes. Where the partners eye each other with suspicion, there are forbidding cliffs and boulders strewn everywhere. Elsewhere, they fight. At the least sign of negligence, the earth throws up an island or a peninsula, or scatters an archipelago across its enemy's territory. The sea immediately responds, cutting a deep strait or ria, digging out a vast bay, or pushing back the shoreline. Sometimes the sea resorts to the cleverest of tactics, by creating a broad, impassable fjord right through the land, so that it may effectively divide and rule.

PORTUGAL, CABO ESPICHEL
The dynamic, ever-changing landscape of the shore is constantly being redesigned by coastal erosion. The retreat and transformation of the coasts depends on their layout, the nature of the rock, the movement of pebbles, the strategy of the sea (the strength and direction of the currents, the waves, coastal drift and the nature of the swell), and the work of the wind launching abrasive spray and particles. The crumbly limestone walls that were once formed by the accumulation of sediments are now collapsing in whole sections. The piles of fallen rocks bear witness to the disintegration of the cliffs, remorselessly undermined by the backwash.

FRANCE, NORMANDY, ÉTRETAT
Arches and crags of chalk denote the dazzling white cliffs of Étretat, a symbol of the coast of Normandy. Unchanged throughout the brief history of mankind, these limestone ramparts are at last breaking up under the constant assaults of the waves that relentlessly batter their foundations, and of the rain which insidiously seeps into them, dissolving them from the top. The Aiguille d'Étretat is now a mere vestige of the cliff that stood there millions of years ago, and these chalky edifices are now dwindling at an average rate of 0.2 m a year. In this process of disintegration, even new arches and crags will one day find themselves sinking below the waterline.

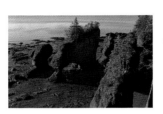

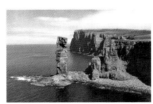

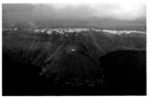

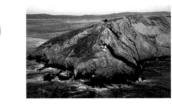

CANADA, BAY OF FUNDY, THE HOPEWELL ROCKS
The tides, caused by the gravitational pull of the moon and the sun on the waters of the Earth, vary at all points of the planet. On the Atlantic coast of Canada, in the immense Bay of Fundy, they reach record heights of 16 m. These gigantic tides, which can temporarily reverse the flow of tributaries, give the river a chocolate hue by constantly stirring up the mud. Over many thousands of years, the erosion caused by the daily ebb and flow of billions of tonnes of water has shaped the rocks on the banks into a vast gallery of strange, baroque sculptures.

SCOTLAND, ORKNEYS, THE OLD MAN OF HOY
To the north of Scotland, in the Orkneys, the red sandstone cliffs of Hoy confront the ocean like ramparts. Some 60 m in front of this wall stands a rectangular tower 137 m high and 30 m wide. The Old Man bravely defies the Atlantic, standing solidly on a base of basalt. A promontory in 1750, an arch in the 1820s, the Old Man of Hoy is now a single pillar and a pile of fallen rock. There is a deep gash 40 m long at the top of the column, and the waves and storms continue to pound away at its base. The Old Man's days are numbered.

GREECE, SANTORINI, VILLAGE OF THIRA
Around 1500 BC, the Mediterranean experienced a disastrous eruption – that of the volcano Thira, now known as Santorini, in the Cyclades archipelago. In 1967, archaeological excavations on the island uncovered the remains of a rich city that had been destroyed and buried beneath the ashes of the cataclysm. In the light of this glorious past, Santorini gave life to the myth of Atlantis, the drowned continent first mentioned by Plato. Along the steep face of the island stand majestic cliffs, streaked with layers of pumice stone, scoria, ash and kaolin, and crowned with a huddle of white houses, some of which appear to be dangerously close to the edge.

CALIFORNIA, POINT REYES
With its lighthouse perched 180 m up, Point Reyes juts out 20 km from the coast of northern California. For a long time, the granite cliffs of this peninsula posed a geological riddle, because nowhere else on the continent are there any rocks to compare with these. Not until the theory of continental drift was any light shed on the mystery. The Point Reyes peninsula is in fact a continental fragment welded to the Pacific tectonic plate, which for the last 28 million years has been drifting north along the San Andreas fault. Beneath the feet of the walkers innocently strolling along the paths of the peninsula, the Earth's crust is imperceptibly moving.

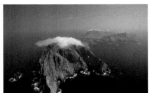

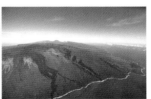

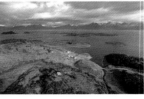

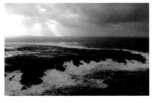

SCOTLAND, ST KILDA
Off the west coast of Scotland, west of the Hebrides, lies St Kilda, which boasts the tallest cliffs in Europe. Inhabited since prehistoric times, this island was home until the middle of the 19th century to an self-governing community that lived on hunting, fishing, sheep-farming, and seabirds such as gannets, petrels and puffins, which were an important feature of their diet. Emigration brought about a major decline in the population, and the government's reluctance to give aid to such a tiny, isolated community resulted in the 36 remaining inhabitants being finally evacuated in 1930. The remnants of thousands of years of human occupation make the now deserted St Kilda into a timeless relic.

RÉUNION, LA SOUFRIÈRE
Volcanic islands thrust their way up through the ocean depths, according to the activity of the hotspots down below. That of Réunion initially created the Deccan Traps massif in India, 65 million years ago. While the Indian plateau headed northwards, the hotspot continued to perforate the earth's crust below the Indian Ocean with its bursts of magma, creating the Lakshadeep Islands, the Maldives, the Chagos archipelago (35 million years ago) and the Mascarene Islands (10 million years ago), including Réunion with its two volcanoes, Piton des Neiges (now extinct) and Piton de la Fournaise (still active). Crowned with an underwater volcano, the hotspot currently lies 280 km south-east of the island.

CHILE, PATAGONIAN CANALS
At the southernmost tip of South America, the land breaks up into a vast archipelago consisting of hundreds of islands, separated by deep fjords. This is Tierra del Fuego, into which runs the Beagle Canal, 240 km long. To the west it is linked to the Pacific by the Darwin Canal. Together they provide a natural passage between the Atlantic and the Pacific – a navigable waterway across Tierra del Fuego, as an alternative to that of Cape Horn in the south and the Strait of Magellan in the north. In this turbulent part of the world, where calm waters are rare, the choice of route is paramount.

IRELAND, TORY ISLAND
The effects of global warming are manifold and complex. In some places, we can expect the winds to whip up the waves to ever greater heights, increasing the floods caused by high tides and storms. Elsewhere, the expansion of the ocean and the melting ice will bring about a rise in sea level (from 15 to 80 cm before 2100). This alarming phenomenon will reshape our coastlines, and submerge low-lying islands, fertile, densely populated deltas, coastal plains, rich estuaries and lagoons now used for fishing. A rise in sea level of just 1 metre would be enough to flood 1 per cent of Egypt, 6 per cent of the Netherlands, 17 per cent of Bangladesh, and 80 per cent of some atolls.

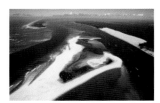

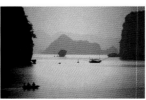

FRANCE, BANC D'ARGUIN
Between the Dune du Pilat and the Pointe du Cap Ferret, the huge sandbank of Arguin emerges from the jade-green waters of the Atlantic. A great favourite with yachtsmen, oyster-farmers and migratory birds, it has been classed as a nature reserve since 1972. The winds, tides and currents are constantly reshaping this moving, underwater dune which partially obstructs the entrance to the Arcachon basin, where it forms unpredictable channels of changing depth. The somewhat futile project of permanently anchoring sandbanks has never come to fruition. The channels continue along their erratic routes, and from decade to decade the marker buoys follow the wanderings of nature.

BRAZIL, STATE OF CEARÁ, JERICOACOARA
The undulating sand dunes are the combined work of the earth, the sea and the wind. The earth provides the material, by way of sediments from the rivers or eroded rocks. The sea and its currents, the great architects of the coasts, distribute these materials all along the shore to create the beaches. And then the wind piles the sand up into constantly shifting dunes. On the coast of the Brazilian state of Ceará, the giant dunes bordering the lagoons unfurl their hills and dales across dozens of kilometres. Such sandy coasts cover 20 per cent of the world's shorelines, protecting the land with a natural barrier. Two-thirds of them, however, are shrinking.

VIETNAM, ALONG BAY
In the beginning was the sea.... Some 340 to 240 million years ago, a warm ocean flooded the Along Bay region and then withdrew, due to tectonic activity. Its limestone bed then evolved into a mountainous massif. Fresh water inexorably eroded this massif throughout the Quaternary era, creating the rocks, isolating the peaks, and hollowing out caves. The 1,600 limestone islets that make up the karstic landscape are relics of these eroded mountains. At the end of the Quaternary, the sea once again entered the scene to put the finishing touches to this natural masterpiece, flooding the region once more and creating Along Bay as we see it today.

FRANCE, MONT-SAINT-MICHEL
On 29 September every year more than 3,000 pilgrims brave the tides around Mont-Saint-Michel. Once an island, now a peninsula, the mount is in danger of silting up. Even if this may seem like a natural process, it has nevertheless been accelerated by earlier development intended to extend the agricultural polders. In order to restore the insular nature of Mont-Saint-Michel, attempts are now being made to re-engage the erosive forces of nature by shifting the seawall and the car parks, and by freeing the flow of the Couesnon river. This would enable the river and the tides to fulfil their cleaning and clearing roles, blocking the advance of the salt marshes and once more setting the mount in a shifting space of land and water, open to the sea.

incorporated itself into what we now call Asia. This gigantic collision caused a mighty crumpling of the land, and up rose the Himalayas.

The sea, with its white-knuckled waves, had moulded five continents. Some might suggest that it is the land that holds the ocean in its grip – as if the English Channel, Weddell, North, d'Urville, Mediterranean, Norwegian, Scotia, Tasman, Coral, Bering, Philippine, Okhotsk, Chukchi, Caribbean, Black, White, Adriatic, Beaufort, Greenland, Amundsen, Kara, Laptev, Bellingshausen, Barents, Davis, Lincoln, Tyrrhenian, Yellow, Red, Laccadive, Celebes, Adaman, Japan, Banda, Java, Arabian, Arafura, Ionian, Timor, Sulu, China, Siberian, Ross, Labrador, Sargasso, Aegean, Molucca and Solomon seas were ever captives!

No, the ocean is a single whole, and it covers the world. The Indian Ocean tsunami that ravaged several countries on 26 December 2004 came as a terrible reminder of this fact: the devastating wave went around the Earth several times. In Halifax, Canada, 23,000 kilometres west of the epicentre, it reached 50 centimetres on its first journey.

The movement of the continents across the waters has not yet ended. We are all sailors travelling on our respective vessels of land to wherever the watery helmsman wishes to take us. After another fistful of aeons – perhaps 30 million years – Australia will put into port, anchoring in the south of Asia. Those countries that border on the eastern Mediterranean are in danger of ending up in dry dock when the good ship Africa moors alongside the Eurasian platform. Indeed it won't be long before once again the eternal Tethys brings us all together again in a new Pangaea.

The ocean is constantly making alterations, like a painter adding more and more touches to his work. A little more sand here, a bare patch there; a little bit of green here, but not so many red rocks there. The sea gives up its land in one place, and takes it back in another. And we humans bustle about, trying to protect ourselves, to 'defend' – as we put it – our terrestrial borders. Just like children, we want to save our

sandcastles from the inexorable rise of the waters. Such stubbornness, such folly…but such grandeur too.

Mankind has perhaps never achieved more greatness than when fighting against the sea. Can there ever have been a finer testimony to human ingenuity than the canals which, by defying geography, have at least for a while put humans on a par with the gods? Ferdinand de Lesseps, the guiding spirit of Suez, Panama and many other such projects, was a magician. This was the task of a Titan: more than 250 million cubic metres had to be shifted for the Panama Canal alone – a superhuman task, for which 25,000 workers and engineers paid the price with their lives.

Let us raise our hats to the men who built the Corinth Canal, who dug out the Channel Tunnel which has transformed Great Britain into a peninsula, who constructed the bridges that span the sounds and inlets and reach up to touch the skies, who break the ice and open up new maritime routes, who defy the waves with their *Titanics*, their *Gigantics*, and all their other mighty floating cities. But let us also bear in mind the eternal lesson of history: that man must treat the sea with respect and humility.

Playing the role of the sorcerer's apprentice is a dangerous game. The sea is an astonishing, life-giving machine. Its currents create our climate. It is worth remembering that the icy coast of Labrador in Canada is on the same latitude as the south-west corner of England where, thanks to the warm ocean currents, even palm trees can flourish. The Gulf Stream moves some 30 million tonnes of water per second, whereas all the rivers of the Earth combined can barely manage a million. But be warned: a grain of sand can cause the breakdown of the mightiest machine. Human actions, whose ramifications can sometimes go completely out of control, may change the fundamental framework of our climate and, through a chain of reactions, may alter the conditions that balance life itself.

The all-important Gulf Stream is now losing its power, and we must face the fact that the ocean – under attack from the billions of tonnes of carbon being discharged into it – may one day call us to account.

INDONESIA, BANDA ACEH
On 26 December 2004, a violent quake shook the Indian Ocean off the island of Sumatra, giving rise to a monstrous tsunami. Lying close to the epicentre, the town of Banda Aceh was devastated. On the coasts of the Indian Ocean, 295,000 people lost their lives in this catastrophe. The cataclysm even changed the geography of Mother Earth, reshaping shores and shifting islands. The positive side of this tragedy was the extraordinary solidarity that raised some $12 billion in aid for the victims, but no one will ever forget the terror of a raging sea transformed into a force of almost total annihilation.

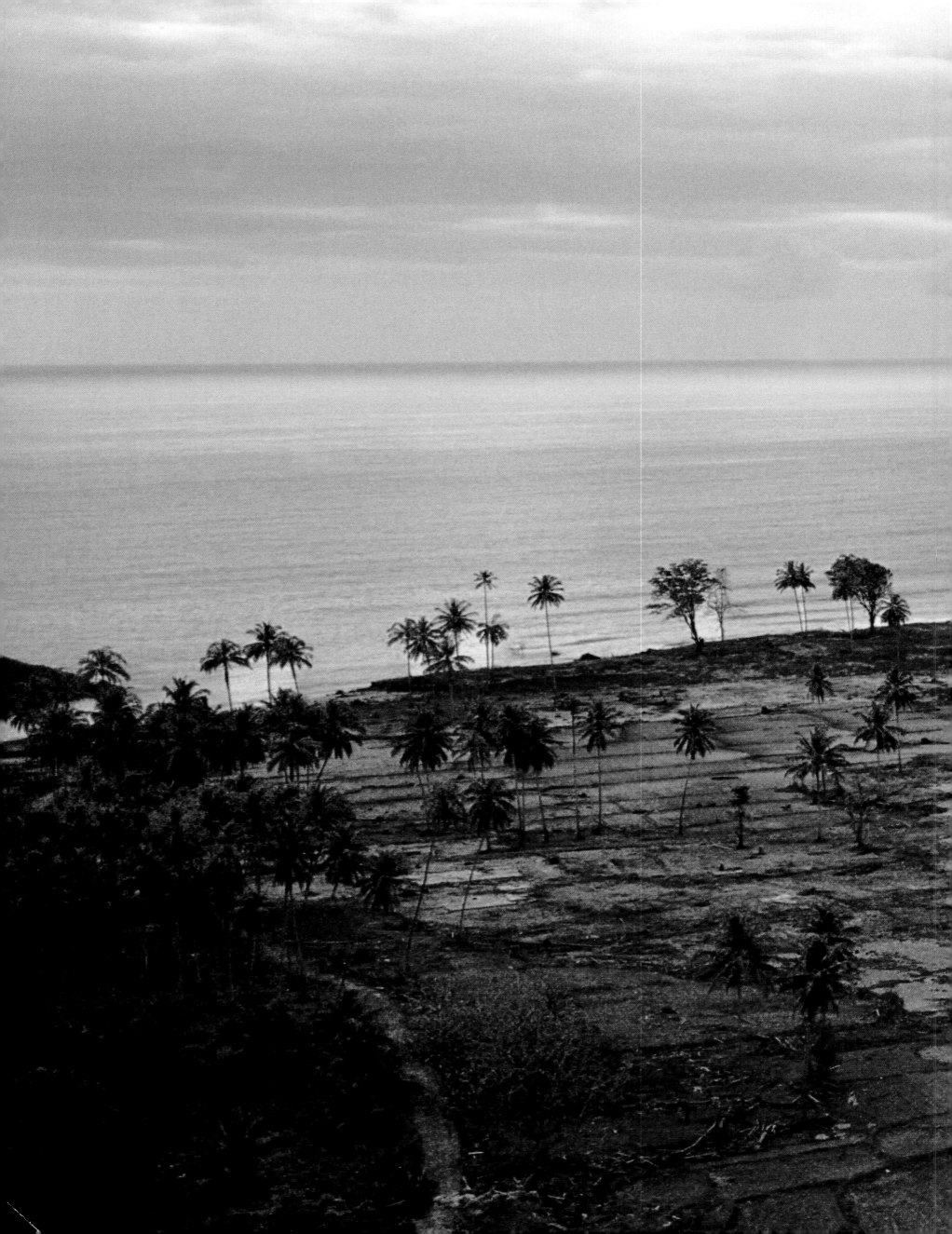

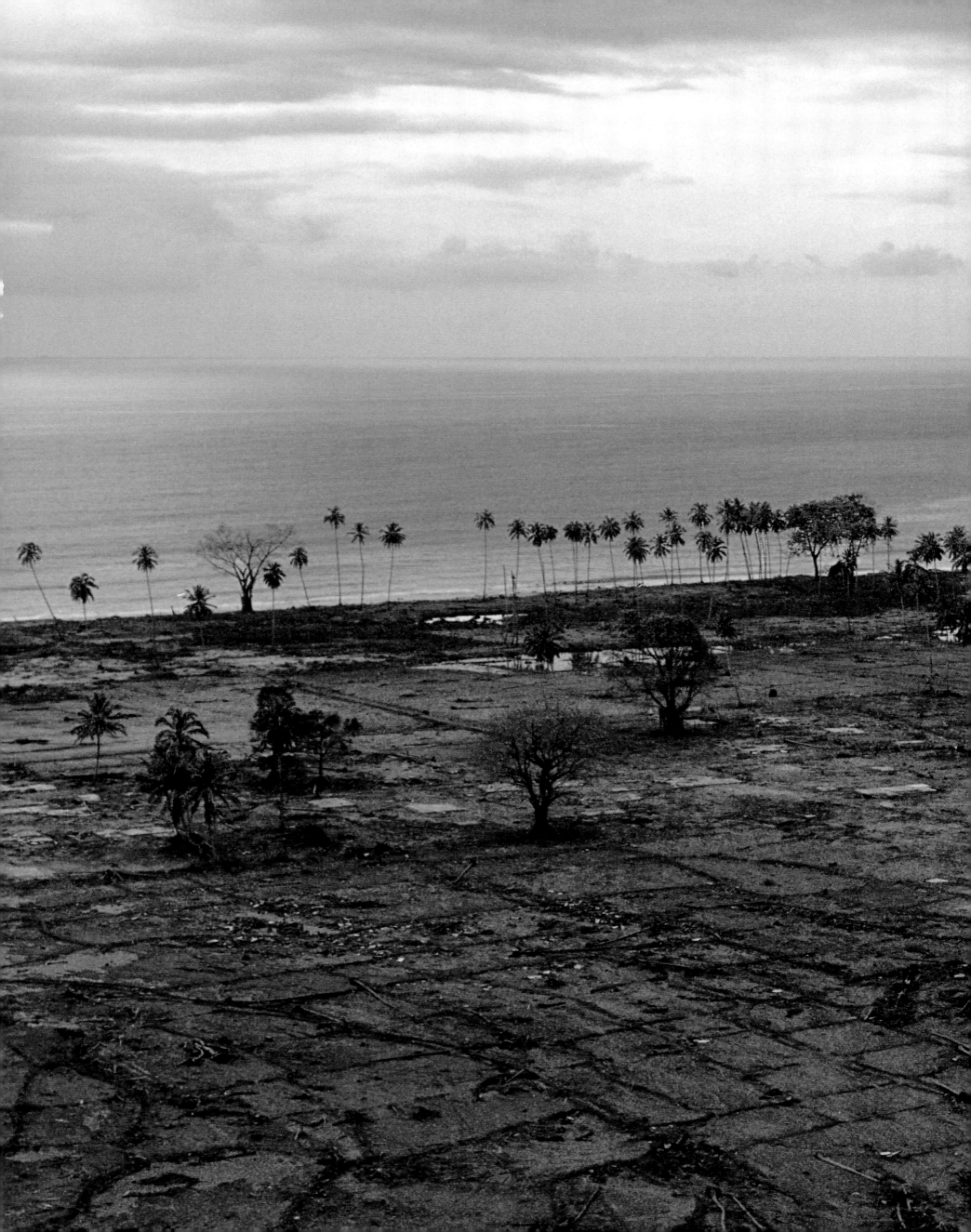

2 The Ocean Shapes the Land

From the point of view of a rose, it seems as if a gardener never dies. For us in our own brief span it is almost impossible to visualize the immensity of geological time. It is equally difficult for us to realize that the ocean too has a history of its own, a history that has been built up not over centuries but over millions, even billions of years. This history is also our own – it is the history of the Earth itself, a story without end and yet full of new beginnings.

NORTHERN IRELAND, GIANT'S CAUSEWAY
The Giant's Causeway, at the foot of the cliffs that border the Antrim plateau in Northern Ireland, is a strange natural phenomenon created by the cooling of basalt lava from volcanic eruptions between 50 and 60 million years ago. This geological upheaval resulted in some 40,000 polygonal columns that form a geometrical pattern of vertical, interlinked prisms, rather like an immense honeycomb. There is a similar formation to be seen on the Scottish island of Flacca directly opposite. Where the Giant's Causeway sinks into the water, the sea has added its own personal touch. It has levelled off the volcanic forms, rounded their shapes and eliminated the ridges, gradually replacing the perfect polygons with smoothly rounded spheres.

Long, long ago, in a universe that was already some 15 billion years old, a rotating cloud of gas and crystals shaped itself into a vast cluster at the centre of a flat disk that was strewn with much smaller clusters: the solar system was about to be born. Thermonuclear reactions ignited the fire of the sun, and the remaining matter linked up to form the first ring of planets, which had solid surfaces – Mercury, Venus, Earth, Mars – while solar winds drove away the more volatile elements; these gathered on the edge of the system to form more new planets, mainly consisting of gas – Jupiter, Saturn, Uranus and Neptune.

The Earth was built in less than 100 million years. Under the influence of gravity, the heavy elements such as iron and nickel were concentrated at the core, while the lighter components lay on top to form the mantle and the crust. The Earth was then basically barren, without oceans and without life.

For a long time it was believed that the seas came into being through the melting and evaporation of the rocks in the Earth's crust. Scientific study, however, beginning with the work of William Rubey from 1951 onwards, shows that at most 10 per cent of the sea's mass is of earthly origin. Now we know that the oceans fell from heaven!

During the first few hundred million years of the solar system, huge asteroids constantly bombarded the Earth. Among these heavenly bodies, the most likely water-bearing candidates are the comets, which are composed of ice and silicates. Detailed analysis of seawater, which is characterized by a precise balance of deuterium and hydrogen, has led researchers to

highlight the role played by carbon chondrites, the most common of the meteorites with the largest quantity of water (up to 0.22 grams per gram of rock).

What a sight it must have been! After this long period of bombardment, the oceans were formed by condensation in an atmosphere composed of steam and carbon dioxide. The never-ending showers of large meteorites raised the temperature to such levels that the emerging oceans were vaporized many times over. Not until just under four billion years ago, when these celestial attacks began to ease off, was the sea able to attain a measure of stability.

From that time on, it set about shaping the Earth. The ocean is a living thing, and like a child playing with a toy in the bath, it pushes the emerging land masses around, regrouping them, separating them, watching them change direction…almost as if it were a game. A billion years ago, it reshuffled the whole pack into a megacontinent that geologists have called Rodinia. About 700 million years ago, it broke the whole thing up, only to reassemble it some 150 million years later. Then, very quickly – what, after all, is 10 million years? – Laurentia, corresponding to what we now call North America, broke off from the southern continent of Gondwana, but 200 million years later it all came together again in a single land mass known as Pangaea, situated mainly in the southern hemisphere. The name given to the ocean at that time is Tethys.

After that, the process accelerated: around 130 million years ago, a new break-up gave birth to the Atlantic and the Indian Oceans. Africa and America arrived. India continued to sail along at top speed and

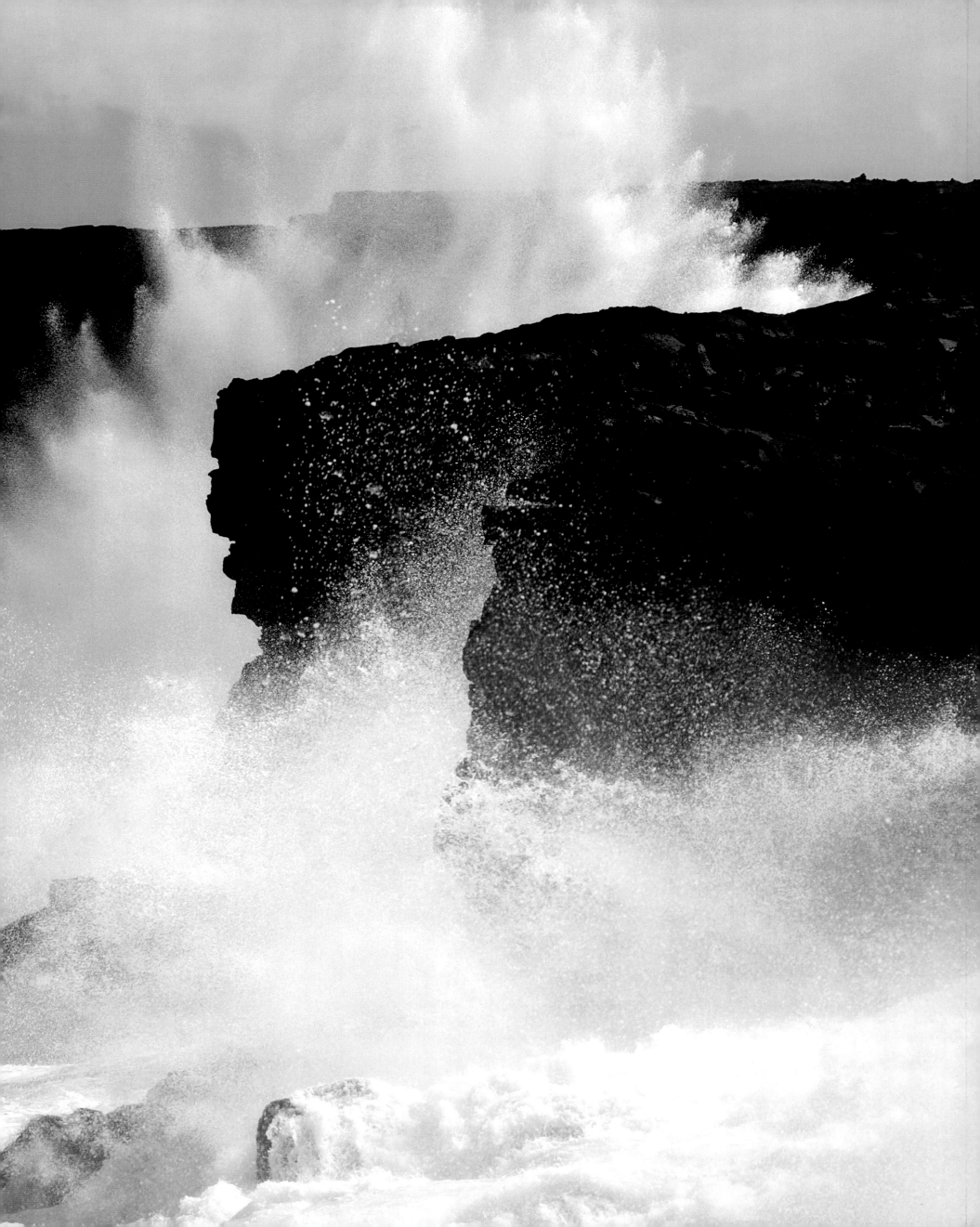

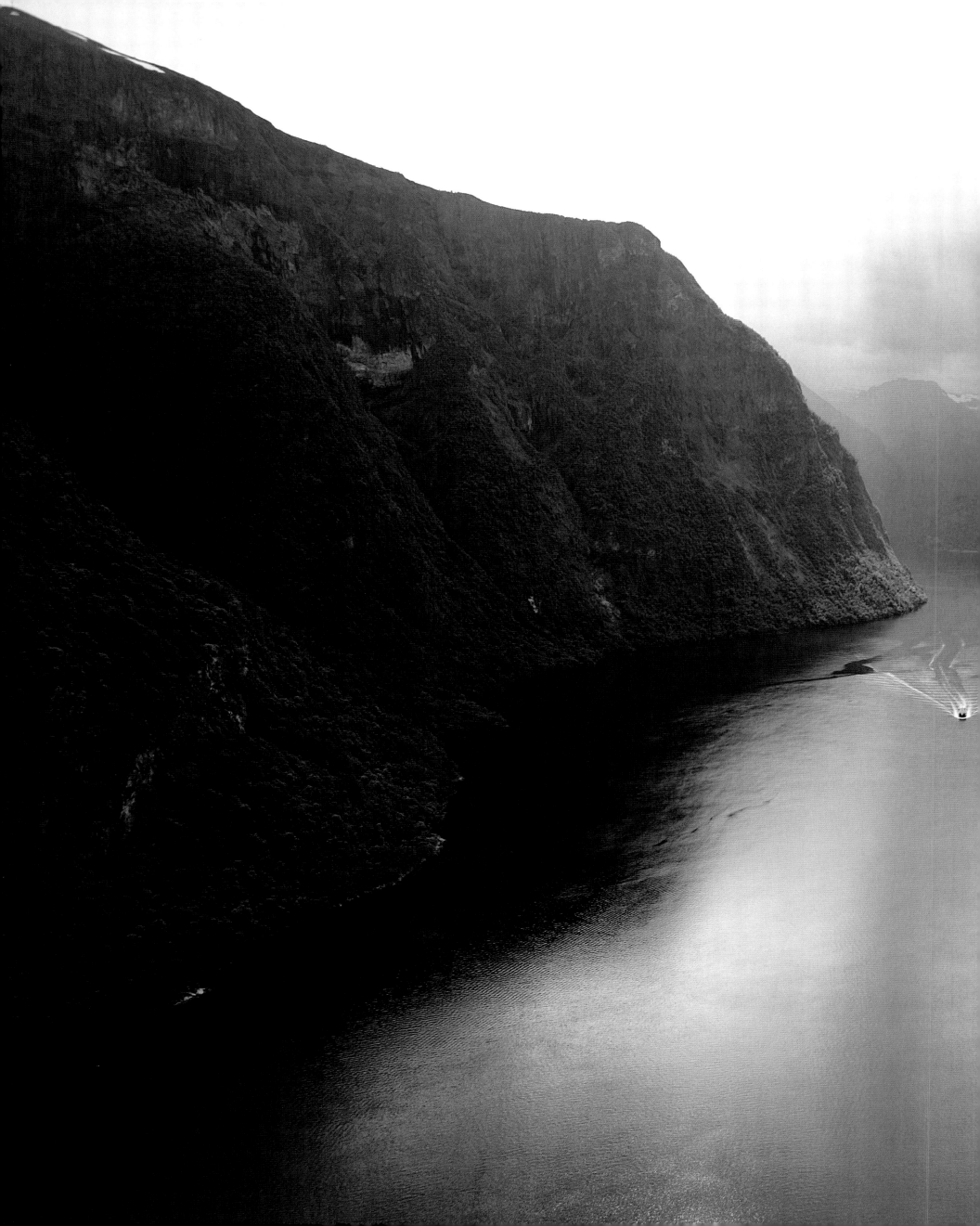

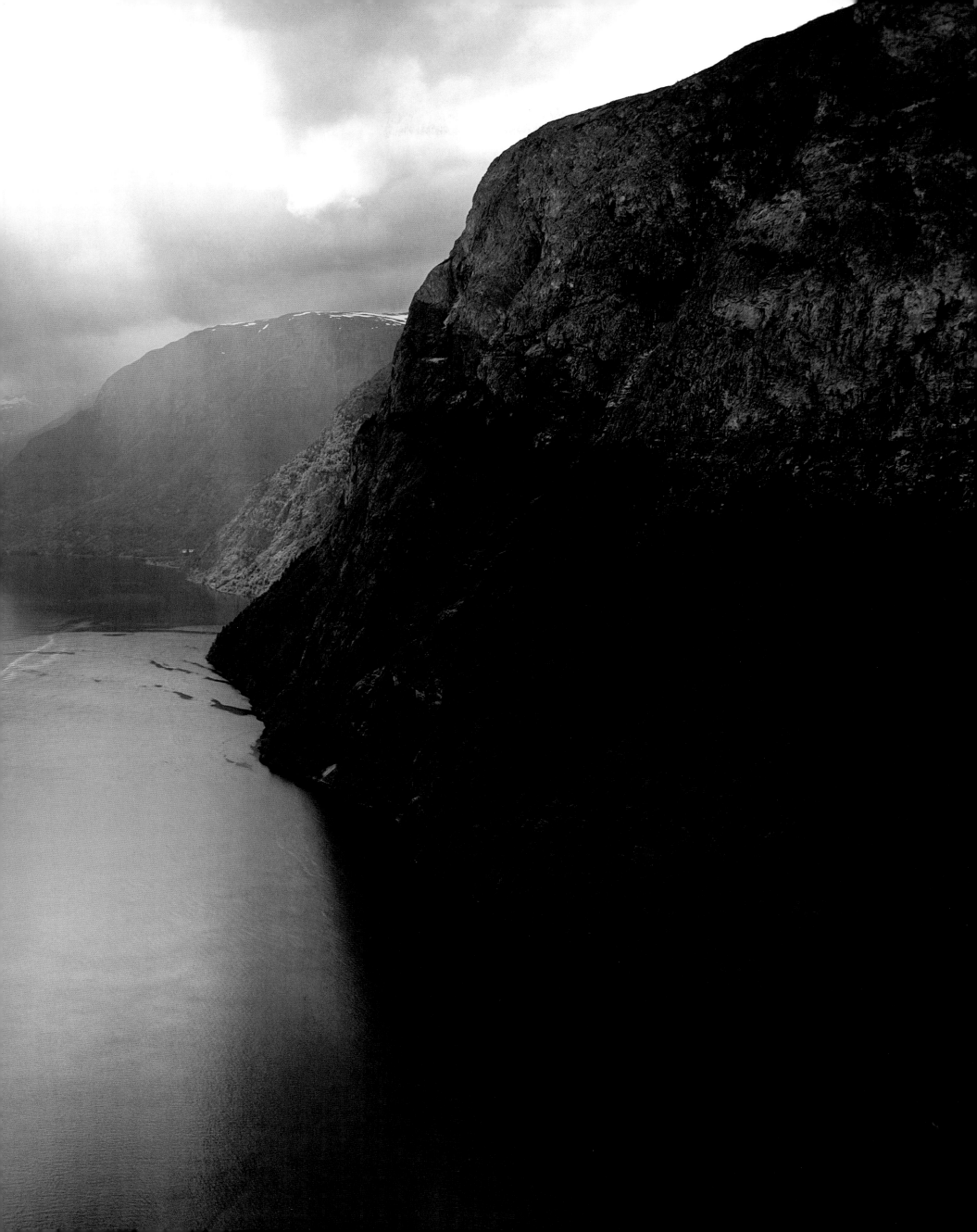

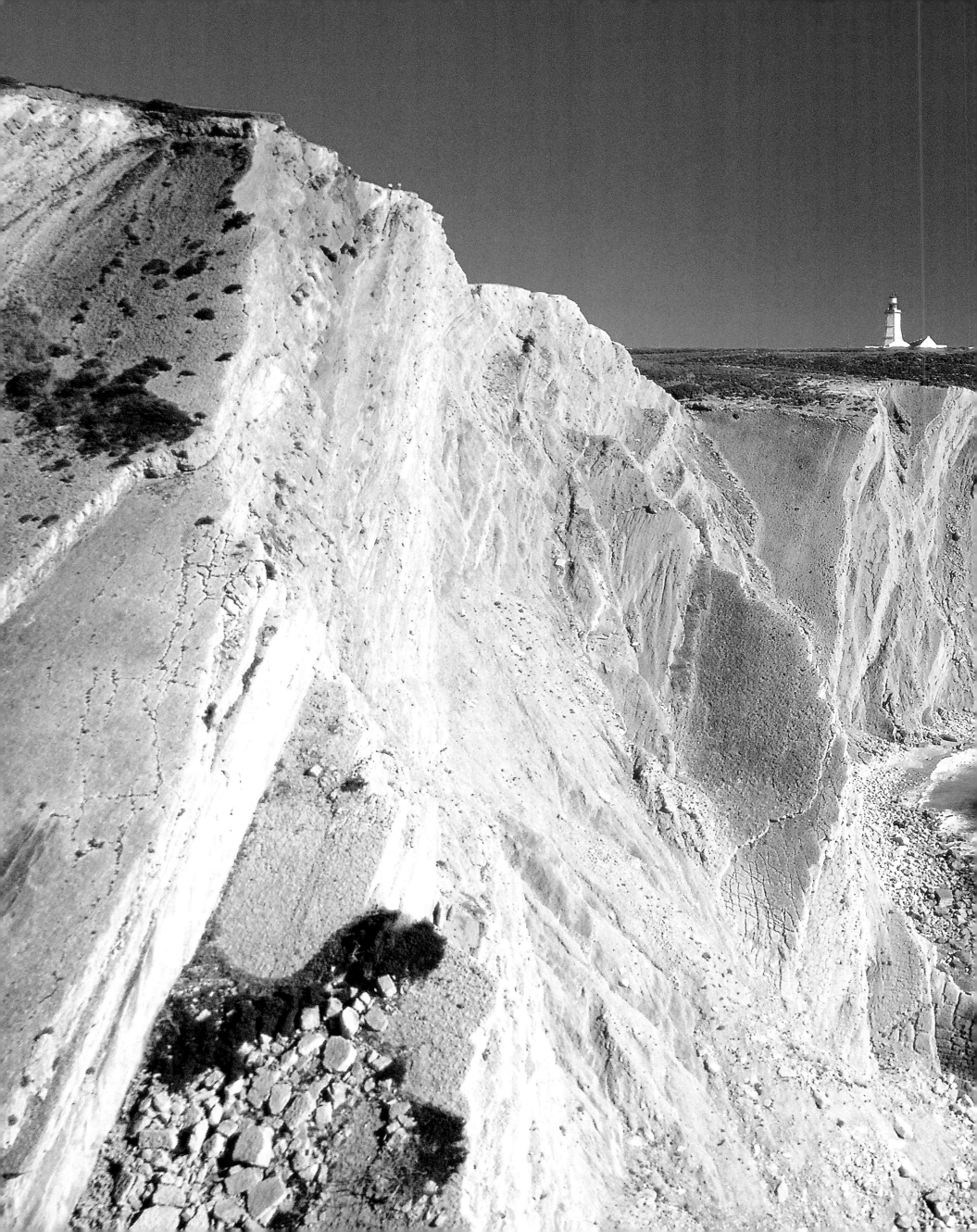

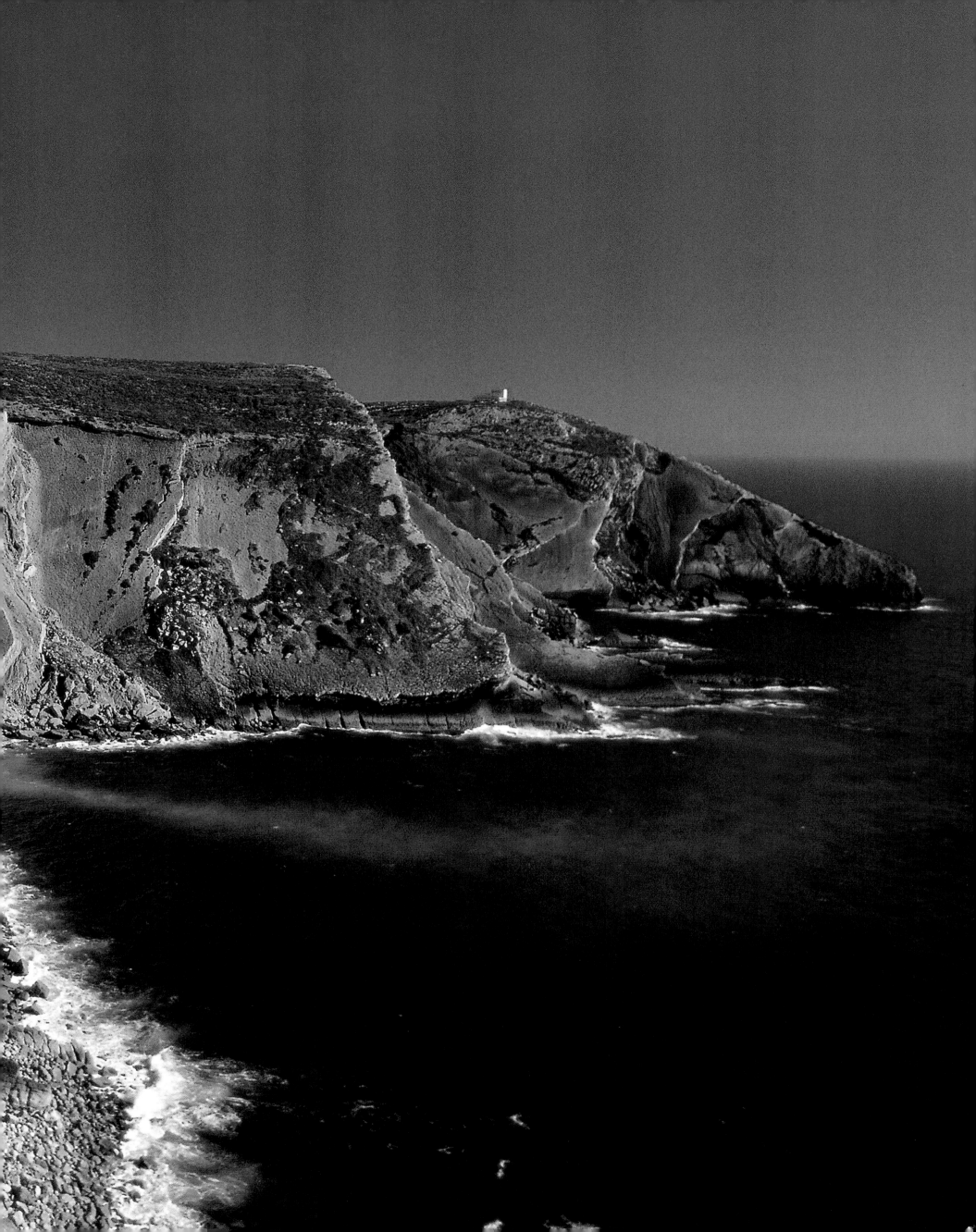

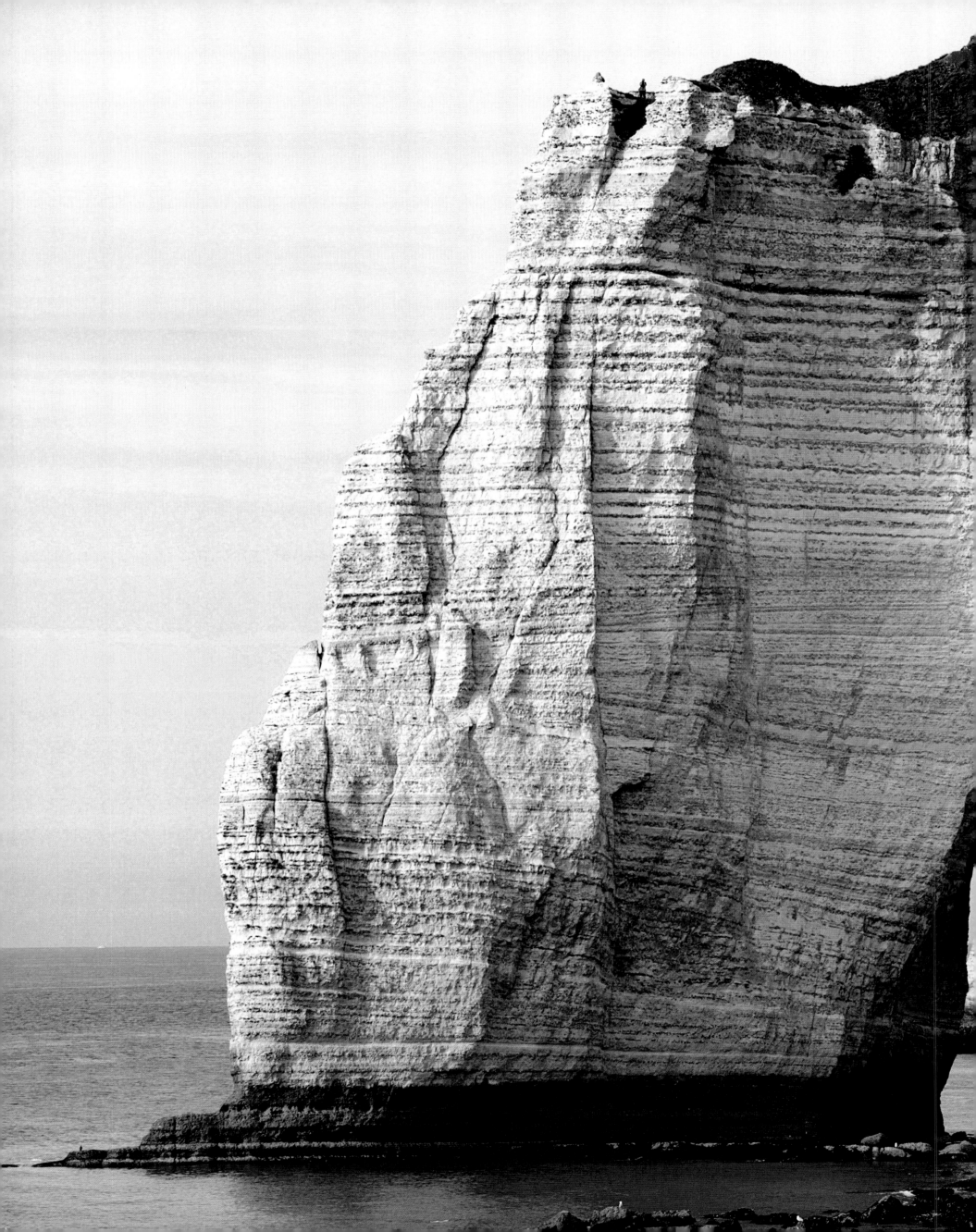

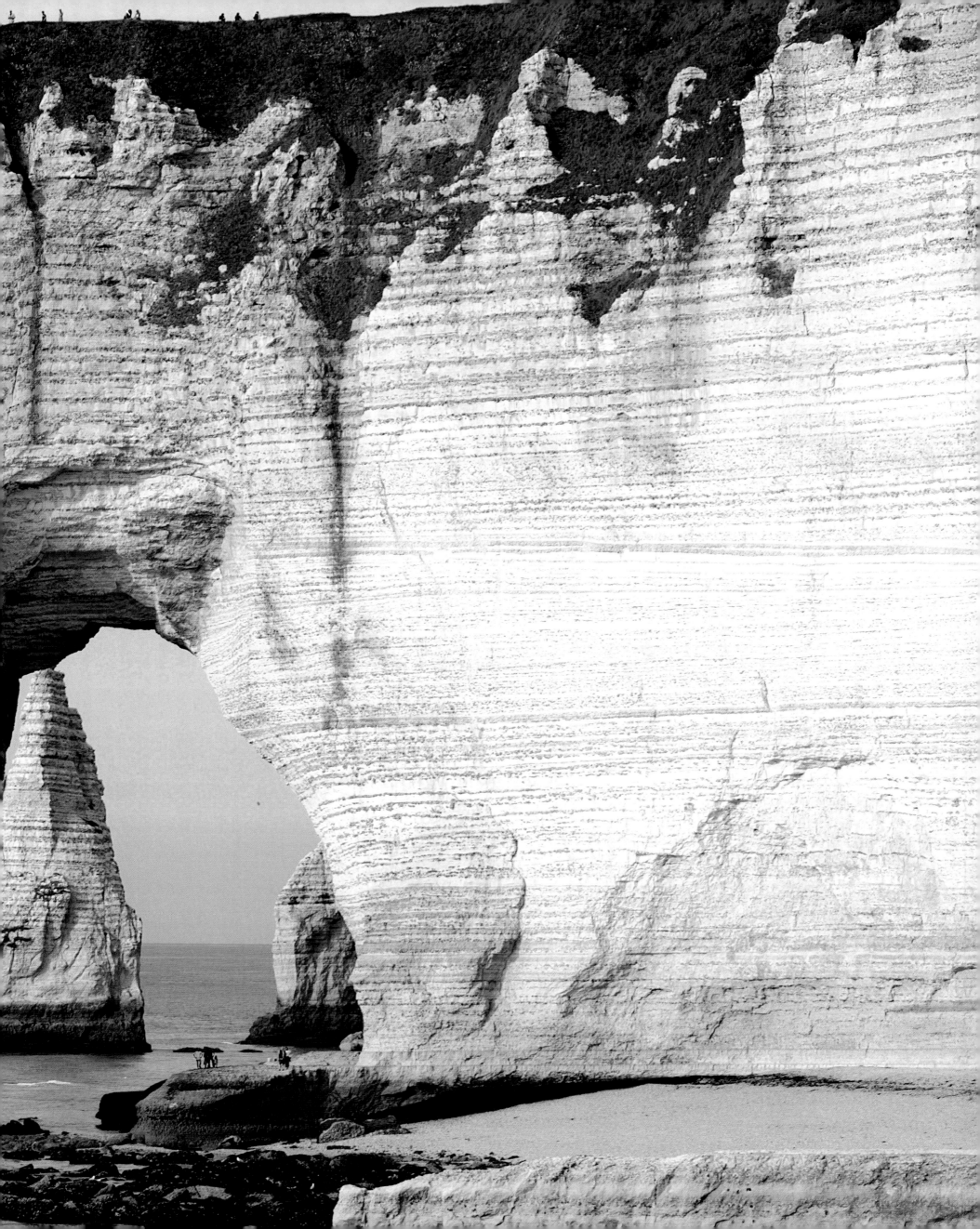

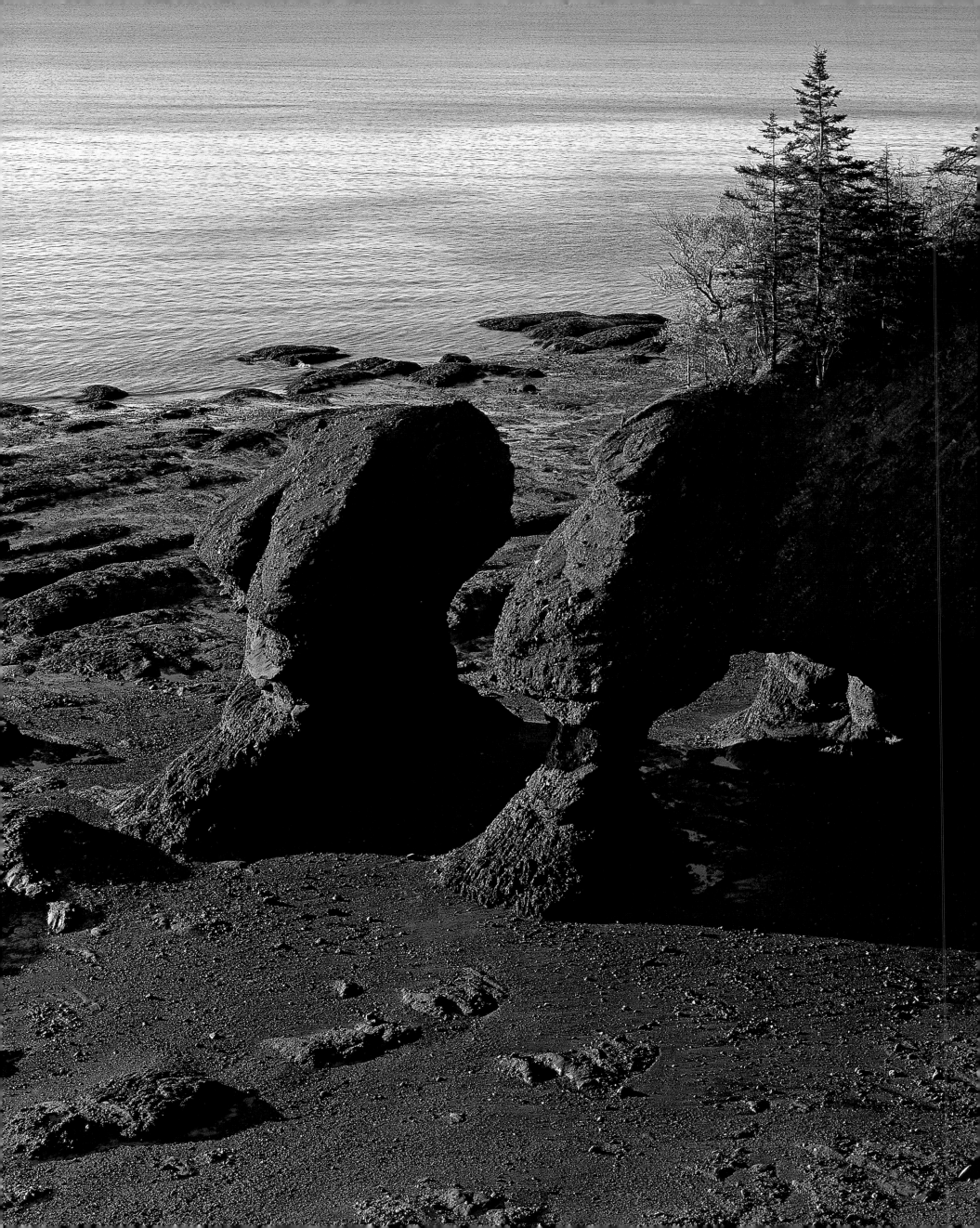

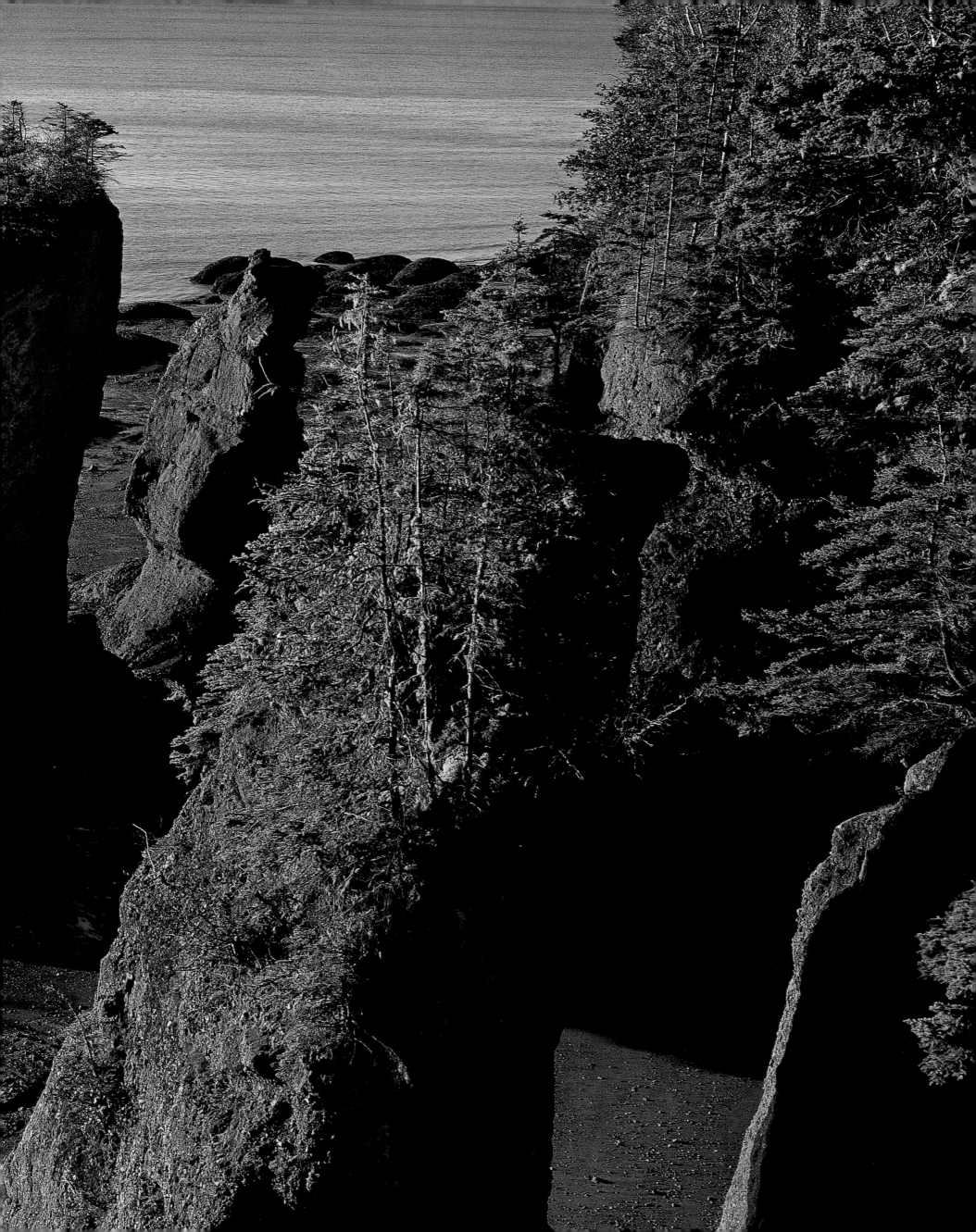

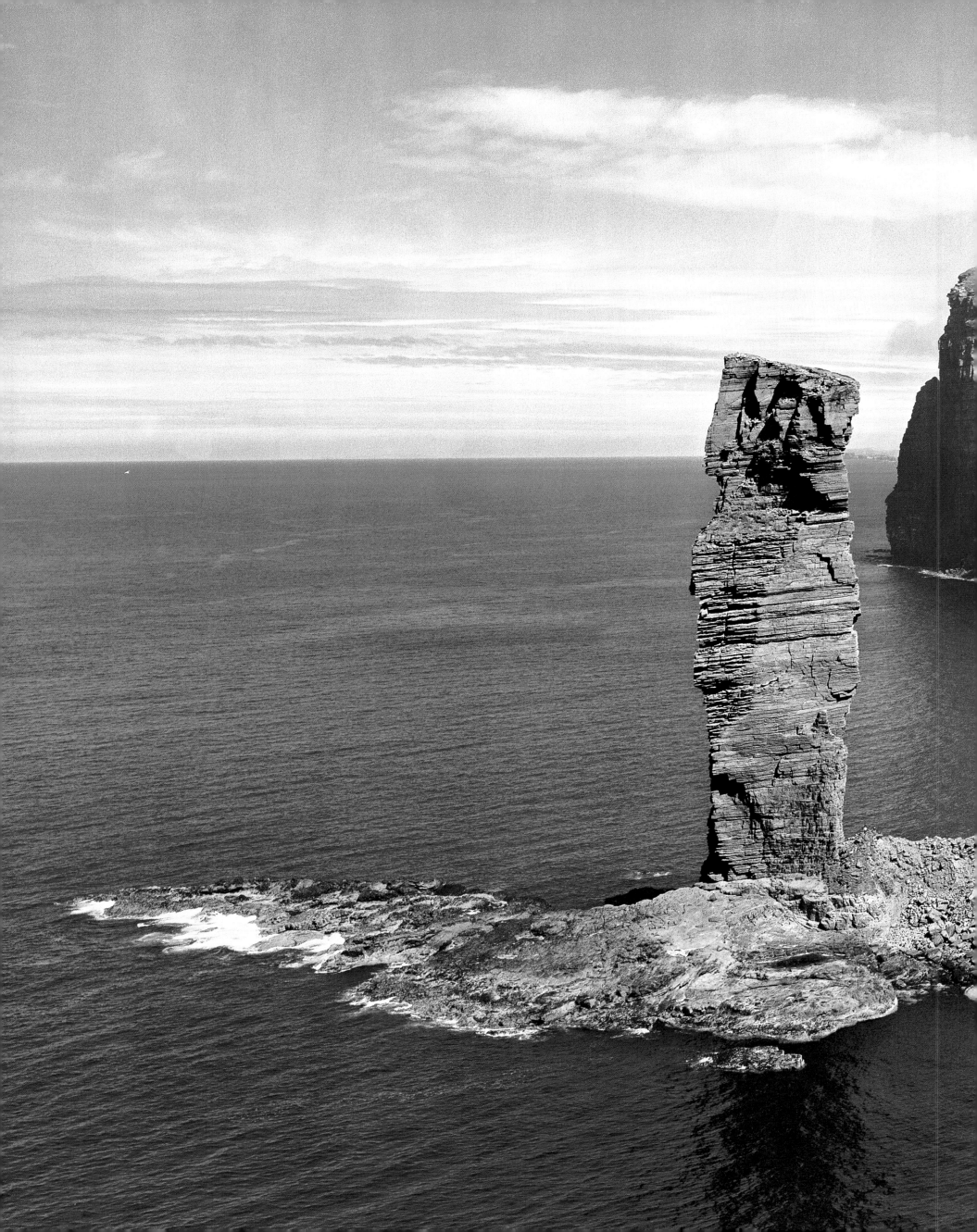

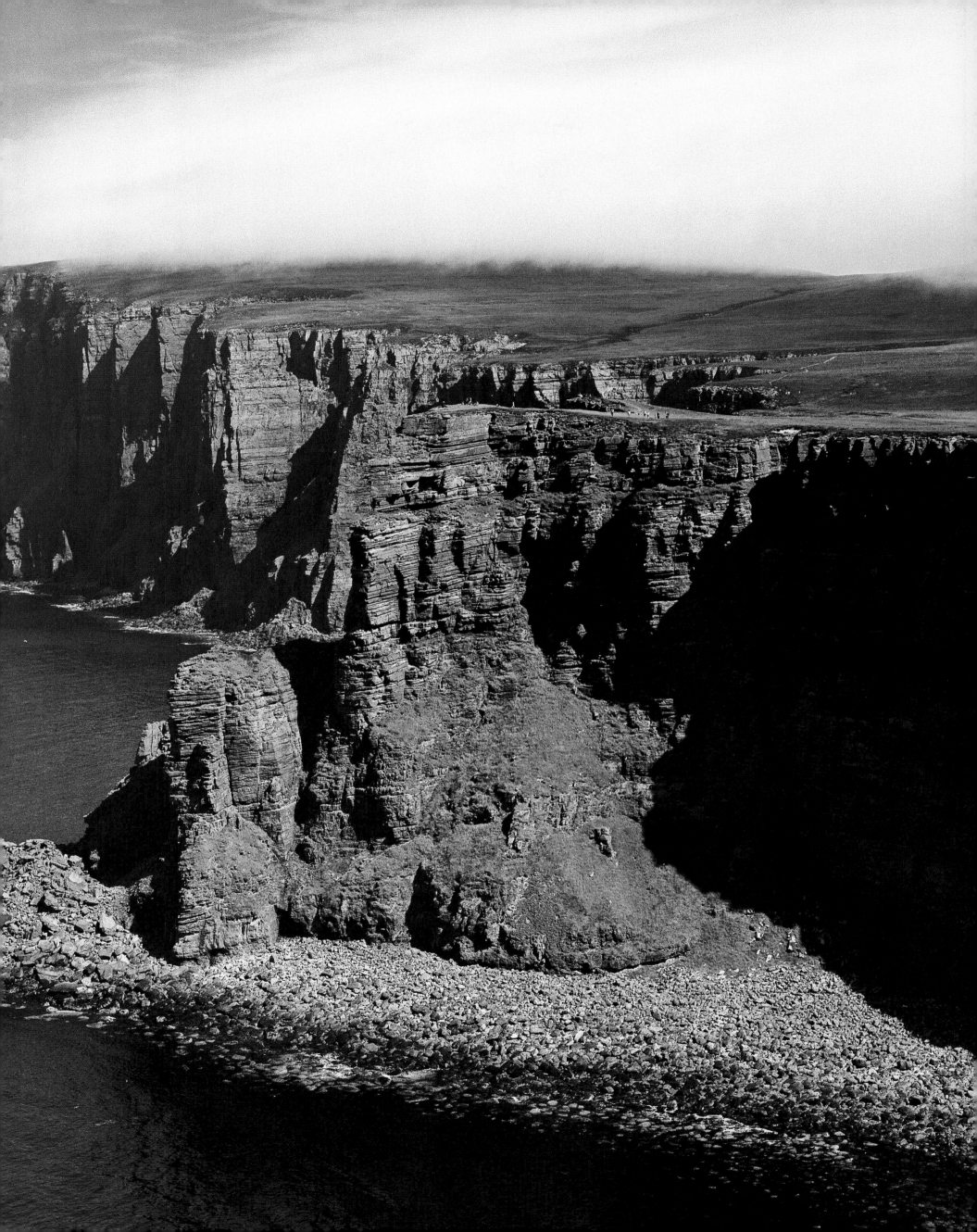

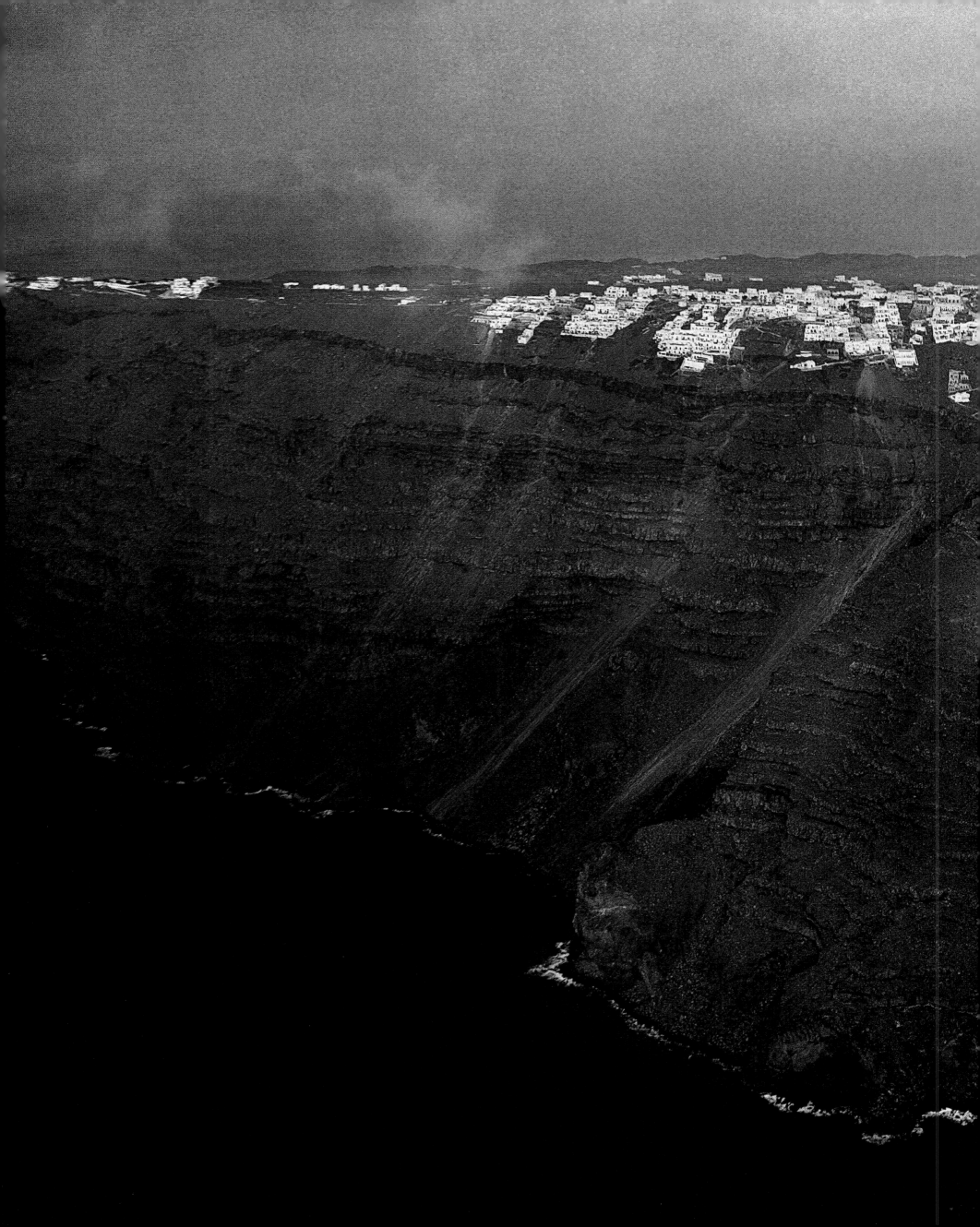

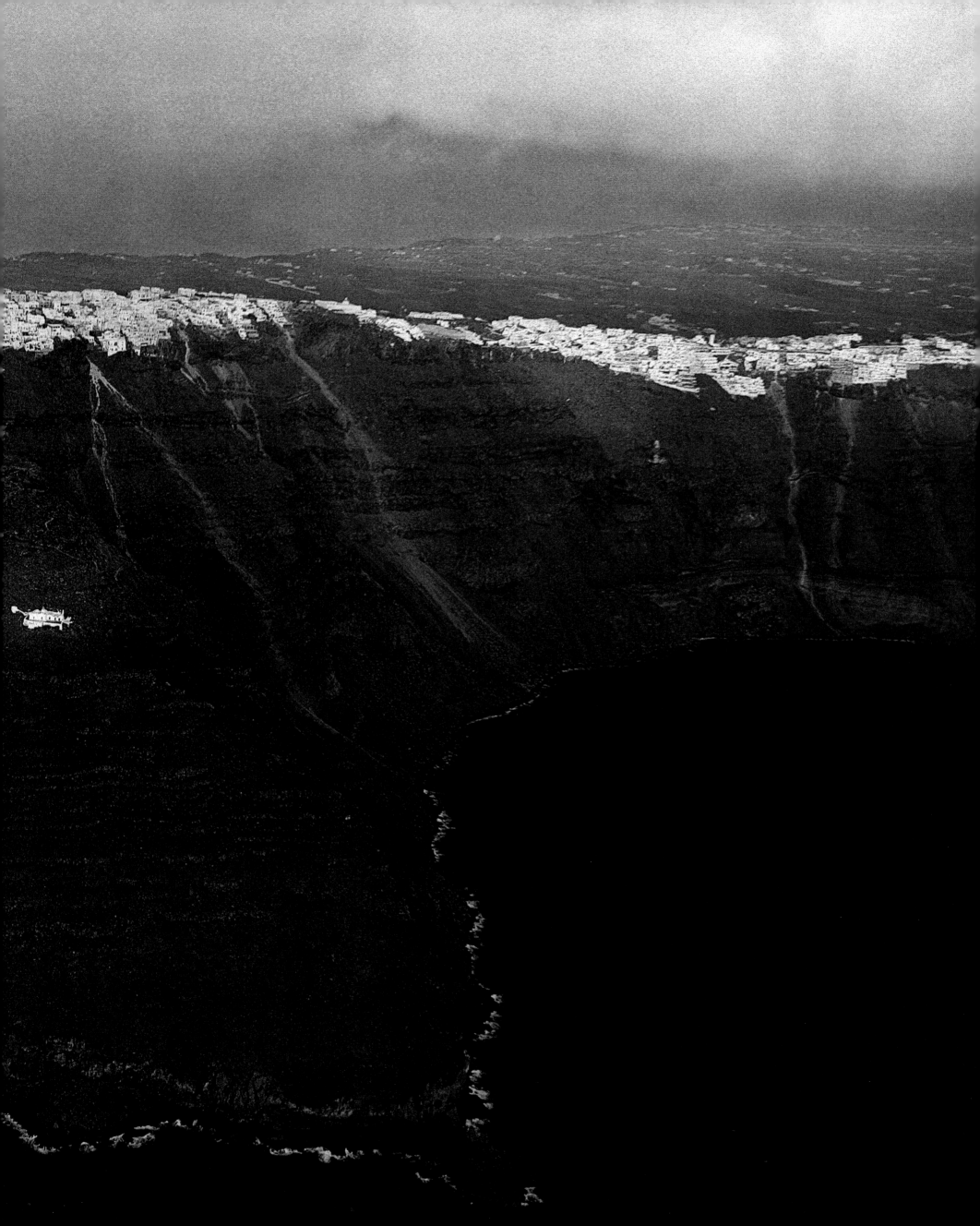

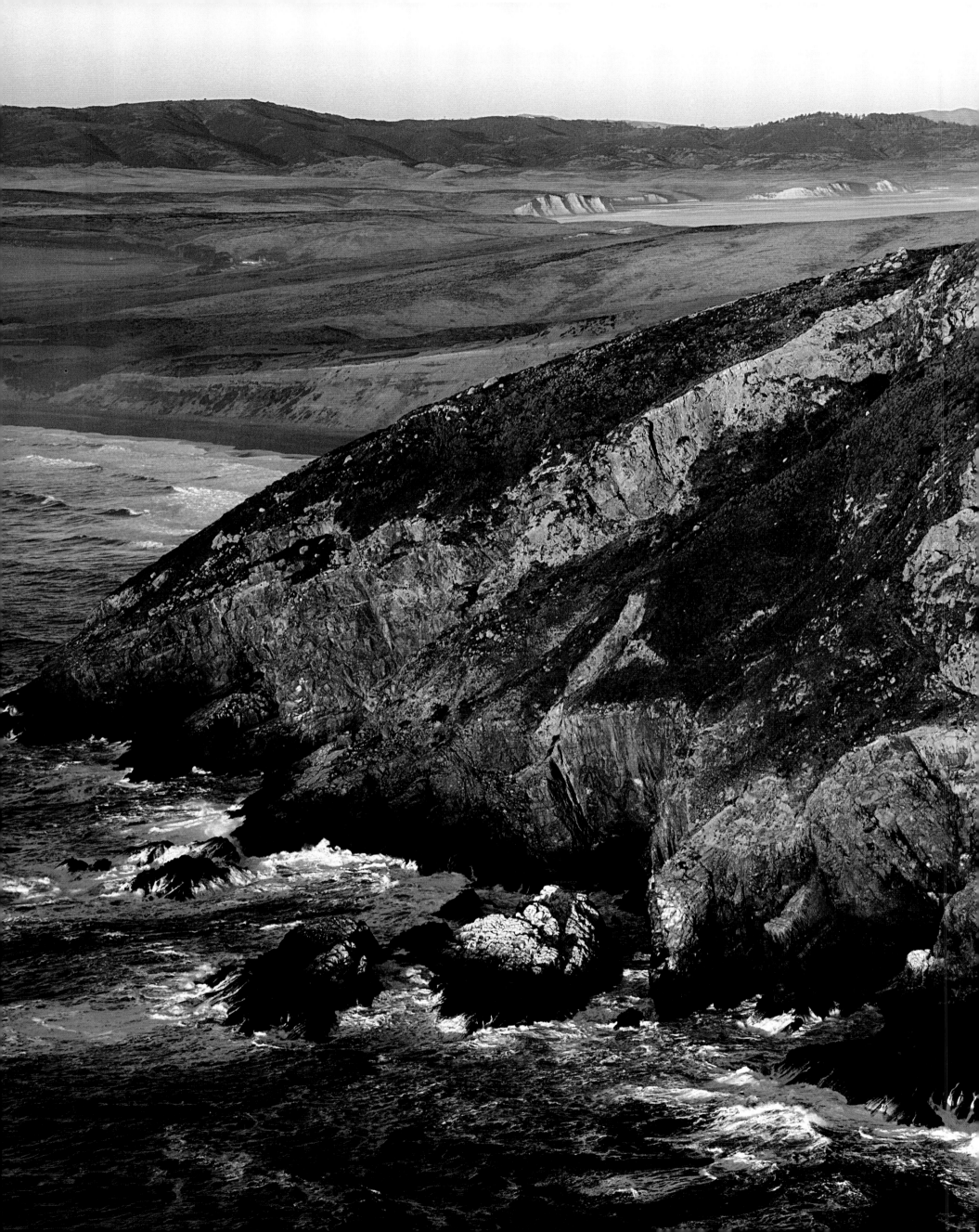

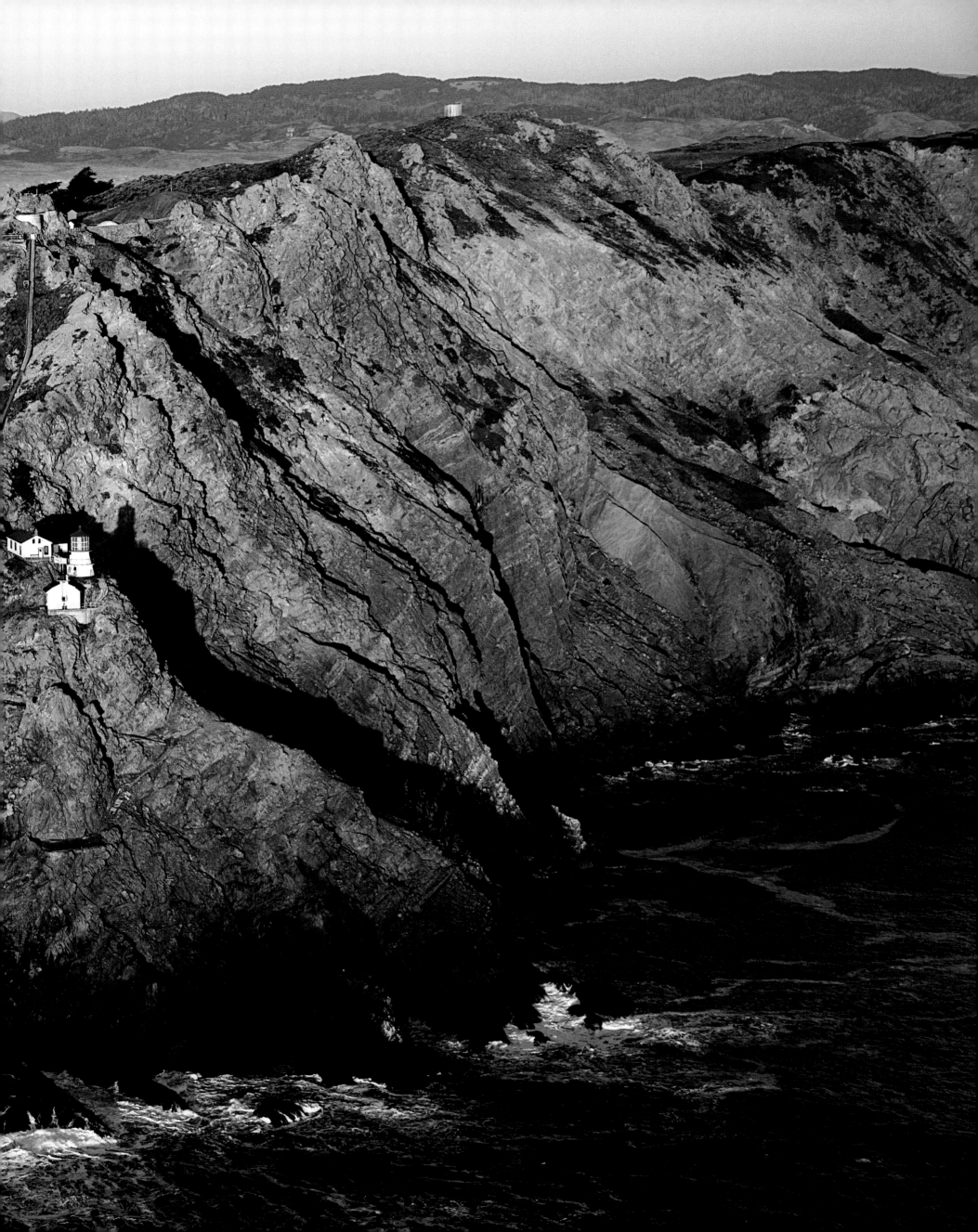

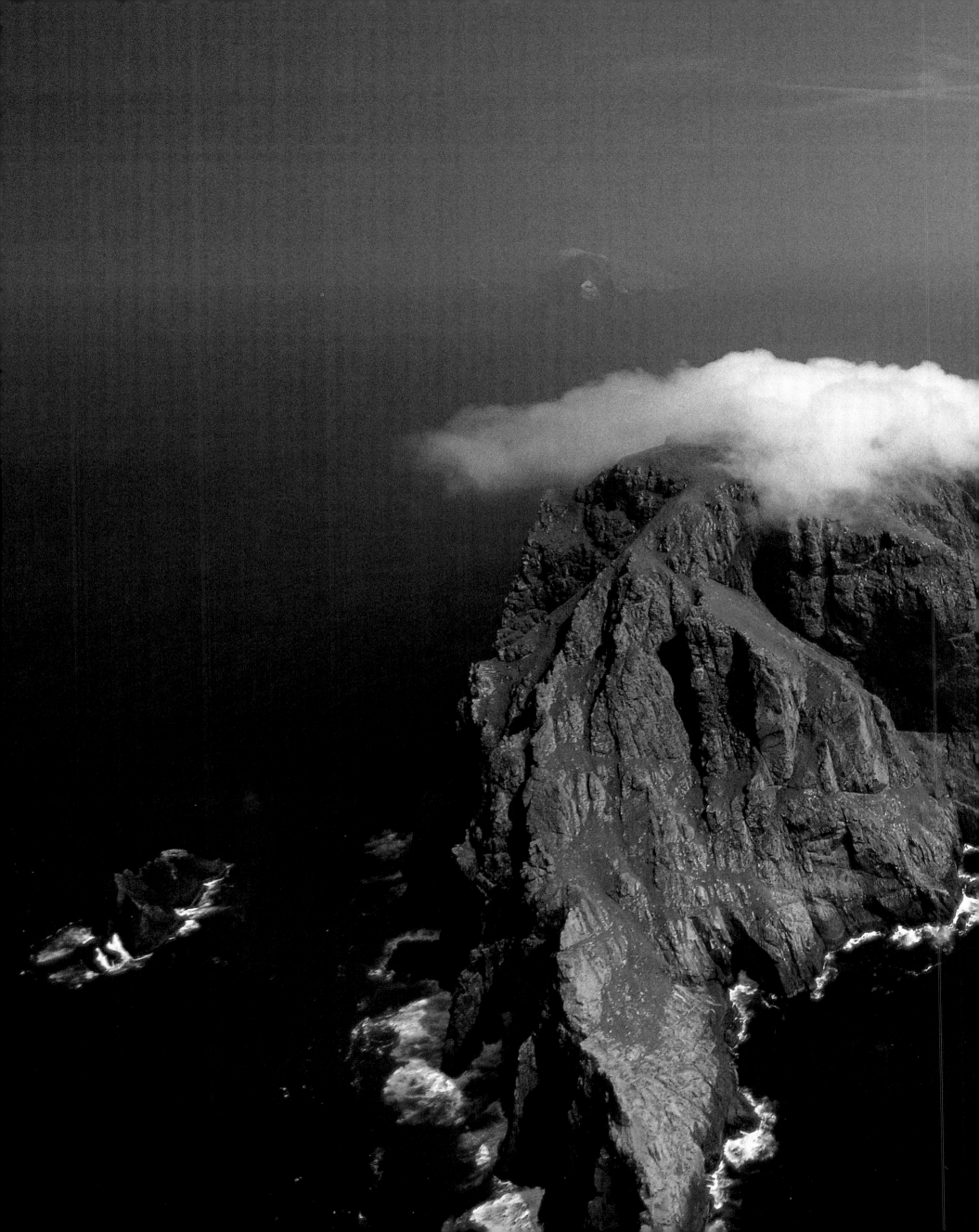

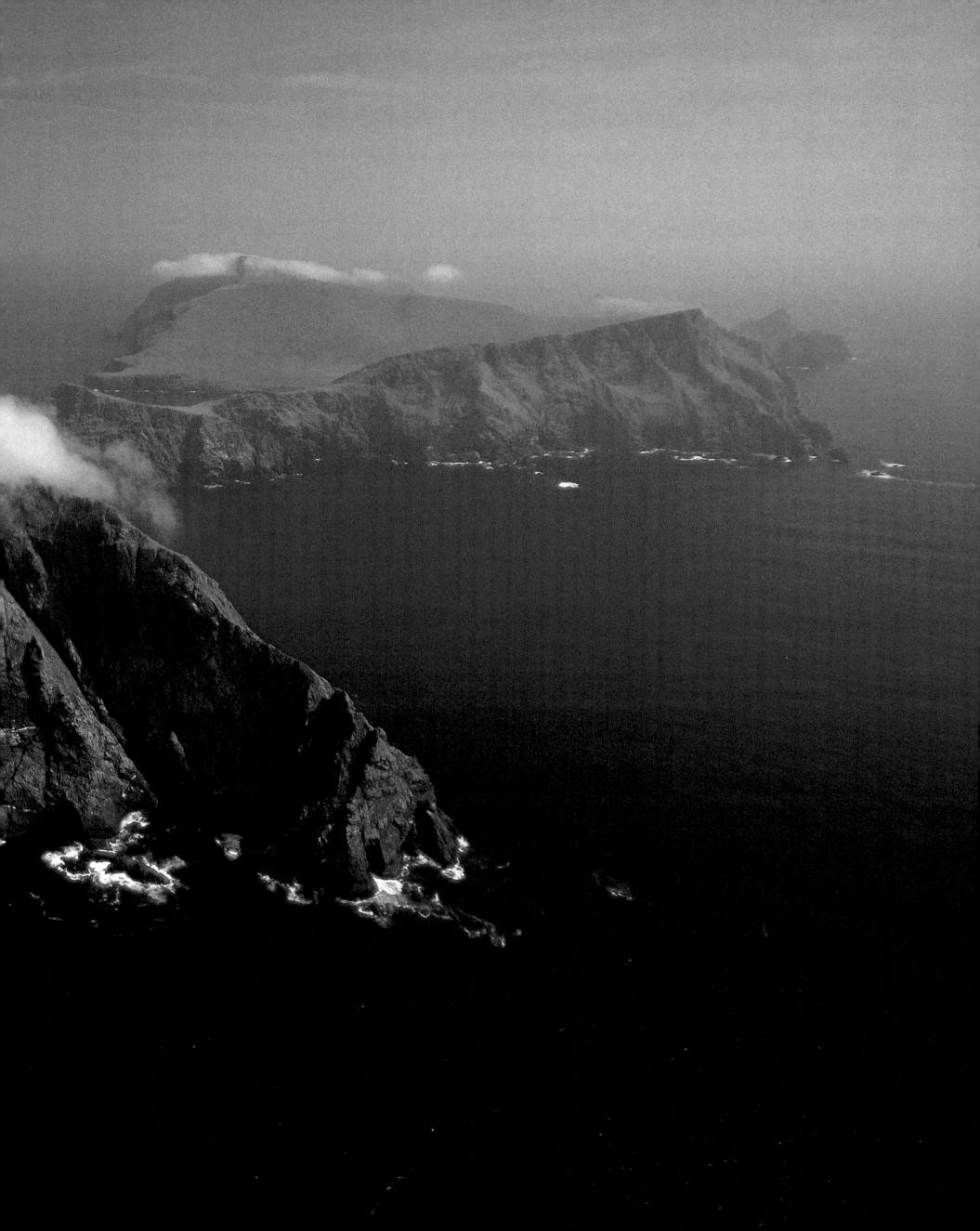

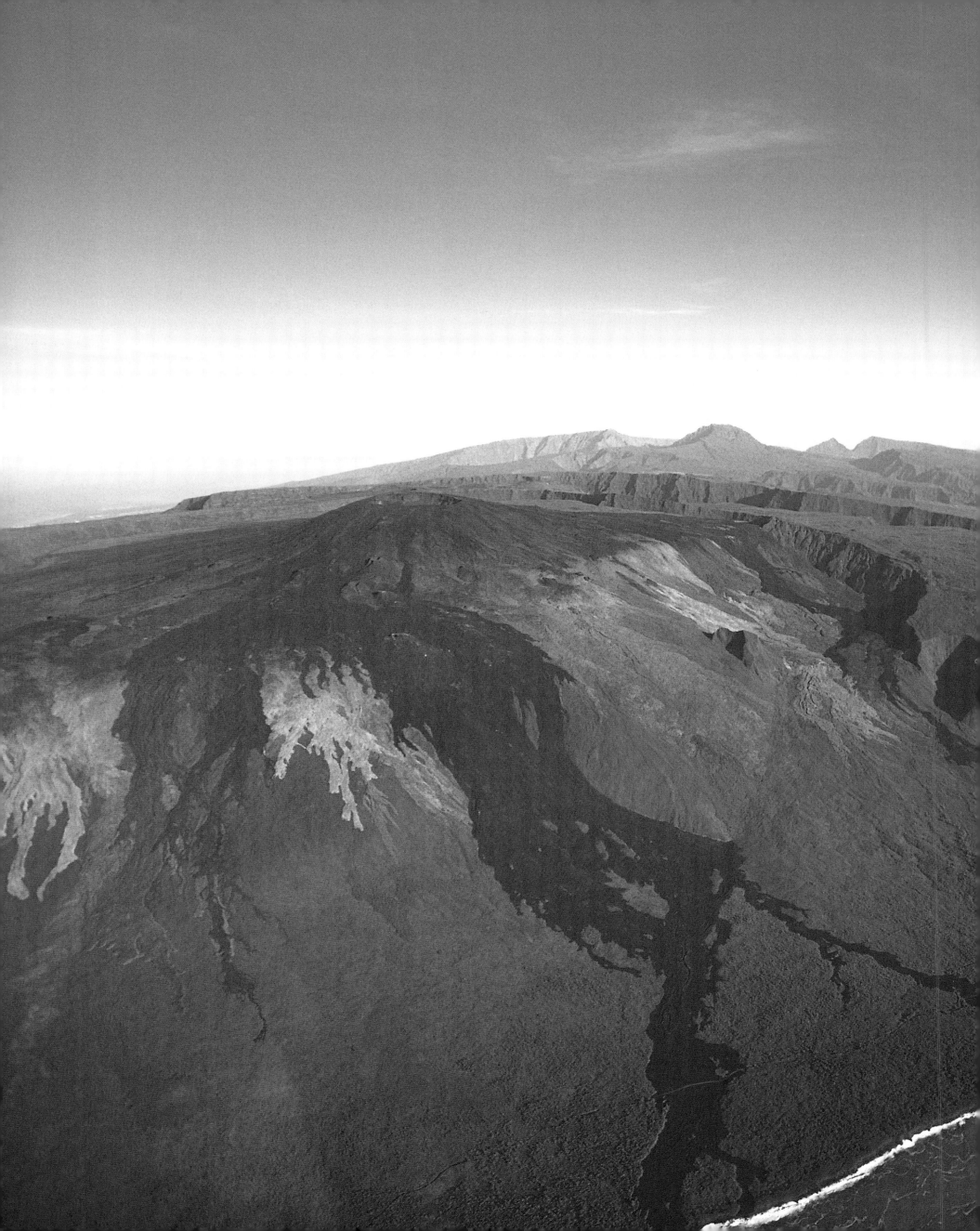

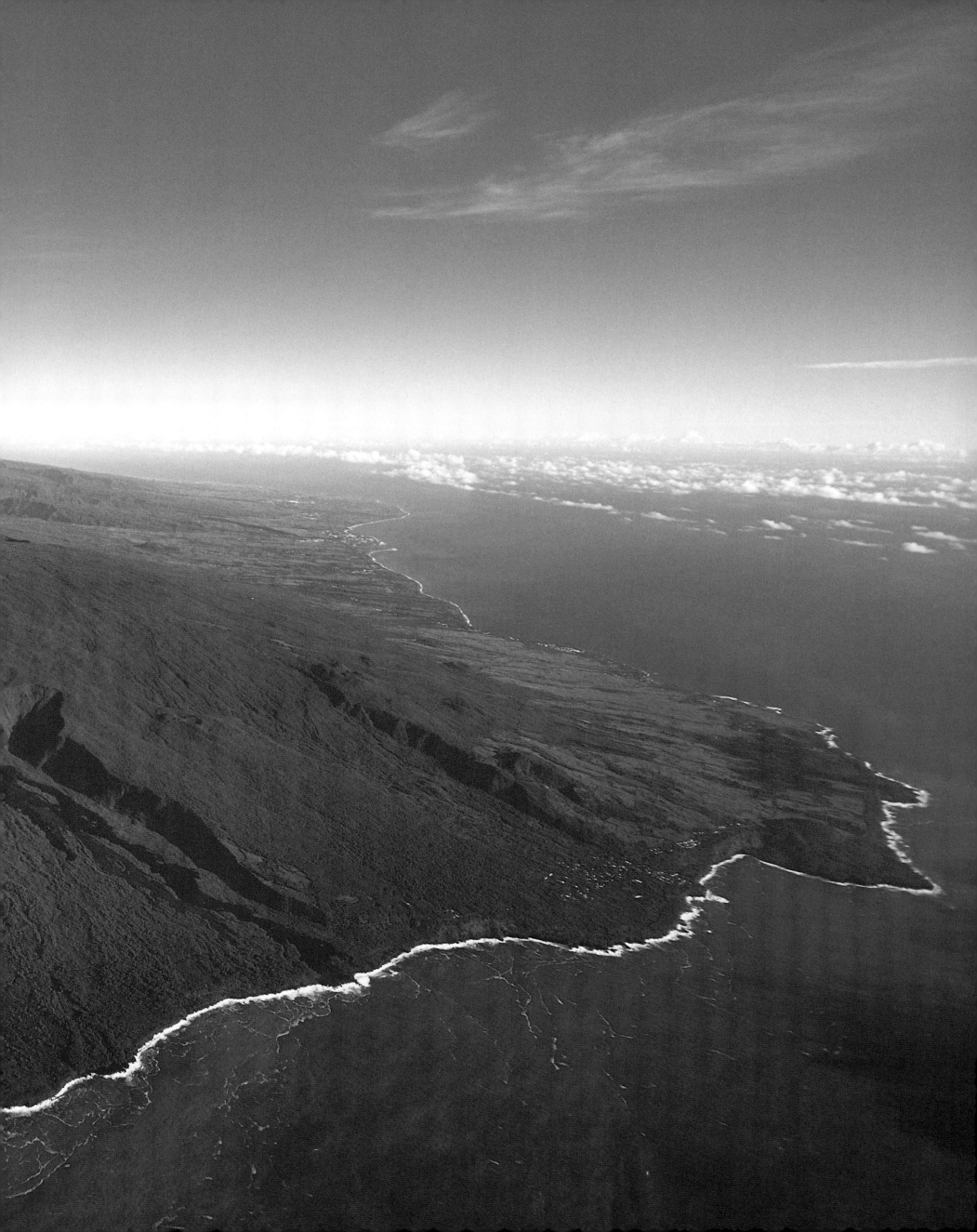

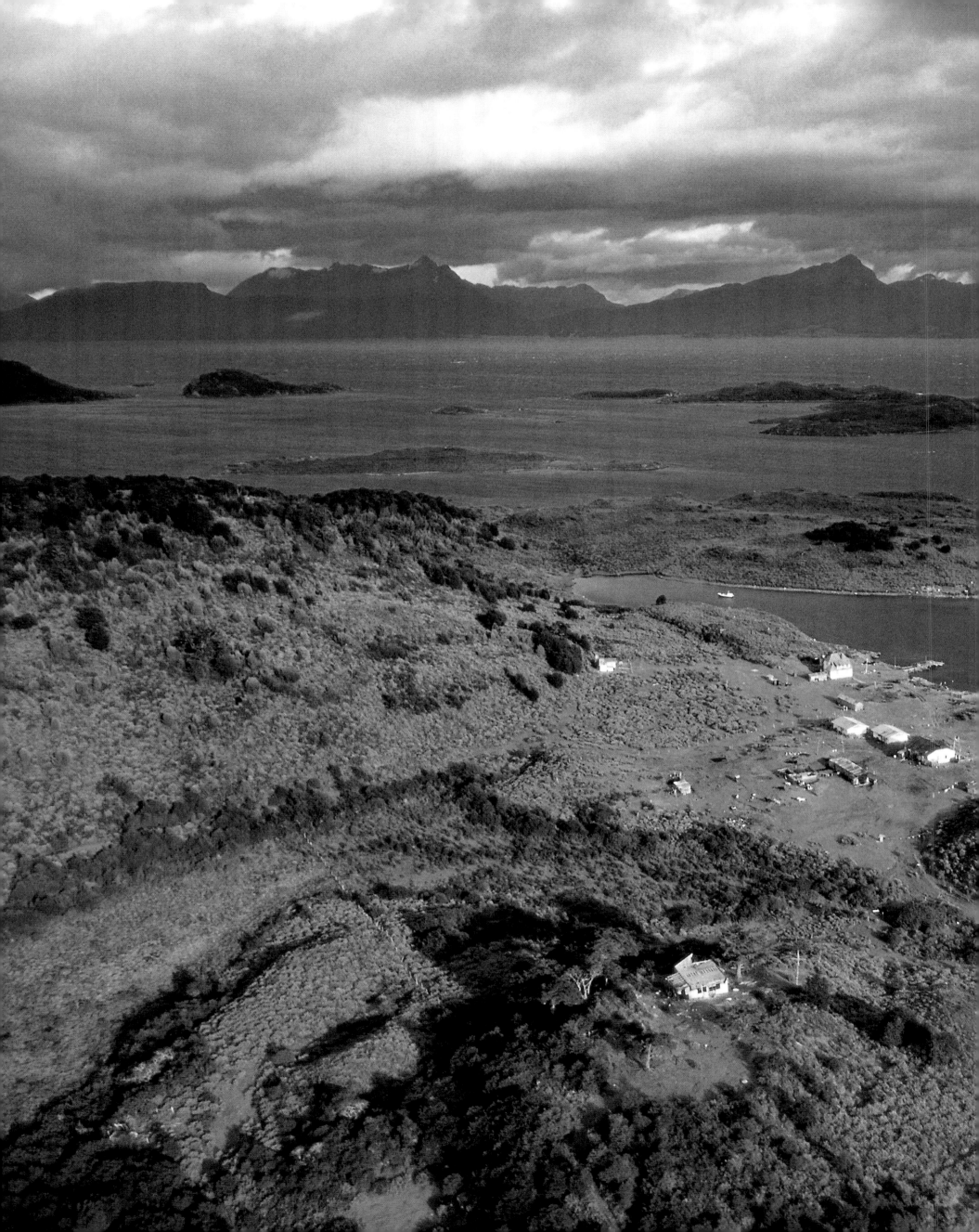

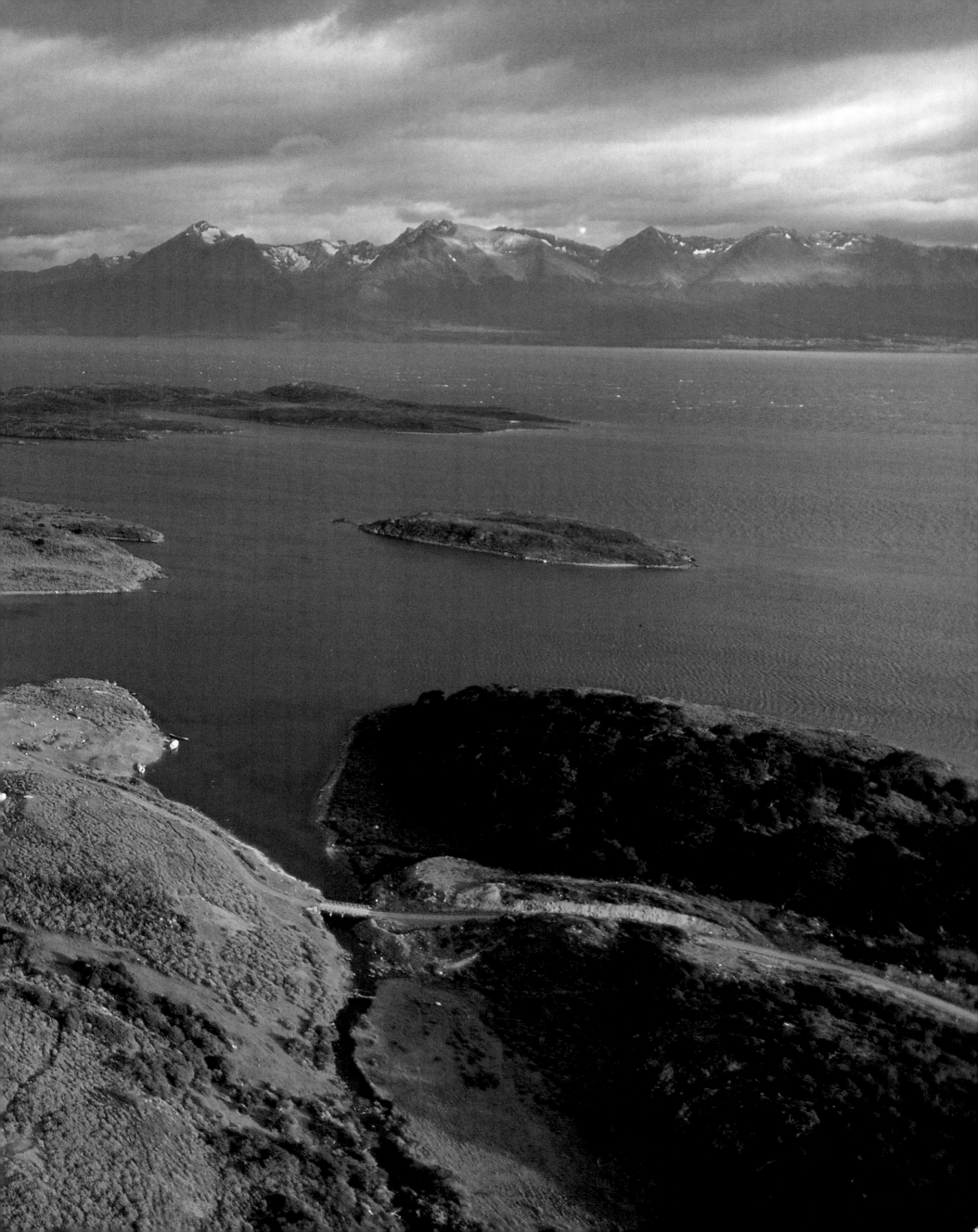

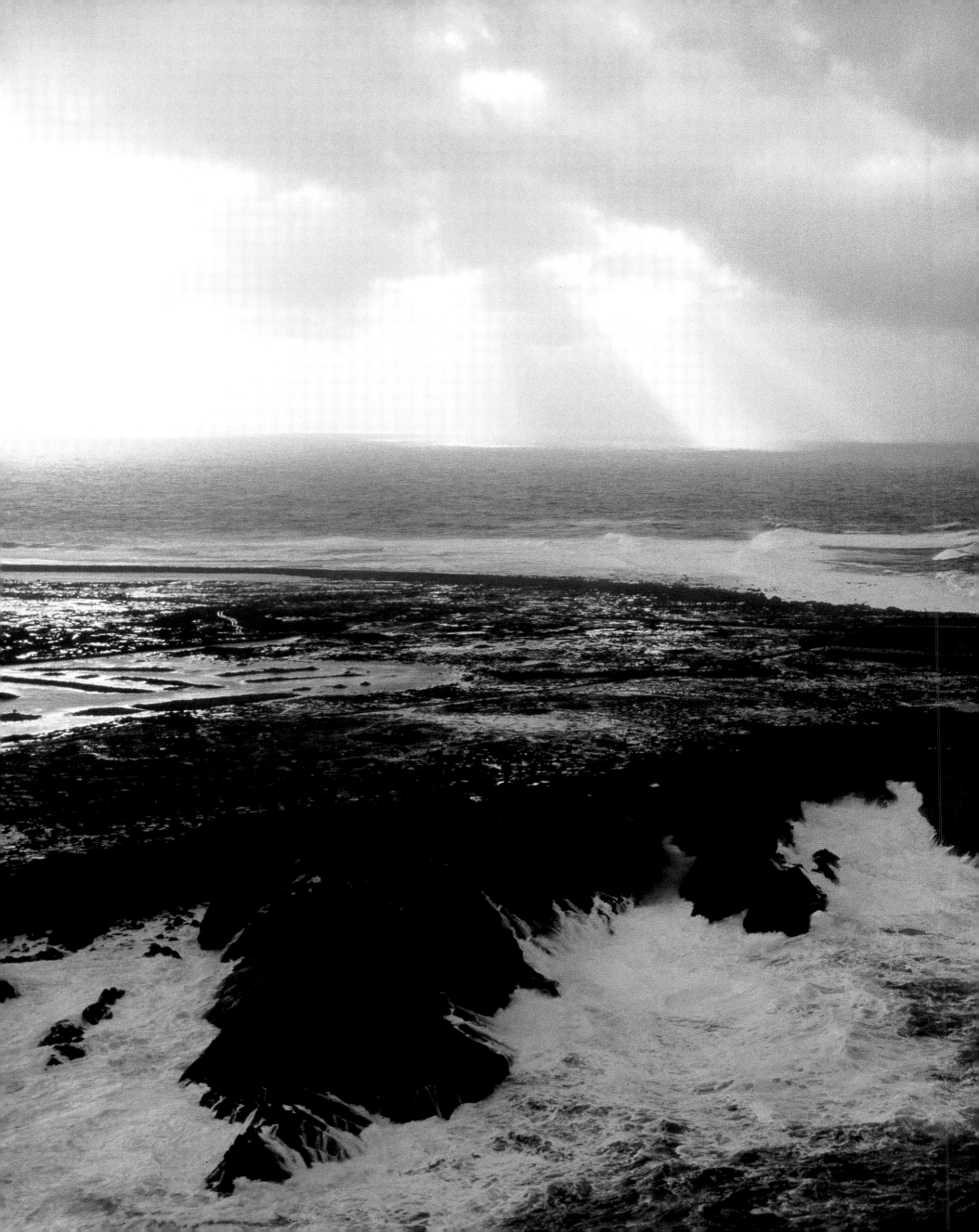

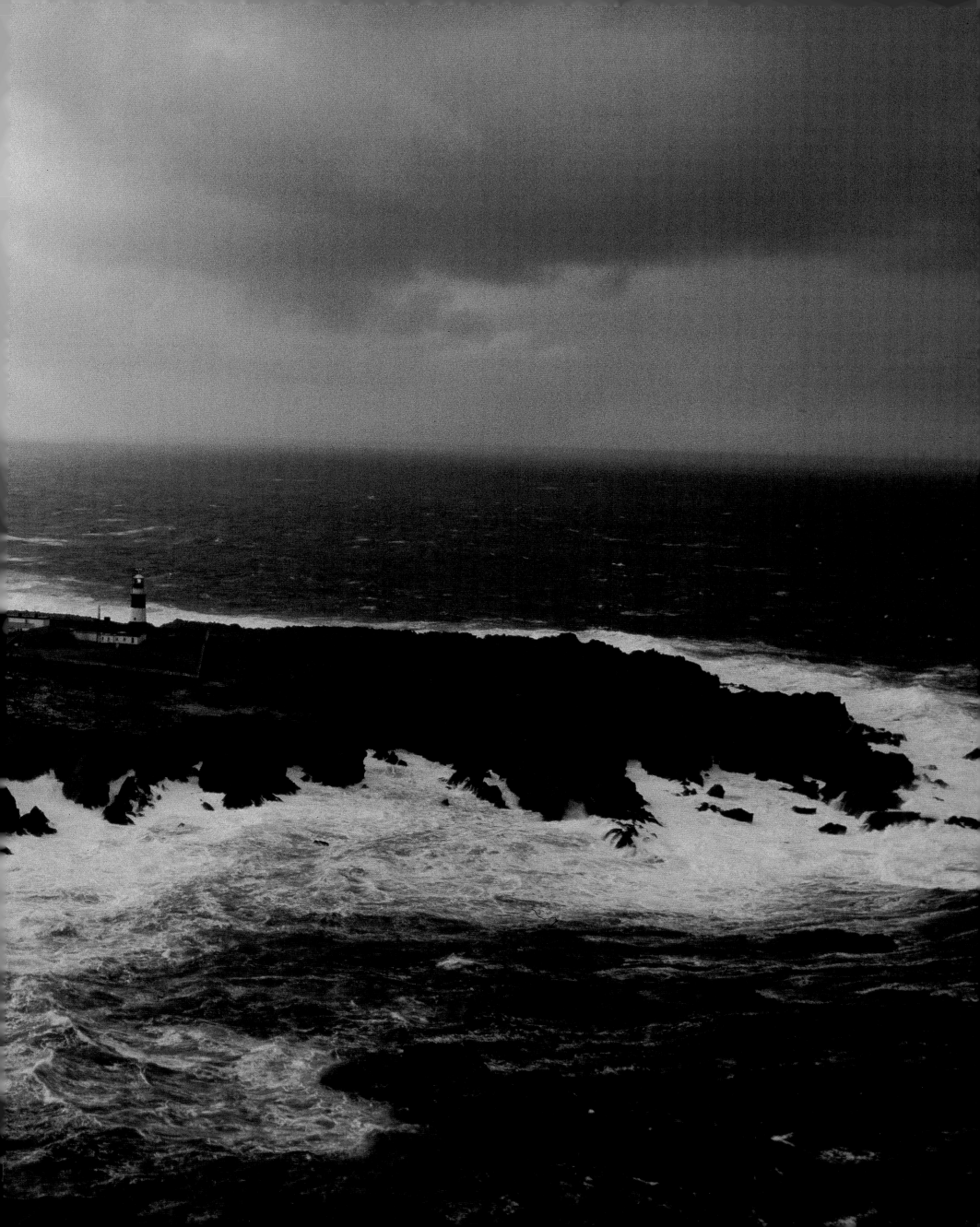

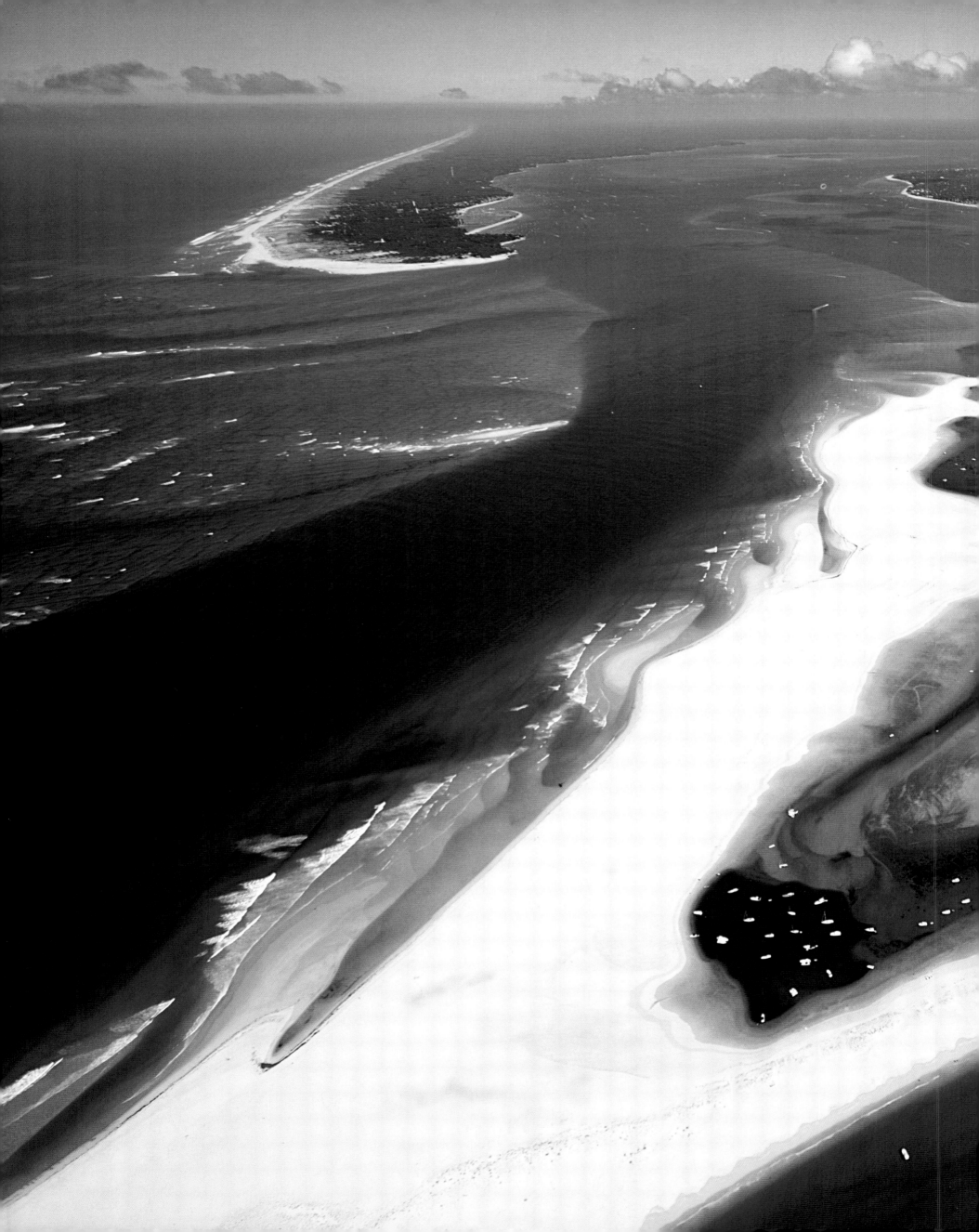

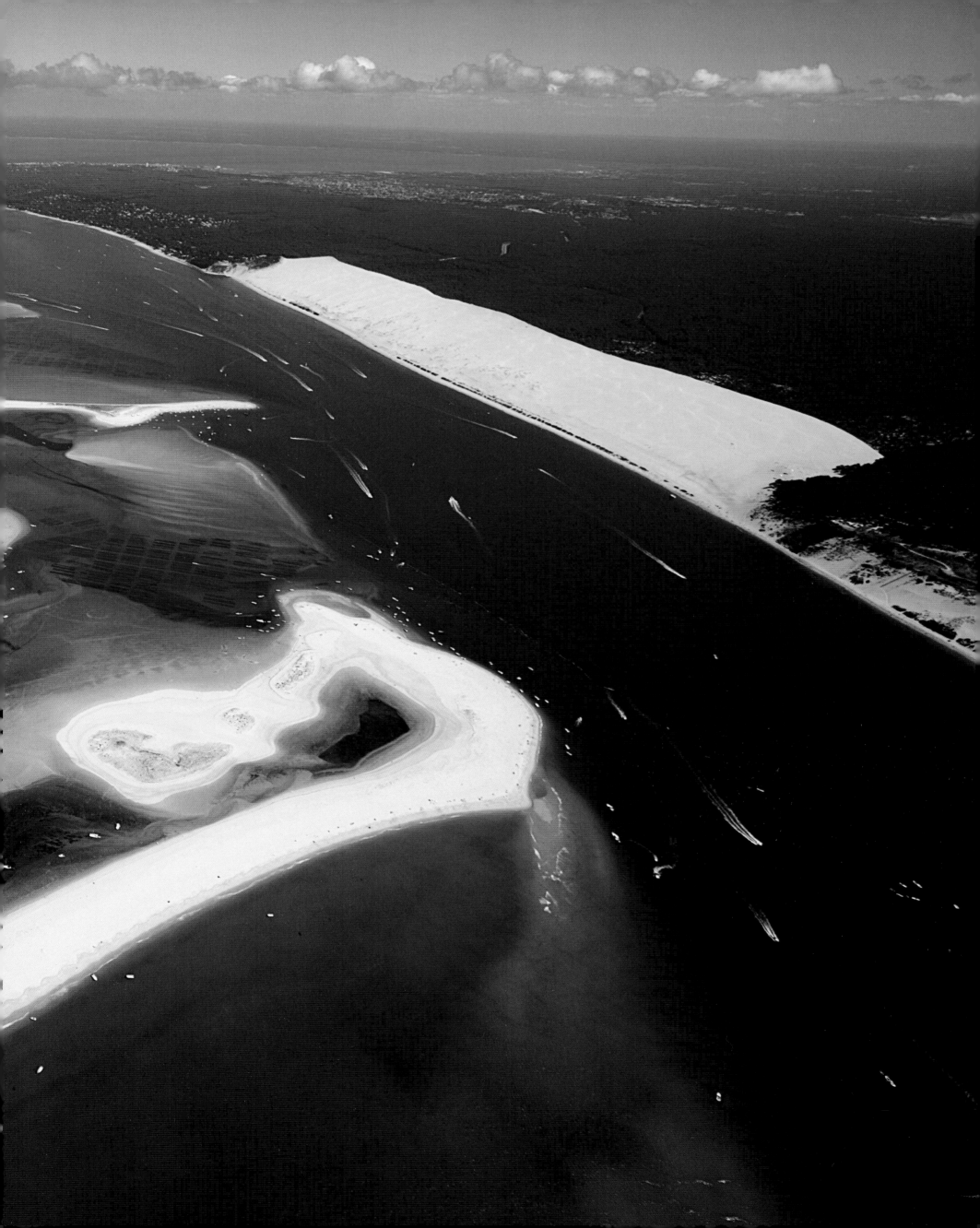

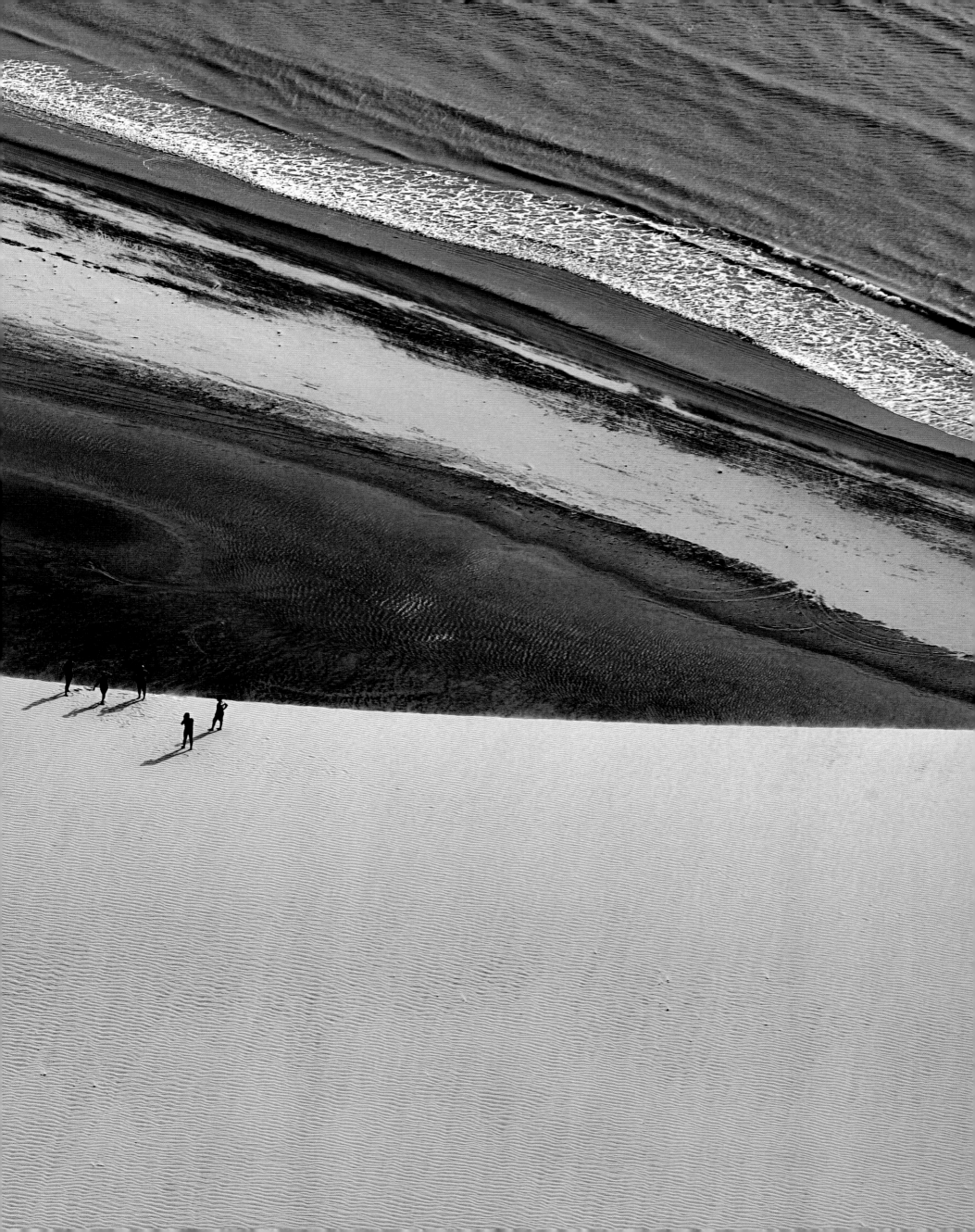

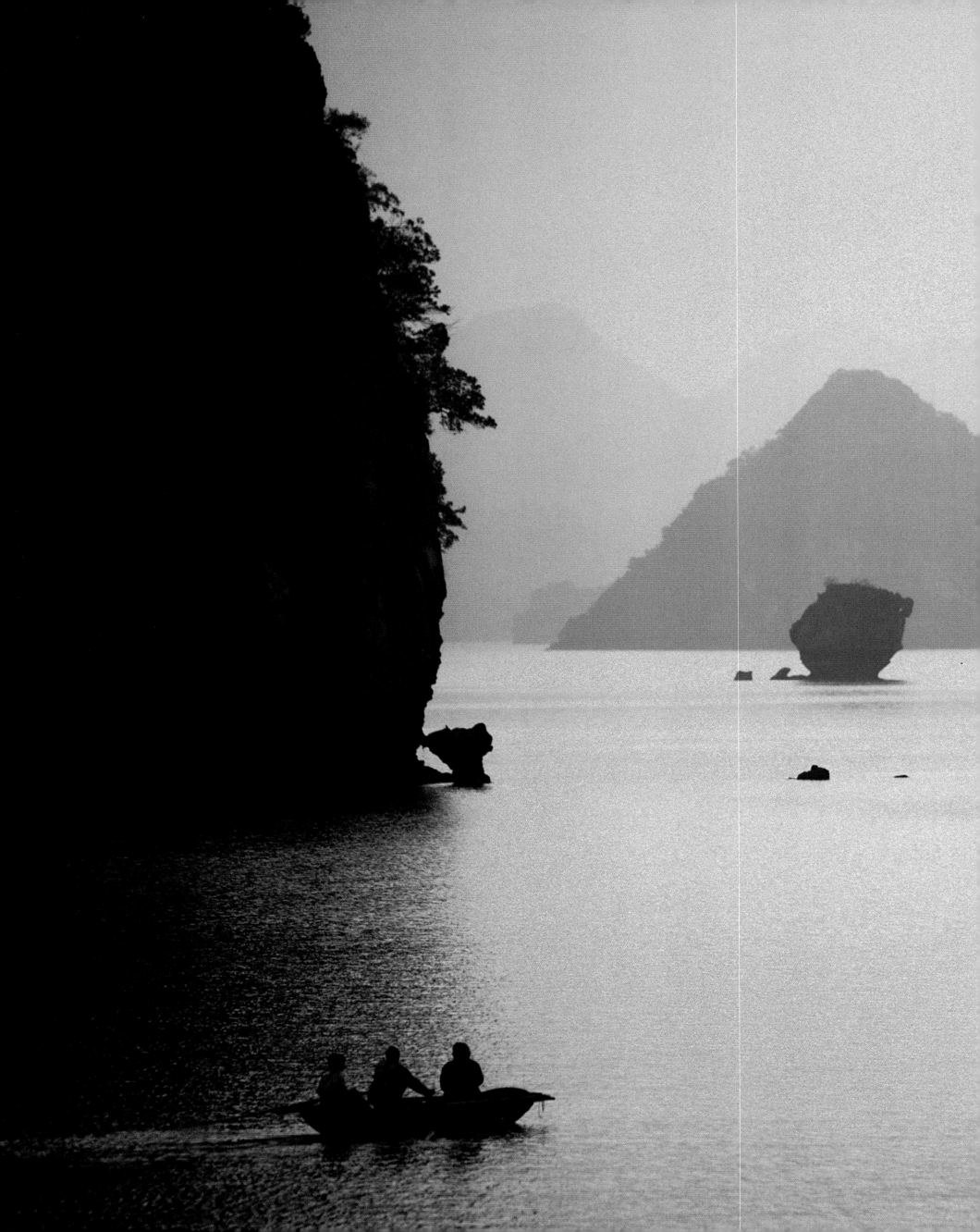

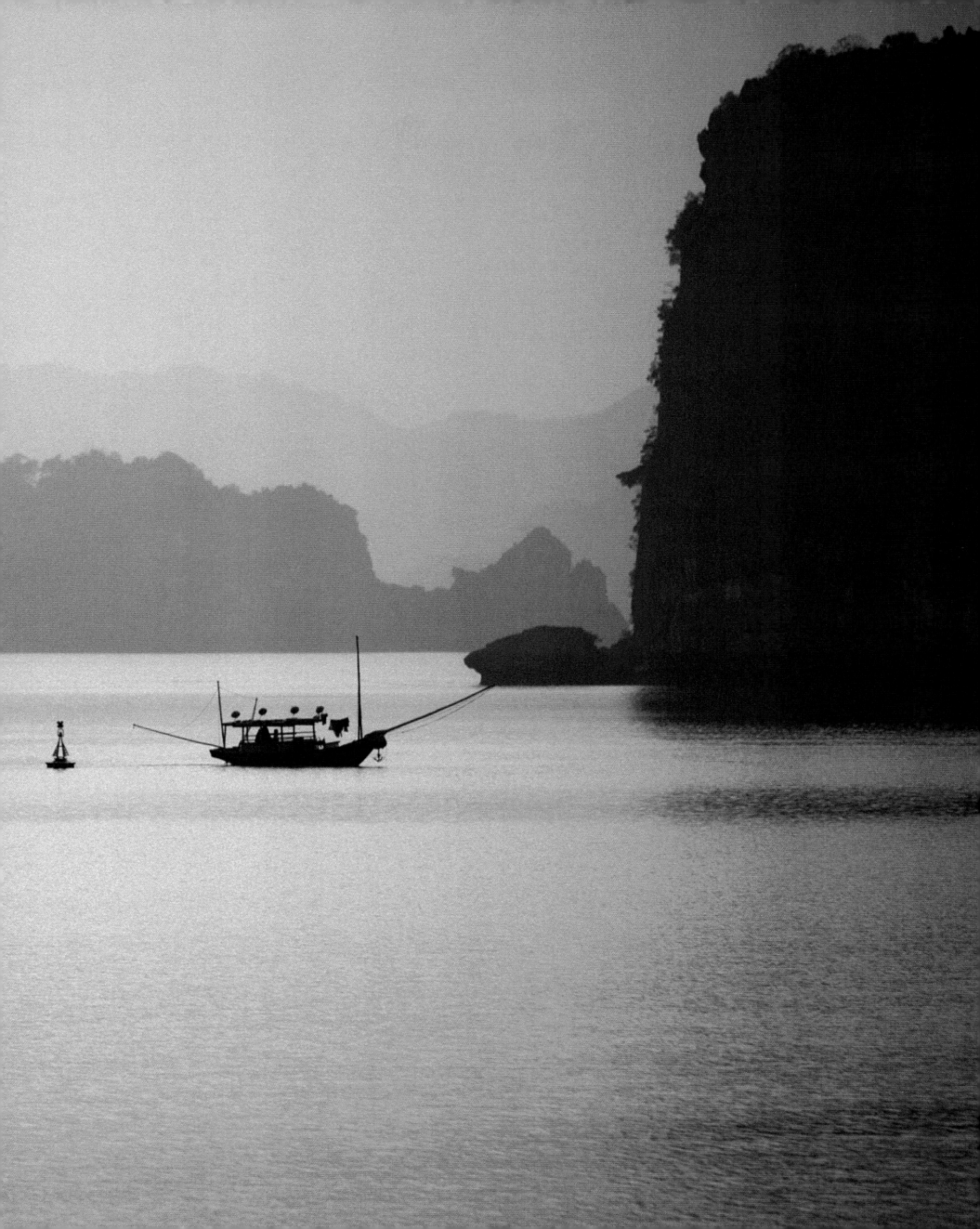

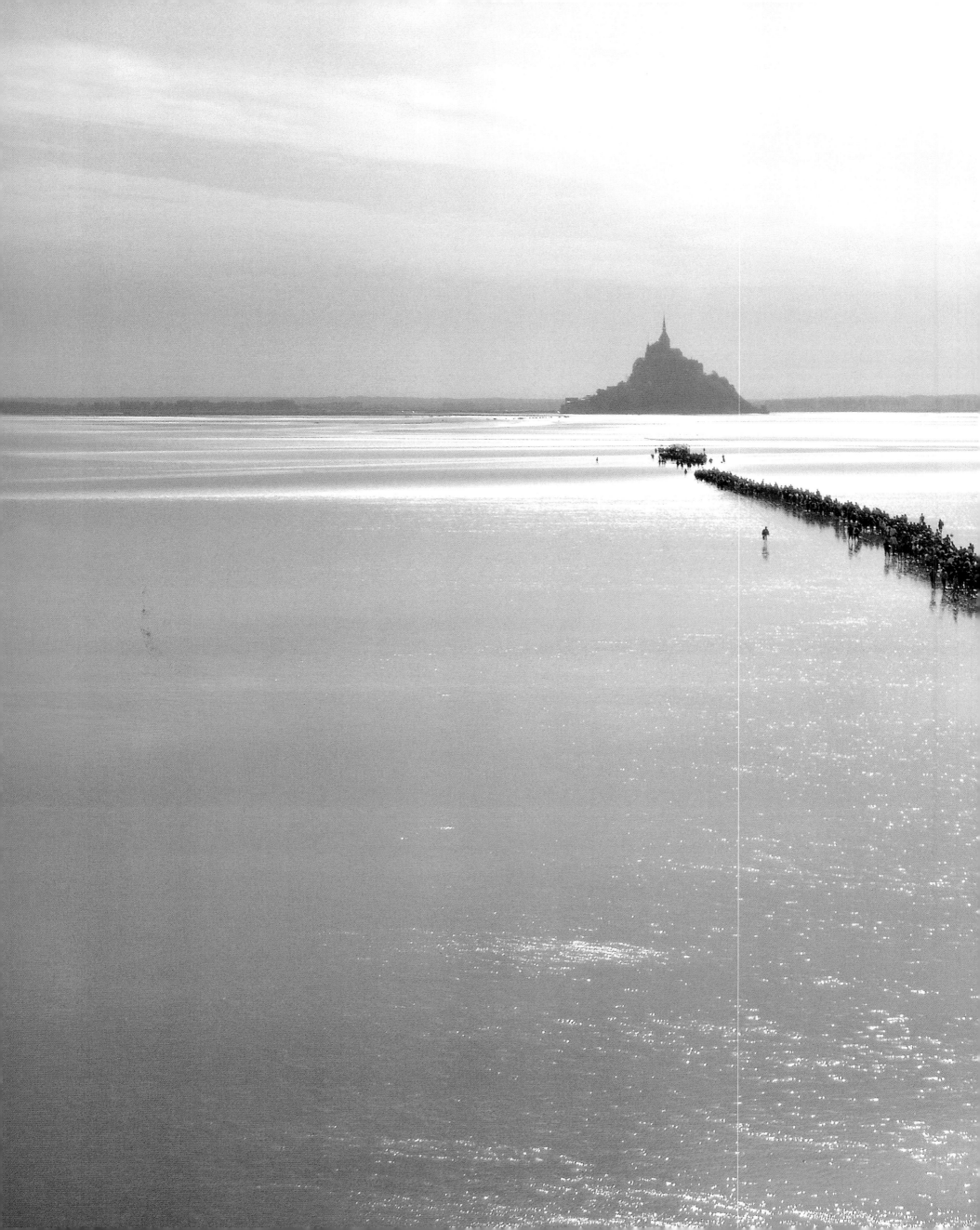

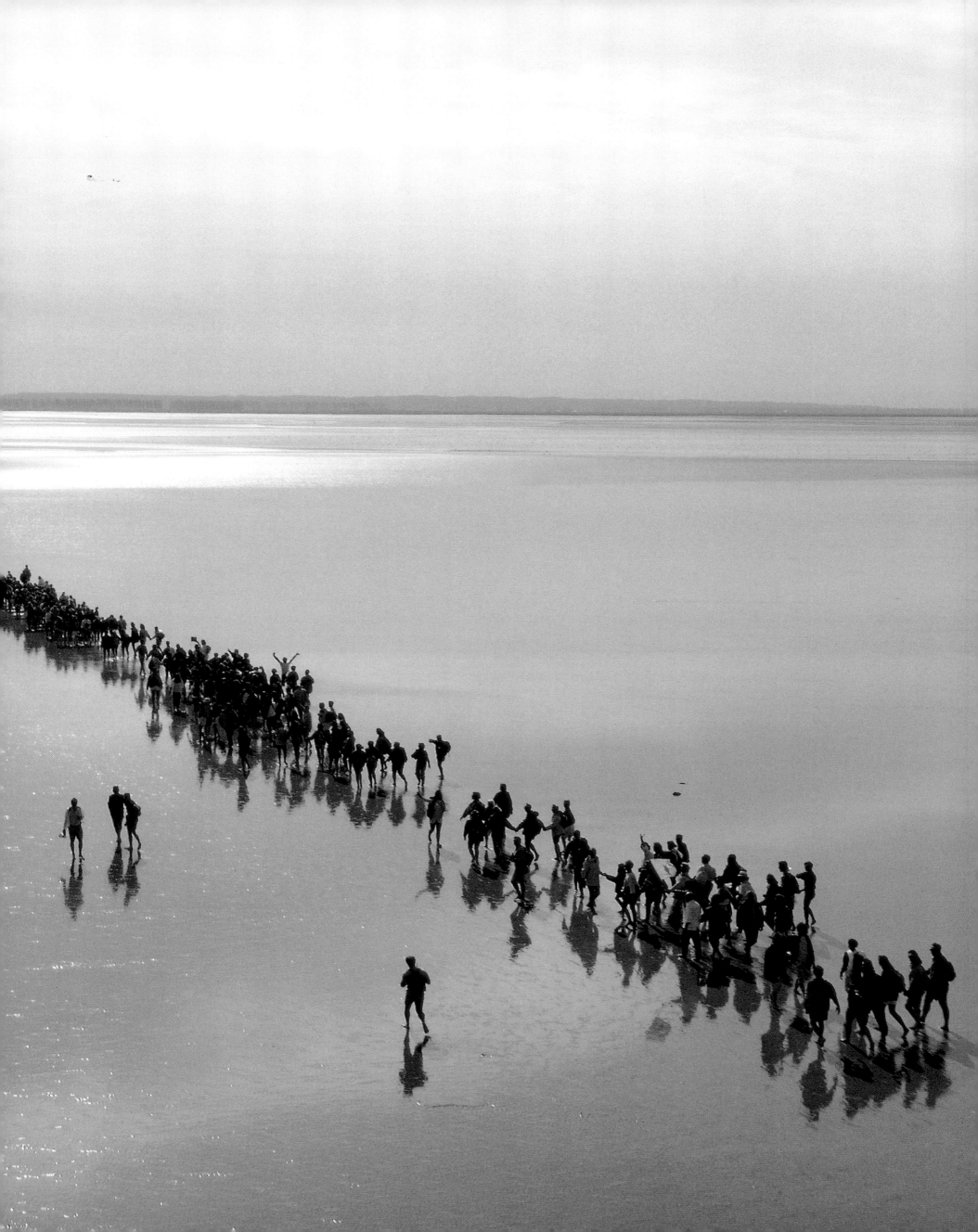

3 The Ocean: A Cradle of Life

On 21 July 1969, the eyes of the world were riveted to the black-and-white images that flickered across the TV screen, as man took his first steps on the moon. At last, after what seemed like an eternity, Neil Armstrong spoke the words we had all been waiting for: 'That's one small step for man, one giant leap for mankind.' It was all in stark contrast to the media's treatment given over the years to the ocean. And yet in 1977, mankind took another giant leap, although practically no one except the scientific community was aware of it.

While astronauts were out looking for signs of little green men on the moon and beyond, ocean explorers were discovering new forms of life around the Galapagos Islands. In total darkness, in a highly acidic environment, at a pressure that defies belief, and amid high concentrations of toxic compounds, there are living, moving creatures.

They do not live as humans, animals and vegetables do by photosynthesis, through the energy supplied by solar light, but by chemosynthesis, feeding on the sulphides emitted through chimneys in the earth's crust from the volcanic chains at the bottom of the sea. These are hydrothermal springs, and the deep-down oases present an extraordinary spectacle: 'Gardens of Eden', or 'Rose Gardens' were the first names given to them by the astonished oceanauts. In the searchlights of their submarine vessels, the predominant bright reds and pearly whites created a wonderful contrast. But that was not the most extraordinary discovery. In 1979, they found other hydrothermal waters that were not just warm but reached temperatures of more than 350° C at the mouths of the chimneys. Around these vents were worms, soon named 'Pompeii worms', which fed on the shower of ashes at a temperature of over 200° C, compared to the 80° C that had previously been considered the maximum compatible with life. Close by, a previously unknown species of crab was feeding on these marine organisms in its turn.

With one astonishing discovery after another, a long list of new species and new forms of life emerged. And from one oasis to another, the creatures varied according to the temperatures, the bacteria and the sulphides. Once they had recovered from their initial euphoria, the geochemists got to work. The 'extremophile' lifeforms became the object of intensive international research. The extraordinary nature of these microorganisms is such that extraterrestrial life now seems a plausible possibility, and they provide a launchpad for research on other planets. As a result of these discoveries, NASA is embarking on a significant astrobiology programme.

These recently discovered forms of life are well on the way to helping us understand the alchemy that gave rise to life on Earth and hence to ourselves. The days are long since past when people believed that life could appear spontaneously. In 1650, the Dutchman Van Helmont claimed to have created a mouse by pickling a cloth soaked in human sweat together with some grains of corn. As for the theory that outer space sprinkled the Earth with the seeds of life – one of several developed at the beginning of the 20th century by a Swedish chemist named Arrhenius – it left the scientific community perplexed in view of the phenomenal range of temperatures involved, and especially the intense cold of outer space, as well as the immensely powerful ultraviolet radiation, all of which would appear to represent insurmountable barriers to life.

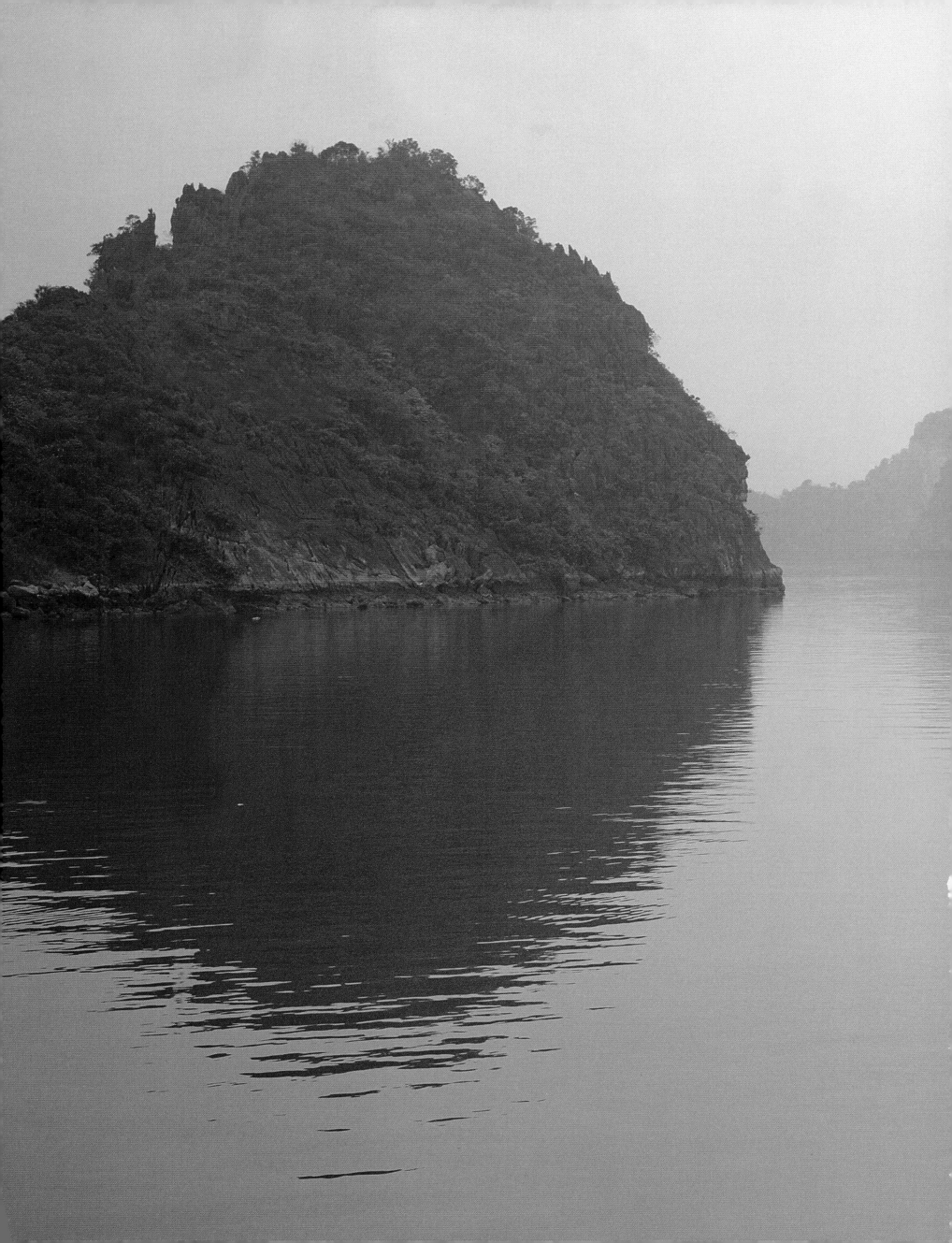

An increasing consensus is now emerging: that life began in the sea. The sea is our mother and our motherland. A Frenchman named Benoît de Maillet was the first to propose this theory – in a work published in 1748 – albeit in picturesque fashion. Birds were said to have evolved directly from fish, whereas humans and land animals developed from marine animals that had learned to crawl. As for where these 'mermen' went when they had come out of the water, it was mainly to the countries of the north, which at the time were rarely visited. But even if we did happen to be nearby, we would still not be able to witness this transformation because, as he wrote, 'there can be no doubt that these animals on leaving the sea are so primitive that anything unusual they see or hear will terrify them and make them flee back to the abyss.' An irrefutable argument.

In fact, 'extremophile' creatures have revolutionized the world of biochemistry in a far more subtle manner. A bacterial structure has been discovered which allows them to flourish at a base temperature of 85 to 115º C. This new or, to be more precise, extremely ancient form of bacteria – has been given a name to denote its distant origins: the archaebacteria.

To be able to live in physicochemical conditions analogous to those that existed on Earth some 4 million years ago, these archaebacteria would appear to be the closest that we can get to the earliest forms of life. We may have descended from apes, but both ape and man seem in all likelihood to have descended from these archaebacteria – real live fossils hiding away in the depths of the ocean.

Perhaps this is one reason why the sea goes on singing its songs to us, still dwelling inside us, land creatures who nevertheless consist of 80 per cent water, and before we are born, swim in the amniotic fluids of our mother. Like a shell that one holds to one's ear in order to hear the sound of the sea, poetry and the inner explorations of writers and artists have enabled them to sense instinctively, long before the scientists, that we belong to the sea. In his memoirs, *Les Mémoires d'outre-tombe*, Chateaubriand proclaims himself to be as much a son of the sea as of his mother. And the poet

Guillaume Apollinaire, in *Cortège*, reconstructs mankind's journey from the sea to the land. It is, he writes, the sea that drives 'the blood in my veins and makes my heart to beat.'

Such is the fleeting awareness that so many seafarers can feel within their bones. How else can we explain the attraction that draws fishermen to practise this most dangerous of professions, with a mortality rate of 2 per cent, which is 16 times higher than that of firefighters? How else can we begin to understand the passion, the fascination, and the grandeur, other than by acknowledging that the sea lives within us? It has so much to tell us, to show us, and to give us.

One of the finest of all the songs of the sea is perhaps that which Saint-John Perse included in his collection *Amers*, a truly epic account of man from his origins through to the present day:

> *And it is a song of the sea such as has never been sung,*
> * and it is the Sea within us that will sing it:*
> *The Sea, borne within us, till the satiation of breath,*
> * the peroration of breath,*
> *The Sea, within us, bearing its silken sea-sound and its*
> * great god-given freshness round the world.*
> *…The Sea, woven within us, to its bramble-patched*
> * abysses, the Sea, within us, weaving its great hours*
> * of light and its great paths of dark.*

And once more, as he affirms in the last song:

> *Womblike Sea of our dreams and Sea haunted by the*
> * true dream.*
> *…Thou who art versed in all things and in all things*
> * silent.*
> *…Nurse and mother, not stepmother, mistress and*
> * mother of the younger brother,*
> *O blood related yet so distant, O thou the incestuous*
> * and thou the primogenitor!*
> *O Sea of plenitude and reconciliation.*

We all come from the sea, and the sea is the mother that we carry within ourselves.

VIETNAM, ALONG BAY
In the strange fairytale world of Along Bay, islands emerge in their thousands from an emerald sea, mysteriously changing their appearance, sometimes transmuted into men, sometimes into animals: two roosters, a giant tortoise, a monk with hands clasped in prayer. Among these rocky peaks and weird configurations are secret caves teeming with legends. And enveloping this enchanted bay with their own magic are the sugar loaf hills, which from afar seem to rise up like an impregnable fortress built on immutable rock, but when you approach them, they seem to part imperceptibly and let you through.

3 The Ocean: A Cradle of Life

FRANCE, MONT-SAINT-MICHEL BAY, TIDAL BORE
In the wide bay of Mont-Saint-Michel, where the tidal range is 10 m on average, the ebb of the sea at low tide uncovers up to 6 km of sandbanks and water that create an endless shore. The coefficient tidal forces combine to create the rare spectacle of a tidal bore. The rumbling wave appears on the horizon, spreads itself wide and comes roaring up the Couesnon river, hurtling against the current and creating mayhem amid the waters. This sudden invasion, swift, shattering and remorseless, is terrifying while it lasts. But then the wave dies, everything settles, the currents slip back into their natural order, and the bay is quiet once again.

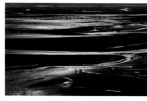

FRANCE, BAY OF THE SOMME
There is a huge gash in the coast of Picardy. Where the Somme meets the English Channel, the land opens up round a massive estuary of 70 km², very popular among anglers. When the sea recedes, it lays bare a vast desert of silt, interspersed with sparkling puddles, in which you will see flocks of gulls and migratory birds happily splashing around. For a few hours, the sea carelessly abandons its shellfish and crustaceans to the hunters with their nets, knives and buckets. Their hours are numbered, however, because before long the sea will change its mind, come back, and slam the door on this Aladdin's cave.

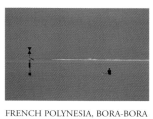

FRENCH POLYNESIA, BORA-BORA
What miracles did the Maoris perform to take possession of the little Polynesian islands that are scattered over the heart of the great Pacific? In the middle of the third millennium BC, these intrepid mariners set sail from south-east Asia in their great pirogues, guided by their instinct, their knowledge of the stars, and their observations of the currents, clouds and birds, and they gradually colonized all the archipelagos of the Pacific. Part of their ancestral heritage, the emblematic pirogue still plays a vital role in the Polynesian way of life. But one question remains: did they already know of the existence of these islands before they set out on their perilous journeys? Perhaps they had visions of them in their dreams....

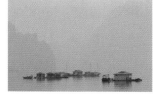

VIETNAM, ALONG BAY, FLOATING VILLAGE
To the north of Vietnam, tucked away in the Gulf of Tonkin, the mythical Along Bay is wrapped in impenetrable mists. In and around this bay, people live on sea transport, agriculture and fishing. There are fishing villages on some of the hundreds of islands dotted around these peaceful waters, but the majority of the villages are on the water itself. Fishermen and fish-farmers live at the very heart of this mysterious seascape, and they keep their catch live in tanks that are incorporated into the pontoons that carry their homes.

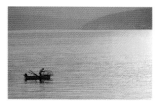

OMAN, NEAR STRAIT OF HORMUZ, BAY OF KHASAB
A fisherman prepares to sink a shellfish pot off the Strait of Hormuz, the narrow bottleneck between the Persian Gulf and the Indian Ocean, squeezed in between Iran in the north and the Sultanate of Oman in the south (to which it belongs). Since the 16th century, cargo ships loaded with all the merchandise of India and China have plied this channel. Today, more than 150 ships – half of them supertankers – use the strait every day, carrying 40 per cent of America's oil supply, 85 per cent of Japan's, and 60 per cent of Europe's. Its strategic and economic importance is such that it is a constant source of conflict.

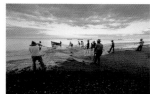

MARTINIQUE
The shores of the French overseas territory of Martinique are home to a number of delightful little ports, in which is perpetuated a traditional way of life based mainly on coastal fishing. On the north Caribbean coast, it is the beach seine that prevails – an ancient, collective technique which is becoming more and more rare. Early in the morning, the fishermen go out in their *gommiers* (gum-tree boats) to drop more than 500 metres of net at some distance from the shore. Then, with the aid of all the villagers, they stand on the beach and pull in the two ends of the net, which is full of squirming mackerel and bonito. The fish are served as *blaff*, one of the many traditional seafood dishes of Martinique.

INDIA, KERALA, VILINJAM BEACH
Thirty fishermen strain every sinew to haul their seine net ashore at Vilinjam. But there will be due reward for their efforts: the net will bring in scarcely a kilo of live and edible fish. Could this be due to the dwindling of resources caused by over-fishing? Here it may just be sheer bad luck, but there is no doubt that many fishing zones have been drastically over-exploited. In order to slow down this stripping of the ocean's resources, there are now regulations to limit the catch – through quotas, zoning, fixed timetables and restrictions on the methods used. If every country in the world adhered to these rules, we would already have established a lasting and equitable international fishing industry.

INDIA, KERALA, BACKWATERS
The state of Kerala in southern India is the home of a shifting landscape known as the Backwaters. This 1,500-km network of natural and man-made canals, lagoons and brackish lakes is fed by several rivers that flow down from the Western Ghats. The movements of the waves and the coastal currents, added to the effects of sedimentation, have gradually given rise to a barrage of low-lying islands at the mouths of the rivers, thus isolating the Backwaters alongside the Sea of Oman. In this watery world, the people cultivate their polders, move around only in boats, throws fishing nets out over their doorsteps in the morning, and live a life that is almost amphibian.

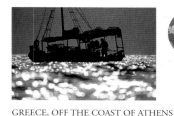

GREECE, OFF THE COAST OF ATHENS
Less than a mile offshore, this fishing boat is going about its daily business. The crew must know that their job is surely one of the most dangerous of all, with an average of over seventy deaths a day worldwide. In actual fact, the annual number of deaths among fishermen, estimated at 24,000, may well be considerably higher, as very few countries keep a systematic record of accidental deaths at sea. But even these grim statistics are not enough to deter the fishermen. The sea lures them instinctively, and its siren call seems irresistible.

MOROCCO, ESSAOUIRA
Today, three-quarters of the world's stock of commercial fish have been either exploited to the maximum of their renewal capacity, over-exploited, or exhausted. Only a quarter of them remain in a reasonably healthy state. Overequipped fleets, subsidies that encourage surpluses, badly distributed fishing rights, illegal fishing and destructive techniques constitute the main causes of the shortages. One day it is even possible that these fishing boats may be grounded indefinitely. Overfishing could have disastrous consequences for the world's food industry, particularly in developing countries.

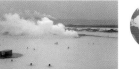

ICELAND, BLUE LAGOON
The Blue Lagoon (or Bláa Lónid) is a hydrothermal complex that is fed by the warm geothermal waters of Svartsengi, on the Reykjanes peninsula in south-west Iceland. The source of the water lies some 2,000 metres underground, in volcanic layers caused by the active rift of Reykjanes, where sea and freshwater mingle together in a brine, two-thirds of which consists of sea water, reaching a temperature of 2,400° C through the molten magma. The surplus water, thrown up into the 'blue lagoon', is packed with mineral salts and silica which, combined with the presence of algae, gives the basin an almost milky appearance. The water here is renowned for its therapeutic qualities – particularly for skin diseases.

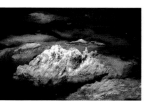

FRANCE, CORSICA, SOUTH-EAST COAST
If you go down into the depths of the ocean, you will find yourself plunged into a frightening world of darkness and cold. The deeper you go, the more the colours will fade. At 20 m everything is blue. The light also fades and then disappears, while the blackness thickens: at 200 m there is total darkness. The cold intensifies, pressure becomes enormous, and sounds are distorted. Between 2,000 m and 6,000 m, you enter the world of the abyssal plains, with active rifts and unplumbable chasms. Dark and inhospitable, unknown and terrifying, this strange world covers no less than two-thirds of our planet's surface.

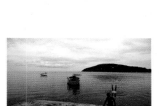

MAURITIUS
Off the east coast of Madagascar and close to Réunion, the little island of Mauritius emerges from the waters of the Indian Ocean. Wherever you go on this patch of land, 2,000 km² in area, you will find the sea, both in the landscape and in the lives of its inhabitants. As in most island and coastal communities, children grow up in close contact with the ocean. Right from the cradle they are made aware of its riches, its moods, its dangers, and they learn to move in, on and under it, fishing for a thousand and one of its wonders. Ignoring the prying eye of the camera, these children amuse themselves for hours in their daily playground – the sea.

FRANCE, LA TURBALLE
After the Second World War, the French introduced the concept of paid holidays for the first time and it became customary to escape for a few weeks to the seaside. Half a century later, their love affair with the coast has not abated. In fact, three-quarters of the French take their holidays in France, and for half of them the great summer break is inseparable from the beach. Whether it be the Mediterranean or the Atlantic coast, each has its faithful devotees. But no matter which region people opt for, some features remain the same: sunshine, hot sands, rest and relaxation – that is how the French like their life by the sea.

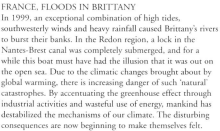

FRANCE, FLOODS IN BRITTANY
In 1999, an exceptional combination of high tides, southwesterly winds and heavy rainfall caused Brittany's rivers to burst their banks. In the Redon region, a lock in the Nantes-Brest canal was completely submerged, and for a while this boat must have had the illusion that it was out on the open sea. Due to the climatic changes brought about by global warming, there is increasing danger of such 'natural' catastrophes. By accentuating the greenhouse effect through industrial activities and wasteful use of energy, mankind has destabilized the mechanisms of our climate. The disturbing consequences are now beginning to make themselves felt.

USA, CALIFORNIA, MONTEREY BAY AQUARIUM
Since 1984, the Monterey Bay Aquarium – the largest in the world – has attracted nearly 2 million visitors a year to marvel at the wonders behind its giant panes of glass. Without getting wet, visitors can 'dive' down among tuna, shark, turtles, jellyfish, penguins, seals and hundreds of other marine species that frequent sandy and rocky shores, ice floes, or the vast kelp forest created specially for this aquarium. All over the world, large sea-life centres such as this one are opening their doors to a varied but unfailingly enthusiastic public. The sea remains endlessly fascinating for young and old.

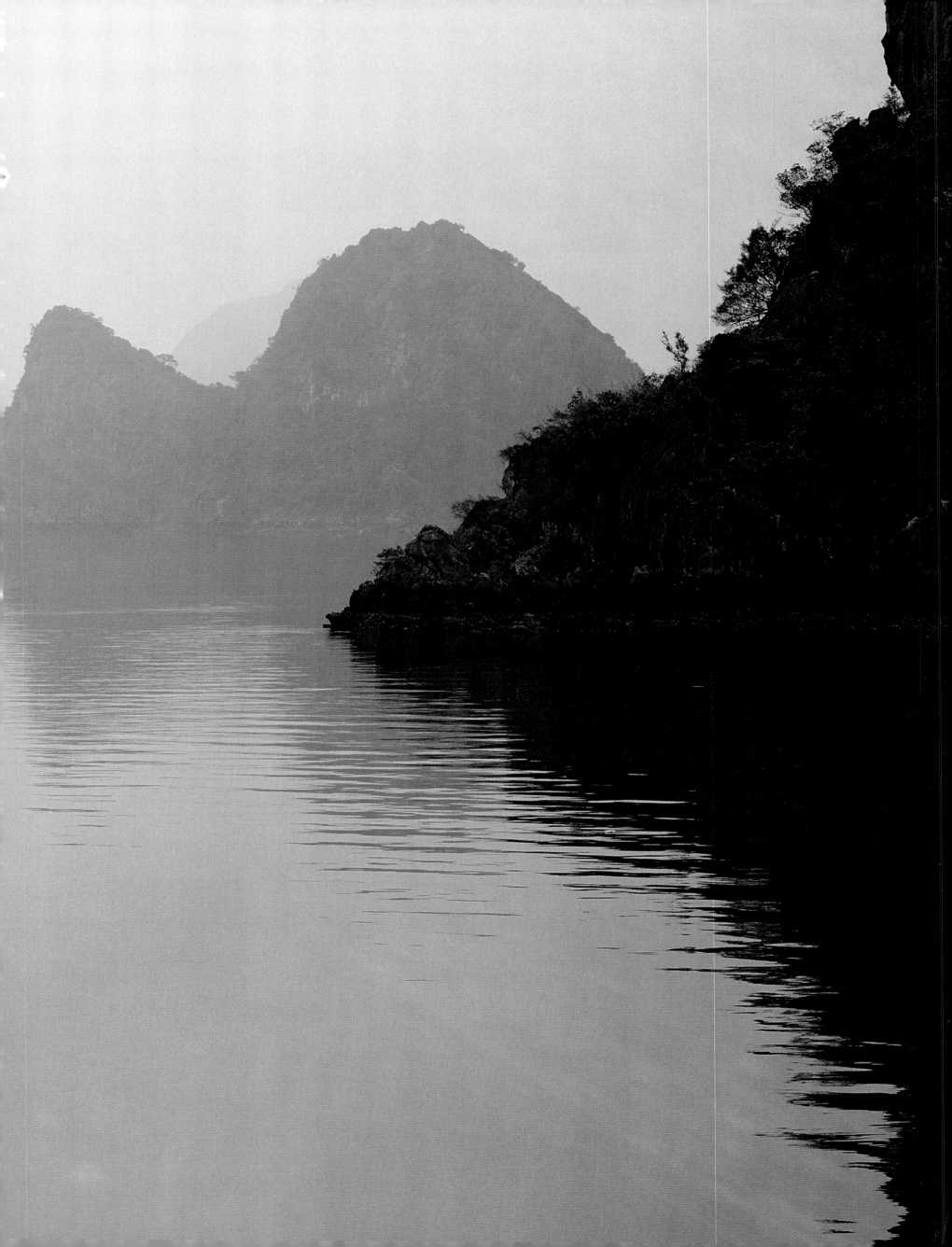

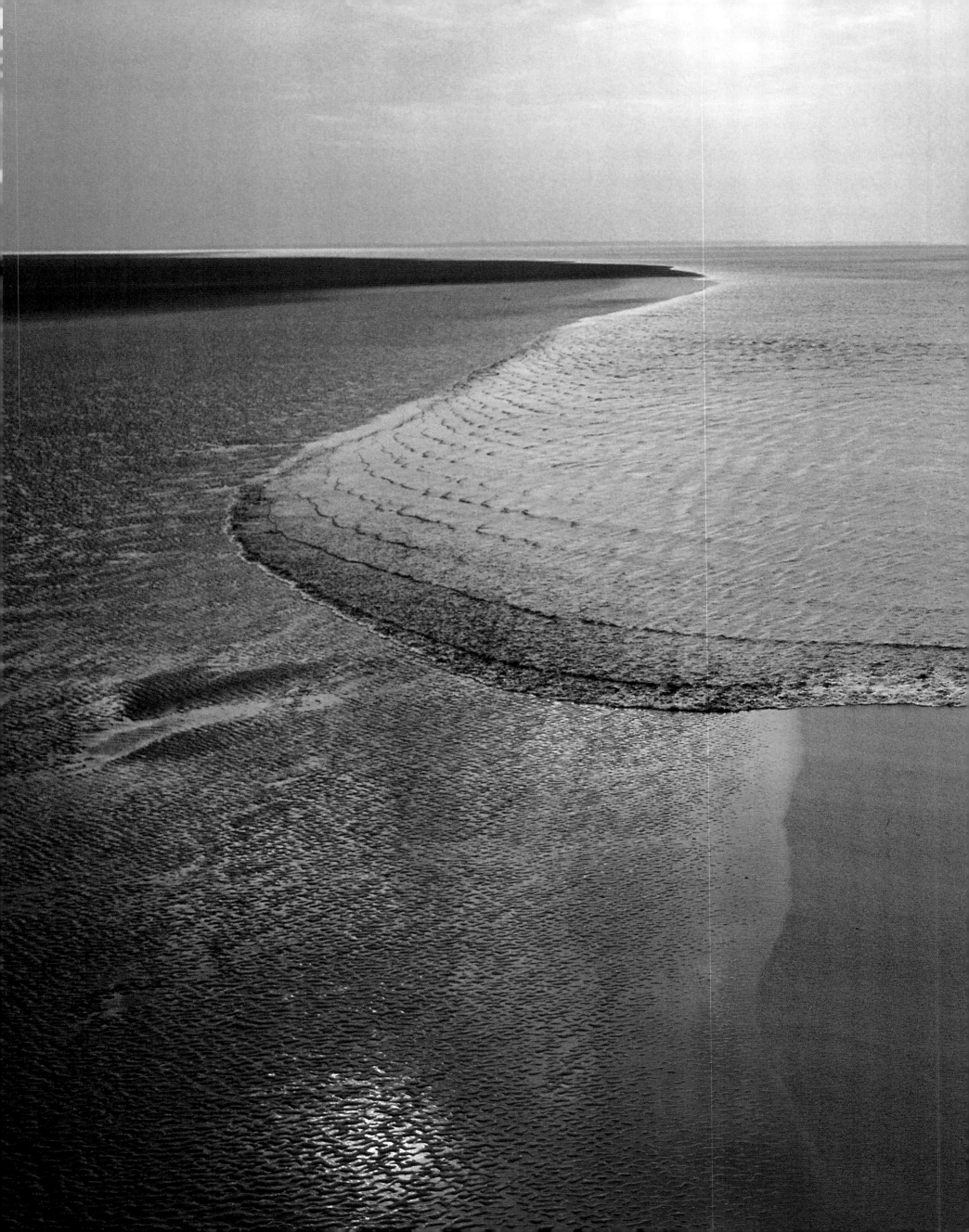

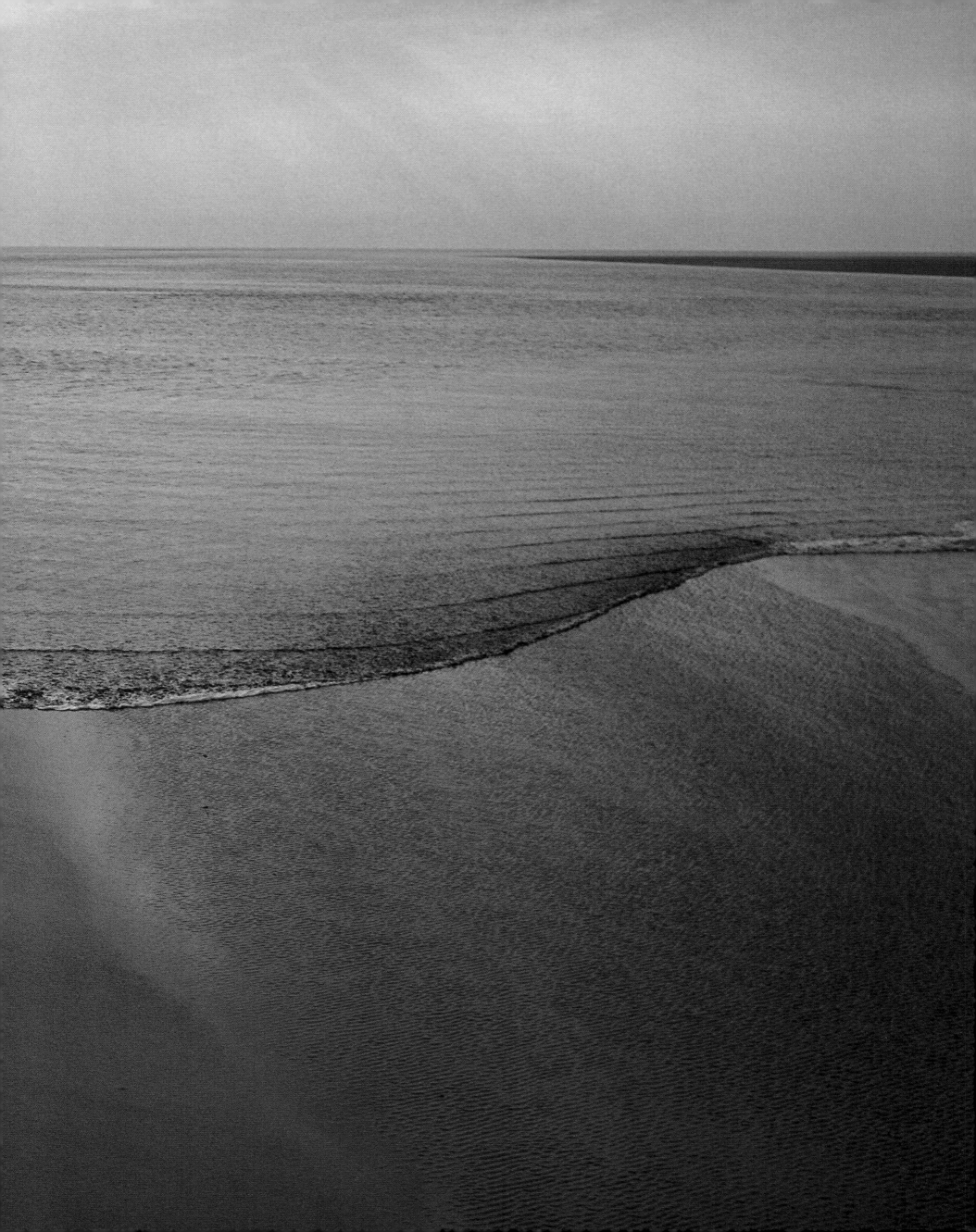

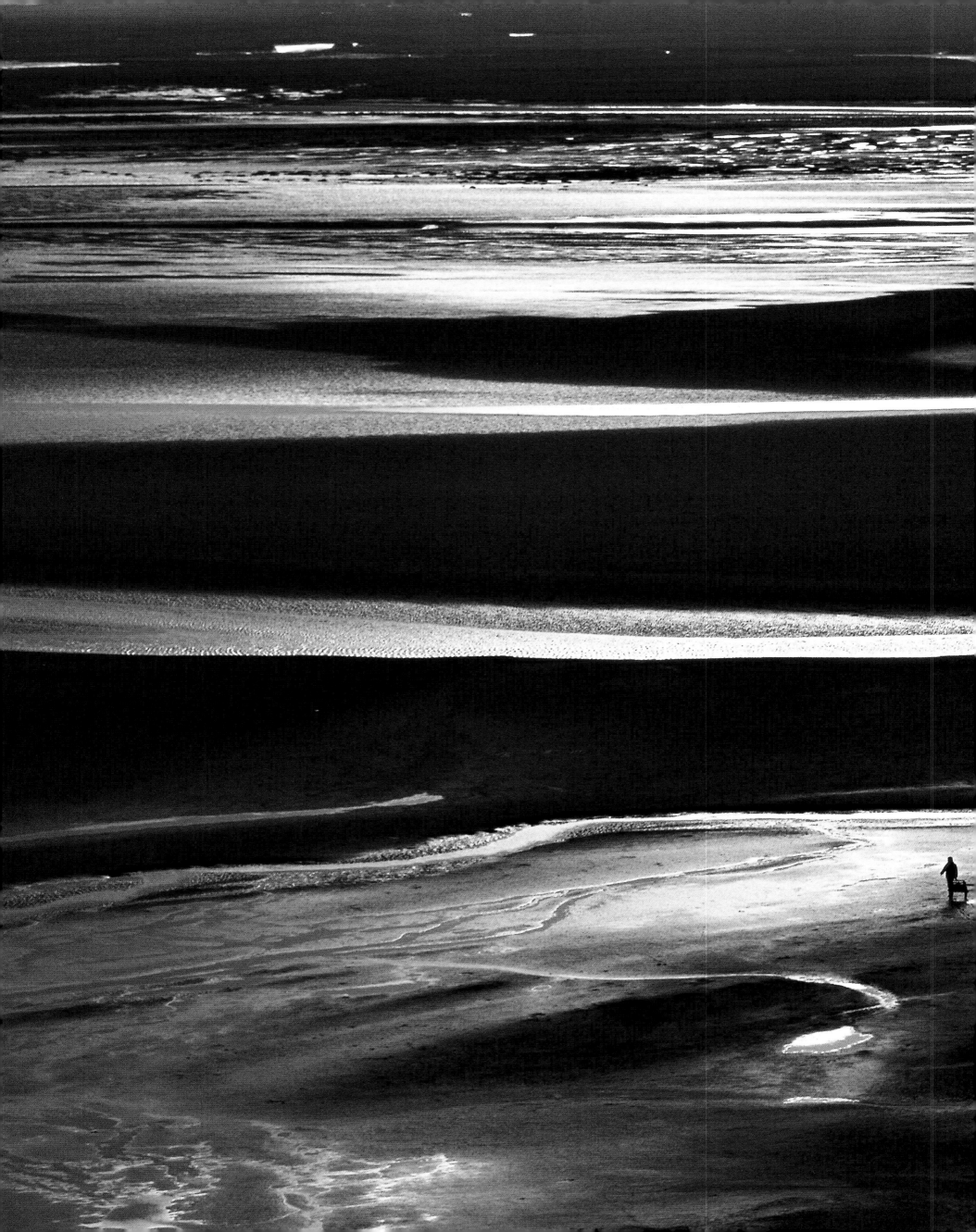

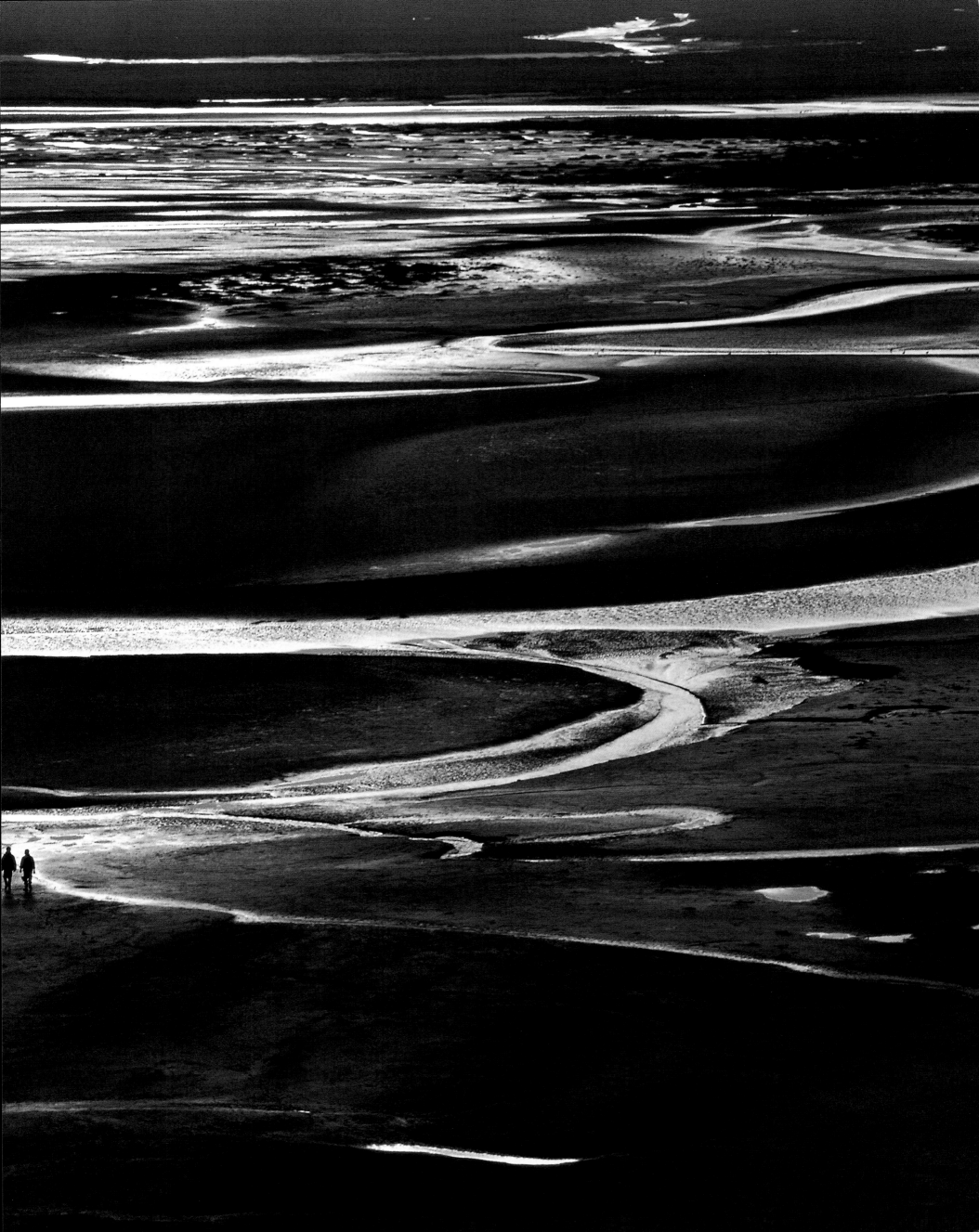

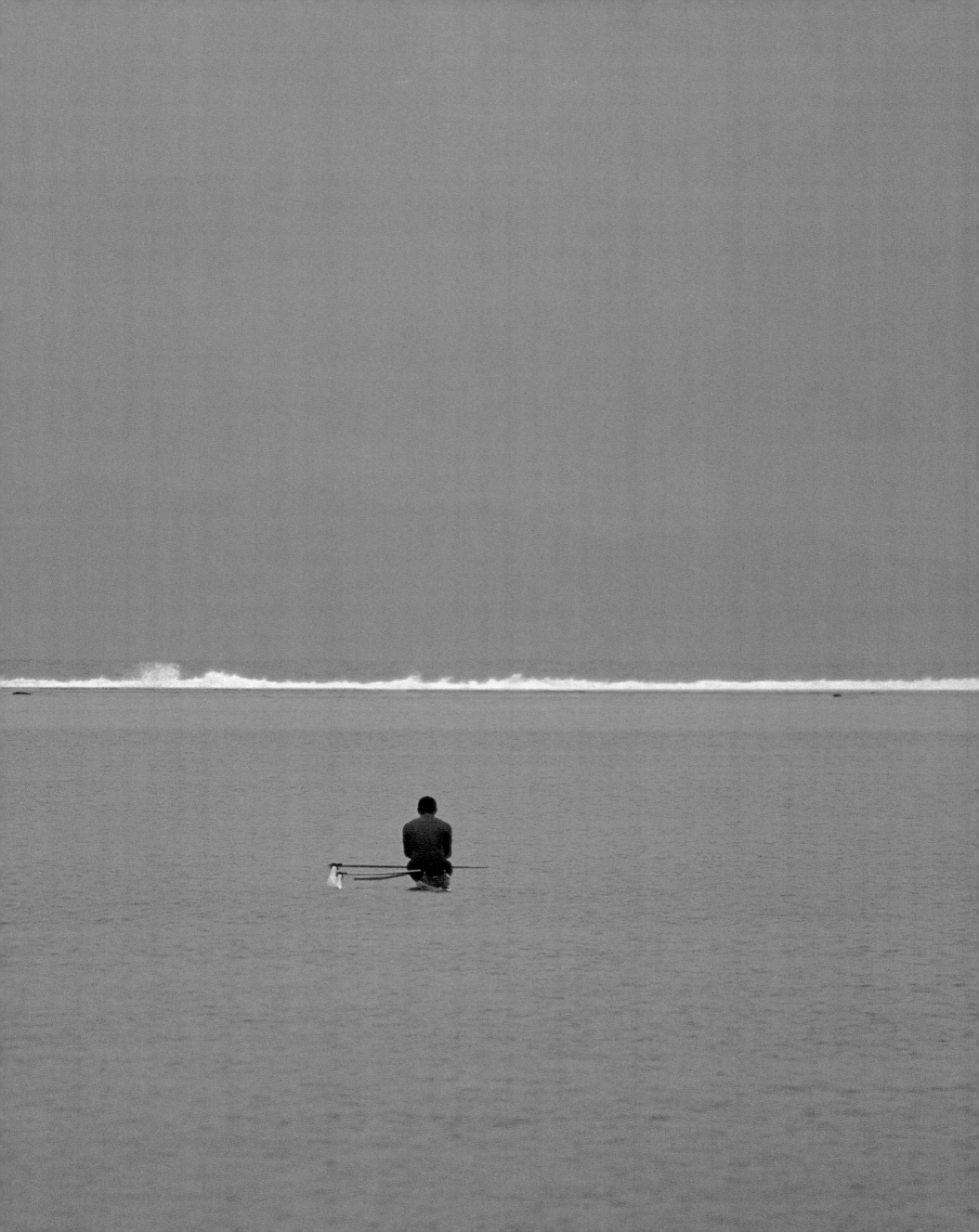

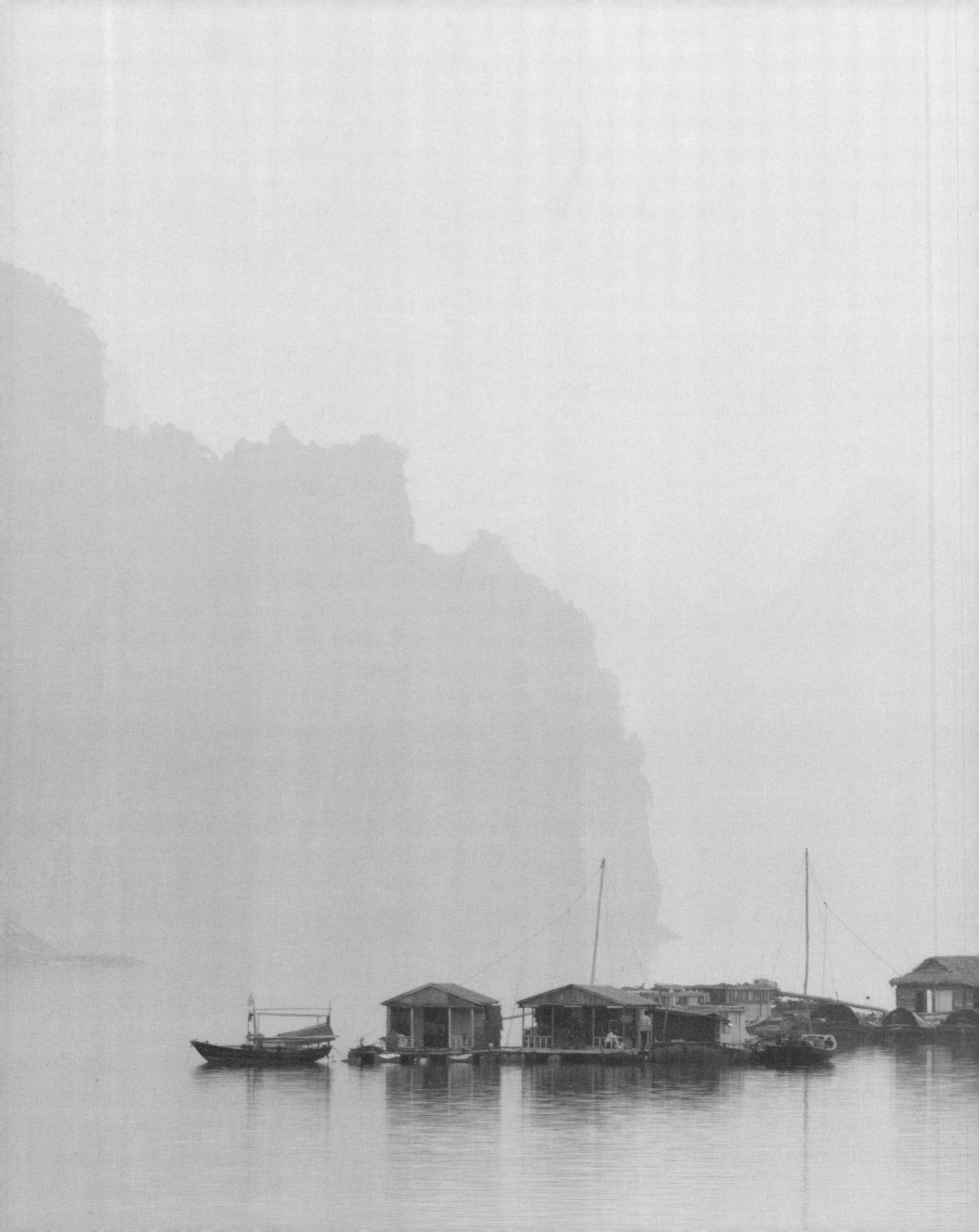

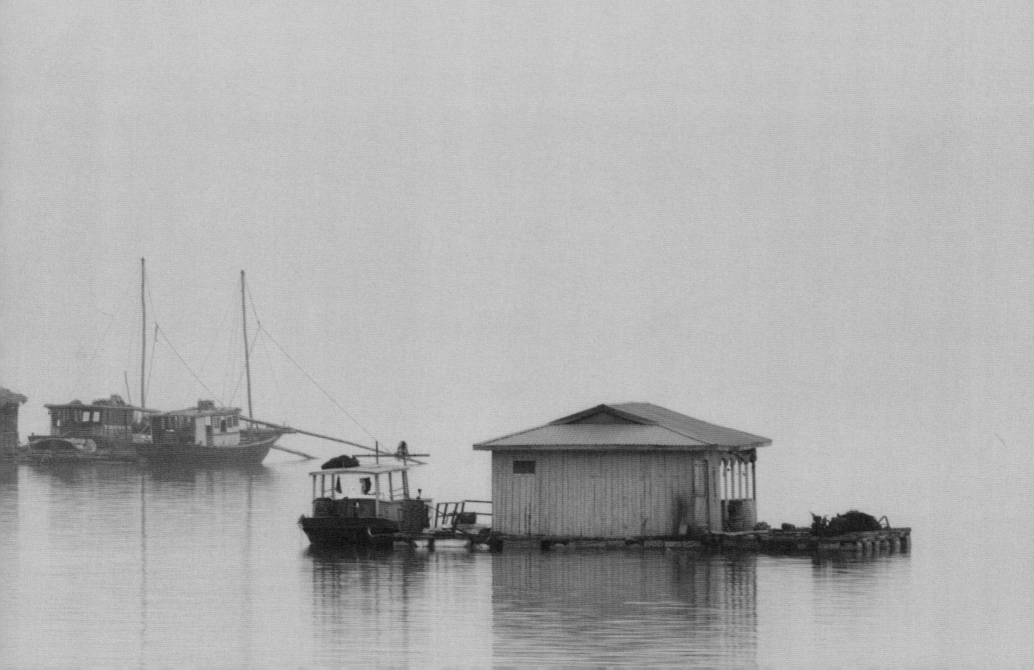

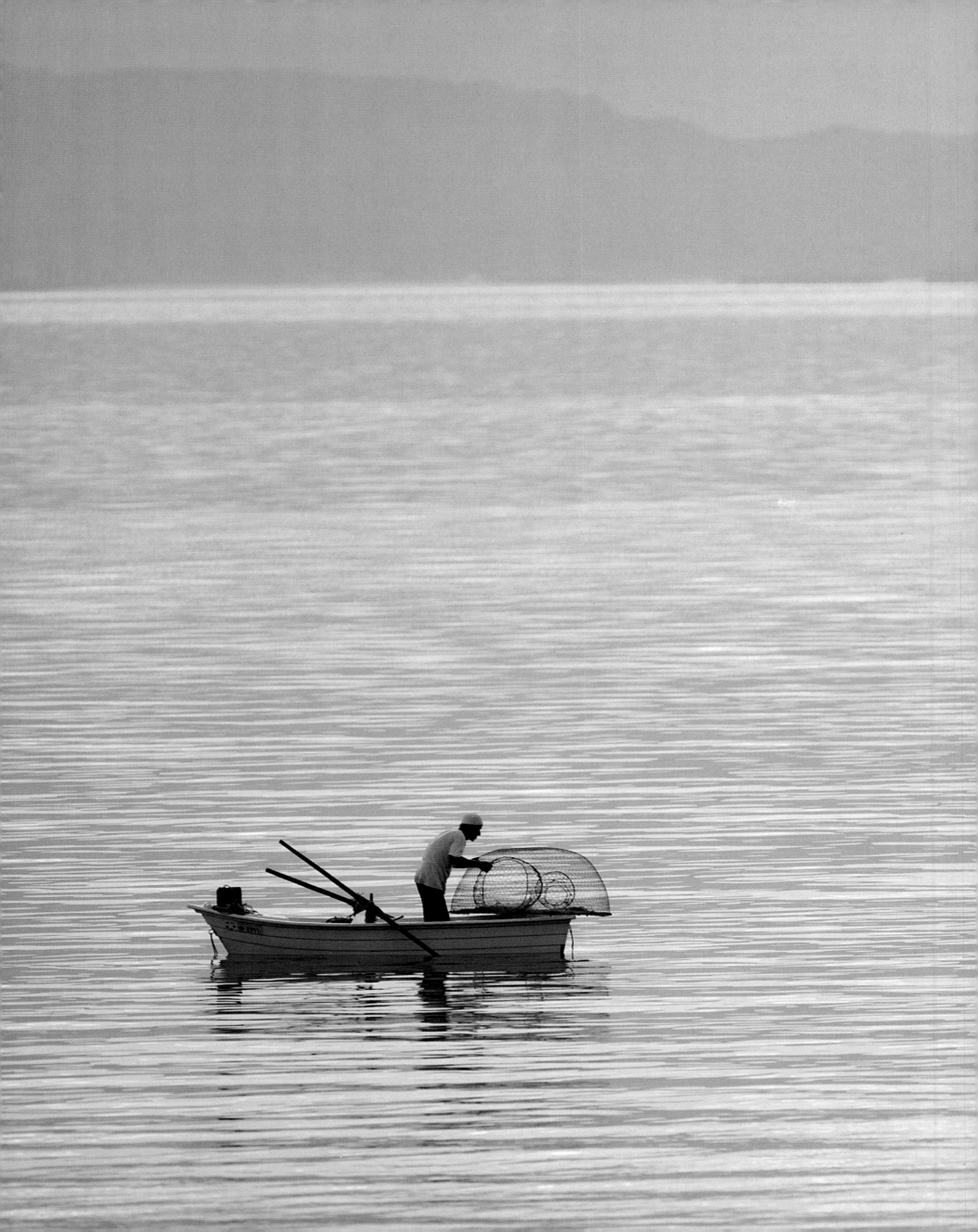

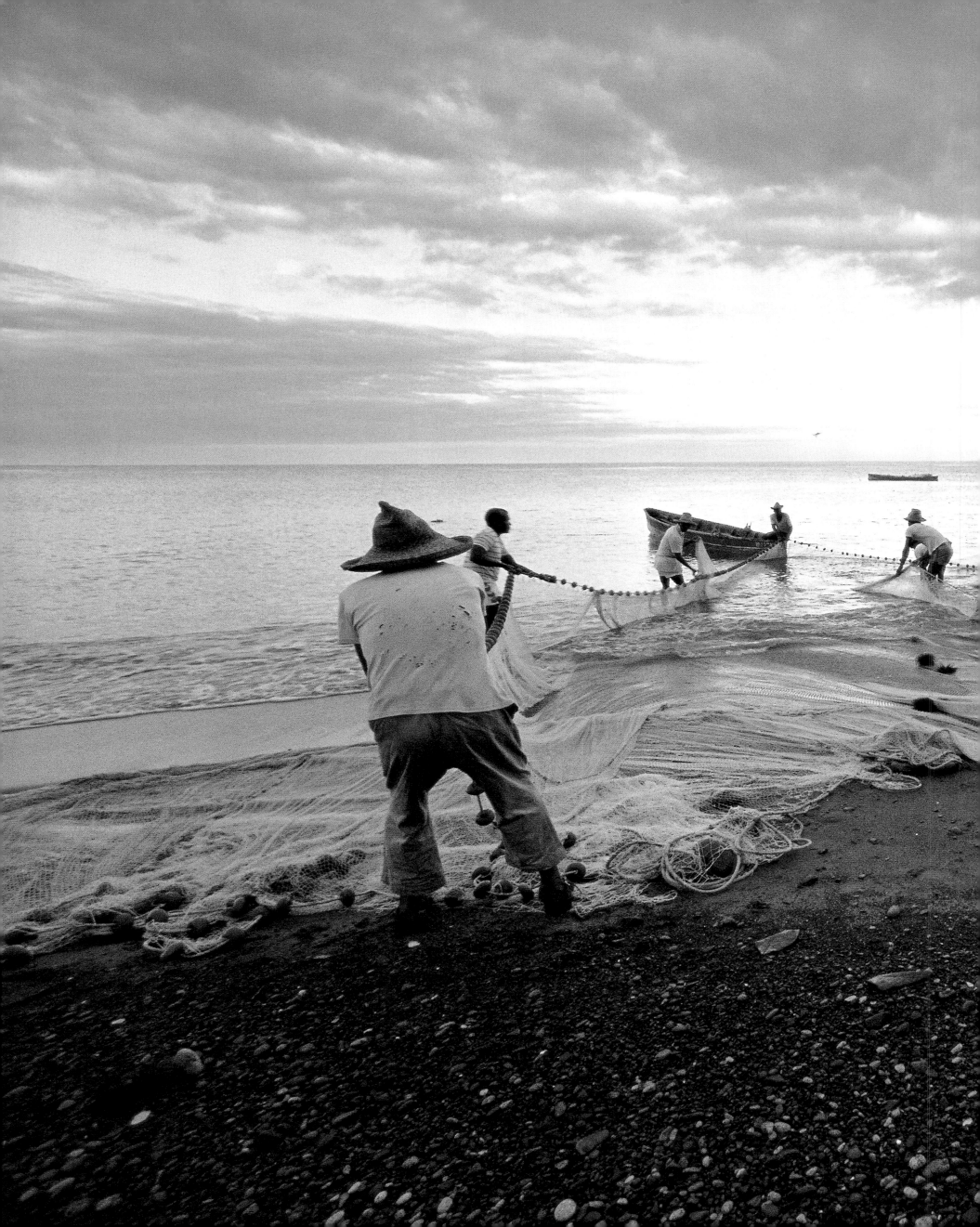

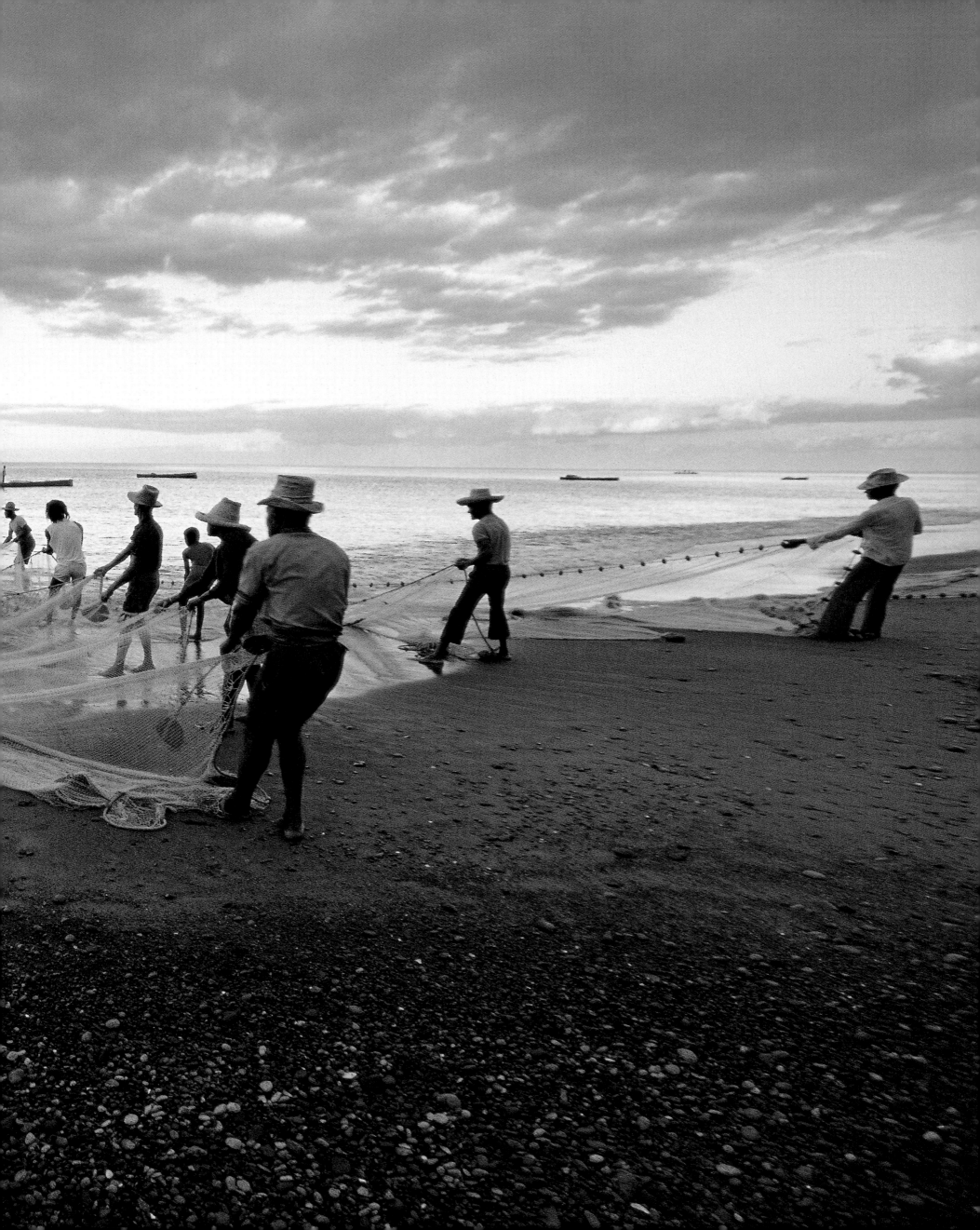

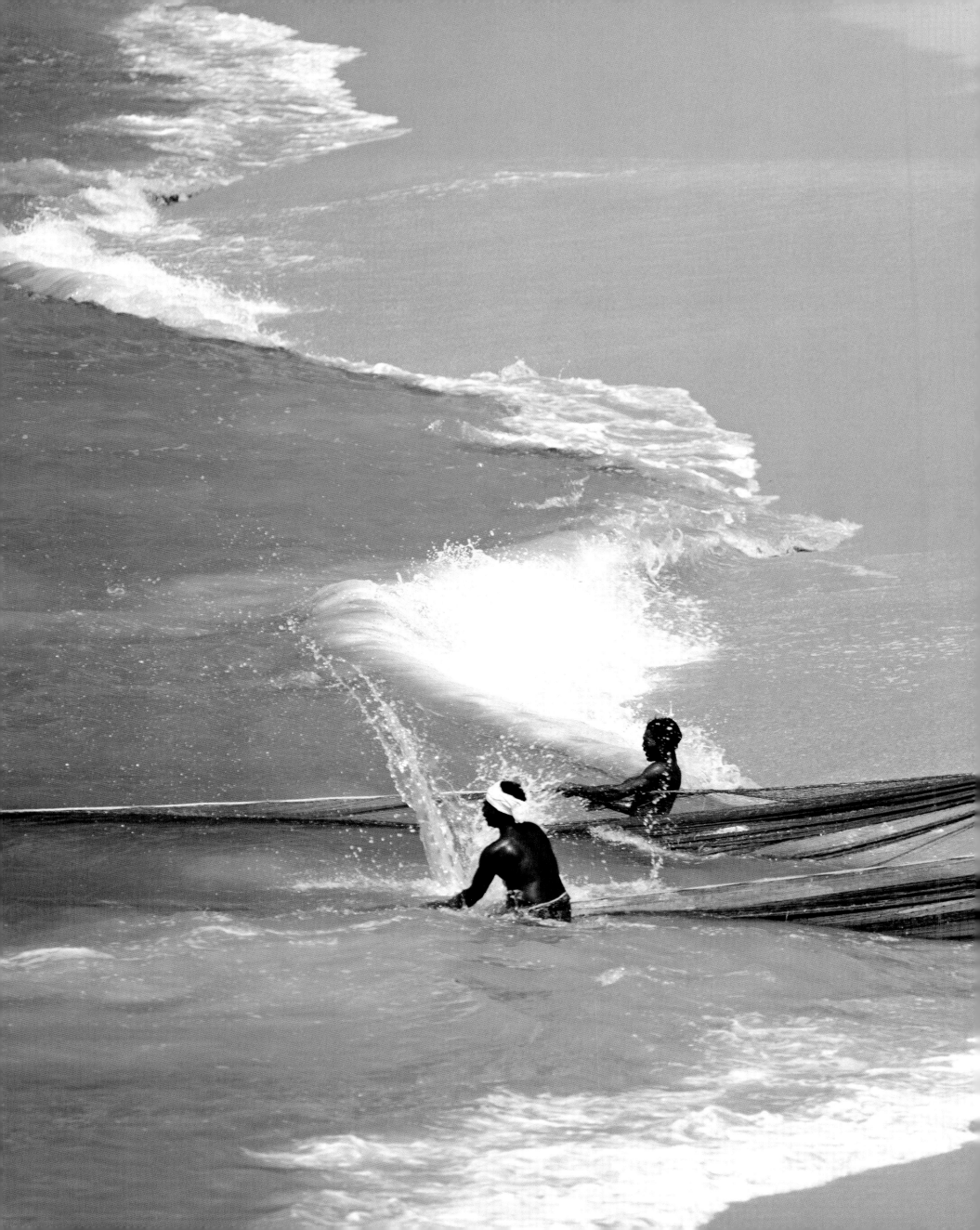

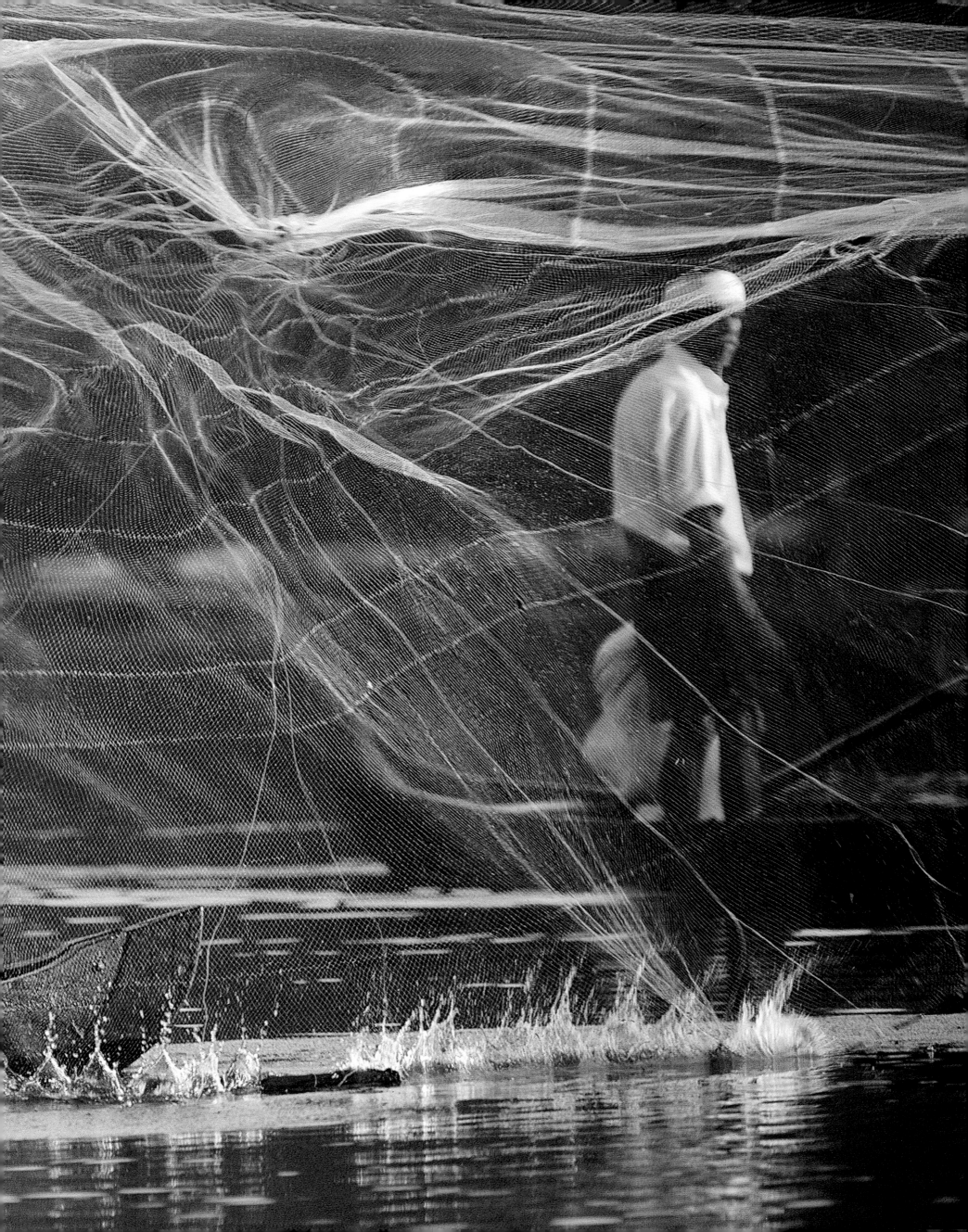

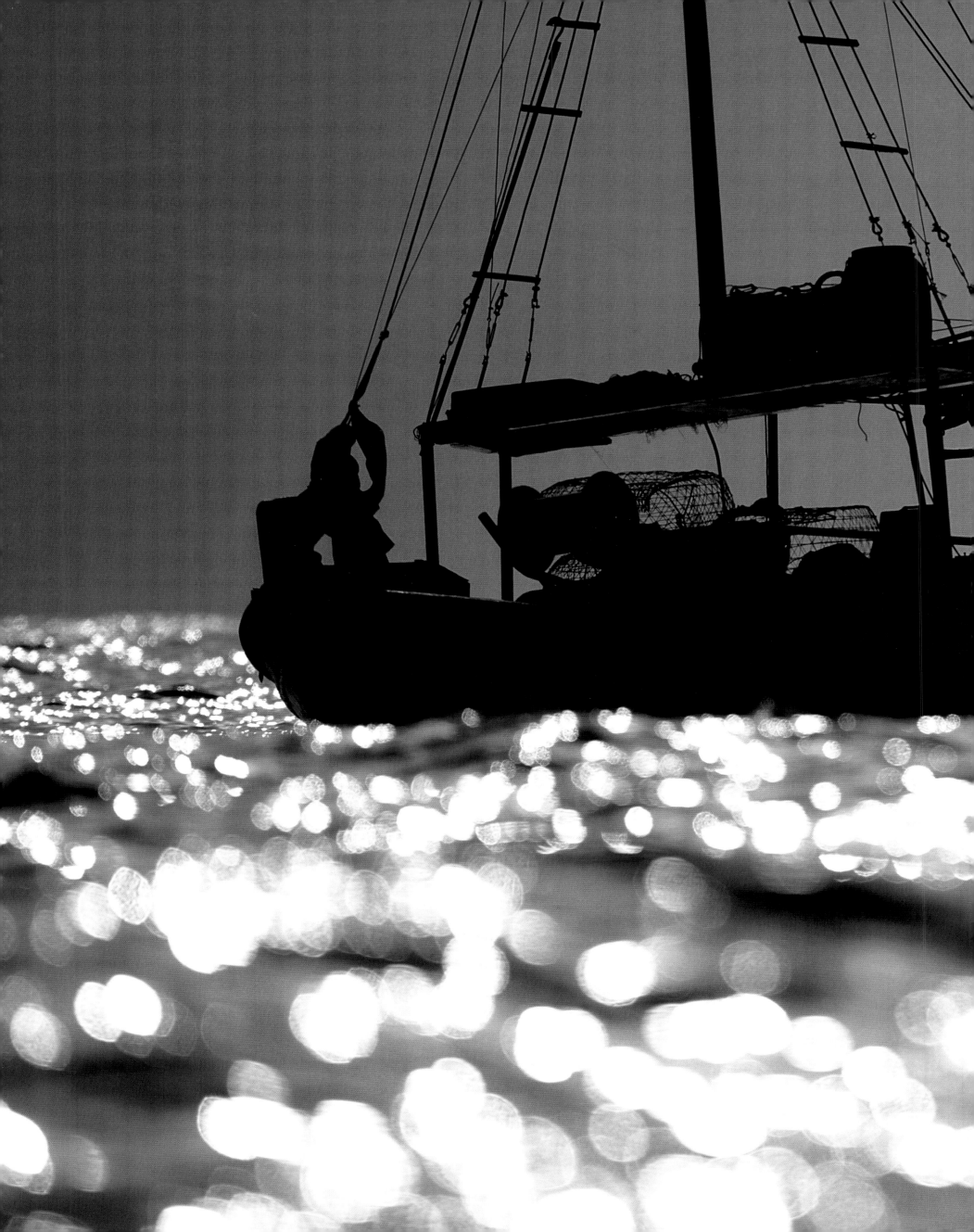

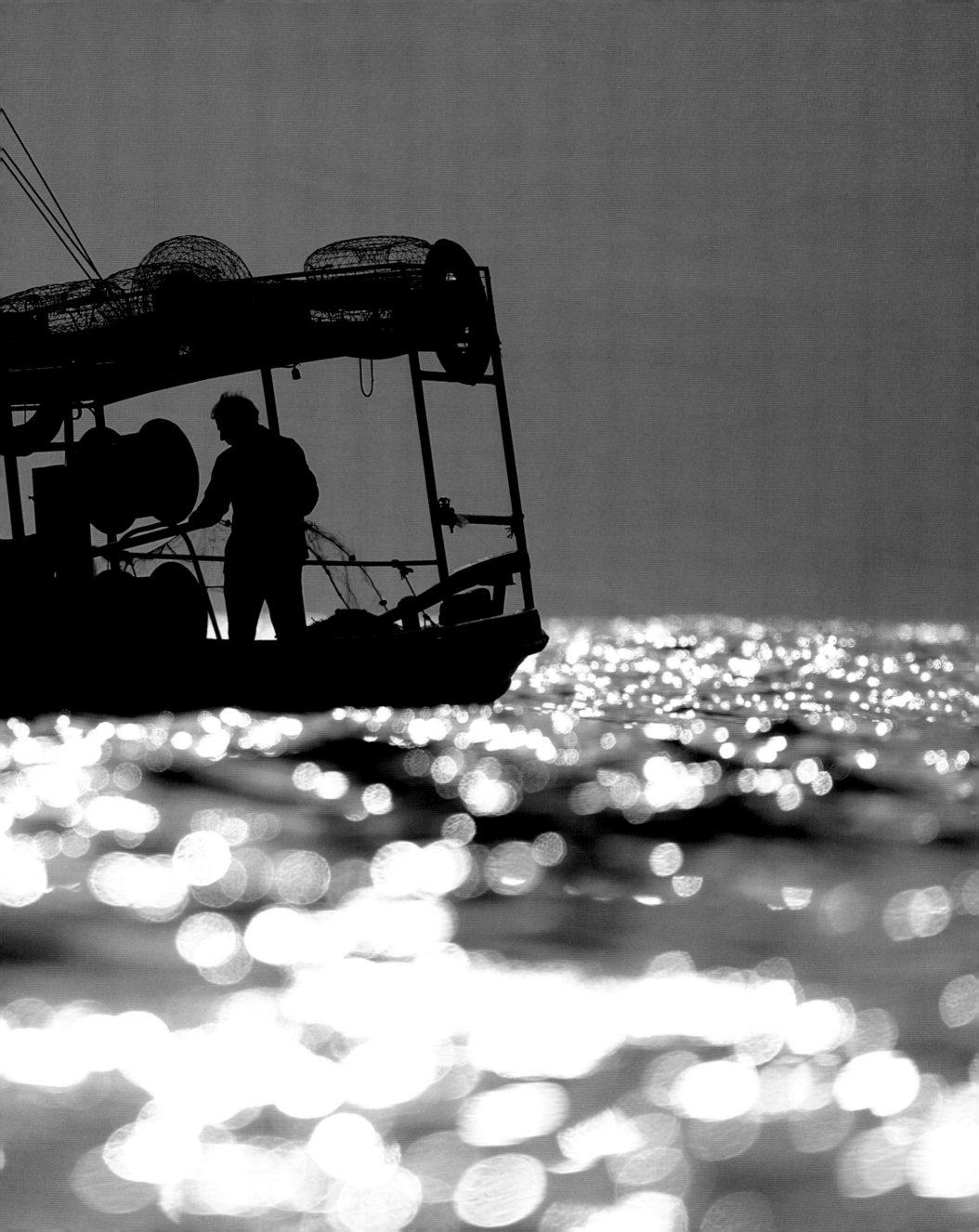

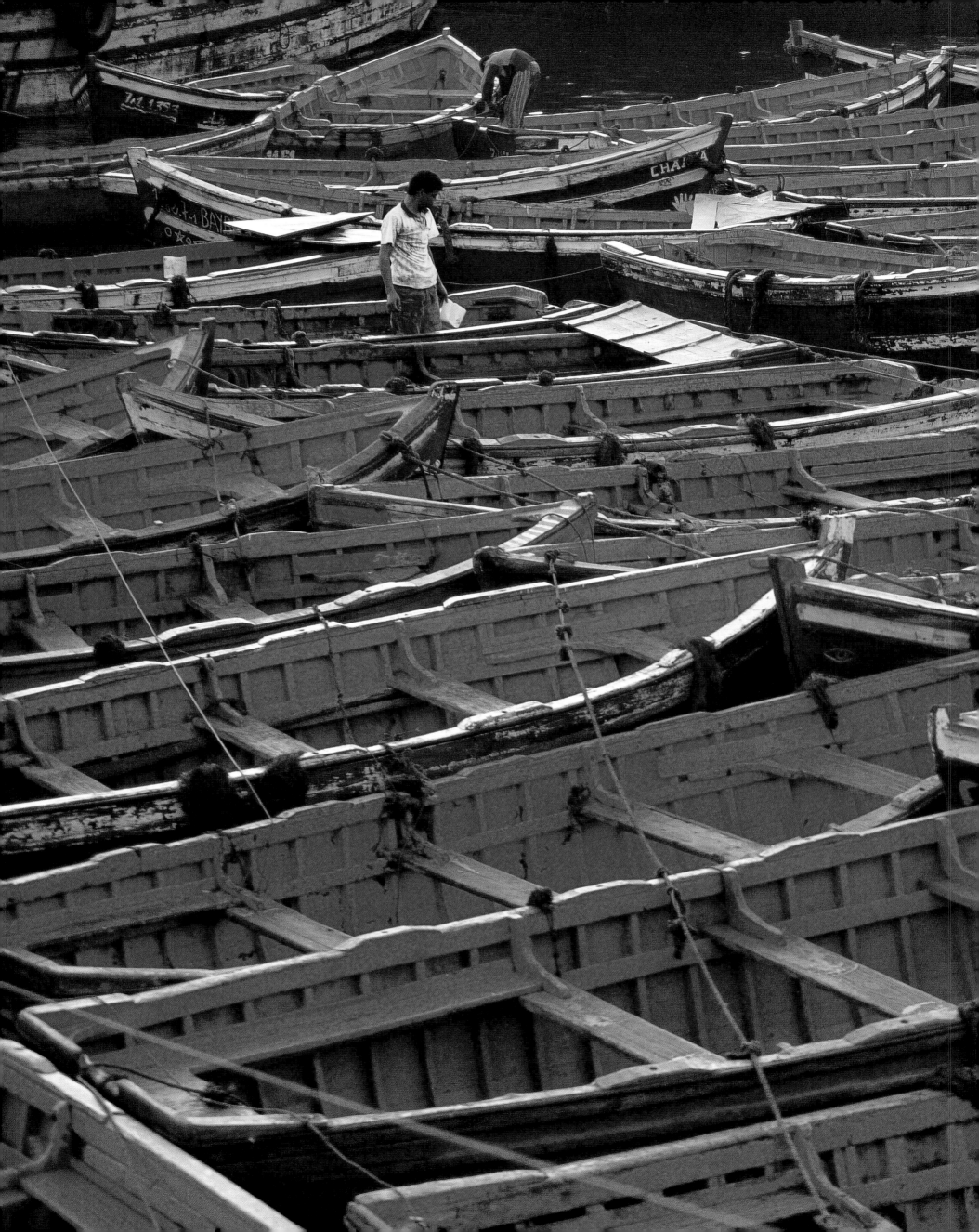

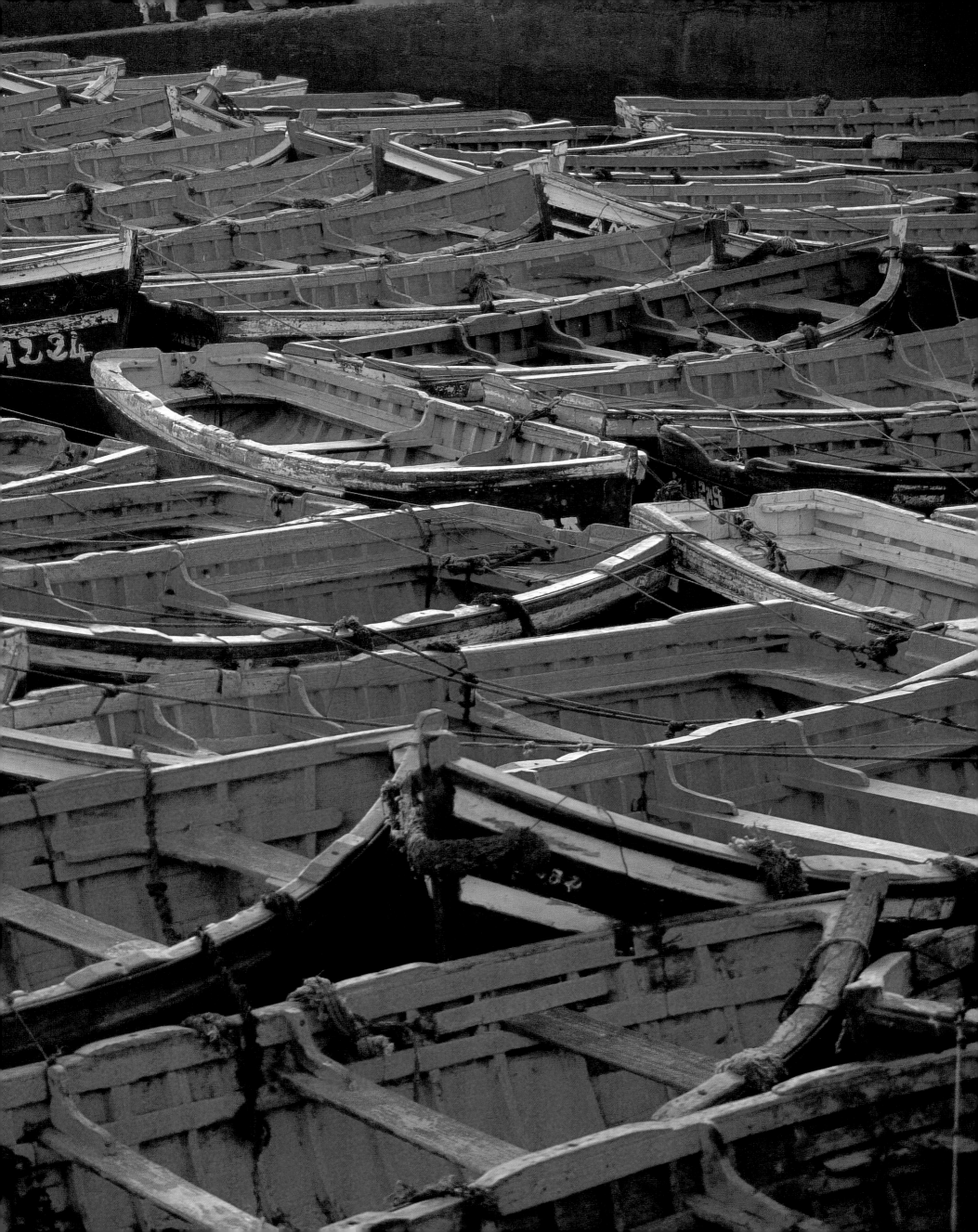

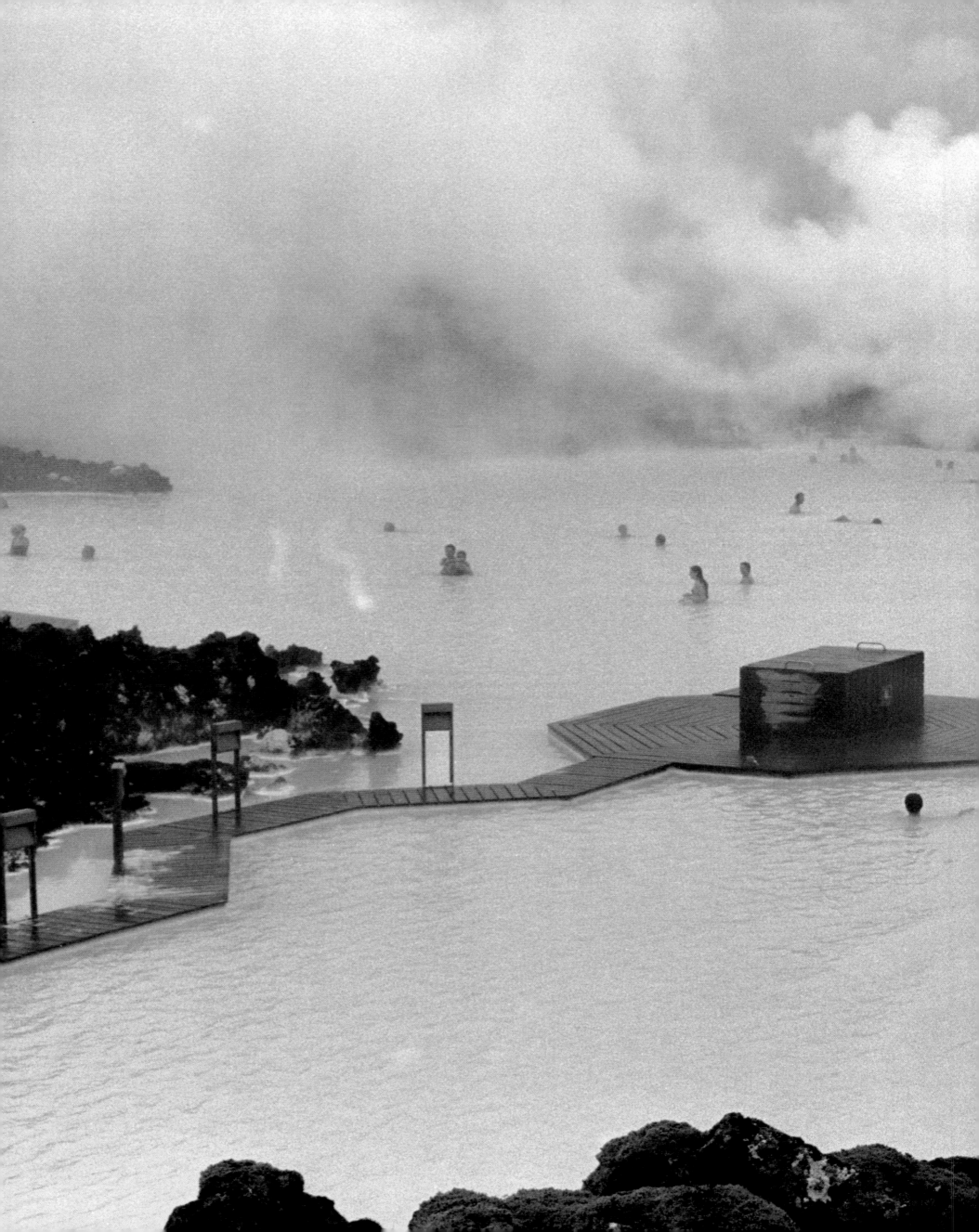

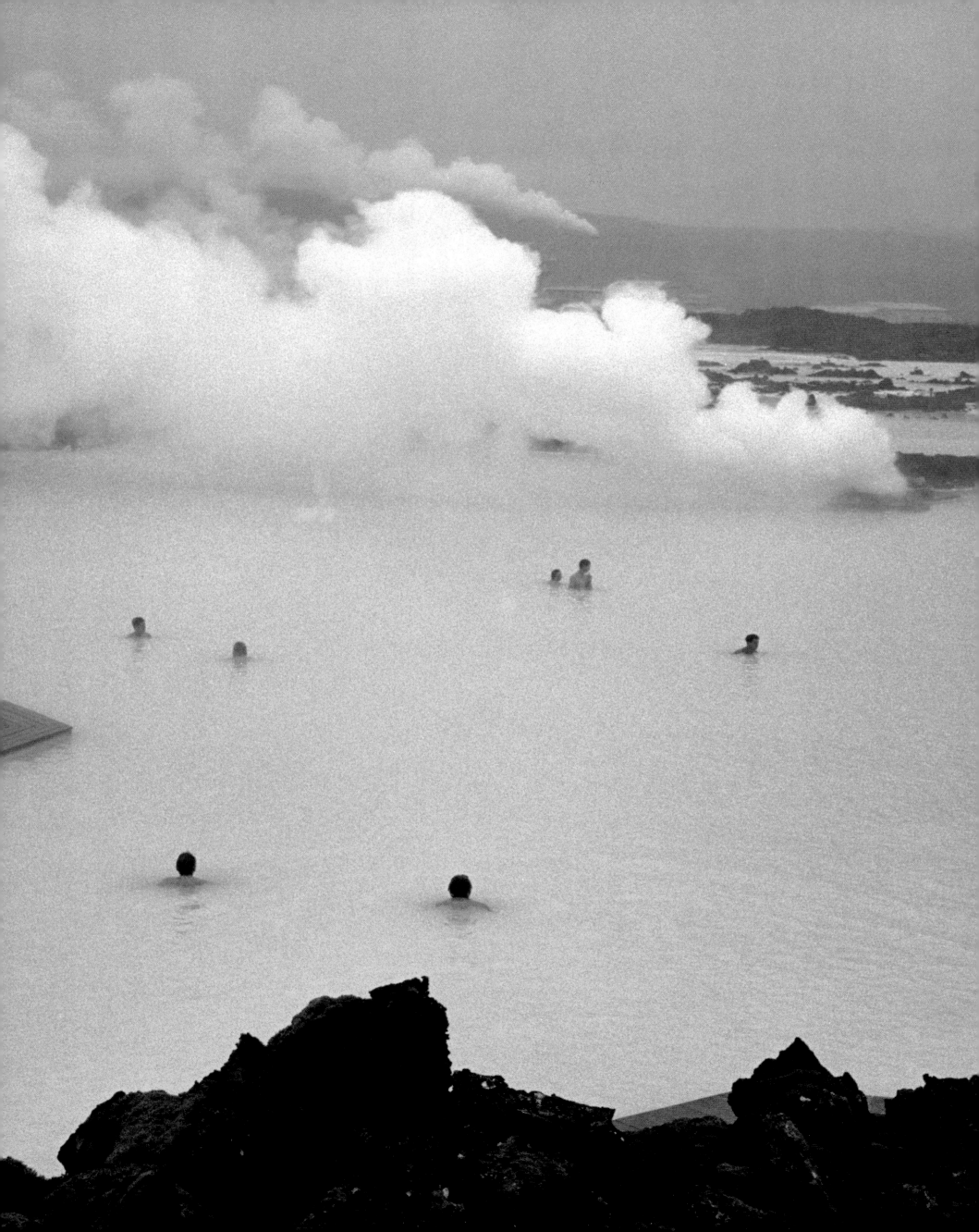

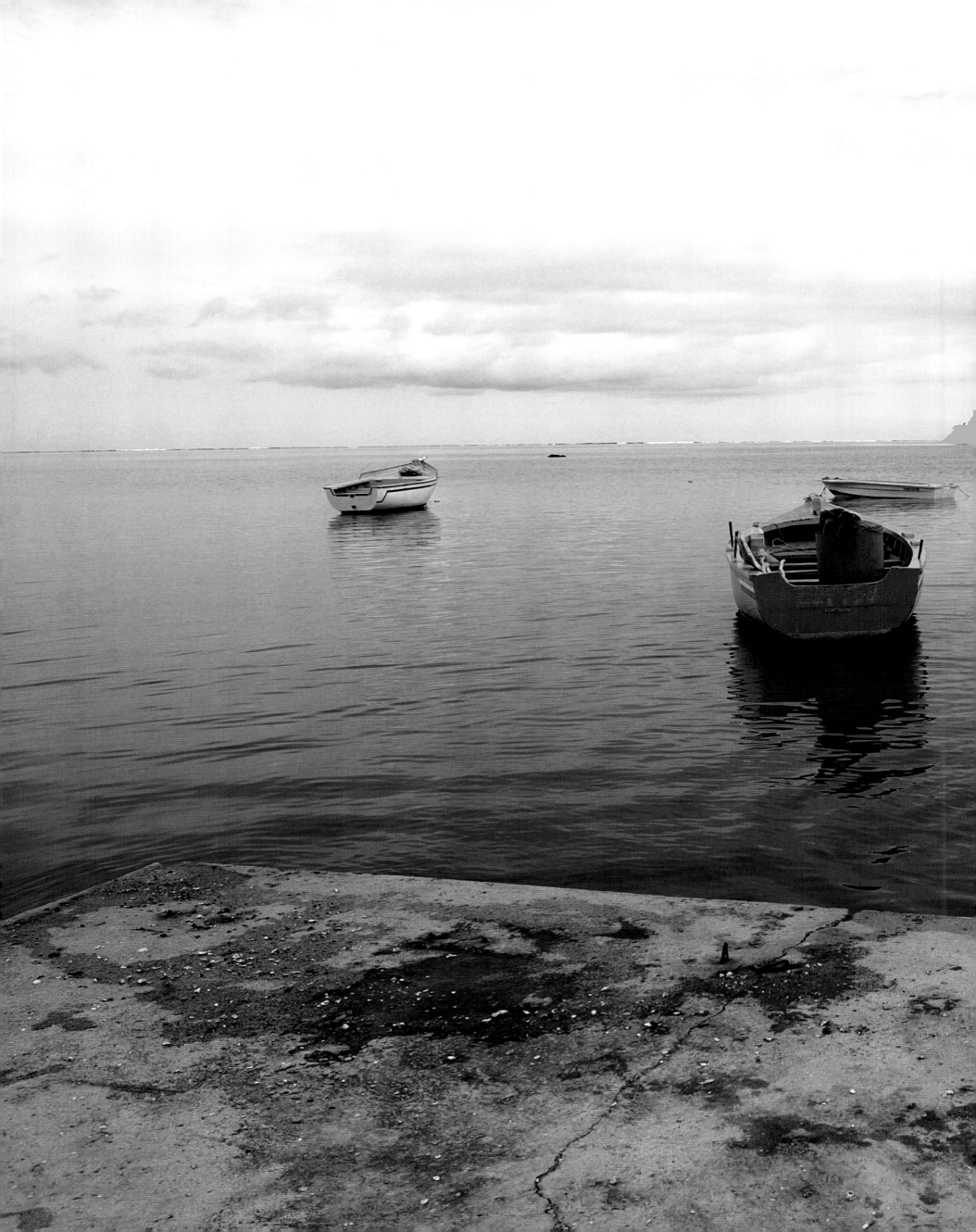

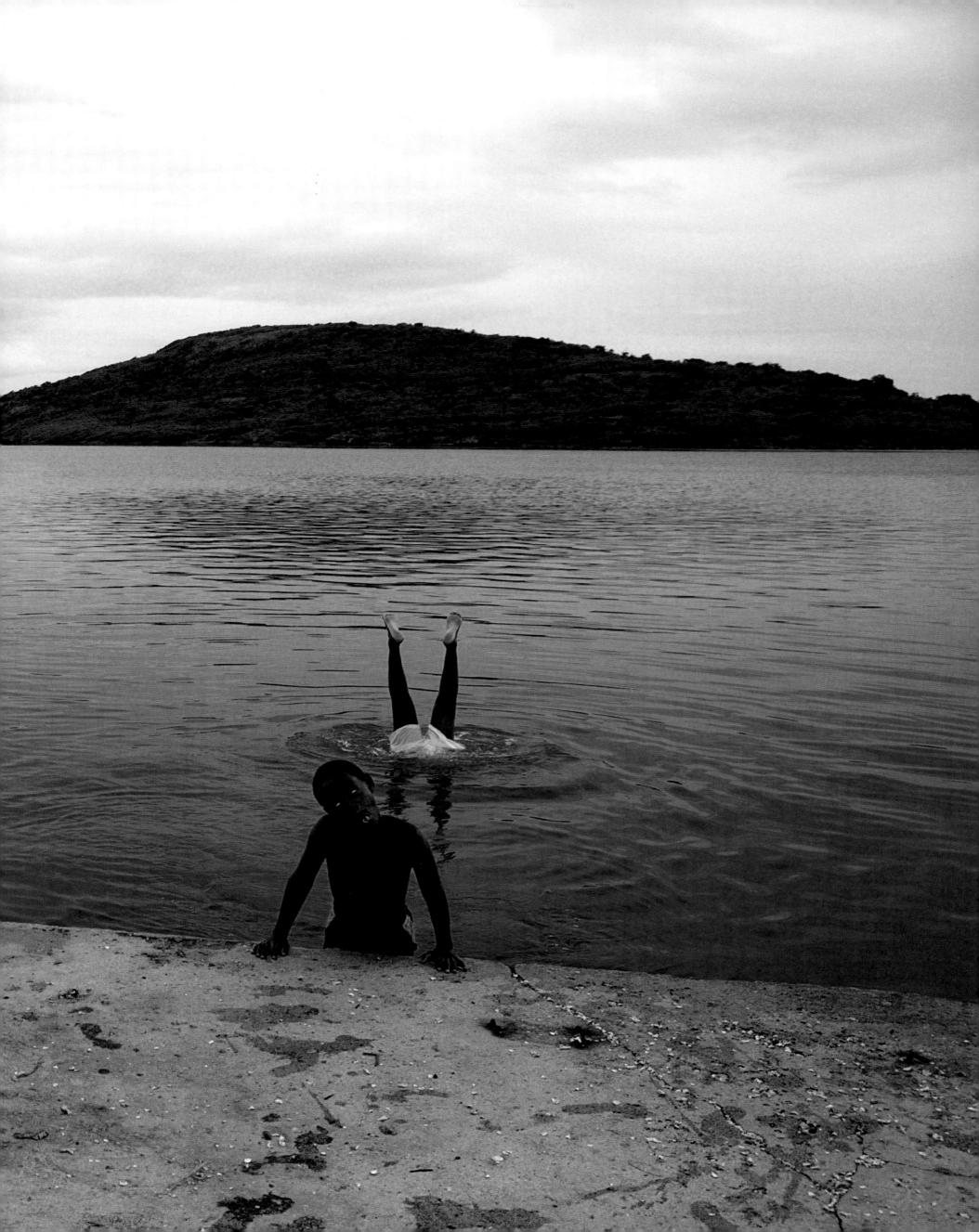

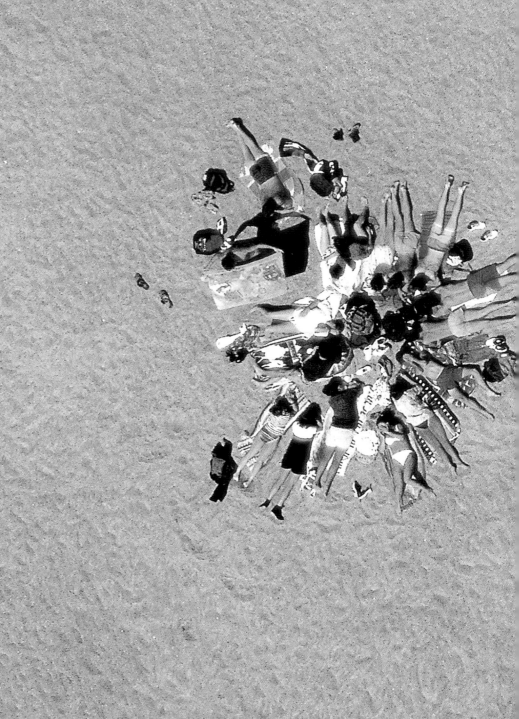

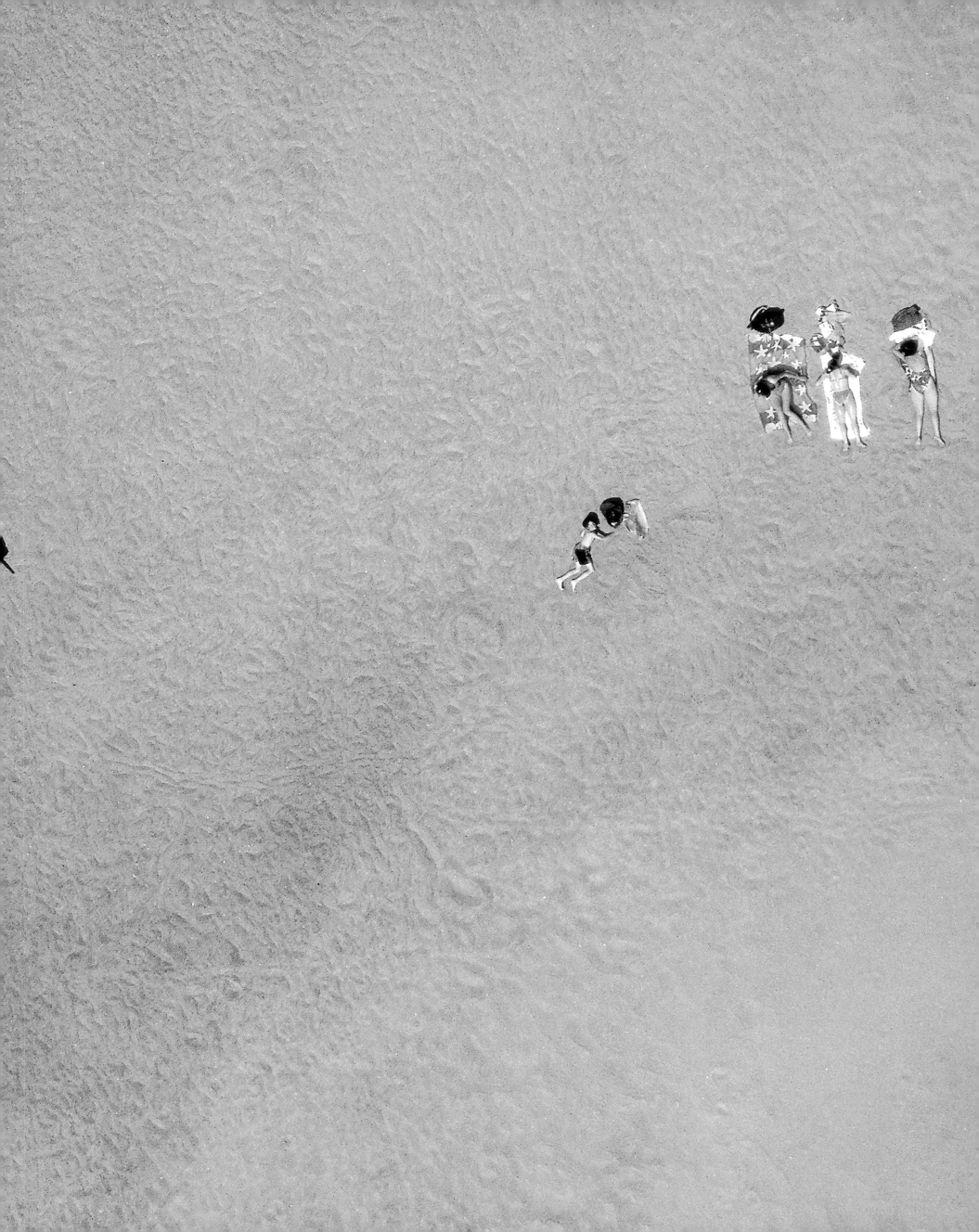

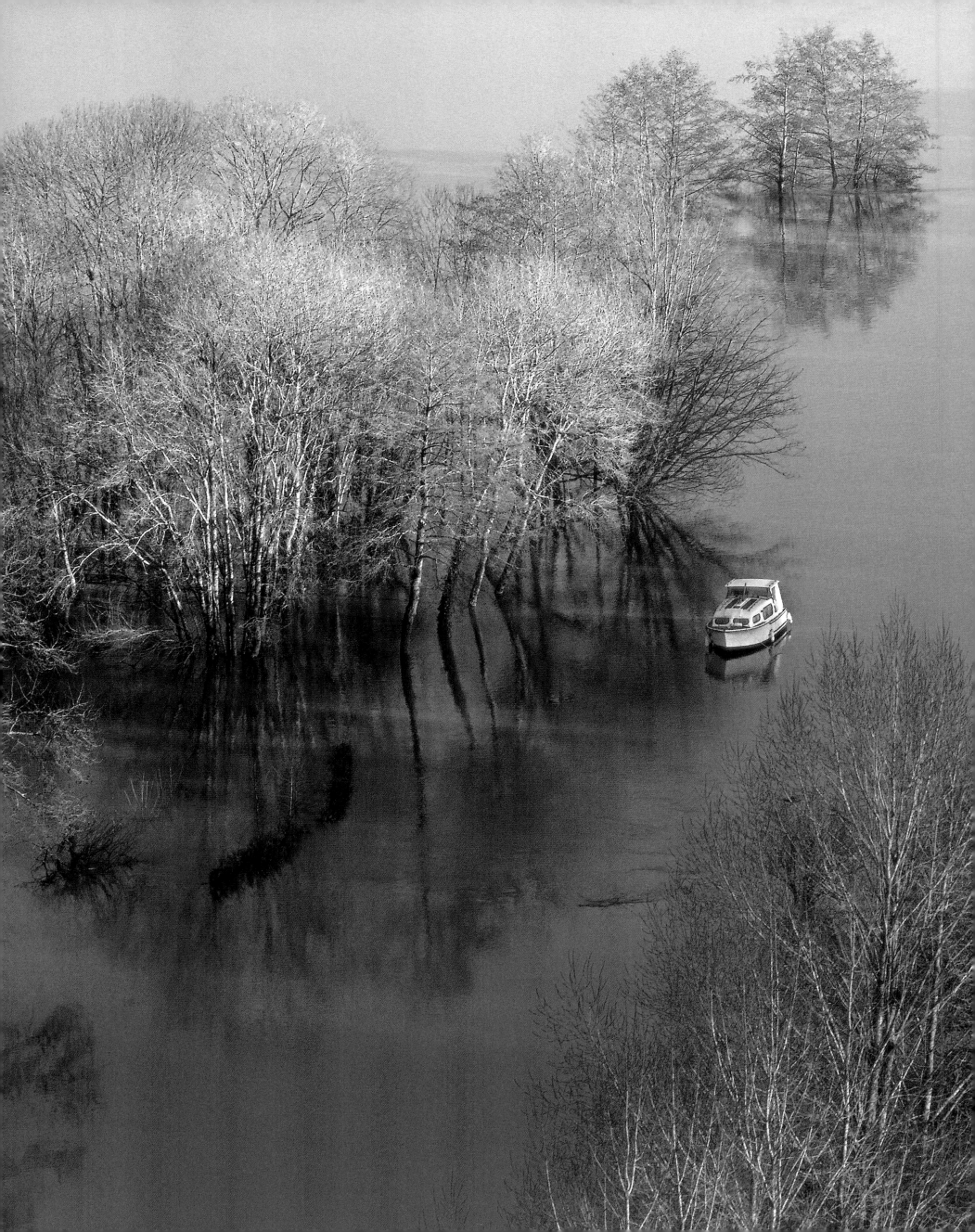

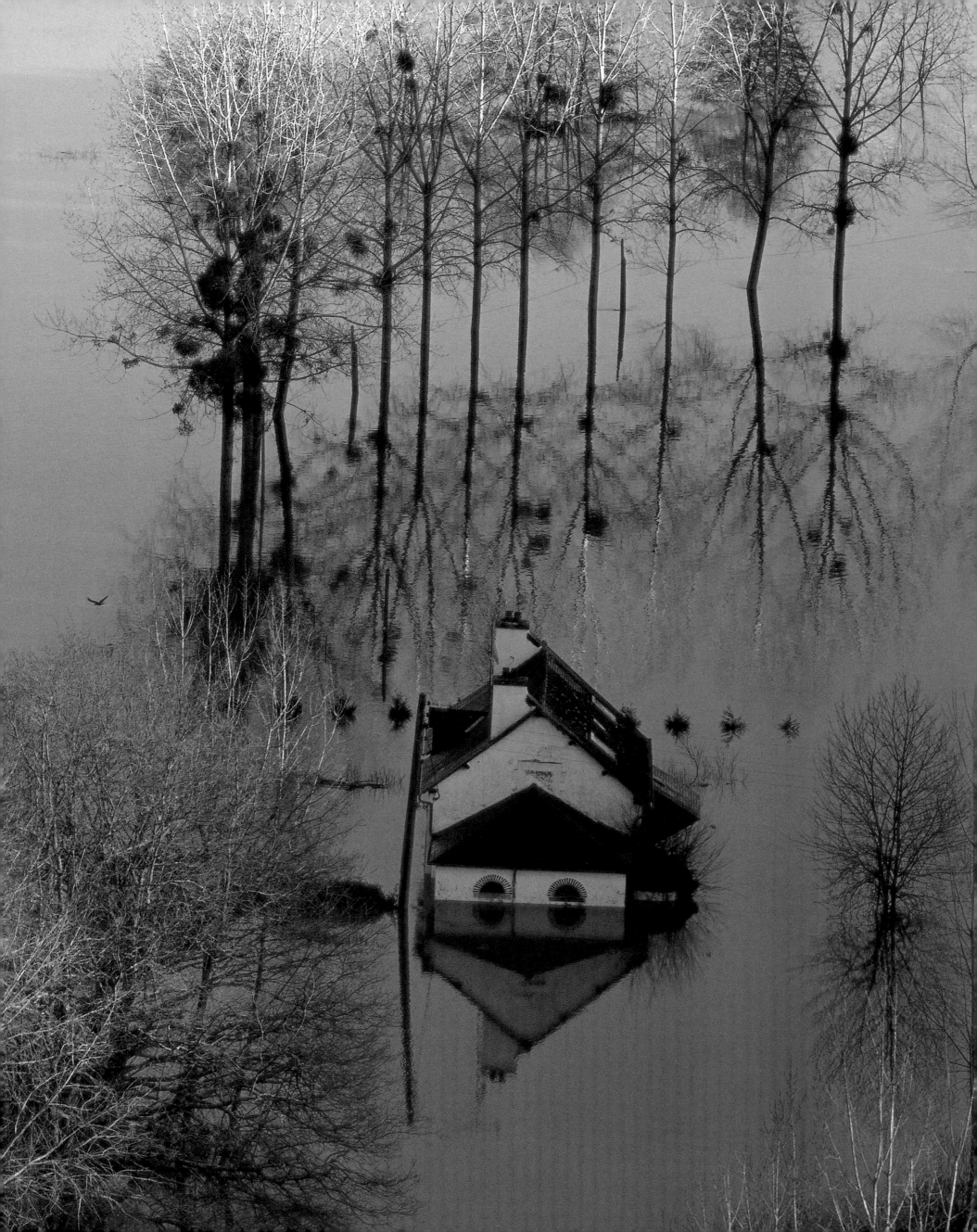

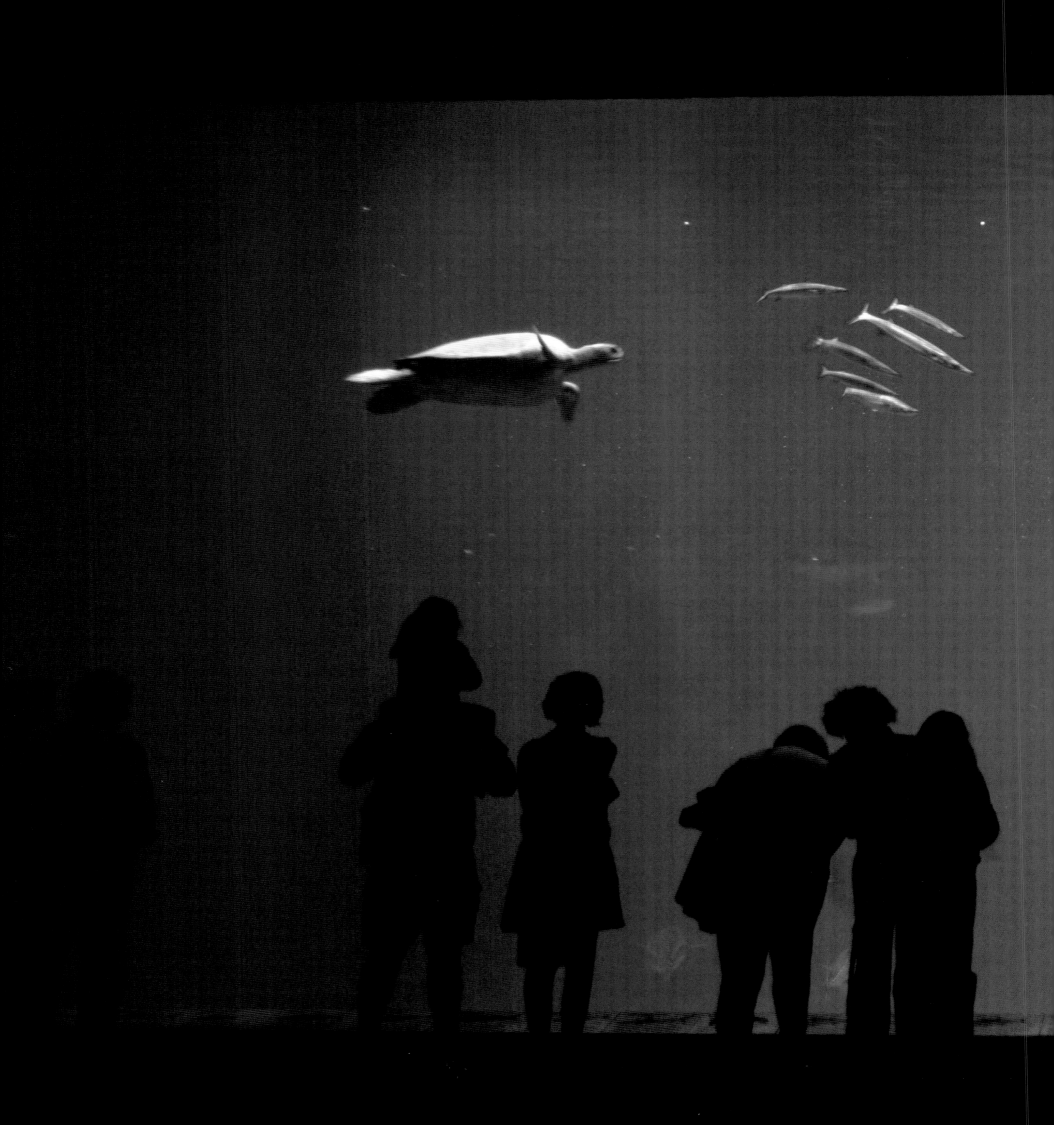

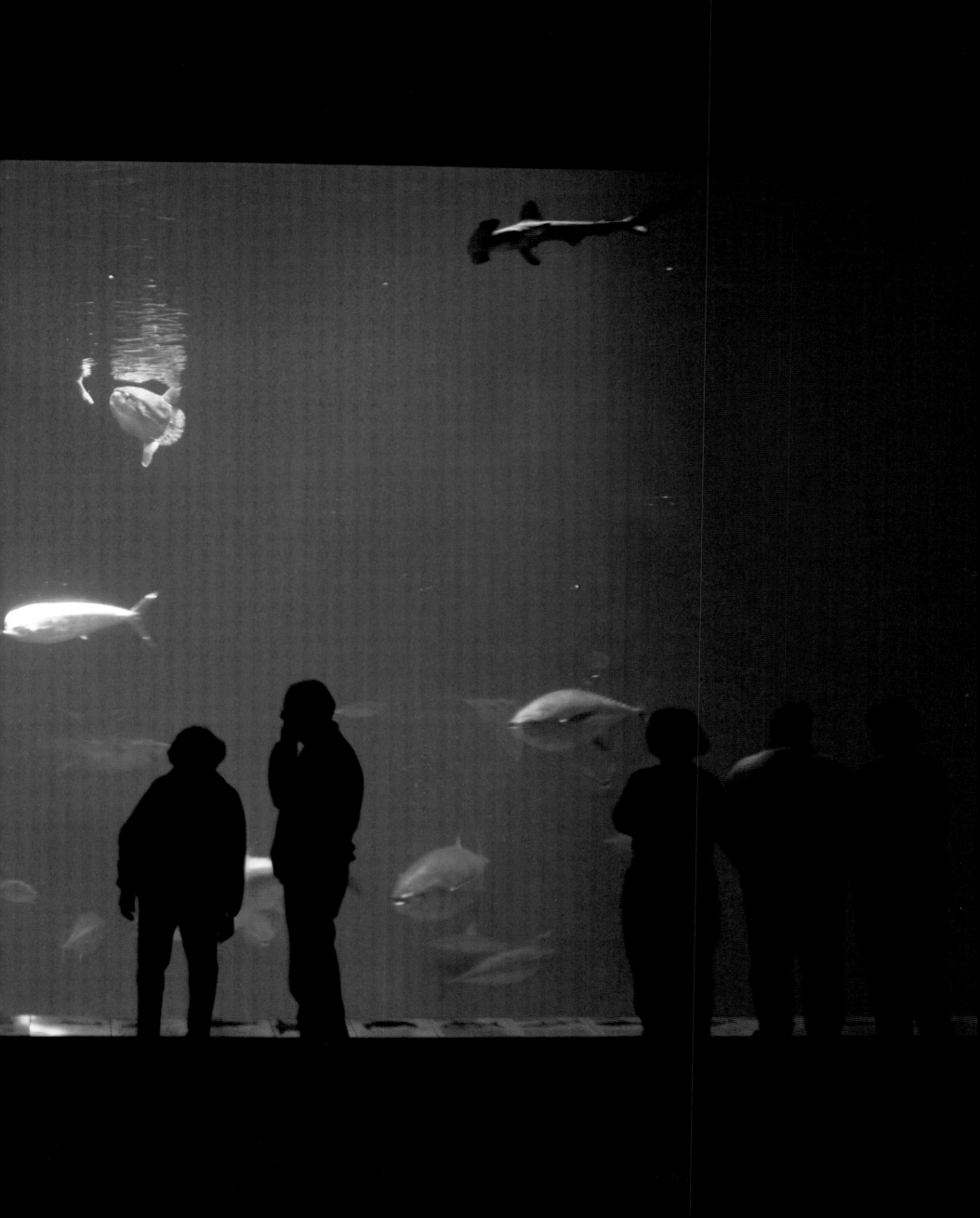

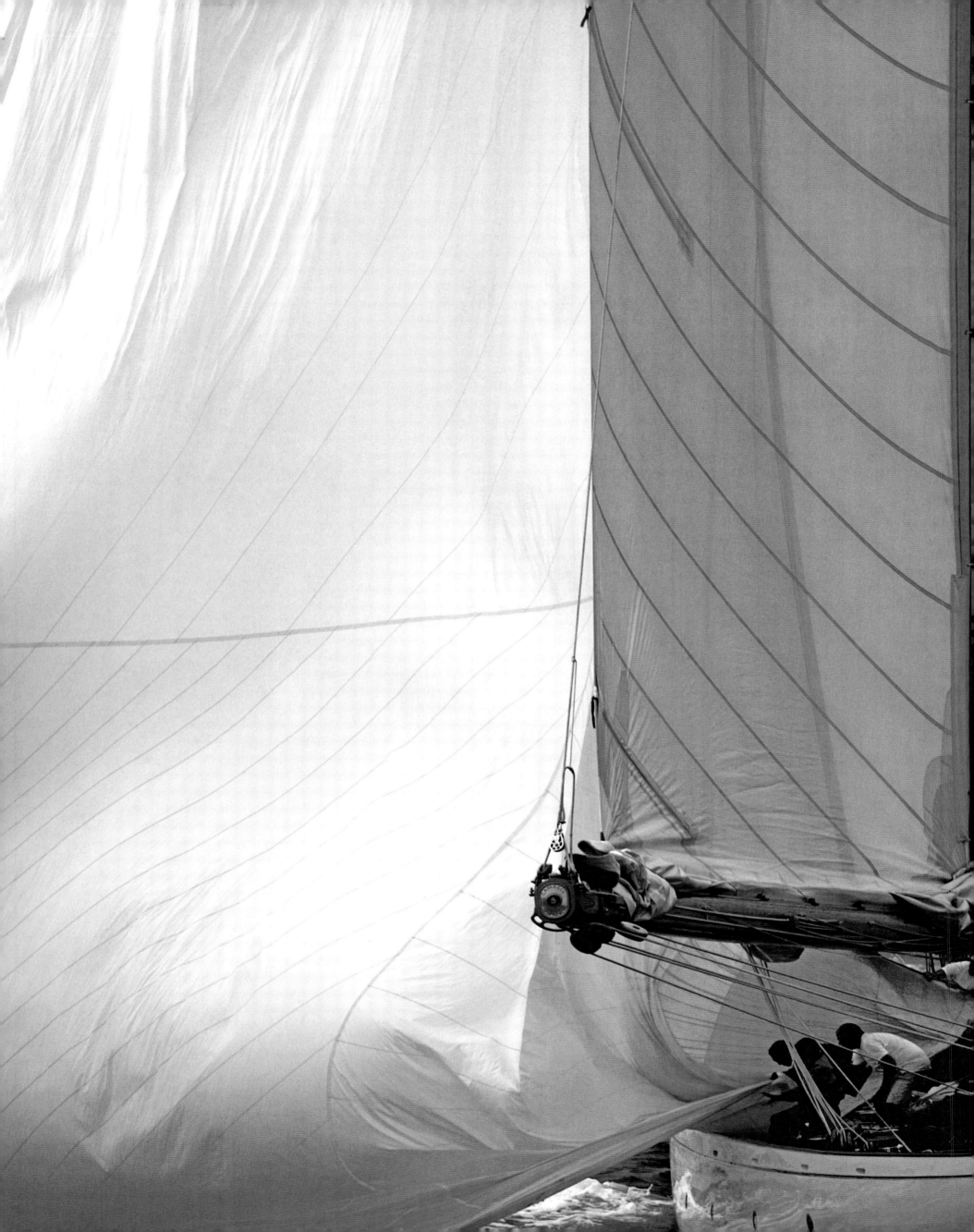

4 A Longing for the Ocean

The Romans were well aware of the allure of the ocean. What joy to relax on the shores of the Gulf of Naples; what sights to behold as they gazed down at the boundless sea from a lofty villa, or fished for lobsters on Capri, like the languid Lucullus, without ever leaving their couches. The emperor Tiberius himself was in love with the same island, where he owned no fewer than twelve villas, one for each of the gods of Olympus.

FRANCE, ON BOARD
THE *CAMBRIA*
The ports and yacht clubs of Saint Tropez, Cannes, Monaco, Porto Cervo and Newport, Maine, stage the most illustrious gatherings of the old, classic sailing ships. Around such marvels of elegance as the *Cambria*, a J Class yacht designed by William Fife and built in 1928, there are men and women who simply live for these beautiful wooden boats and for the great traditions of sailing, and their one aim is to preserve the priceless nautical heritage that is symbolized by these antique yachts. Most of these vessels have escaped falling into neglect and disrepair thanks to wealthy owners who have fallen in love with the legends of yesteryear and have patiently restored them to their pristine glory.

Then the shores gradually became the 'territory of emptiness', to quote Alain Corbin – unfit for habitation, where nothing grew and Satan and his fiends would roam, emerging from the depths of the ocean. Was not the boiling, freezing foam their filthy sweat, and the kelp their excrement? The mangled, tormented shores were the image of primeval chaos, and with each wave it seemed that the sea wanted to engulf everything in its path. The shore was a place of abduction, where Jupiter carried off Europa, and onto the coasts of Europe came the Vikings and other barbarians, axe in hand to wreak havoc wherever they went – before setting sail again and then returning in even greater numbers.

The sea, the shore, the impenetrable frontier, and the waters themselves were all agents of fear. No more bathing, for by dilating the pores, people were afraid that the water would penetrate into their bodies and corrupt them – hence the use of bathing suits and dry toilets, which do not require water.

It was hard work for the sea to overcome these fears and win back the hearts of humankind. But little by little, it returned to favour, creating a longing for the shore which, as if carried along by an inner swell, has never ceased to grow.

Mankind's view of the water began to change. With a host of great discoveries, the sea became a provider of wealth. It was still dangerous, of course, but now it was also a source of power and growth. And as the mightiest element of Creation, it could also be the greatest of

healers, for was not the universe pacified by Christ walking on the water and stilling the tempest? Mankind's vision changed, and we saw the world anew, with nature now viewed not as a threat but as a partner. A wave of optimism swept through the Western world at the beginning of the 17th century; seawater, with its invigorating coolness, became a source of healing and transformation, and the great Avicenna recommended cleaning one's teeth with its foam. Doctors, led by the Englishman Richard Russell, advocated bathing in it as a means of rejuvenation.

The seashore became an attraction. It was the perfect place for solitary wanderers and their daydreams. And the sea, from which people had once fled, could now be gazed upon in all its glory. Brazenly, it opened itself up to reveal its treasures, as if inviting us to enter, to break down the barriers to the impossible love affair between siren and fisherman. It attracted and still attracts our whole being, bidding us to take off our clothes and to move freely. The sea is liberty. It builds the settings for paradise islands, sculpts coves and caverns in the rocks, and offers us both privacy and sensual pleasure – the tingle of the water, the delicate caress of the breeze, the sinking of feet into wet sand, the warm glow when the sand is dry, all of them providing a loving embrace and a gentle thrill. The sea is a pleasure-giver to those who know how to immerse themselves.

Another change was to the 'ill repute' of some marshy coasts where the sea had been falsely accused

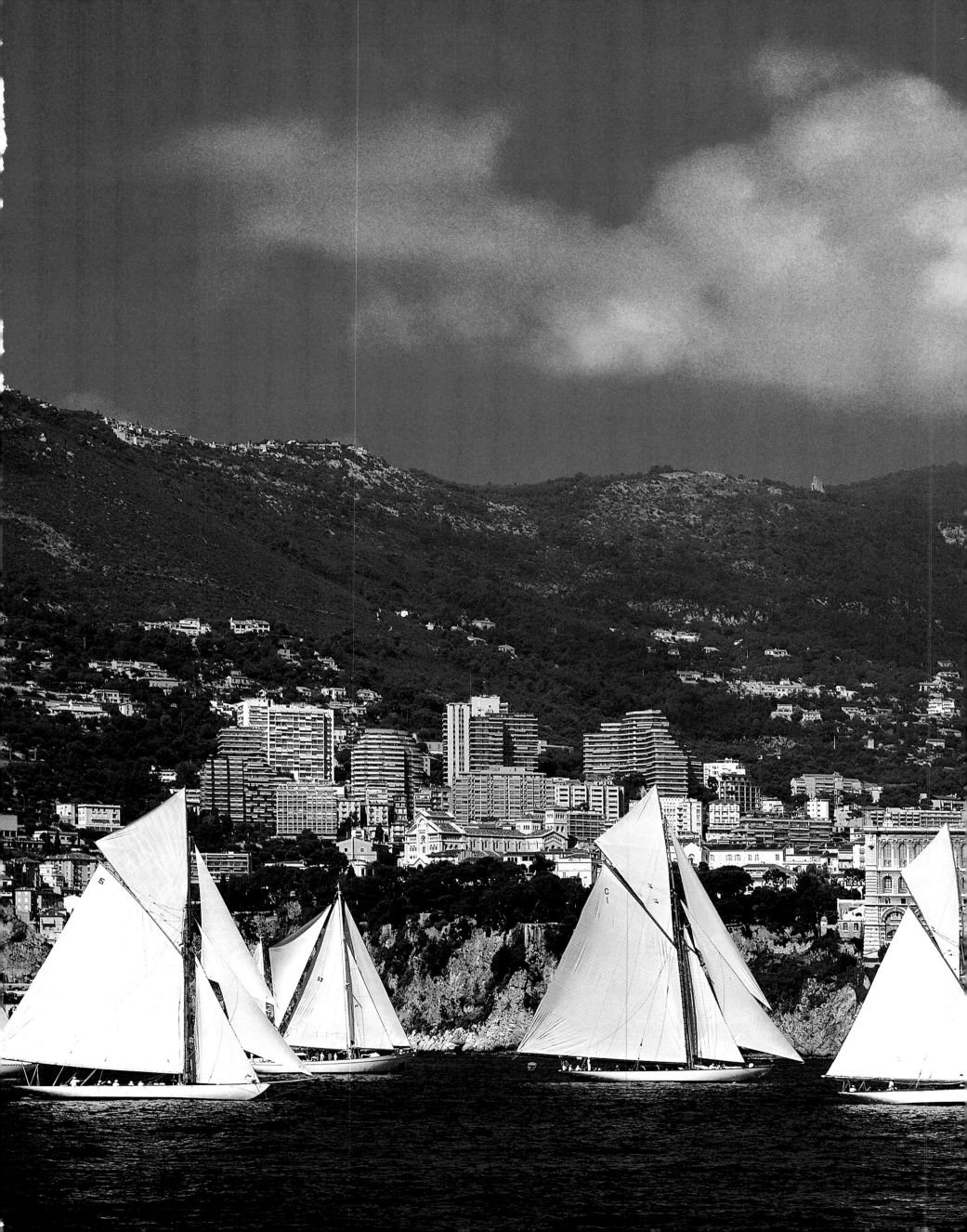

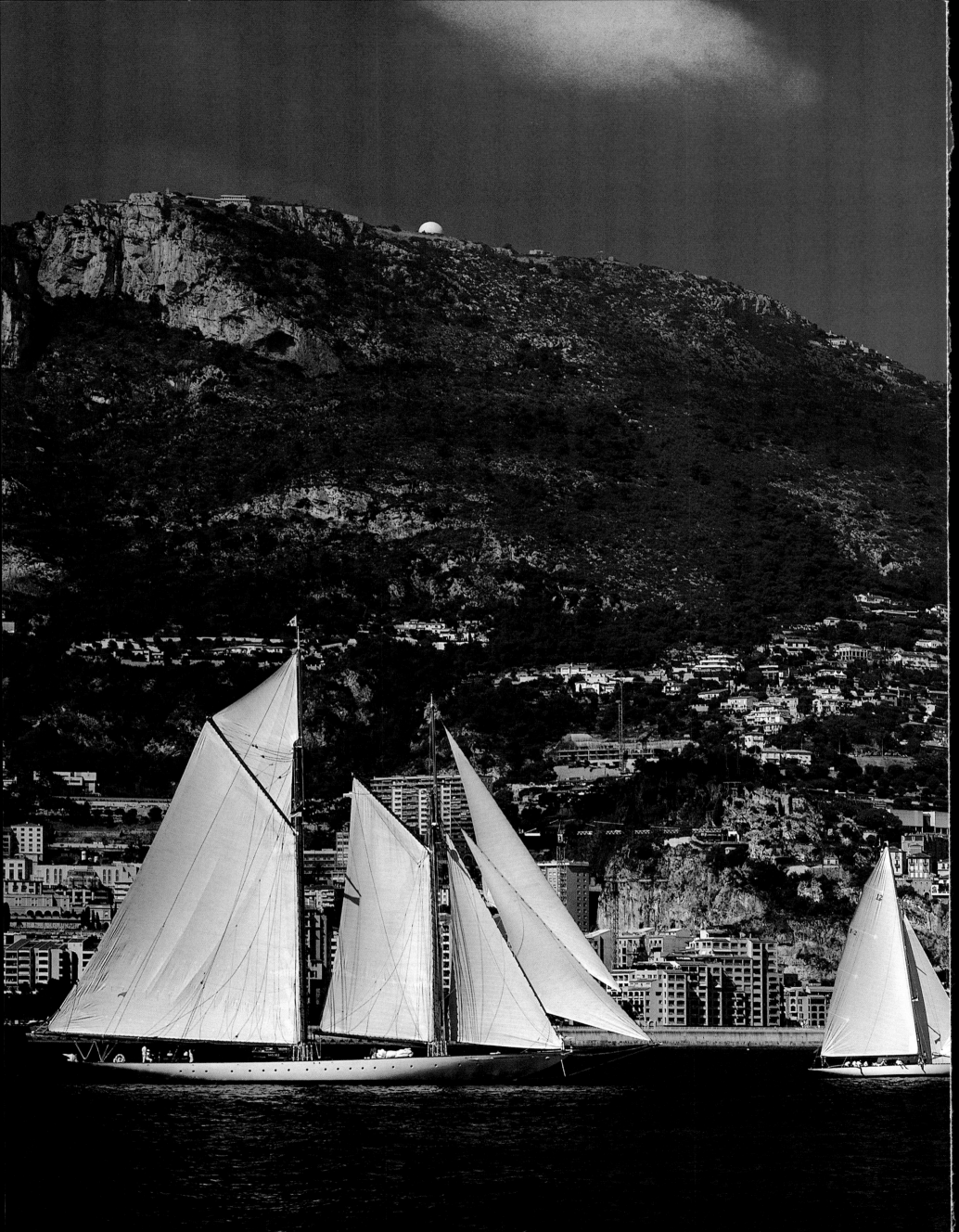

of causing malaria. At the beginning of the 20th century, quinine made life hard for the true culprit: the *Anopheles* mosquito.

In those days, many people had never even seen the sea or its shores, but the advance of rail and air travel, and the increase in leisure time soon brought more and more tourists to the seaside. It became a centre for sailing, holidays and convalescence, with more and more leisure activities. The beach was no longer a horizontal frontier that was fearful to cross; now it was a place of pleasure.

The child, spade in one hand and bucket in the other, shapes the sand to make a sandcastle, and then inevitably the sea comes to lap at it, reshape it, and finally carry it away. This is human destiny, with all its follies, its desires, its utopias, played and replayed over and over again, always and everywhere.

To gaze at the infinite ocean is to contemplate the human condition – the endless undulations of the waves, their folds of glass and silver, their muffled groans, their explosions as they hit the rocks, or their languorous sighs as they splash among the pebbles, creating a fleeting sparkle of pearls. So many emotions, always different, always fresh, finding their echo within us and at the same time reflecting our own souls. The sea is a source, a spring, and a challenge.

As we lie stretched out on the sand, our bodies burning in the sun, are we fully aware of the sea beside us? And do we really hear the song it sings within us, inviting us to set sail across its waters? Clearly many of us do, as more and more people find its appeal irresistible and let themselves be carried away – purely for pleasure. What an adventure it is, what a lesson it teaches us both in grandeur and in humility, and what a feeling of bounty it gives us. The only sounds are the water gently lapping against the hull and the metallic grinding of the halyards.

Mankind also introduced a new dimension: speed. During the 17th century, rich Dutch merchants enjoyed parading along the Zuider Zee on board their *jaghts* (derived from the Dutch word for 'hunt') – swift little boats that were used to chase smugglers. King Charles II of England, then in exile in the United Provinces, also acquired the taste for this way to experience the sea – so much so that the Dutch East India Company presented him with a *jaght* or yacht when he was restored to the throne in 1662. The *Royal Charles* was the first of a long series of royal yachts, which the king had the bad taste to name after his various mistresses. He also organized regattas.

Yachting is therefore an English sport by adoption. In 1851, however, a New York schooner named *America* defeated 14 British yachts in a race round the Isle of Wight, and gave its name to the most famous of the trophies: the America's Cup. The cup remained on the western side of the Atlantic until 1983, when it was briefly held by Australia, only to be regained by the United States – although it also had short stays in New Zealand and Switzerland.

Over the last twenty years, the number of races and sea challenges has vastly increased in all four corners of our blue planet. Some of the most exciting human adventures imaginable occur during the Vendée Globe, a single-handed round-the-world race, and the Route du Rhum, at the end of which in 1978 two competitors arrived at Pointe-à-Pitre with just 98 seconds between them after 23 days of racing. And we must not forget the homage paid to Jules Verne: one must go round the world in less than eighty days in order to beat the record of his hero, Phileas Fogg.

Mankind is never nobler than when confronting the immeasurable transcendence of the sea. It is the setting for all our desires and all our follies. Man the alchemist transformed his modest 'packet boats' of yore into floating cathedrals that moved more and more rapidly in their quest for the coveted Blue Riband. Happily, this particular folly has now died out with the demise of the great transatlantic liners. These ships grew and grew: 200 metres for the *Kaiser Wilhelm* in 1897; 232 metres for the *Mauretania* and the *Lusitania* in 1907; 268 metres for the *Olympic* and the Titanic in 1911; 313.75 metres for the *Normandie* in 1935, with a dining-room larger than the Hall of Mirrors in Versailles; 315 metres for the *France* in 1960; a blip of 293 metres for the *Queen Elizabeth 2* in 1967, which then had to curtsey in reverence before the largest liner ever built, the *Queen Mary 2*, stretching out to 345 metres. How many dreams did these liners carry with them? Dreams of new shores, new lives. The ocean allows us to cross to the other side, that eternal elsewhere that always haunts us. No airliner could take us there, for planes go too quickly, leaving no time to measure the world or to enjoy the anticipatory pleasure as we slowly approach the shore.

Anyone who puts to sea, no matter where their origin or their destination, knows that there are new shores and new worlds waiting. The sea is both an end and a beginning. Baudelaire wrote: 'Free man, you will always cherish the sea.' It is our mirror, in which we may see our souls in the swell of the waves.

MONACO, CLASSIC WEEK
Like his ancestor Rainier I, Admiral of France, Prince Albert I of Monaco was passionate about the sea. Between 1885 and 1915, this indefatigable explorer led 28 expeditions, which took him from the Mediterranean to the Azores, and from the Cape Verde Islands to Spitsbergen. Monaco's museum of oceanography, built on his initiative, opened its doors to the public in 1911. Today, his grandson Albert, another devotee of the ocean and president of the Monaco Yacht Club, carries on the tradition, and has added Monaco to the list of prestigious events that bring together the classic yachts of the past. Such continuity ensures that the life of the Principality remains for ever indissolubly tied to the sea.

4 A Longing for the Ocean

FRANCE, MARSEILLES, AMERICA'S CUP
In 2004, under the benevolent gaze of Notre-Dame-de-la-Garde, Marseilles was the setting for some preliminary rounds of the 32nd America's Cup. Six teams (Team Alinghi, BMW ORACLE Racing, Emirates Team New Zealand, LE DEFI, k-Challenge and Team Shosholoza), representing five nations, alternated between match racing and fleet racing (for three or more boats). Fleet racing dates back to the beginnings of the cup and the celebrated race of 1851 around the Isle of Wight. Match racing (a duel between two boats) came later but is the speciality of the America's Cup, and so the introduction of fleet racing is in fact a new variation on an ancient tradition.

FRANCE, LA TRINITÉ-SUR-MER, SPI OUEST
It is from the Italian dialect word *regatta*, meaning a contest or challenge, that we derive the word for these sporting contests between human, wind and sea. At all times and on all shores, regattas attract a passionate crowd. They all revel in the sight of the spinnakers blossoming on a sea transformed into a spring meadow, with a thousand sails billowing in the breeze. Experts or amateurs, sheet in hand or binoculars to the eyes, they are all fascinated by the spectacle on the sea.

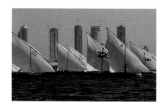

UNITED ARAB EMIRATES, DUBAI, DHOW RACING
Dubai is a square of sand covering 3,800 km² on the edge of the Persian Gulf. A century ago, it was only desert; now there stands a cosmopolitan city that is changing by the day. In anticipation of the time when it will run out of oil, Dubai has decided to bank on tourism and business, and to this end it has invested in an ambitious architectural programme dealing in superlatives. With skyscrapers reaching to a height of 800 m, shopping malls, marinas and residential areas, the coast is now being transformed into the Dubai Waterfront, the largest seafront development in the world. In its race against time, Dubai seems to be hurtling into the future.

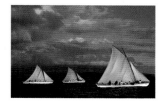

PORTUGAL, AZORES, WHALEBOATS ON A PRACTICE RUN
With its nine volcanic islands like mid-Atlantic gardens, the Azores offer a wonderful training ground for whaleboats that have been converted into racing yachts since whaling was banned in 1987. These boats are 2 m wide and 11 m long, with the seven crew members having to sit out in the breeze, with one of them standing on the outside edge of the deck, gripping a rope attached to the shroud and with his feet wedged against the gunwale. As in the days of the hunt, when they raced to reach the whale and then used all their strength to harpoon it, the yachtsmen go all out for victory.

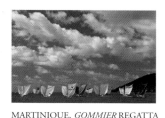

MARTINIQUE, *GOMMIER* REGATTA
The *gommier* of Martinique is a vessel inherited from the pre-Columbian peoples. These sailing boats take their name from the gum tree out of which they are made, and they used to serve as means of transporting people and goods, as well as for fishing. No longer needed for those purposes today, the *gommier* with its hollowed-out tree trunk might easily have disappeared into the past, but history decided to resurrect it for leisure and sporting use. The *gommiers* now race each other round the island all year long, to the delight of all who watch and sail them.

GREAT BRITAIN, ISLE OF WIGHT, COWES
In 1851, the schooner *America* crossed the Atlantic to challenge the fleet of the Royal Yacht Squadron to a race round the Isle of Wight. America was victorious, and so carried off the silver cup designed for the winner. This was the start of the saga of the America's Cup, the aim of which has always been to regain the trophy lost on 22 August 1851. To celebrate the Cup's 150th jubilee in 2001, the Royal Yacht Squadron organized a festival in which everything was staged in the style of the 1851 event. The Isle of Wight's most famous yachting tradition is the annual Cowes Week, which brings together a thousand yachts of all classes.

GREAT BRITAIN, THE ISLE OF WIGHT
Is there anyone who does not, in some distant corner of their memory, recall a boat struggling to advance against the wind, a kite refusing to take off or refusing to come down, a windsurf board flopping pathetically onto the beach, a pedalo that was incredibly hard work in the hot sun, a yacht that insisted on losing every race, a gripping novel whose pages crinkled in the sand or flapped uncontrollably in the wind? But in time, all these things turn into happy memories of a seaside holiday.

FRANCE, SAINT TROPEZ, *LES VOILES DE SAINT TROPEZ* REGATTA
Whenever there is a major regatta, the density of boats on the same stretch of water is often unbelievable. There are racing boats, spectator boats, official boats and press boats, all milling around in one another's erratic wakes amid a forest of sails. And there is no rule to bring order to this nautical chaos, which indeed can sometimes lead to accidents. The Nioulargue regatta once ended in mourning for some of its participants. In view of the growing popularity of these sailing extravaganzas, the need for an independent authority responsible for organizing events on the water is clear.

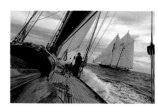

FRANCE, SAINT TROPEZ, ON THE *MARIQUITA*
The sails flap noisily in the wind, the helmsman shouts his instructions, the sheets clatter, the winches grind as they swallow up the halyards. Then the breeze fills the sails, and at once they fall silent. A few more rattles and groans, as the boat gently lists, and suddenly you feel it lift and accelerate, driven by an invisible force. Now there is nothing but the sound of the water against the hull, the ripples of the wake, the sparkle of the waves as the yacht sails through them. And sometimes the joy of seeing another sail silently approaching.

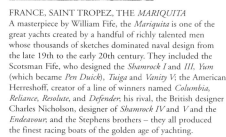

FRANCE, SAINT TROPEZ, THE *MARIQUITA*
A masterpiece by William Fife, the *Mariquita* is one of the great yachts created by a handful of richly talented men whose thousands of sketches dominated naval design from the late 19th to the early 20th century. They included the Scotsman Fife, who designed the *Shamrock I* and *III*, *Yum* (which became *Pen Duick*), *Tuiga* and *Vanity V*; the American Herreshoff, creator of a line of winners named *Columbia*, *Reliance*, *Resolute*, and *Defender*; his rival, the British designer Charles Nicholson, designer of *Shamrock IV* and *V* and the *Endeavour*; and the Stephens brothers – they all produced the finest racing boats of the golden age of yachting.

FRANCE, MARSEILLES, LOUIS VUITTON CUP
On 2 March 2003, Team Alinghi beat Team New Zealand, thus winning the 31st America's Cup and bringing the trophy back to Europe for the first time in 152 years. Valencia, Spain, has been chosen to stage the 32nd race in this famous competition. An ambitious programme of regattas began in 2004. These preliminary stages mixed fleet and match racing, and took the competitors from Marseilles to Valencia, and from Malmö-Skane (Sweden) to Trapani (Sicily). In 2007, the challengers will finally compete for the Luis Vuitton Cup, and then comes the top duel, the match for the 32nd America's Cup, which is awaited with eager anticipation.

FRANCE, OUISTREHAM, CROSS-CHANNEL
Caen, 230 km from Paris, and Portsmouth, less than 2 hours from London, are situated at the two ends of a cross-Channel line sailed by the ferries *Normandie* and *Mont St Michel*, with three round-trips a day. The leading ferry company in the west and central Channel, with more than 60 per cent of the market, Brittany Ferries passed the 3 million passenger mark in 1994. Nevertheless, it is now suffering from strong competition in the cross-Channel business, thanks to new sea and air companies and the Channel Tunnel, which since it opened in 1996 has captured 25 per cent of the market.

CHILE, VALPARAISO
The fashion for seaside resorts began in the 1840s in Trouville, and at the time the main reason was therapeutic. Following the example of these Norman pioneers, there were soon thousands of such resorts flourishing all over the world. Seaside tourism, which for a while was a privilege reserved for the social elite, became more and more popular. Going to the beach is now an international pastime, and even if the waters are not always as salubrious as they should be, this does not deter bathers. Consequently, every year around 250 million people contract diseases that stem directly from bathing in polluted water.

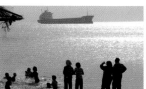
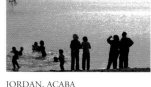

JORDAN, ACABA
On almost every shore on the planet, there are people relaxing, swimming, or dipping their toes in the water. On some beaches, they stretch out naked, bathing for hours on end in the sun. People may behave with complete decorum in other places, but once they are beside the sea, off go all restraints. Depending on their culture or their religion, people experience the sea in different ways; here, at Acaba in Jordan, women go down to the water veiled and covered from head to toe. Back in 19th-century Britain, etiquette required that beach huts must be as close as possible to the water, to allow ladies – in full bathing dresses – to slip discreetly into the sea.

INDIA, KERALA, VARKALA BEACH
On the south-west coast of the Indian peninsula, the shores of Kerala are bathed by the waters of the Indian Ocean. The idyllic beaches of sunlit sand around Varkala, a popular seaside resort, are flooded every year by Western holidaymakers. But away from these overpopulated areas you can still find scenes of traditional life that go on regardless of the tourist hustle and bustle next door. Here, on the anniversary of the death of a close relative, members of the family assemble on the beach at Varkala to engage in prayer and to commune with his soul. A moment of pure peace which, let us hope, will never change.

DOMINICA, *QUEEN MARY 2* COMES INTO PORT
A luxury liner offers its leisured clientele peace and quiet and a change of scenery, taking them on a cruise with various stopovers and excursions on land, and no need to pack or unpack their bags. Speed is of no importance to the passengers, who revel in a feeling of security, the high quality of service, food and accommodation, the atmosphere on board ship, meeting people, and the many entertainments on offer day and night. But as they flit from port to port, what will they remember of their stay in Dominica? Will they even notice the locals gazing through the fence at a ship the like of which they have never seen before?

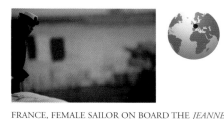

FRANCE, FEMALE SAILOR ON BOARD THE *JEANNE*
Head of a naval base, manager of a fishing business, shellfish-farmer, diver, leader of a team of offshore oil riggers, naval officer…Such jobs may be traditionally associated with men, but a career at sea is no longer a male prerogative, and from fishing to oceanography, from the deep seas to the coasts, women now work in the service of the sea. Most of the world's navies are now integrated, and 11 per cent of the French Navy are women, who can attain all ranks and hold almost all posts – officers, quartermasters, and ordinary sailors. Serving on submarines remains the sole exception.

USA, SAN FRANCISCO, GOLDEN GATE BRIDGE
After his discovery of the Sandwich Isles, now Hawaii, in 1778, Captain Cook brought back reports of a local sport which consisted in launching oneself into the breakers, balanced on a long plank of wood. A true artform, surfing became a craze in California during the 1960s, and then in Brazil around 1980. From the breakers of Newquay in Cornwall to the shark-infested coasts of South Africa, from Pipeline in Hawaii to the turquoise waters of Tahiti, the experts surf the waves of the world. And even in muddy waters at a temperature of 8° C, as at this particular venue, the urge to surf appears to be irresistible.

PANAMA, SAN BLAS ARCHIPELAGO.
Nestling in a fold of the Caribbean, the jewel-like chain of the San Blas Islands decorates the Atlantic coast of the Panamanian isthmus over some 300 km. If you explored one island per day, it would take you exactly a year. Protected by a long barrier of coral, the archipelago offers an idyllic cruise across a tranquil sea, accompanied by gentle breezes and anchorage in peaceful isolation. Anxious to preserve the integrity of their territory, the Kuna people of San Blas have banned all modern fishing technology from their waters. You must compete on equal terms with the creatures of the sea. The coral reef, which is very old and exceptionally well preserved, can only be seen by snorkellers.

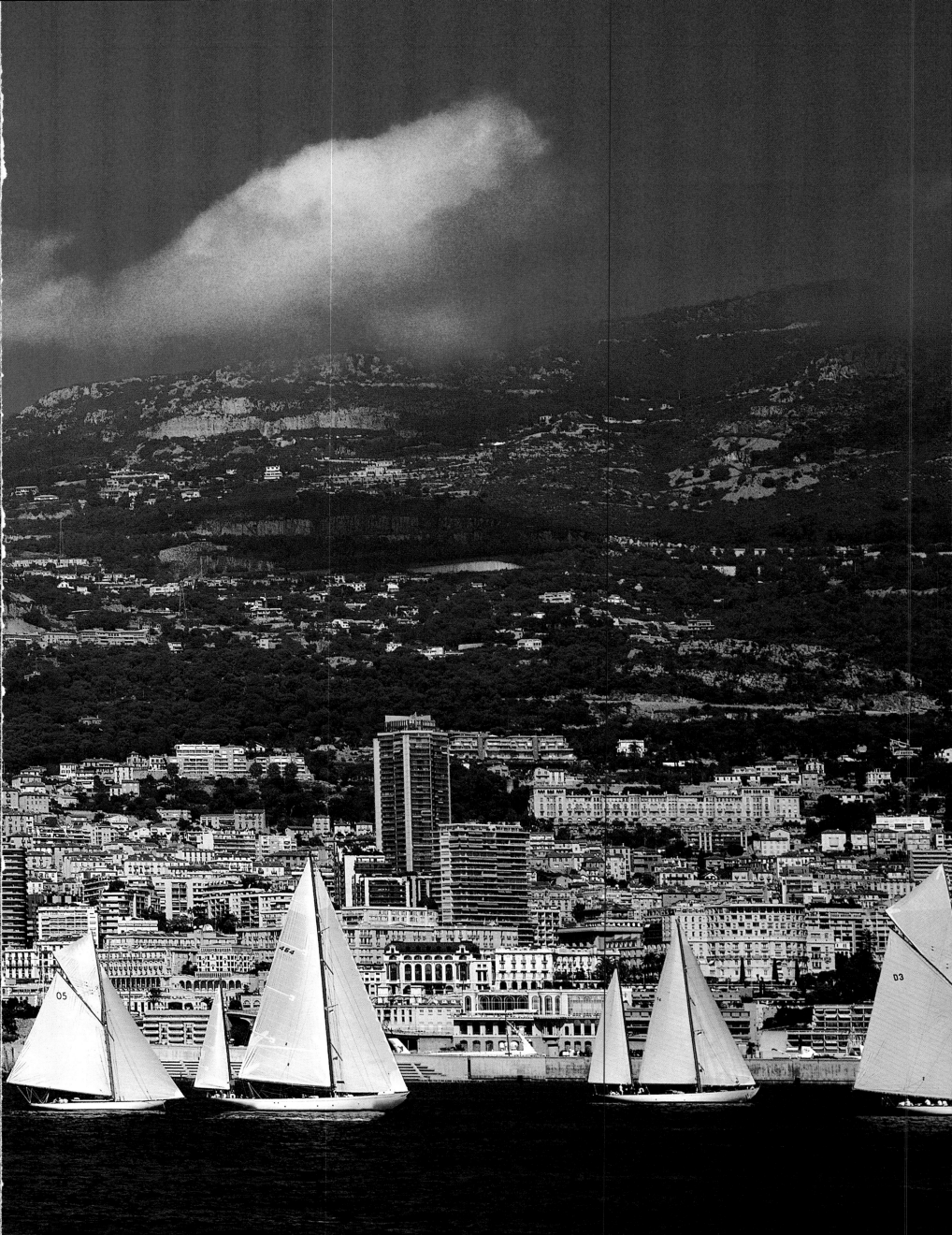

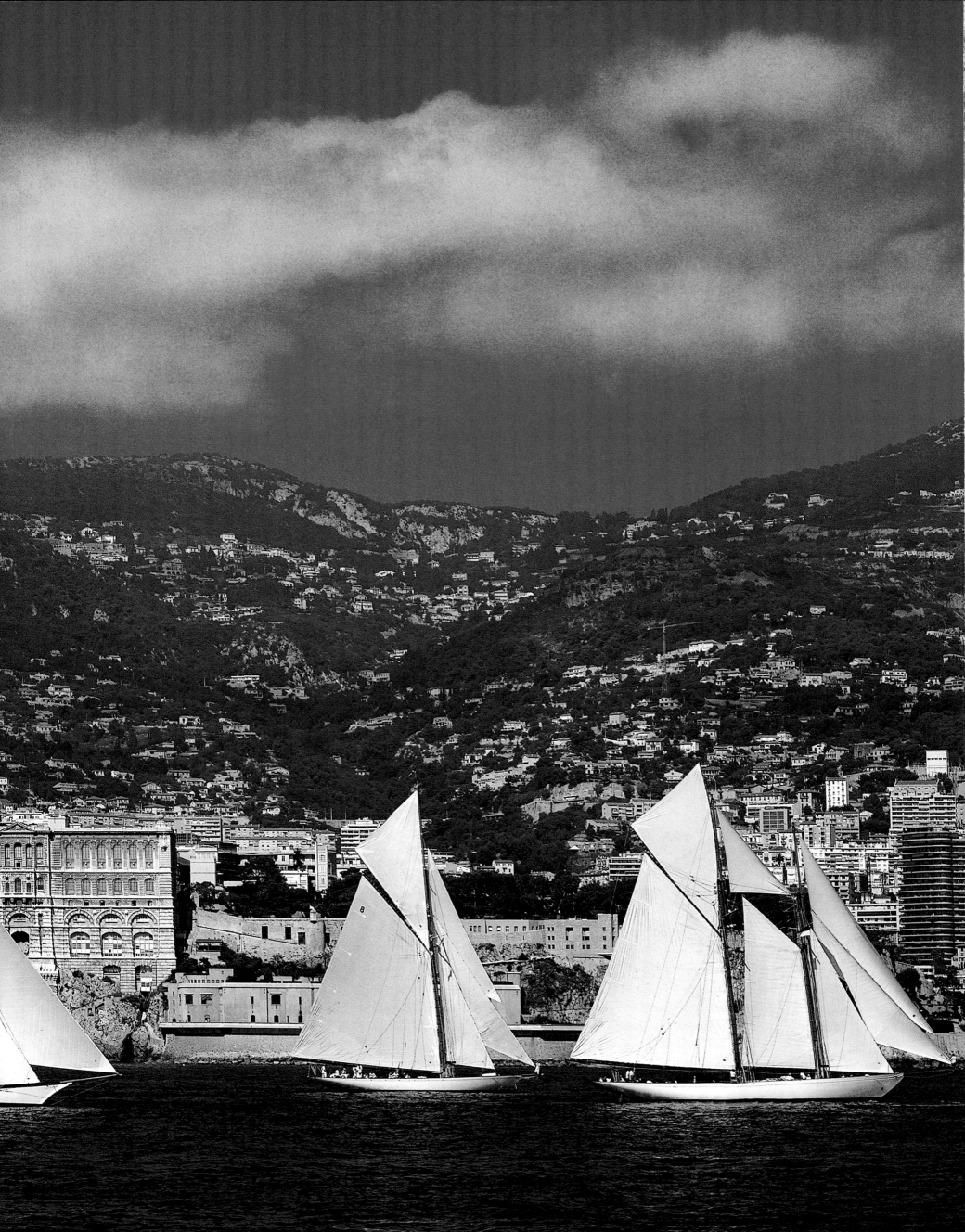

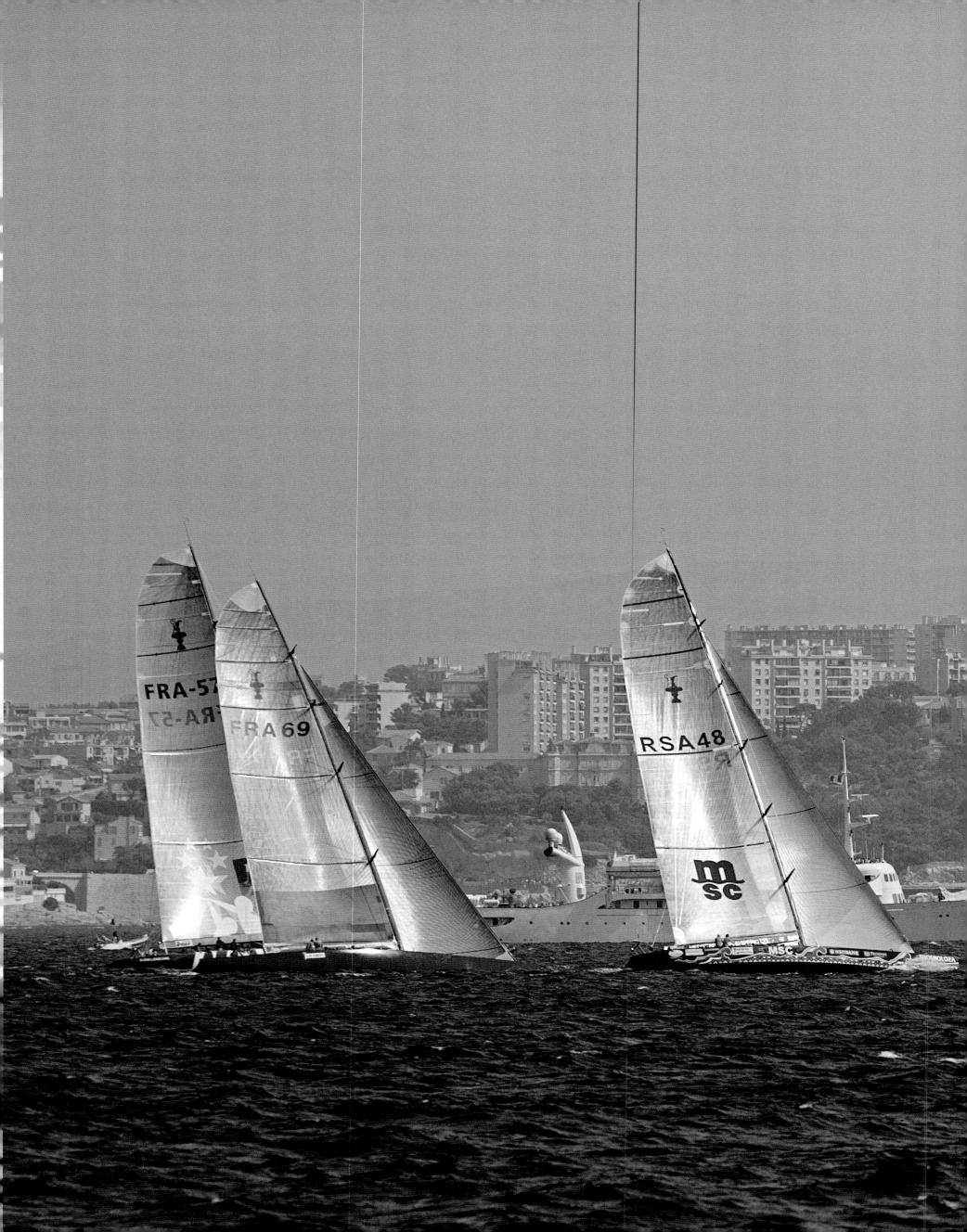

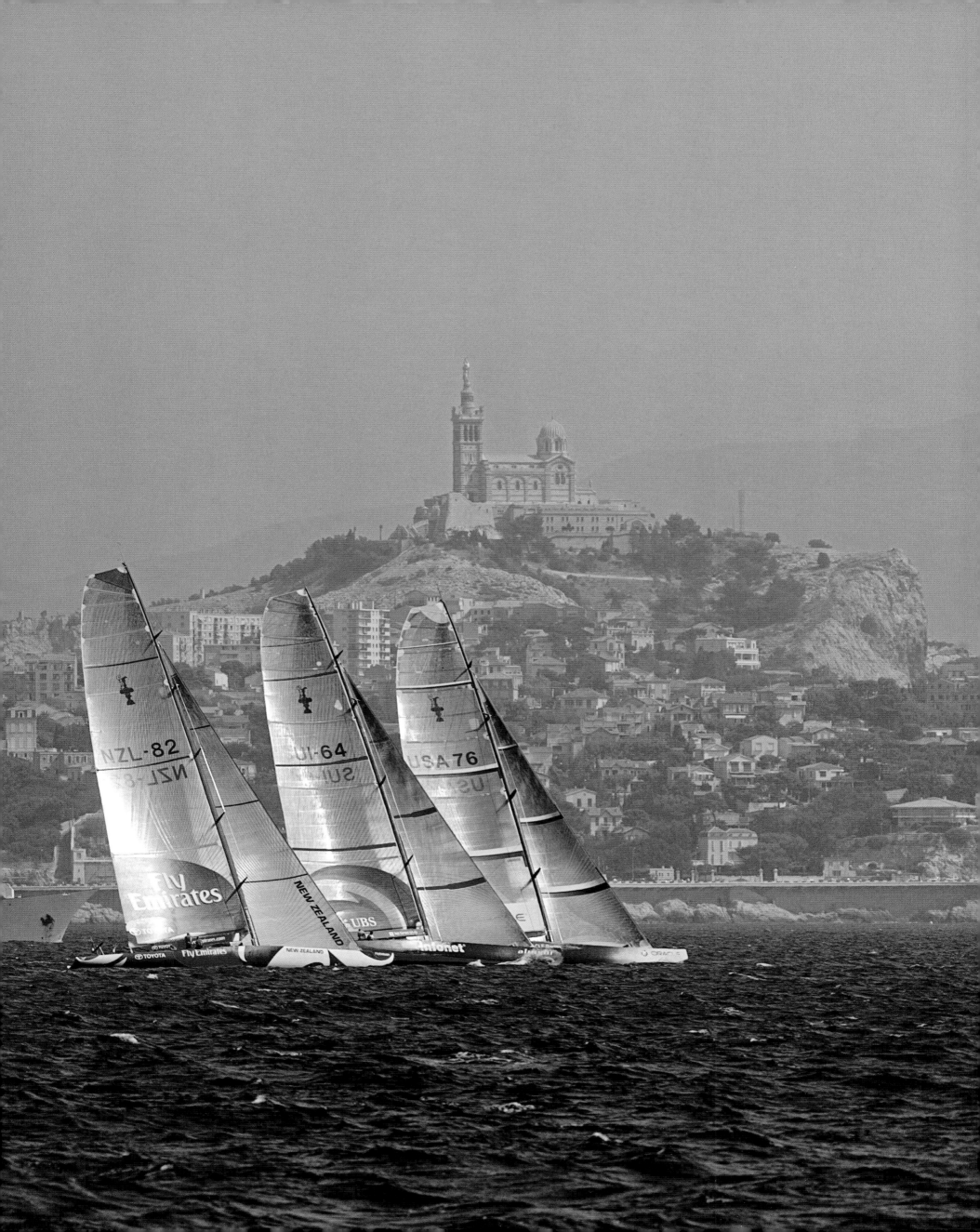

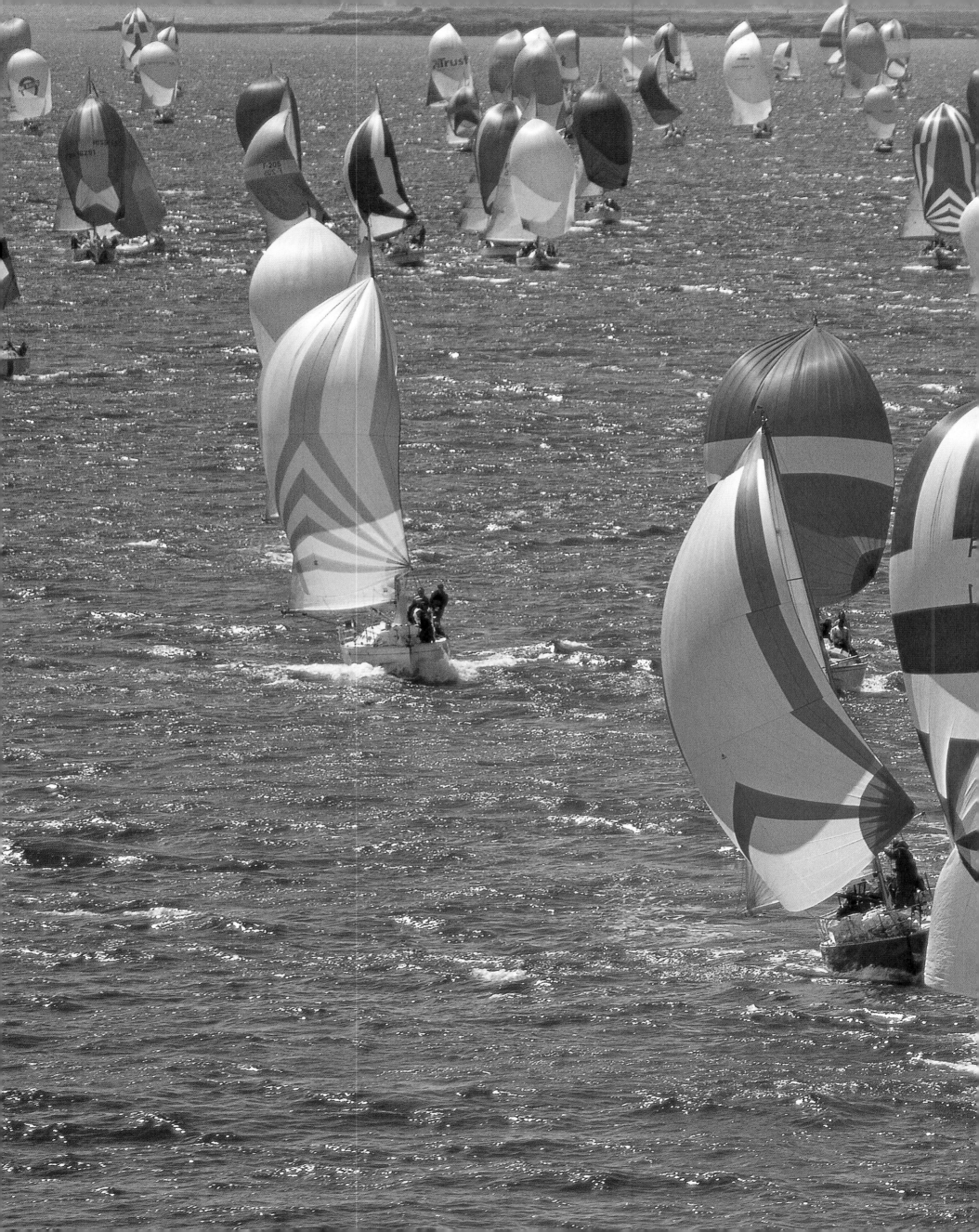

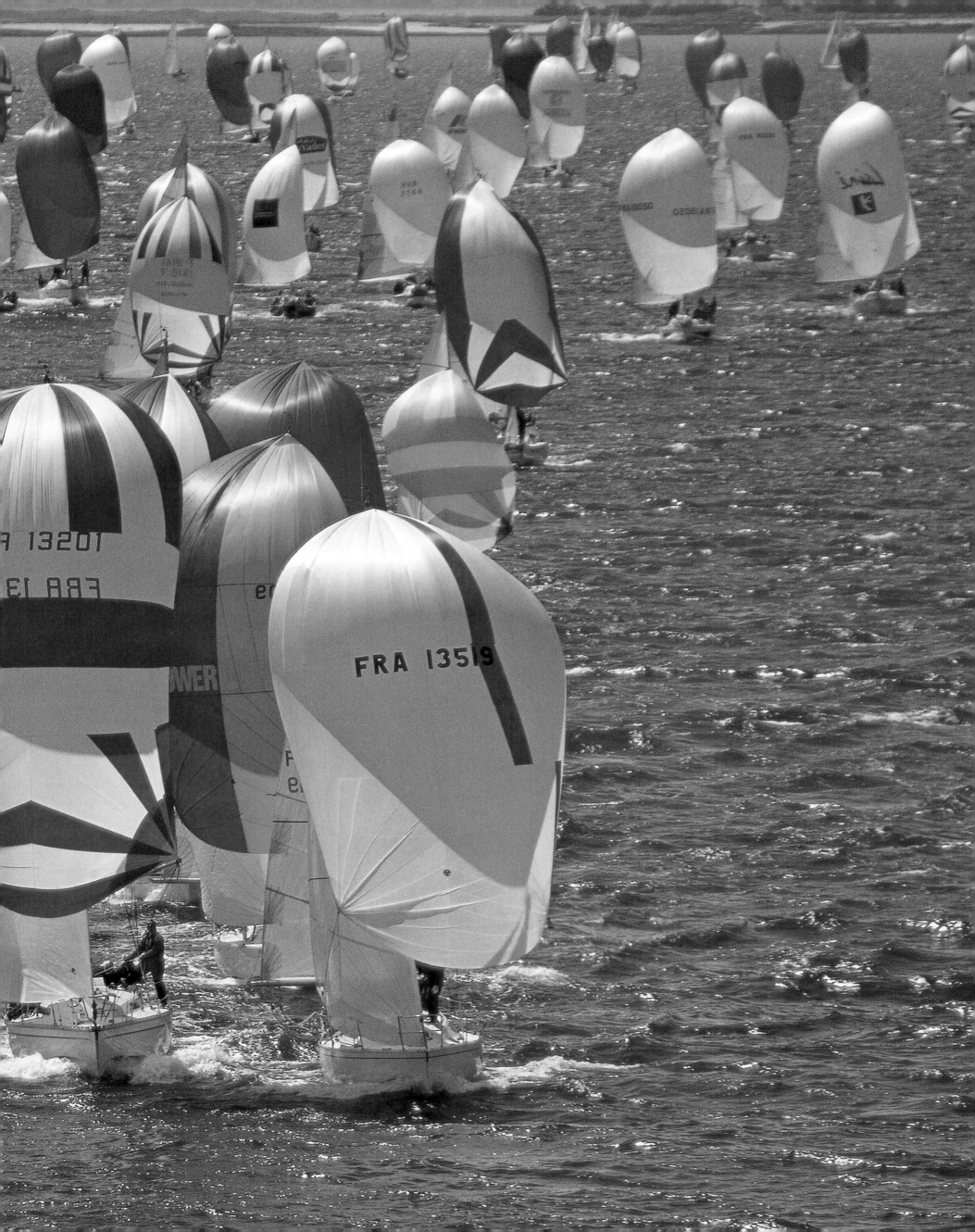

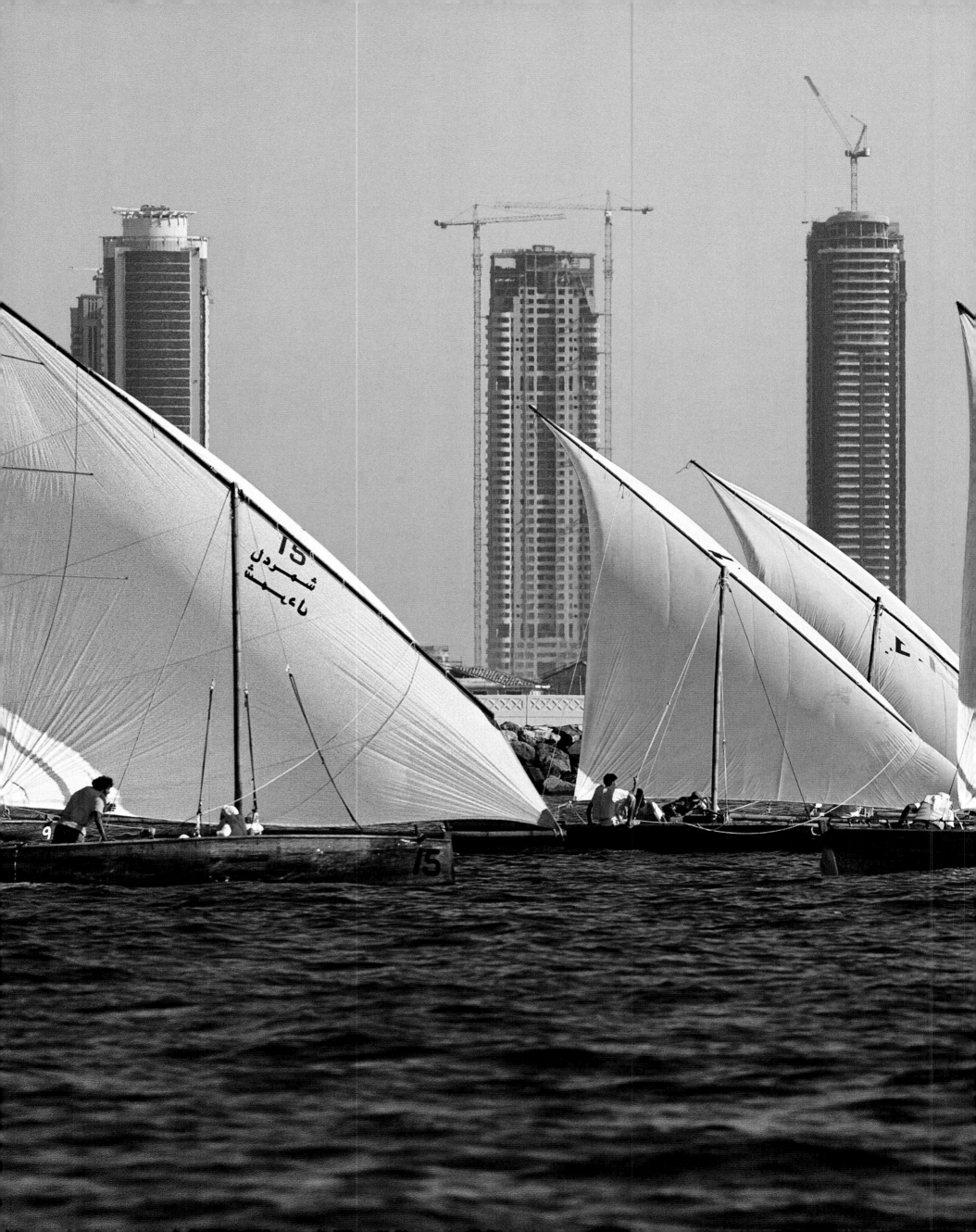

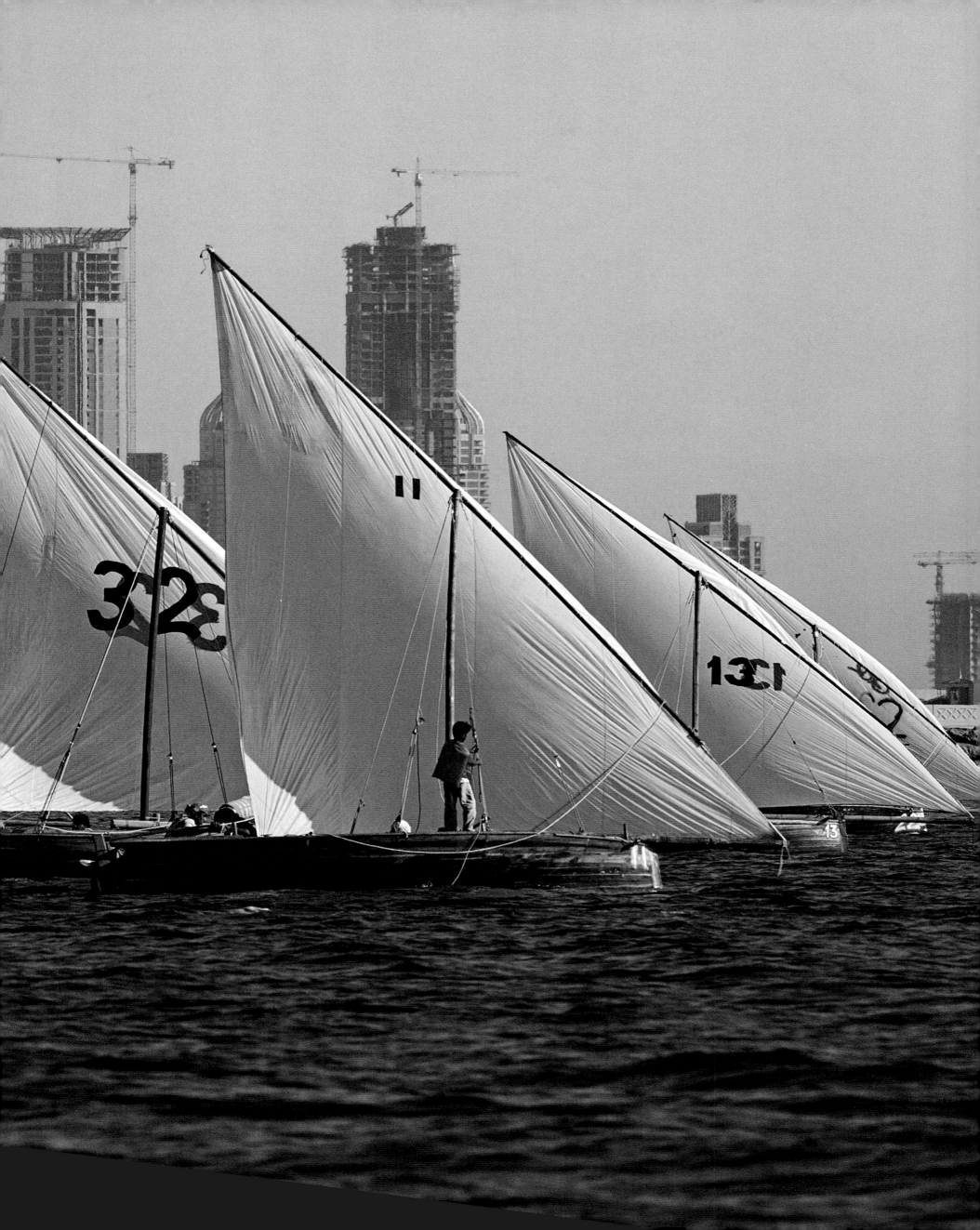

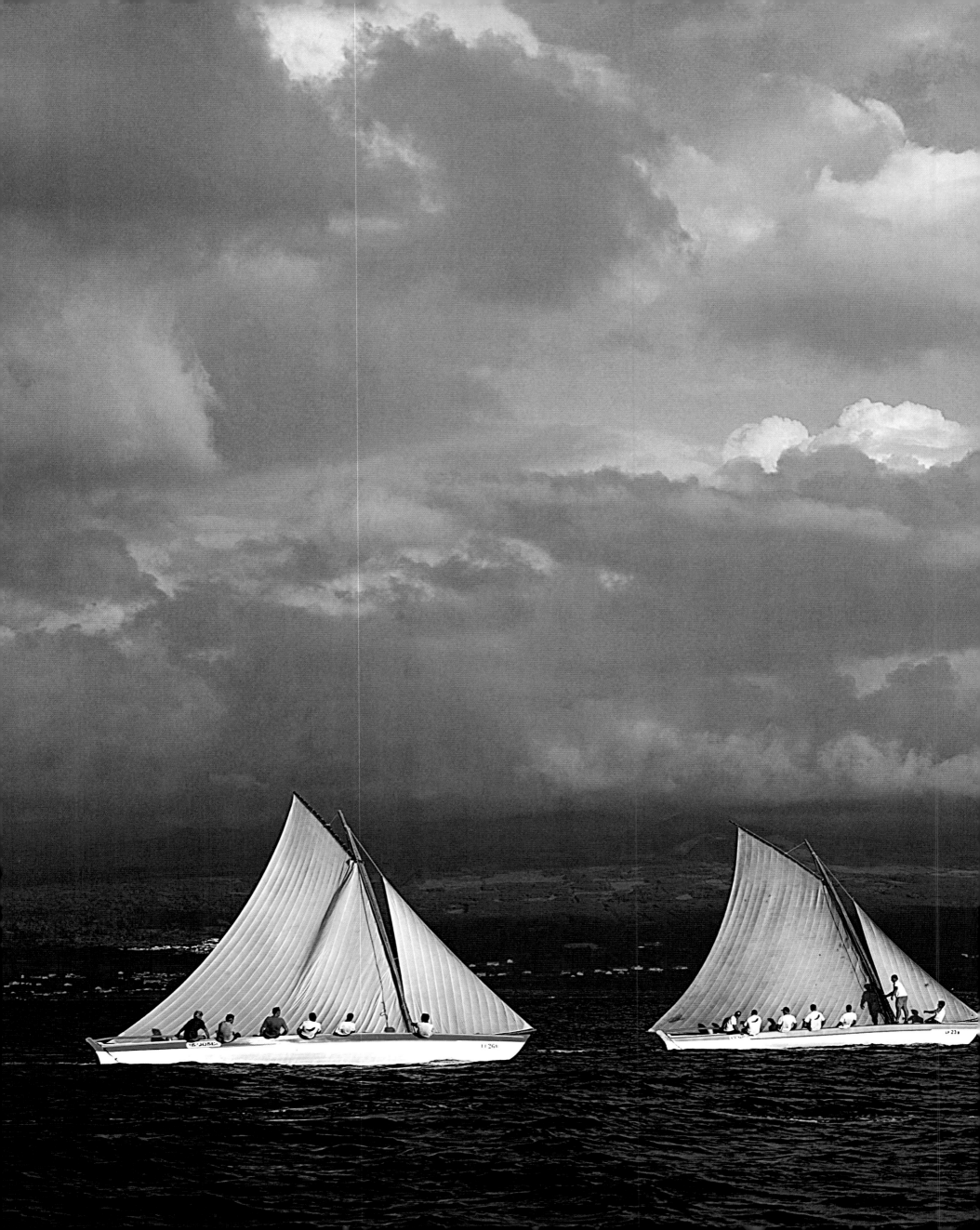

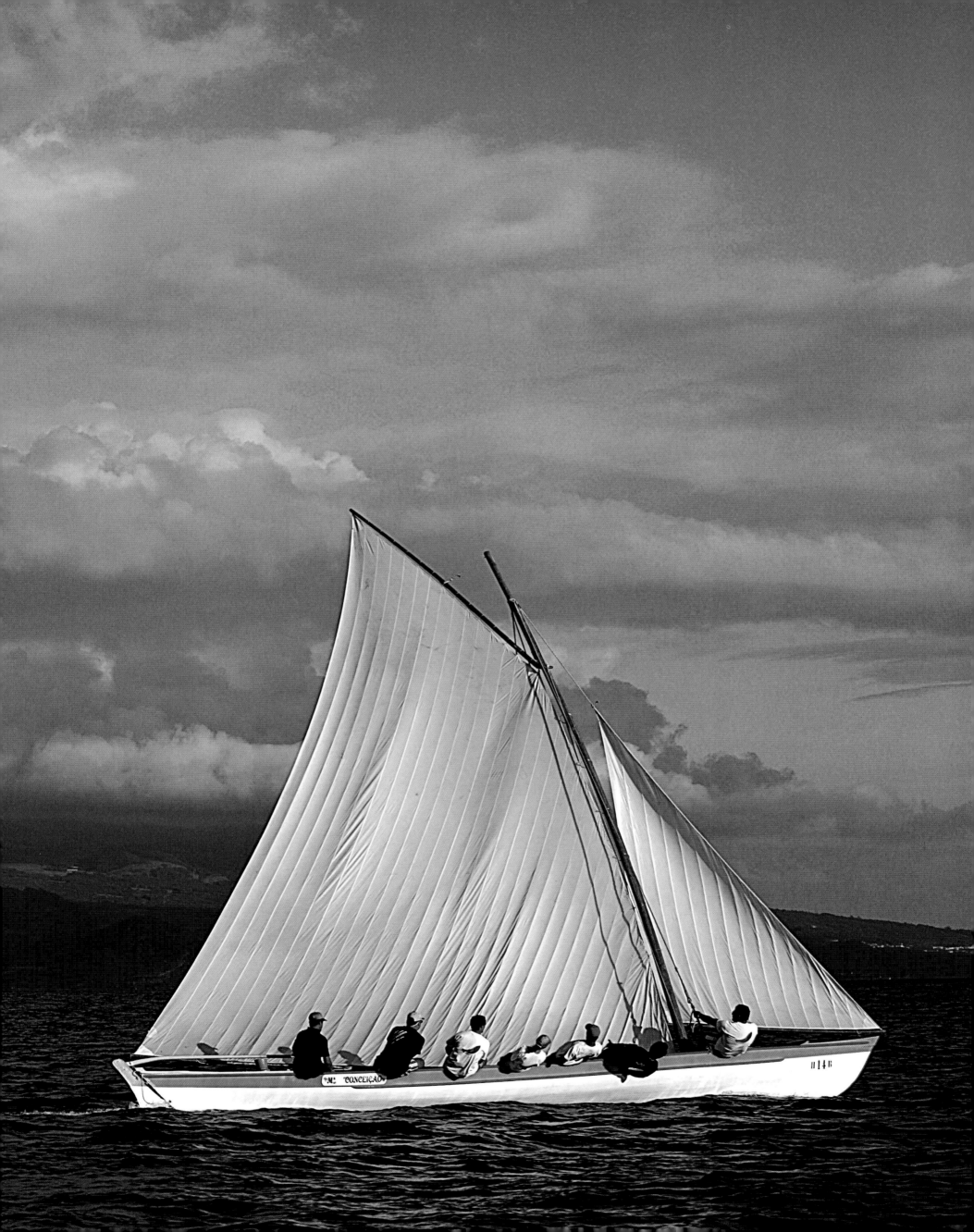

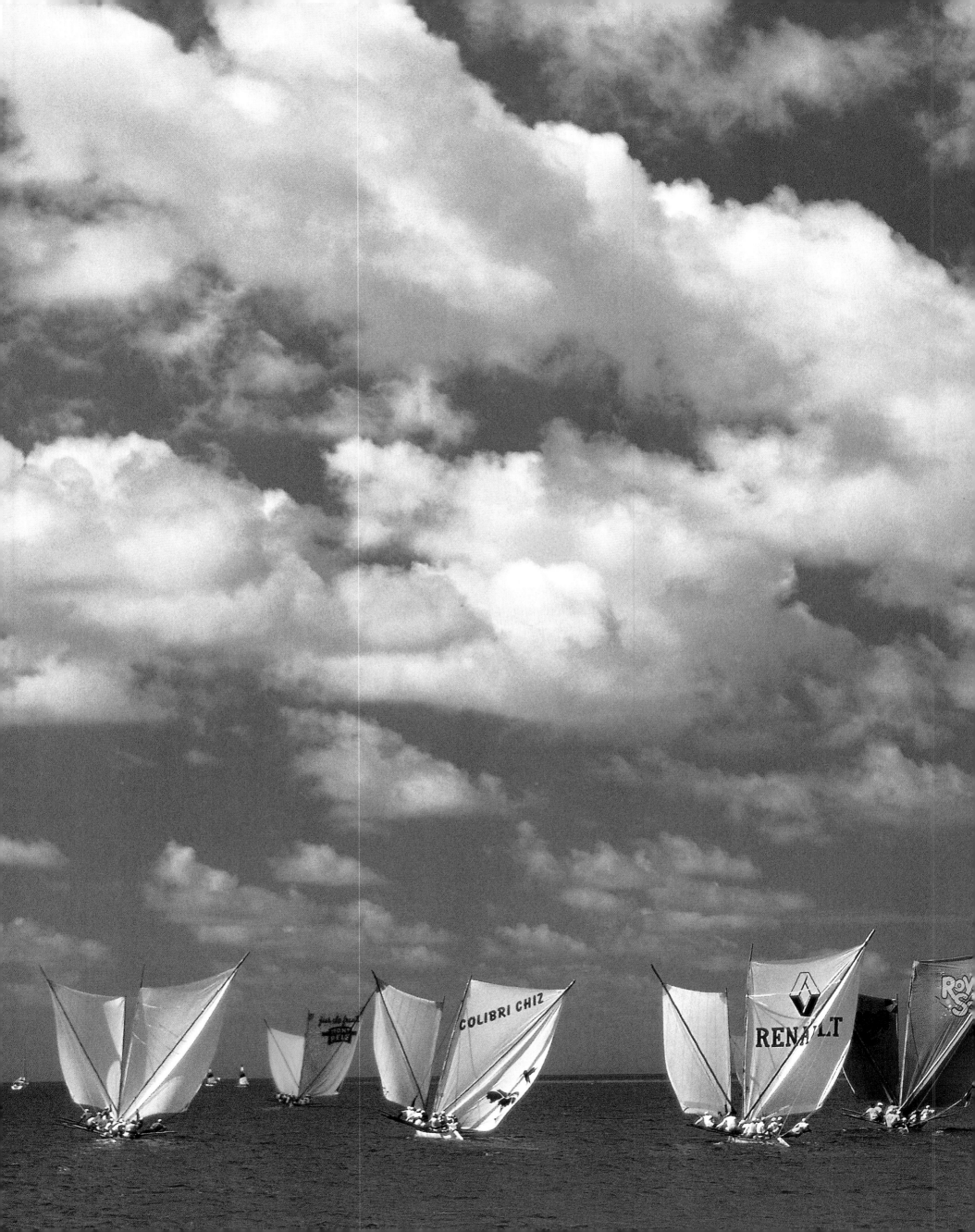

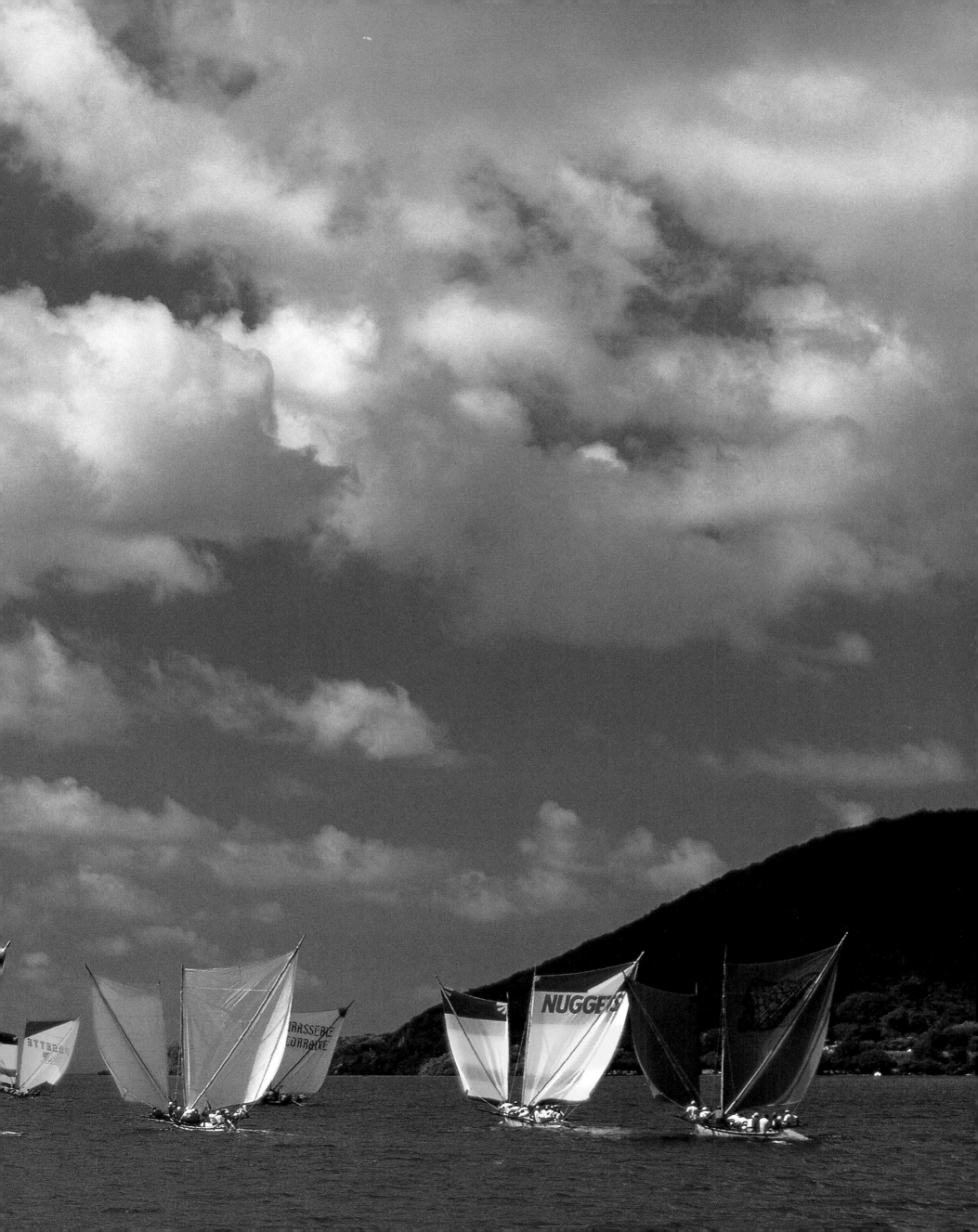

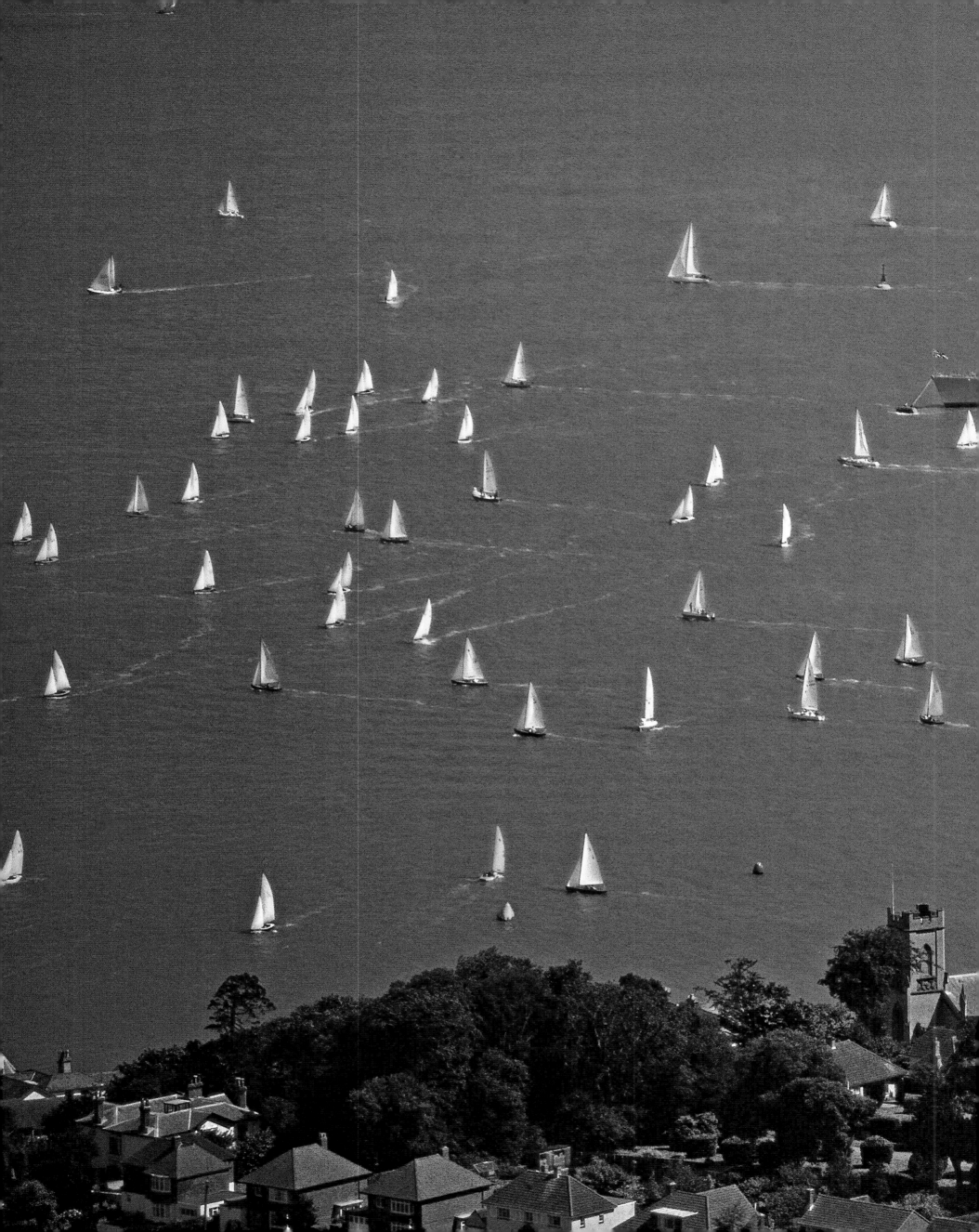

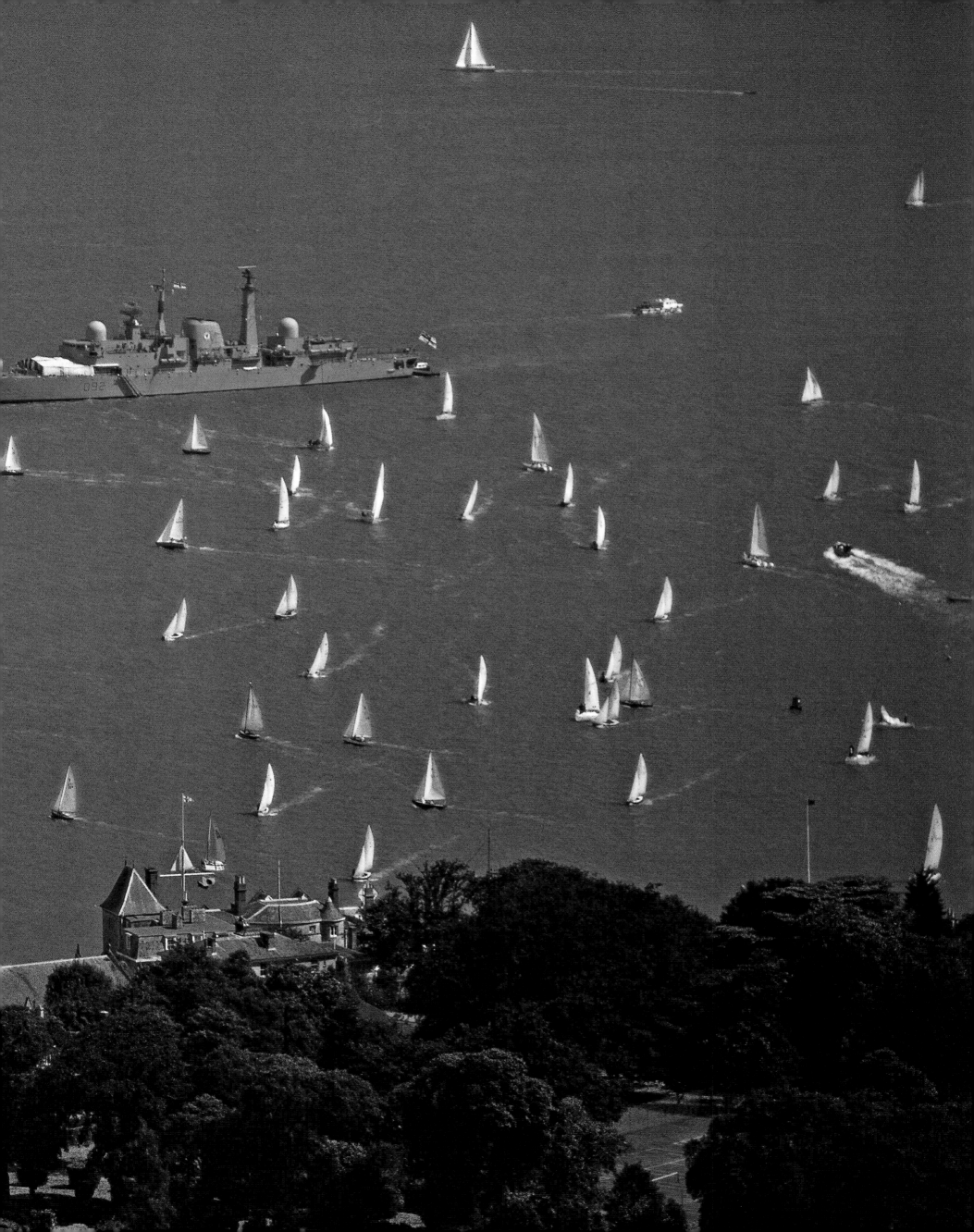

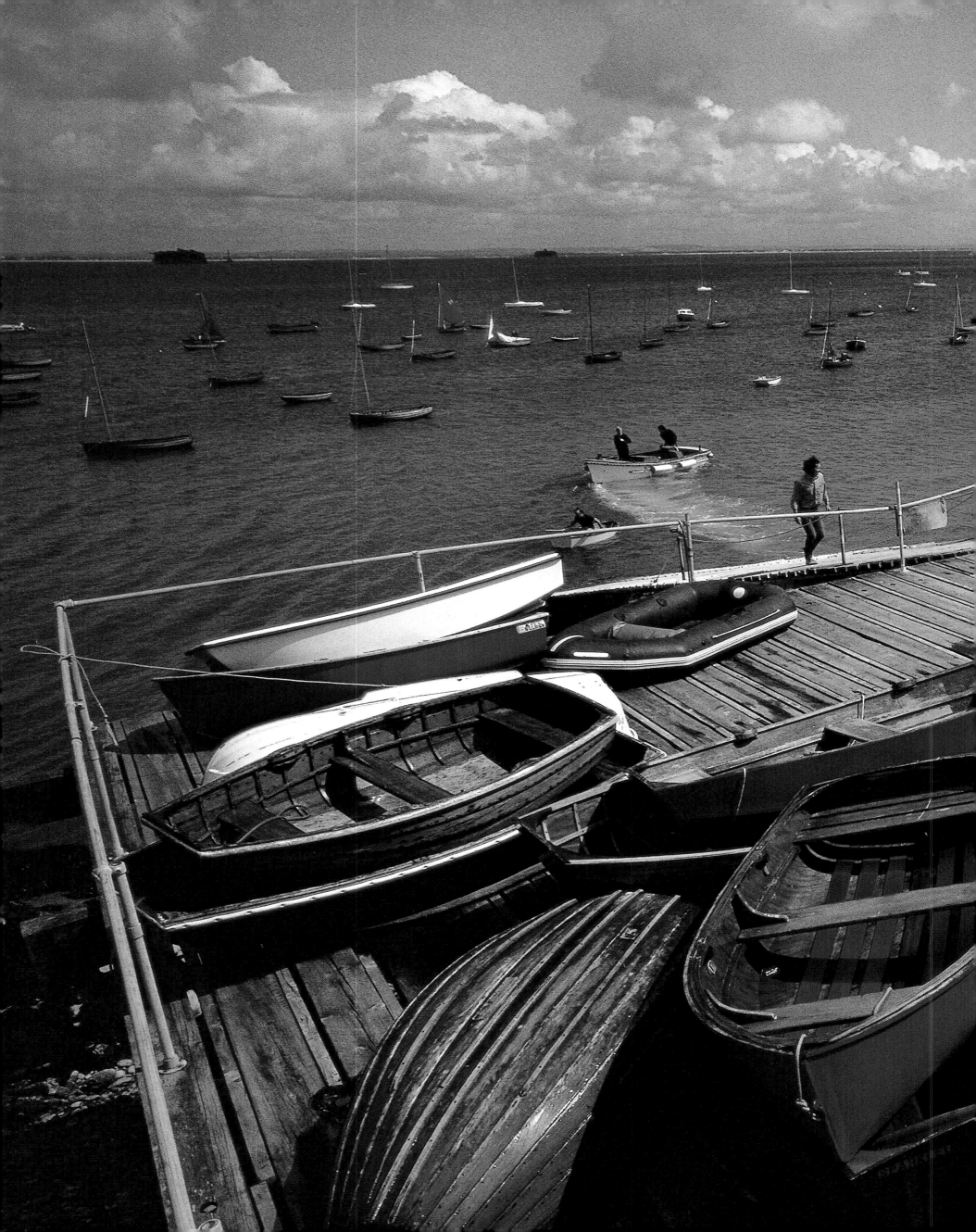

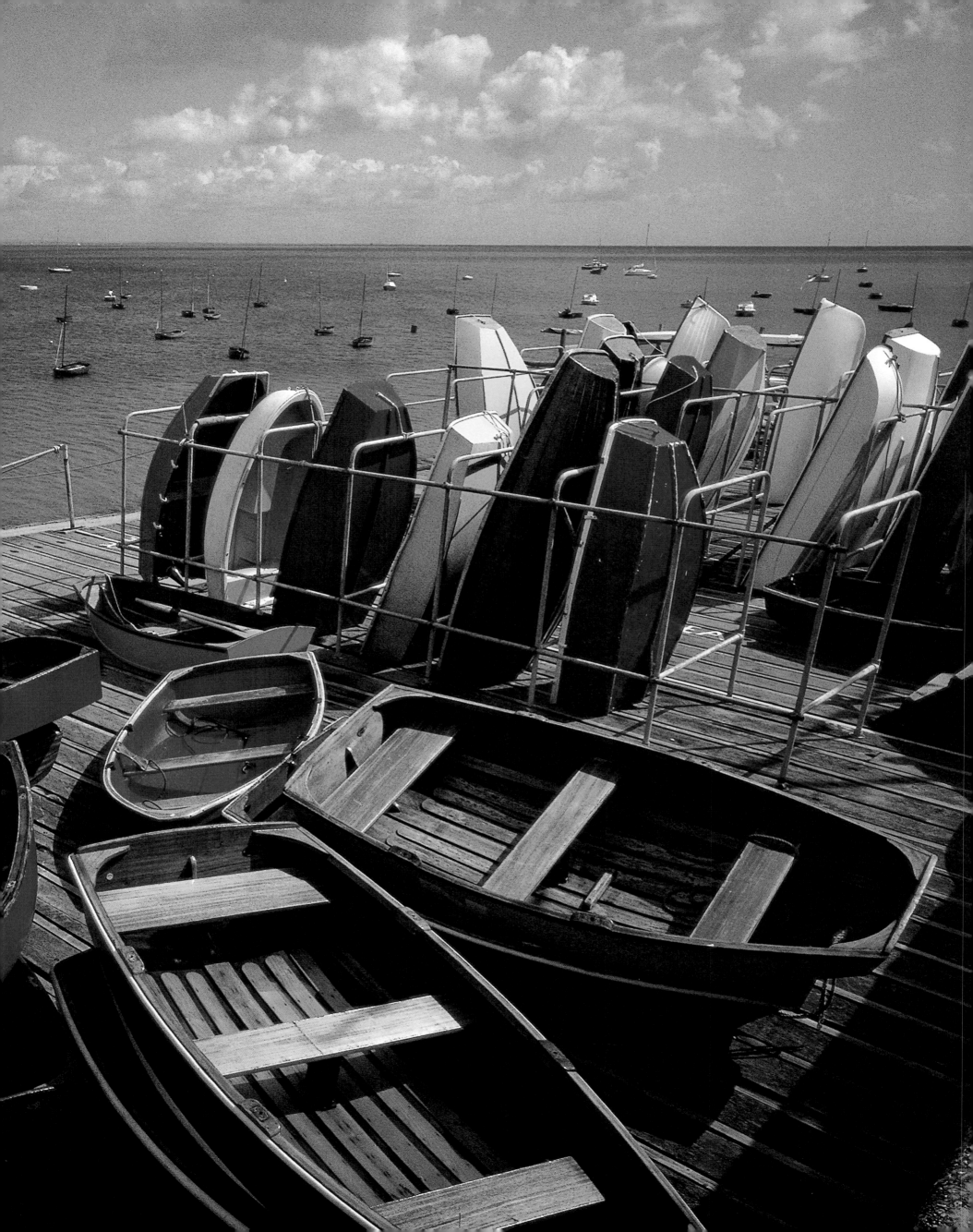

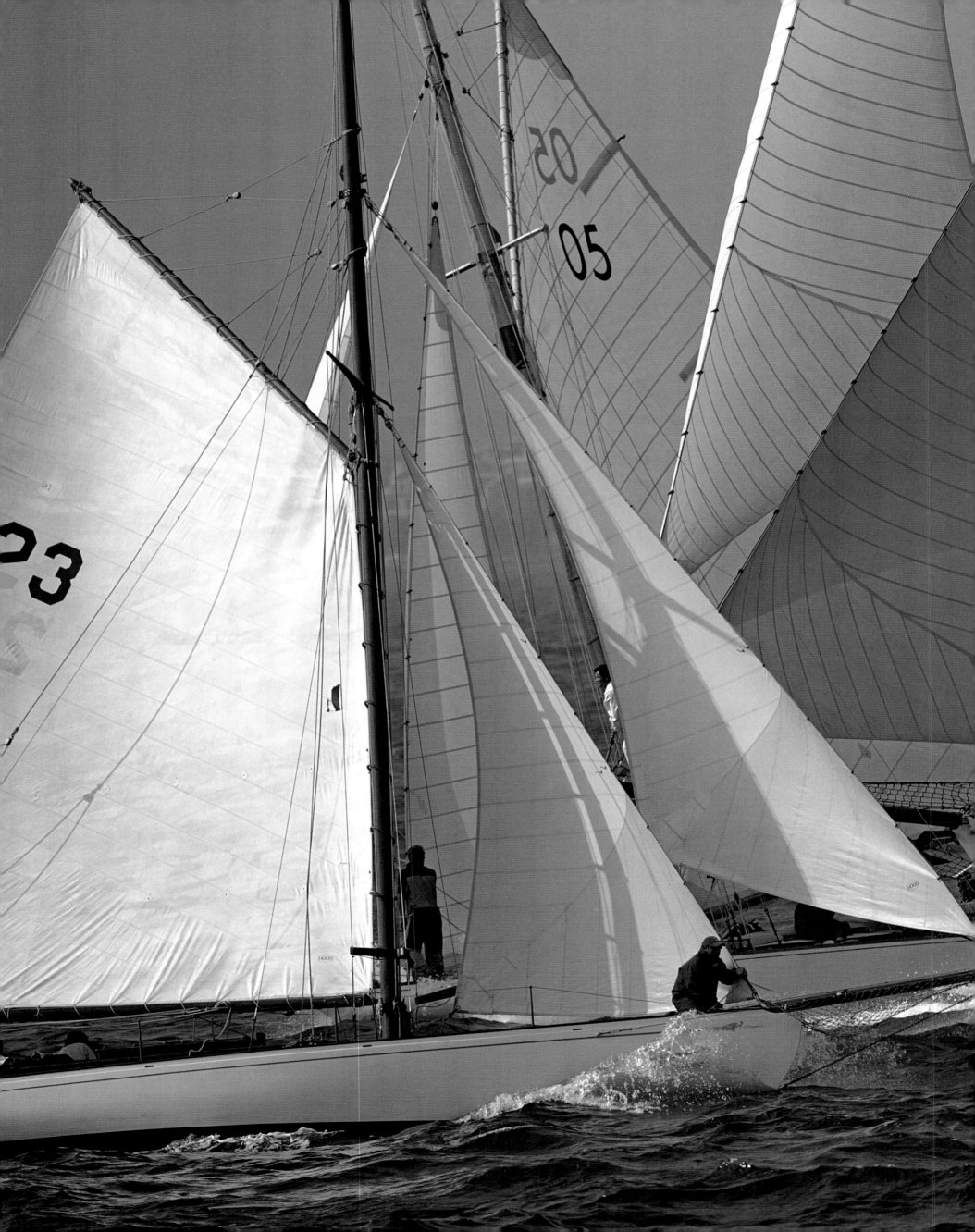

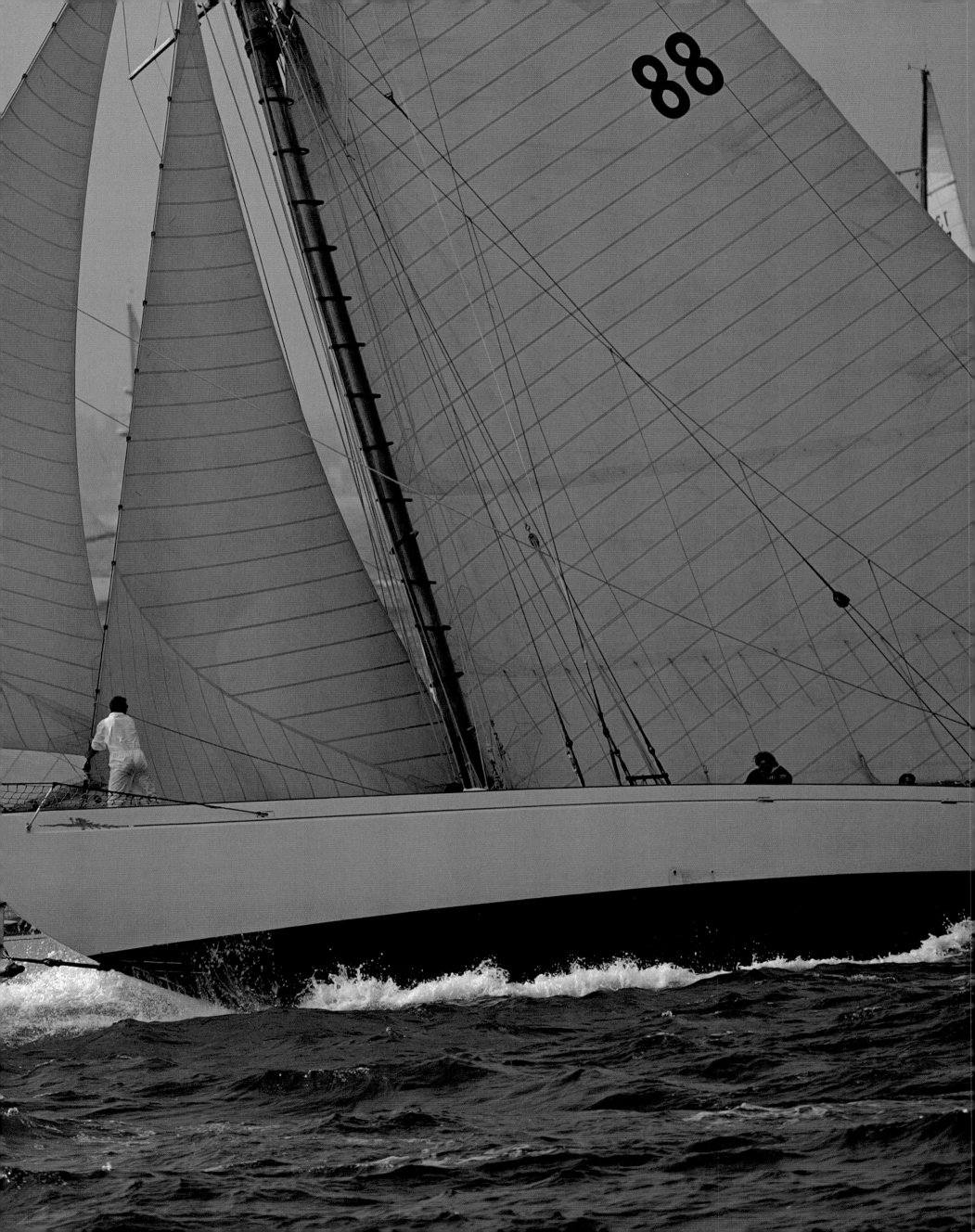

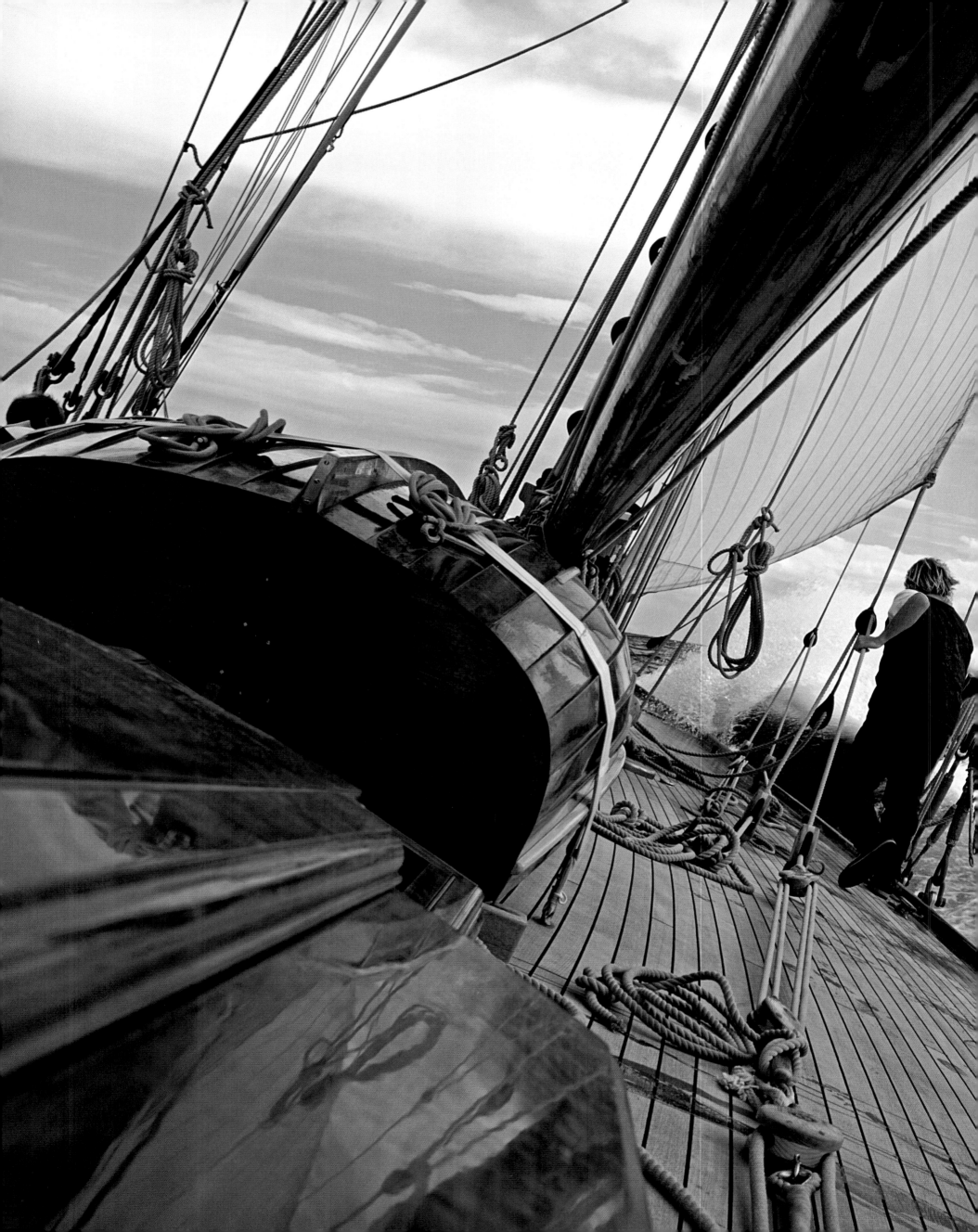

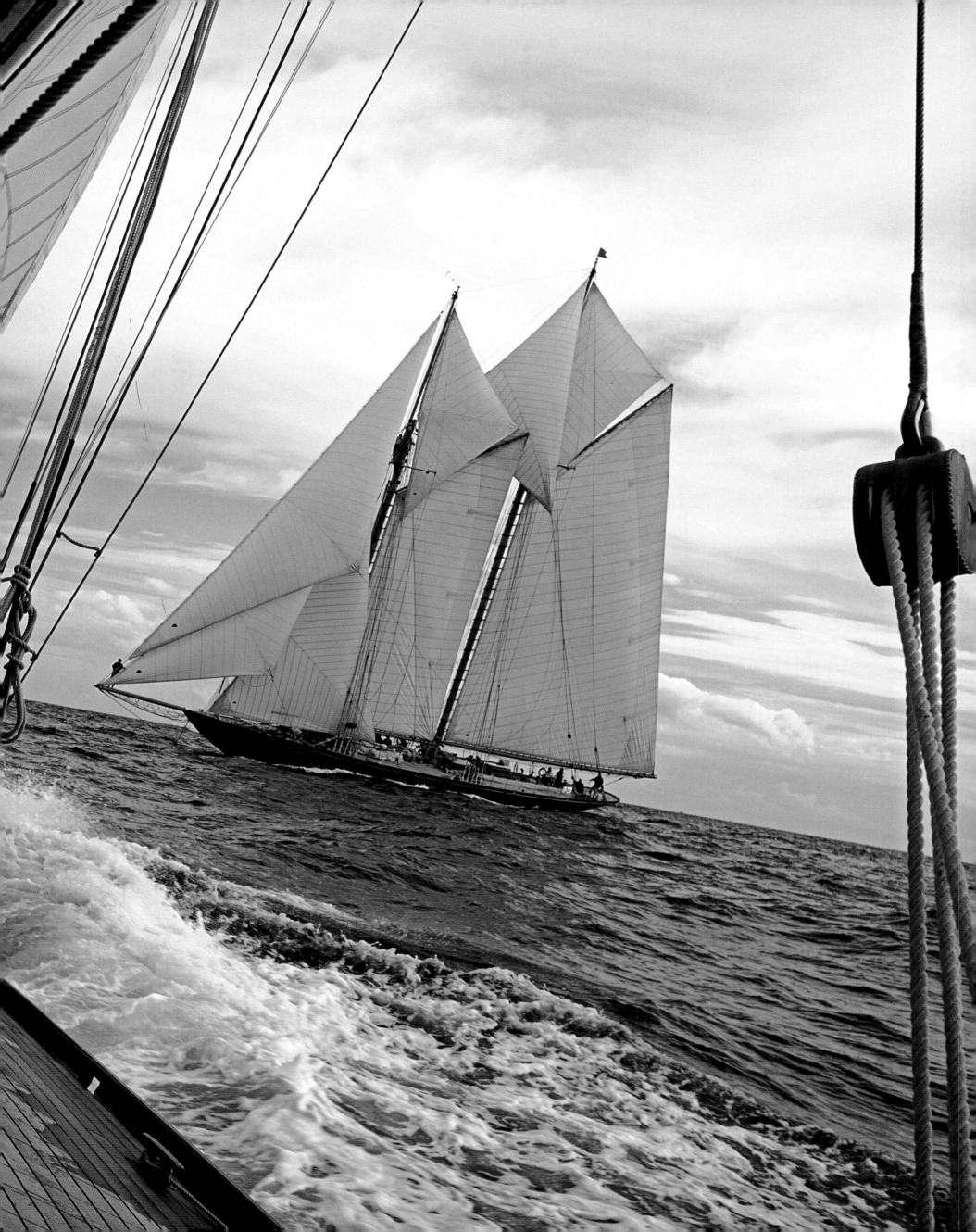

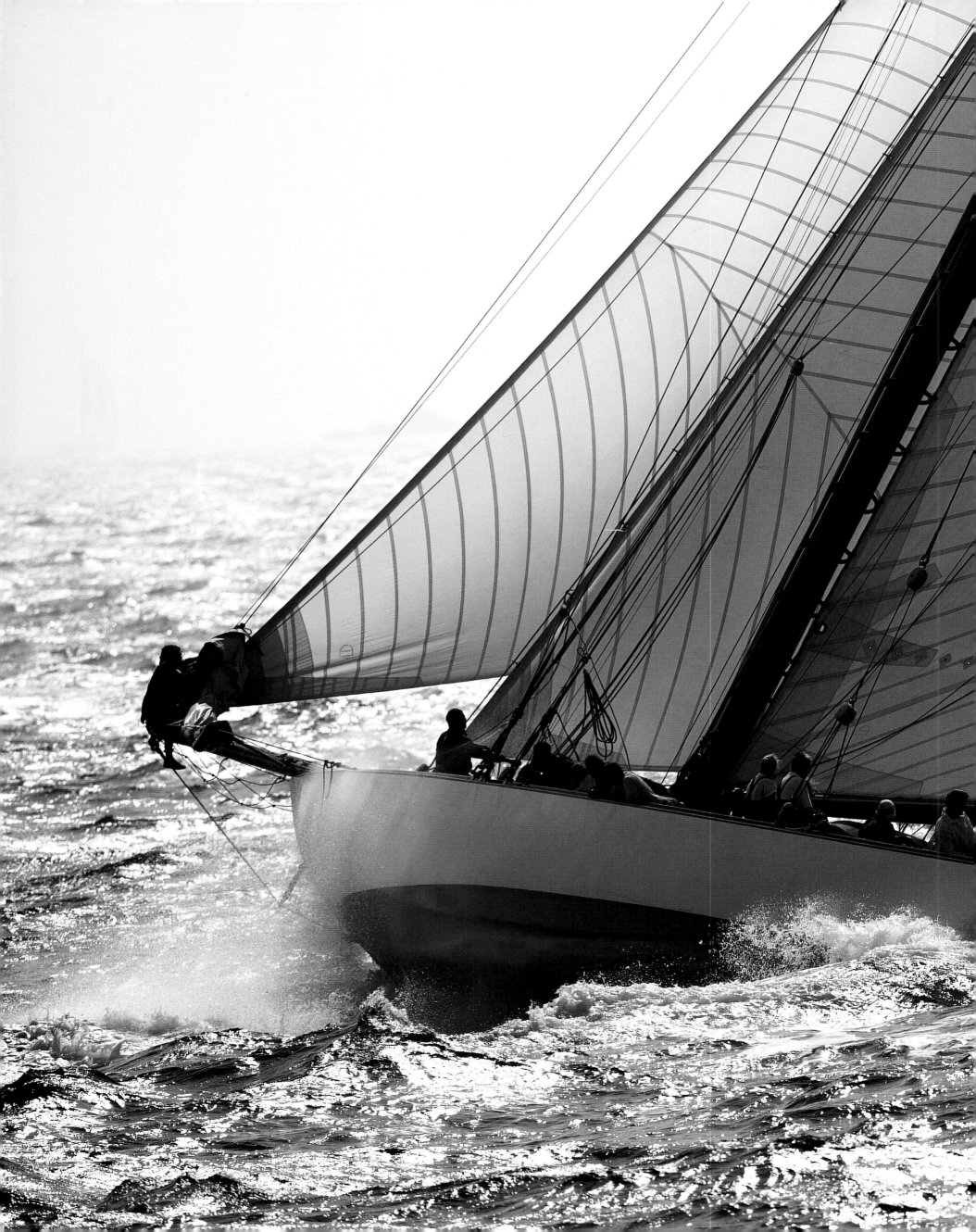

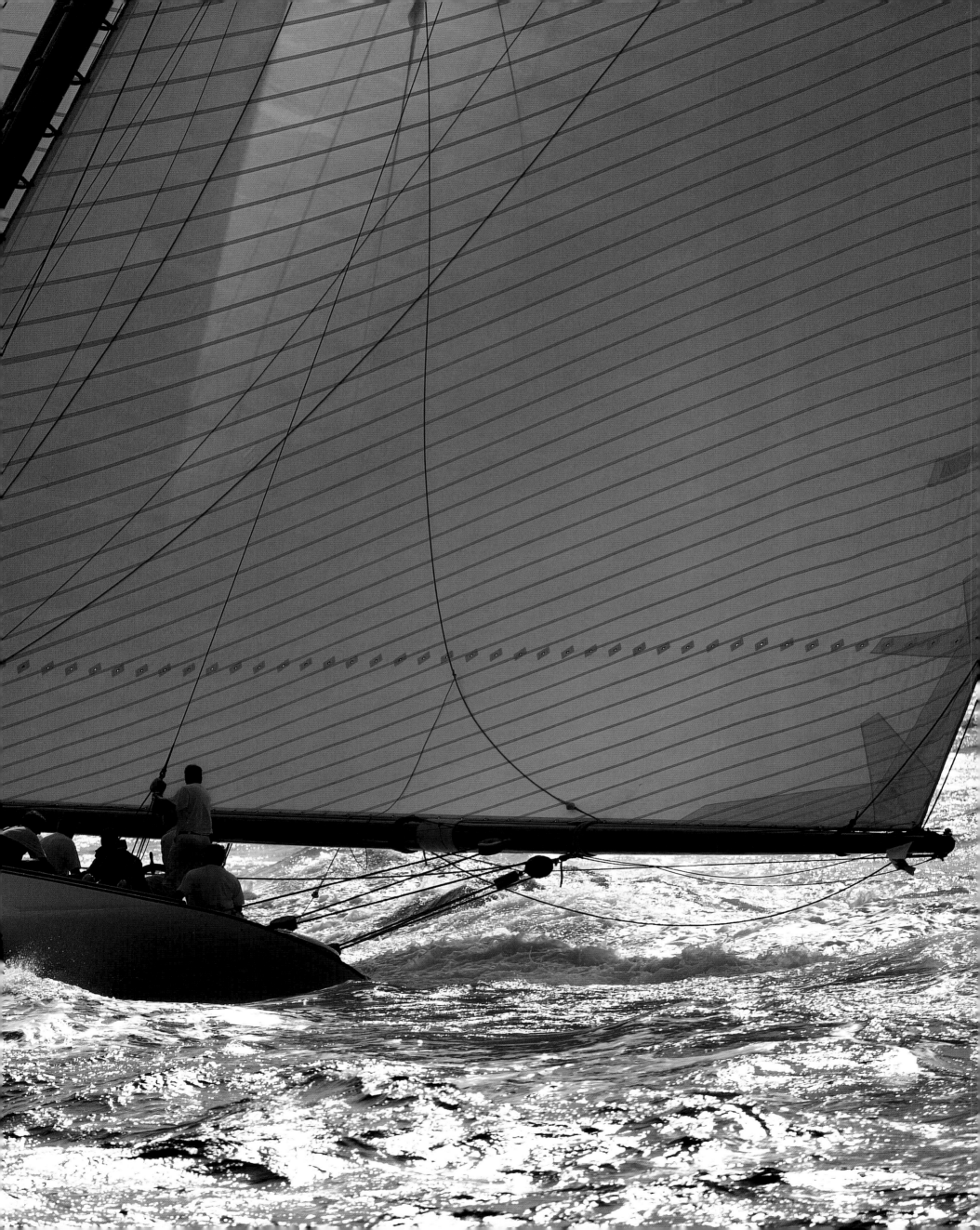

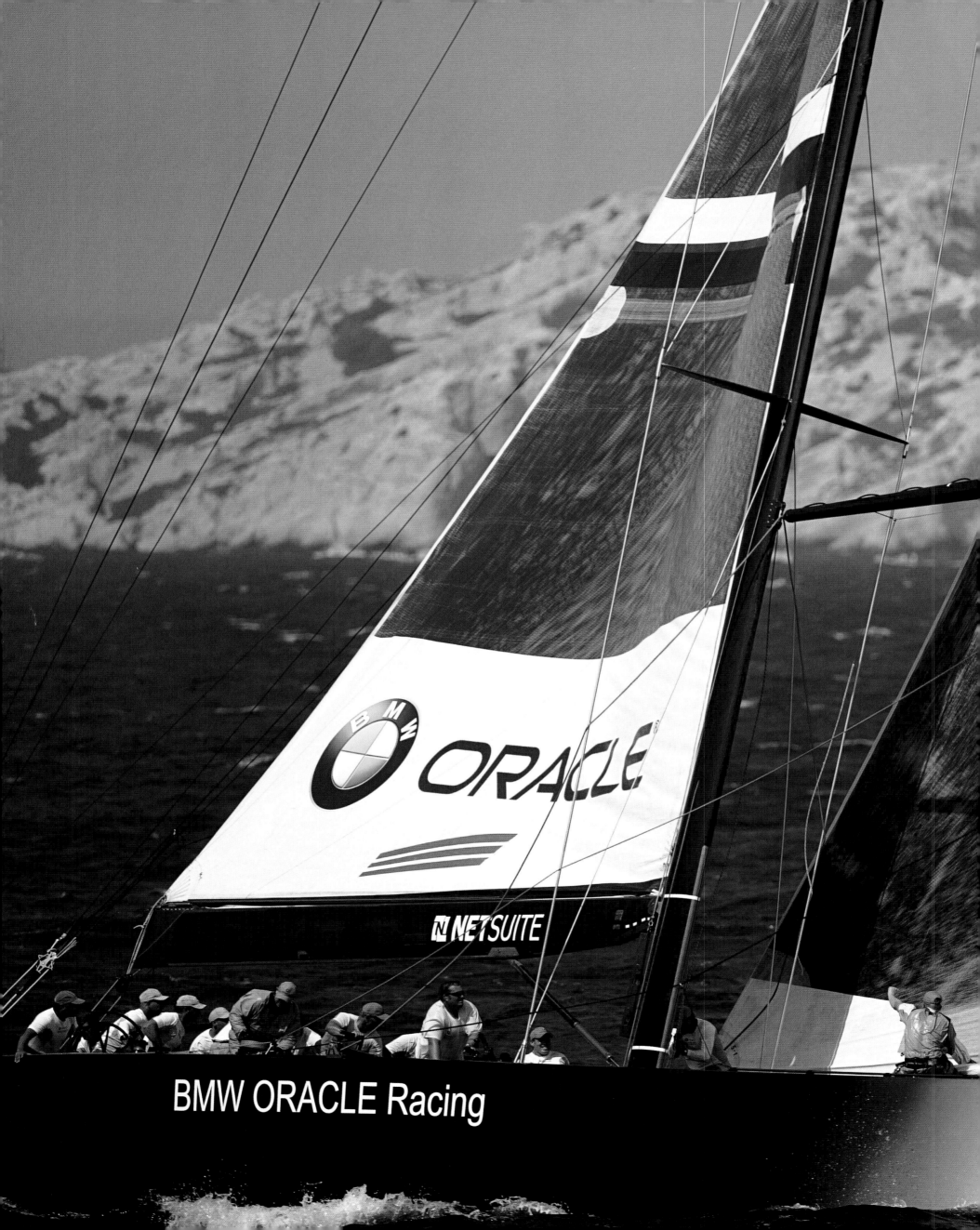

BMW ORACLE Racing

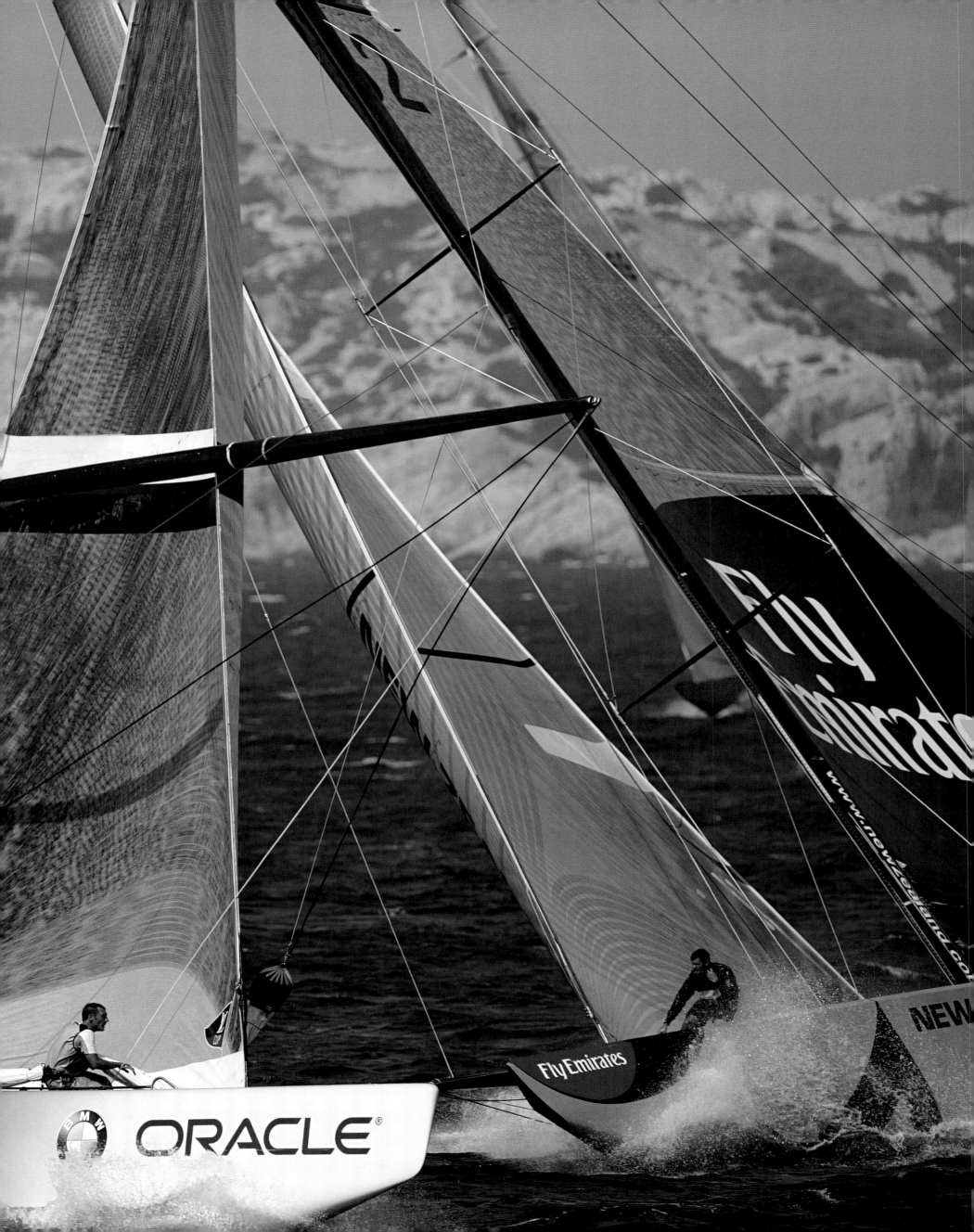

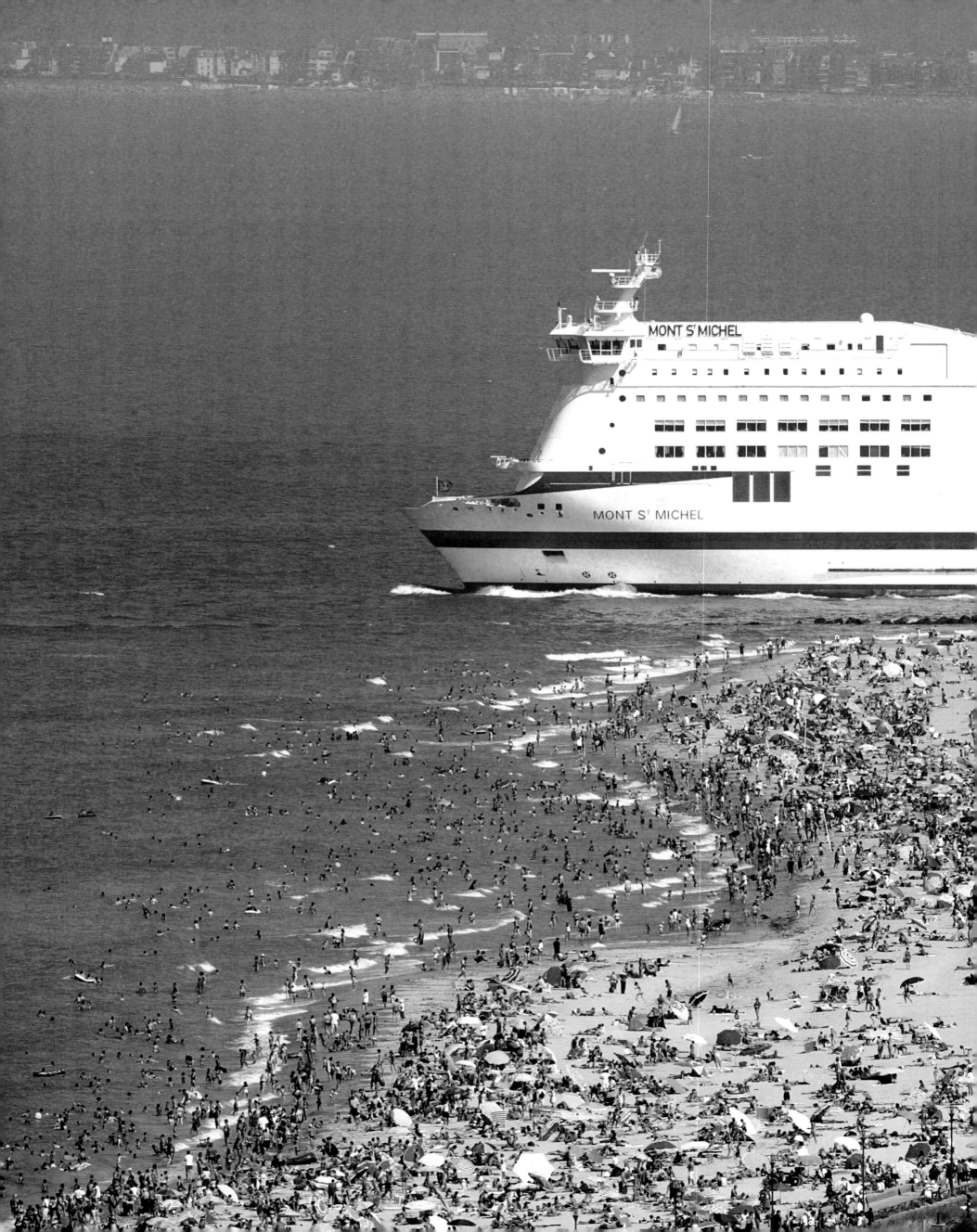

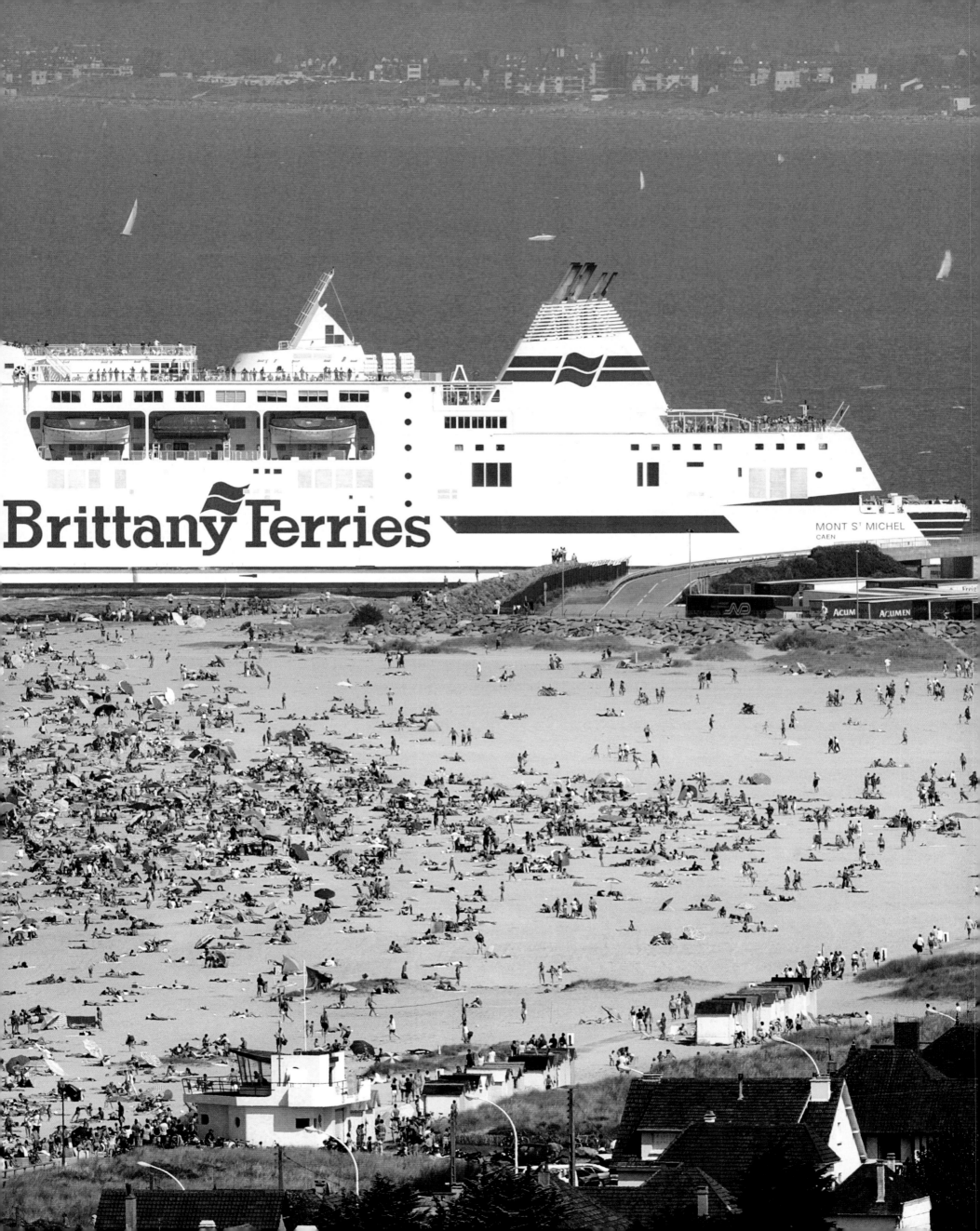

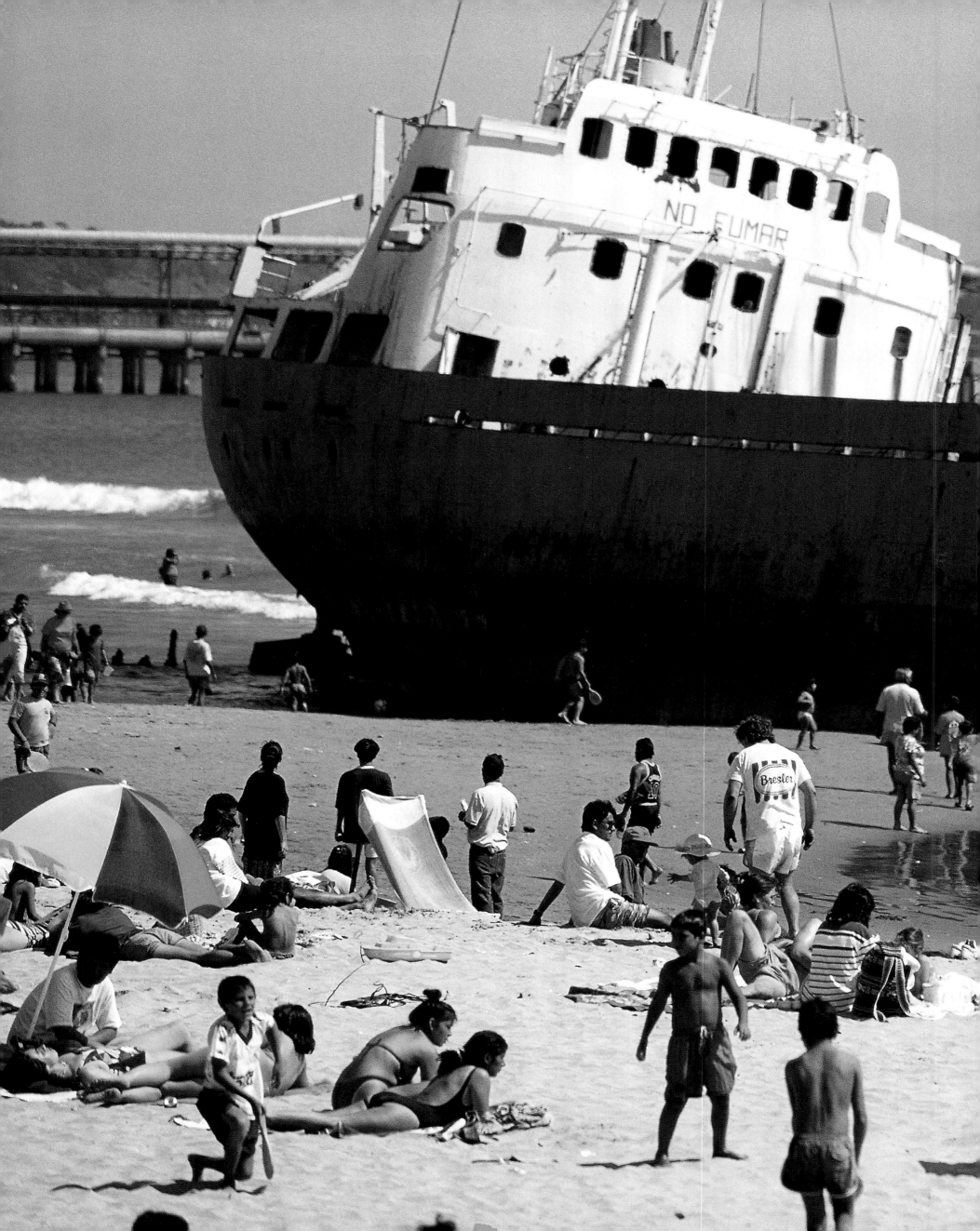

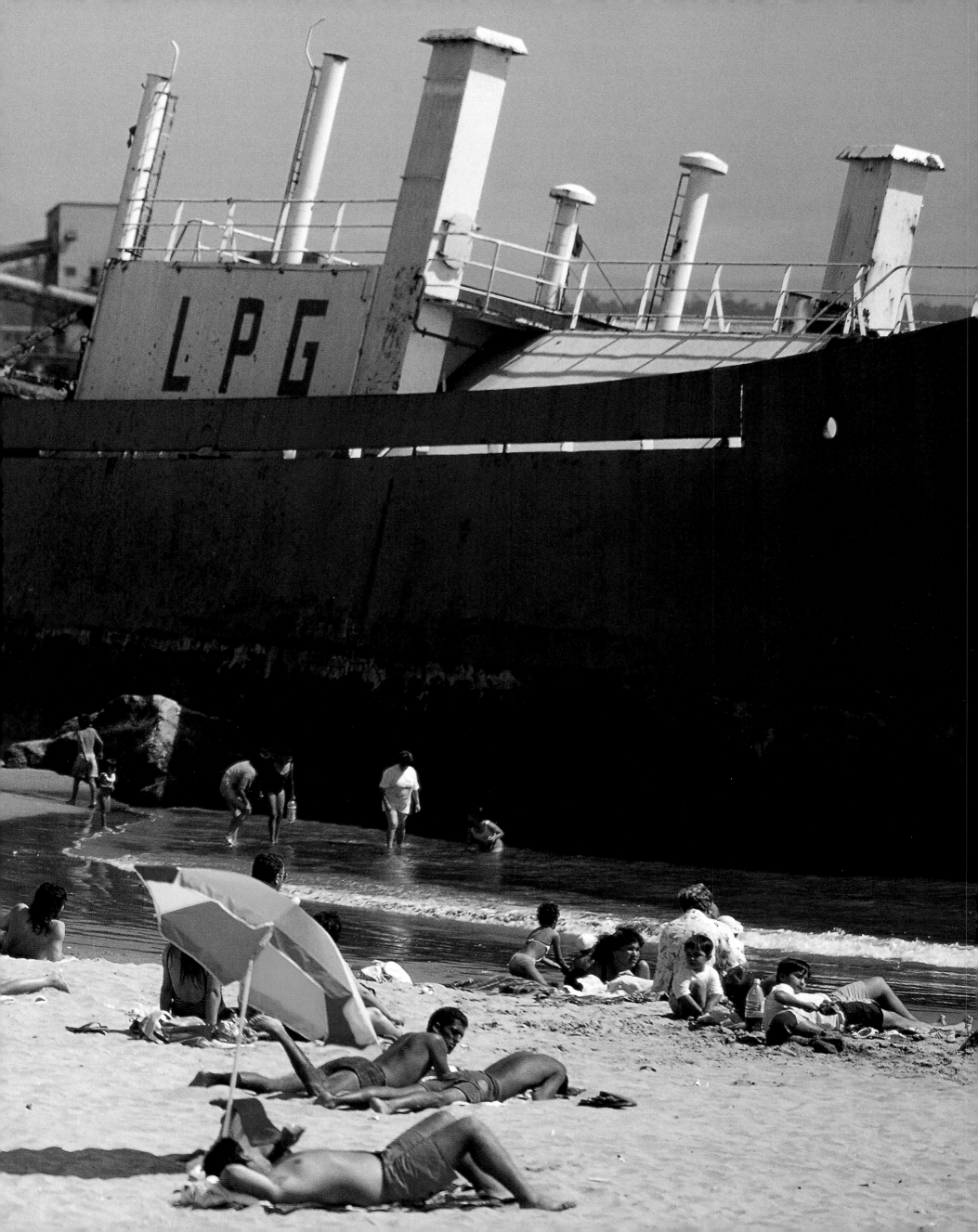

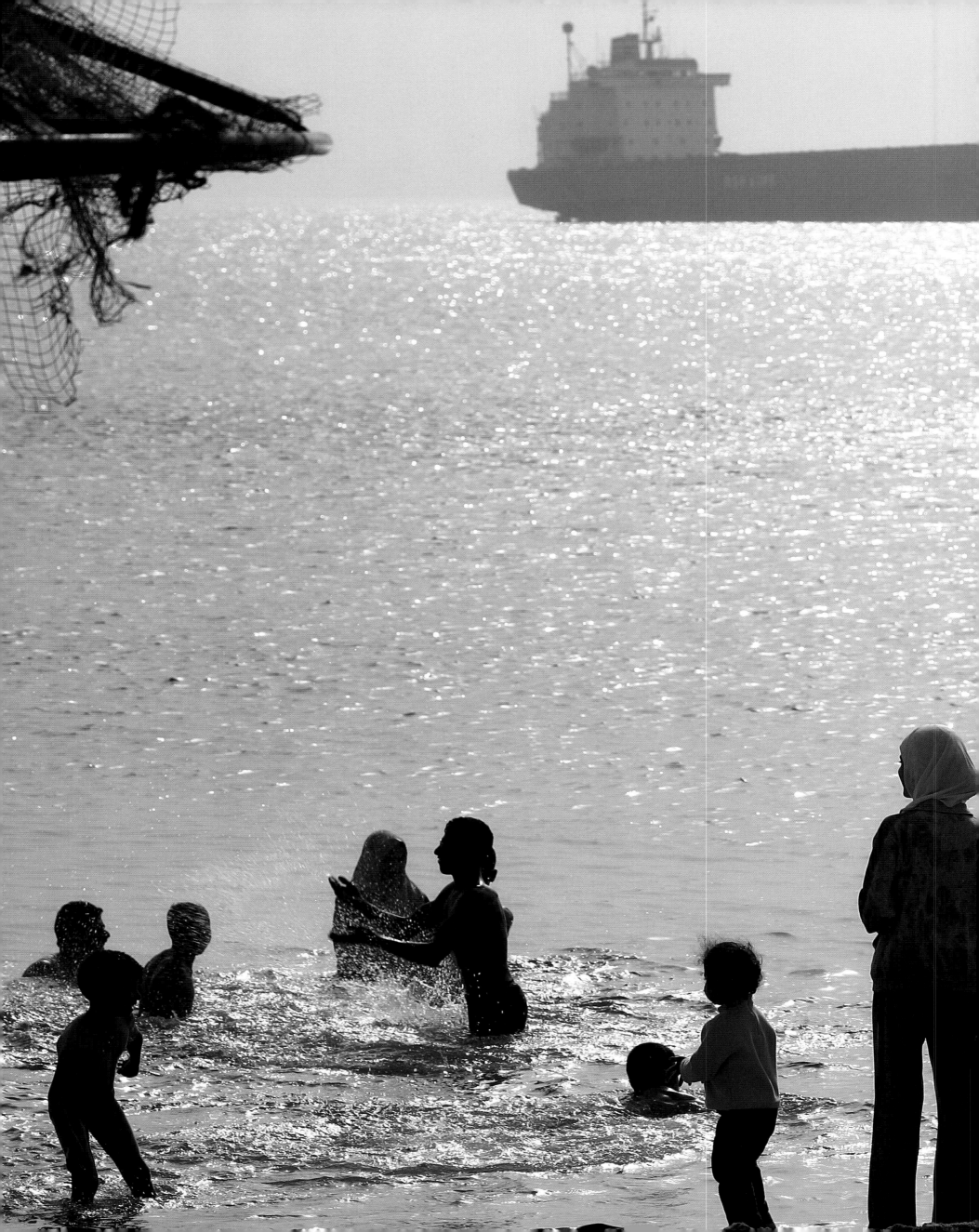

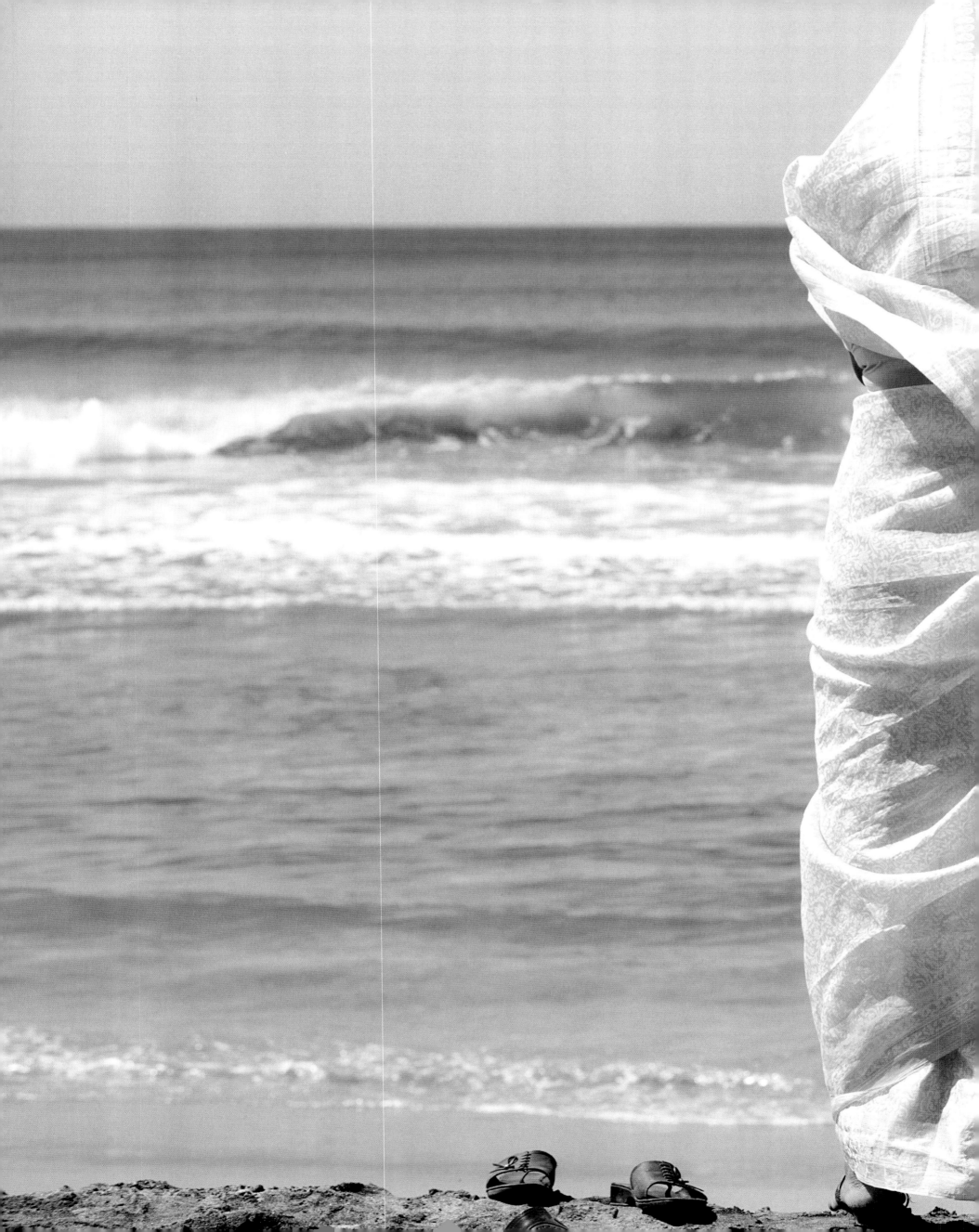

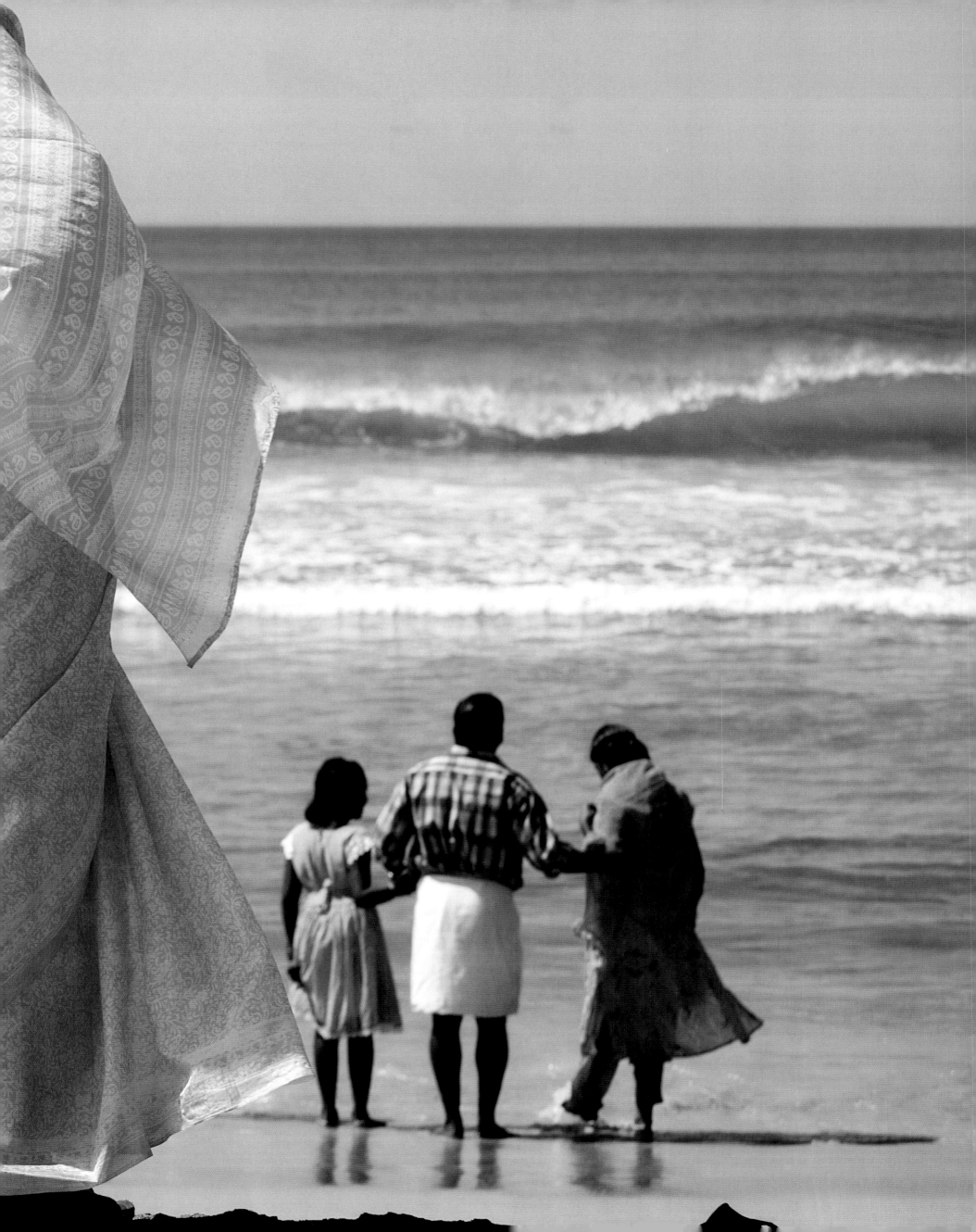

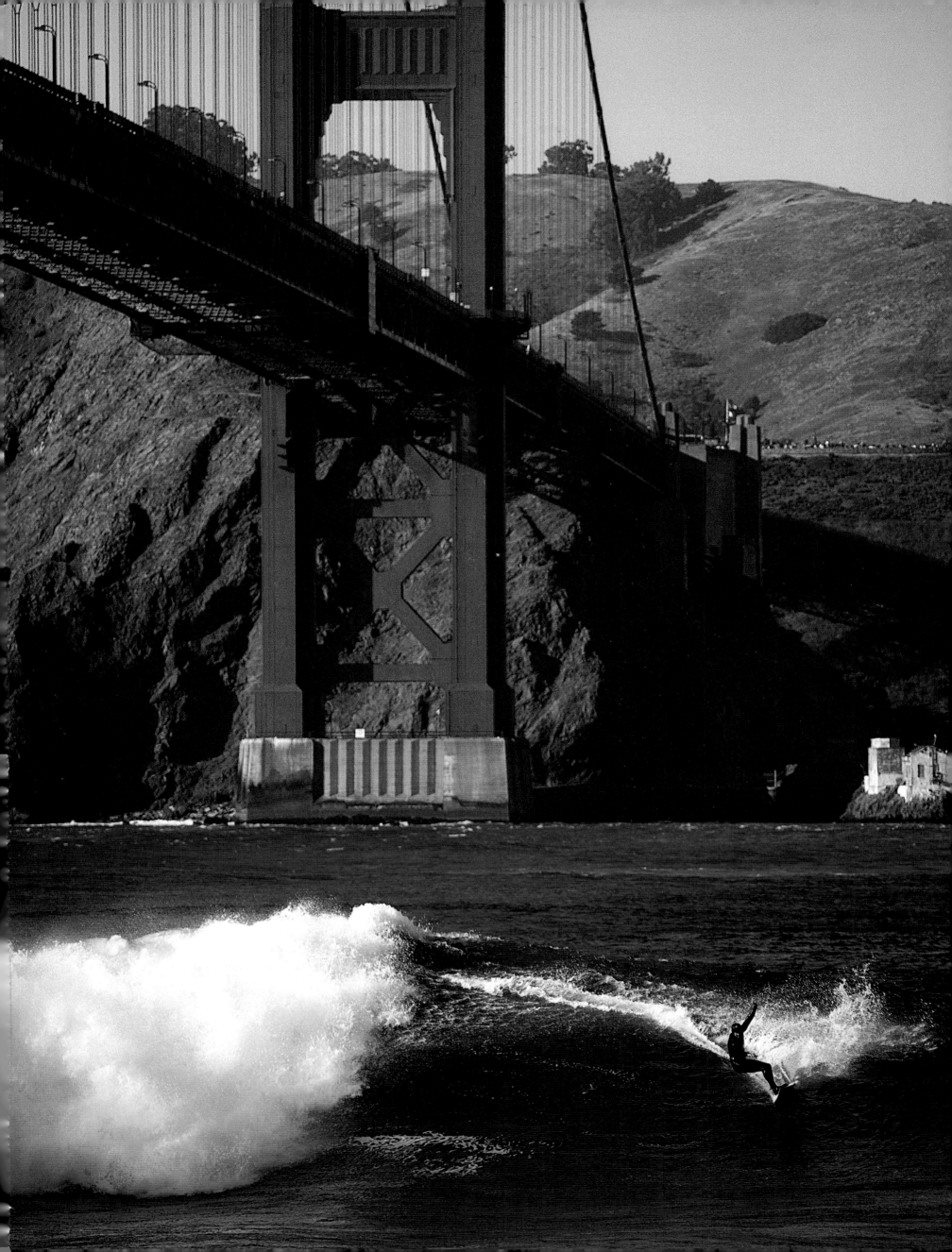

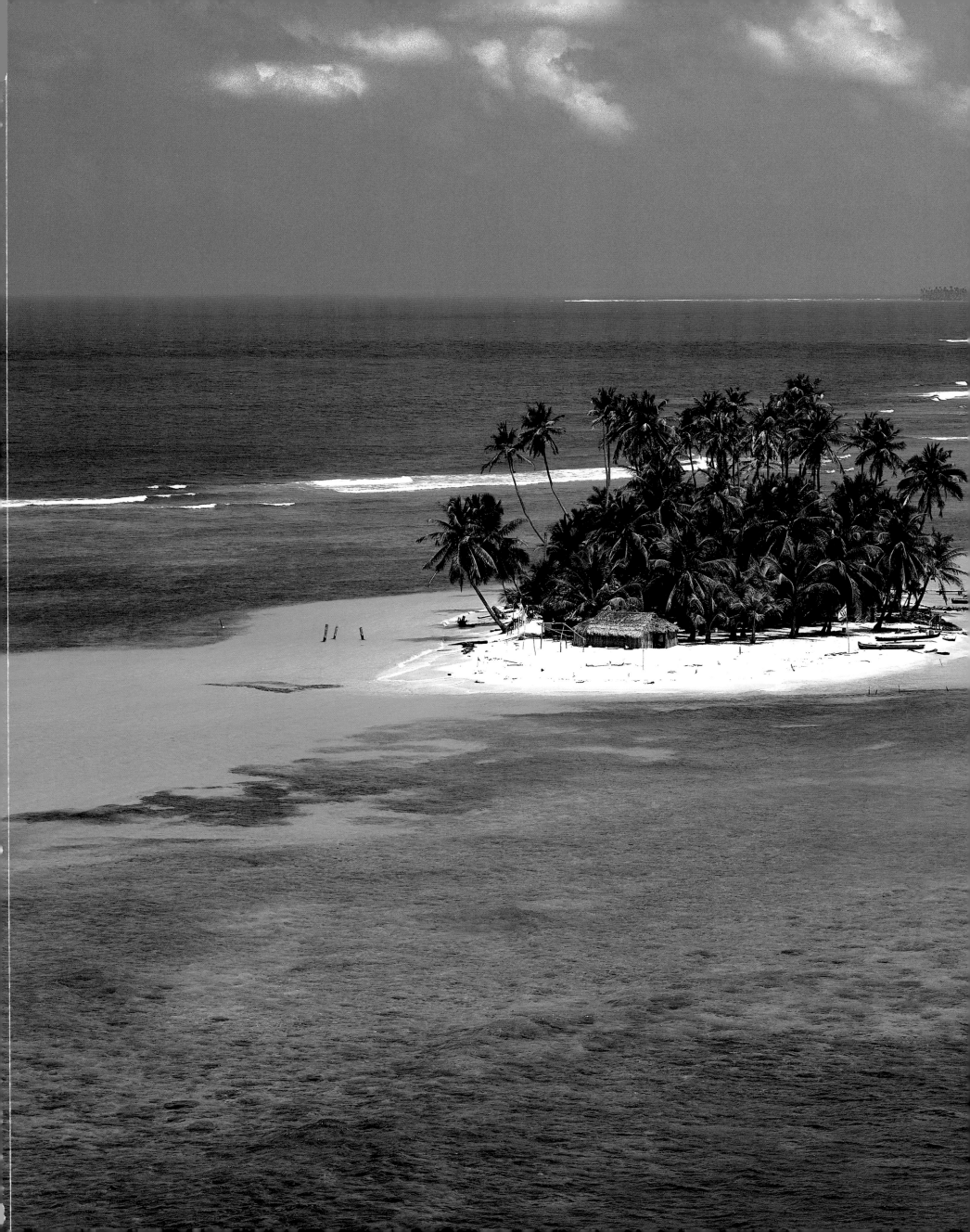

A Longing for the Ocean

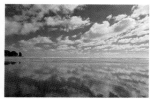
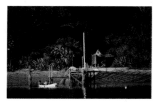

NEW ZEALAND, PIA BEACH
Mankind has given a name to practically every area of the sea. However, this vast directory with its endless list of names really refers to small parts of a single ocean – one that covers the whole world. To whom does it belong? To nobody – or rather, to everybody. We are all 'citizens of the sea', and as the World Ocean Network maintain, we all have the same right to travel on it, together with the same responsibility to protect this common ground, the only place in the world that belongs to the whole of humanity. It is also the only one that is of equal importance to all of us.

MOROCCO, ESSAOUIRA
The fortified town of Essaouira, formerly known as Mogador, stands on the coast of Morocco, with its ramparts facing the Atlantic. Its long history goes back to the Phoenicians, who made it a stopping place on their route around Africa. After them the Romans arrived, collecting the rare molluscs from which they extracted purple dye for their togas. The medina you see now, with its narrow lanes and majestic ramparts and bastions, goes back to 1765, when Sultan Mohammed ben Abdellah decided to construct the largest port in the country, and commissioned the French architect Théodore Cornus to design the new town.

FRANCE, ISLAND OF HOUAT
In the great family of sailing boats, vessels are subdivided into two main types. One has a keel, a long fixed structure that increases the stability of the boat as well as its draught. The other can have its ballast on the inside and a moveable centreboard. At low tide, keeled boats remain at anchor in deep water, with a vigilant eye kept on the depth indicated by the echosounder, while the latter type can rest on the bottom, leaving them completely immobile at low tide. Both types have their own supporters, and of course neither would choose to change their favourite for all the wind in the world.

NEW ZEALAND, BAY OF ISLANDS
The willing castaways of today do not drift across the Atlantic in an inflatable dinghy. They deliberately set out in search of an earthly paradise far from the madding crowd. They live in modest homes, close to nature and its healing calm, such as one finds here in New Zealand, a sparsely populated country that can easily grant the wish for isolation and the wide open spaces of the sea. But many of these latter-day Robinson Crusoes, weary though they are of the pace and triviality of the modern world, still like to maintain contact with that world from their desert island, and to do so, they often use the most modern means of communication.

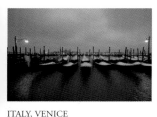
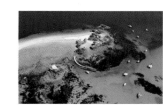
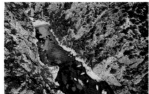

ITALY, VENICE
Venice is an archipelago of 118 islands, separated by 200 canals and spanned by 400 bridges. The Grand Canal has been described as the most beautiful street in the world, and is the main artery. On its banks, the Venetian aristocracy built the finest palaces of the Middle Ages and the Renaissance. The extraordinary history of *La Serenissima* has always been linked to her mastery of the seas. From the year 1000, she imposed her power on the Mediterranean, but now, a thousand years later, the sea threatens to impose her power on Venice, as she tries to defend herself against ever more frequent flooding. The means may have changed, but the human race's battles against the sea are never-ending.

FRANCE, CORSICA, CORSE-DU-SUD
The recesses of Corsica's beautiful rocky shores conceal many lovely spots. In order to protect its exceptional coasts, France set up the Conservation du Littoral in 1975, an organization to monitor of all outstanding or endangered areas of natural beauty. It now protects 11 per cent of the Mediterranean coastline, and 21 per cent of the Corsican coast. It also manages several nature reserves. On an international scale, there are 1,000 marine locations under protection, but their total area amounts to barely 1 per cent of the oceans – as compared to the protected 13 per cent of land areas – and in many cases there is a lack of funding for the measures needed to maintain and conserve these regions.

GREAT BRITAIN, CHANNEL ISLANDS, LES ECRÉHOUS
Between Great Britain and northern France, the Channel Islands lie a stone's throw from the coast of Normandy. They are, however, British dependencies, and the Crown has sovereignty by reason of its descent from the duchy of Normandy. Jersey, Guernsey, Alderney and Sark, havens of socio-economic peace in which 147,000 inhabitants rub shoulders over an area of just 195 km², owe their charm to the sea that embraces them. These islands contain a large number of second homes, perched on foundations of sand and rock that are bathed in emerald waters and offer the most relaxing of holidays.

FRANCE, CALANQUES, NEAR MARSEILLES
Only by boat can one gain access to the rocky inlets and wild creeks of the Mediterranean shore. In order to regulate such trips and preserve the most delicate of these areas, new regulations have now been put into force. Keeping sewage on board and discharging it into specially designed harbour installations is just one of the changes imposed on the pleasure boat industry in order to protect the marine environment. Some boat-owners have also agreed to observe the good practice codes recommended in a charter drawn up for amateur sailors. This is essential in order to safeguard such exquisite sites as the deep coastal valleys called calanques.

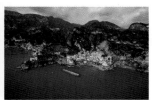

ITALY, GULF OF SALERNO
In the calm of winter, the Gulf of Salerno enjoys some peace and quiet after the hectic comings and goings of the summer. The population of the Mediterranean regions increases by 220 million in the summer, and over 100 million of them descend on the beaches. This seasonal tourist invasion may well double over the next twenty years. But for the moment, at least during the low season, the world-famous blue Mediterranean shores still show off their picturesque charms.

FRANCE, OUESSANT
The moving masses of the oceans, eternally changing, are irresistibly fascinating. Their shores are a magnetic, hypnotic attraction, and every day people come to look at the colour, movement, intensity and mood of the waters. You go to see the sea as you go to visit a friend or relative, to get the latest news. A breath of sea air is like a tonic. You study the endlessly variable, unpredictable expressions on its face. And on every shore, at the foot of a lighthouse, at the end of a sea wall, at the bottom of a sand dune, at the top of a cliff, you will find a pair of human eyes gazing out over the ocean.

NORWAY, NEAR BERGEN
Serrated by the indentations of countless fjords, like the rest of the Norwegian coast, the shores around Bergen in the south-west of the country are a natural landscape that has been completely infiltrated by the sea. Nestling within this grandiose setting of snow-capped mountains, blue glaciers, green fields and sheltered bays, the colourful wooden houses of the fishermen, with an authentic charm of their own, seem to invite you to set sail on the water. It is a hard invitation to refuse in a country where, since time immemorial, sailing has been second nature to all who live there.

GUADELOUPE, LES SAINTES
The coconut palms of the South Sea islands are the perfect symbol of paradise on Earth. Constant sunshine, waving palms, golden sands, and blue lagoons swarming with exotic fish make up the picture-postcard setting to which those with the means can never tire of escaping. But the more these means increase, the more their owners search for isolation, away from their peers, pushing Utopia ever further afield in a vain attempt to keep their personal paradise to themselves.

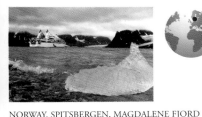
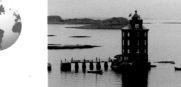

NORWAY, SPITSBERGEN, MAGDALENE FJORD
More and more people are now taking luxury cruises, and their destination is not always the tropics or the South Seas. They also dream of icebergs and penguins. To keep up with this new trend, tour operators are varying their itineraries: the Caribbean, hitherto the most popular destination but close to saturation point, now finds itself in competition with the Mediterranean, Scandinavia, Polynesia, the Far East, Alaska and the Antarctic. Cruises to the Arctic Circle are also enjoying a boom. But this fragile, previously virgin territory, so well preserved until now, could swiftly be ruined by indiscriminate tourism.

ITALY, GULF OF SALERNO, POSITANO
The Mediterranean is a mecca for world tourism. Lining the hill, the houses of Positano in the Gulf of Salerno can almost make you forget that nearly 40 per cent of the 46,000 km of the Mediterranean coast have already been developed. Some regions, swamped by the infrastructures of tourism, have suffered from several decades of bad planning, and the concreting of the coasts is now being exacerbated by the expansion of ports and marinas for the leisure industry. Plans to develop an additional 4,000 km of coast before 2025 also pose a major threat to the Mediterranean shoreline. Surely saturation point has already been reached?

USA, CAPE COD, BUOYS FROM LOBSTER TRAPS
At high tide, the sea makes a few small deposits on its shores, to show that it was there. You can collect algae, shellfish, cuttlefish bones, coloured pebbles, shining shards, gnarled sculptures of driftwood, a stray pot, a piece of netting, a wandering lifebuoy. Some people take them away, determined to create a work of art that will fill their rooms with the scent of spray and the sound of the tides. Such recycling is a source of endless inspiration, as can be seen from this wall in Cape Cod, completely covered with second-hand fishing tackle. Unquestionably the prettiest and jolliest of murals.

NORWAY, LIGHTHOUSE AT KJEUNGSKJAER
Washed by the Norwegian Sea, the lighthouse at Kjeungskjaer is on the maritime route of the Coastal Express. Regardless of storms and blizzards, these cargo boats have been carrying passengers, goods and post up and down the Norwegian coast since 1895. They serve thirty ports, from Bergen in the south to Kirkenes on the Russian border along a route of 2,000 km round North Cape and past sublime landscapes lit by the aurora borealis and the midnight sun. Nowadays, they are also vessels for a new form of tourism, introducing cruise passengers to the cool delights of the north.

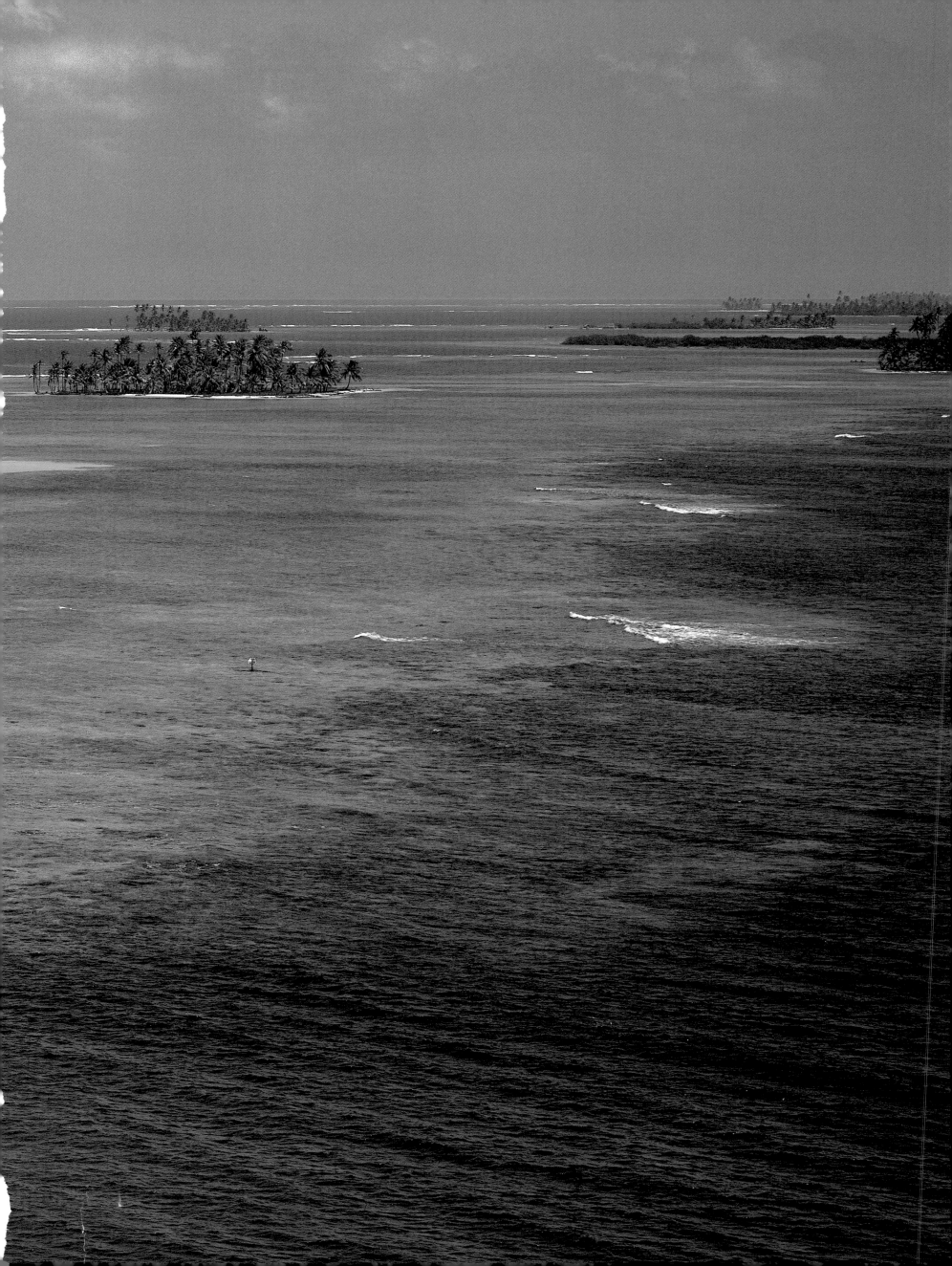

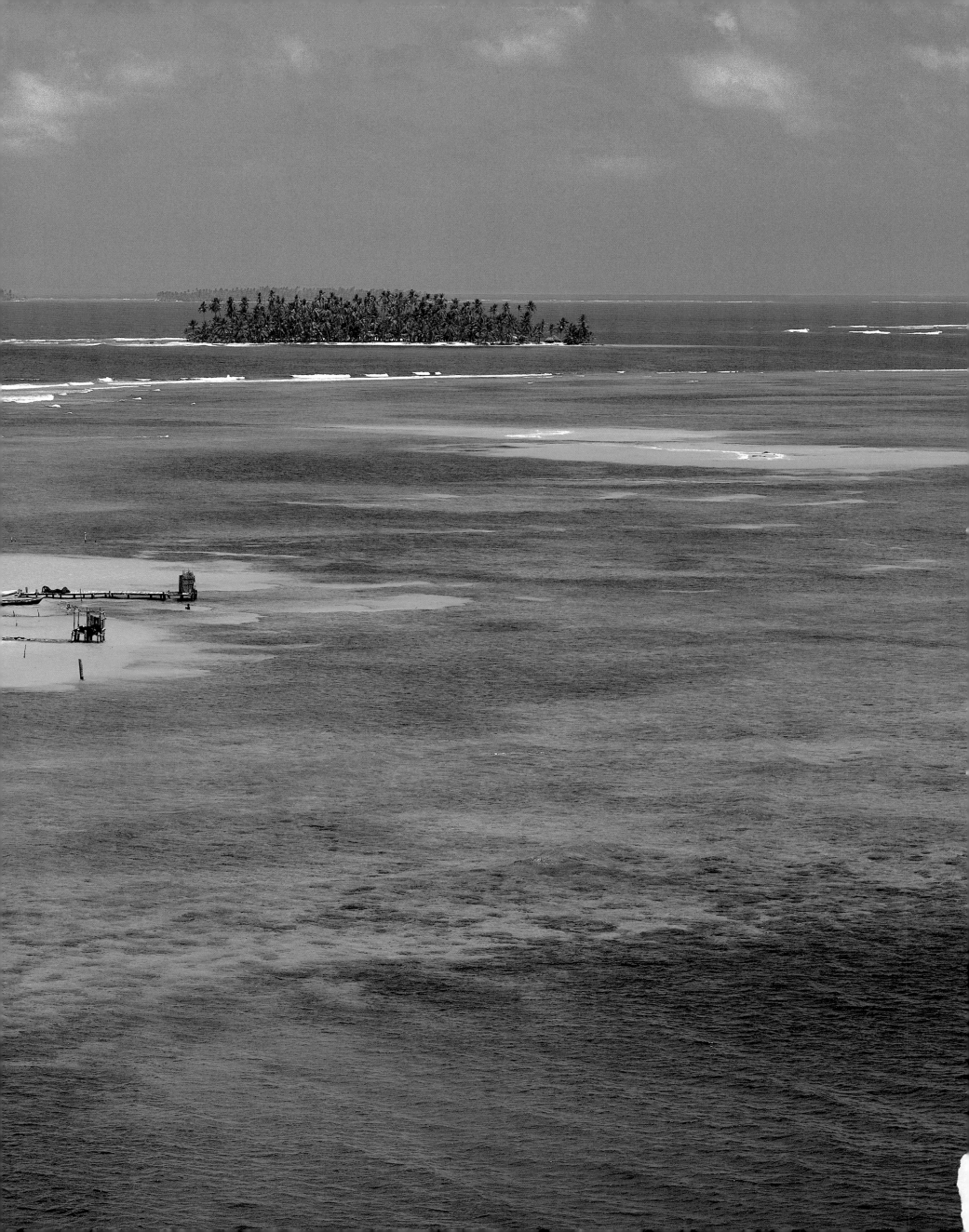

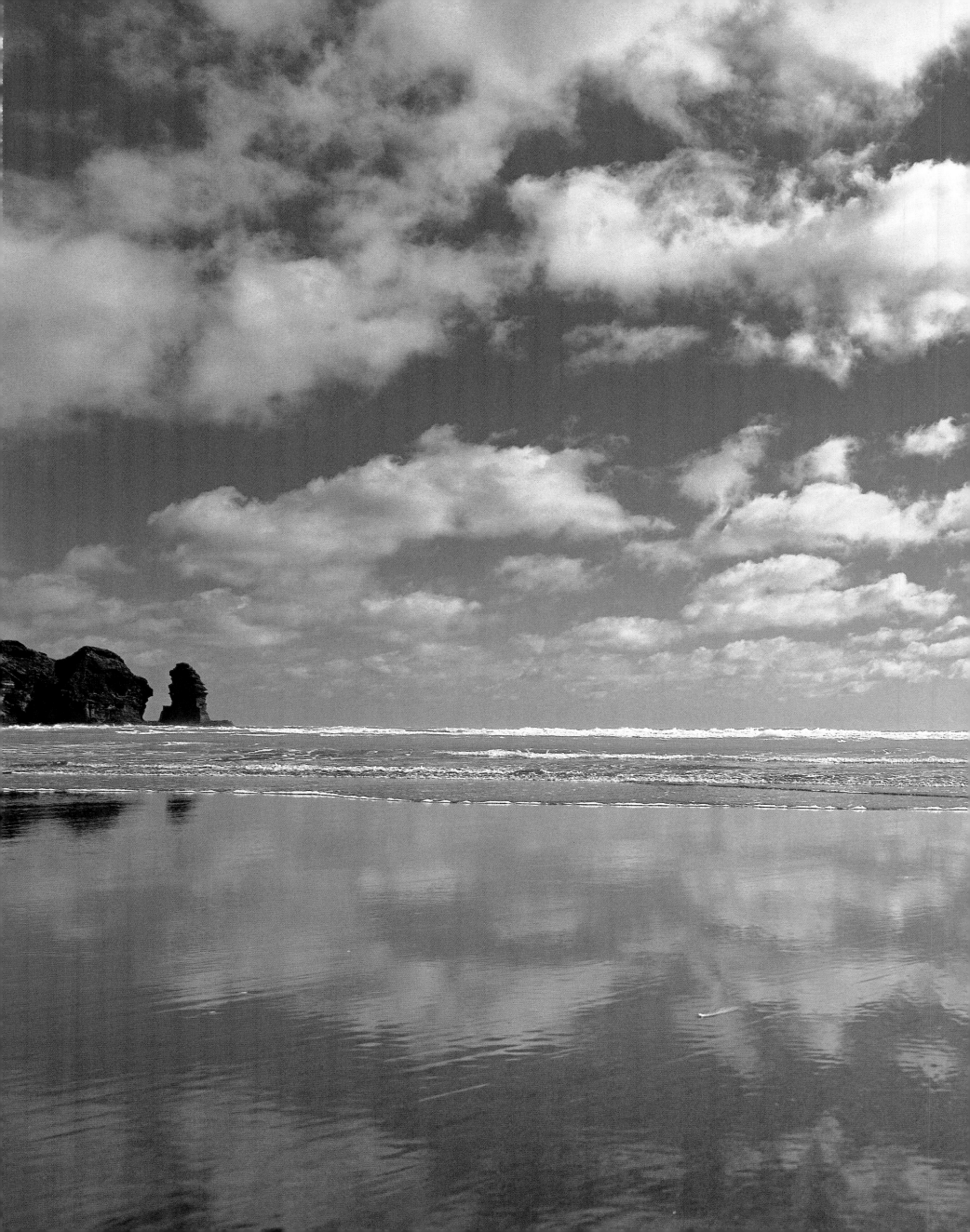

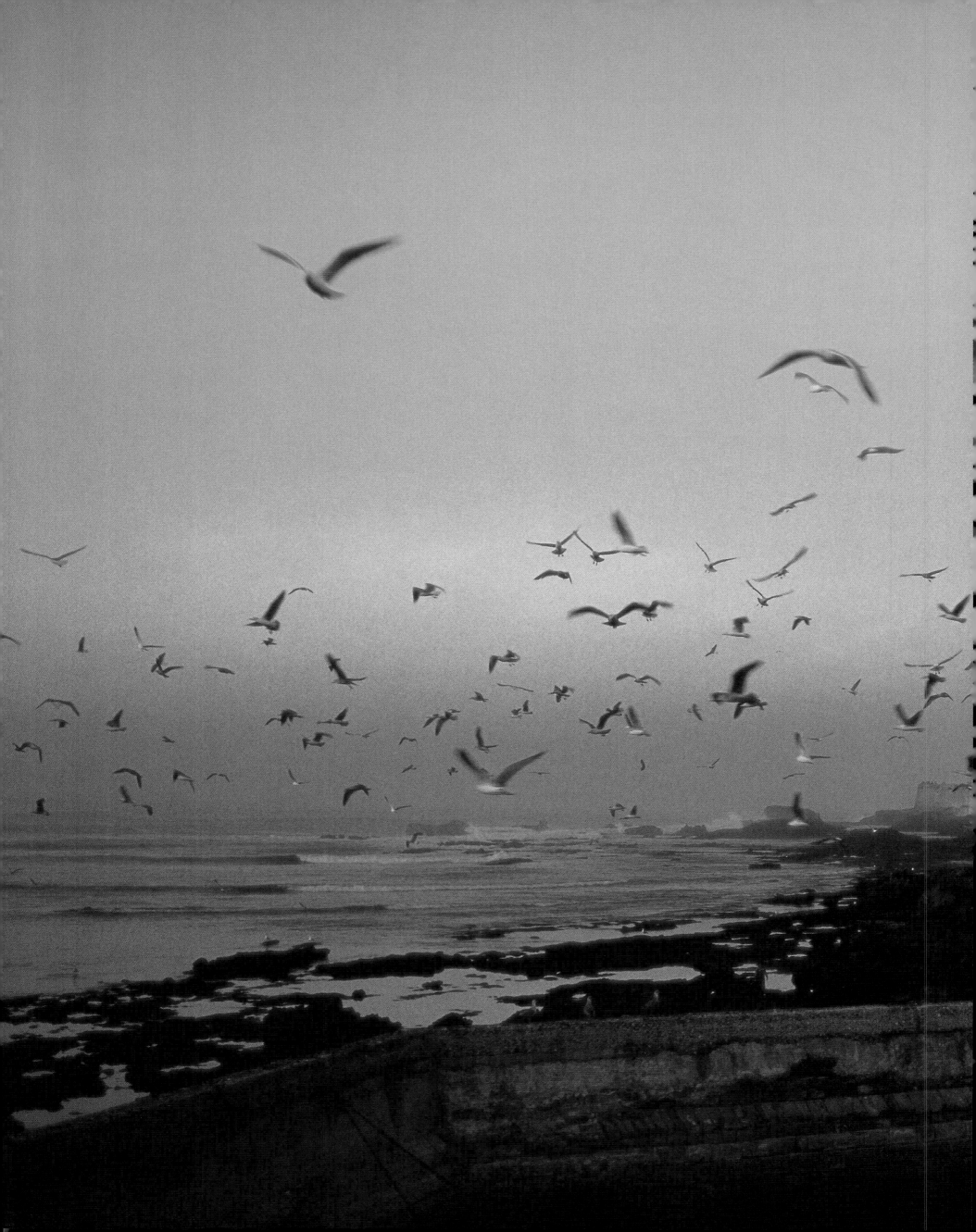

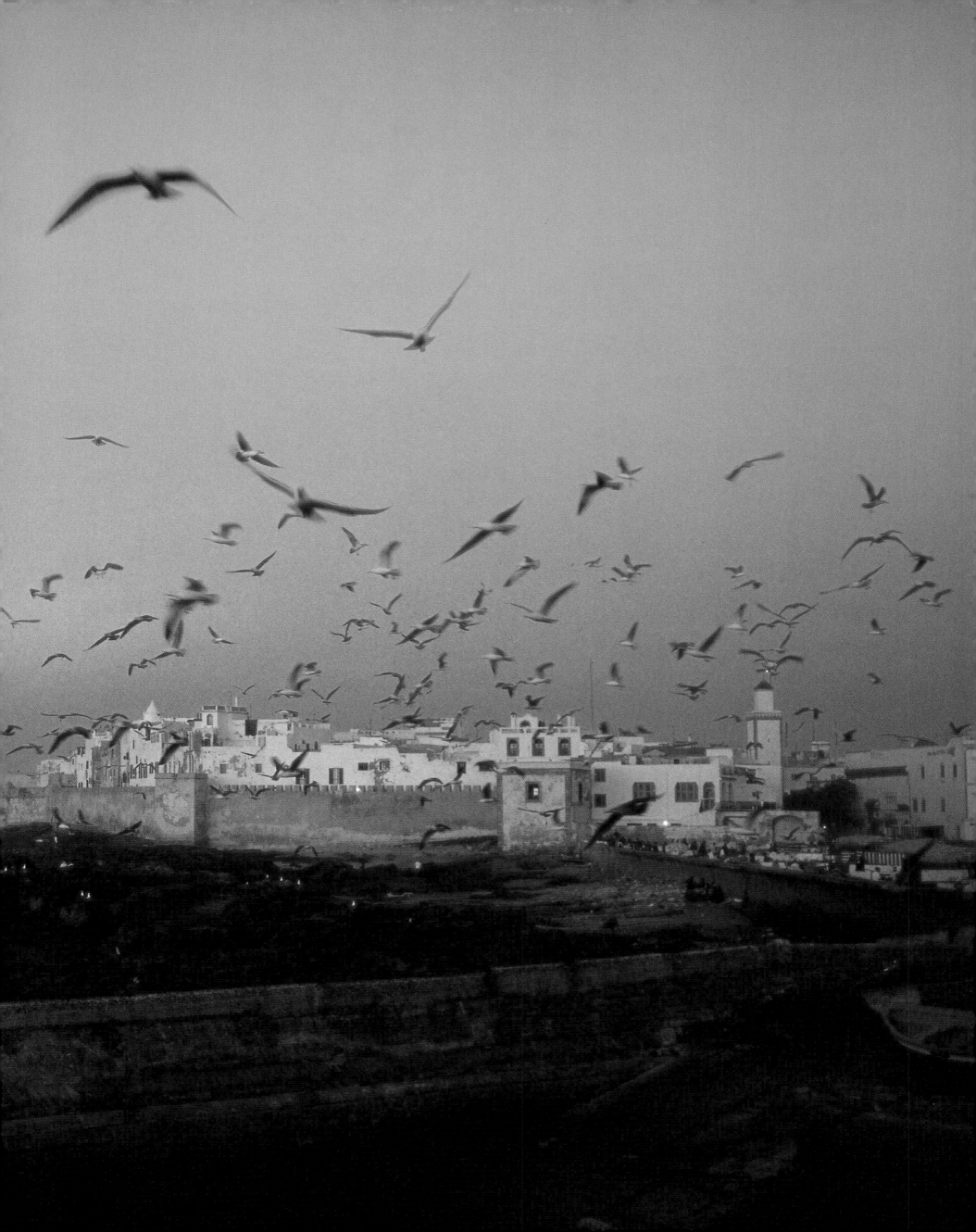

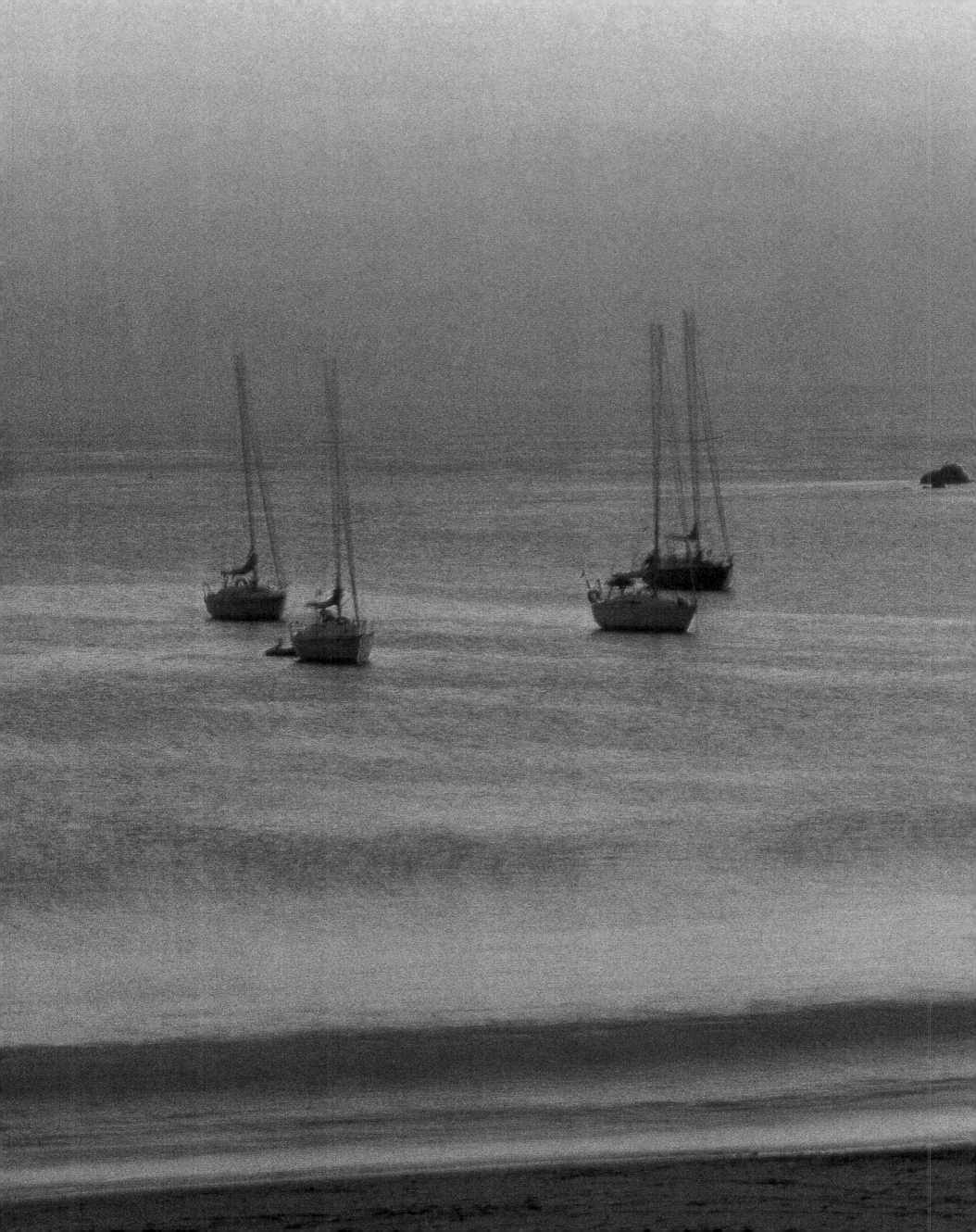

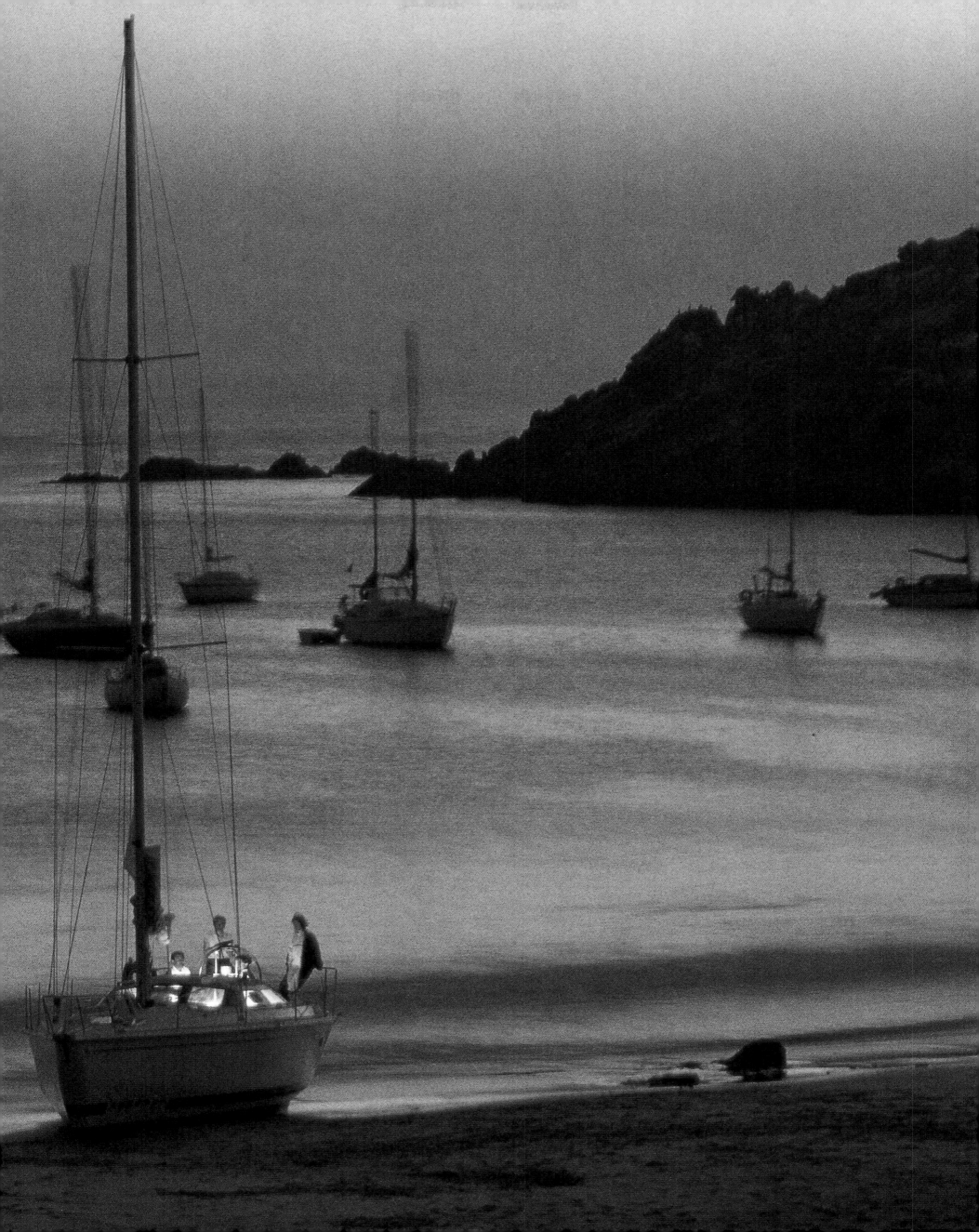

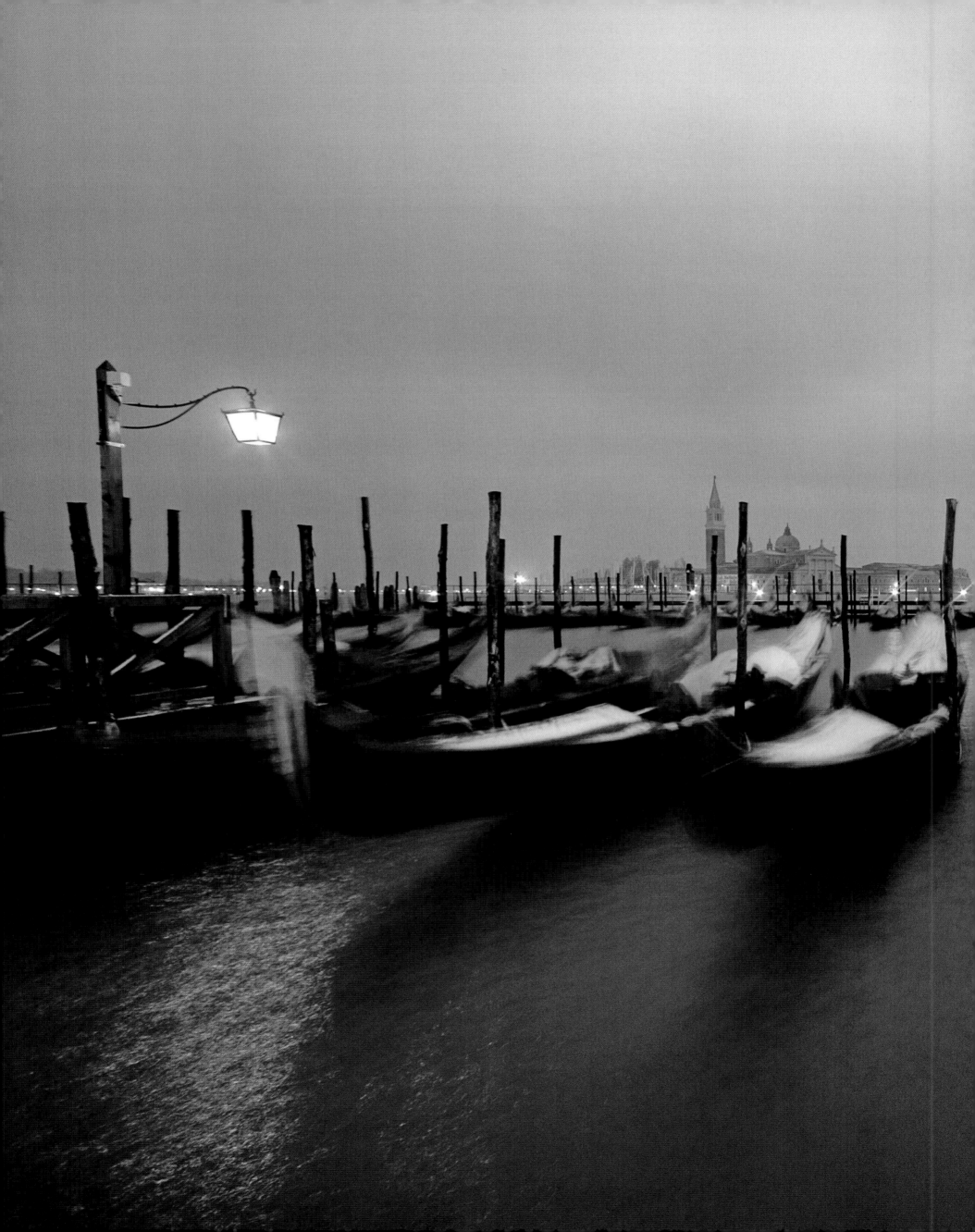

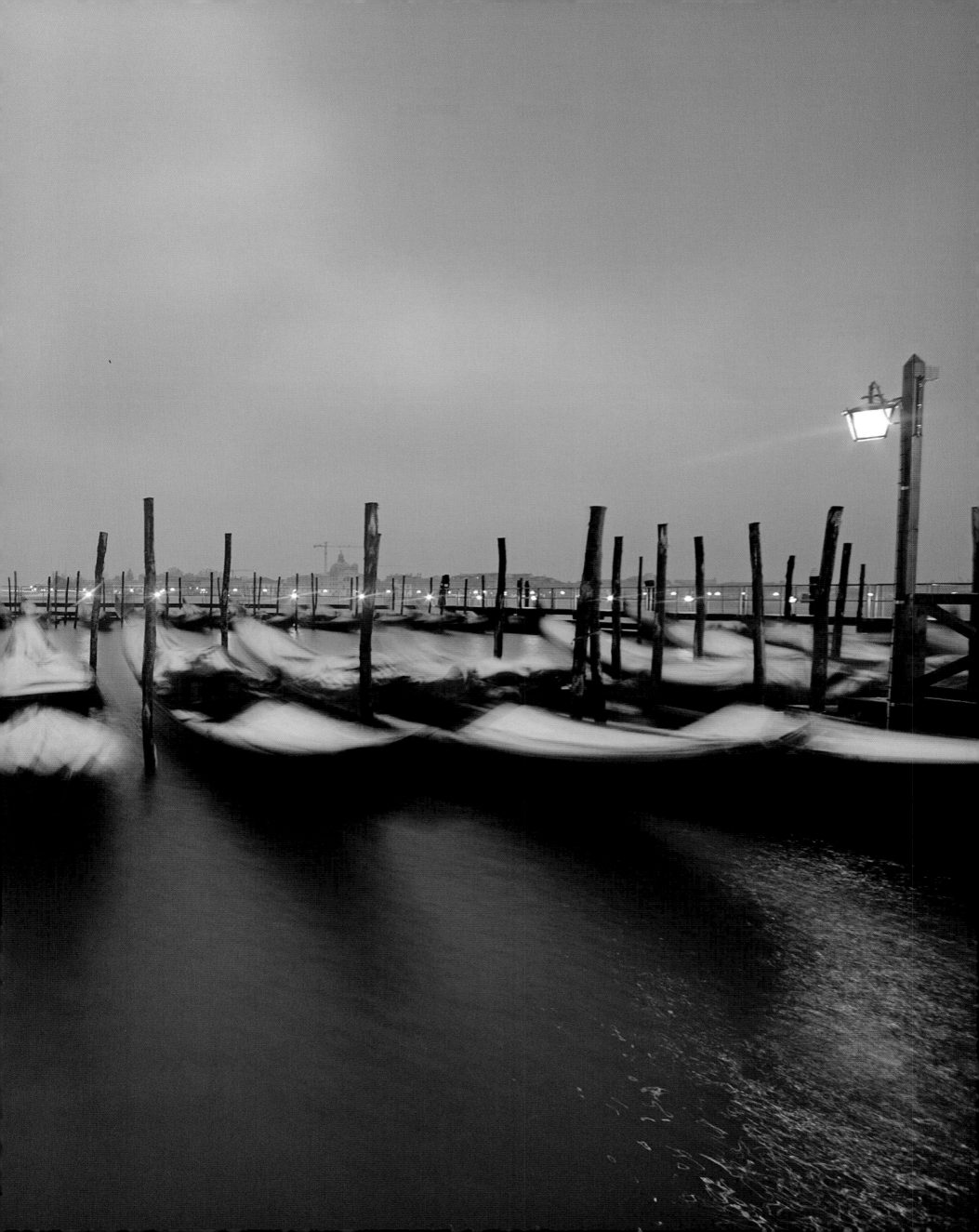

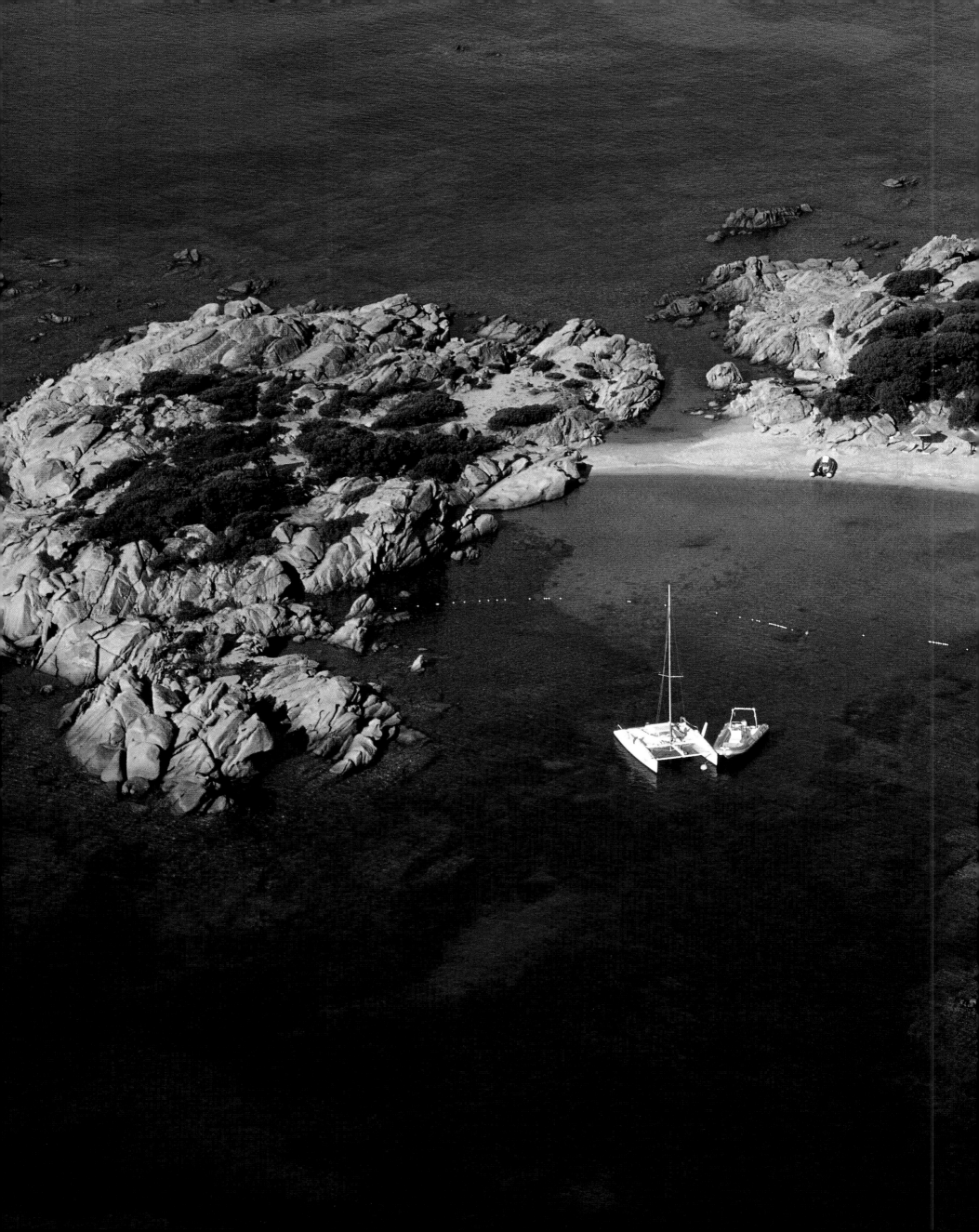

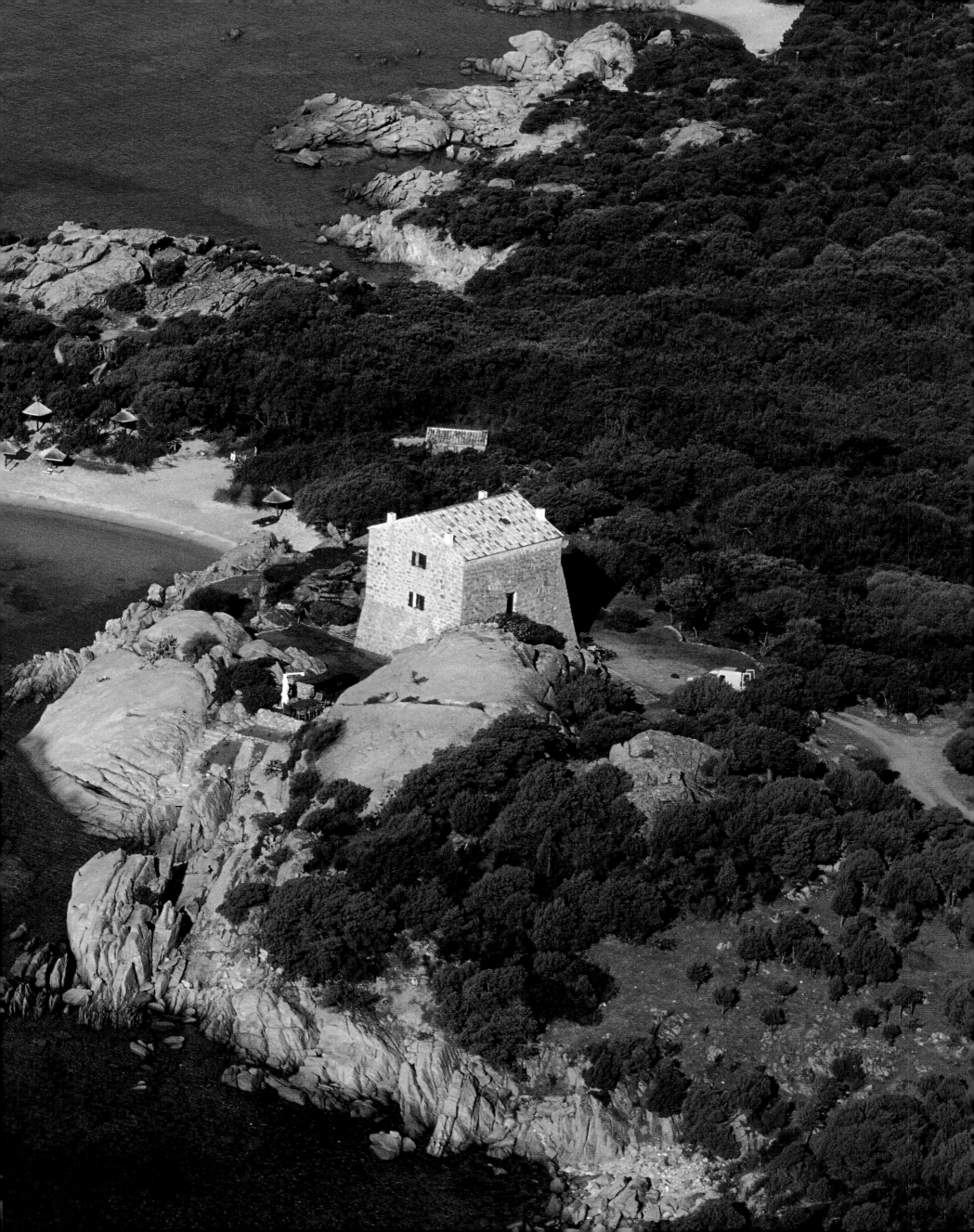

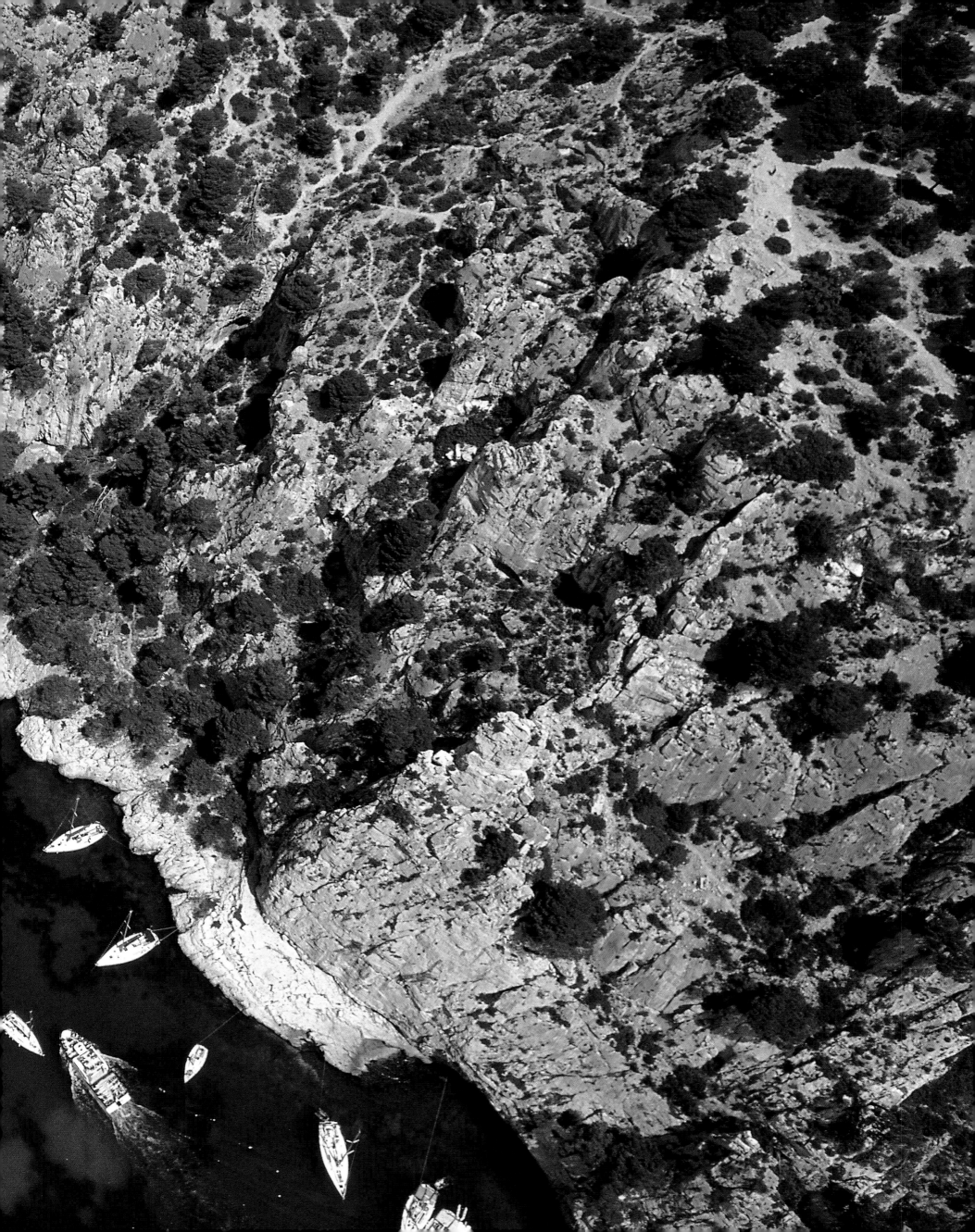

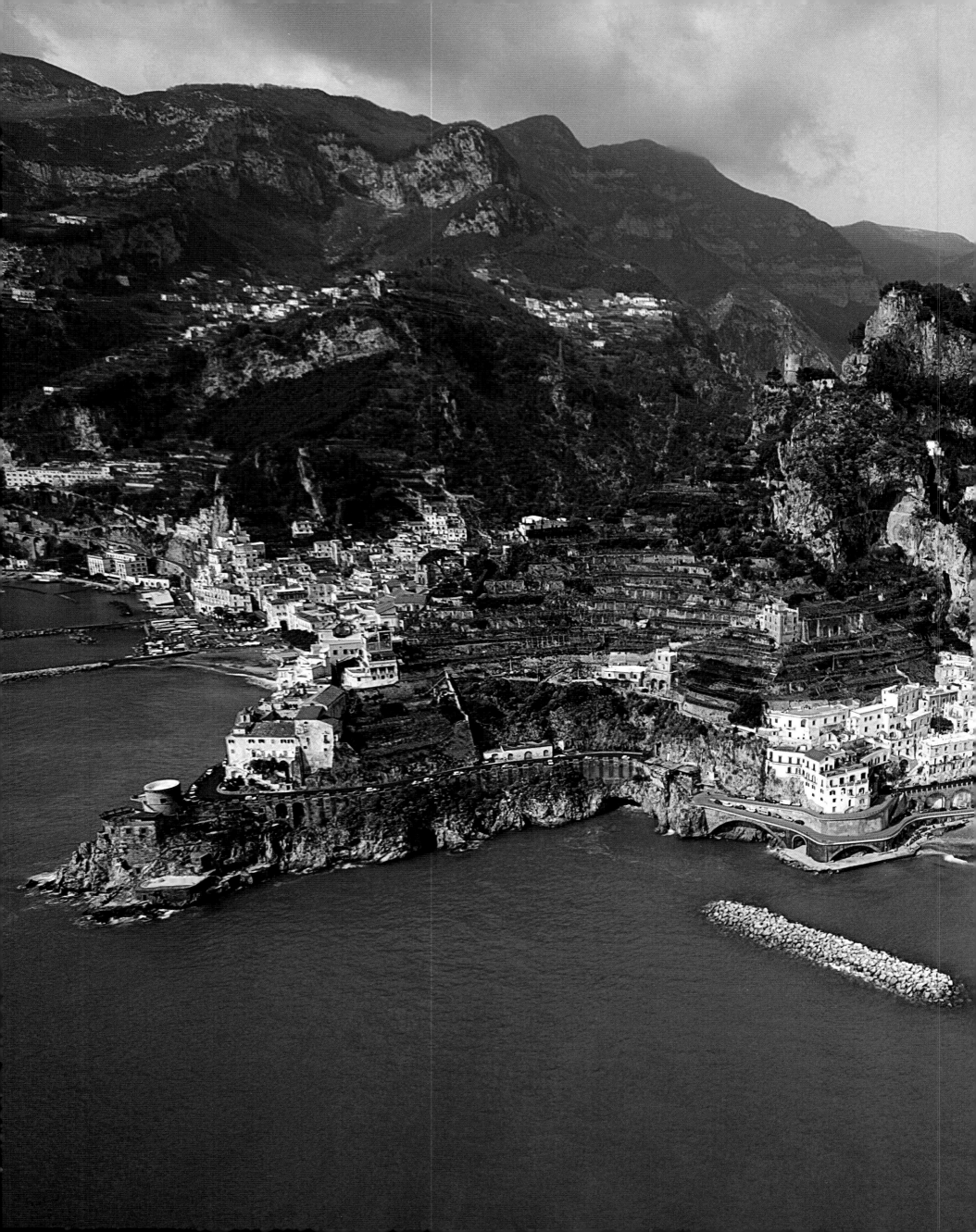

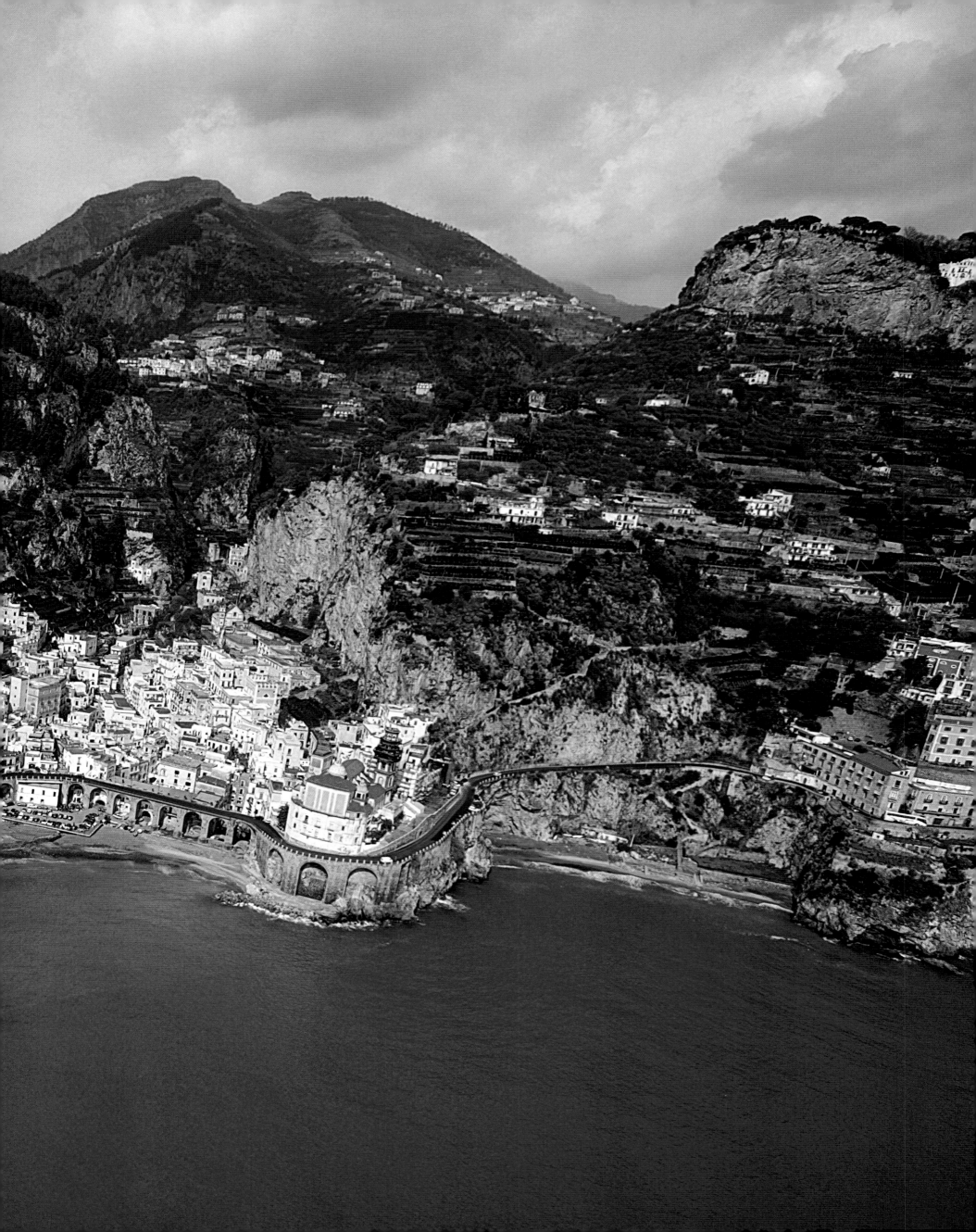

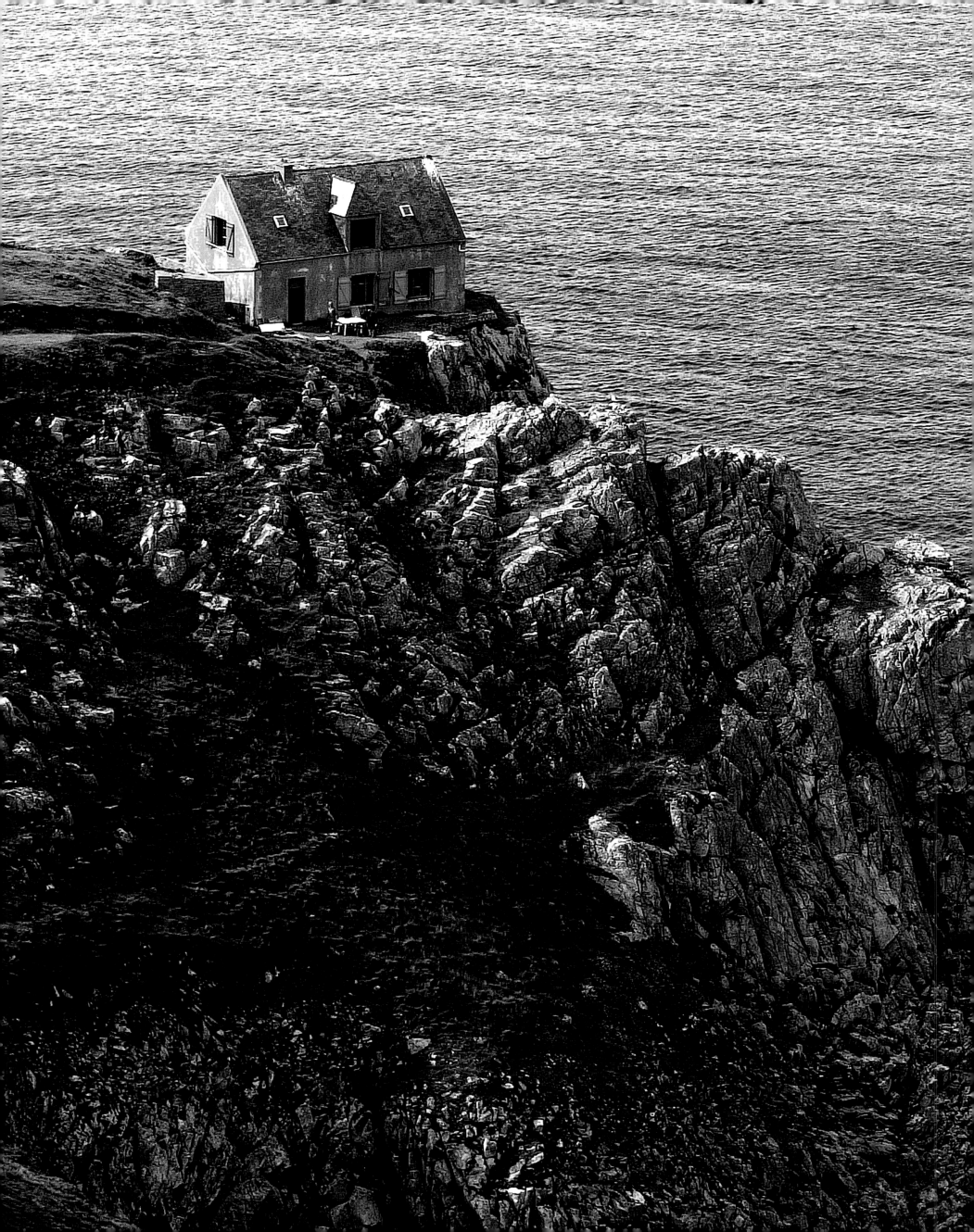

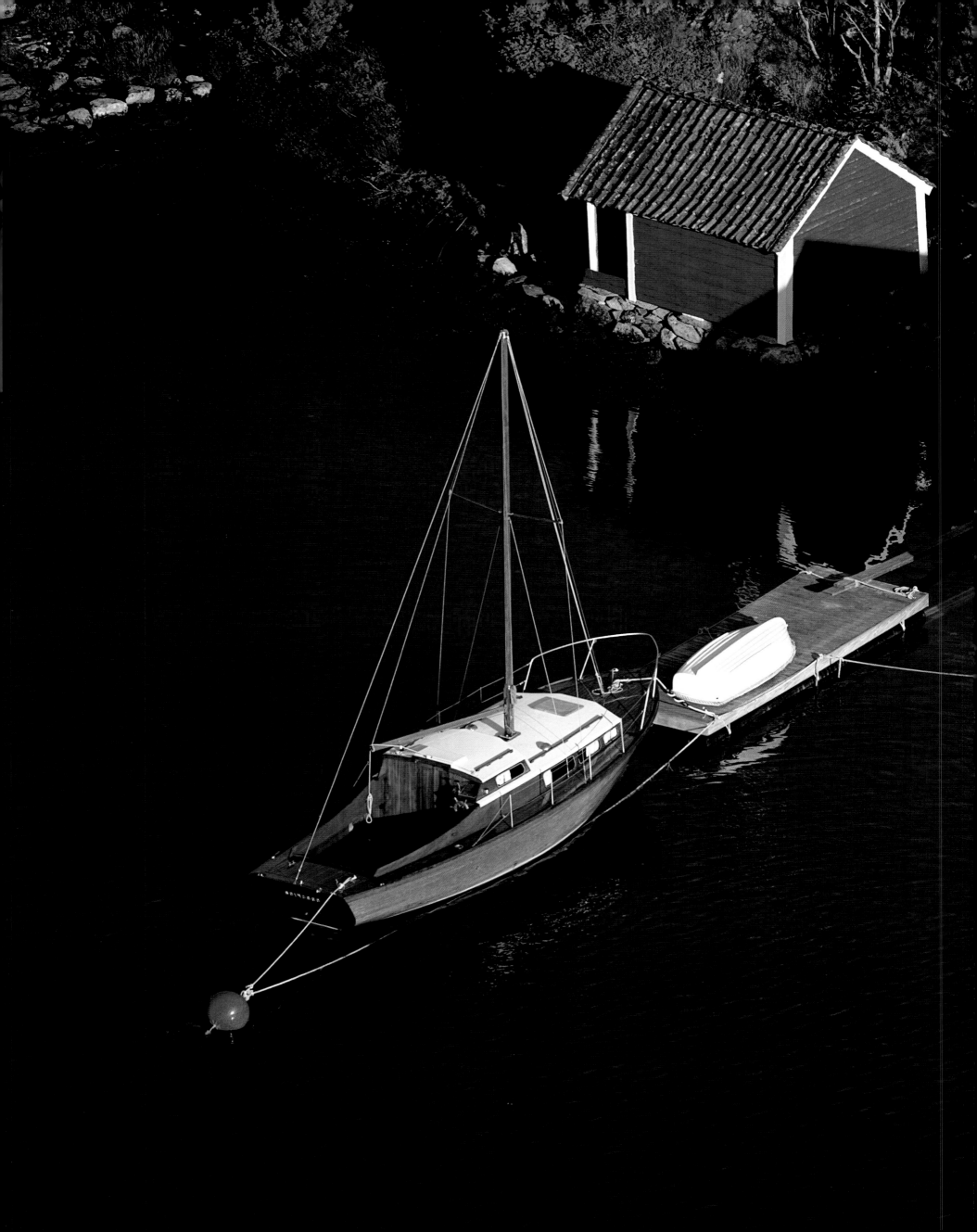

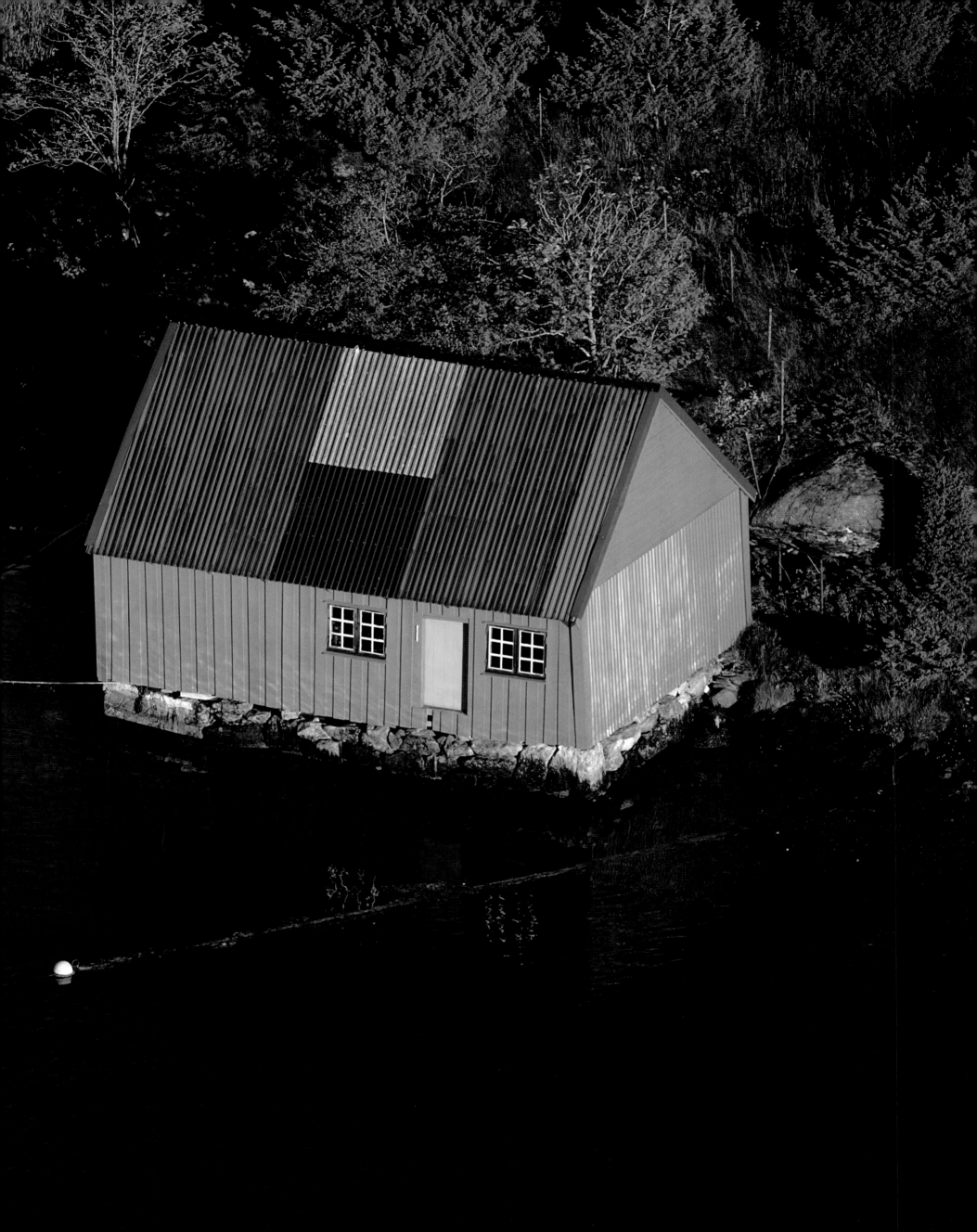

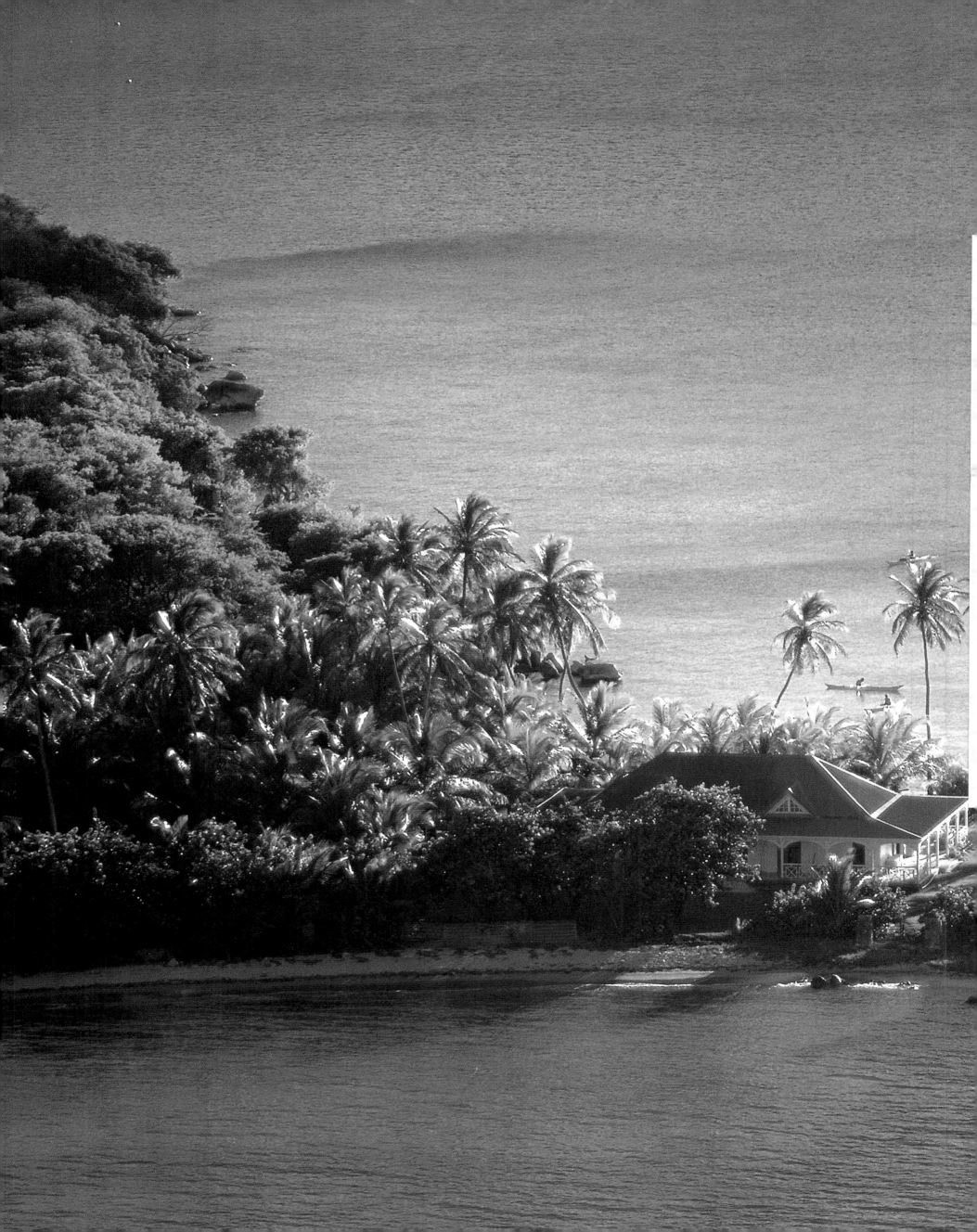

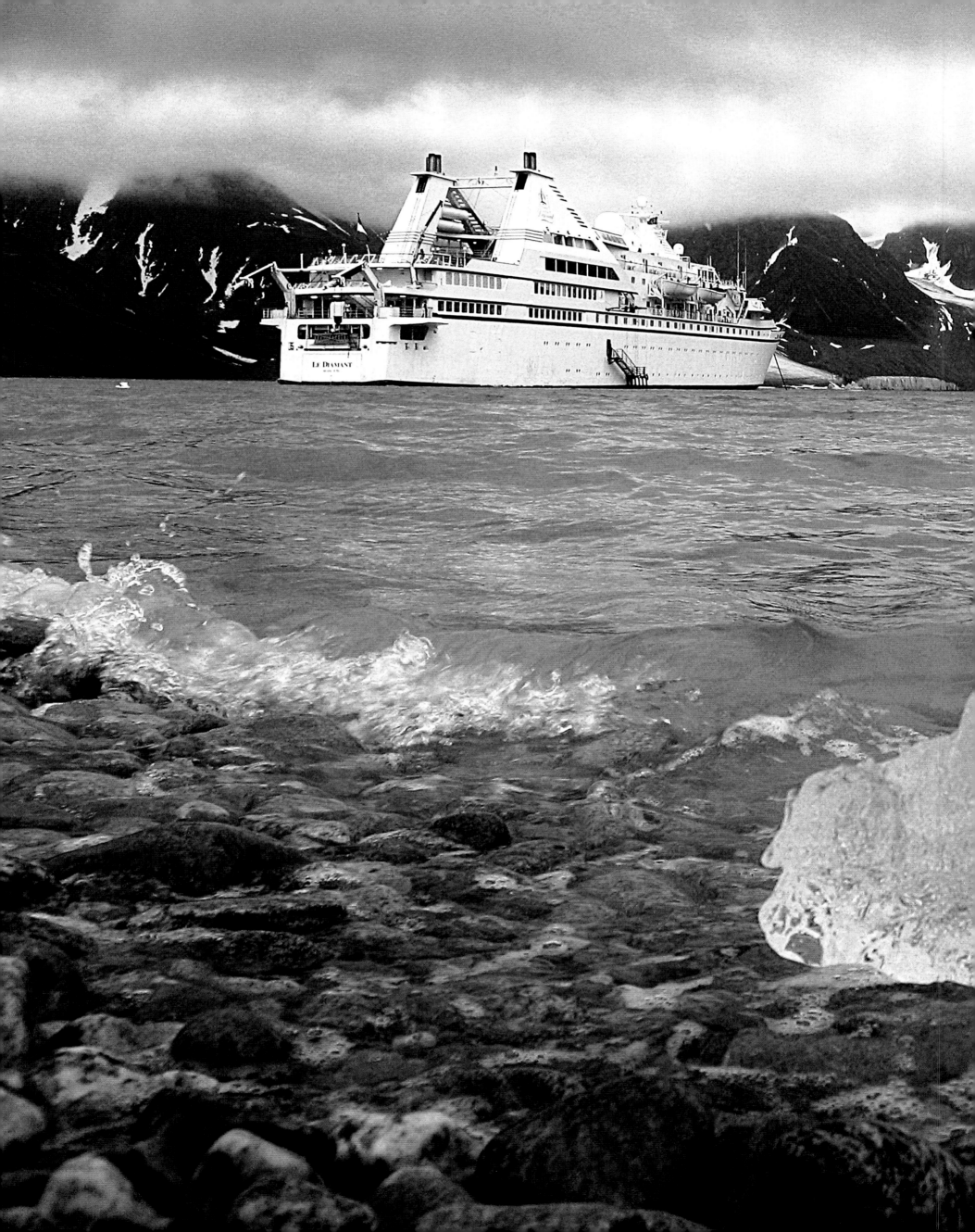

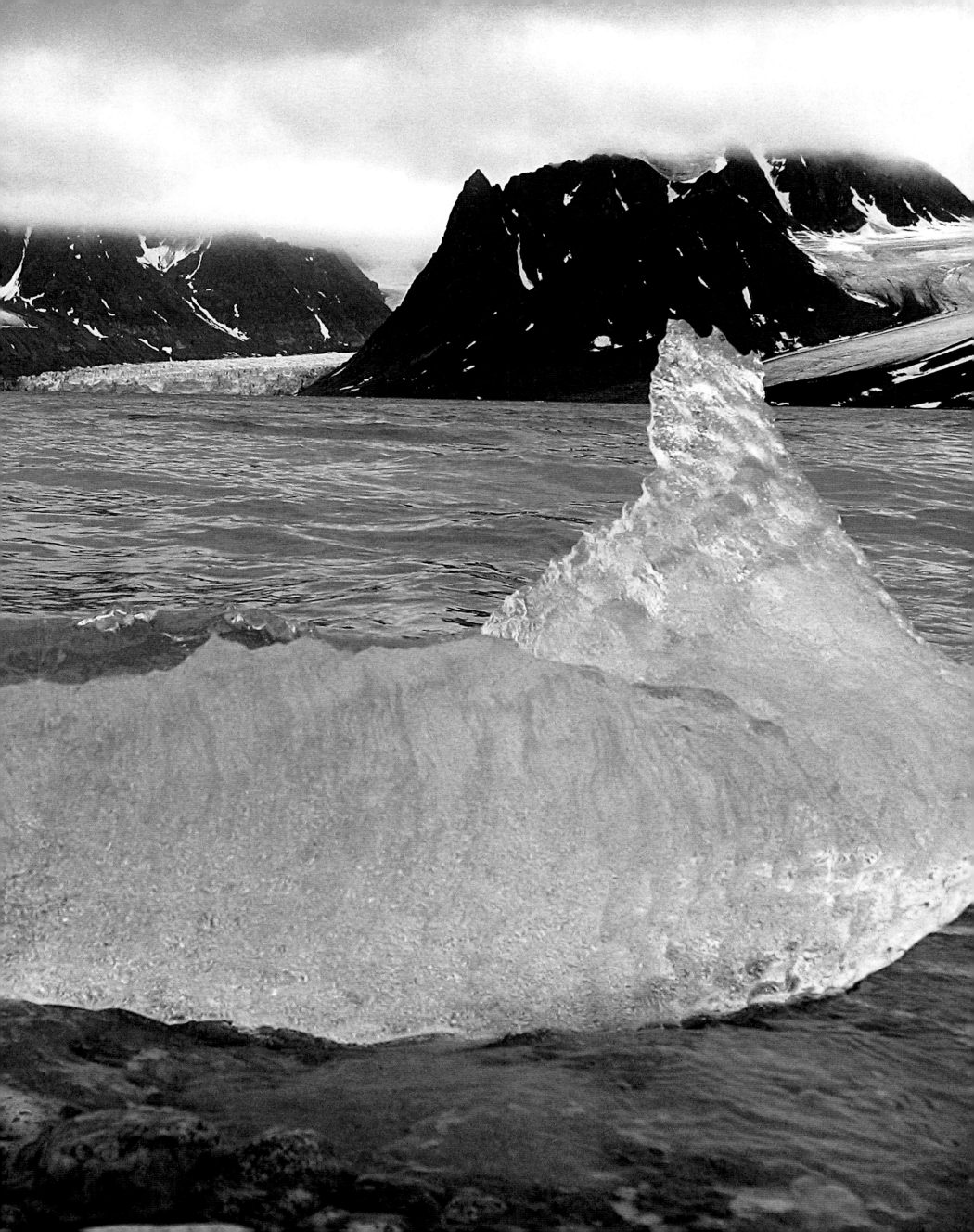

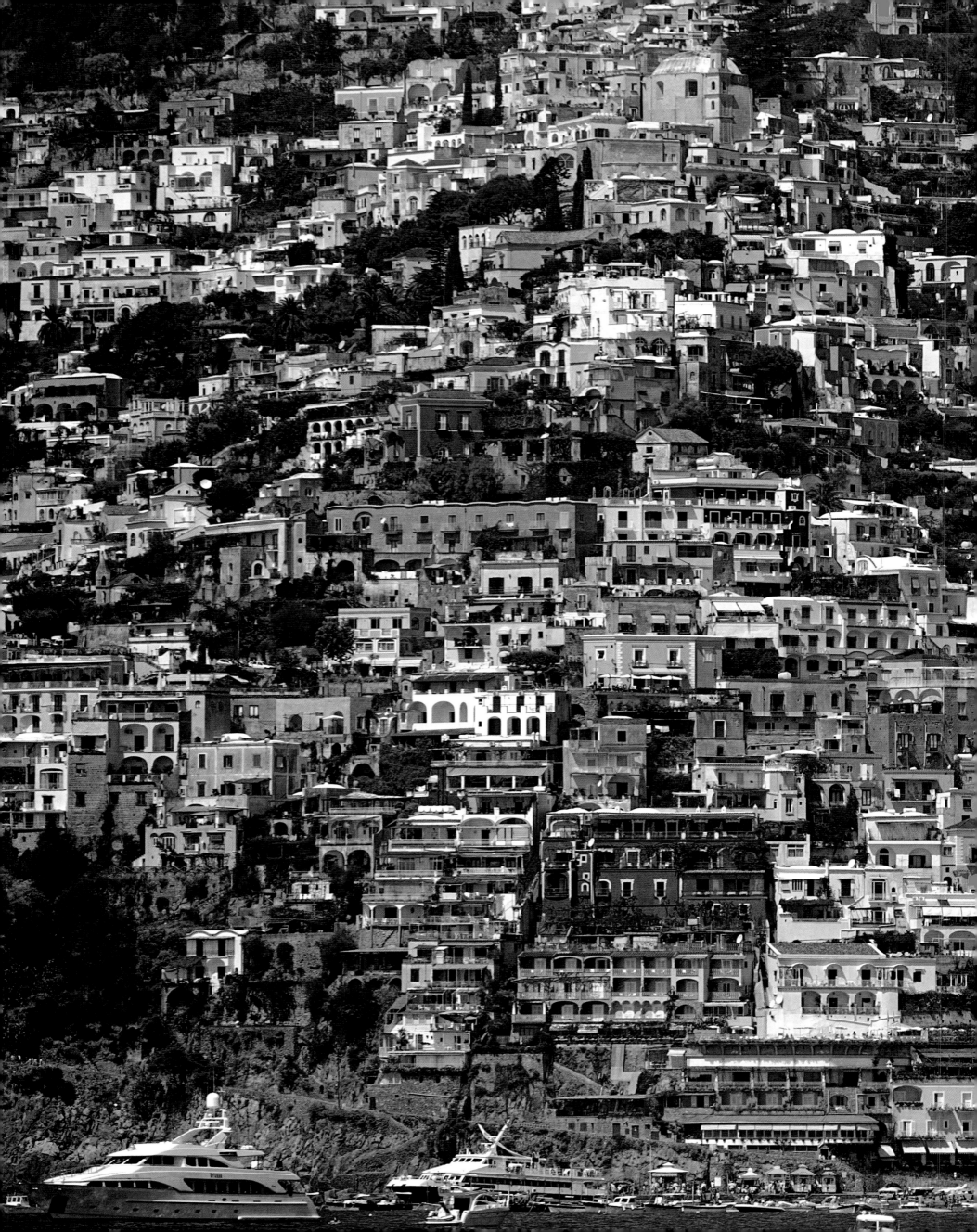

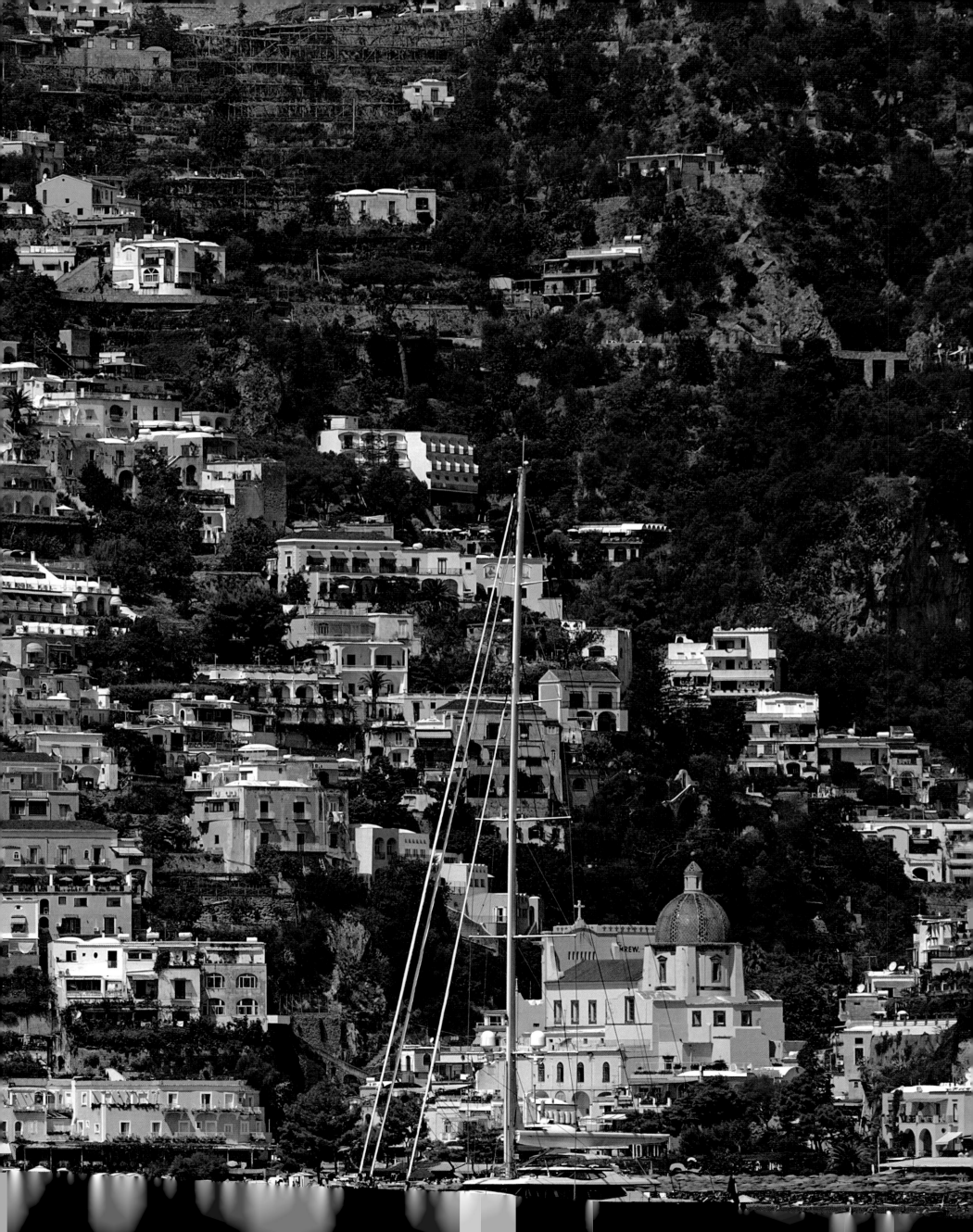

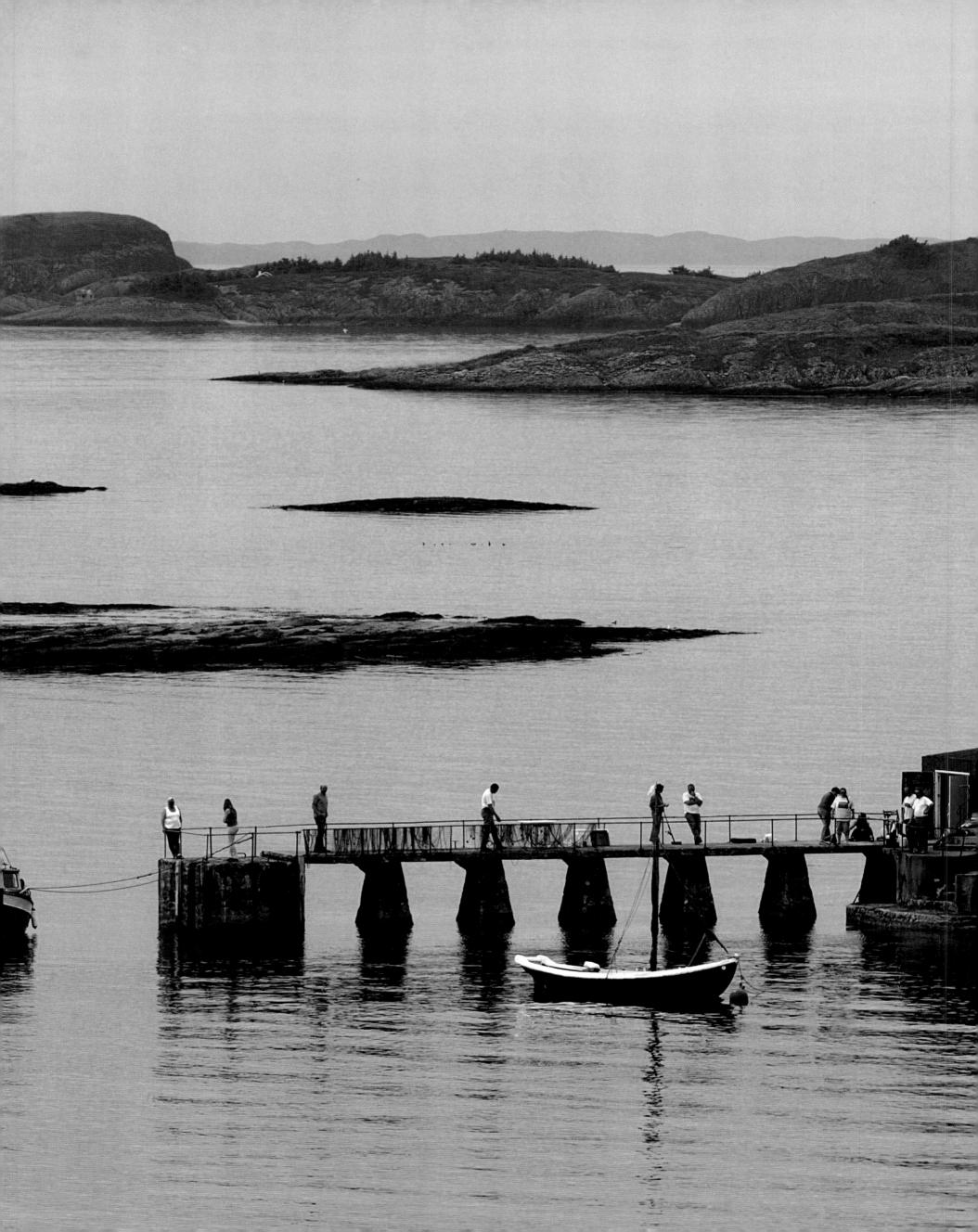

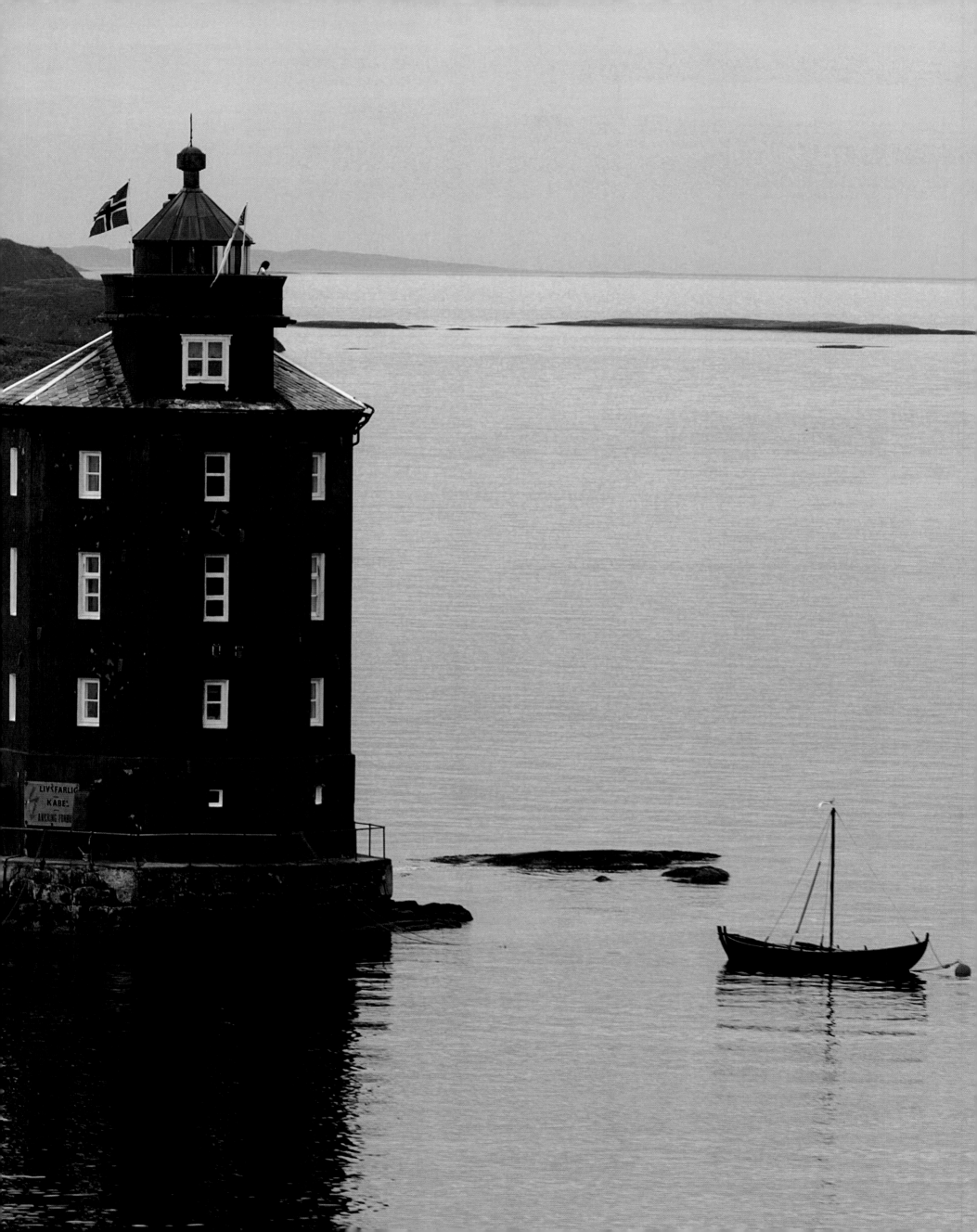

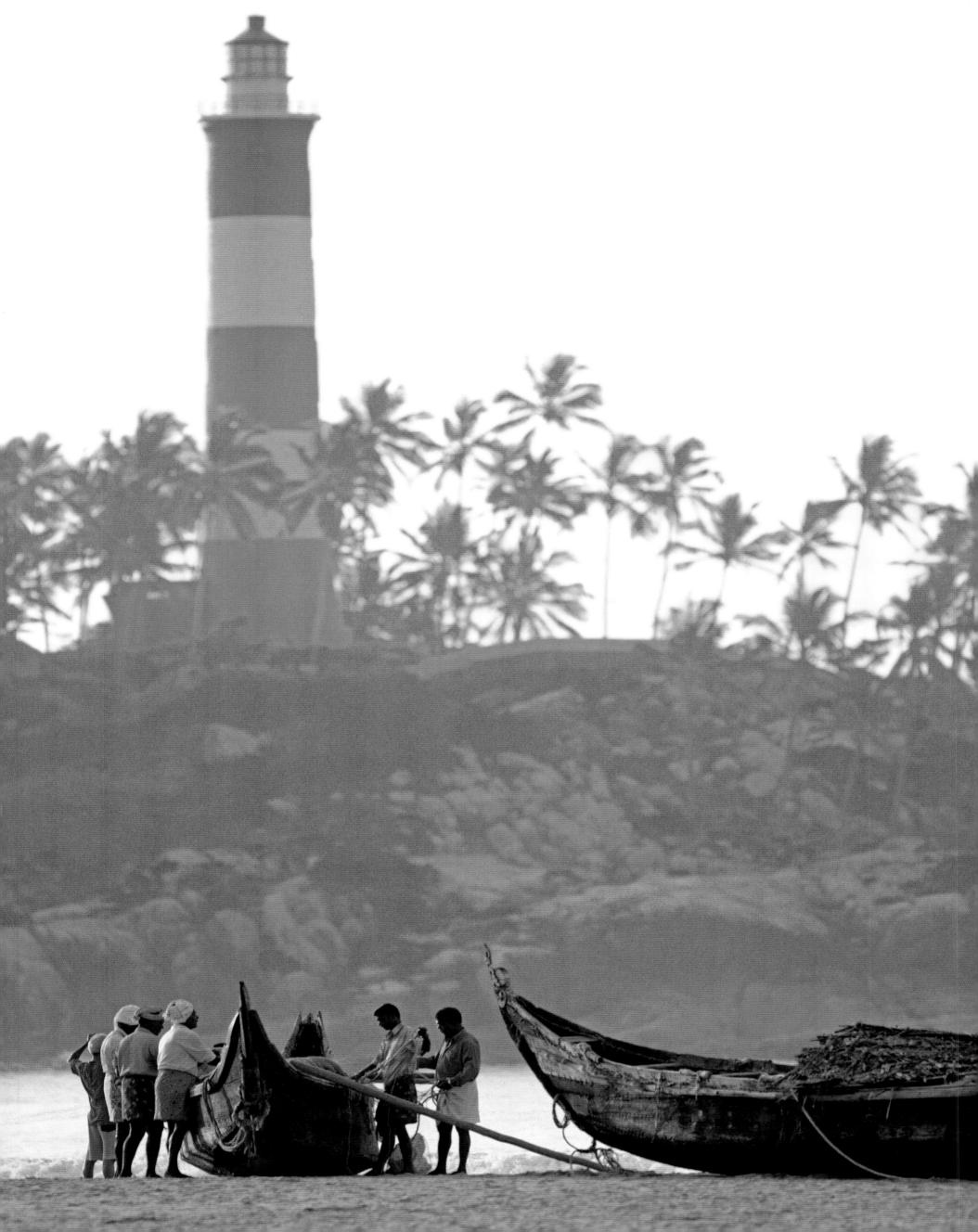

5 The Ocean Under Threat

On a worldwide scale, the many thousands of tons of hydrocarbons discharged by the *Erika* and the *Prestige*, along with all the other oil slicks worldwide, are a mere drop in the oceanic rubbish bin. Every year, some 6 million tonnes of different pollutants soil the waters that cover 72 per cent of our planet. Accidental pollution, caused by the 115 to 120 shipwrecks per year of boats weighing more than 300 tonnes – which means one major wreck every three days – accounts for barely 150,000 tonnes, or 2.5 per cent of the overall total.

INDIA, KERALA, VILLAGE
OF KOVALAM
Fish provide employment and
income for some 38 million people
worldwide – most obviously for
fishermen, but also and increasingly
for fish-farmers. Since the 1990s,
this workforce has increased by an
average of 2.6 per cent per annum.
About 97 per cent of fishermen live
in developing countries, and they
provide some 70 per cent of the
fish consumed all over the world –
a vital contribution to the economies
of their countries. But it is also in
these poorer regions that hurricanes,
floods and tsunamis wreak the most
havoc on fishing communities,
which are particularly vulnerable
and poorly protected.

Deliberate dumping causes twelve times as much pollution as shipwrecks – in other words, 1.8 million tonnes of pollutants are dumped into our oceans every year. Apart from hydrocarbons, there are detergents, chemical products and various types of oil, all of which are jettisoned with impunity, and even quite legally when it is done outside the exclusive economic zones (200 miles out), since it is quite permissible to dump waste in the so-called open sea, albeit with restrictions.

At the same time, two-thirds of maritime pollution (over 4 million tonnes) comes by way of the atmosphere – the main source of several particularly noxious substances found in our waters, including mercury and lead – and also our rivers and estuaries.

All over the world, rivers have all too often been used as open sewers. For example, the Río Bogotá in Colombia is now so polluted that no form of life is possible there, and no human settlement comes near it. In turn, it has polluted the basin of the Río Magdalena, with the result that its mouth spews out pollution over dozens of kilometres into the Caribbean. In China, 80 per cent of industrial waste is discharged untreated into the rivers, so that now more than half the country's network of rivers are suffering from pollution. The Volga carries 42 million tonnes of toxic waste, and in developing countries 20 per cent of aquatic species are believed to have become extinct in recent years.

The Royal Society, along with thirty researchers from all over the world, has now sounded the alarm signal. Discharges of CO_2 into the atmosphere – a good third of which is absorbed by the surface waters – are acidifying the sea. The 20 to 25 million tonnes of additional carbon monoxide which dissolve every day in the ocean are changing the pH (a measure of the acidity level) of seawater. During the 20th century, the average pH of the oceans fell by 0.1 per unit, which is substantial. There may well be worse to come, for evolution is logarithmic: a fall of 0.3 to 0.4 is predicted by the year 2100. The sea will not have endured such a level of acidity for more than 20 million years. All marine life, already badly affected by global warming, is now facing ever greater dangers. Sceptics may like to know that the University of California recently produced evidence that the skeletons of organisms that form plankton – which lie at the very heart of all marine ecosystems – are becoming smaller and increasingly deformed. Researchers have also shown in laboratory tests that the shells of pteropods dissolve when seawater reaches the corrosive level predicted in 2100 for the southern seas, where acidity is and will be the highest.

This information is being supplied by some of the most prestigious research centres in the world. Reality must be faced: it is imperative that we reduce our

emissions of CO_2. We must stop plucking the golden goose, and we must also stop shrugging our shoulders and crying *que será, será*. The process is still reversible, but it requires the awareness and the cooperation of all of us. No generation has ever borne such a weight of responsibility on its shoulders. The sea, if we can preserve it, represents the future of the planet. The time has come to place our bets, knowing that we will get back a hundredfold of what we invest.

The sea is no longer the endless space that it once was, and it can no longer be the world's dumping-ground. According to the American Food and Drug Administration and some laboratories specializing in ecotoxicology, some species of fish, including shark and swordfish, now contain levels of methylmercury above 1 ppm (parts per million). This level can even rise to 8 ppm among some species of whale.

The European nations have set criteria for toxicological evaluation, and have specified the levels of concentration beyond which there is cause for alarm (EAC criteria); these levels have been exceeded in a large number of products at various places bordering the north-east Atlantic.

Heavy metals can accumulate in crustaceans and molluscs as well as in predatory fish, and they are passed on to humans. Organic substances – PCB (polychlorinated biphenyl), dioxins and certain pesticides, pharmaceutical and chemical products – are a threat to reproduction, even at low levels. PAHs (polycyclic aromatic hydrocarbons) are no less dangerous. Research has shown a correlation between precancerous conditions in the livers of North Sea flatfish and an environment where PAH levels are high. More and more cetaceans, especially dolphins, have been found dead on the shores, their immune systems destroyed by toxic substances carried out to sea by our rivers and sewers.

Large-scale use of chemical fertilizers, intensive farming and the massive increase in effluents that are rich in phosphates and ammonium have resulted in a proliferation of algae, either in the form of microplankton – which leads to the phenomenon known as 'algal bloom' (the cause of 'red tides') – or of macroalgae, leading to 'green tides'. These phenomena cause eutrophication of the coastal waters, and the resultant lack of oxygen literally stifles marine invertebrates and fish.

Human activity is endangering the flora and fauna of the sea, and in so doing it is also threatening the future of mankind. Our predatory ways are in the process of destroying nature's balance, for the sea is not infinitely renewable. Most marine life is concentrated in relatively shallow waters. Estuaries in particular – those waters most directly threatened by human pollution – are the true kindergartens of the sea. The damage being caused to these confined spaces, where 80 per cent of marine species are born, endangers the density of ocean life out of all proportion to the geographical area of the estuaries themselves. This is a phenomenon that is all too easily overlooked.

Under assault from mechanical diggers, the 'lungs' of all this biodiversity – the coastal marshlands, the muddy shores of the estuaries, the mangrove swamps, the coral reefs – are rapidly shrinking, to be replaced by concrete. Half the world's wetlands, both inland or coastal, disappeared during the 20th century, mostly over the last few decades. Nearly two-thirds of European and North American wetlands have been destroyed, while 85 per cent of those that remain in Asia are now rapidly disappearing. Between Kazakhstan and Uzbekistan, the Aral Sea has dwindled by 40 per cent over the last forty years, and now echoes with the agonized cries of a entire region that has been economically and irrevocably ruined.

Half the world's mangrove forests have also been destroyed. Some 60 per cent of the mangroves in Guinea and Ivory Coast, and 70 per cent of those in Liberia have been uprooted. In fifty years, the area of such forests in the Philippines has shrunk from 450,000 hectares to 120,000; in Thailand from more than 300,000 to 190,000; in Vietnam from 250,000 to 130,000. Mangroves have disappeared completely from many islands in the Caribbean, the Indian Ocean and the Pacific.

No less than 70 per cent of the Earth's coral reefs are now endangered, either directly by human intervention or by the effects of global warming and pollution. The destruction of these natural habitats – the coral reefs, the wetlands, the mangrove forests – lowers the reproductive rate of flora and fauna, and also exacerbates the damage caused by atmospheric disturbances to the coastal environment.

The cyclone that struck the east coast of India in October 1999, causing a tsunami that penetrated 50 kilometres inland and killed some 10,000 people, would have wrought less havoc if the coast had been protected by its former mangrove forests. As for the even more devastating tsunami of 26 December 2004, it only adds fresh evidence to the findings of the US National Oceanographic and Atmospheric Administration that the number of exceptional natural catastrophes has increased by 20 per cent since 1990.

Individuals also play a part in the destruction of the environment. The drink and food containers left on our

5 The Ocean Under Threat

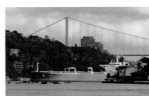

VENEZUELA, ORINOCO

The Orinoco crosses Venezuela and joins the Atlantic, where it meanders along 350 km of coast in the vast Amacuro Delta. This mixture of marshes, mangroves and lush forests covers 25,000 km². It also contains a network of canals, on the banks of which live nearly 20,000 Warao Indians, masters of the pirogue. Small, light, and low in the water, these boats weave their way through the labyrinth of canals. Such manoeuvring is child's play to the Warao, who from a very early age entertain themselves in the artificial waves created by the wake of the cargo ships that sail up the river.

INDONESIA, JAKARTA

In the Sunda Kelapa docks in Jakarta, where you can see lines of these traditional wooden schooners, time seems to have stood still. These boats, combining sails and motors, are the work of the Bugis, one of the peoples of Sulawesi, who are master joiners and shipbuilders. Long ago, such ships carried cargoes of spices originating from the islands of Indonesia and destined for Europe, but now they take wood to Borneo – a four-day journey. The wood is unloaded onto the backs of the men, along a narrow, shaky gangway. But the overexploitation of these valuable woods, which are used to make furniture, is making some tropical species increasingly rare.

EGYPT, NILE DELTA

Since time immemorial, Egyptians have sailed along the Nile. Blocks of stone and whole obelisks were transported from Aswan to the pyramids in wooden boats with a draught of barely 50 cm. The boats unloaded their cargo at the foot of the construction site, and it seems there was nothing they could not carry. In the wake of their ancestors, these feluccas with their load of large stones sail between the sandbanks of the river. Even today, transport by such sailing boats is still viable, but modern barges are increasingly replacing the majestic feluccas with their great white sails, and many of these have already been abandoned on the banks of the Nile.

TURKEY, ISTANBUL, THE BOSPORUS

The shipping route between the Black Sea and the Mediterranean runs through the Bosporus Strait, a pinched and winding arm of the sea that runs longitudinally through Istanbul. One of its shores is in Europe, and one in Asia. The narrowness of the channel, the volume of shipping, and the hazardous nature of some of the cargoes make it one of the most dangerous passages in the world to navigate. But despite the known risks, captains who use the Bosporus are under no obligation to employ the services of a pilot. In the course of the last few decades, the strait has been the scene of several serious accidents, including ships running into the banks.

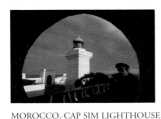

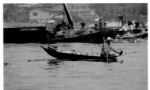

 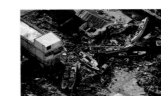

MOROCCO, CAP SIM LIGHTHOUSE

On all the shores of the world, mankind has built lighthouses to guide sailors towards the land, and to help them avoid the perils of the sea. In every country, there are look-out posts. But uniformed keepers are becoming a rarity in our time, removed from their watchtowers by the increasing automation of lighthouses. Out on the open sea, when the horizon is desperately dark and there is no glimmer of light to betray a sign of human life, salvation now comes increasingly from the skies. Distress signals, whose calls for help are caught and relayed to the land by satellite, pinpointing the exact position of the endangered ship, have revolutionized rescue at sea.

THAILAND, BANGKOK

Despite appearances, the grim-looking oil tankers that ply the oceans are responsible for only a small proportion of marine pollution. The bulk of this (70 per cent) in fact comes from the land, through discharges into the rivers and estuaries. Worldwide, only one town in ten collects and purifies its waste water. Elsewhere, everything is discharged into rivers and seas, transforming them into vast open-air sewers. In poor countries, there are even people who will search through the sewage for anything that might be worth keeping or selling. When the detritus floats on the rising tide, the search is often conducted by pirogue.

IRELAND, ARAN ISLANDS, INISHEER

Exhausted sailors, the heavy increase in maritime transport, dilapidated ships, and disdain for the rule of law – these are the main causes of accidents at sea. On average, two large ships are wrecked every week, and fishermen at sea are thirty times more likely to be killed at work than people in ordinary jobs. But not all disasters have a tragic outcome, as can be seen from the improbable adventure of Tavac. On 15 March 2002, he left Tahiti on a day's fishing trip, but proceeded to drift for four months, all alone in his 8-metre boat, buffeted by storms and with hardly any water, until he ended up on Cook Islands, 1,200 km away from his point of departure. He was saved by his faith and his knowledge of the sea.

INDONESIA, MEULABOH, TSUNAMI DAMAGE

The tsunami in south-east Asia destroyed the fishing industry in several countries on the Indian Ocean. Thousands of fishermen disappeared, 80 per cent of their boats were wrecked, and hundreds of fishing ports and business were ruined. After the catastrophe, faced with very high demand, a large number of inexperienced ship-builders – sometimes simply furniture-makers – constructed boats that did not meet safety standards. Those fishermen who escaped the tsunami are now risking their lives on badly designed boats that have replaced those which they lost in the disaster of 26 December 2004.

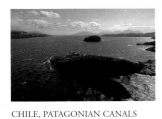

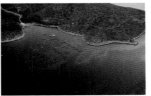

CHILE, PATAGONIAN CANALS

The steady increase in maritime traffic has been accompanied by a concomitant growth in the number of crimes and accidents at sea, with severe consequences for human life, the environment, and the character of coastal regions. Most of the public are unaware that increasing crime on the high seas has become a major problem, in particular through illegal immigration, drug smuggling and terrorism, as exemplified by the attacks on the USS *Cole* in October 2000, the French oil tanker *Limburg* in Yemen in October 2002, and more recently *Superferry 14* in Manila Bay, with more than a hundred people killed or unaccounted for.

MAURITANIA, HARBOUR OF NOUADHIBOU

Countless wrecks and decommissioned fishing boats, rusted to their very core, obstruct the approach to the Mauritanian port of Nouadhibou. A bitter consequence of the overfishing that plundered the Saharan coasts of Africa and decimated stocks of fish, more and more of the old redundant boats are being abandoned on the shore. Added to this dereliction is the phenomenon of silting, caused by the advance of the western fringes of the Sahara, which prevailing winds are driving towards the Atlantic. Little by little, the sea and its fish are withdrawing from Nouadhibou, leaving the grotesque hulks half-buried in the sands of the desert.

MEDITERRANEAN, POLLUTION

Not far from these aquaculture farms, a film of hydrocarbons gives an unhealthy glow to the surface of the water. Illegal dumping in the Mediterranean has reached alarming proportions: every year, merchant and passenger ships dump an amount of waste equivalent to 50 *Erikas* or 15 *Prestiges*, polluting between 75,000 and 150,000 km² of the sea. Heavy metals and carcinogenic substances from these waste materials poison the natural environment and the flora and fauna, and accumulate in the food chain. One can only view with cynicism the fact that the Mediterranean has been declared by the Marpol Convention to be a Special Marine Zone in which the dumping of hydrocarbons is subject to a total ban.

USA, CALIFORNIA, POINT REYES

Chemical products have invaded our lives. Some 63,000 substances are being used throughout the world, and every year a thousand new synthetic molecules come on the market. By way of rain and rivers, countless chemicals are contaminating the oceans. Some are non-biodegradable, and accumulate in the tissues of live organisms within the food chain, at the head of which is man. These pollutants have also been identified as the cause of endocrine and reproductive problems in marine mammals and also polar bears. But these sea lions, lazing on a private beach that can only be reached from the sea, seem blissfully unaware of the dangers.

NORWAY, SPITSBERGEN

The ocean and all the species that depend on it, from plankton to polar bears, will be irreversibly affected by global warming. An increase in the temperature of the water, the bleaching of the coral, the damage caused by coastal storms, the retreat of the ice floes, reducing the salinity and affecting the movement of land masses in the ocean, the rise in sea level and the acidification of the waters will all change countless habitats and are already threatening large numbers of species. The confirmation in July 2005 that the Greenland glaciers are melting at an unprecedented rate is just one more proof that climate change is now an alarming fact of life.

FRANCE, BATZ-SUR-MER, POLLUTION FROM THE *ERIKA*

On 12 December 1999, the wreck of the *Erika* resulted in 20,000 tonnes of heavy fuel oil being spread along 400 km of French coastal waters, from south Finisterre to Charente-Maritime. An army of volunteers, like these people holding up the dead bodies of oil-covered birds, fought long and hard against this slimy pestilence. And yet these black slicks represent only a minute proportion of marine pollution. Of the 6 million tonnes of substances that pollute the oceans every year, only 2.5 per cent come from accidents involving oil tankers, whereas 30 per cent are the result of dumping. The rest stems from land-based industrial waste and from the great cities, the atmosphere, natural wastage from underground, and offshore oil production.

FRANCE, BAY OF DOUARNENEZ

There are some sheltered, shallow coastal bays which are fed by rivers overloaded with nutrients – notably nitrates originating from agricultural concerns – and which combine conditions that are ideal for the proliferation of algae. This abnormal abundance colours the water green (and sometimes red). Apart from the fact that they are something of an eyesore, the green tides stifle the environment and have a damaging effect on its biodiversity. This process is known as eutrophication. In the most badly effected coastal regions of France, strict controls over the amounts of fertilizer spread over the fields, and treatment of domestic and industrial waste, are important weapons in the fight against green tides.

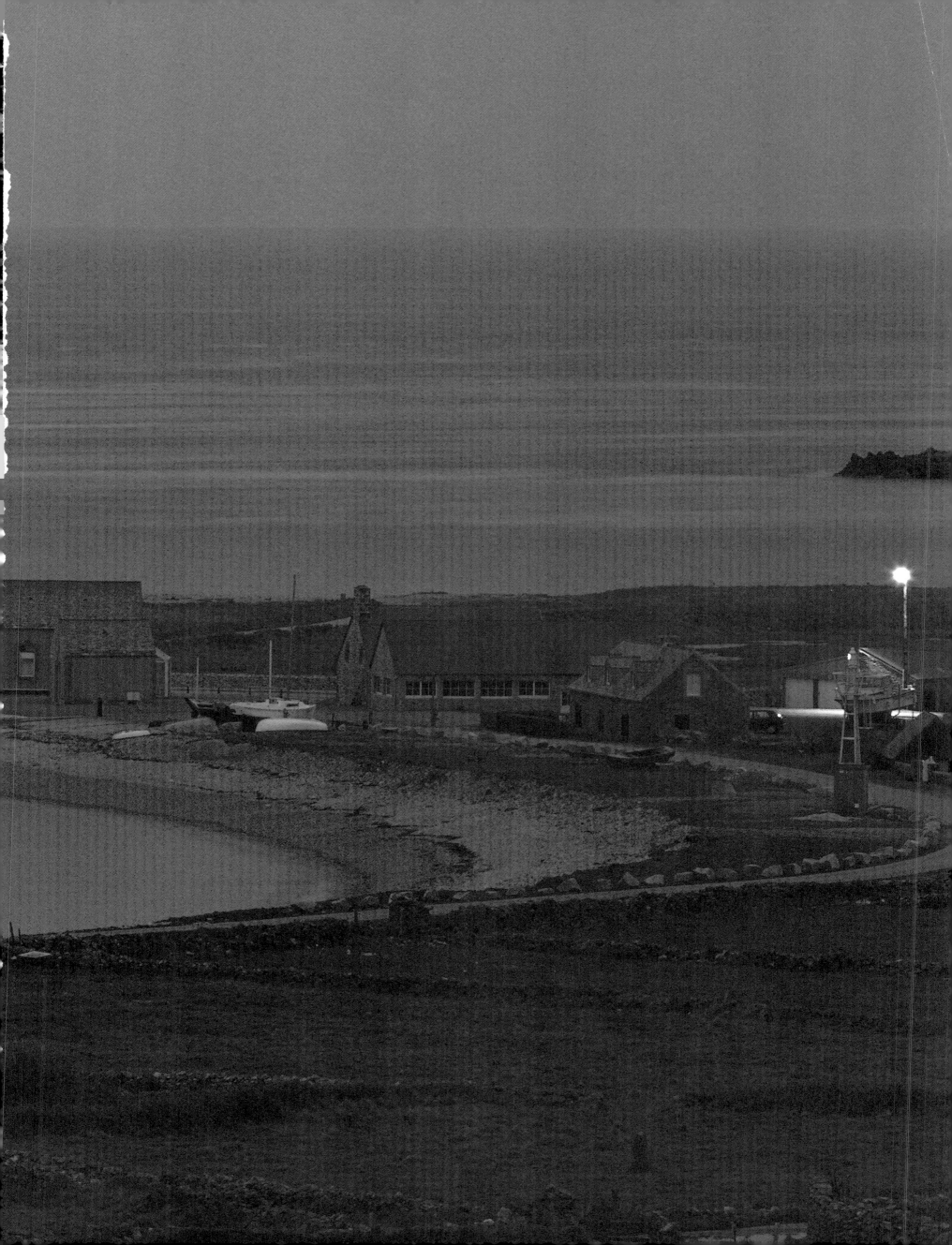

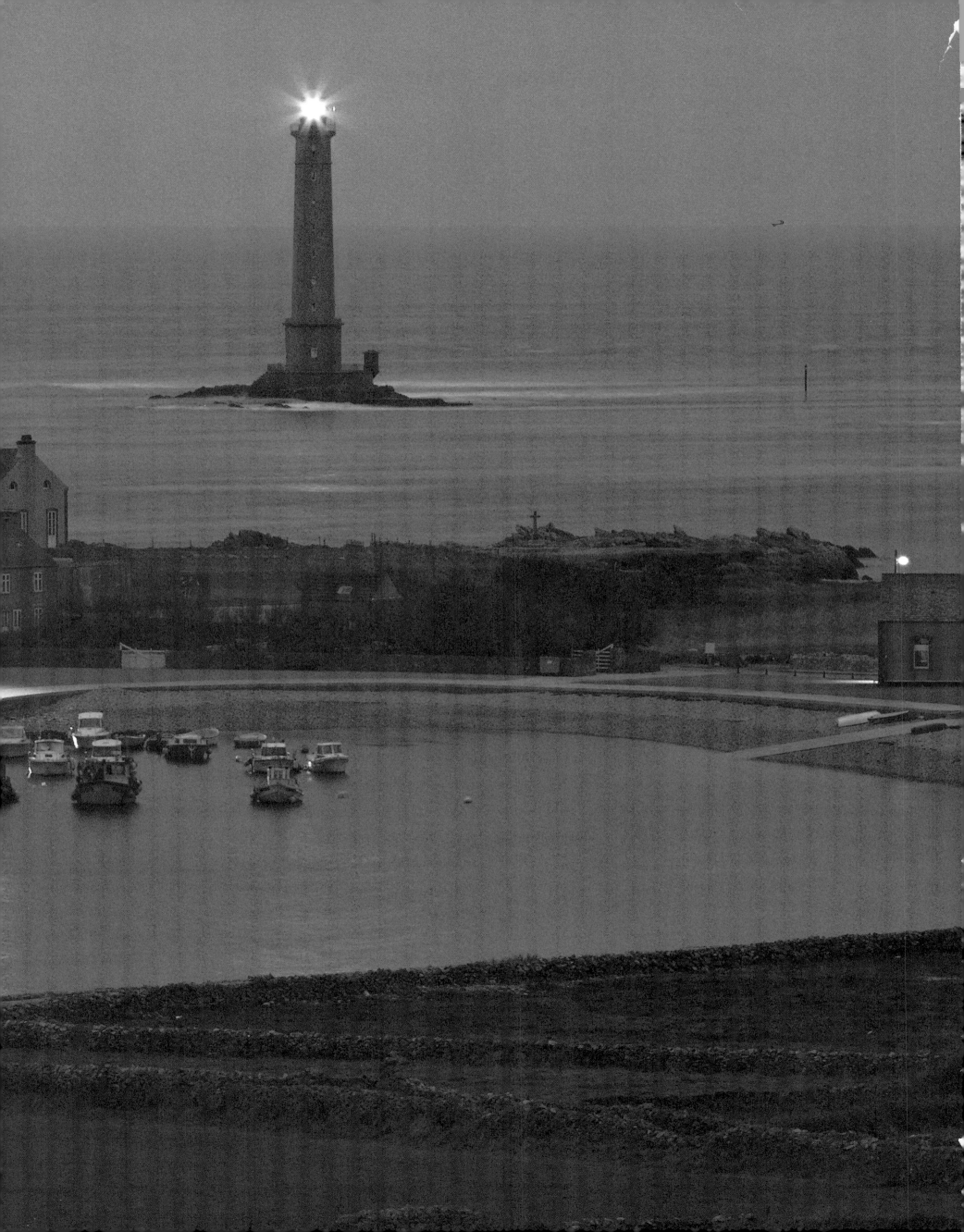

beaches are typical of the growing problems posed by waste. It is a pity that people cannot actually see the seabed littered with garbage. A study carried out in the Bay of Biscay – an area that is considered to be one of the *least* polluted – has shown that between 20 and 200 metres down, there are at least 50 million individual items of waste, most of them plastic and non-biodegradable. Their impact on marine life is considerable: they kill birds and turtles, which often mistake plastic bags for jellyfish, and whales and dolphins also die when they consume these objects.

Digging for shellfish on beaches damages microorganisms; underwater hunting – if practised irresponsibly – reduces the stocks of the many species of fish that live among the sedimentary rocks; collecting shells and corals as souvenirs is simply pillage; and the thousands of pleasure boats dropping their anchors wreak havoc among the coral reefs and the rich plant systems of the undersea kingdom.

There is one activity in particular which on the surface seems innocent and natural but which, when done to excess, constitutes one of the most serious threats to the future of the human species: fishing.

Stocks of some fish have already been reduced beyond the sustainable limits. In some of the coastal regions of Europe, two-thirds of the sixty most common commercial species have been exploited to the verge of extinction. Now that overfishing has decimated these traditional species, attention has turned to other creatures, especially those that live in deeper waters – different varieties of shrimp, for instance – which are particularly vulnerable because of their low rate of reproduction. There are signs that this deep-sea trawling has already caused large-scale damage, and that in most cases overexploitation has also gone beyond safe biological limits.

Current legislation has laid down a minimal size for some species, and fish must be thrown back in the water if they are below the minimum, but in general these do not survive to adulthood. Such rejects are, by definition, smaller than the fish that are landed, but in terms of weight they often represent half the catch, which means a considerably larger number of individual fish are rejected – a huge loss and waste of life. This state of affairs is all the more worrying because it will also lead to a drop in the size of these species. Rigorous measures must guarantee the maintenance of fish stocks, and this is also imperative for the future of the fishermen themselves, whose job is the most dangerous of all.

Every year, 24,000 fishermen die in the course of their work. Even in the most developed countries, where safety is of prime importance, fishermen are just as much at risk. Every year some 150 trawlers from the European Union are wrecked. In France, the death rate among these workers is

2 per cent – four times greater than that of construction workers, whose job is rightly regarded as one of the most dangerous. This 2 per cent is in fact forty times higher than the national average. There are more than 3,000 accidents a year among 22,000 professional fishermen in France, which means that one in seven will become a victim.

Behind these appalling statistics lies the fact of overfishing. Nowadays, it is necessary to fish for a longer period of time in order to keep up with demand, and expeditions are more frequent and take place in all weathers. This is not only dangerous but also expensive, because the price of fuel continues to rise. Fishermen are the prime victims of overfishing, and they are worthy of greater consideration.

The picture is a grim one, and there needs to be infinitely more transparency; people must be provided with the facts, so that they can adjust their behaviour accordingly, and also put pressure on the politicians to implement policies that will lead to lasting development. They should know that the World Health Organization already logs some 250 million cases a year of gastroenteritis and respiratory diseases resulting from contamination through bathing in polluted waters. In the sea, pathogenic bacteria can survive for days or even weeks, and some viruses live for months. Research has shown that even in moderately polluted waters (still rated as 'acceptable' by the standards of the EU and the US Environment Protection Agency), the risks of contamination from a single swim are as high as 5 per cent.

The consumption of contaminated shellfish also has disastrous effects both on health and on the economy. Seafood is believed to be responsible for 11 per cent of all digestive ailments in the United States, 20 per cent in Australia, and 70 per cent in Japan. Two and a half million new cases of hepatitis are recorded every year, with some 25,000 deaths and 25,000 people permanently affected. Poisoning through algae (ciguatera, *Dinophysis*, *Alexandrium*) is also significant: it is estimated that there are 200,000 cases a year in a world population of 6 billion.

The balance of nature is already precarious, and unless draconian measures are taken today, demographic growth will result in a veritable explosion tomorrow. It is predicted that there will be 8 billion people by 2020 and 9.3 billion by 2050, and so the problems listed here will simply increase proportionately. Waste, whether from agriculture, industry or individuals, will reach unheard-of levels.

This demographic growth will weaken the ocean's defences even further, since inevitably there will be more and more development on the coasts. Today, 60 per cent of the world's population lives on a coastal band 60 kilometres wide, representing just 15 per cent of the Earth's surface; within twenty years, that figure will increase to 75 per cent.

Bangkok, Mumbai, Buenos Aires, Cairo, Jakarta, Lagos, Los Angeles, New York, Shanghai, Manila, Tokyo, along with many other towns, will turn into coastal megacities, and one of their countless problems will be the quantity and the quality of water they need. Demographic pressure will simply exacerbate the existing health problems connected with the polluted waters in many regions of our planet.

Along with the density of the world's population we can add the predictable rise in tourism. Today the Mediterranean welcomes some 135 million tourists (about a third of the international total), and by 2023 this number will have risen to 235 to 253 million. This influx will affect not only countries like France, Italy and Spain, but also places like Morocco, Tunisia, Greece, Turkey and Croatia, where there will be a massive rise in the tourist industry. Numerous regions have been earmarked for development, and most of them will be in danger of losing their biodiversity by the year 2020.

At the same time, sea traffic, which has already increased 4.7 times since 1970, will continue to grow. There may be a positive side to this, but safety precautions are paramount, since the risk of accidents rises according to the density of traffic.

What is urgently required is an environmental maritime policy. The credibility of nations is at stake here, for all citizens have every right to be protected. The dangers can be contained, if governments and citizens have sufficient determination to deal with the three components of sea pollution: transport, dumping, and waste emanating from the land. Solutions can be found to the problems in these areas, but it is primarily a question of political will, and this depends to a large degree on public awareness of the issues.

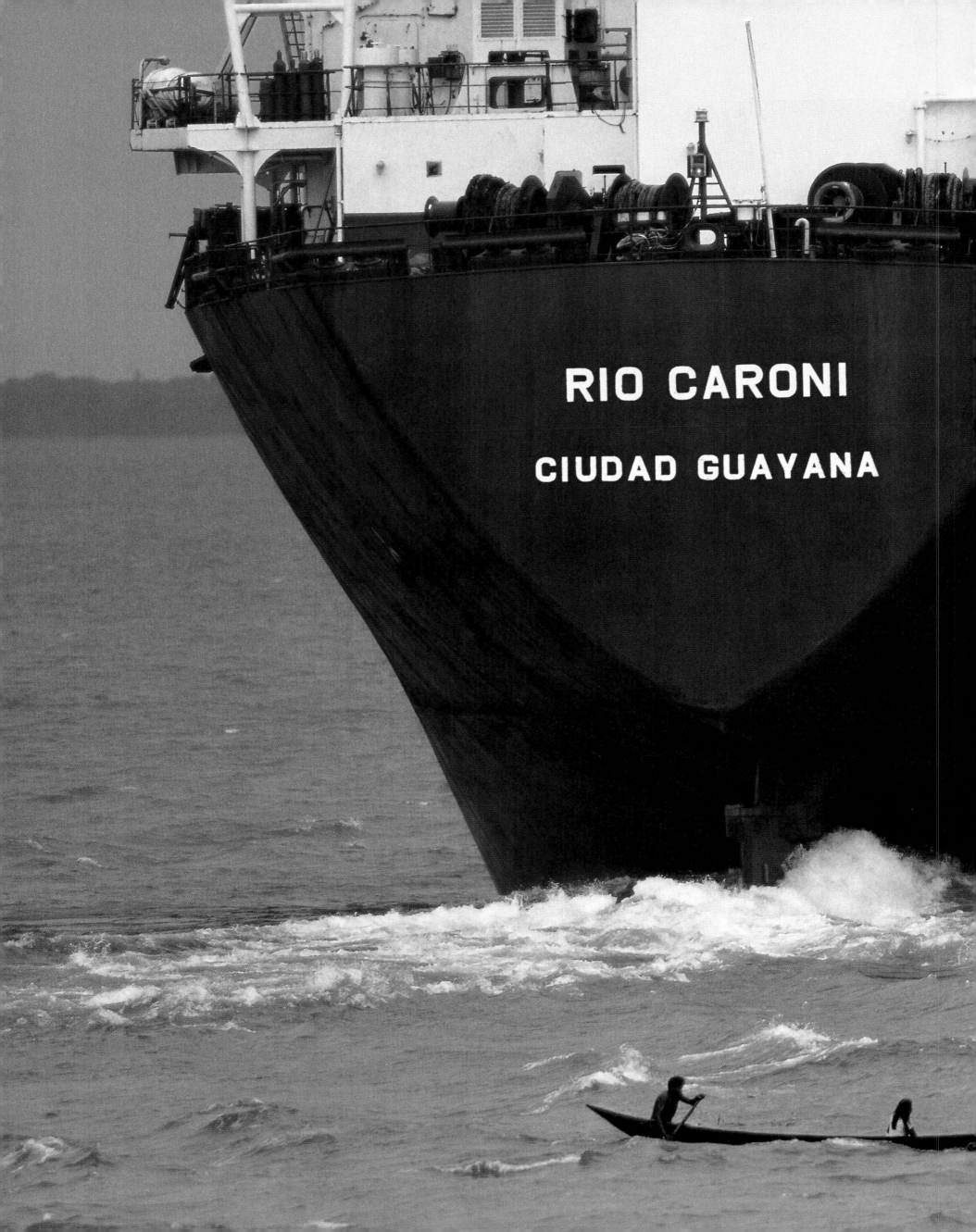

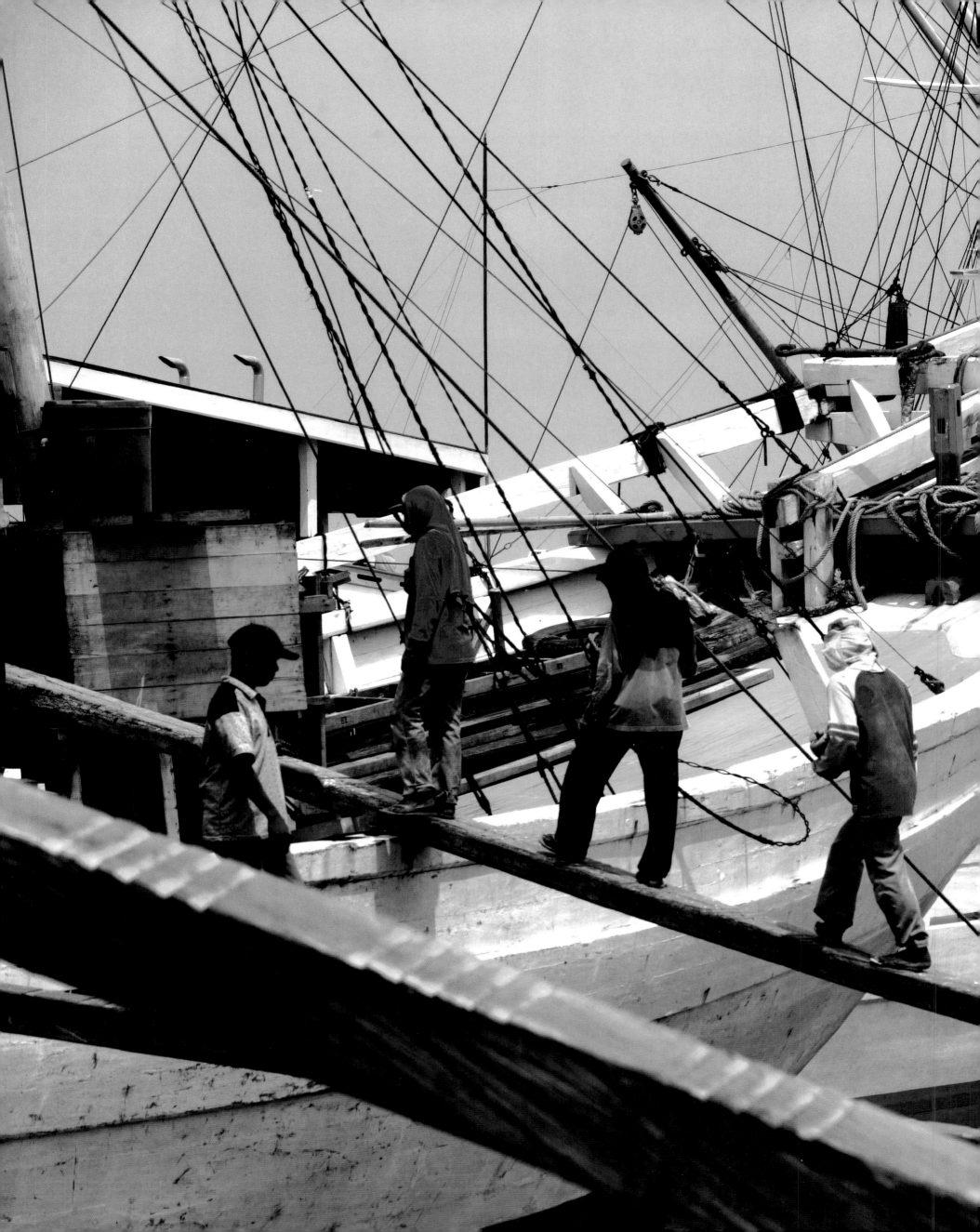

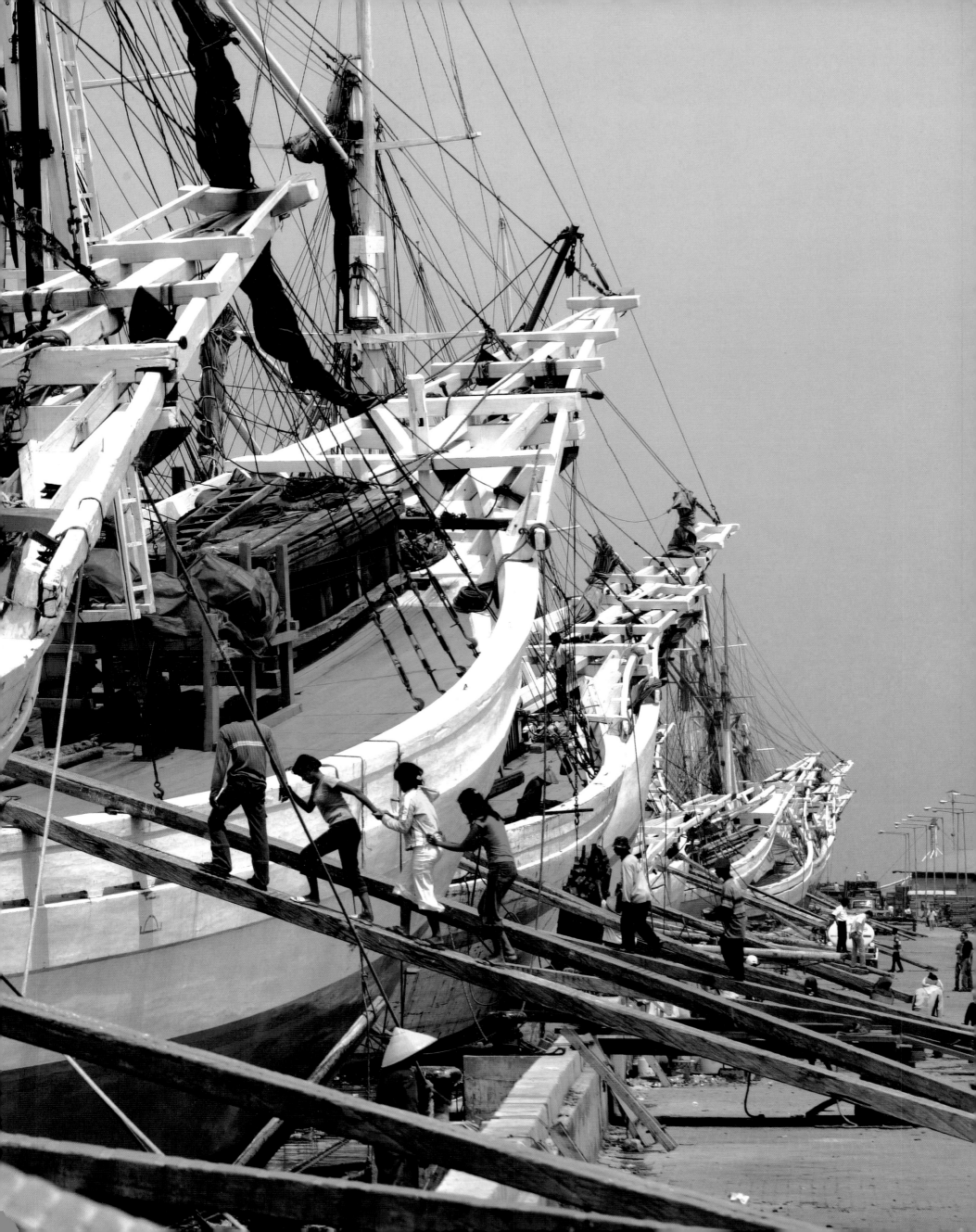

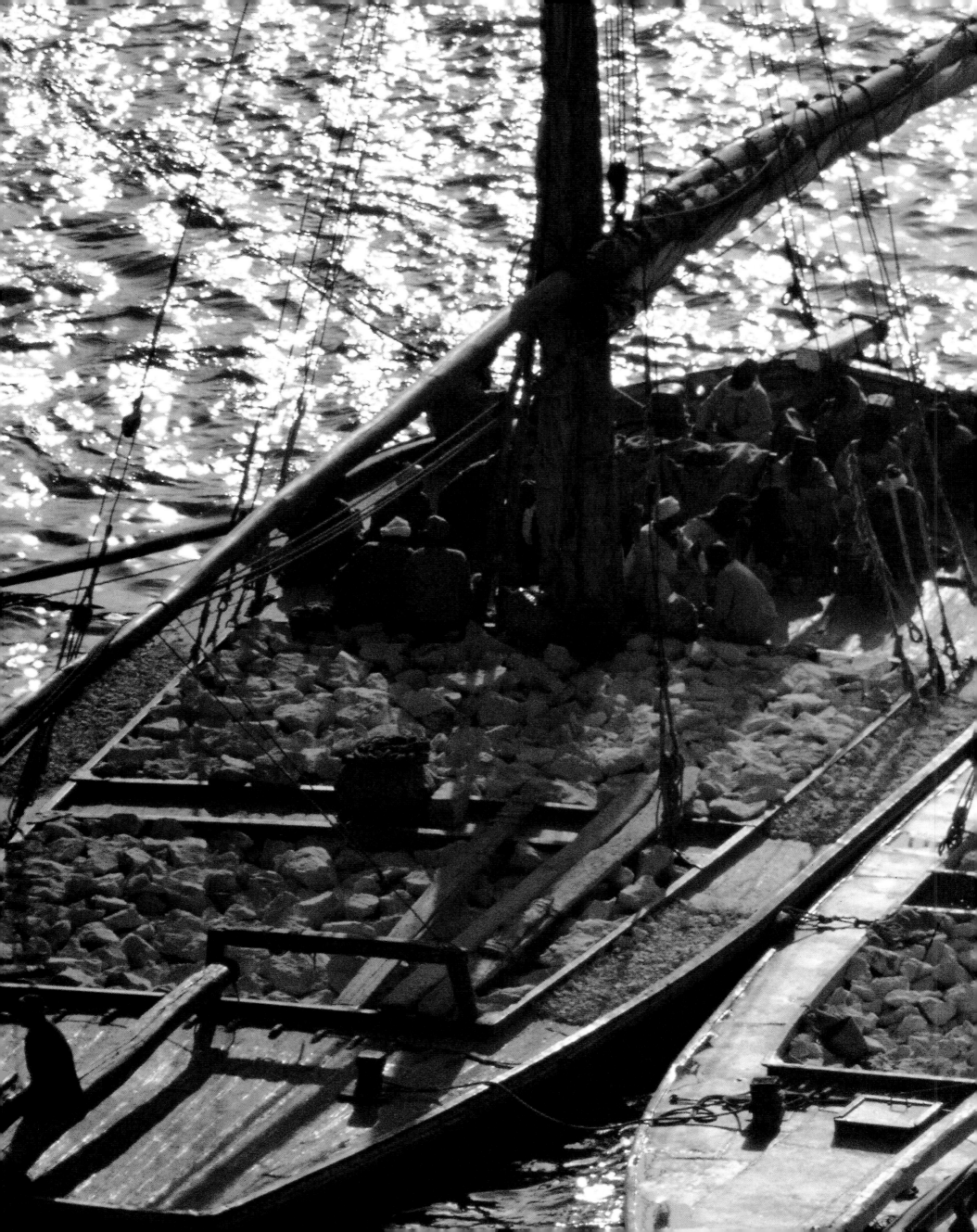

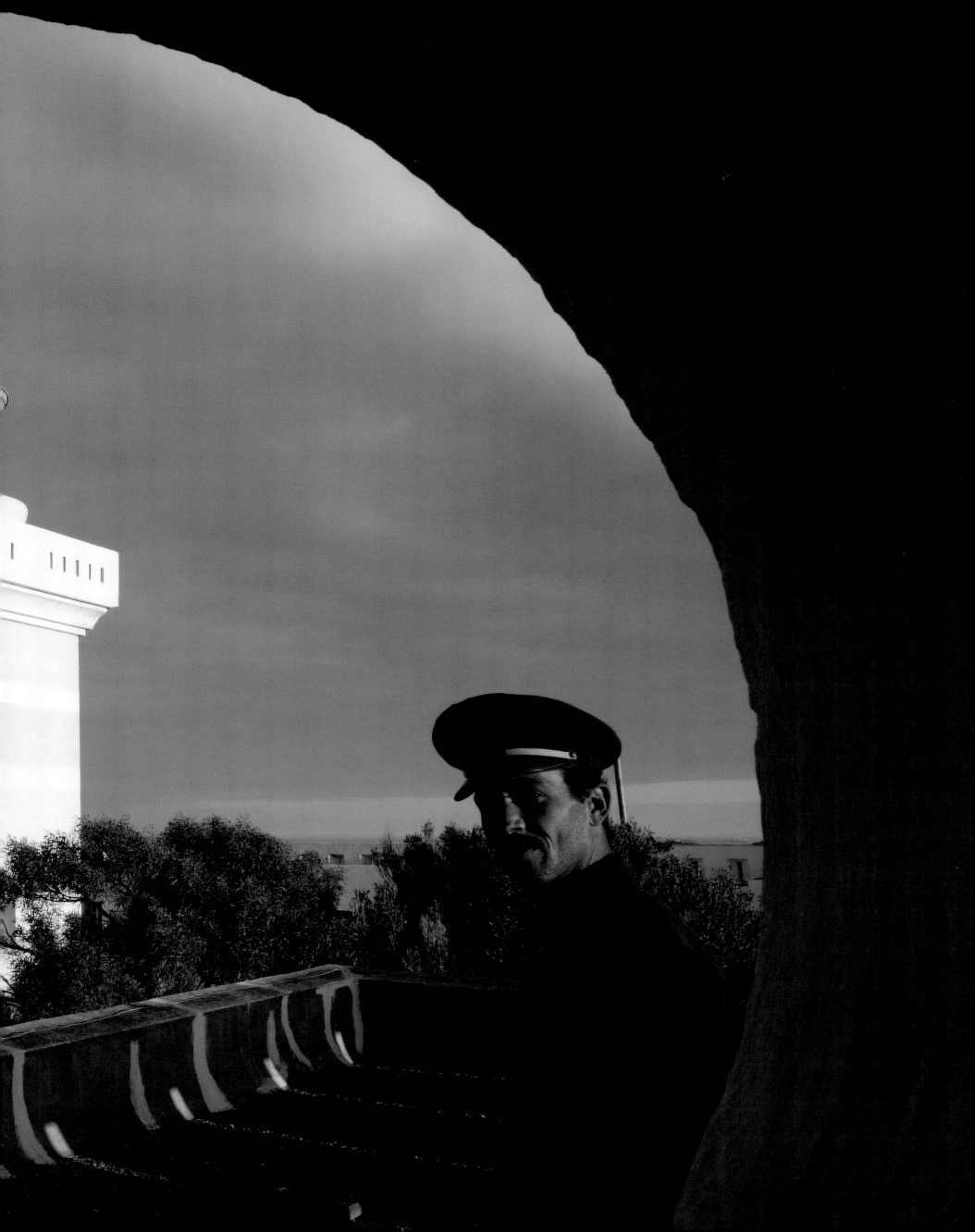

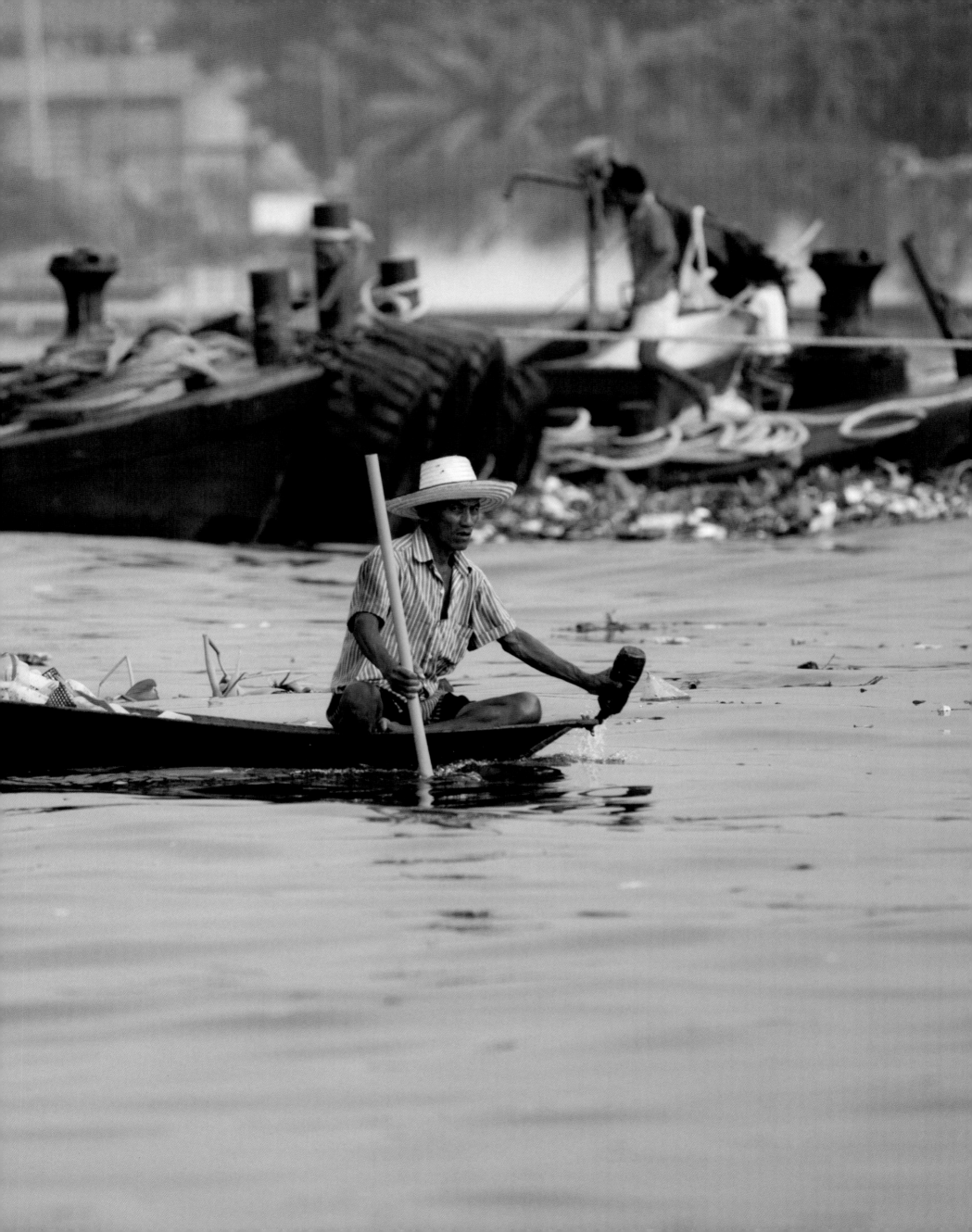

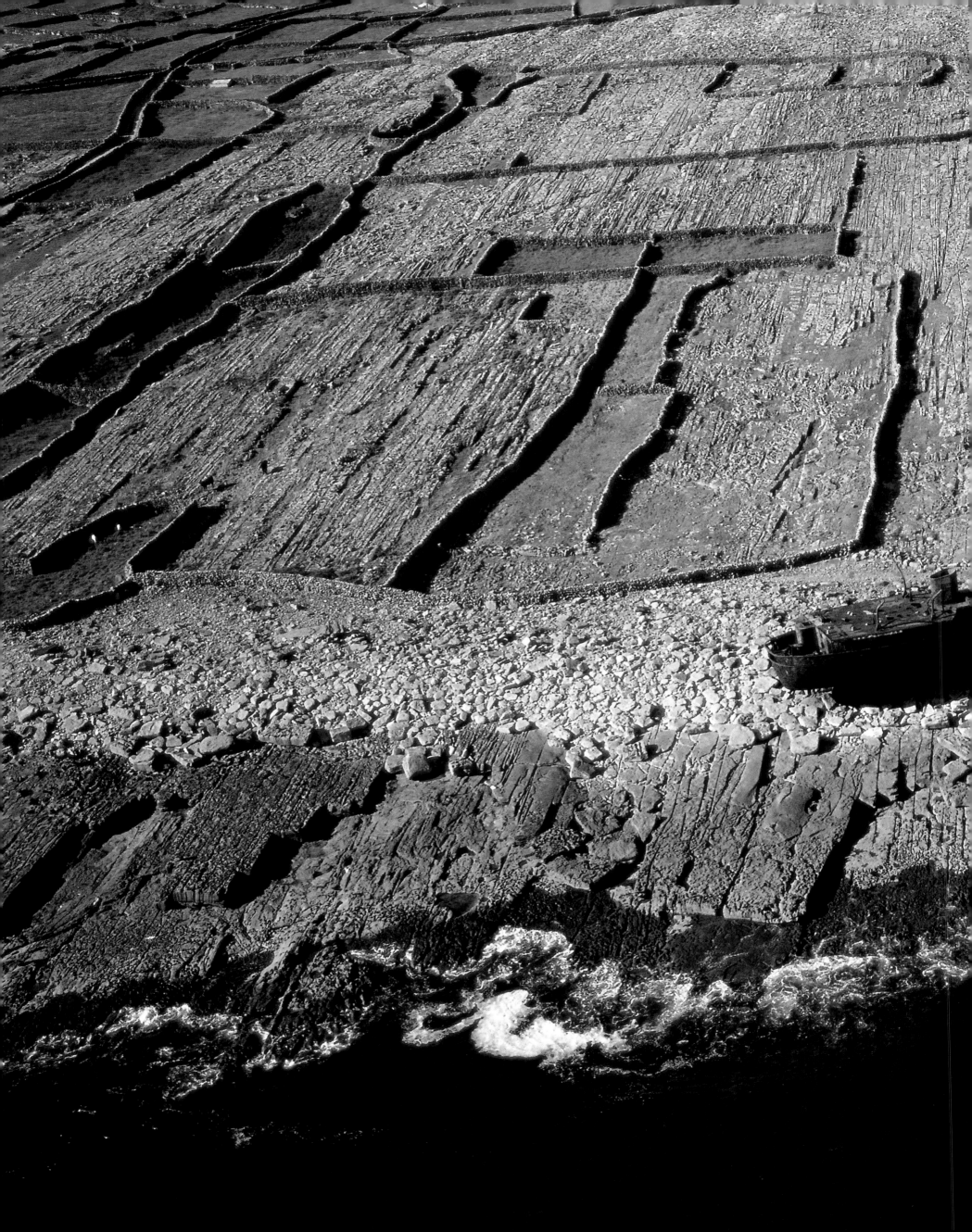

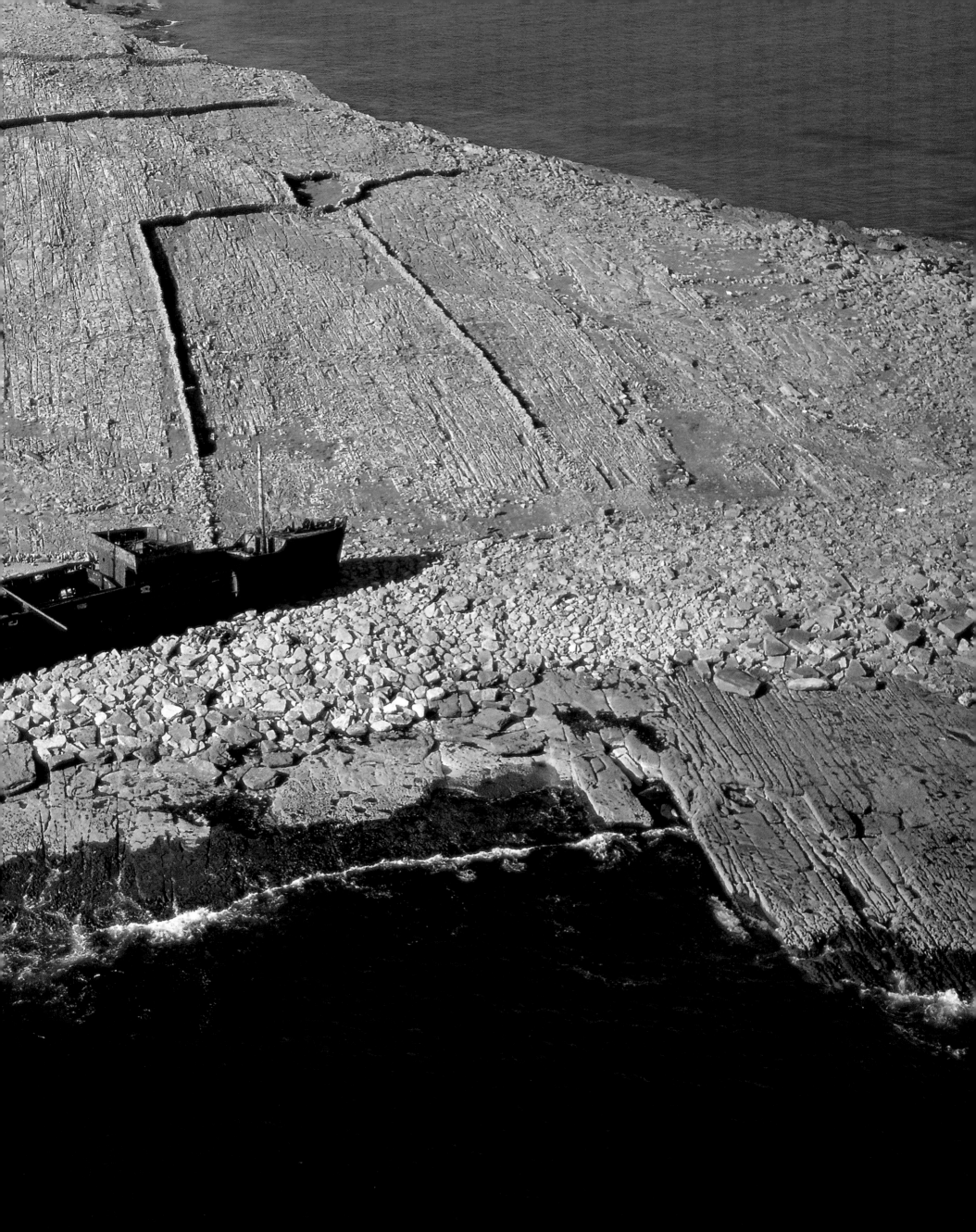

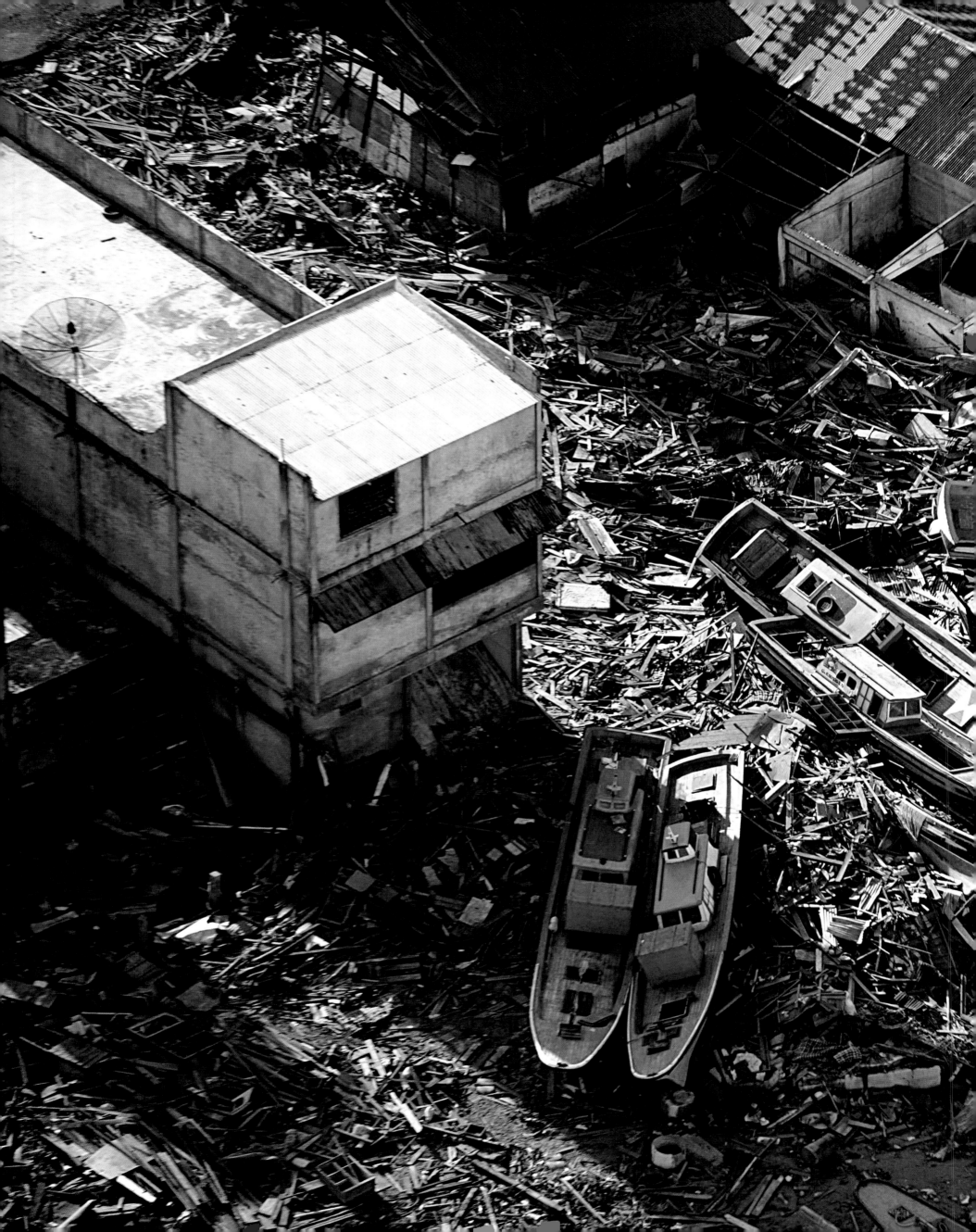

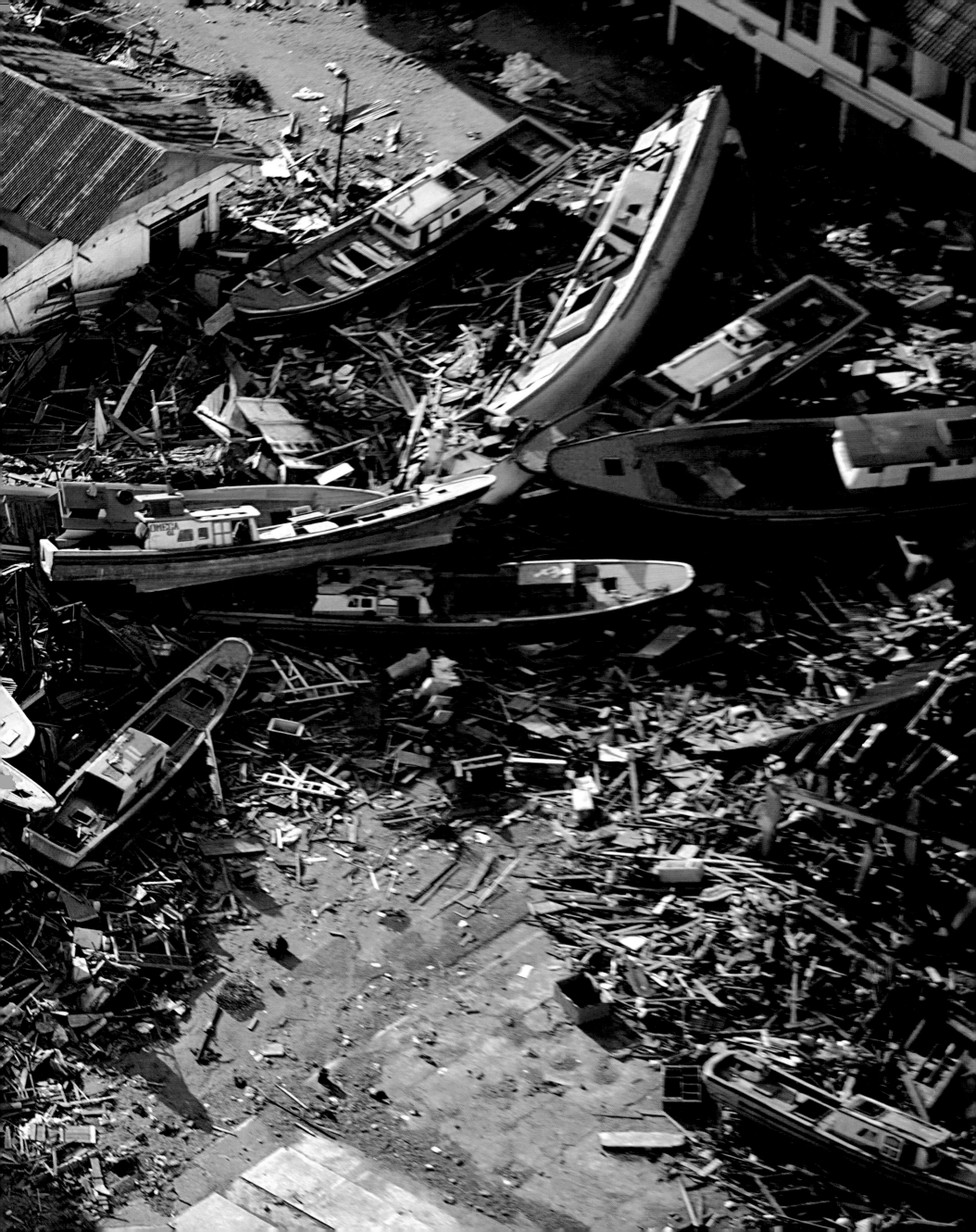

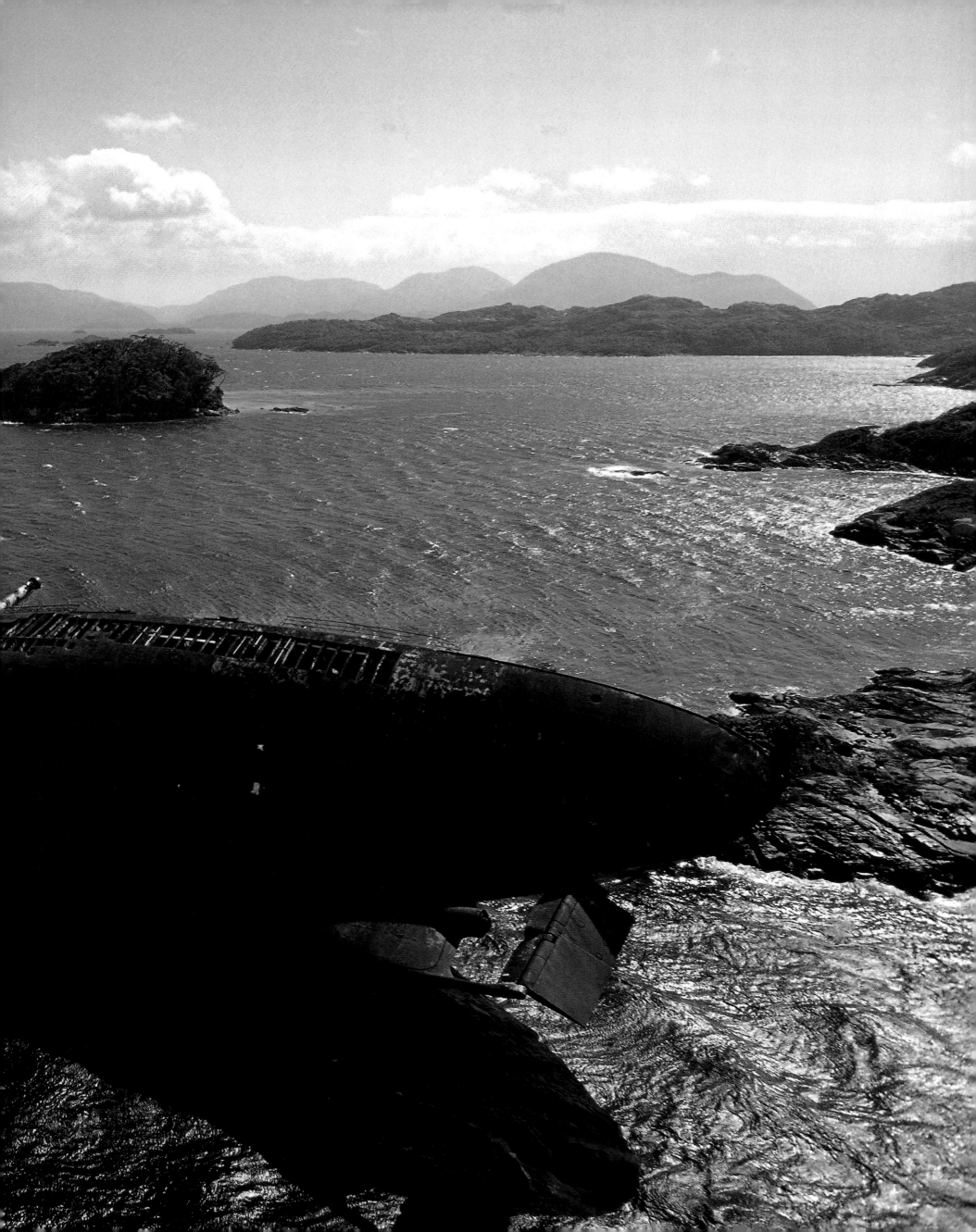

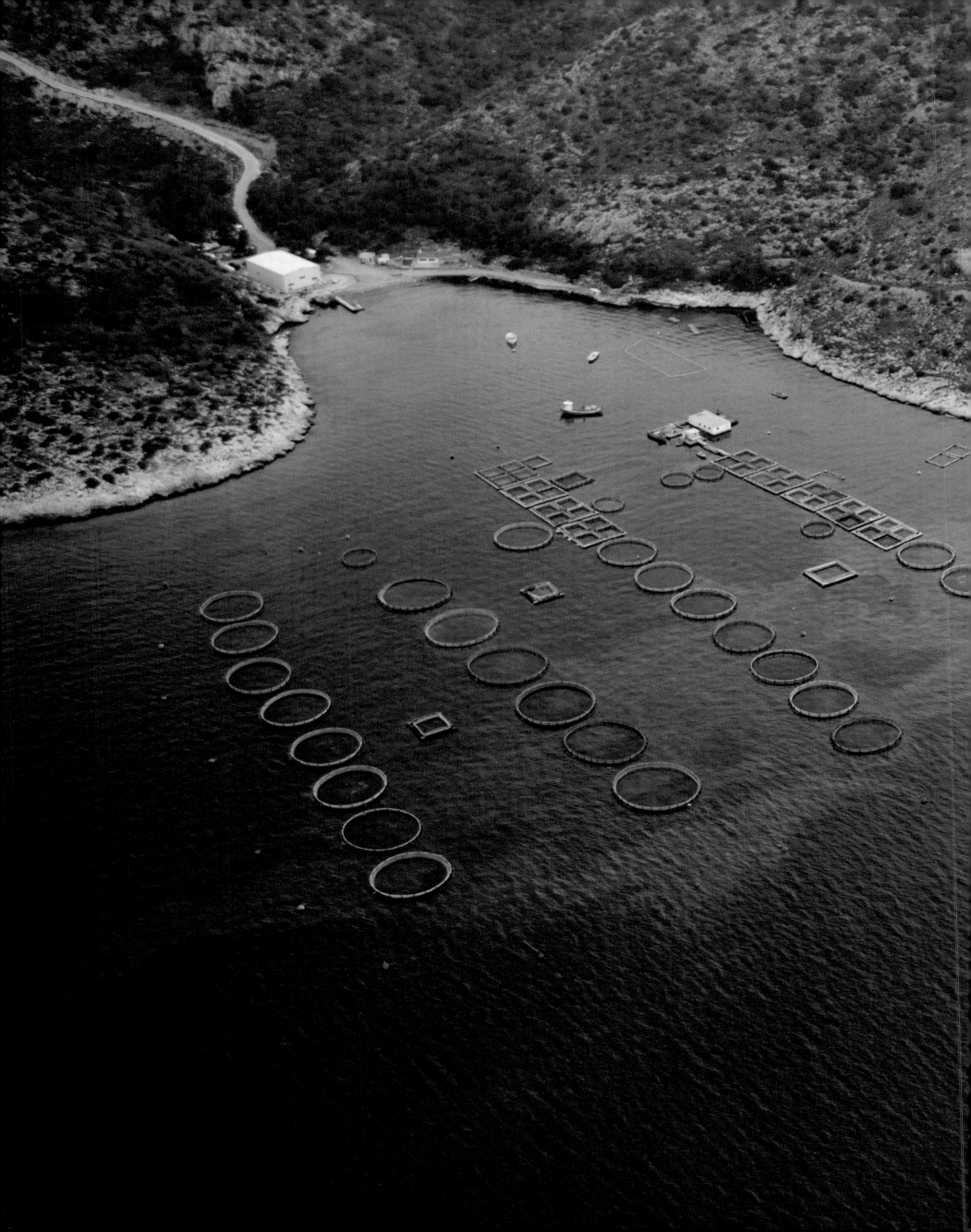

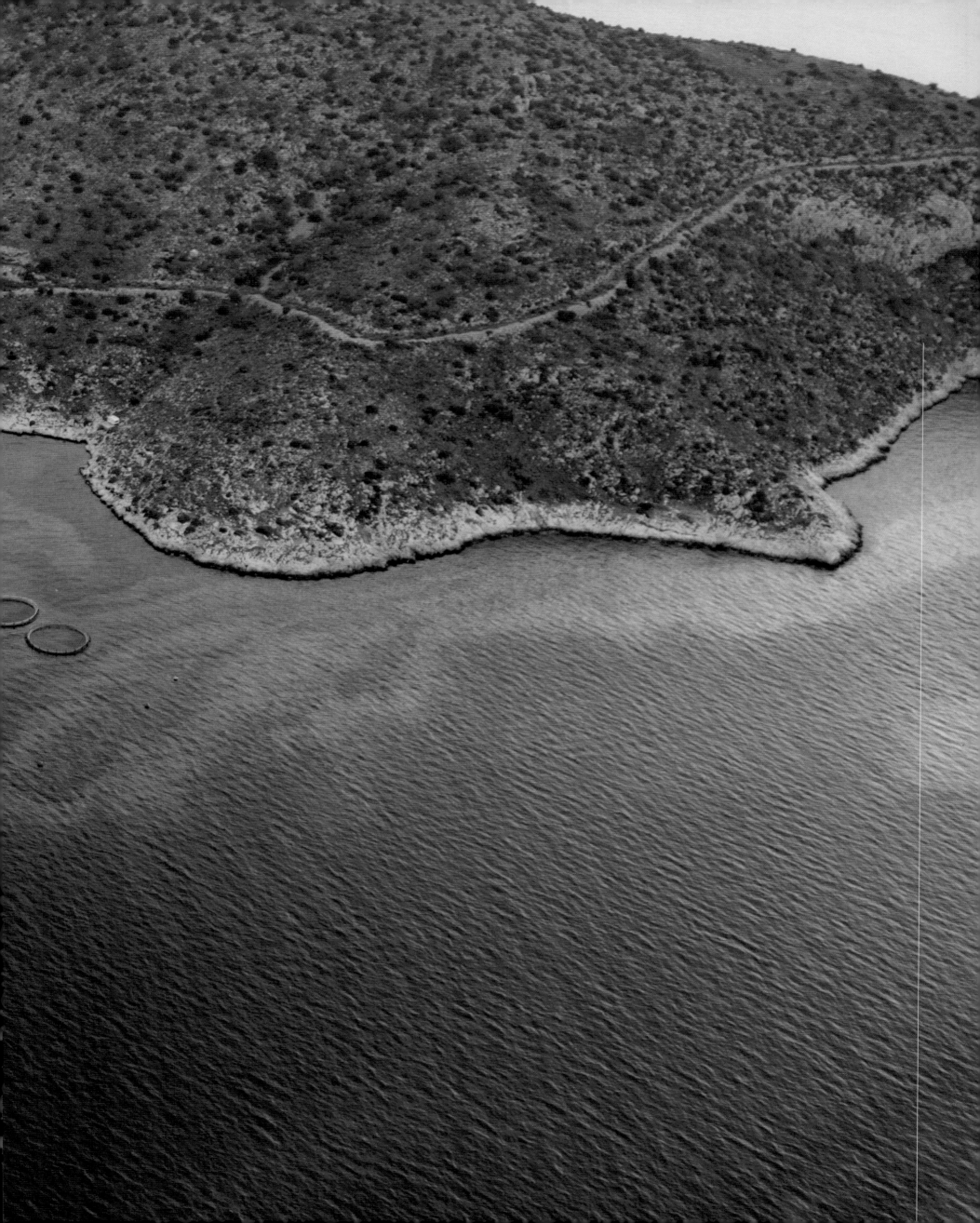

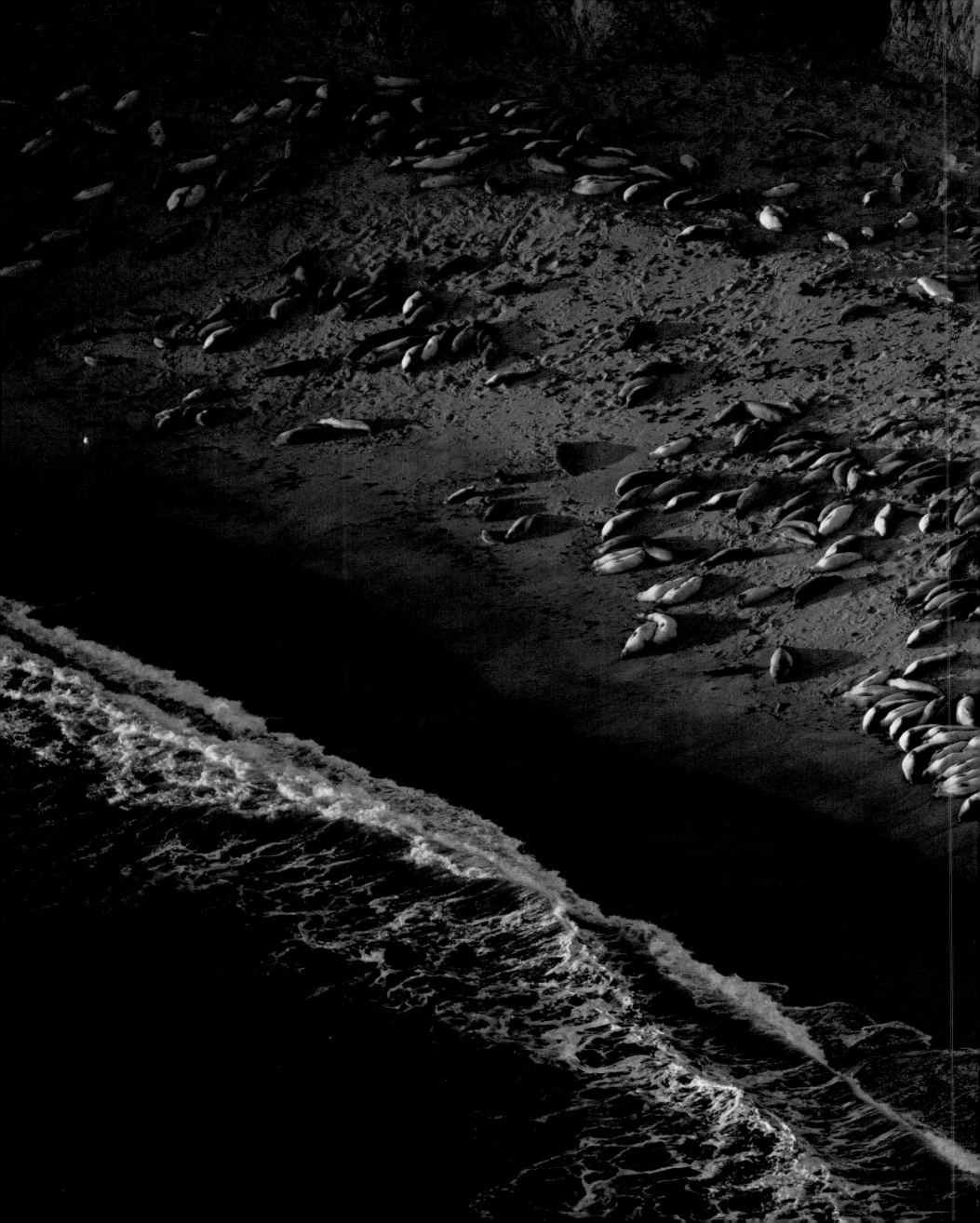

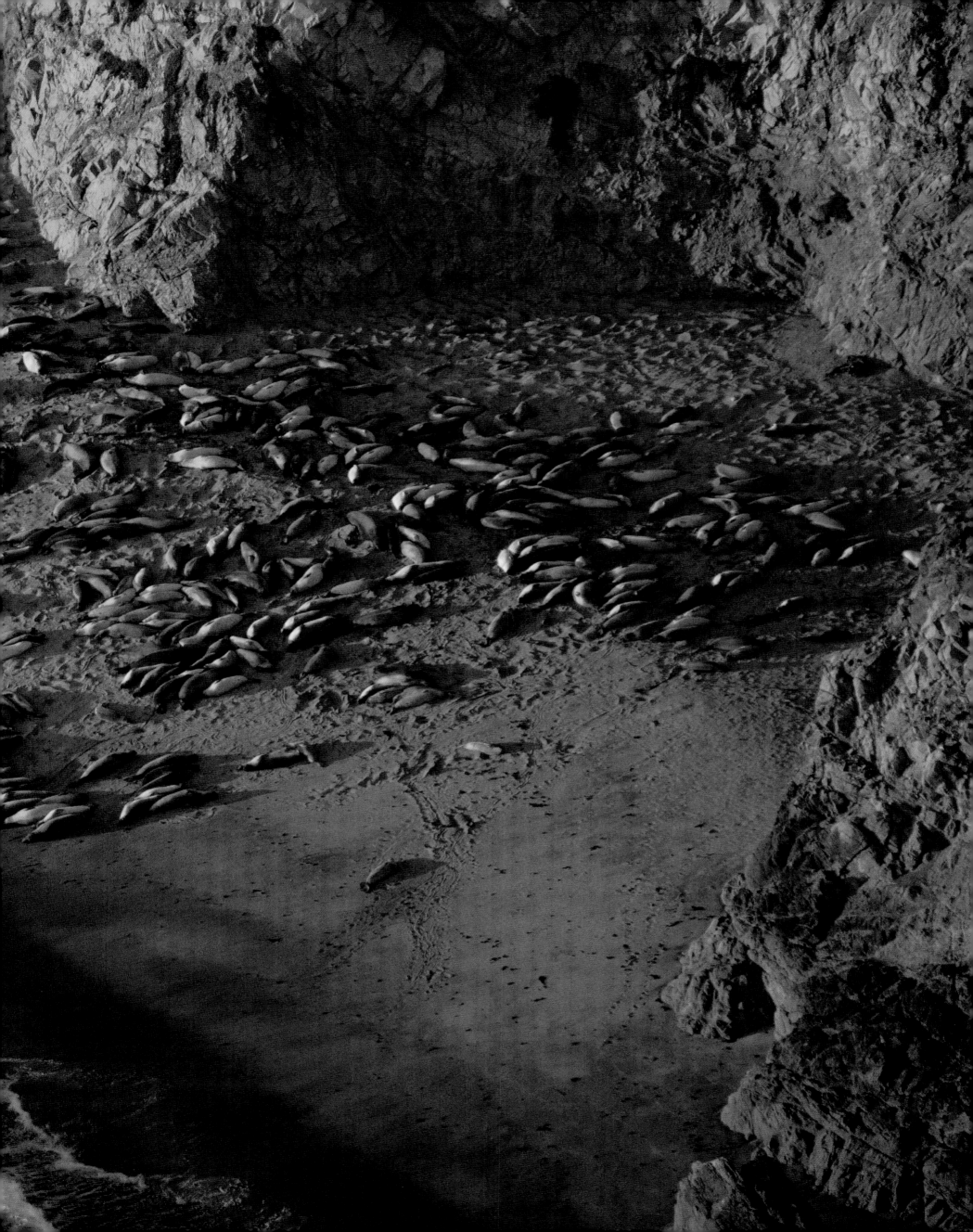

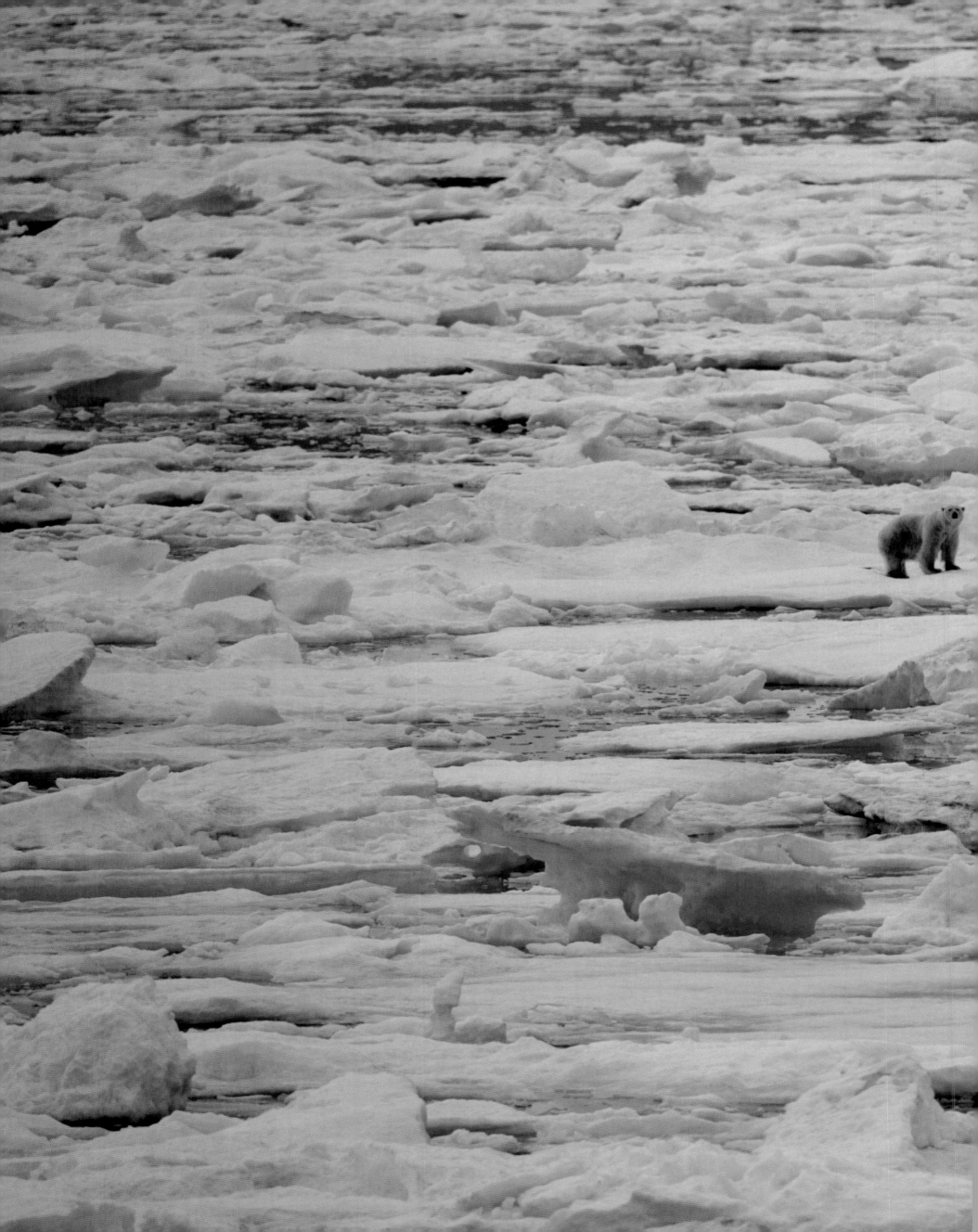

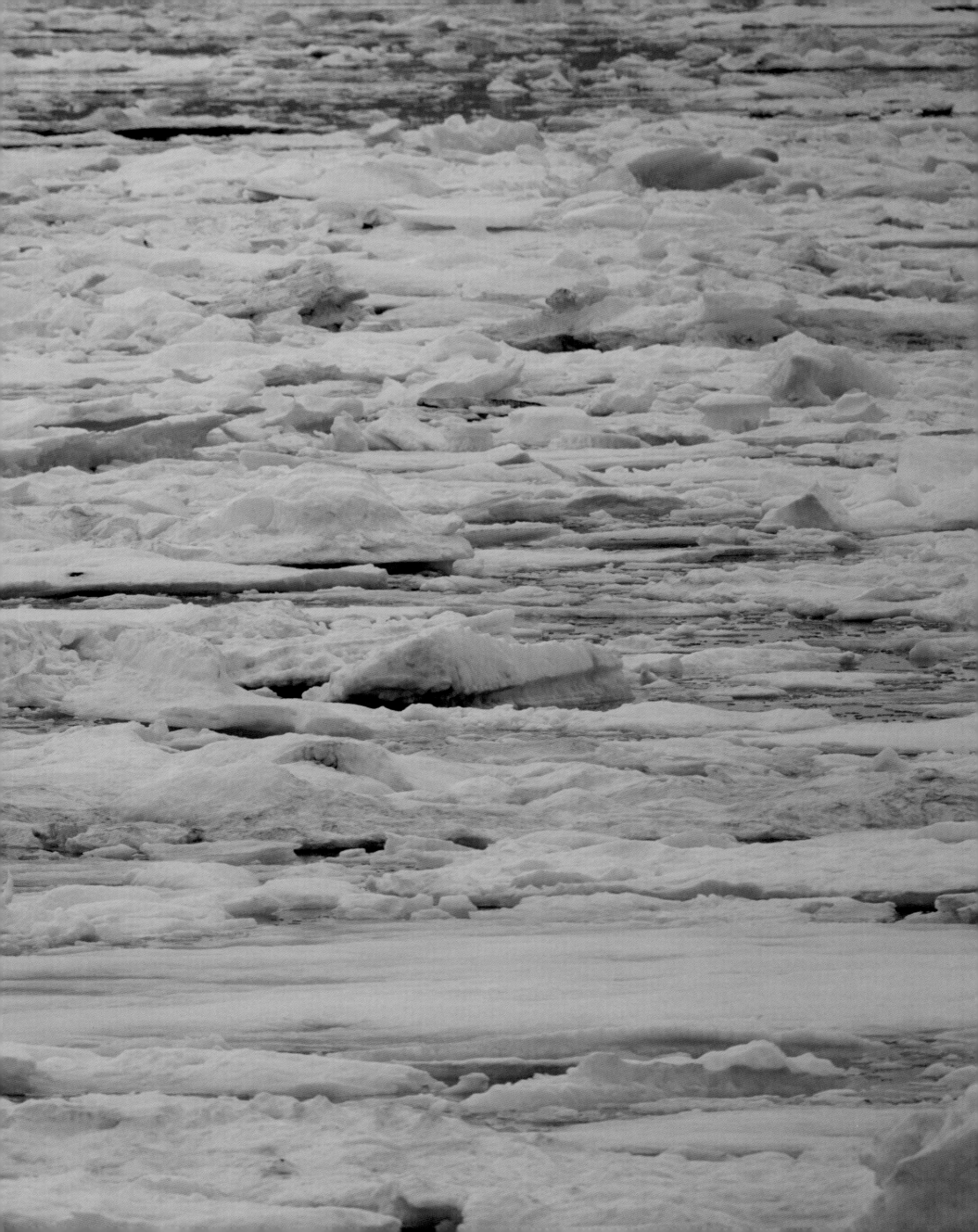

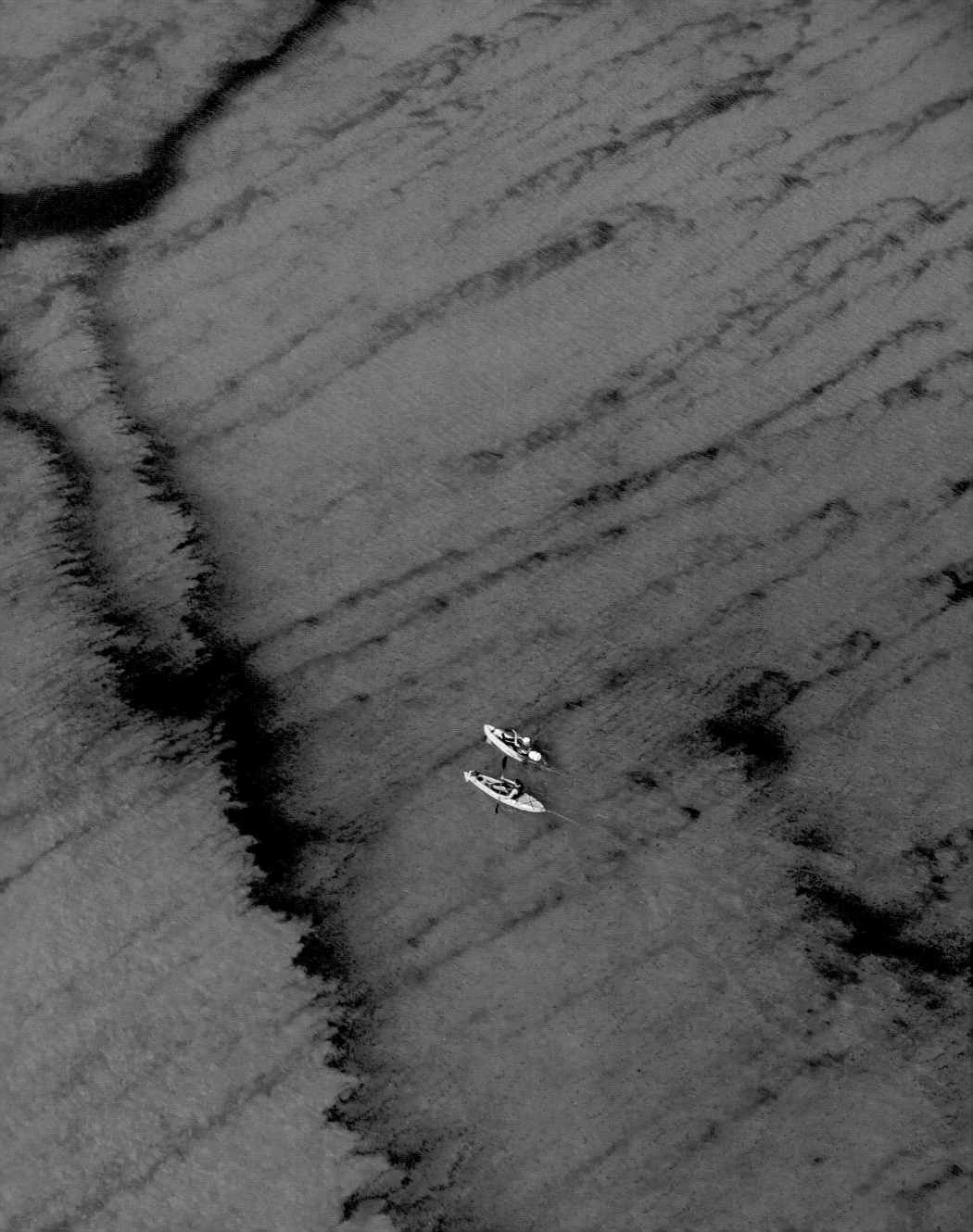

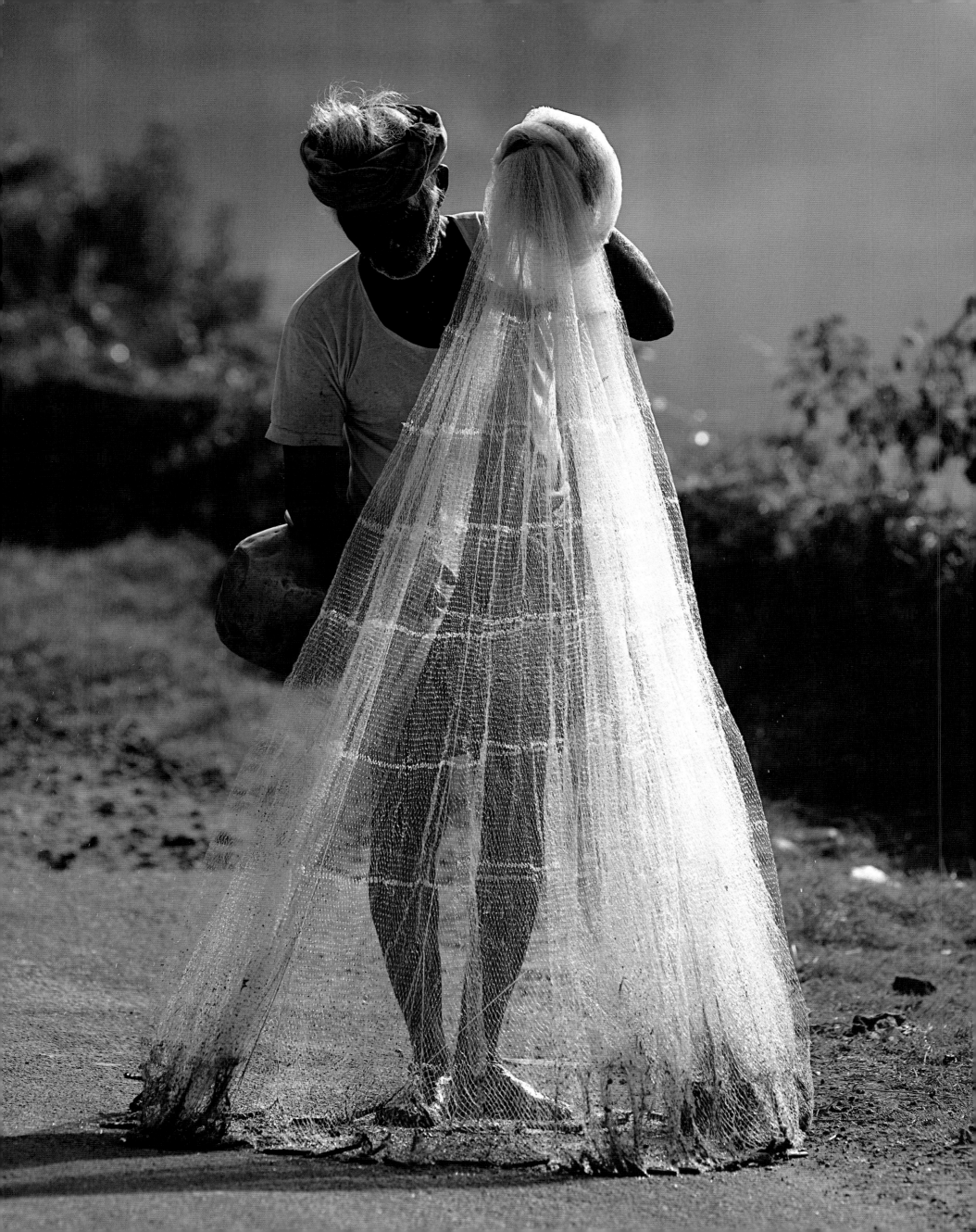

6 A Continent in Itself

When you are at sea, your dreams always lie out beyond the next wave. From one land to another, humanity roams ever further across the oceans in search of the treasures we long to possess. 'The Kingdom of Prester John'. 'The Fortunate Isles', 'The Seven Cities of Gold', 'El Dorado' – these have always been symbols of our desires, the long lost realms where, instead of milk and honey, there flow rivers of gold and fountains of youth, along with fantastical women, like the Amazons. There had to be women there, of course, for in the old days ships were a world of men.

INDIA, KERALA, FISHERMAN IN THE BACKWATERS
More than 100 million tonnes of fish are consumed every year in the world. In providing a living and food for millions of small fishermen and fish farmers, the industry is of vital importance both for the world's consumers and in the battle against poverty, especially in Africa and Asia. Here, on the south-west coast of India, a whole community depends on fish, which they catch with methods that are rudimentary but nevertheless efficient. These are the Backwater fishermen, whose hunting-grounds are an intricate network of ocean inlets that seep through the land of Kerala.

But these lost countries have never been found, and there is no land left to explore. Have we, then, entered the era of the 'finished world', to quote Paul Valéry? No, for the sea is a moving screen, a curtain to be opened. The invention of the aqualung by Yves Le Prieur, Émile Gagnan and Jacques Cousteau in 1942–43 enabled us to go down into the depths and move about freely, and ships specially built and equipped for scientific research are now beginning to reveal what had formerly been invisible. A single drop of seawater is a universe in itself, containing up to a million cells per millilitre. This is the world of the picoplankton, even smaller than that of the phytoplankton, and still unknown just fifteen years ago. It is indeed infinitely smaller, with billions of microorganisms which are set in motion by the tiniest movement. This world, whose vital role in the absorption of carbon becomes more apparent by the day, is the blue lung of our planet, and among other things it opens up vast fields of medical research. The only truly new antibiotic of recent years is cephalosporine, which comes from the sea, as does AZT, one of the drugs now being used in the fight against AIDS. Research being done on *Bugula neritina*, a marine invertebrate, offers new hope to cancer-sufferers, while a number of anti-inflammatory drugs and various other medications derived from the sea have now

reached Phase II, the final stage before they are put on the market.

There seems to be no limit to the potential for new discoveries when one takes into account the fact that only 500,000 marine species have been classified out of the 10 million that scientists believe to be living in the oceans. It is incredible but true to think that we know barely 5 per cent of them. Every week, some thirty-five new species are discovered, and we can only dream of what might emerge if the international community were to make sufficient funds available for further exploration of the universe beneath the waves.

The ocean is a wondrous garden – the sixth and last continent to be discovered, the El Dorado we have all been looking for. Not so much in the literal sense – 5.3 million tonnes of gold do lie trapped in its waters, but are very difficult to extract, since you have to treat 15 tonnes of water to obtain just 0.09 milligrams of gold – but because of the vast wealth of mineral resources that are known to be down there. High density ores are to be found near the coasts, where conditions are favourable for exploitation: platinum in Alaska, for instance, and pewter in Thailand, Burma, Malaysia and Sumatra, amounting to 30 per cent of the world's production. There are also diamond deposits (ilmenite, monzanite and zircon) off the coasts of South Africa and Mozambique.

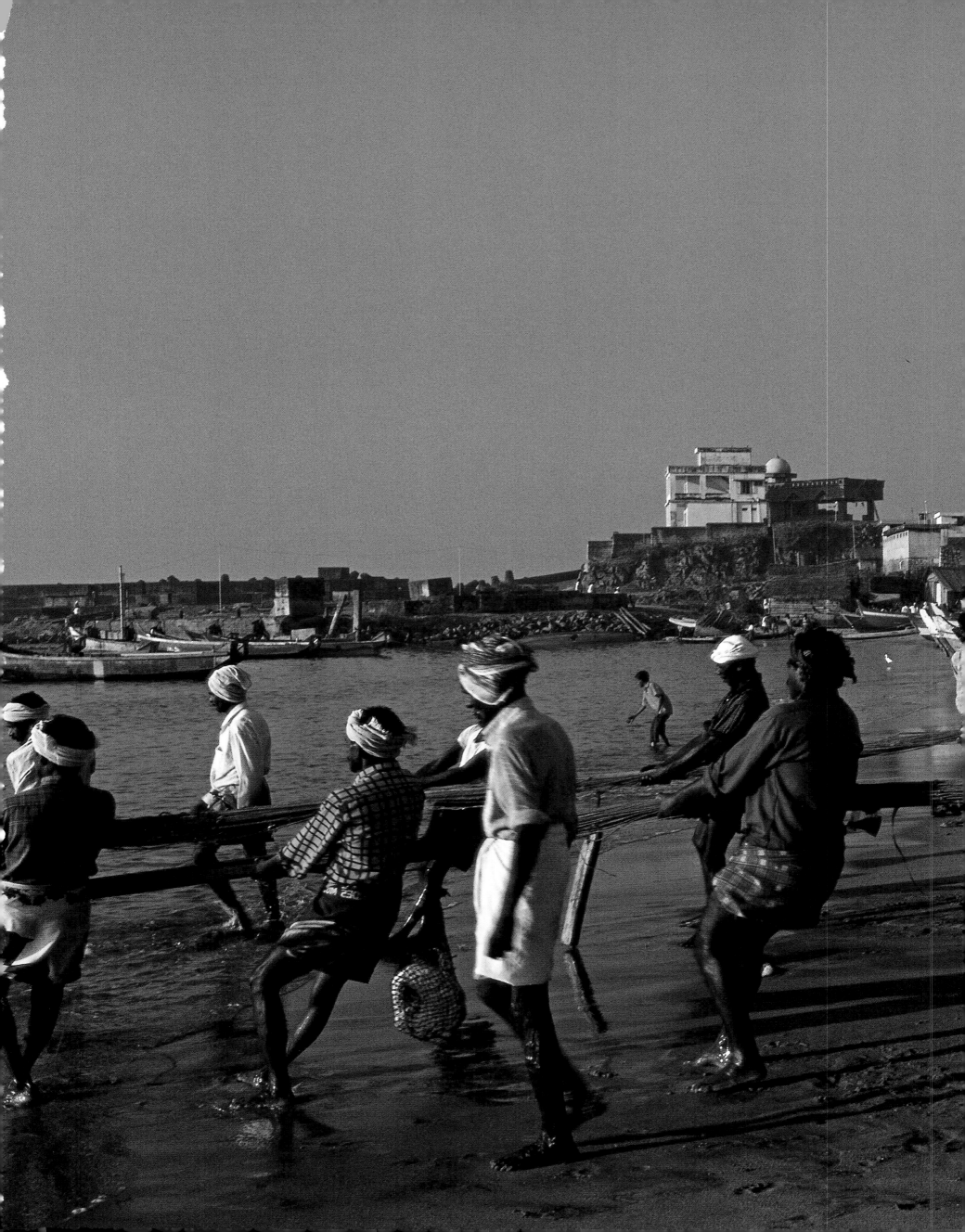

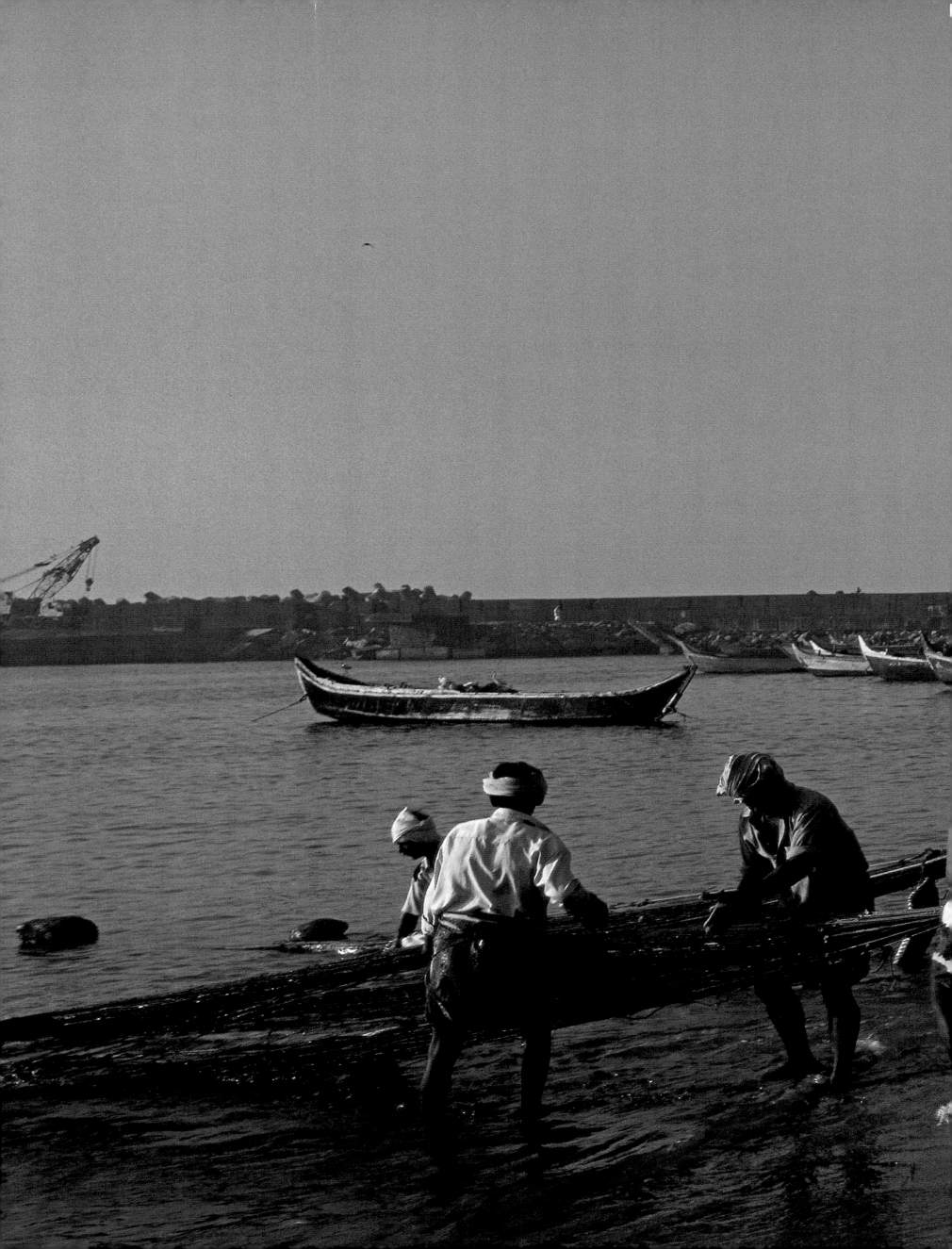

The depths of the ocean are lined with polymetallic nodules, great black lumps containing a cocktail of metals – manganese (20–30 per cent), iron (10–20 per cent), nickel (0.2–2 per cent), copper (0.1–1.6 per cent), and cobalt (0.1–2.5 per cent). These were first discovered by the *Challenger* expedition during the 1870s. Reserves are currently estimated at up to 1,500 billion tonnes in the Pacific alone, but these fields are still too expensive to exploit. Prospects are far better with the deposits recently discovered along the sides of the mid-oceanic ridge, where sulphides have created highly concentrated sediments that are easily accessible.

Rapid advances in deep-water oil prospecting have massively expanded the number of known reserves, and the potential for discovery is now estimated at more than 100 billion barrels. Furthermore, these deposits are accessible to new technologies. To pinpoint the limits of current technology, drilling recently reached down to a depth of 2,352 metres in the Gulf of Mexico, and an oilfield off the coast of Brazil has been exploited at 1,709 metres. These limits will soon be surpassed, as all the major oil companies have been given permits to drill to depths of more than 3,000 metres, into the regions known as 'ultra-deep waters'.

The ocean depths, where temperatures are relatively low and pressures high, are equally conducive to the formation of gas clathrates, which some experts estimate to contain the equivalent of all known reserves of coal, oil and natural gas. In future, the seas will supply us with more than 30 per cent of the oil and 20 per cent of the natural gas that we use now, to which we can add among other things 90 per cent of the world's bromine – used increasingly in the film and pharmaceutical industries – and 60 per cent of industrial magnesium.

The sea is also one of the most richly stocked larders on our planet. In fifty years, the world's fishermen have more than quadrupled their catch, from 20 million tonnes in 1946 to 70 million tonnes during the 1970s and nearly 90 million tonnes today. But these resources are under threat: for the last ten years, despite technological modernization, there has been no increase – a sign that stocks are dwindling virtually everywhere, although demand is still growing. In ten years, the number of fish sections in supermarkets has almost doubled, and in 2005, fears of avian flu and mad cow disease were also factors in European fish sales rising by almost 10 per cent.

If we are to go on enjoying this manna from the seas, it is clear that we must change our approach and use every means at our disposal to increase stocks, not least because fish is becoming more and more vital in the light of the demographic explosion. Aquaculture could go hand in hand with future prosperity. The development of this technology is a vital step, just as important as that which saw the hunter-gatherers of old turn to breeding and farming. We might even envisage cultivating plankton offshore – protected from predators – for along with the seaweed that is such a popular dish among the Chinese and Japanese, plankton could become another highly nutritious foodstuff.

After sugar and oil – the two products that have left the most indelible marks on human history – plankton may be the substance of the future, as it has so many different potential uses. In aquaculture it is a food for larvae and young fish; in agriculture it is used as fertilizer; in the food industry it is an ingredient in many pastries, creams and desserts, as well as being a nutritious additive and a rich source of minerals; in the pharmaceutical industry, it is valuable for its vitamin content, and it can also improve the environment because some microalgae, fed on nitrates and phosphates, provide an excellent means of purifying effluents; and finally, in the energy sector, it can be fermented to produce alcohol, methane and hydrocarbons.

If mankind could only act responsibly and reasonably, the ocean represents a field of vast potential. All that we need to do is follow the spirit of the sea....

INDIA, KERALA, VILLAGE OF VILINJAM
The fishing industry uses a wide variety of techniques. Factory ships ply the oceans for months on end, freezing and processing the catch as they go. Large trawlers are used for deep-sea fishing, whereas coastal fishing is done by smaller boats working less than 90 km from the shore. There are also the traditional fishing methods practised close to the shore, and varying according to the species being targeted and the possible effects on the natural resources – this kind of fishing generally being the least damaging to the environment. Despite the hopeful efforts of these 27 men, the seine net has brought in only 2 kg of fish, for which the wholesaler will pay them the equivalent of just $5.

USA, FLORIDA, MIAMI
The city of Miami, which now has 6 million inhabitants, has undergone an almost explosive growth: the population of southern Florida is increasing by about 900 people a day, causing a proportionate expansion of the vacation resorts along the coast. Pollution, the increased demand for water, and the transformation of many square kilometres of coastline into residential areas all make it increasingly difficult to balance urbanization against the need to protect coastal ecosystems. The survival of the Florida Everglades, with their extraordinary biodiversity, is now very much in question.

USA, SAN FRANCISCO BAY, SAUSALITO, HOUSEBOATS
Sausalito lies on the northern side of San Francisco. This old naval base, where warships were built during the Second World War, later became a breaker's yard for ships. During the 1960s and 1970s, hippies and other free spirits came and installed themselves in the old ships, and as time went by, this quiet district with its boats of all ages, styles and sizes gradually became gentrified and rents soared. Once a focal point of the counterculture, Sausalito is now an artists' town popular with bourgeois bohemians. Every year it is the setting for one of the largest art festivals in the United States.

GREECE, GULF OF ELEFSINA, NEAR PIRAEUS, OLD BOATS
These former kings of the sea now wait to learn their fate. When a ship's life is over, disposal of its body presents a major problem. Between 300 and 600 ships are demolished worldwide every year, most of them in India and Bangladesh because labour there is cheap and plentiful, and there is a very high demand for steel. Ship-breaking is often carried out in conditions that entail a high degree of pollution and risk. Almost all the ships bound for these graveyards contain noxious substances – in particular, asbestos, fuels, paint and lead. But the thousands of workers have little choice if they want to earn a living.

FRANCE, CHARENTE-MARITIME
These oyster-farm pontoons cluster around the quay as they wait for the next tide. French oyster-farming is concentrated around Charente, Vendée and Brittany, and has become an important part of the French economy as the fifth largest producer in the world, with 130,000 tonnes of oysters a year (out of 4.3 million tonnes produced worldwide). In other parts of the world, oysters are not regarded simply as a culinary delicacy. They are mainly farmed for the valuable pearls they produce within their shells – white in Japan and Indonesia, and black in Tahiti.

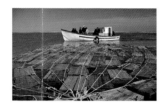

CANADA, MAGDALEN ISLANDS, LOBSTER FISHING
Some 2,500 species of fish, shellfish and other forms of seafood are currently in commercial production worldwide. Some of them, once abundant, are now in short supply, such as bluefin tuna, hake, monkfish, sole, Atlantic salmon, black pollock, herring and cod. In the zone around Newfoundland, stocks of cod are struggling to replenish themselves in spite of a moratorium on cod-fishing. The fact is that within one hour, a factory ship can net as much cod as a 16th-century boat could catch in a whole season. The fishermen illustrated here, however, are after lobster, and to this end they drop lobster traps, into which the king of crustaceans will duly make his way.

FRANCE, VENDÉE, SHELLFISH-FARMING
These thin black strips are to be found along the coasts of mussel-producing regions. They are the stakes to which the spat of the young mussels attach themselves when the breeder collects them in spring, after the female has laid her abundant clutch of eggs. Fixed to these supports, the mussels grow for about eighteen months. The stakes are laid out in beds 50 metres long, and are adapted to the powerful tides of the Atlantic. In the Mediterranean, however, the mussels are attached to long lines in the water and regularly brought to the surface. Throughout the world, 1.5 million tonnes of mussels are produced every year, 78,000 of which come from France, the sixth largest producer in the world.

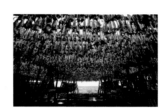

ICELAND, DRYING COD
The cold waters of the Atlantic that wash the coasts of Iceland are rich in cod. A staple food, and driving force of the economy for half a century, cod have been at the heart of Icelandic society since the Middle Ages. Drying is often still carried out in the open air, and on the international market one cod in three is Icelandic. The fact that Iceland is one of the last remaining sanctuaries of the cod is due to her successful battle against the British fishing industry during the Cod War of the 1970s, and her imposition of drastic quotas during the 1980s. Today, in contrast to Canada, she still has her cod and her fishermen.

TURKEY, ISTANBUL, FISHING PORT
The number of fishing boats in the world has settled at around 3.5 million, of which 85 per cent are without decks and often without motors, mainly concentrated in Asia. In contrast to this modest fleet are the high-tech industrial trawlers and factory ships that stay out on the seas for weeks on end, tracking the fish ever more relentlessly with infallible radar systems and data provided by satellite. These 35,000 heavily equipped industrial ships represent 1 per cent of the world's fishing fleet, but they account for more than 50 per cent of the catch. At present, there are 2.5 times more fishing vessels than the oceans can support.

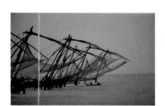

INDIA, KERALA, CHINESE NETS
India has about 6 million fishermen, of whom 2.4 million work full time. Of the 300,000 fishing boats that cluster along the coasts, two-thirds are traditional vessels without a motor. Basically, the old methods are still in use, with seine, fixed and cast nets, lines, and giant 'Chinese nets' like those in the picture, descendants of a type of net used in ancient China. The size of the catch is variable, and is heavily dependant on the monsoon.

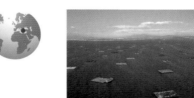

GREECE, NEAR ATHENS
Every year, 1.5 million tonnes of fish are caught in the Mediterranean (only about 1.5 per cent of world production), mainly by Turkey, Italy and Greece. Unlike fishing in the North Atlantic, it is largely done using traditional methods, and continues to play an important social, cultural and economic role in the Mediterranean region. Sardines and anchovies comprise 40 per cent of the catch, but hake, bluefin tuna, swordfish and sea bream have all been exploited beyond their natural capacity for renewal. Recent international agreements are intended to improve management of the Mediterranean's fishing resources.

SPAIN, GALICIA, VIGO
These rectangular pens accommodate a long-line shellfish farm. Aquaculture has grown by 11 per cent a year since 1984, and today, for every 100 million tonnes of wild fish caught, 33 million tonnes are produced by fish farms. Although this may seem to be a solution to the problem of falling fish stocks, it also has its negative side. The production of 1 kg of farmed salmon, for example, requires 4 kg of wild fish, which in turn contributes to the depletion of natural stocks. In Asia the proliferation of fish farms is destroying the precious mangroves. Also, as with all intensive breeding, aquaculture entails processes that may have damaging consequences for us humans at the end of the food chain.

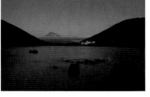

PORTUGAL, AZORES, FAYAL, OLD WHALING STATION
The zone marked out by the islands of Fayal, Pico and São Jorge, housing 23 different species of cetaceans, is one of the biggest game fishing reserves in the North Atlantic. A quarter of the working population is now engaged in fishing. The whaling industry, which used to provide the second largest source of revenue, peaked in the early 20th century, when the town of Horta counted no less than 400 whaleboats, but a decline in the market for whale products, together with a desire to protect these great mammals from extinction, led to the end of whaling in 1987. In the global context, some species, such as the blue whale are still greatly endangered.

PANAMA, CANAL, MIRAFLORES LOCK ON THE PACIFIC SIDE
Oil tankers, bulk carriers and container ships carry 6 billion tonnes of merchandise around the world every year, compared to 1 billion in 1960. And every year some 40,000 merchant vessels loaded with foodstuffs, oil, building materials, chemical products and manufactured goods of all sorts cover 6 million kilometres of ocean. Some 90 per cent of international trade is carried out by sea, which is the least harmful means of transport in terms of carbon dioxide pollution, the gas most responsible for the greenhouse effect and climate change.

EGYPT, THE SUEZ CANAL
The Suez Canal will always be associated with the mirage of a cargo boat navigating the waves of the desert. Built between 1859 and 1869 by Ferdinand de Lesseps's company, this 163-km canal – which unlike the Panama Canal has no locks – links the Mediterranean and the Red Sea. A vital link between Europe and Asia, it takes 11 to 16 hours to navigate, but saves ships from going all the way round Africa via the Cape of Good Hope. Some 15,000 ships, representing 14 per cent of the world's merchant shipping, use the canal every year.

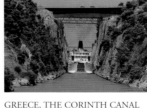

GREECE, THE CORINTH CANAL
The first vain attempt to dig a canal across the Isthmus of Corinth is attributed to Nero in AD 67. Five centuries before that, people had already found a way for boats to cross – by heaving them onto chariots and driving them along a paved route. It was not until 1882–93, however, that the canal finally came into being. This rectilinear trench, 6 km long and 21 m wide, saves ships a detour of 400 km round the Peloponnese by linking the Ionian Sea (west coast) and the Aegean (on the side of the Black Sea). Every year, about 11,000 ships use the canal – fulfilling a dream at least 2,500 years old.

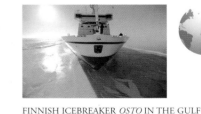

FINNISH ICEBREAKER *OSTO* IN THE GULF OF BOTHNIA
The amount of goods transported across Europe is expected to rise 70 per cent by 2020. Sea freight, which already accounts for 40 per cent of freight volume within the EU, offers an efficient and viable alternative to the HGVs that crowd the roads and pollute the atmosphere. In order to exploit this potential, there will soon be maritime motorways encircling Europe along the coasts of the Atlantic, the Mediterranean and the Baltic. In the north, modern icebreakers ensure that even in the coldest winter, the sea routes remain free. Invaluable aids to sea traffic, demand for their services is likely to increase.

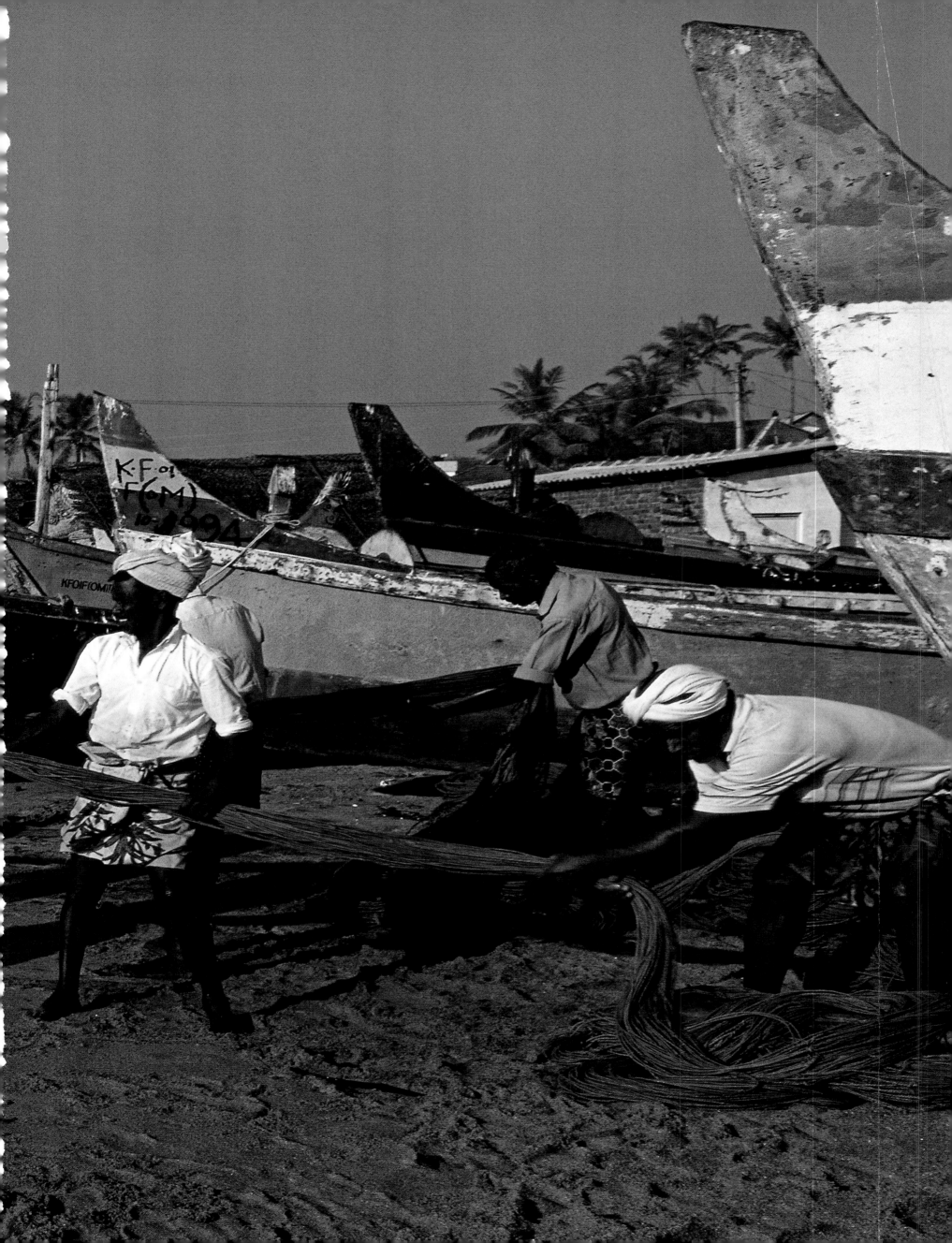

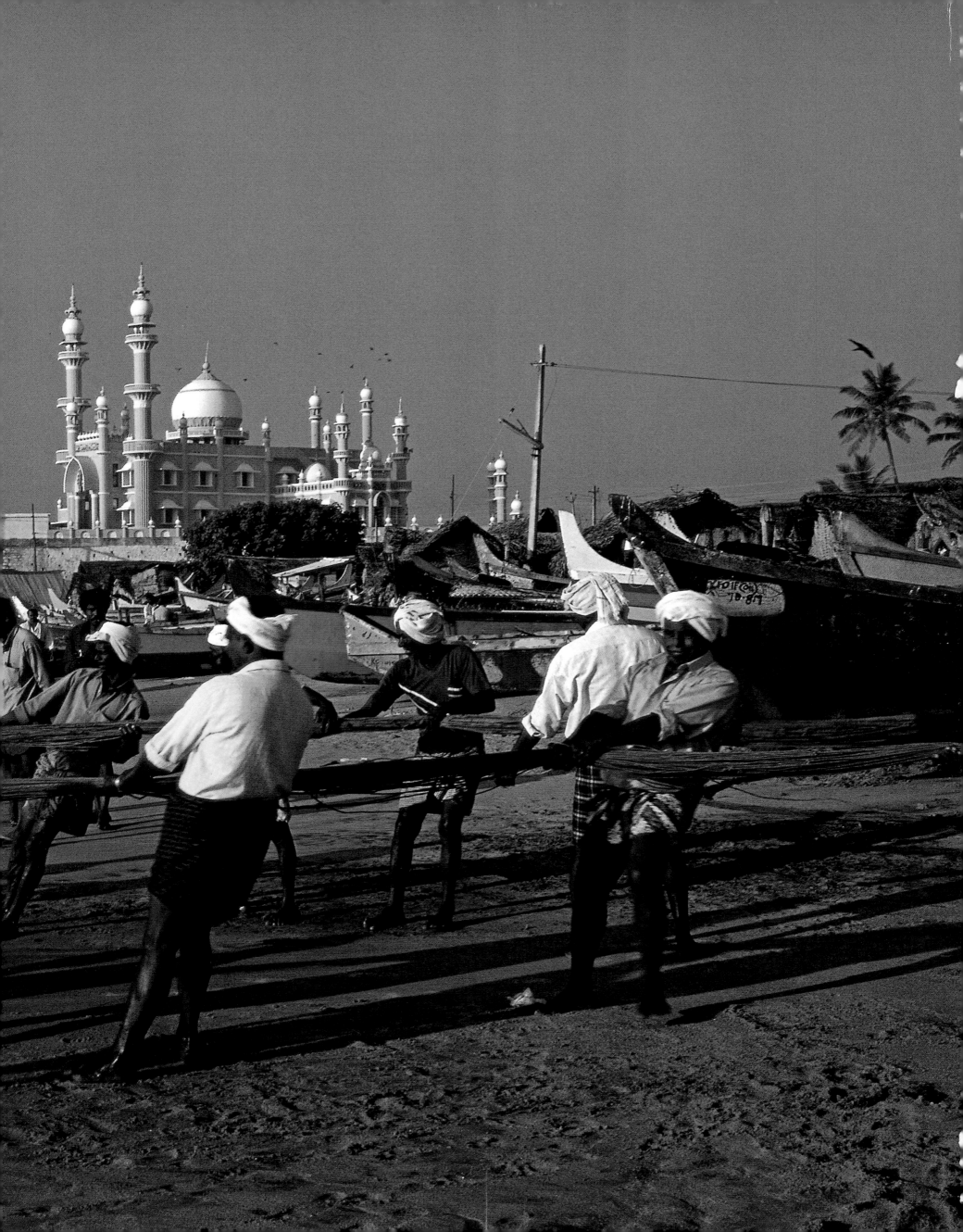

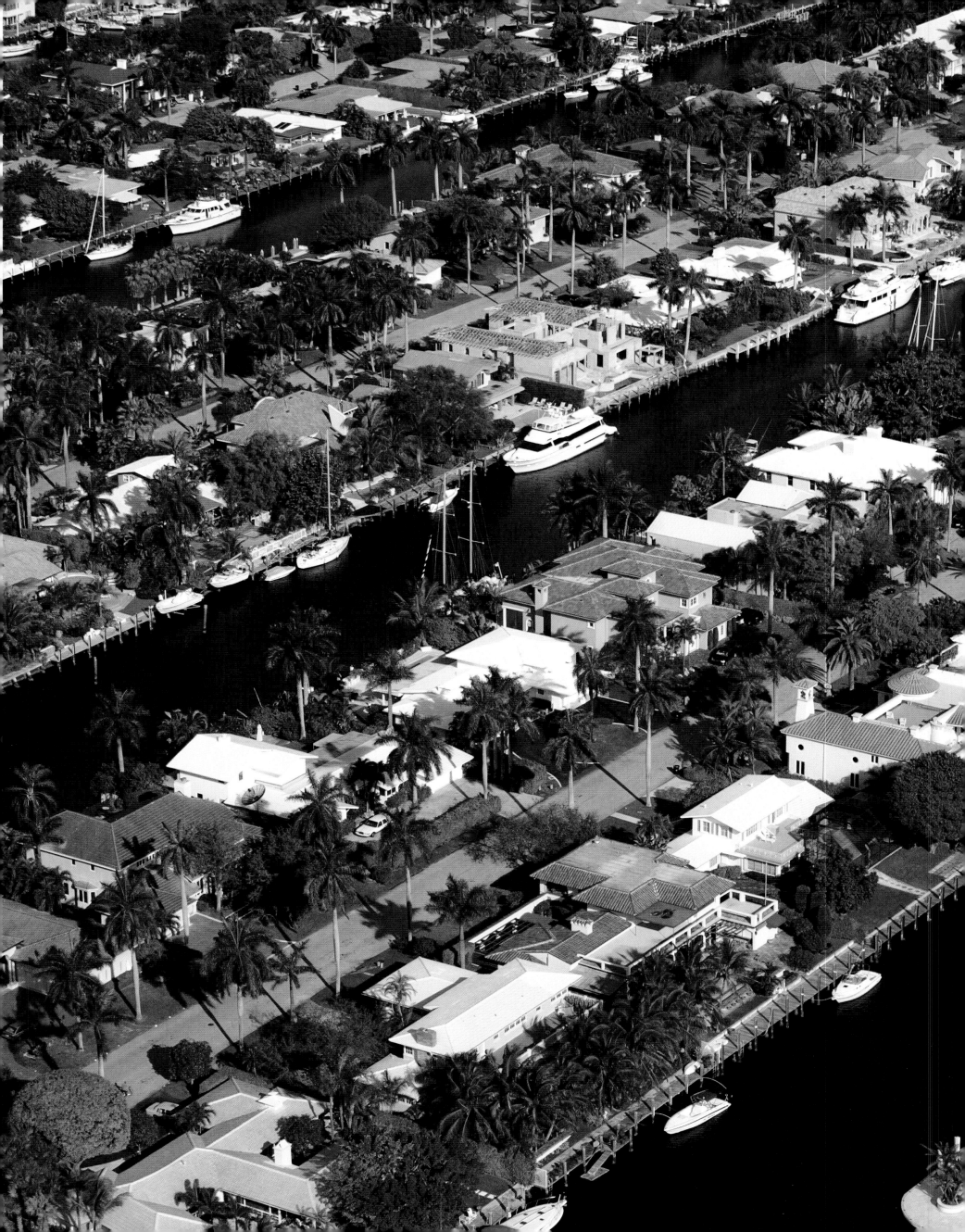

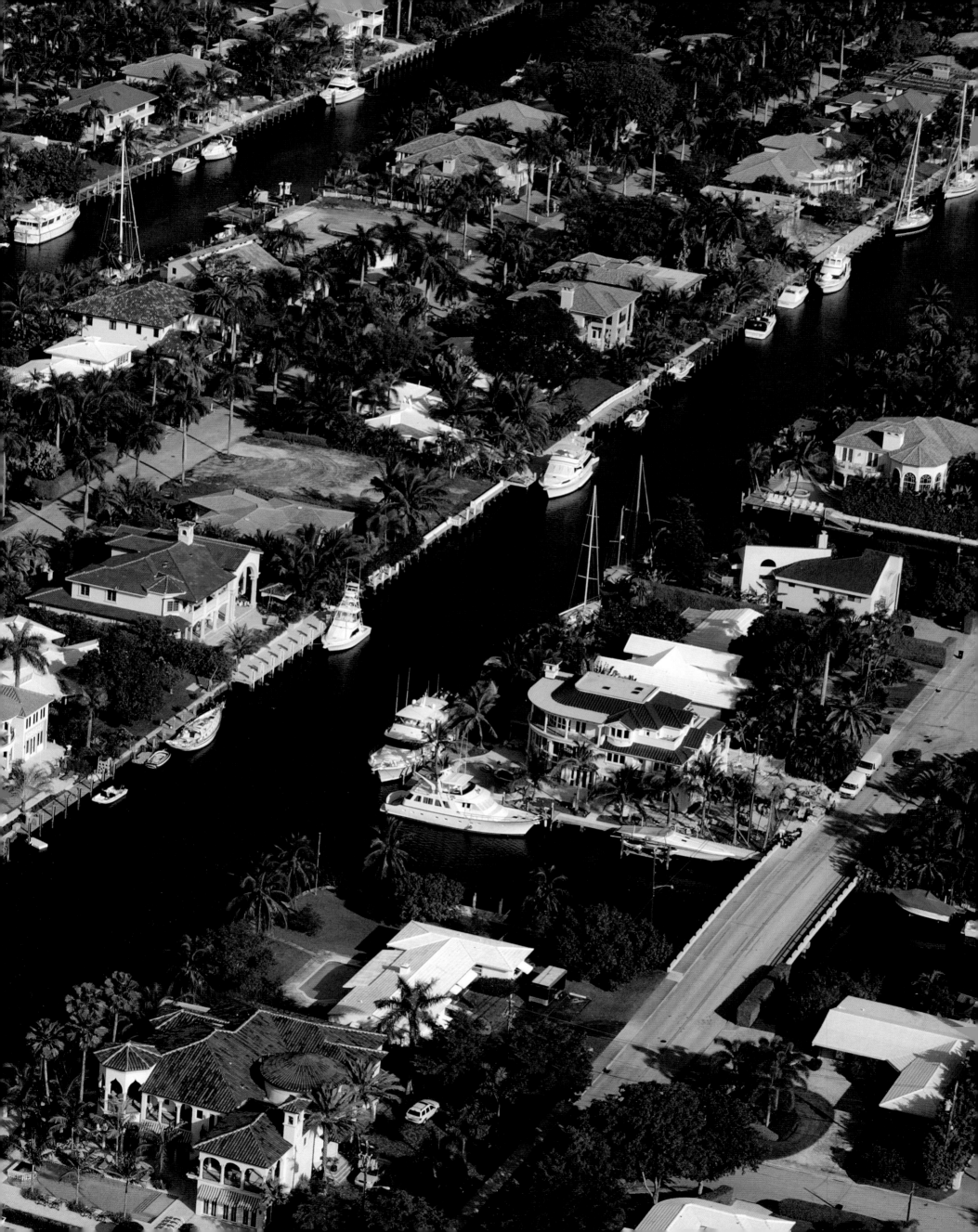

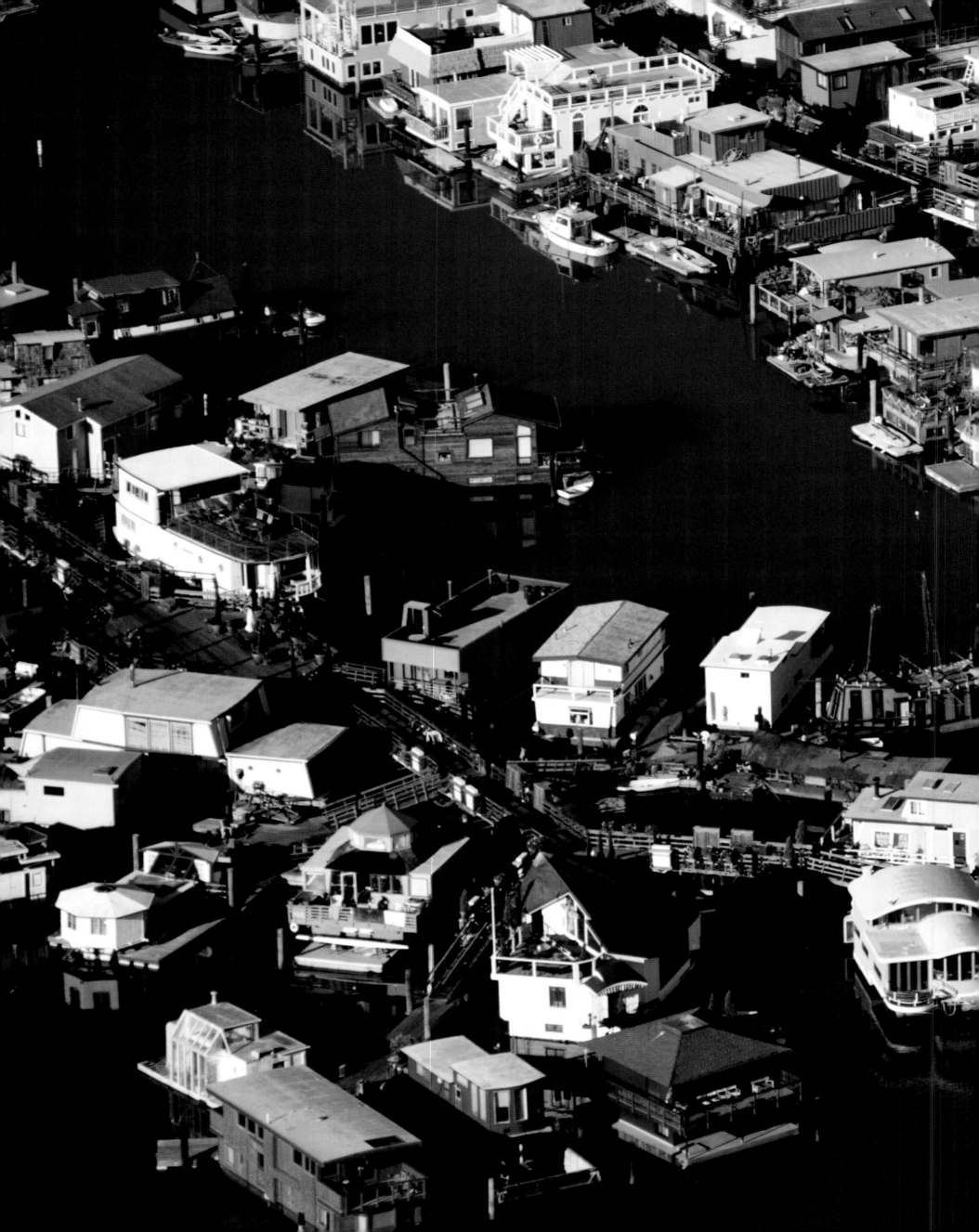

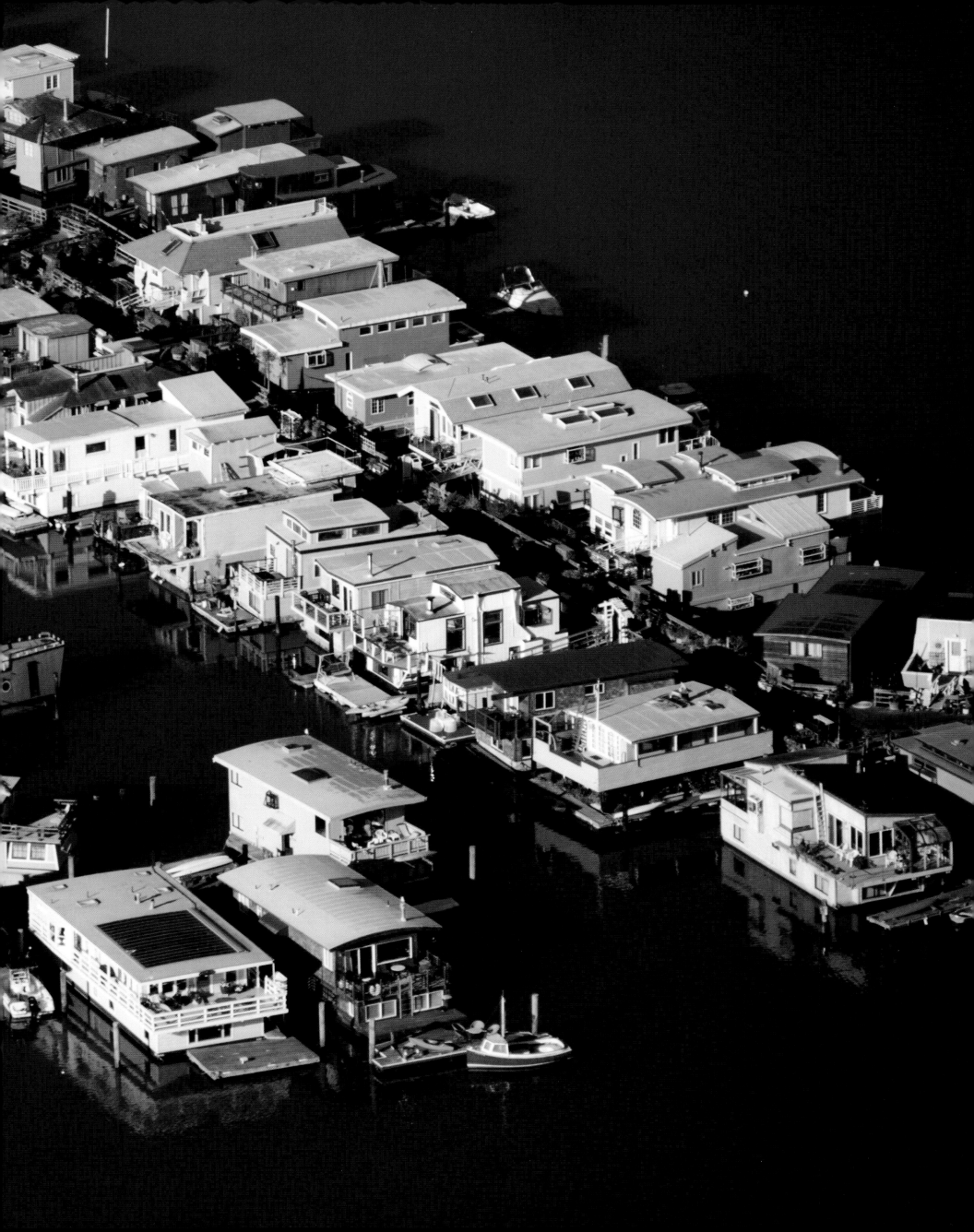

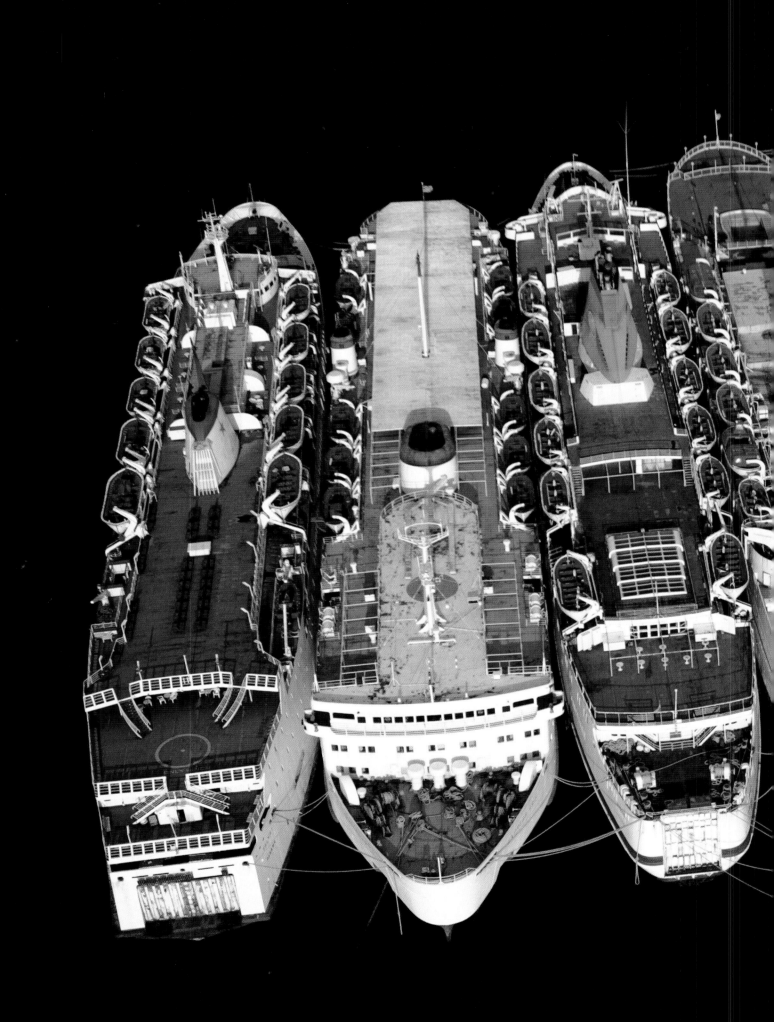

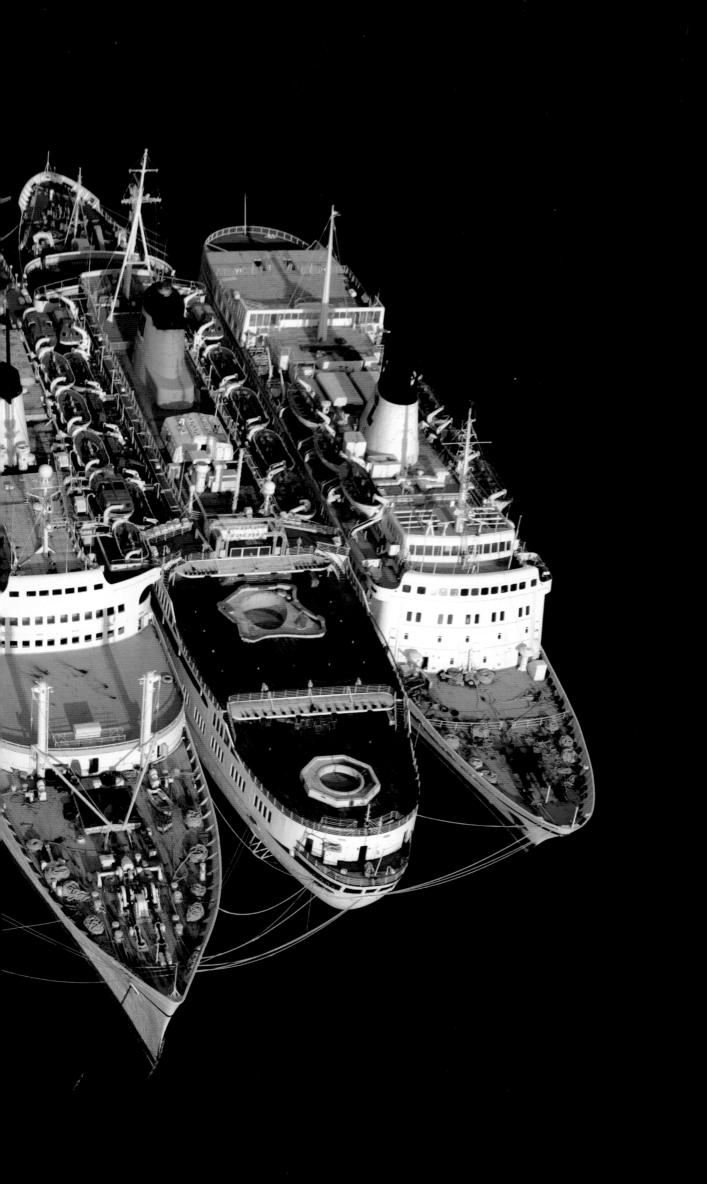

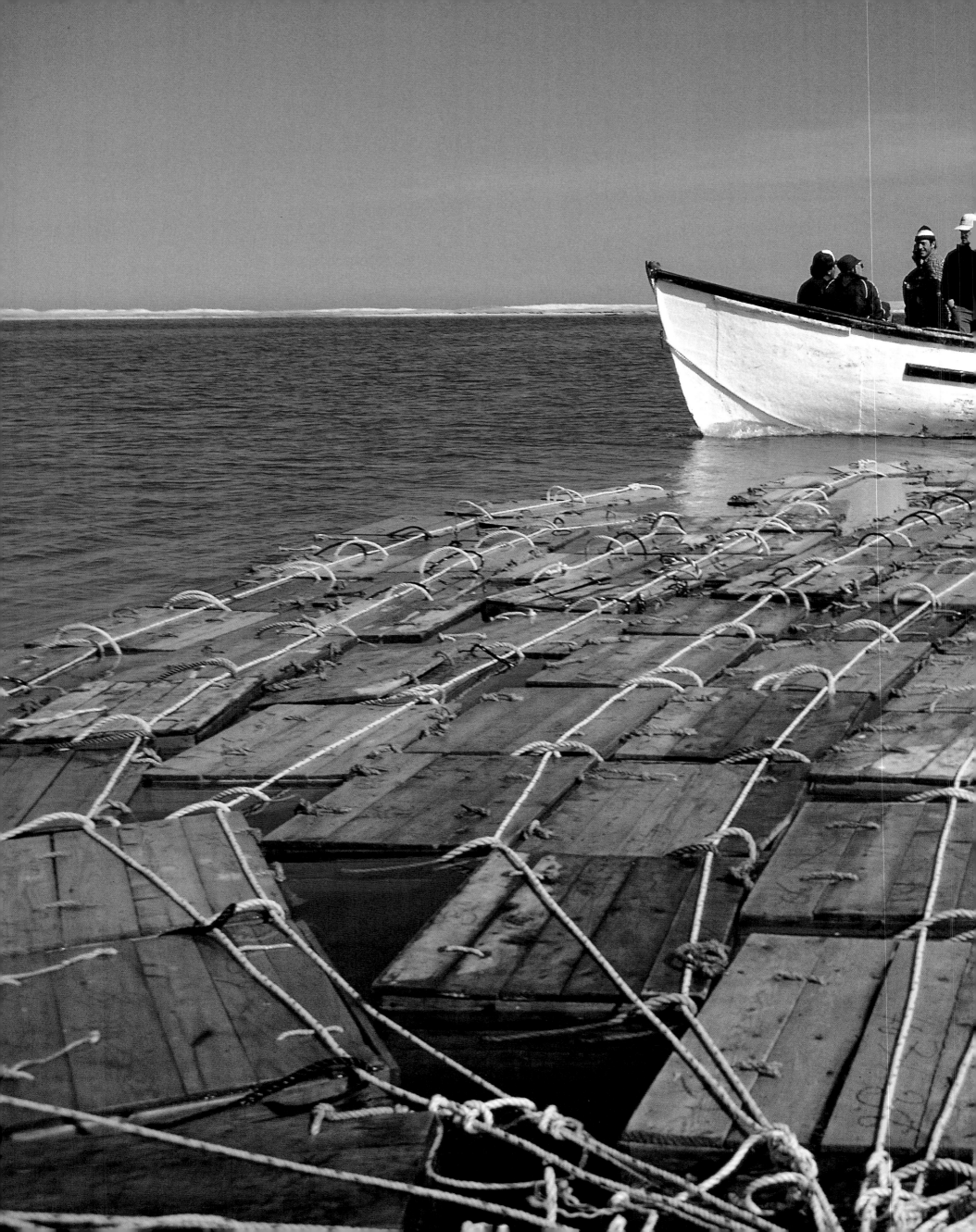

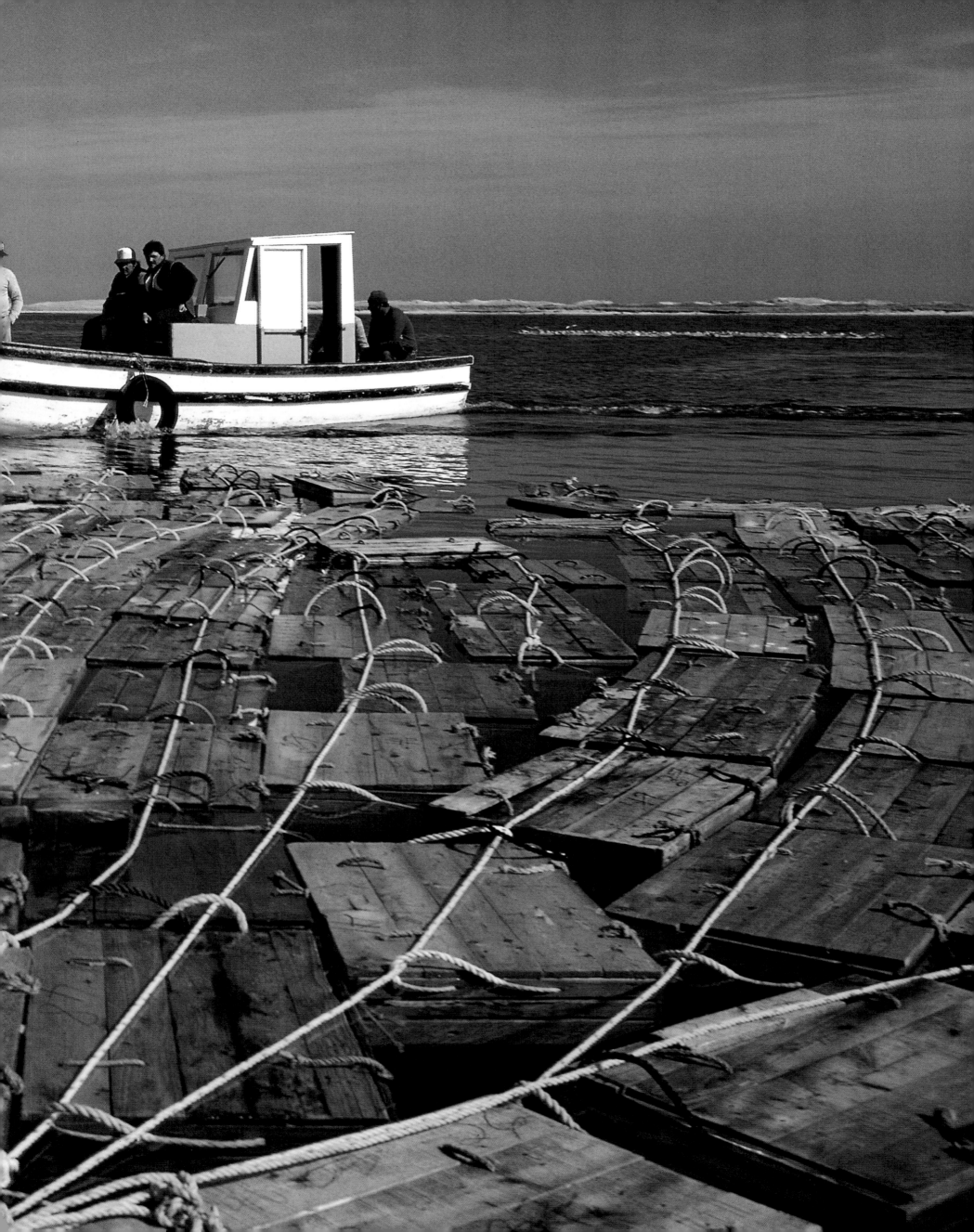

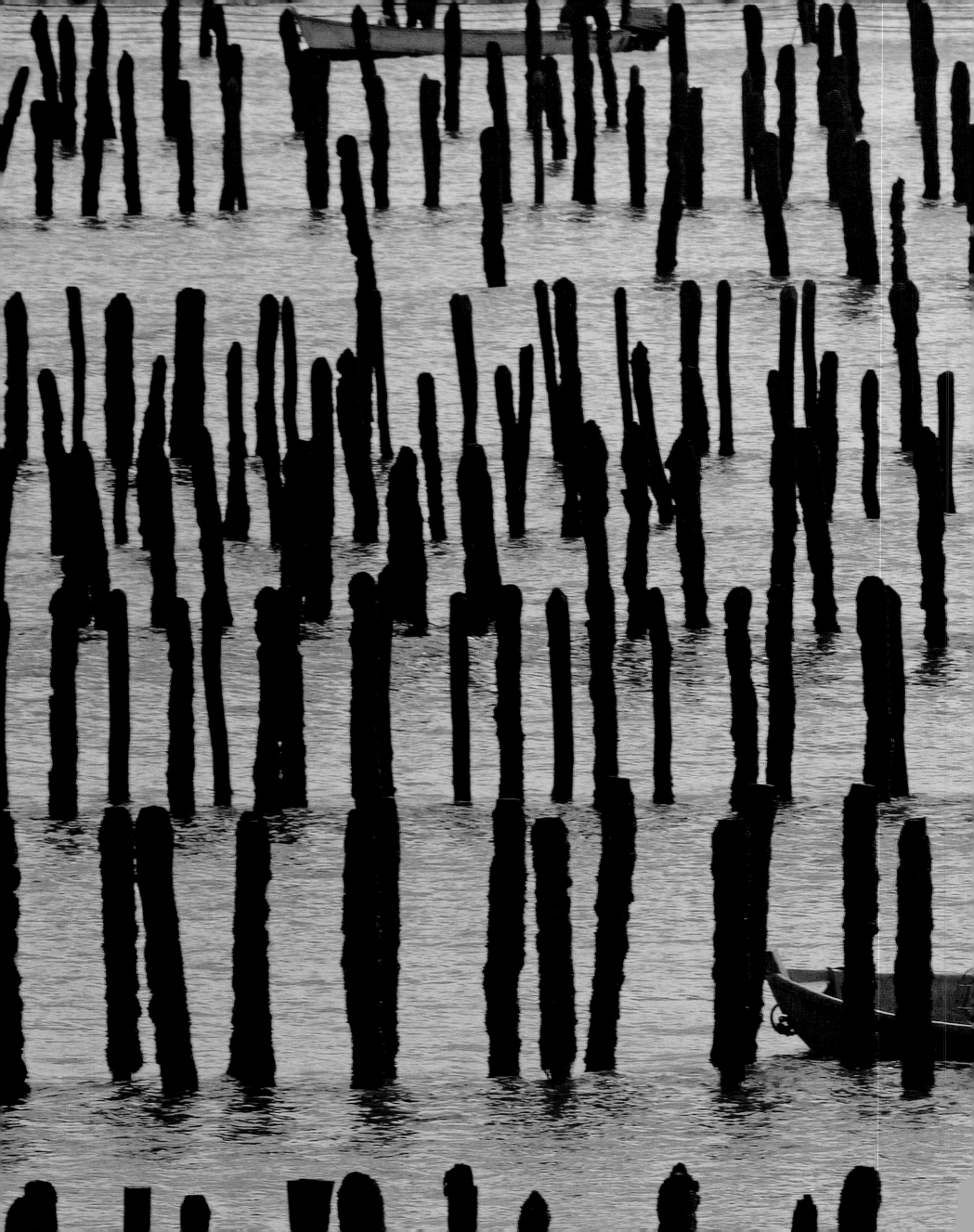

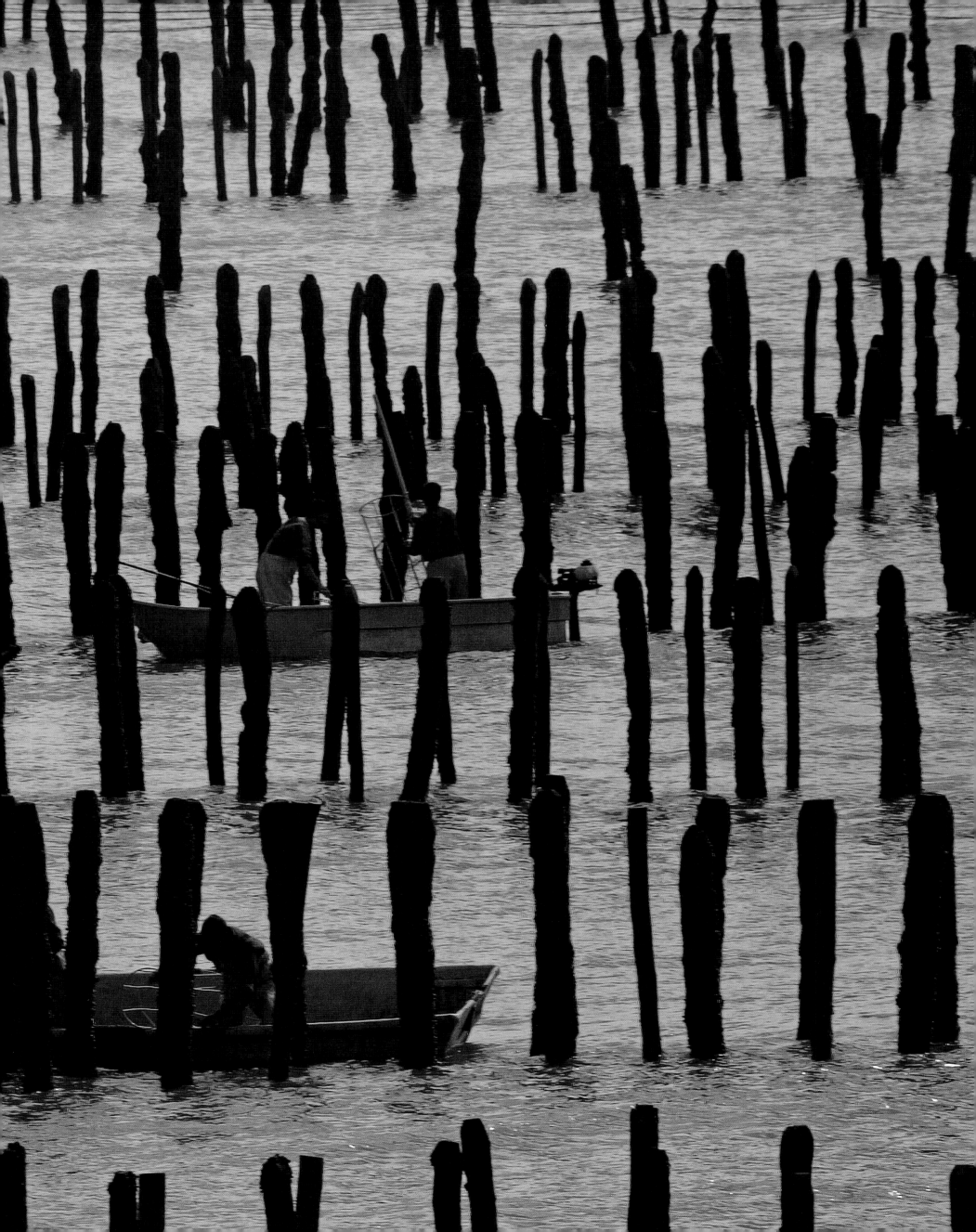

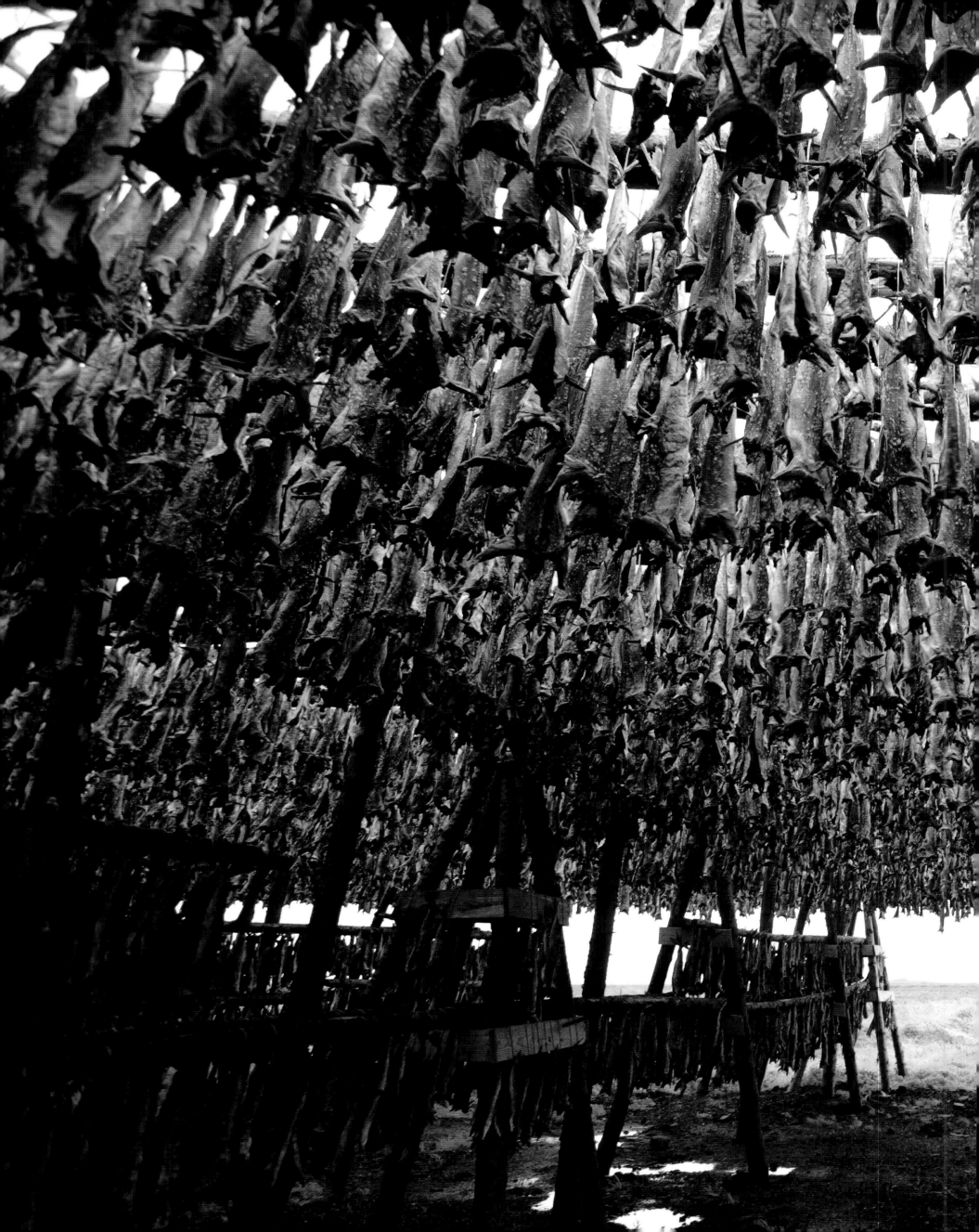

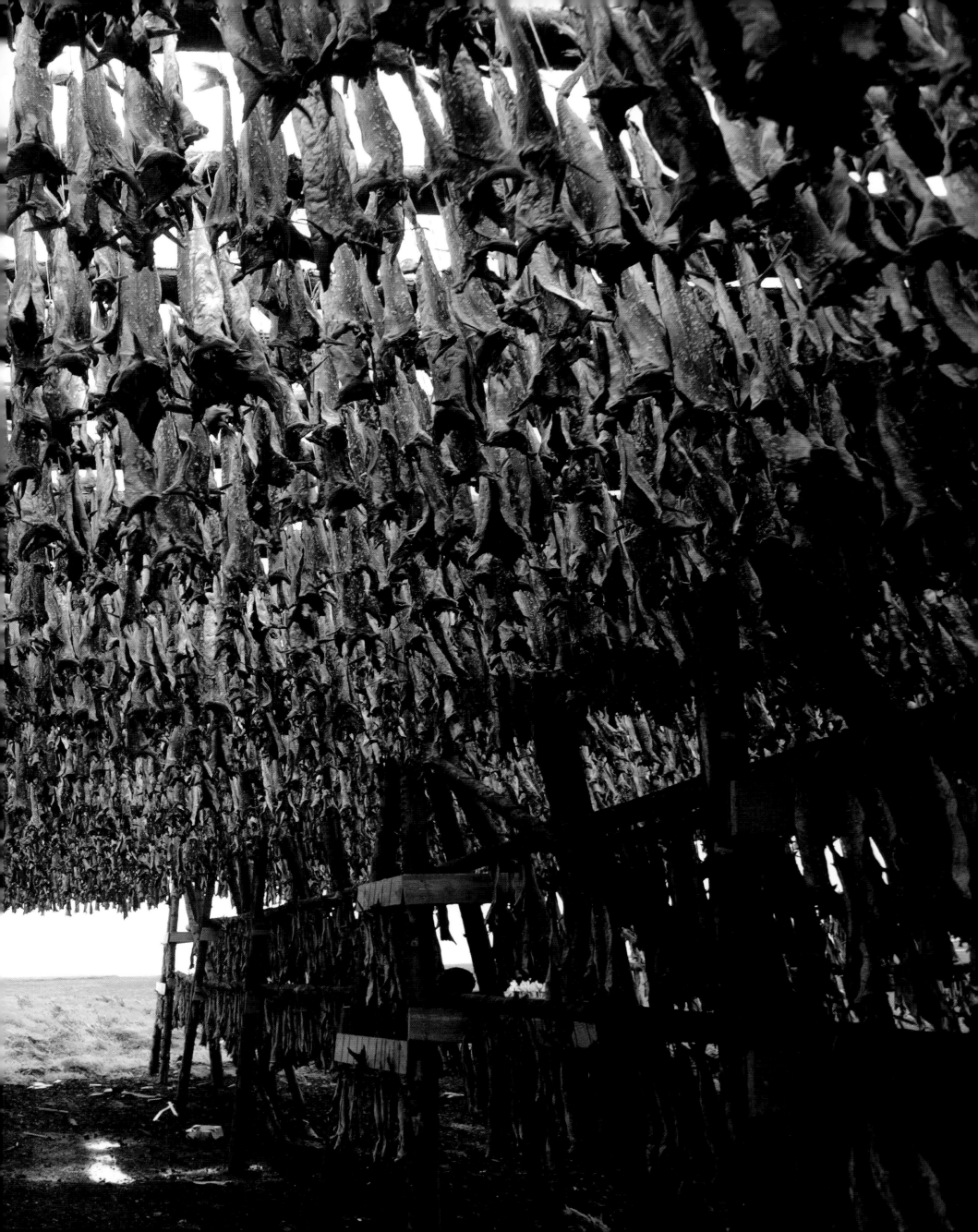

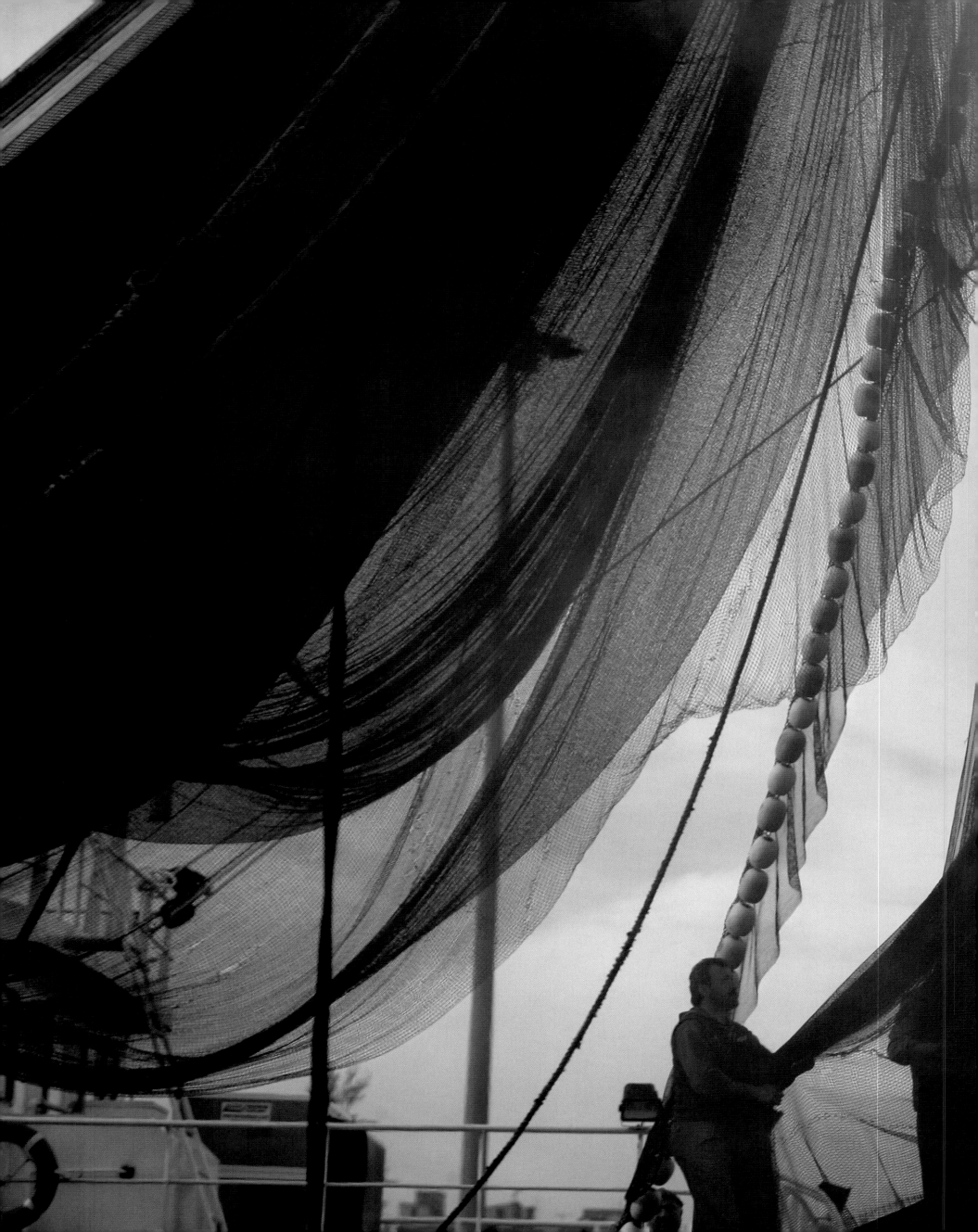

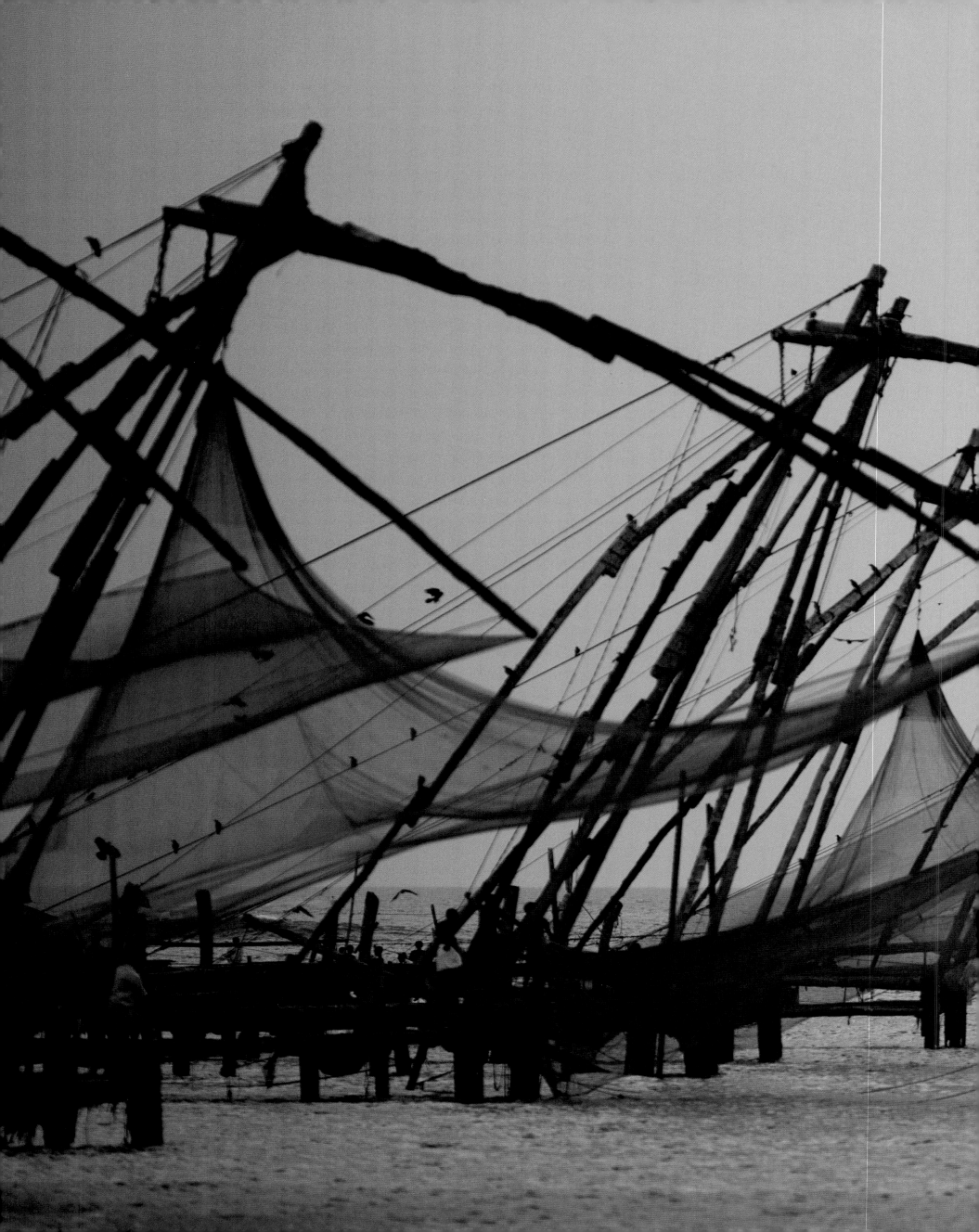

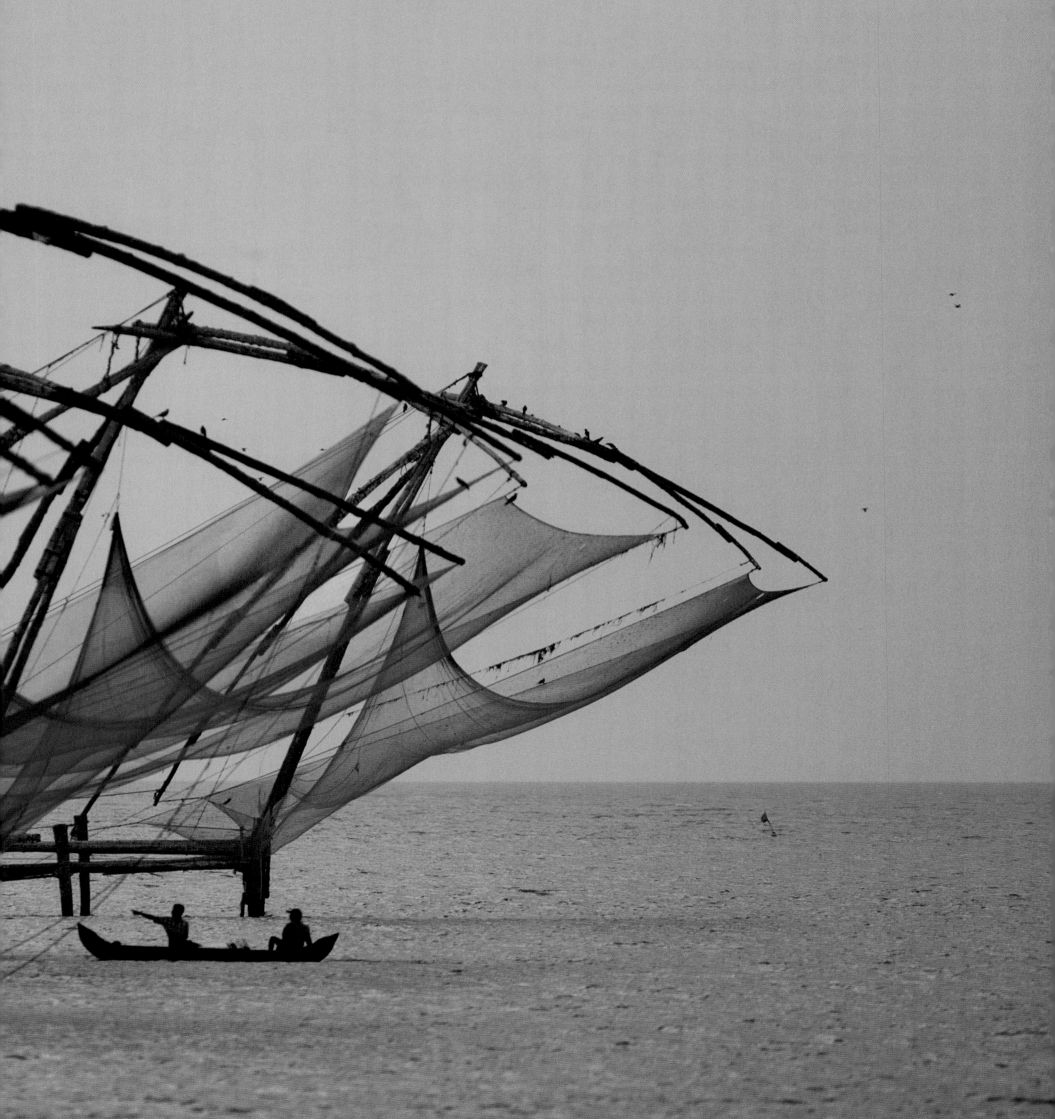

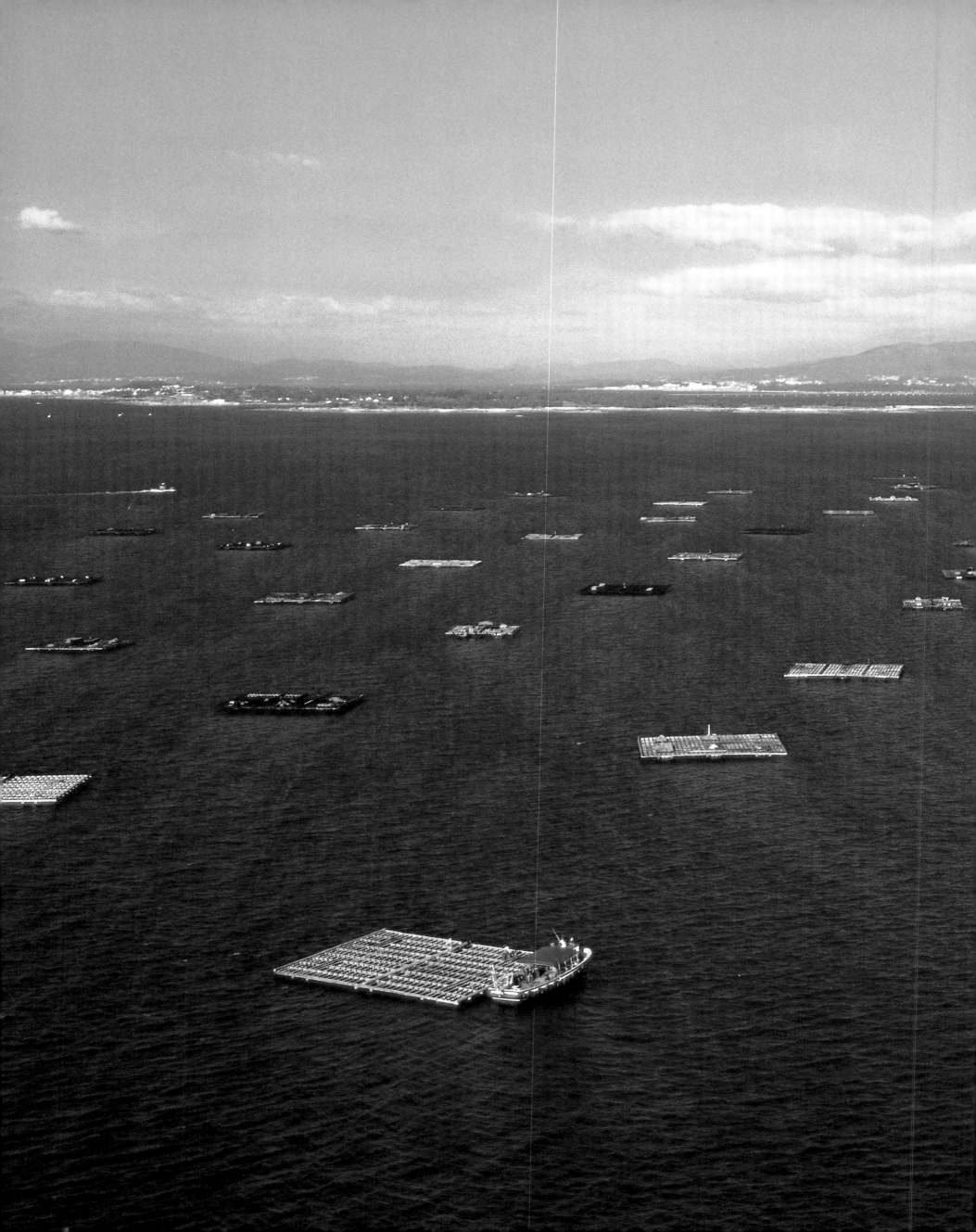

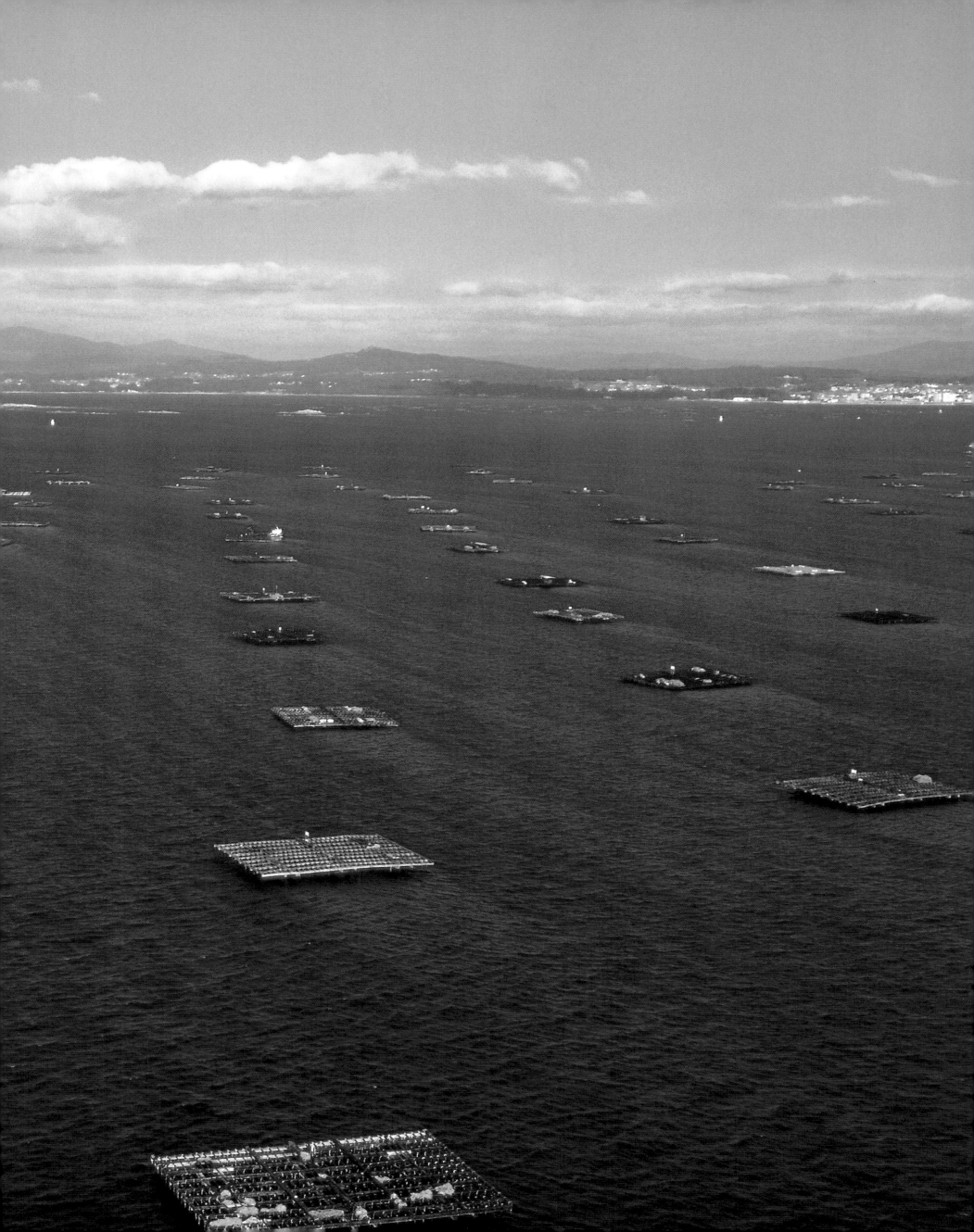

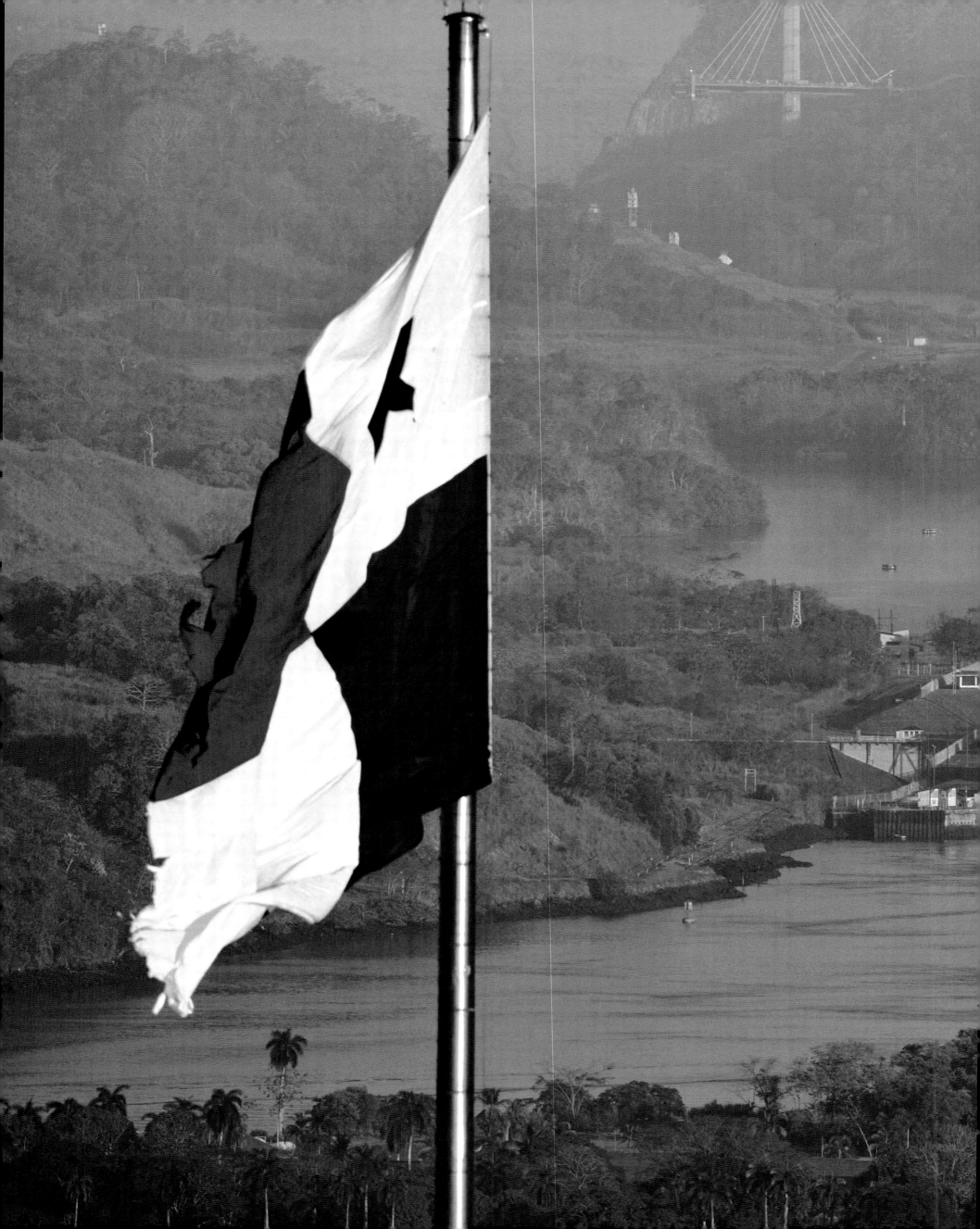

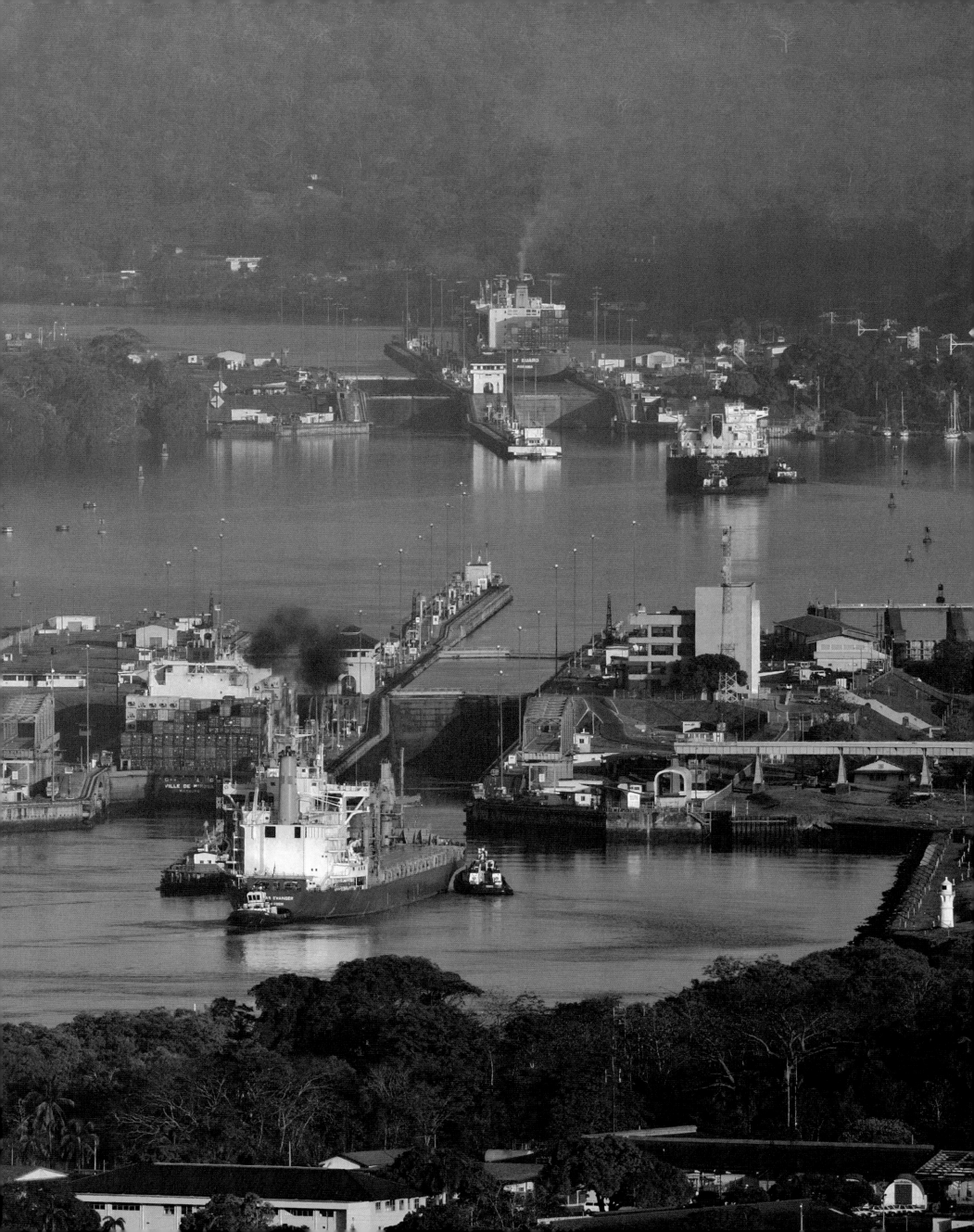

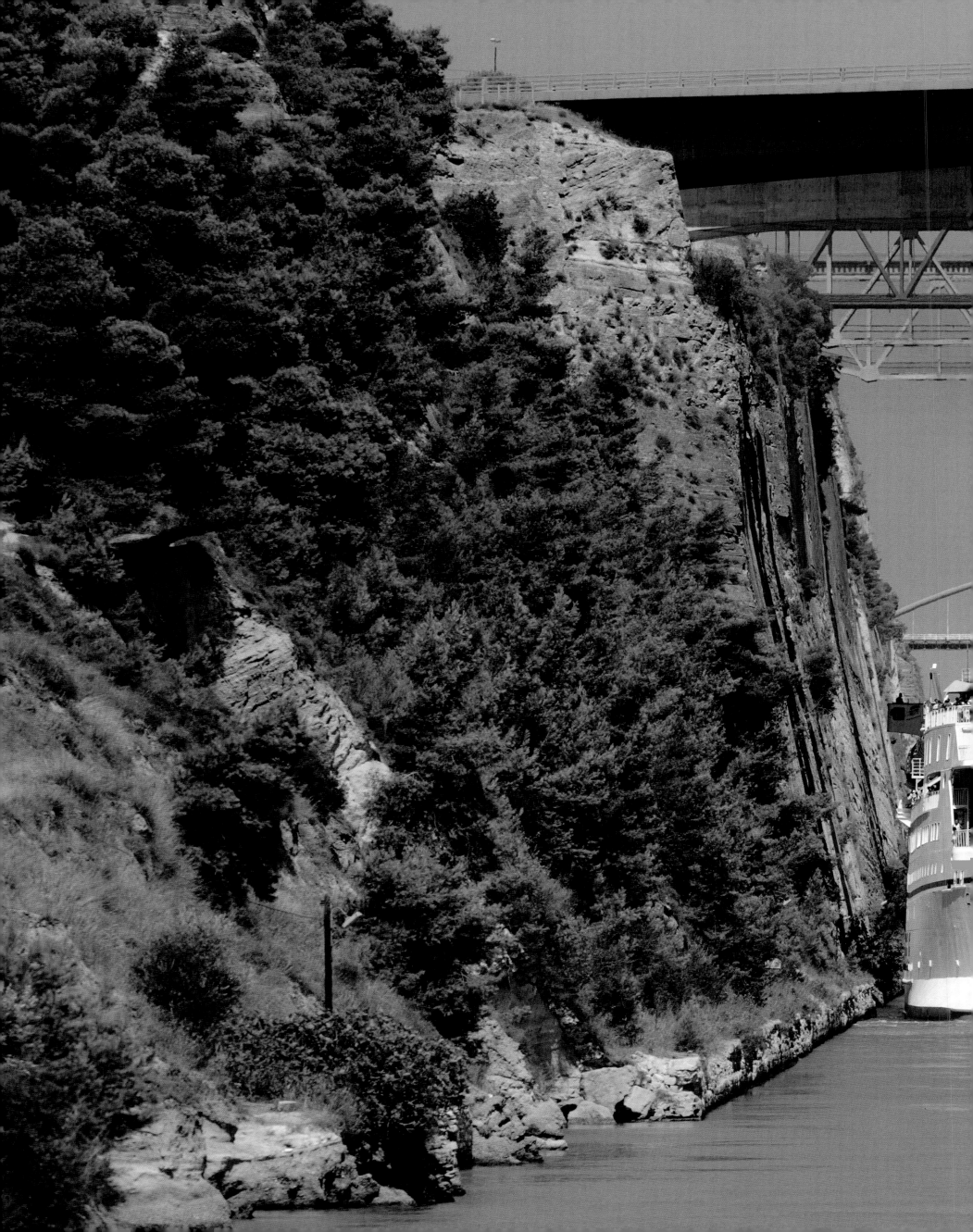

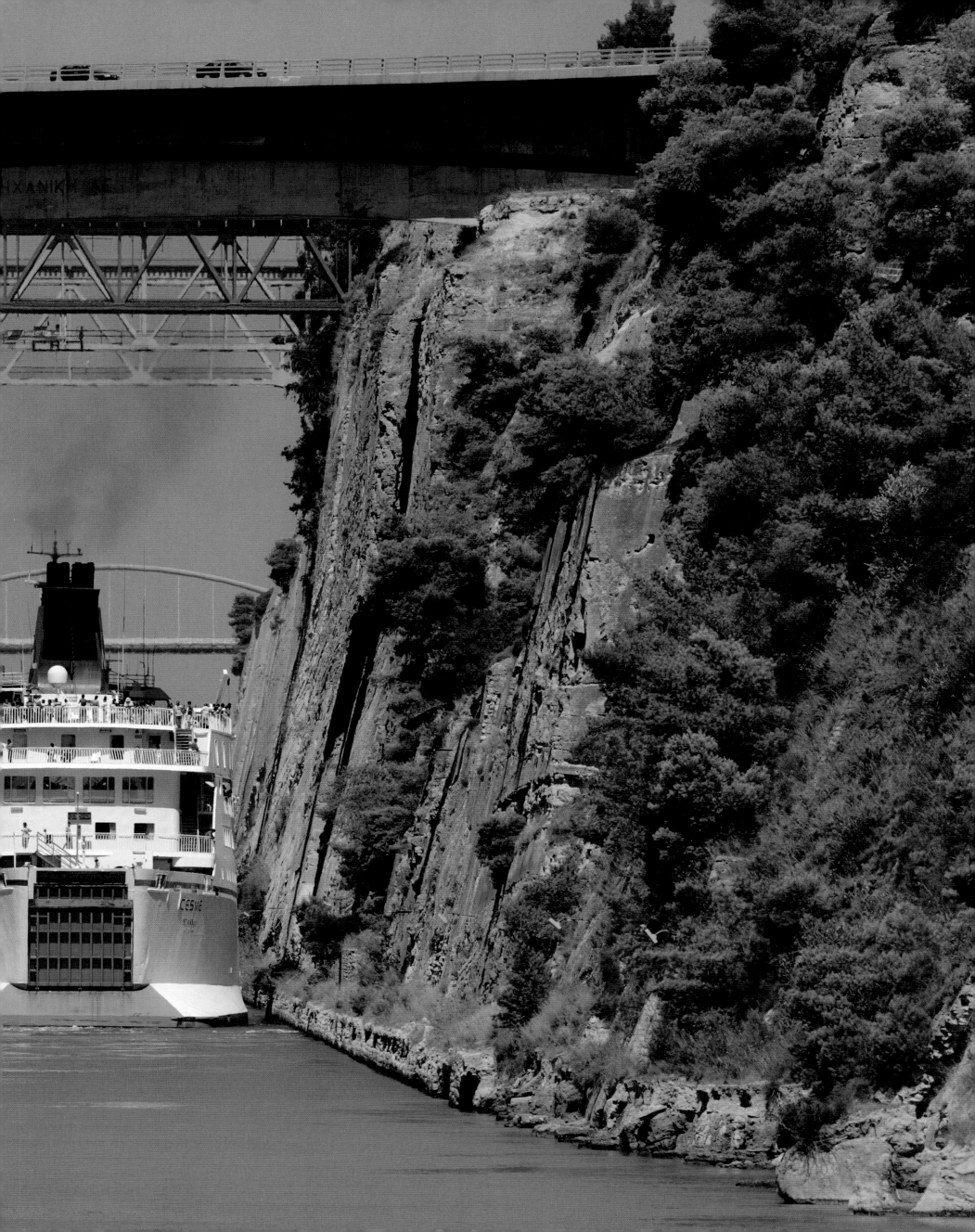

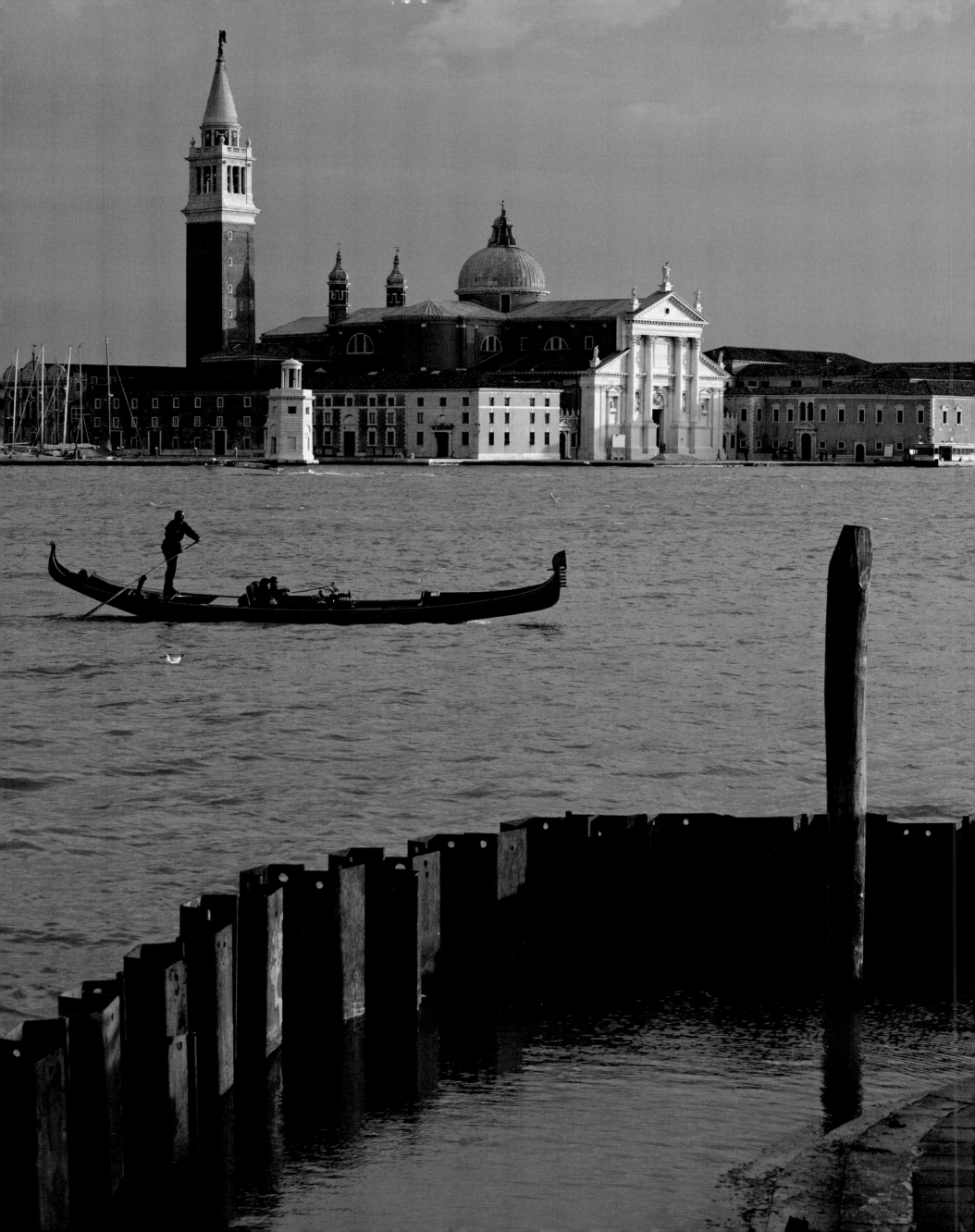

7 A Key to History

The ocean holds the history of the world, and makes it intelligible and easy to grasp. No matter which period or which civilization we look at, the seas have always washed our shores, moulded events, and – today more than ever – presided over the shifting geopolitical balance of the world.

The Egypt of the Pharaohs was a maritime power. The first naval battle on record, around 1191 BC, saw Rameses III using boats to repel the Phoenician invaders, the 'Sea People', and the decline of ancient Egypt can be traced to when the Pharaohs after the 7th century BC decided to use Greek and Phoenician fleets. 'For whosoever commands the sea commands the trade; whosoever commands the trade of the world commands the riches of the world, and consequently the world itself,' wrote Sir Walter Raleigh, as he languished in the Tower of London by order of Queen Elizabeth I. There he had ample time to contemplate the vanities of the world and also to make very acute judgments.

After the Egyptians, it was the turn of the Greeks to build an oceanic empire that stretched as far as their ships could sail, with prosperous trading posts that financed a powerful fleet of warships to outclass those of the Persians. But the sea demands perpetual attention and adaptation, and Poseidon is never satisfied – the smallest technical weakness may prove fatal. The superiority of the Athenians' triremes enabled them to triumph in the Persian Wars, but they paid the penalty for ignoring the new forms of combat that favoured size and boarding enemy ships over mobility and ramming. Athens was defeated at Syracuse and then at Aigos-Potamos. Carthage became the new dominant maritime power, and ruled the western Mediterranean from the 6th century BC until the end of the first Punic War in 241 BC when it was defeated by the greatest naval force in antiquity: Rome.

Long before Caesar and other great leaders sent their legions round the world, Rome was a sea power. Hannibal had to cross the Alps with his elephants simply because of the fact that Rome ruled the sea, and so the only way he could attack her was by making a grand tour overland. It was this maritime dominance that enabled Rome to send Scipio to Africa, where he finally crushed Hannibal at Zama in 202 BC. The splendours of Byzantium and of Venice also derived from the kingdom of Neptune, and the Doges were quite right to stage a yearly celebration of the 'marriage' between their city and the ocean.

The sea, however, has a mind of its own, and refuses to be tied down by the land. The *Mare Nostrum*, cradle of humanity, suddenly exploded with a geographical 'big bang'. Within four years, the history of the world was turned on its head. In 1488, Bartolomeu Diaz sailed round the Cape of Good Hope. From then on, all trade between Europe and Asia followed the Atlantic route, causing the decline of the Mediterranean cities and the emergence of the Atlantic states. Four years later, in 1492, Christopher Columbus discovered the New World, and strengthened still further the primacy of the Atlantic.

The changes were enormous for a country like Britain, which along with Ireland had been a remote region within the old world but now suddenly found itself at the very heart of the new. Thanks to the prevailing winds and currents, the return routes from America led to her shores.

Eastward expansion had long been possible, and indeed had been the root of the Hundred Years War, which went on intermittently for five generations because the kings of France knew little of the sea, and so were unable to cut lines of communication on the English Channel. From then on, Britain was able to expand westwards, towards America, and built the foundations of an enormous empire; France, on the other hand, could only wage a succession of local wars, culminating in the Napoleonic campaigns.

Whenever there is a trial of strength between the land and the sea, it is always the sea that wins. The

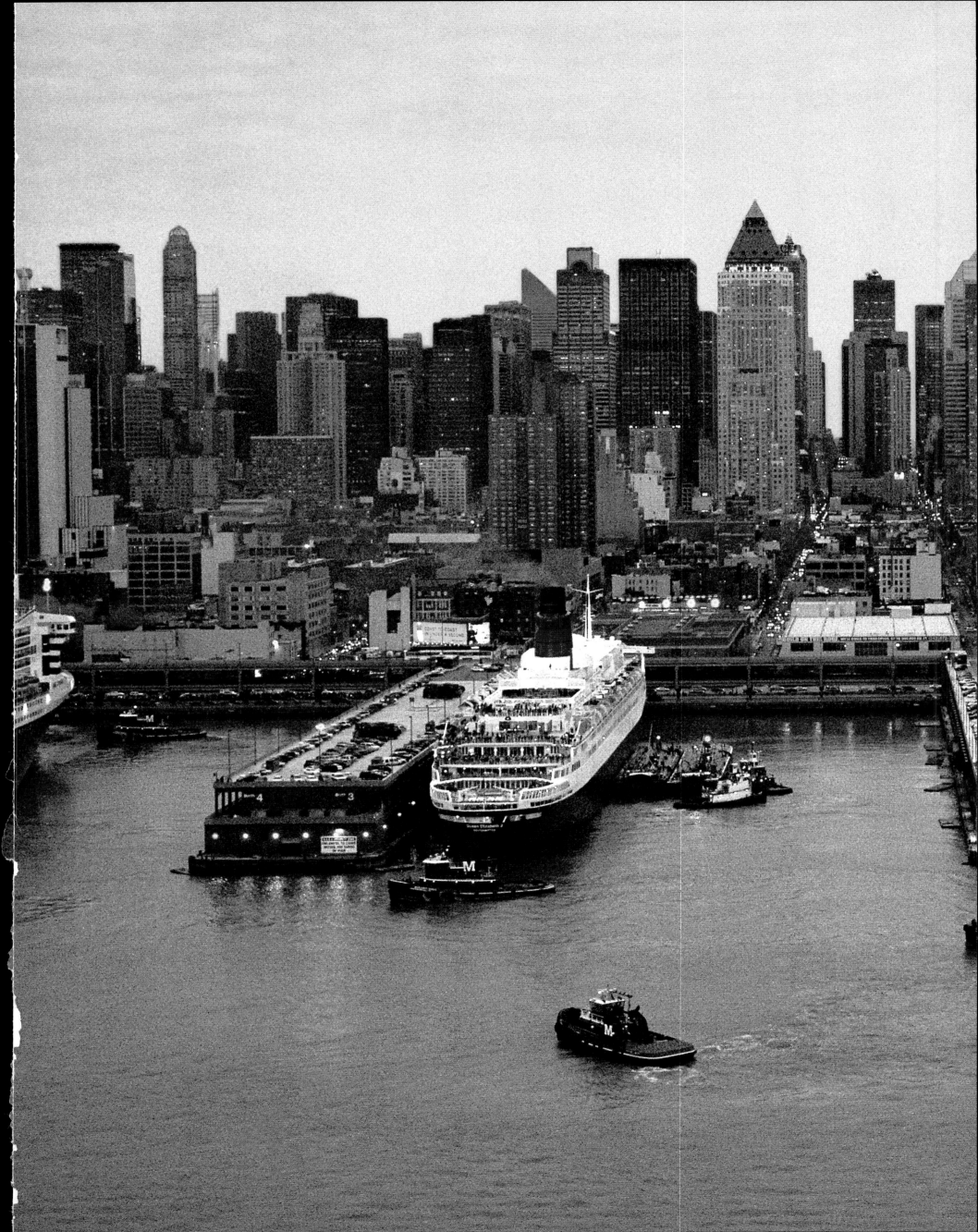

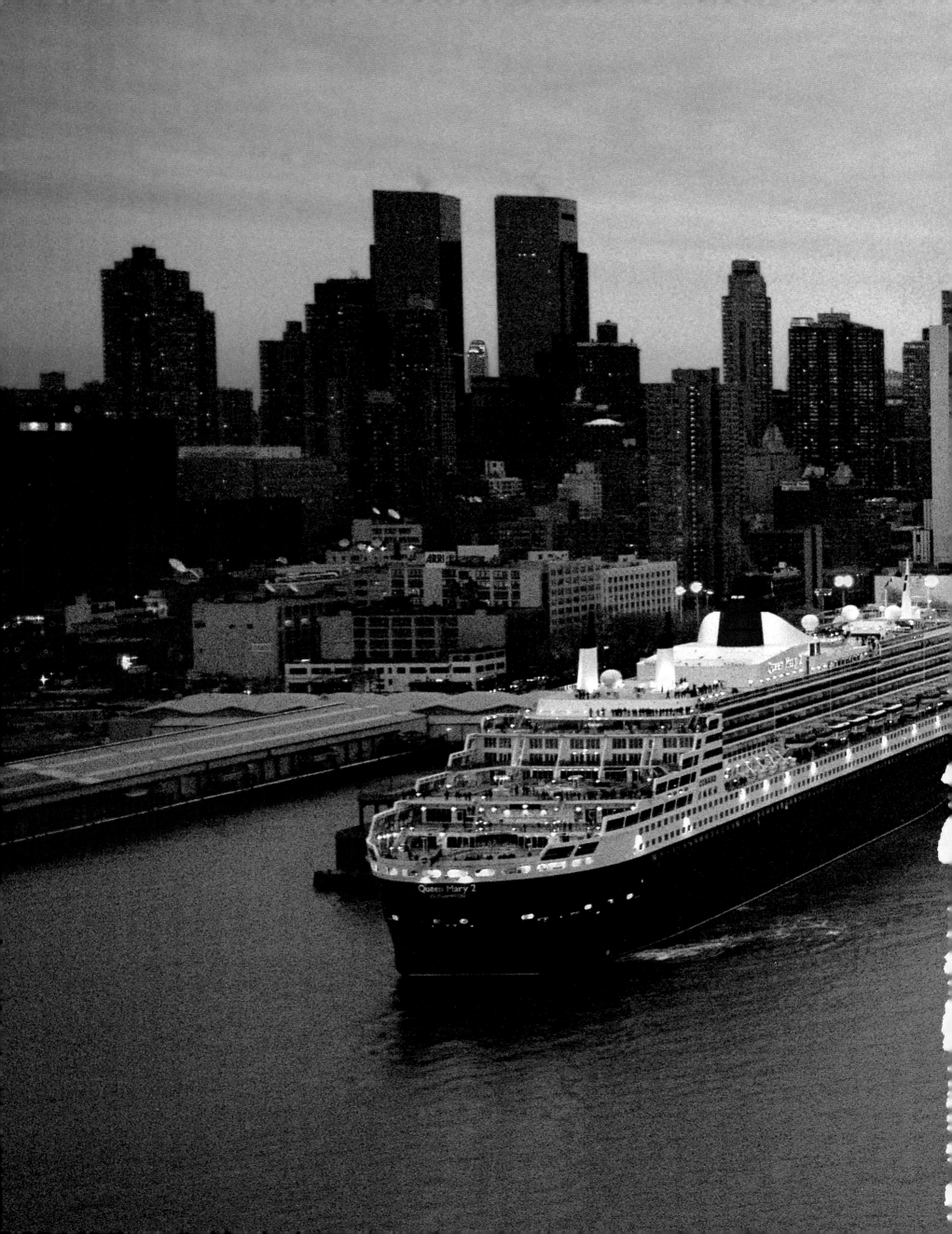

British, the new 'Sea People', seized the banner of world dominance from France, which as a highly centralized and heavily populated state had held it for some time. Great Britain paraded the flag on all the oceans of the world, throughout a maritime empire on which the sun would never set – until at the Washington Naval Conference (1921–22), she agreed to share and share alike with her big American brother. But her unique talent lay in recognizing, before anyone else, that the sea was the largest free-trade area in the world.

The lesson was the same in Asia. In 1434, the Chinese forbade ocean-going transport, replacing it with interior waterways such as the imperial canals, and this hindered the development of what in effect was the commercial capitalism that much later lay at the heart of Japanese power during the Meiji era at the end of the 19th century. There is no gainsaying the evidence – the sea is one of the most powerful driving-forces behind economic development. It is also worth pointing out that all the G8 states are seafaring nations.

History repeats itself, and once more it was an Atlantic battle, this time against Admiral Dönitz's submarines, that along with the construction of 8 million tonnes of merchant ships enabled the Allies to liberate Europe. There is no lasting power that is not naval; that is the lesson of history from the Sumerians to the Cold War – cold because it was essentially underwater. Dominance of the sea is integral to power, whether it be for military or humanitarian purposes, as was evident from the remarkable aid operations carried out after the tsunami of December 2004.

'The Sea, so feared and so desired by nations,' said Charles de Gaulle, 'the sea which separates peoples and yet allows them to join together, the sea through which the worst dangers may threaten states, but without which there is no greatness.' No matter where we are, the sea presents us with a fascinating framework for our history. Within its furrows are planted the seeds of tomorrow's history. In every man there sleeps a sailor, and the future awaits us – on the open sea.

USA, NEW YORK CITY, *QUEEN MARY 2* AND *QUEEN ELIZABETH 2*
For a century the transatlantic liners, which first came on the scene in 1840, were used to transport emigrants to the New World. Large numbers of European migrants used to crowd onto these quays, and until 1960 this remained the only way that they could cross the Atlantic. However, the arrival of air travel gradually put an end to these regular crossings. It was the introduction of luxury cruises that allowed the liners to be converted and brought back into use. Since the 1990s, the growth of the leisure industry has made cruises highly fashionable, and the 21st century is witnessing a huge expansion of the world's fleet of cruise ships. There are currently several hundred such vessels in operation, with a recorded 11 million passengers in 2005 – a rise of 15 per cent over 2004.

MALTA, VALLETTA
The capital and largest city of the Republic of Malta, Valletta was founded by the Knights of the Order of St John, who took possession of the island in 1523. Begun in 1566, a year after the island was besieged by the Ottomans, the construction of Valletta with all its bastions and churches was completed over the remarkably short period of 15 years. Another interesting feature of Valletta is the fact that it was a 'modern' 16th-century city built from scratch – a rarity at a time when most towns grew from an existing settlement. Valletta owes its name to Jean Parisot de la Valette, who was then Grand Master of the Knights of Malta.

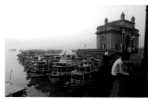 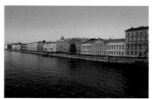

INDIA, BOMBAY, GATEWAY OF INDIA
Bathed by the Sea of Oman, Bombay – which was renamed Mumbai in 1995 – is the largest city in India, with approximately 18 million inhabitants. When you arrive at Bombay by sea, the first thing that meets your eyes is the Gateway of India, a monumental arch that stands on the seafront in commemoration of the visit by King George V and Queen Mary in 1911. Initially, the arch was meant to be part of a much bigger construction, but through lack of funds the project never came to fruition. After India was declared independent in 1947, the last British soldiers left the country through this gateway.

RUSSIA, ST PETERSBURG, NEVA QUAY
On the eastern edge of the Baltic, St Petersburg stretches out over several islands. Its canals and 400 bridges give it the name 'the Venice of the North'. Founded by Peter the Great in 1703, the city became capital of the Russian Empire in 1912. The Admiralty, the Winter Palace, the Marble Palace and the magnificent Hermitage, all built in the 18th and early 19th centuries, provide a rich architectural heritage. It was at the heart of the 1905 and 1917 revolutions, and has changed its name three times, having been Russianized in 1914 as Petrograd, rechristened Leningrad in 1924 on the death of the founder of the USSR, and then restored to its original St Petersburg in 1991 on the break-up of the Soviet Union.

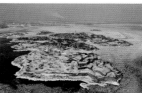 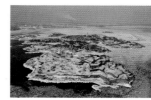

FINLAND, HELSINKI, SUOMENLINNA
In 1747, in order to defend themselves against the Russian Empire, the Swedes built a citadel on the six islands at the entrance to the Helsinki harbour. Initially Swedish, the fortress was taken over by the Russians in 1809 after the annexation of Finland, but it became Finnish in 1917 when Finland declared its independence. It was then renamed Suomenlinna (Fort of Finland). These marine fortifications are a remarkable example of 18th-century European military architecture. The fortress was a prison until 1919, and then a military garrison until 1973. The ramparts and barracks have been renovated and turned into apartments, and the fortress attracts 600,000 visitors a year.

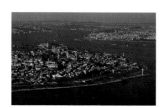

TURKEY, ISTANBUL
Istanbul, the principal city and port in Turkey, stretches out along the two shores of the Bosporus, between the Black Sea and the Sea of Marmara, at the junction between East and West. Following the ancient Byzantium, Constantinople was capital of the Byzantine Empire from AD 395, and then it became Istanbul, capital of the Ottoman Empire from 1453 until 1923. From its past history, the city has inherited a cosmopolitan population and some majestic monuments. Among these is Hagia Sophia, which was Christian for nine centuries and Muslim for over 500 years, and thus vividly illustrates the dual nature of Istanbul, the only city in the world that is divided between two continents.

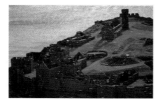

ISLE OF MAN, PEEL CASTLE
In the Irish Sea, the Isle of Man has been inhabited for 8,000 years, and still resounds with tales of the Vikings and the Celts. Built in the 11th century with red sandstone (a local stone in plentiful supply), Peel Castle was a Viking construction. After their rule, the citadel, now with a cathedral, was used by the Church until it was abandoned in the 18th century. Looted and left to the mercy of the weather, the castle is no more than a pile of picturesque ruins, eaten away by erosion and buffeted by the sea winds, but the incessant cries of the gulls and the endless moaning of the waves sometimes sound like the shouts of soldiers and the insistent chants of monks echoing down from the past.

FRANCE, NORMANDY, POINTE DU HOC
In order to crush the Nazi invasion, 5,000 tonnes of shells and bombs were unleashed on the coasts of Normandy by the British and US armed forces during the allied invasion. Emblematic of the courage of the young US soldiers, the famous Pointe du Hoc – one of the Germans' most powerful strongholds – was captured in an assault mounted by Colonel Rudder's Rangers on the morning of D-Day. Of the 225 soldiers that fought on that day, 80 were killed. The desolate lunar landscape that these men discovered when they landed is still to be seen today, bearing witness to the intensity of past battles. Profoundly moving, the site has remained frozen in time since 6 June 1944.

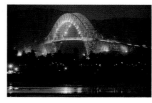

PANAMA, BRIDGE OF THE AMERICAS
The Bridge of the Americas casts its graceful arc across the Panama Canal, on the Pacific side. Completed in 1962, the highway suspended from this arch of steel connects the North American continent with that of the South, directly above the 80 km canal dug in the Isthmus of Panama to join the Atlantic and Pacific Oceans. Dreamed of since 1500, the canal was finally built between 1904 and 1914. Some 14,000 ships use it every year (5 per cent of the world's shipping trade), thereby saving themselves the long diversion around Cape Horn. The Canal Zone, leased to the US in 1903, was officially handed back to Panama in 1999.

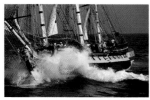

USA, THE *ROSE*
The frigate HMS *Rose*, built in England in 1757, distinguished itself along the US coasts during the American War of Independence. It disappeared in 1779 in Georgia, scuttled by the British, who were then occupying the town of Savannah and needed to block the river in order to stop the French fleet (fighting on the American side) from driving them out. In 1970, as part of the bicentenary celebrations of American independence, a replica was built following designs drawn up two centuries ago for the original ship. A training vessel until 2001, the ship was restored and in 2003 played the role of HMS *Surprise* in the film *Master and Commander*.

GREAT BRITAIN, THE SOLENT, 200TH ANNIVERSARY OF TRAFALGAR
On 21 October 1805, Admiral Nelson routed a Franco-Spanish fleet at Trafalgar, off the Spanish coast, and Great Britain became the undisputed master of the seas. In 2005, the country celebrated the bicentenary of this famous and memorable naval battle. An armada of pleasure boats and old sailing ships escorted over 100 warships into the Solent, the strip of sea that separates Portsmouth and the Isle of Wight. The aircraft carrier *Charles de Gaulle*, the frigate *Jean Bart*, and the sailing ships *Belle Poule* and *Mutin* represented France in this international naval parade which brought together ships from 36 nations.

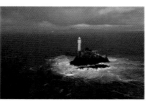

IRELAND, FASTNET ROCK LIGHTHOUSE
Fastnet Rock, a craggy islet that juts out 30 m above the waters to the south-west of Ireland, was the last fragment of coast that the Irish emigrants saw as they set sail for America – hence its nickname 'Ireland's Teardrop'. Sadly, Fastnet was also the last rock seen by the unfortunate passengers on the *Titanic* before they sailed to their deaths. The first lighthouse, built of steel and opened on New Year's Day 1854, gave way in 1904 to the present granite tower, 49 m high. The legendary and highly demanding Fastnet yacht race has been held since 1925, starting in Cowes, sailing up through the turbulence and depressions of the Irish Sea, rounding the rock, and finishing back in Plymouth.

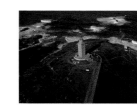

SPAIN, GALICIA, LA CORUÑA, TOWER OF HERCULES
Ever since man first put out to sea, he has needed markers on the land to denote the ports and the dangerous shores. Hence the construction of lighthouses, which are as old as antiquity. The Tower of Hercules has survived the centuries: a symbol of La Coruña, it is situated in the far north-west of the Iberian peninsula, and was built in the 2nd century AD. Changes made to it during its restoration at the end of the 18th century have given it its present appearance. The last Roman lighthouse still in use, and the oldest in the world, the Tower of Hercules still guides modern sailors with a benevolent light that has shone for nearly two thousand years.

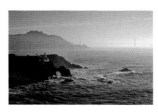

USA, SAN FRANCISCO, PUNTA BONITA, GOLDEN GATE BRIDGE
Since the dawn of civilization, mankind has been joining together places that nature has separated. After having crossed all the rivers with bridges, we have begun to bind shores and islands together by spanning the sea. Thus the Golden Gate Bridge crosses the mouth of San Francisco Bay on the Pacific, linking the towns of San Francisco and Sausalito with a suspended road that is 2,737 m long, with a central span of 1,280 m. Completed in 1937, it was the longest span in the world until 1964, when the record was captured by the Verrazano-Narrows Bridge in New York (a central span of 1,298 m), though this too has since been supplanted.

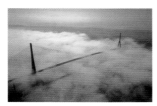

FRANCE, PONT DE NORMANDIE
The Pont de Normandie spans the Seine estuary and takes vehicles in a straight line from Le Havre to Honfleur, at a level of 60 metres above the water. The cable-stayed structure is more wind-resistant than suspension bridges, less expensive to build and easier to maintain. The bridge is designed like two sets of scales: its axes are the concrete pylons 214 metres high, holding 184 cables which support the weight of the roadway. Opened in 1995, after seven years of construction, it was at the time the longest cable-stayed bridge in the world, at 2,143 metres. In 1999, the Tatara Bridge in Japan nabbed the record, but in 2004 it fell once again to the Rion-Antirion Bridge in Greece.

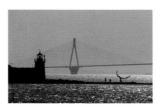

GREECE, RION-ANTIRION BRIDGE
Since 8 August 2004, it has been possible to cross from the Peloponnese to western Greece in five minutes, thanks to the longest cable-stayed bridge in the world (2,252 m). The ferry takes 45 minutes. Fulfilling the ancient dream of bridging the Gulf of Corinth required technological expertise that would have been inconceivable just twenty years ago. The site is in fact subject to frequent and violent tremors. Beneath each of the four concrete pylons, 227 m high and supporting 368 cables, the seabed has been stabilized by sinking huge steel tubes into a bed of gravel. At a cost of 771 million euros, the Rion-Antirion Bridge can resist winds of up to 250 km/h and the impact of a 180,000 tonne oil tanker.

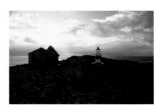

CHILE, CAPE HORN
The winds and waves of the west travel thousands of miles to hurl themselves against the Andes, storming and raging through the exit route that they finally find at the southernmost tip of South America. This is the terrifying realm of Cape Horn, where the weather conditions are among the harshest in the world. This rocky isle, reaching a height of 450 m, is battered for 300 days in the year. Throughout the course of history, the dreaded cape has claimed some 800 ships and more than 10,000 lives. Its dark reputation has earned it the name 'Cape of Storms'.

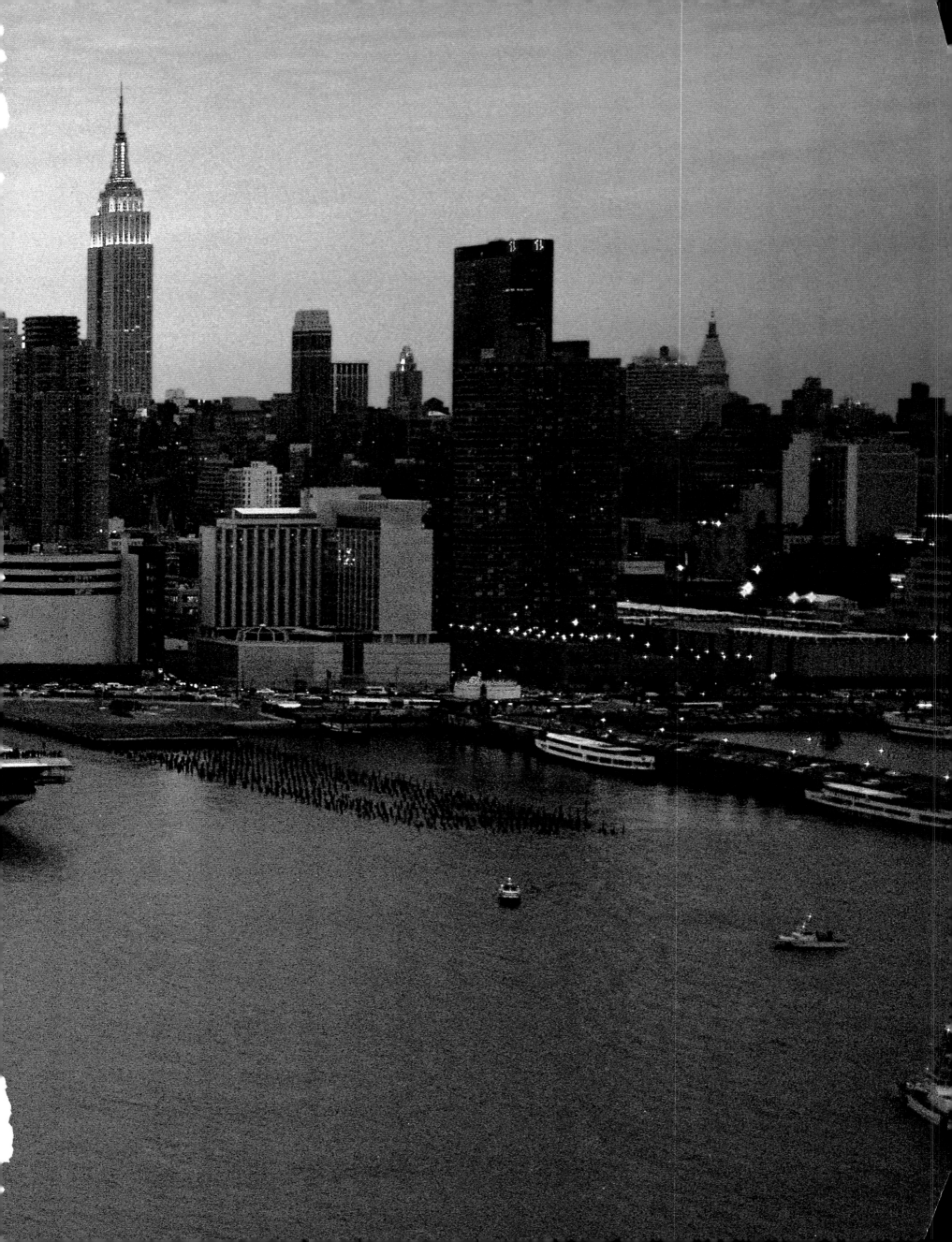

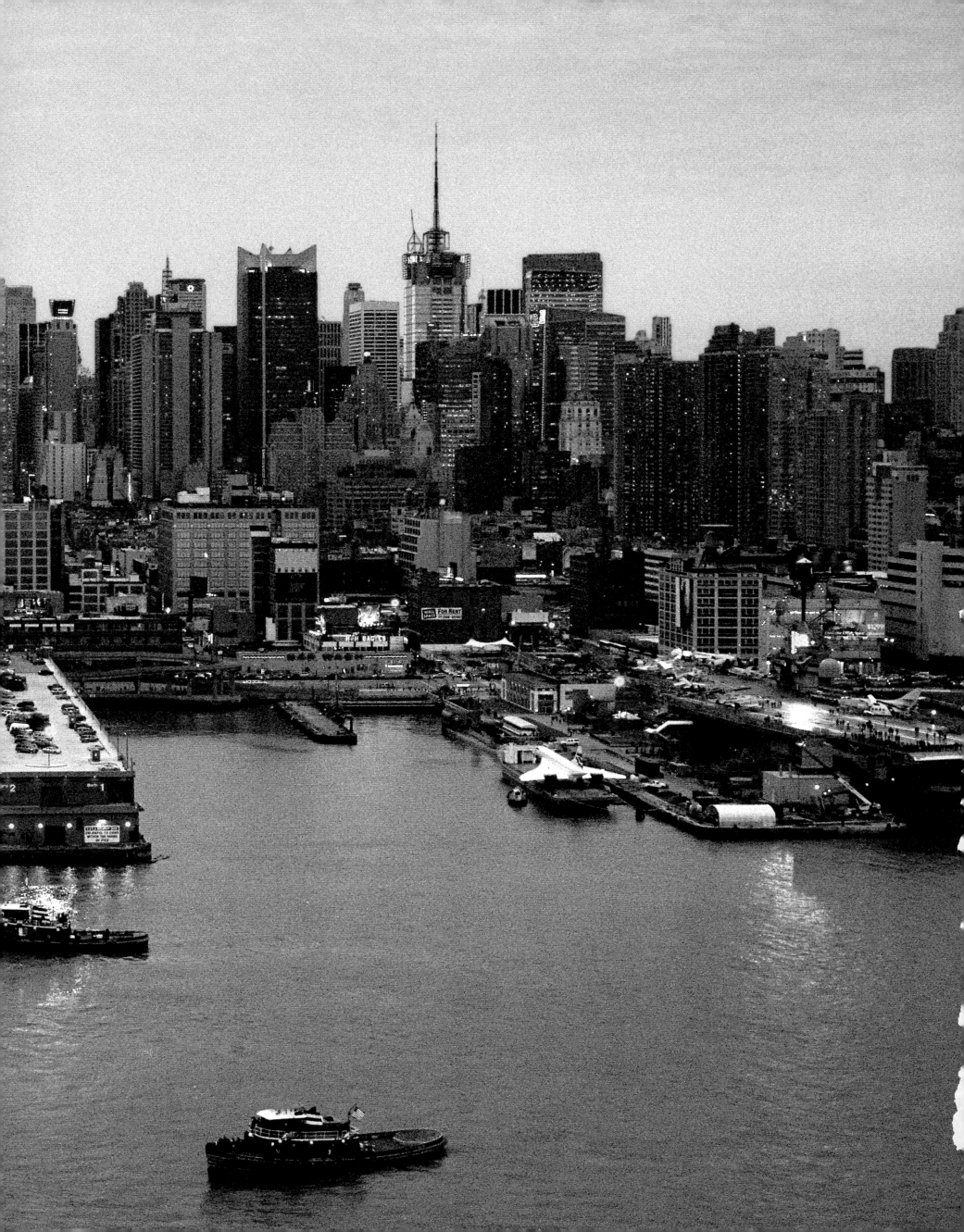

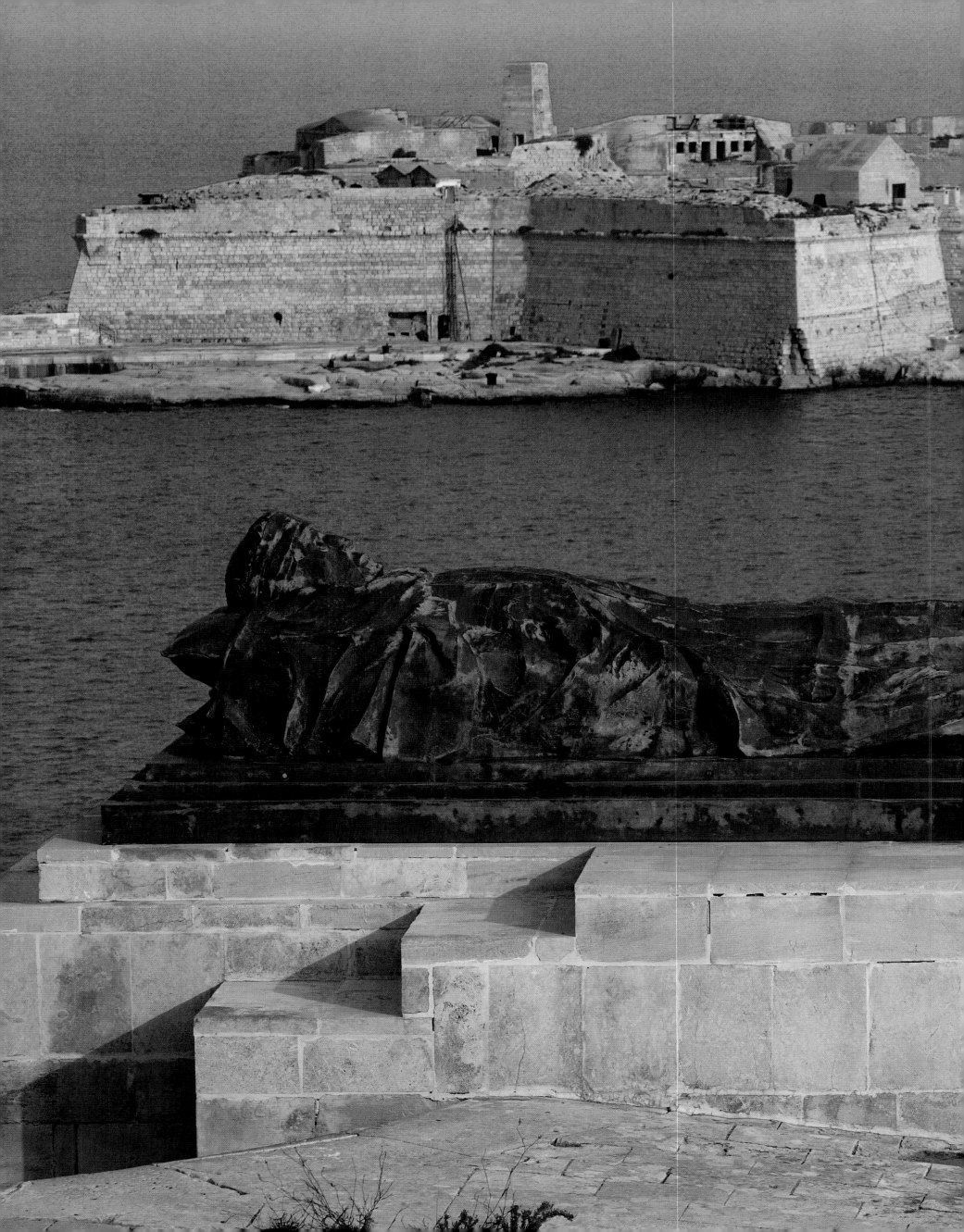

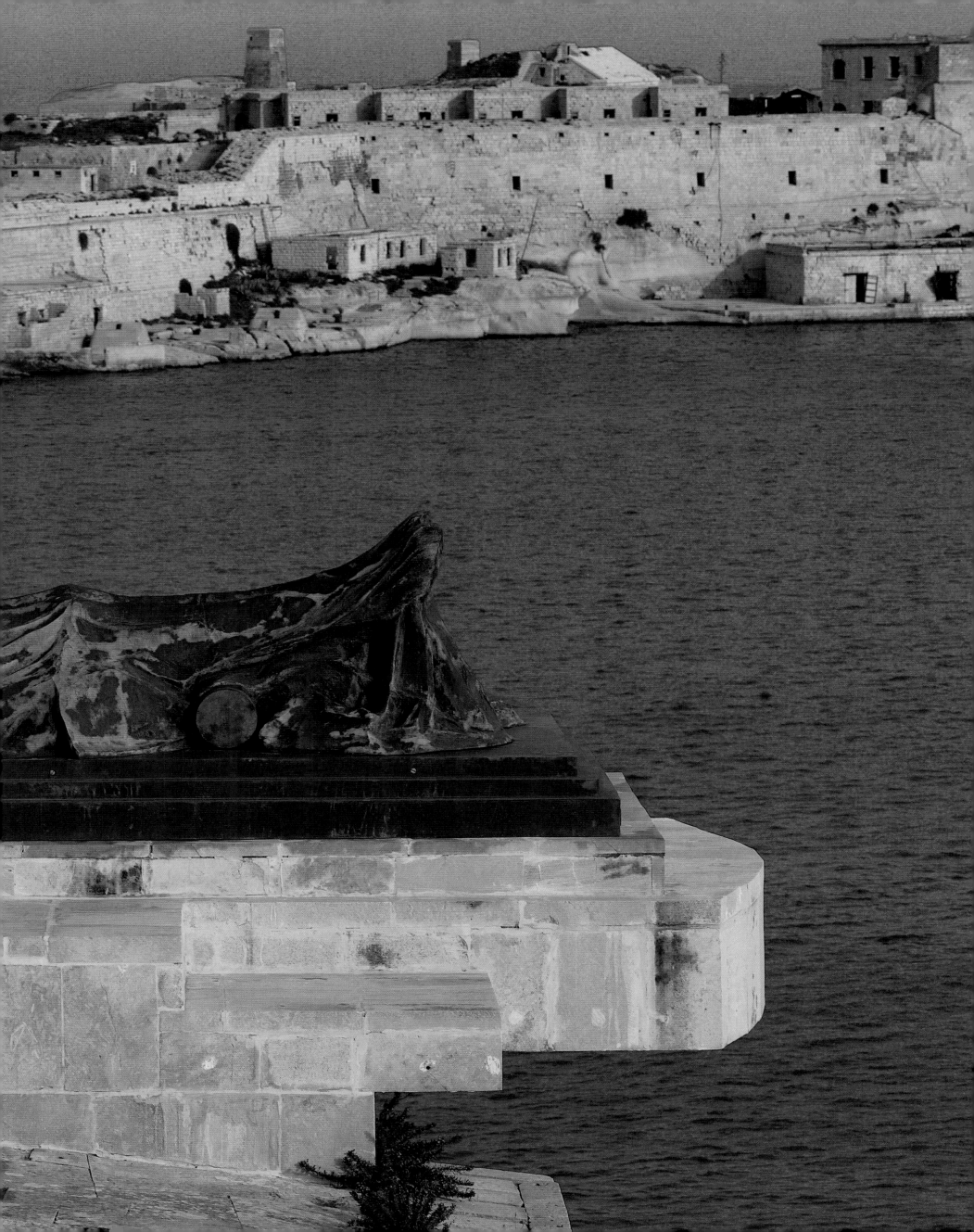

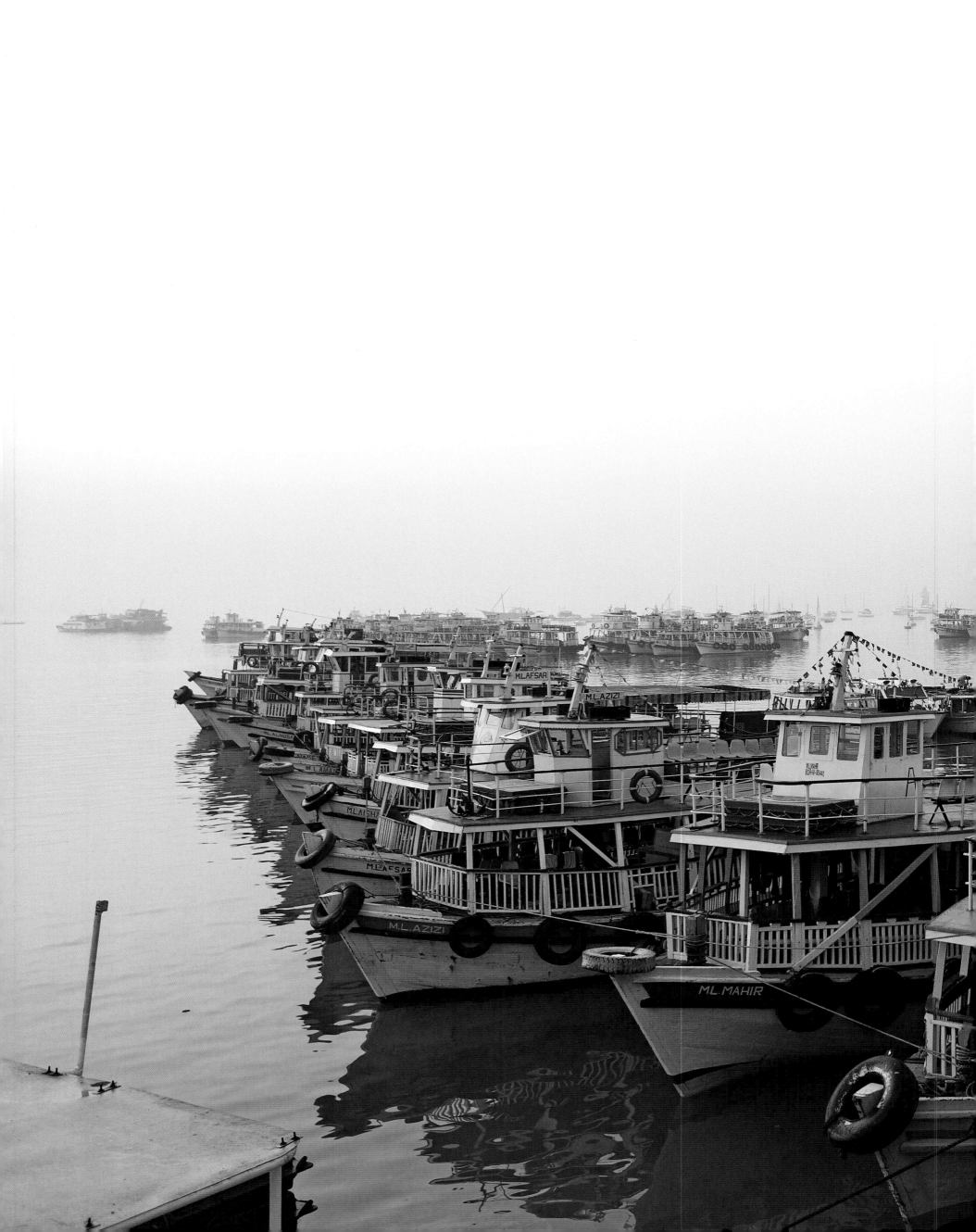

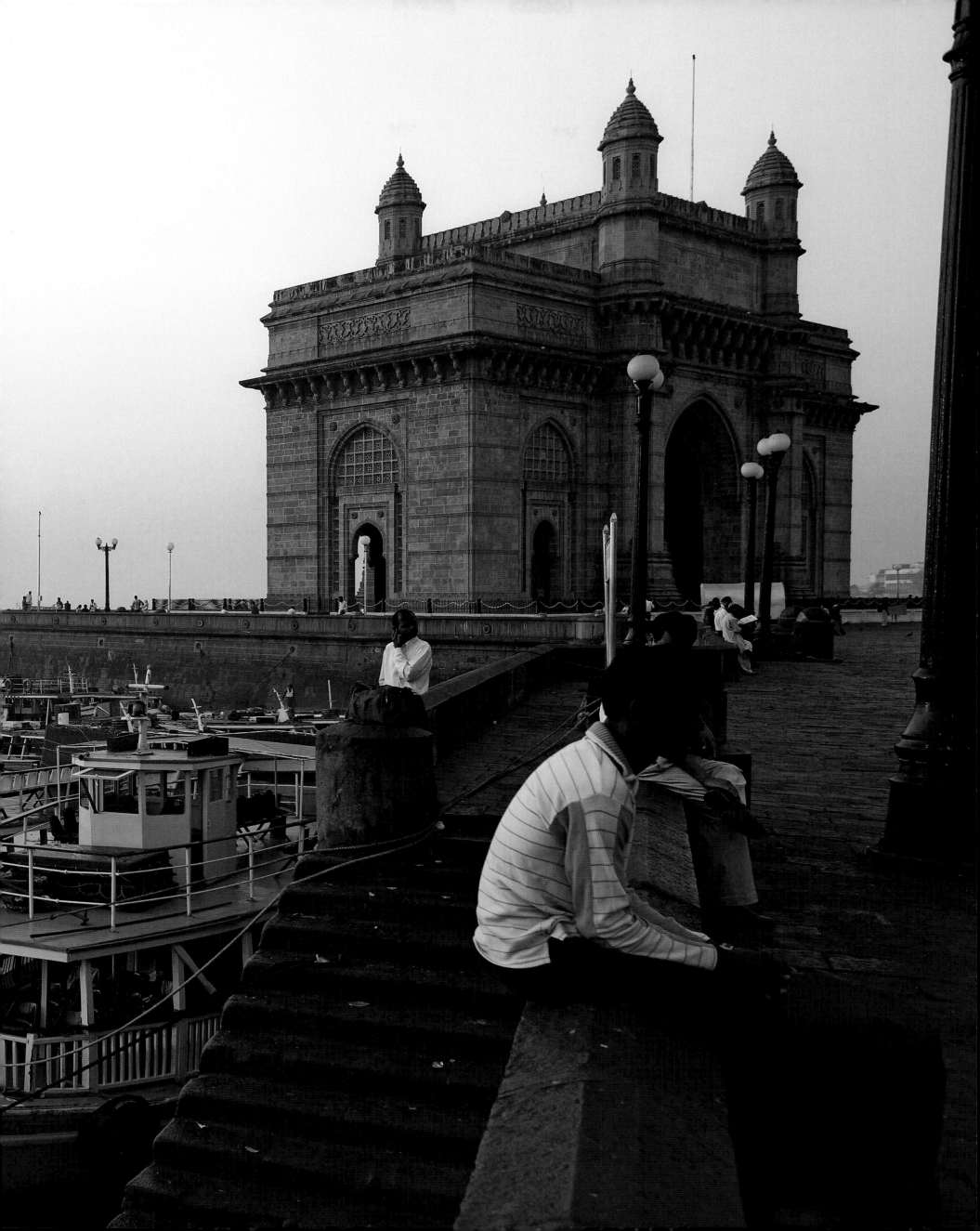

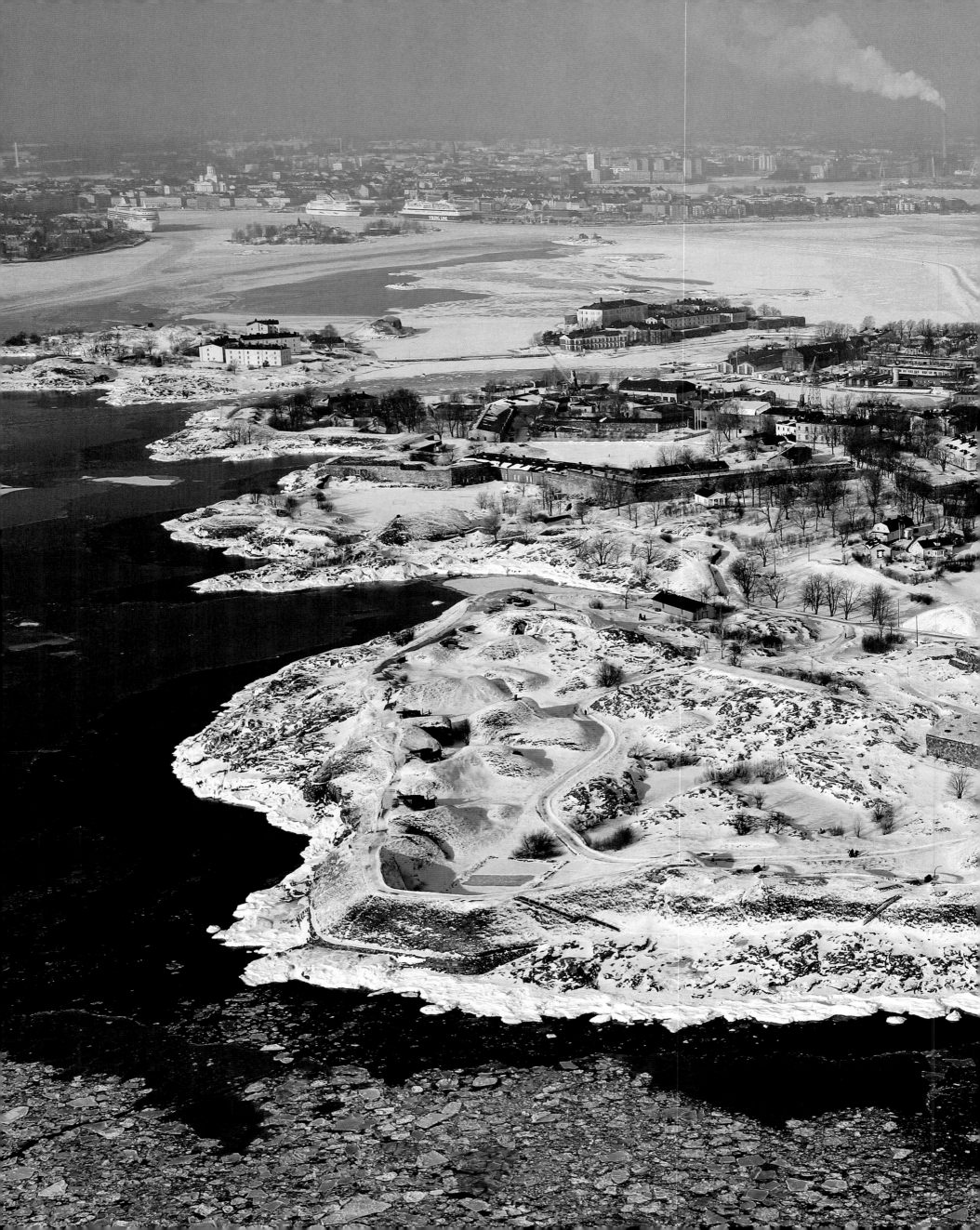

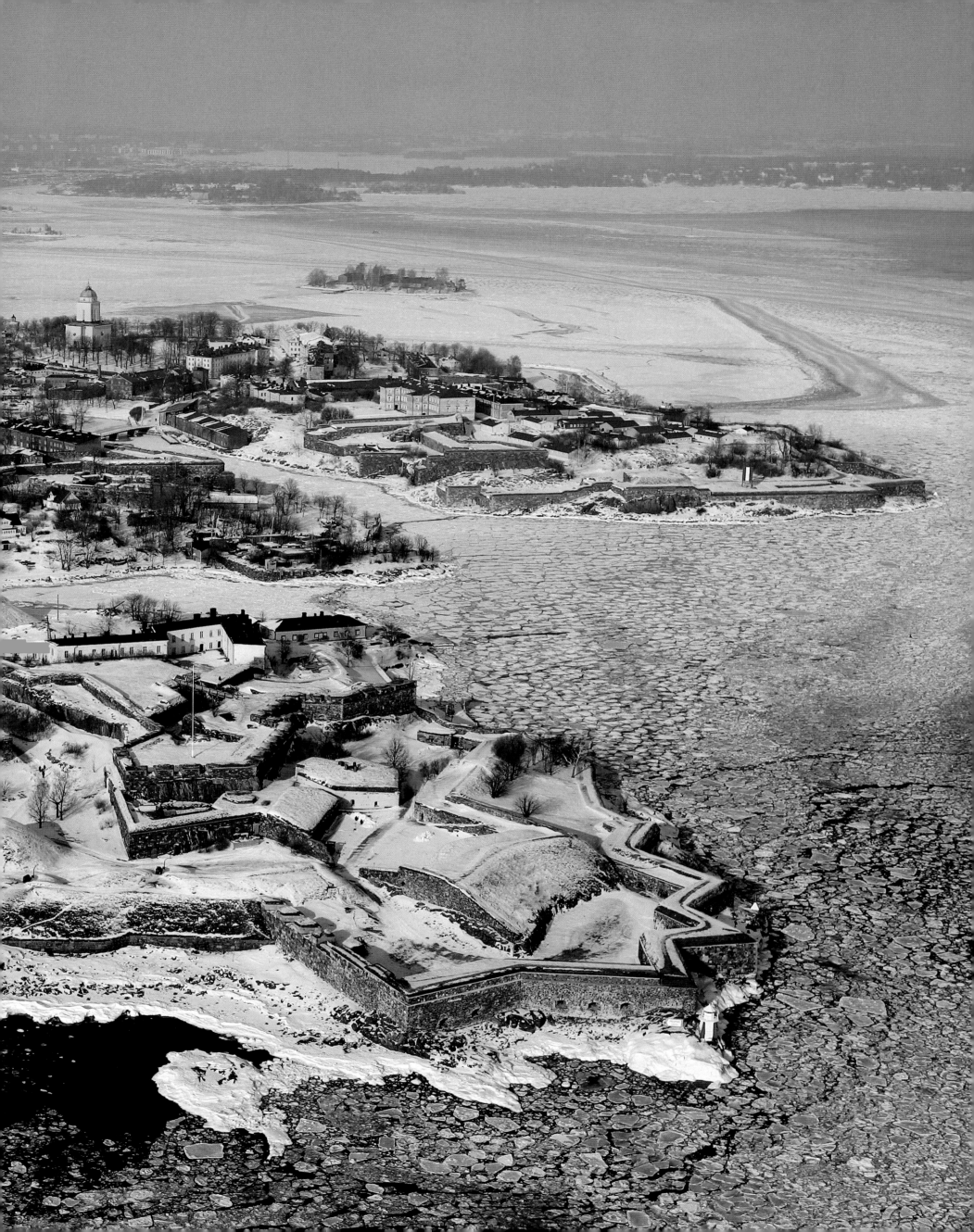

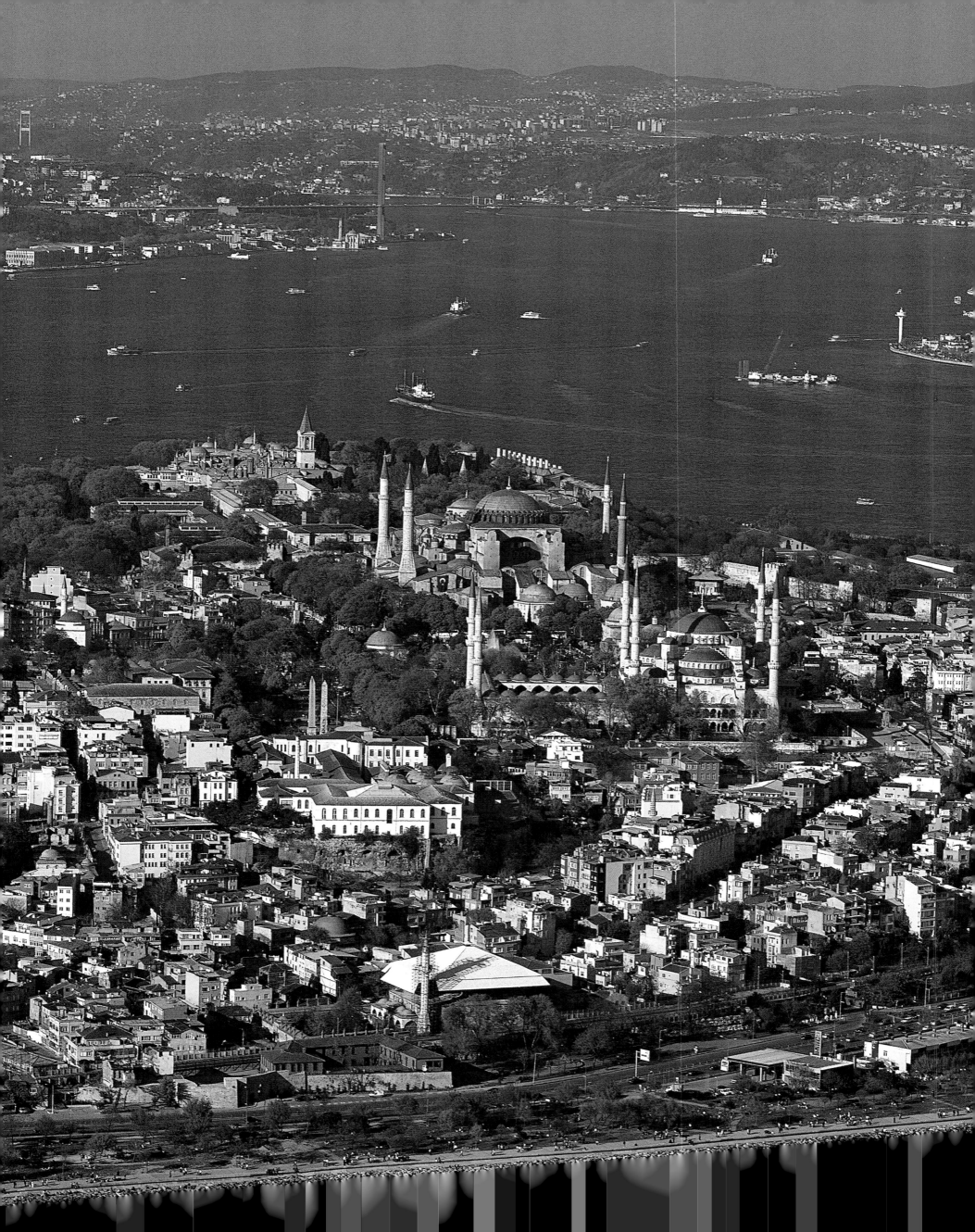

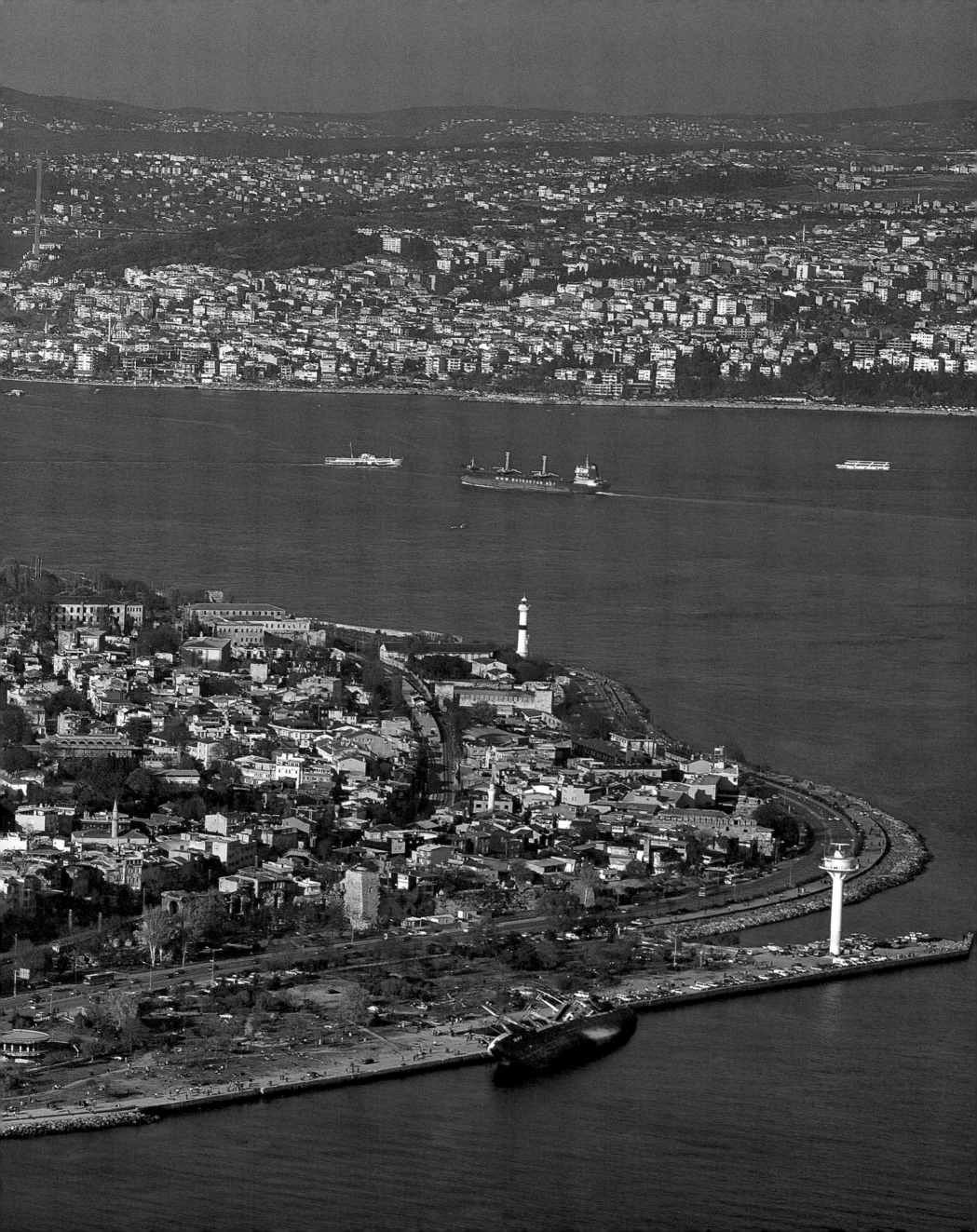

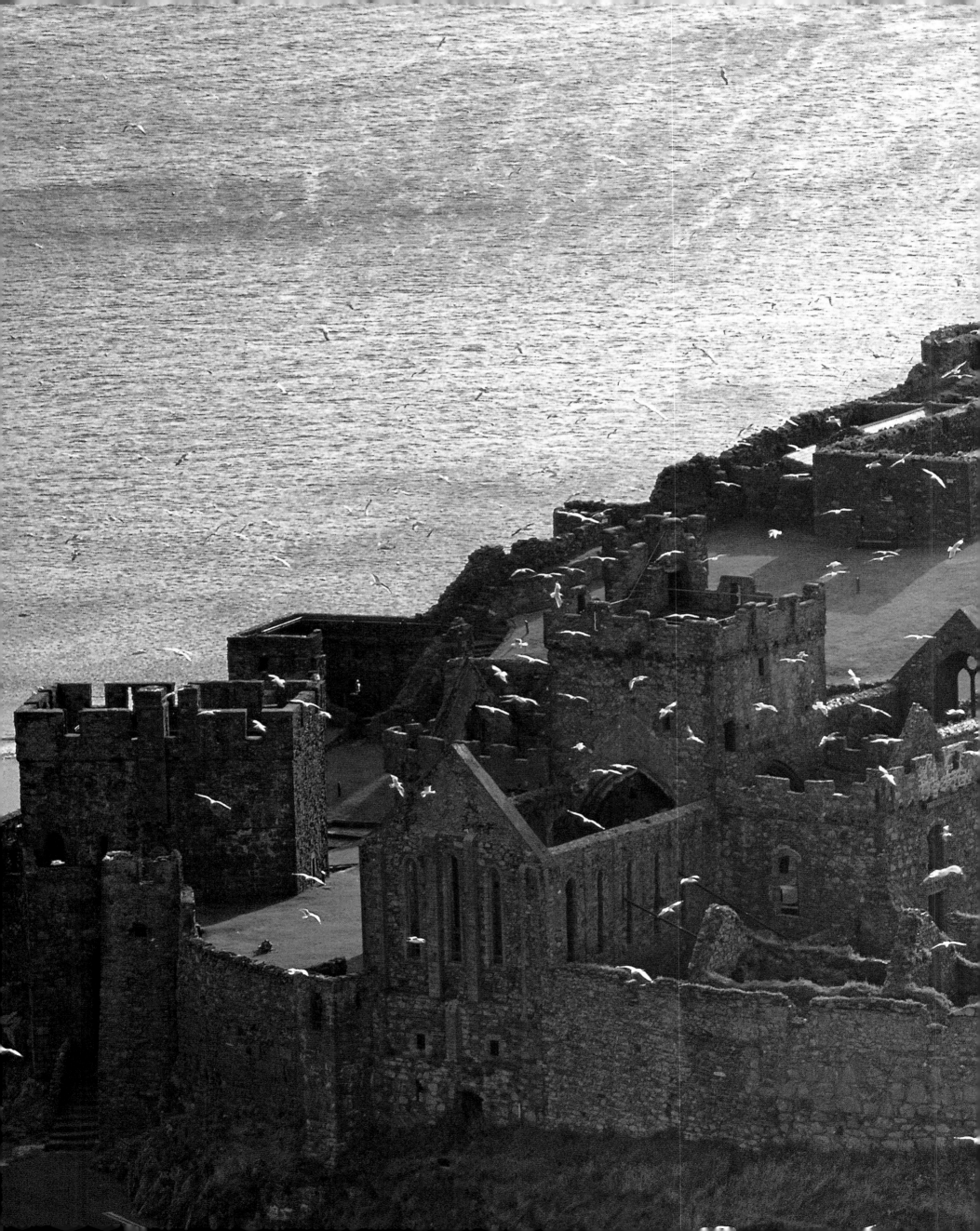

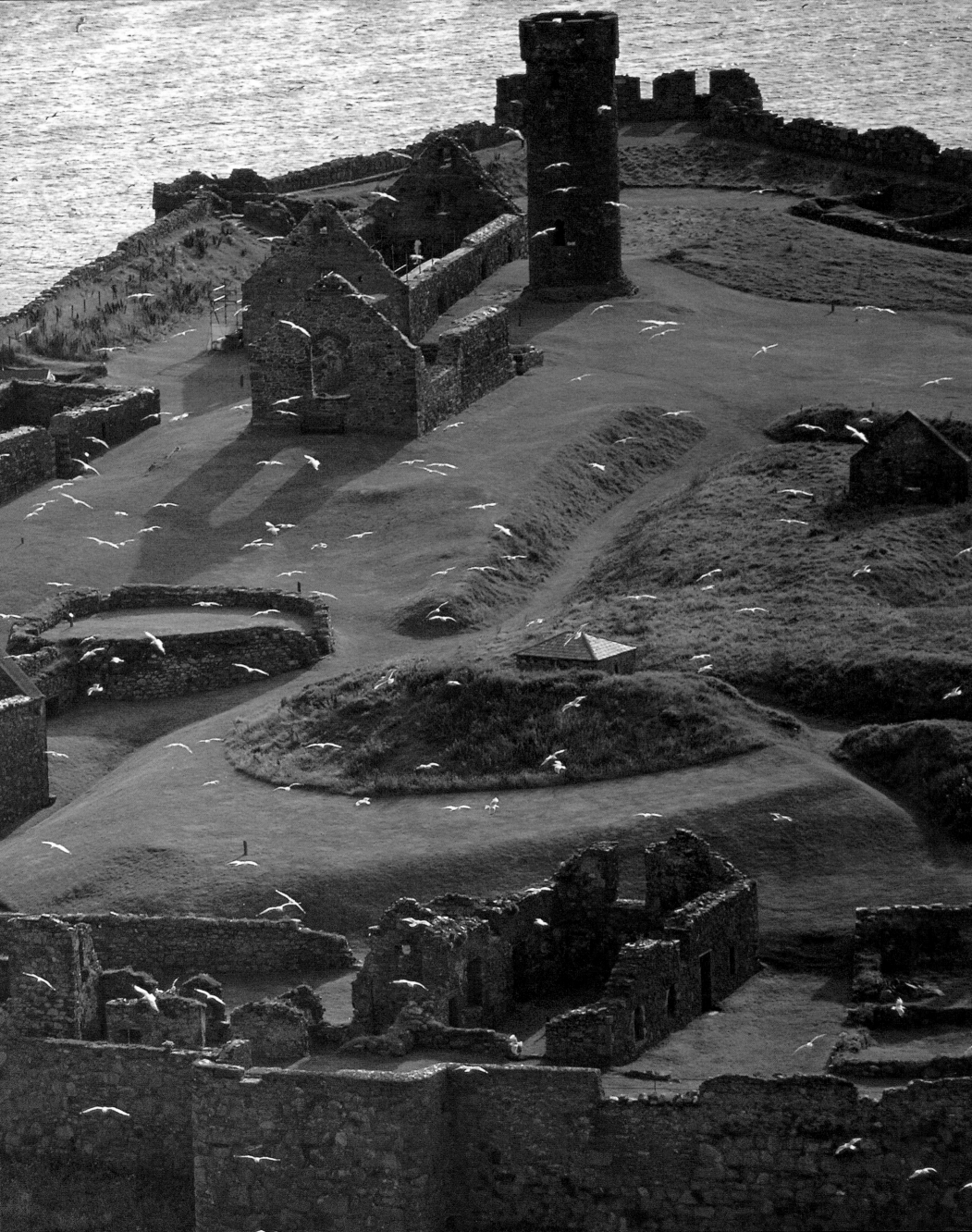

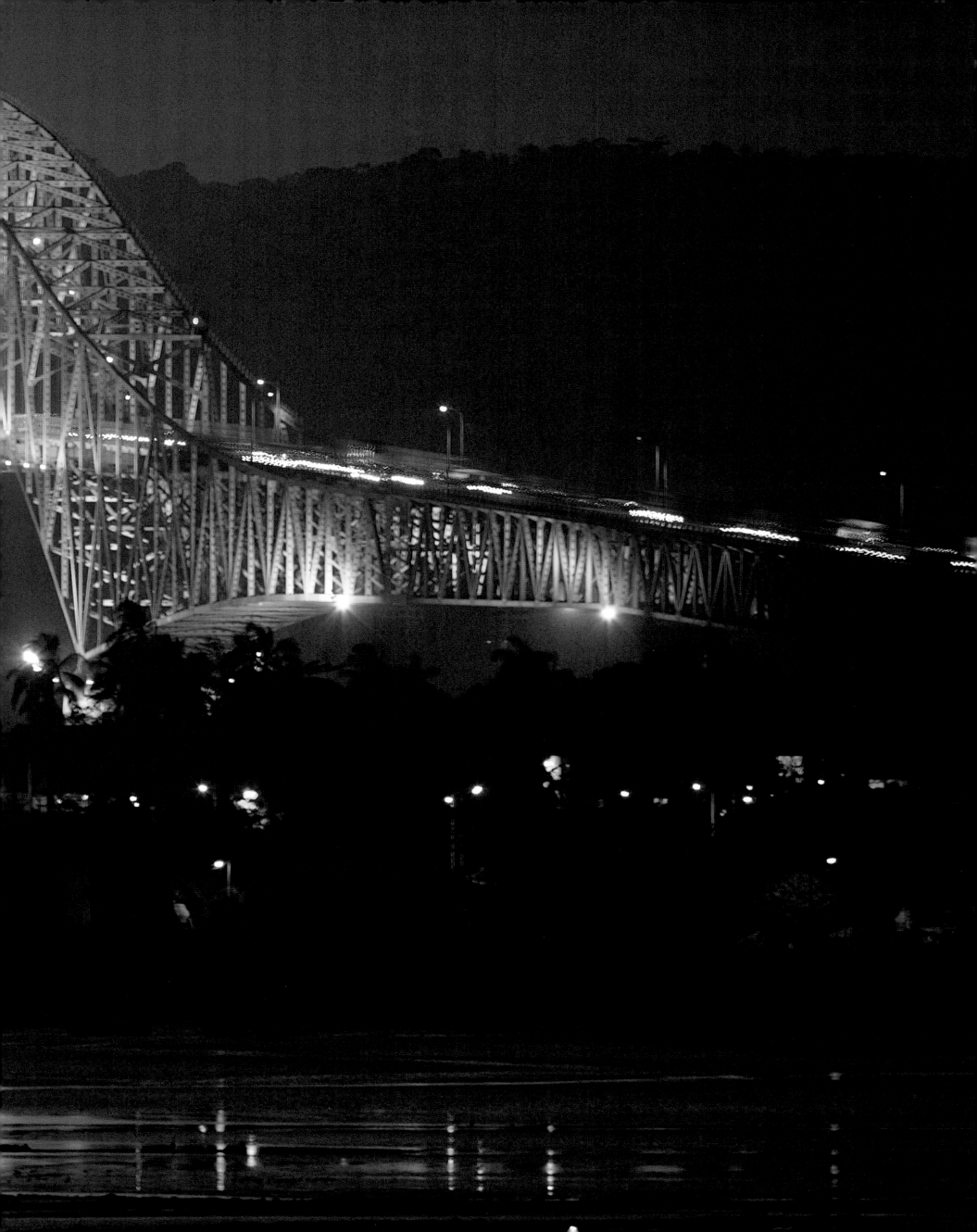

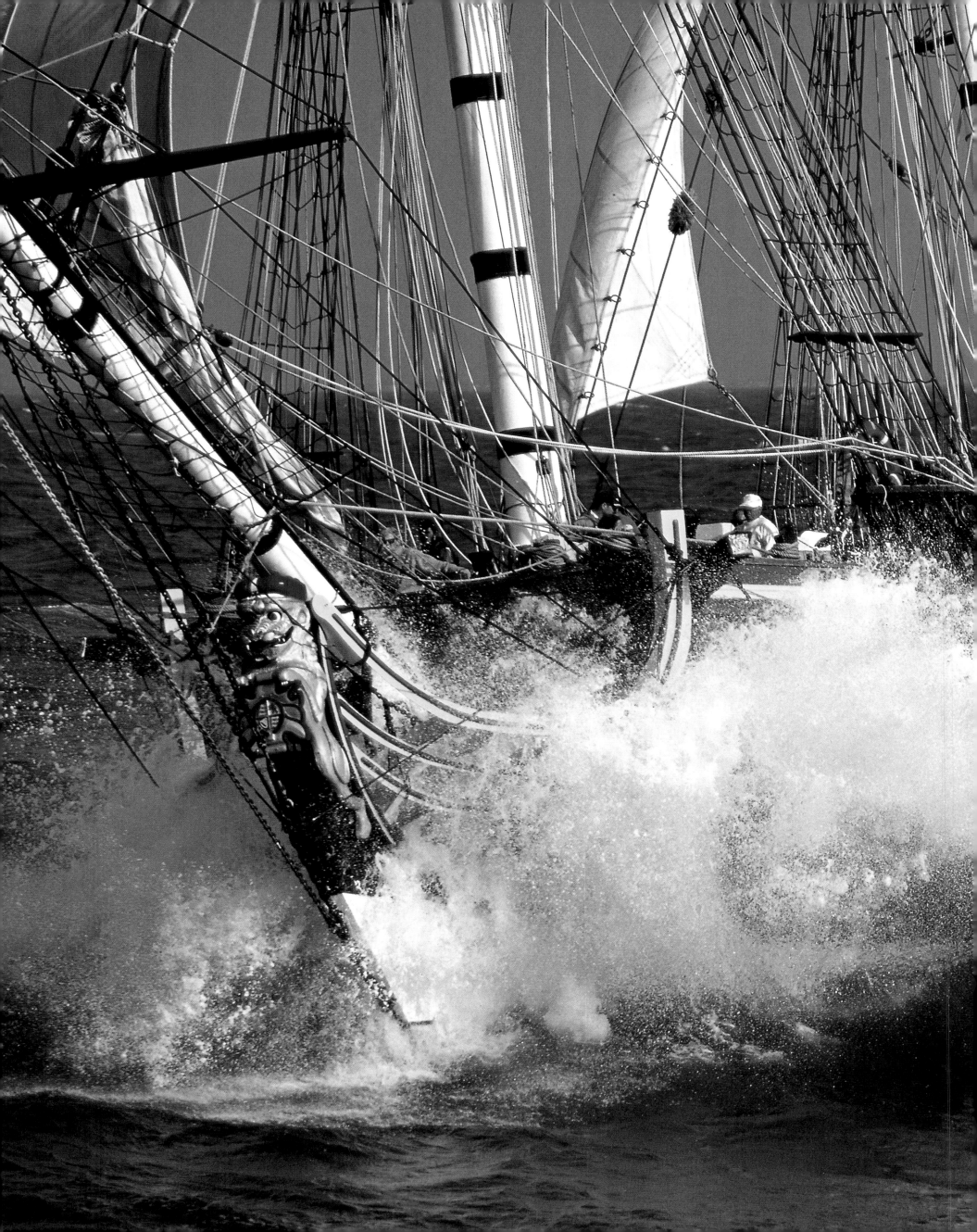

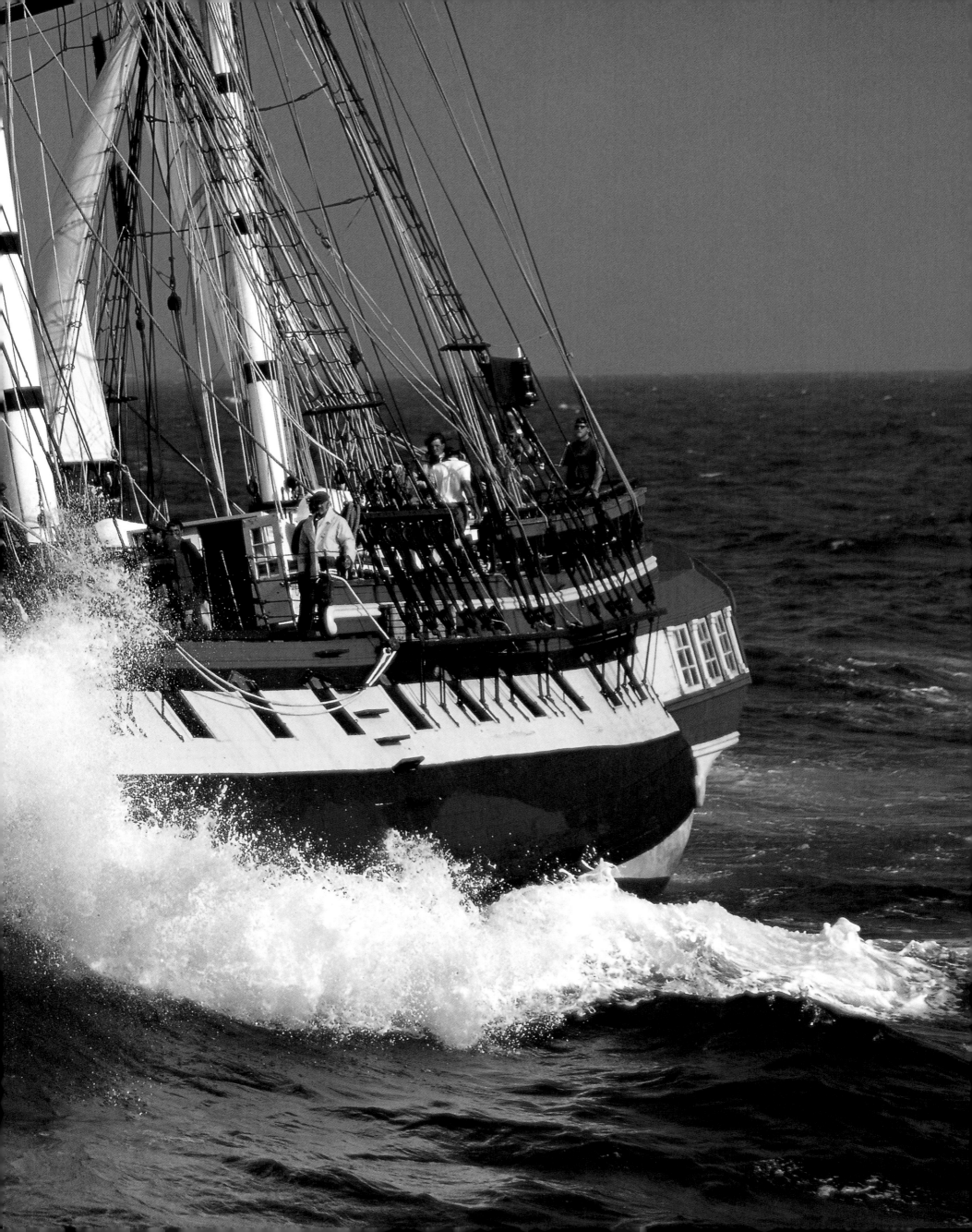

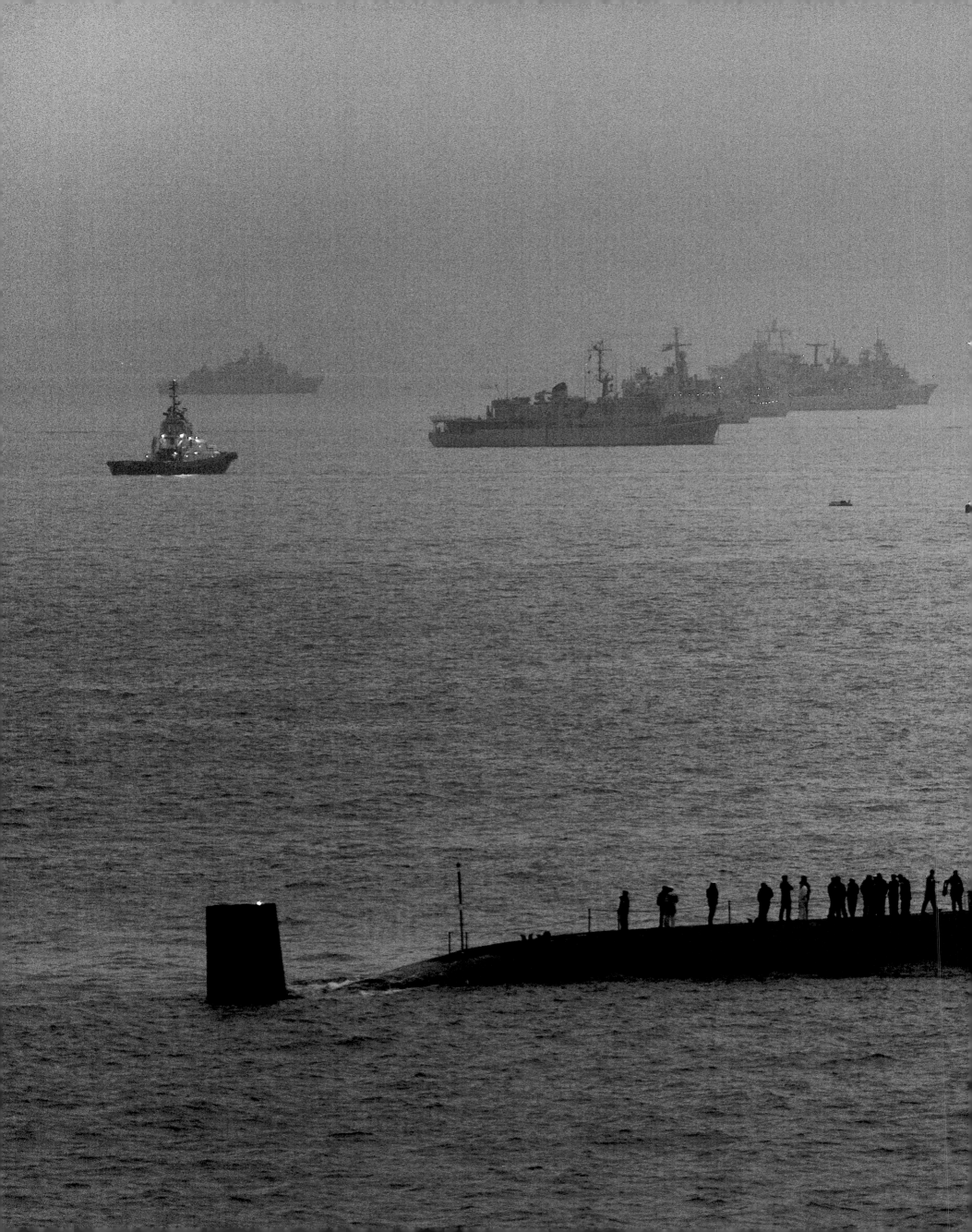

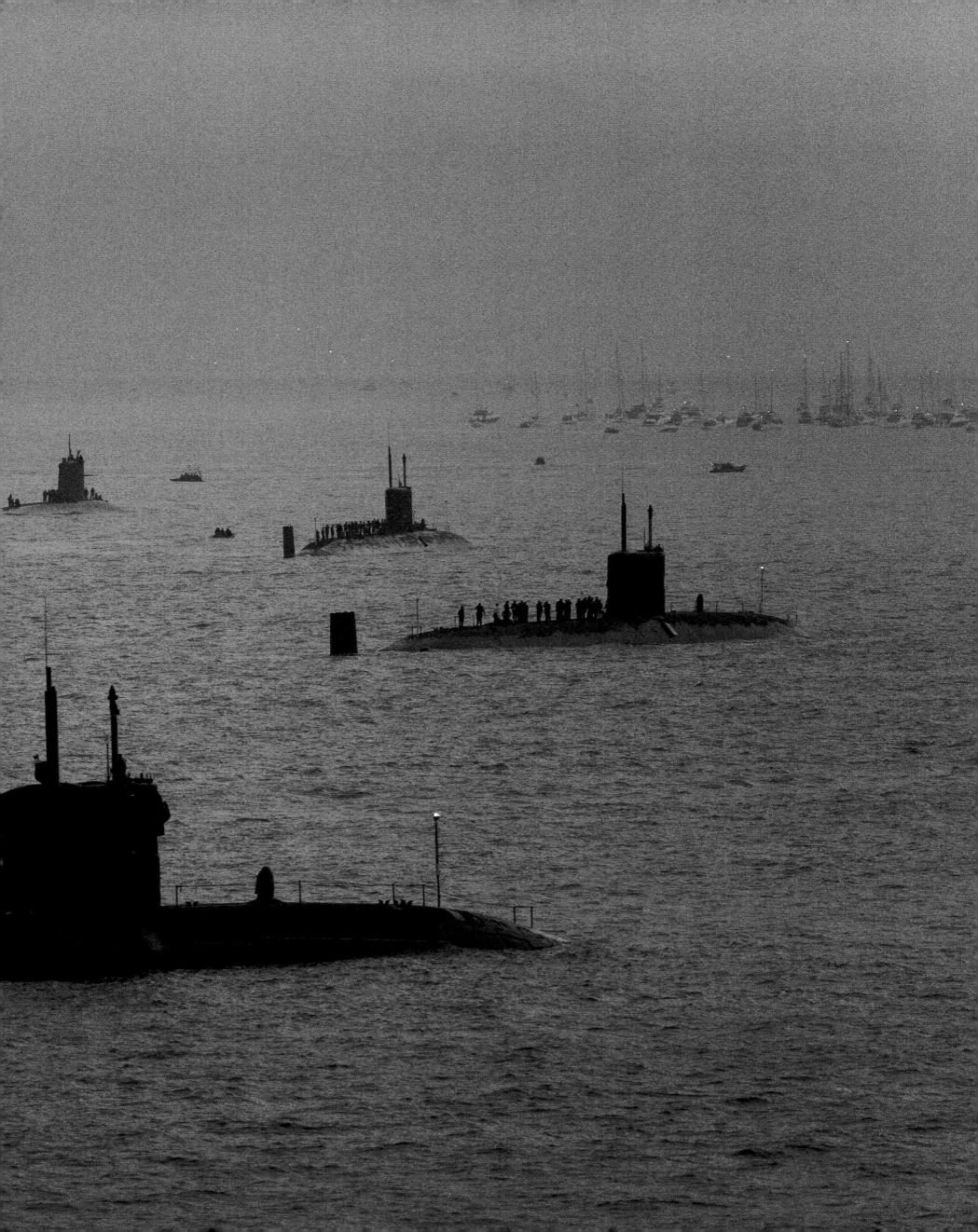

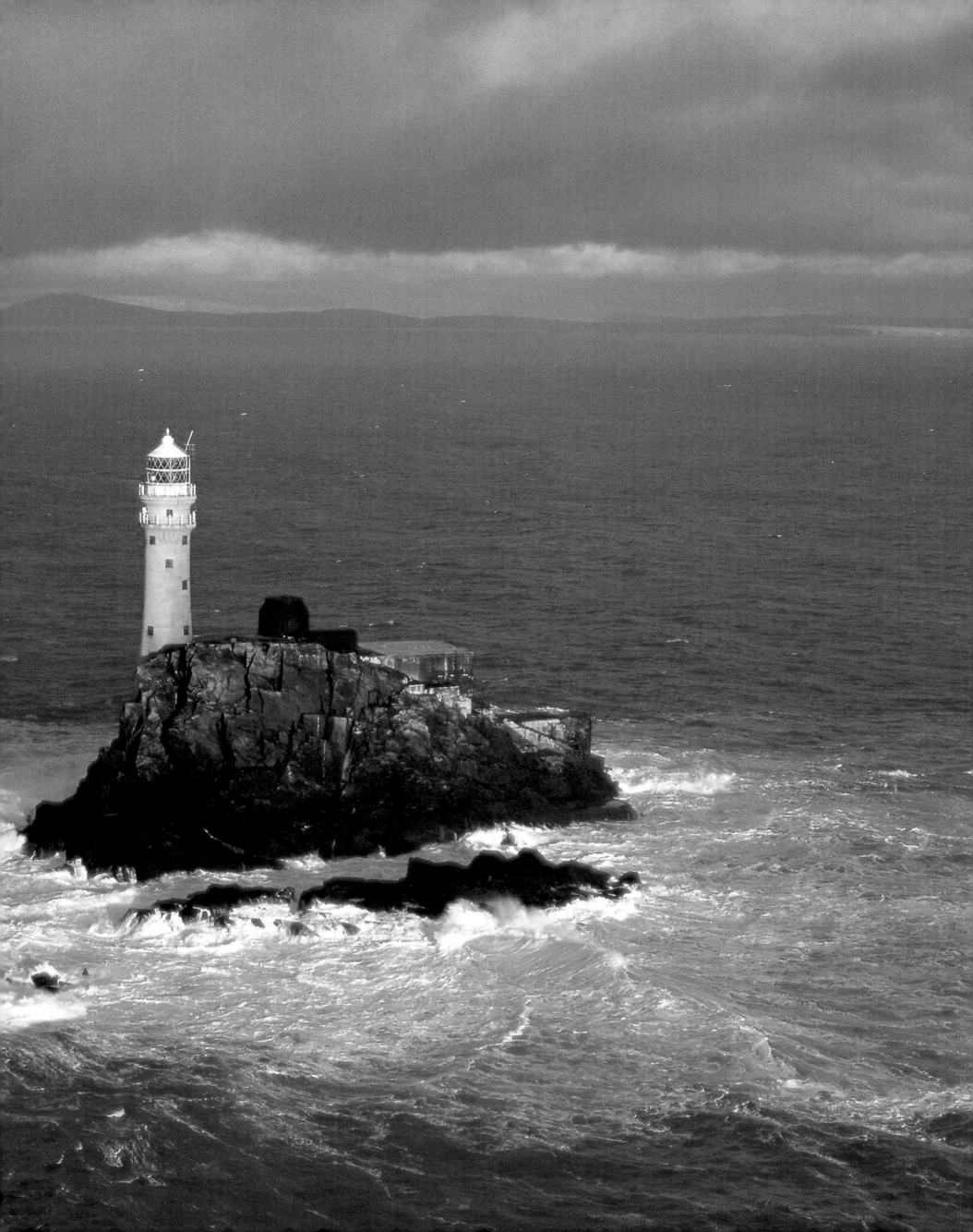

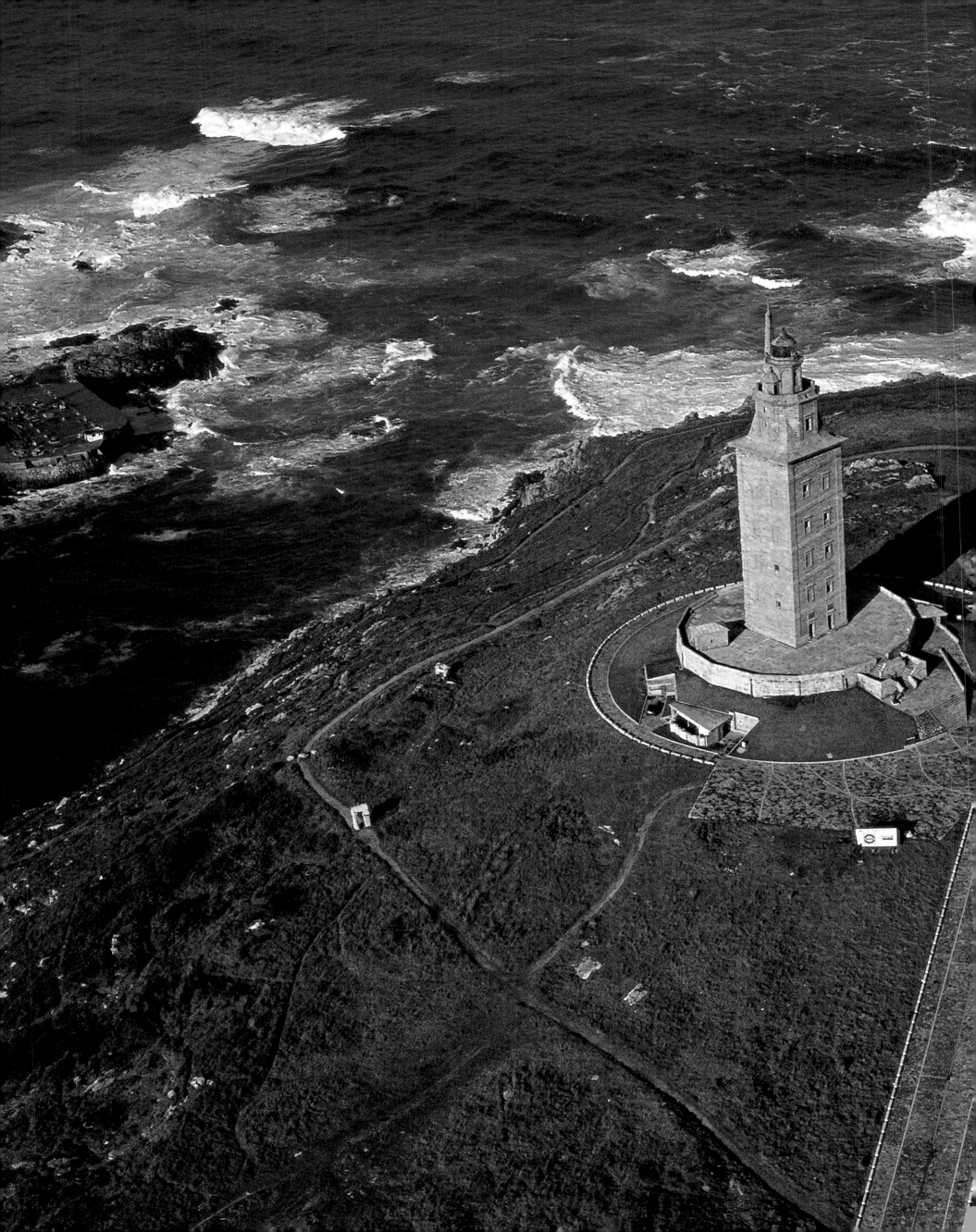

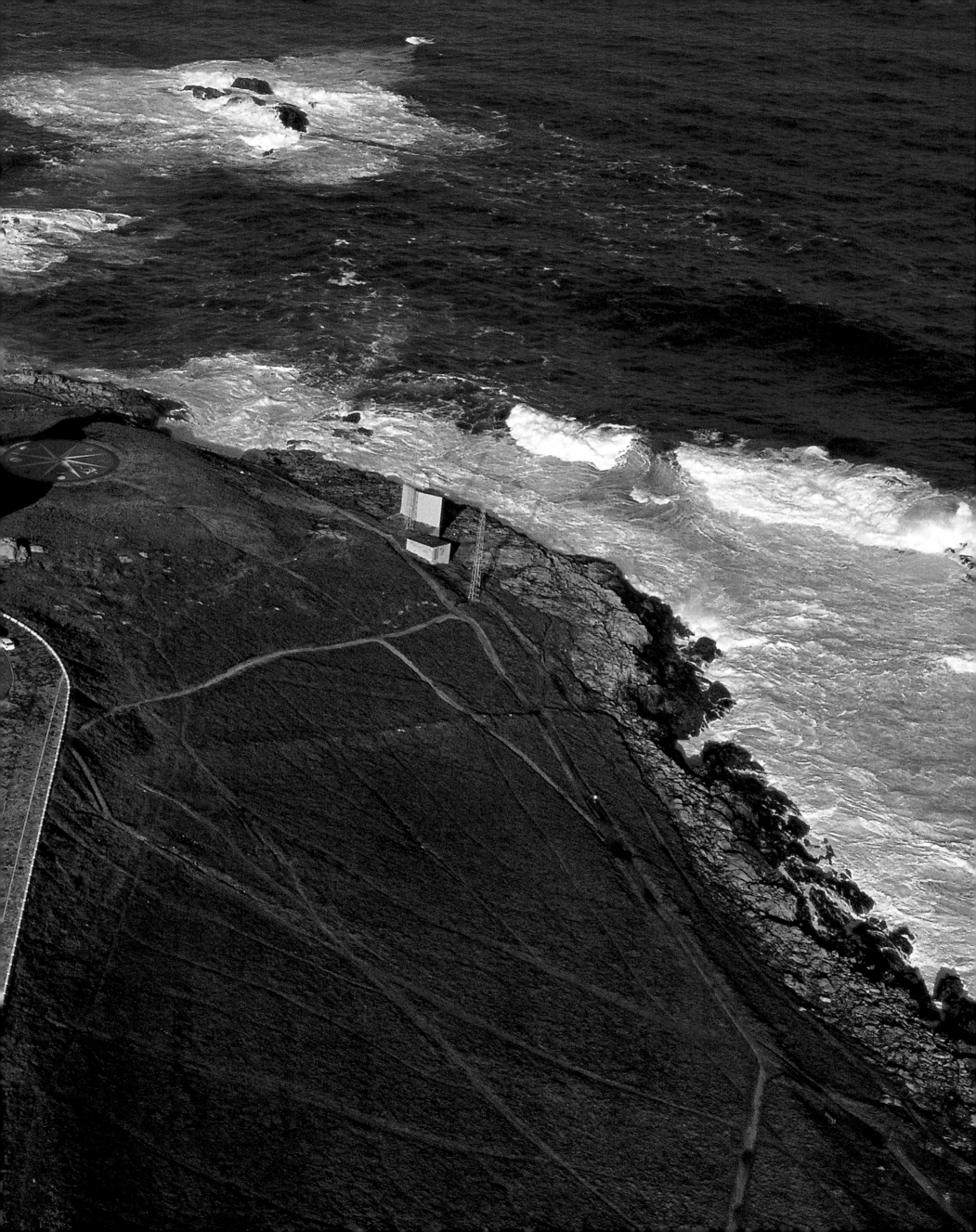

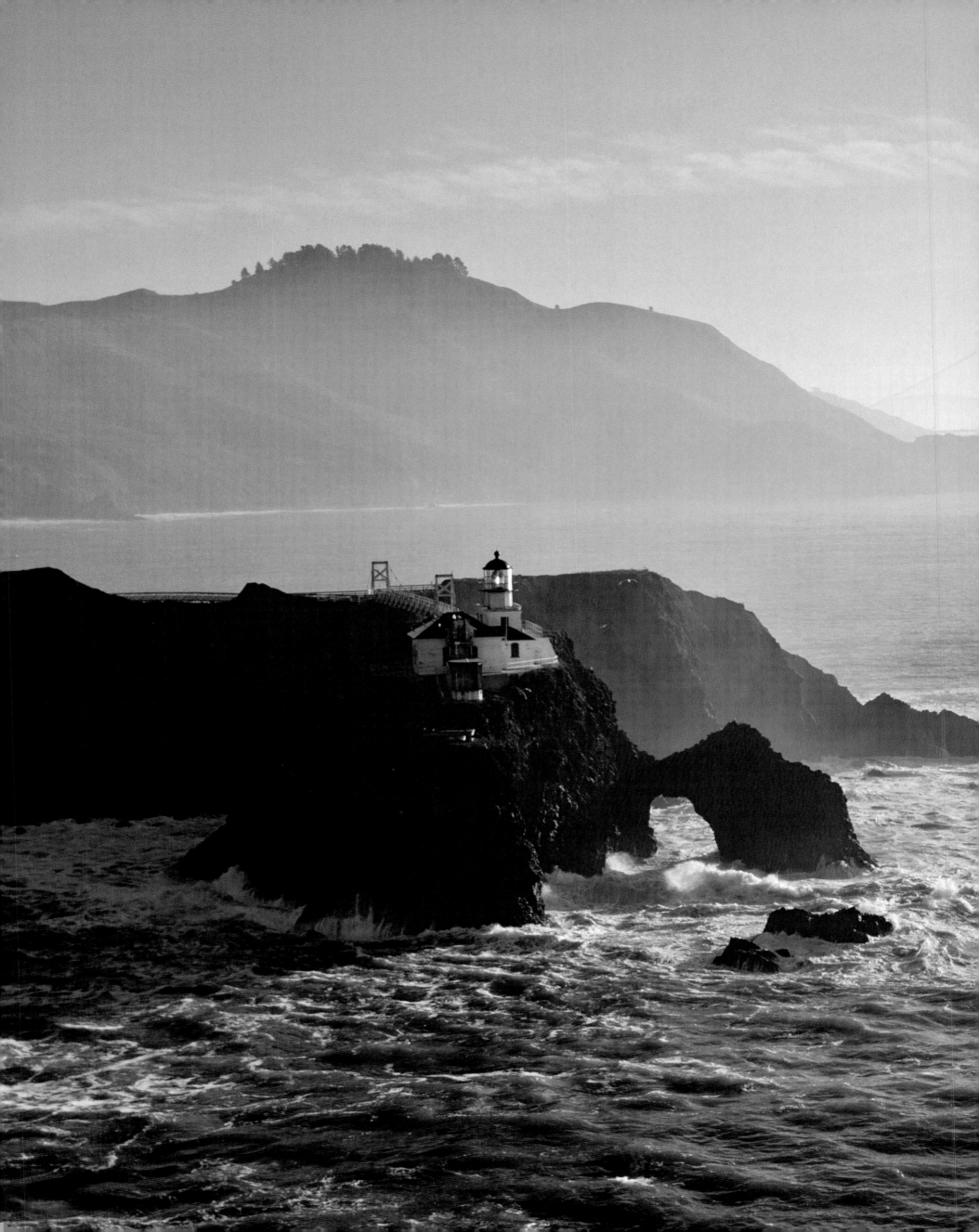

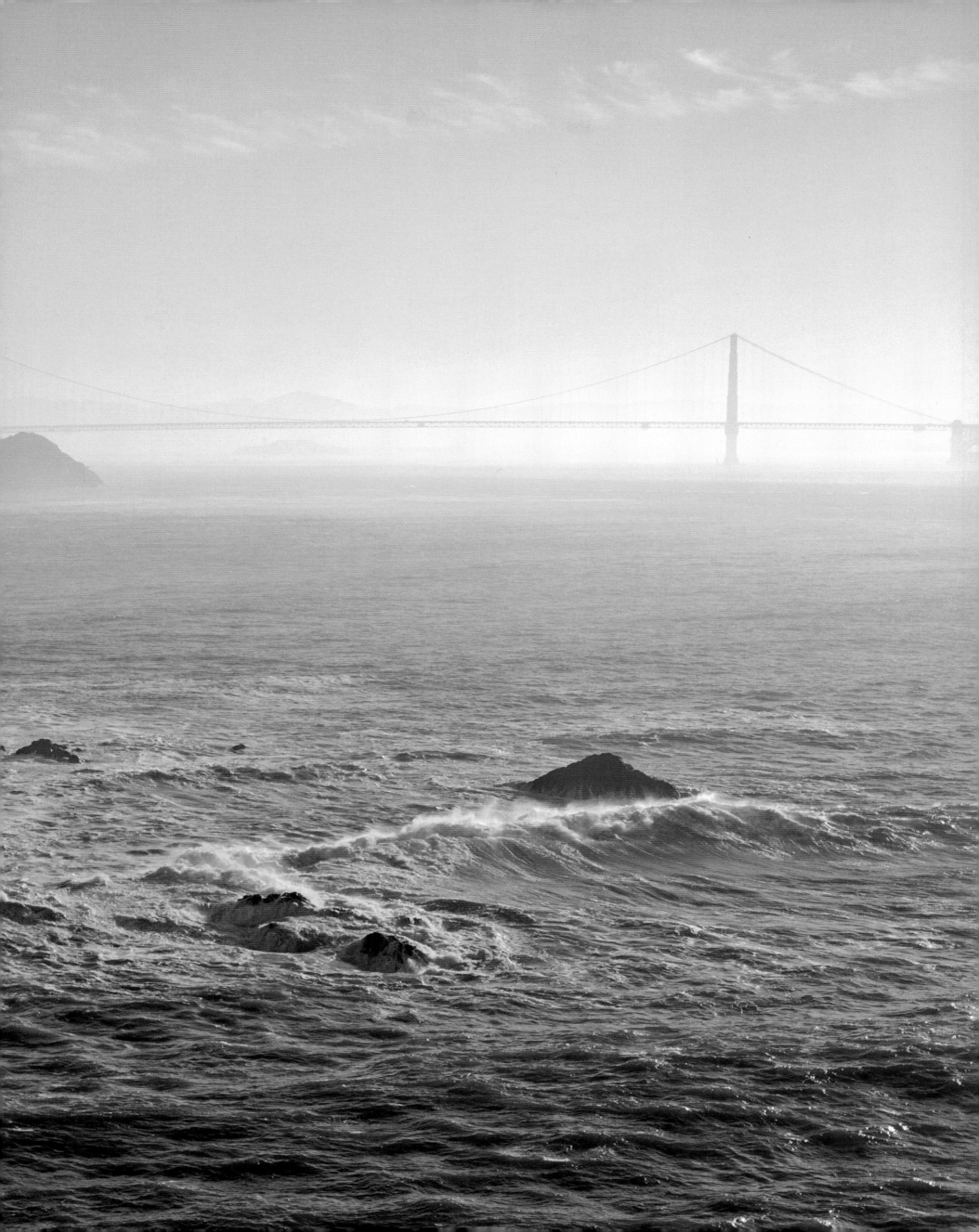

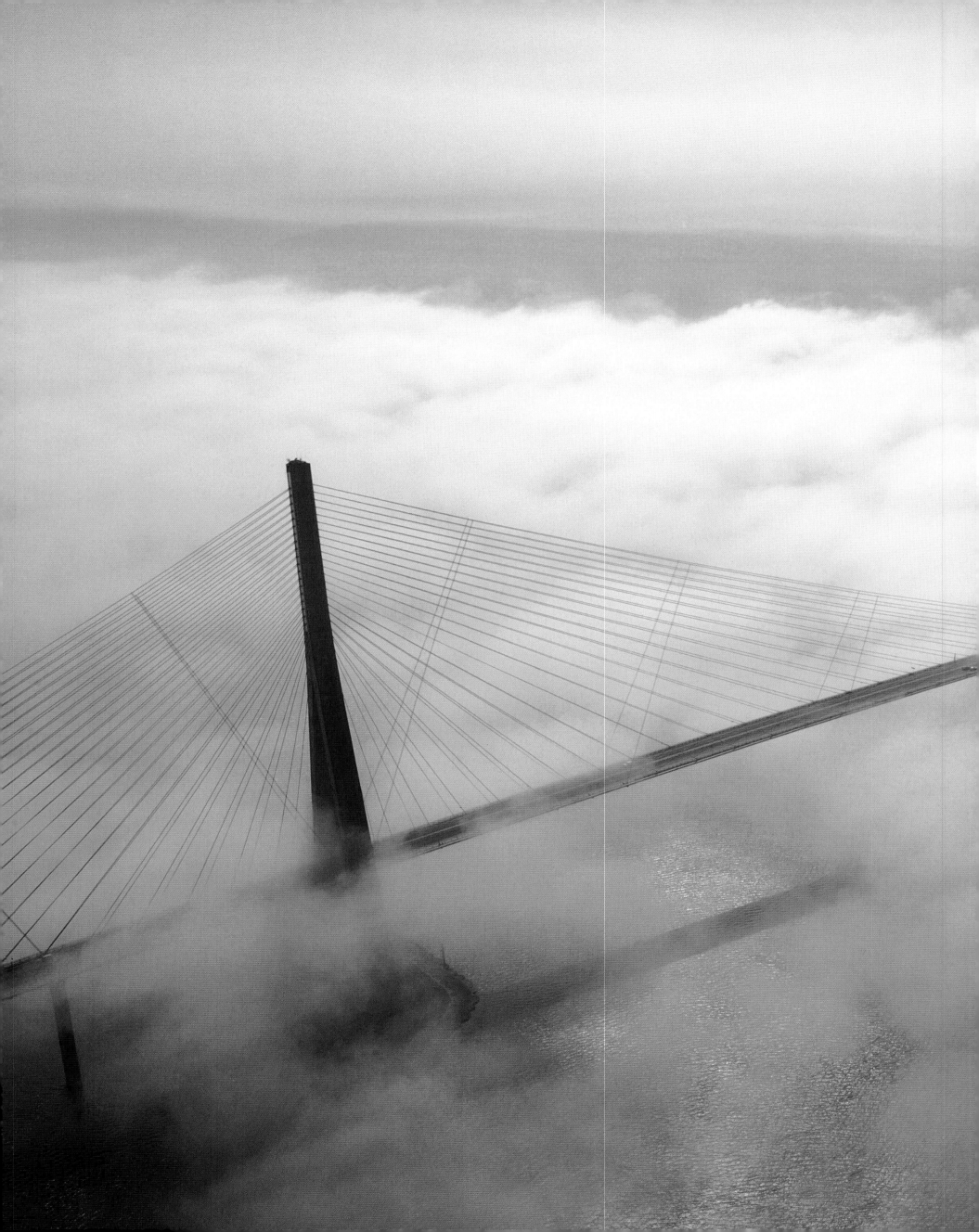

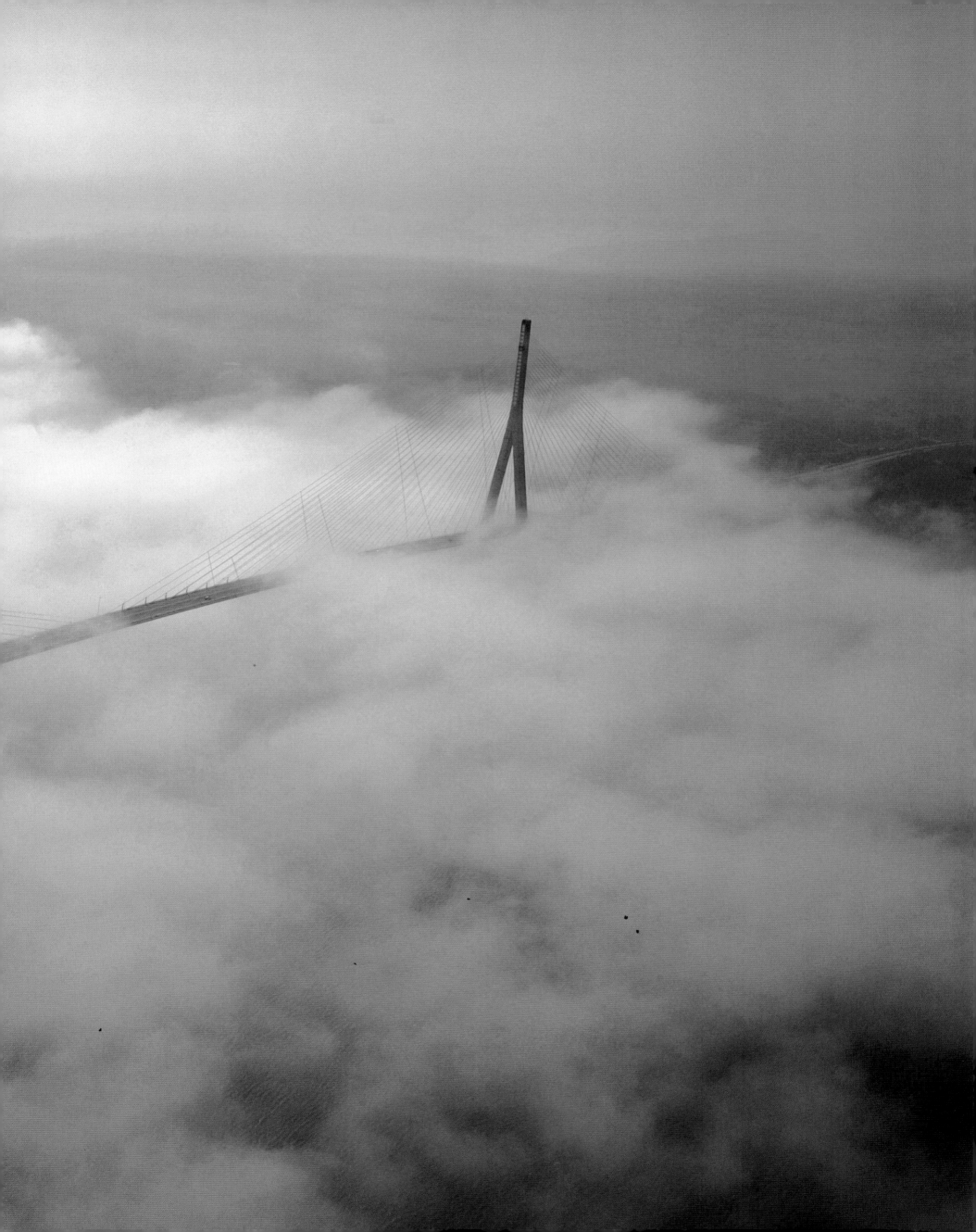

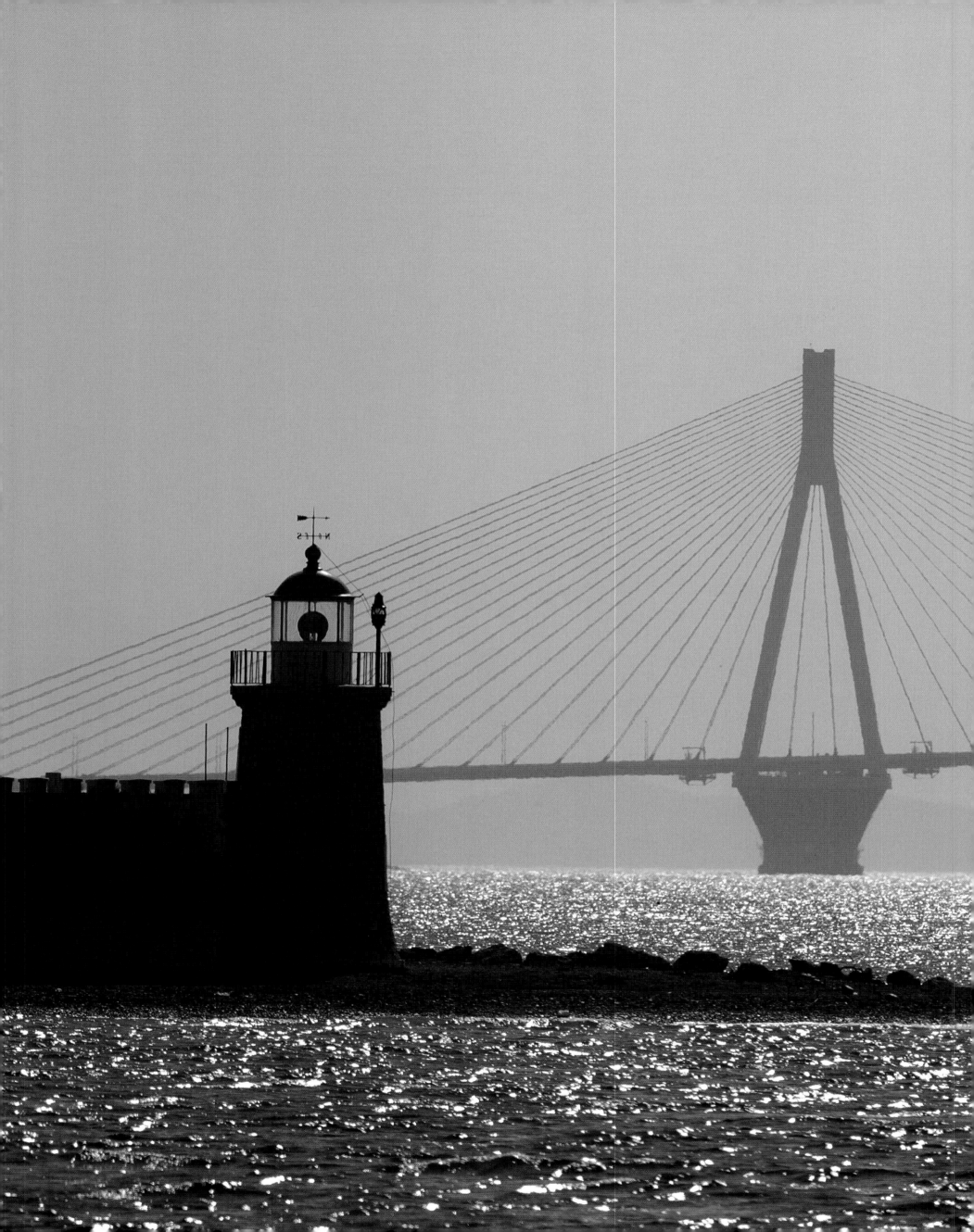

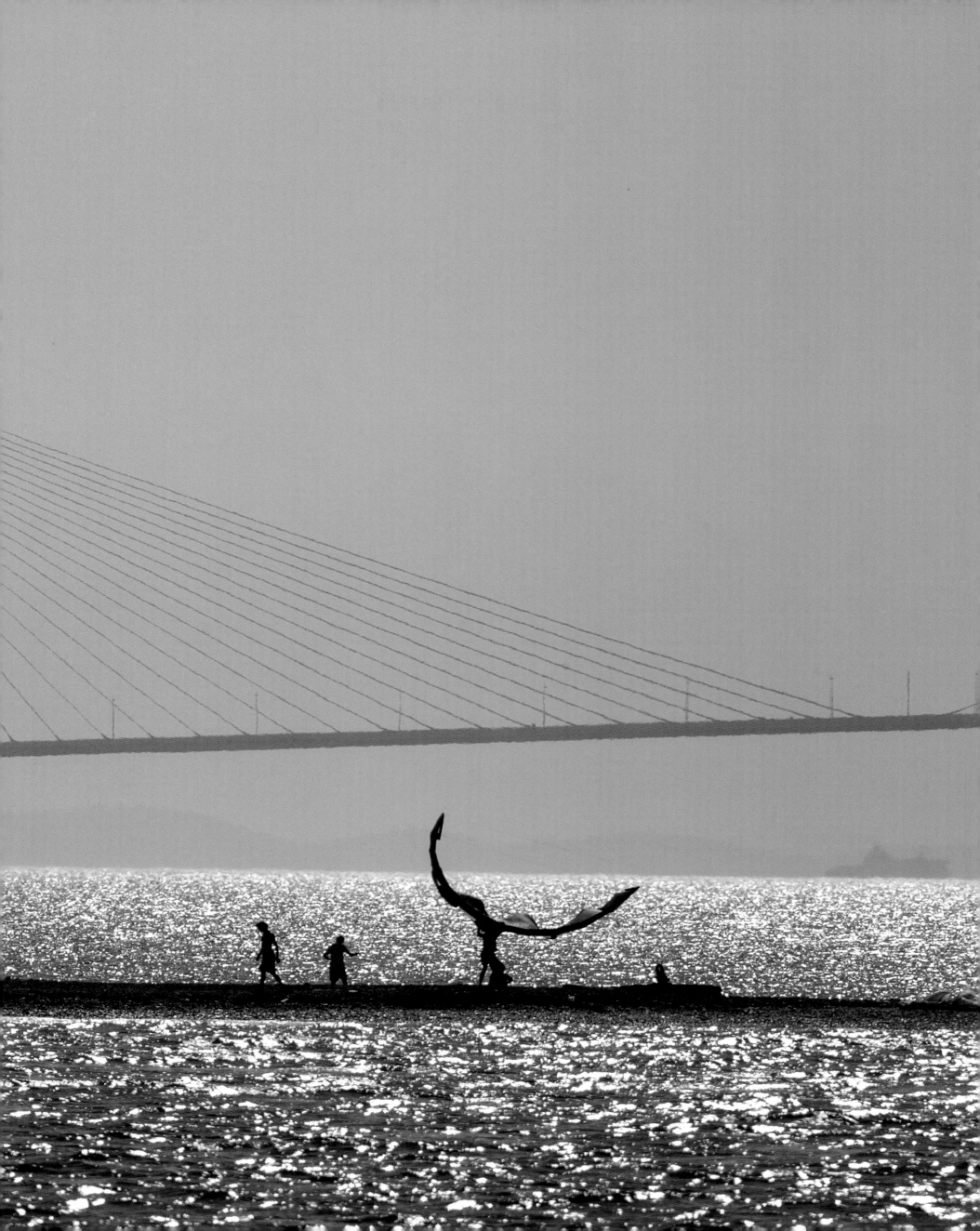

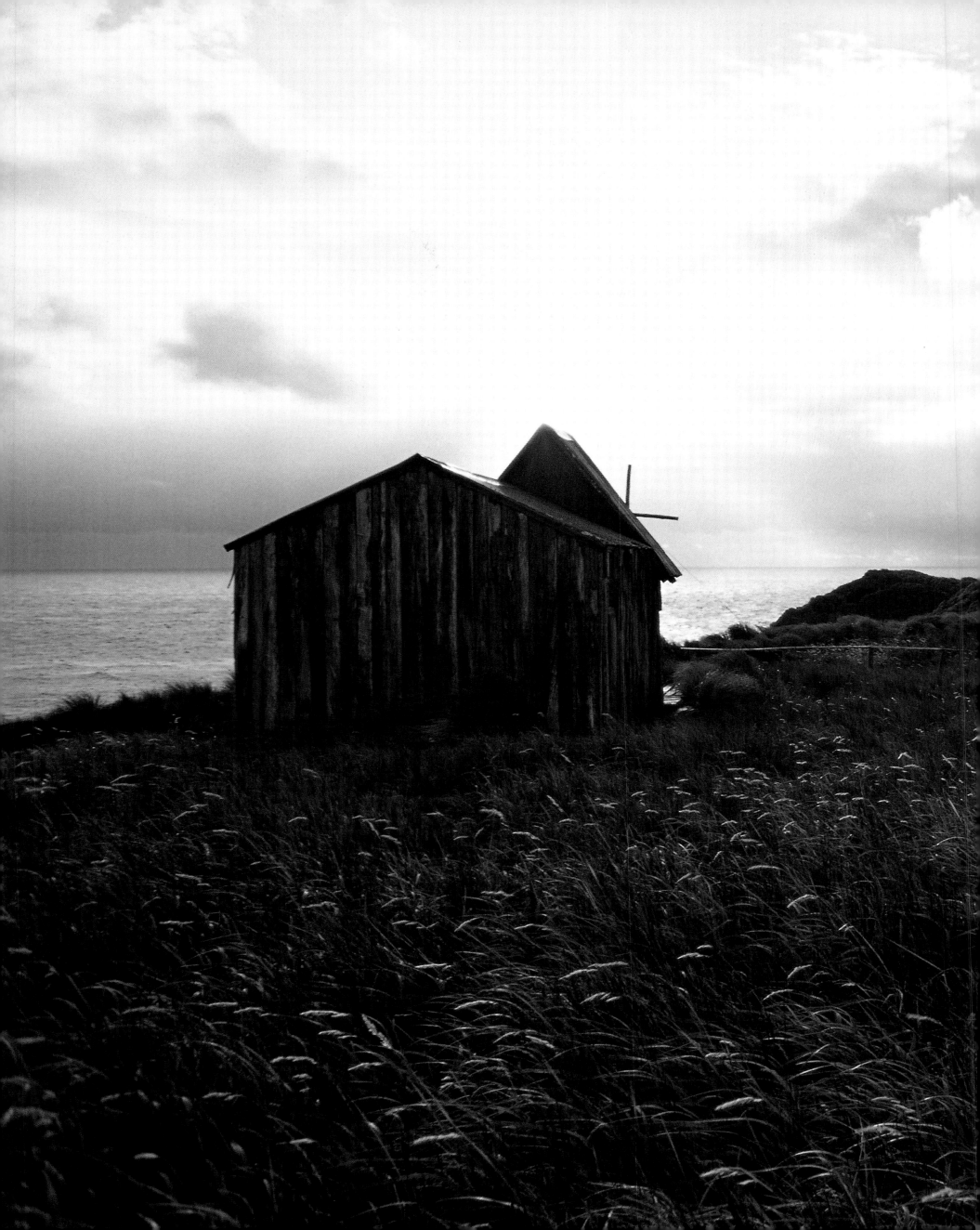

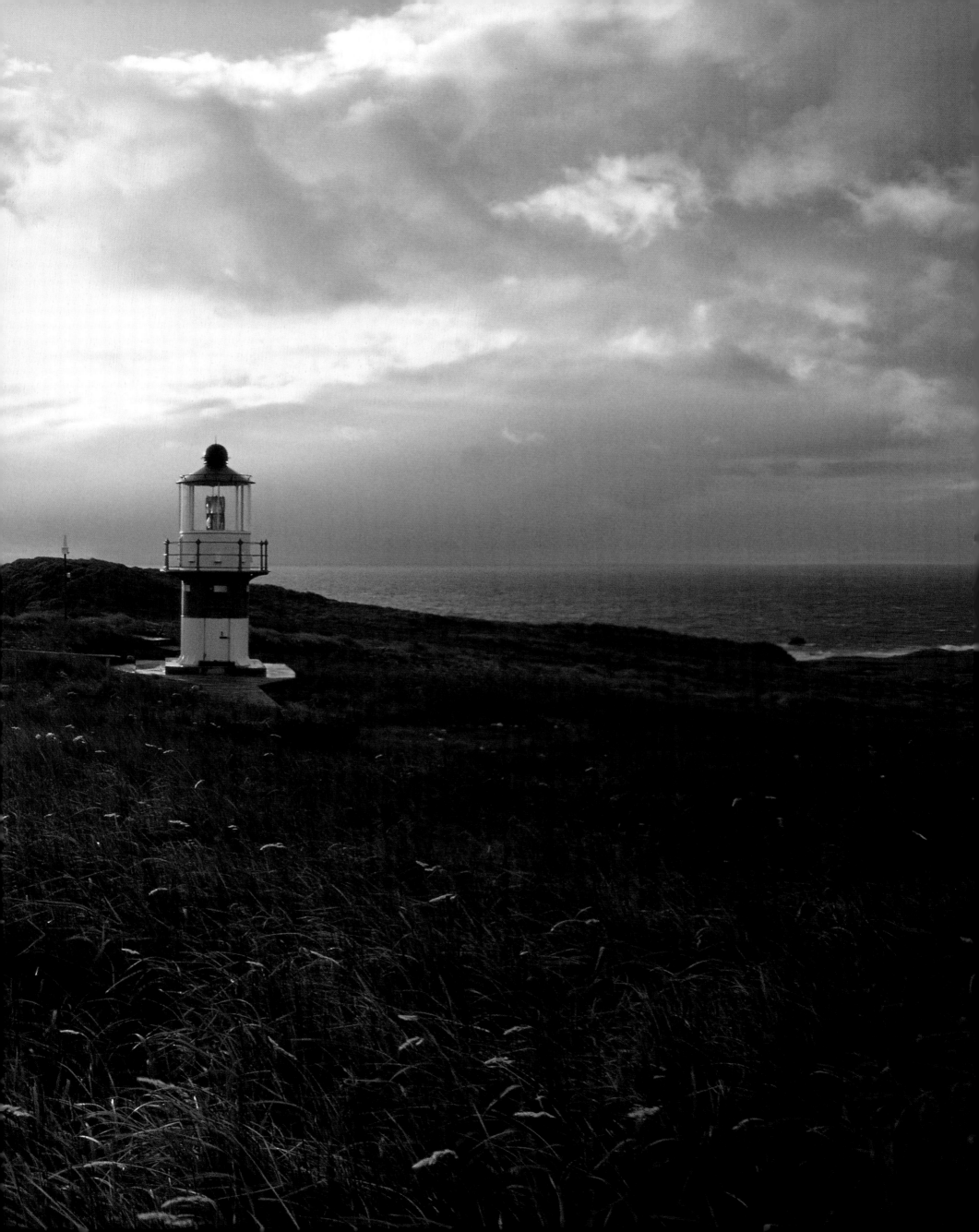

8 The Future of the Ocean

Sixty per cent of the world's population live on a coastal strip that is 60 kilometres wide. By 2025, 75 per cent will be living on this same strip, but it will be 75 per cent of 8 billion instead of the present 6 billion. The Earth is full, and humanity – with very good reason – continues to head for the coasts. One more step, and it will be within the sea itself.

Architects' drawing-boards are covered with seemingly crazy projects, and men of faith can move mountains – or rather they can flatten them, like those around the town of Kobe in Japan, which were then used as backfill to double the area. The hills of Monte Carlo in Monaco also seem to have been swallowed up by an invisible tide pulling them towards the blue horizon. Everywhere, shallow waters are being filled in so that land may be stolen from the sea, to the detriment of aquatic fauna and flora.

Even crazier, though in reality with a good deal more sense behind them, are the projects involving floating islands. Mankind can never defeat the sea, but we can gain a lot by emulating its forms. The Japanese have the right idea, as they are planning to build a floating airport in Tokyo to provide the third airport the city needs. In effect, it will be a gigantic aircraft carrier, and it will serve the additional purpose of protecting the coast against the violence of the waves, especially the dreaded tsunamis.

The United States are not to be outdone, but their floating islands are destined for military use in international waters – platforms that are much easier to defend than installations on land, which are always subject to the whims of those in power at the time. They are island pawns, to be placed at strategic points on the chessboard of the ocean, and in the long term they will change the whole geopolitical order.

We are entering into a new era of the sea, and those people who, prior to the steep rise in property prices, bought themselves a boat to live on – an expanding trend, it has to be said – will not have been disappointed. People used to cruise from island to island, exploring the territory, but now these cruises are gradually giving way to a sedentary stay on board. Hence the launching of bigger and bigger liners, which offer a vast array of entertainments. Soon it may be possible to reach them by means of smaller boats or even directly by plane, as is anticipated by a project named 'Freedom'.

The same developments are taking place within the merchant navy. Soon there will be giant ships carrying all the world's basic goods along an east–west axis linking Asia, Europe and North America; they will head for mega-platforms anchored in the open sea, from which they will transship their cargoes onto smaller vessels that will then carry them to the faithful old ports along our coasts. It will be a kind of east–west chain, with north–south links.

Today more than ever, with trade opening up on a global scale, the world's economy is heavily reliant on transport by sea. Since 1970 this has increased dramatically by 470 per cent. It is expected at least to triple in the next twenty years, which is all to the good, because it is the least expensive and also one of the least congested means of transport. A ship carrying 4,000 containers is the equivalent of a convoy of articulated trucks stretching over 30 kilometres. In this context, it would be well worth investing in coastal trading – which is particularly thin in France, where it represents only 17 per cent of traffic compared to an average of 40 per cent elsewhere in Europe – to take some of the pressure off the land near the coasts, which according to the latest censuses are experiencing demographic increases well in excess of the national average.

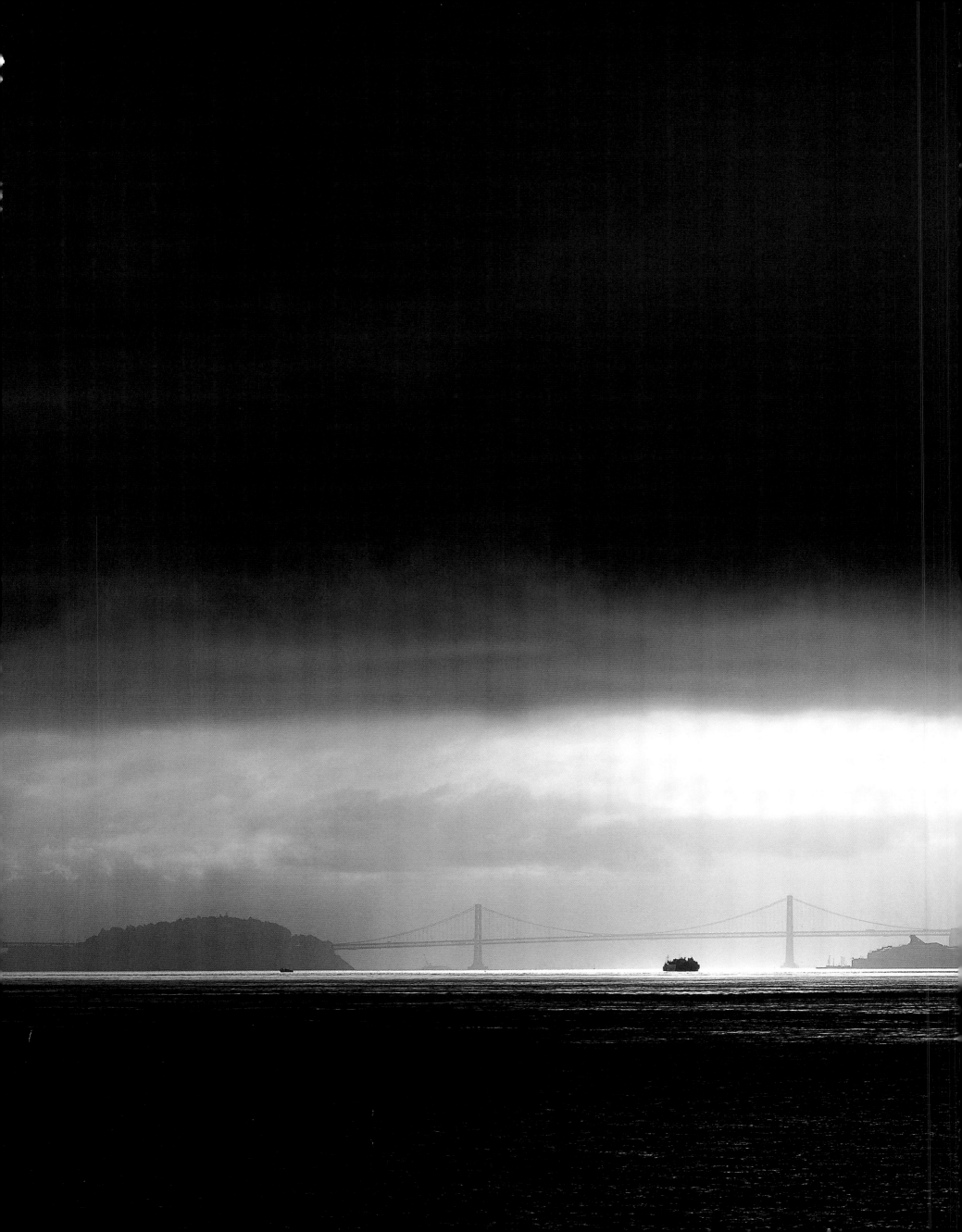

Transport is not the only means of connecting people. The laying of the first operational, underwater transatlantic cable in 1866 opened up new avenues of communication. For the first time in human history, there was almost instantaneous interchange between countries which had previously been irremediably separated by the sea and the time needed to cross it. Twenty thousand links beneath the oceans soon allowed people to talk to each other wherever they were in the world. Satellite communications then made everyone believe that the era of the underwater cable had passed, but the fibre-optic revolution, with a vast data capacity, gave the lie to all the prophecies, and now more than ever the sea is at the forefront in the worldwide growth of the internet. The information superhighway runs, and will continue to run, beneath the waves.

Technological advances have also made it possible for the first time to conduct a global survey of the oceans, and to pursue avenues of research which would have seemed impossible just ten years ago. With a mass three hundred times denser than that of the Earth's atmosphere, the sea plays a vital role in our climate. Little floats known as 'profilers', which monitor the currents and variations in salinity, and observation satellites used in the Mercator forecasting system will allow us to analyse the condition of the oceans at any given moment. By the end of this decade, the organizers of this project expect to have developed a model that will predict the weather several months in advance. One can well imagine the benefits of such data to farmers and industrialists planning production schedules, and also to power companies, which will be better able to anticipate levels of energy consumption.

At the same time, sampling – and in particular the core sampling being carried out on seabeds, sometimes up to a thickness of 50 metres – is providing us with information about past climates. Thus the sea is enabling us to reconstruct not only its own history, but also that of the Earth itself.

Once again, it is essential that funds be made available to continue this work. All too often, concern for 'profitability' places an intolerable burden on the budget for research. When one bears in mind what is at stake for future generations, the sums required are minuscule and the sums granted are derisory. It is clear that most politicians and other decision-makers have not yet understood the scale of economic potential, in terms of resources and employment, that can be generated by the sea. Nor have they taken into account

the fact that in the near future the oceans may well become a source of international conflict unless new laws are brought in to provide a fair and equitable distribution of the enormous wealth contained within them. Some people suggest that the only solution is world governance of international waters. All the evidence shows that the maritime proportion of the GDP, at present between 3 per cent and 5 per cent in the most developed countries, will continue to increase. The creation of exclusive economic zones (EEZ), which gives exclusive rights of exploitation to bordering states up to a distance of 200 miles, has in the truest sense of the term established new frontiers. What might be the effect of extending these zones to 350 miles?

The sea is the largest and most bountiful treasure house ever offered to humanity. If only we can preserve it – and from every point of view, it is now in danger of losing its natural equilibrium – it will provide the resources for a future full of promise. Would it not, then, be to the credit of us all to institute a Universal Declaration of the Rights of the Sea, in order to preserve life on Earth?

Article 1 – All seas and all oceans are one and should be viewed globally as the sea.

Article 2 – The sea contributes to the welfare of humanity and must not be threatened by the growth of the human race.

Article 3 – The sea has the right to be respected, in dignity and in cleanliness.

Article 4 – No one can endanger the integrity of the sea without bearing the consequences.

Article 5 – The flora and fauna of the sea may only be exploited to the degree in which their right to renewal is guaranteed.

Article 6 – The sea must be a special object of research, with a view to its preservation and that of the human race.

Article 7 – The sea is a place of memory, and some of the shrines resulting from dramatic encounters between it and man must remain inviolate.

Article 8 – The sea is the largest museum in the world, and all the relics of the human adventures that it contains must be protected against looting and damage.

Article 9 – Global supervision of the sea is the duty of humanity.

Article 10 – Every person has the right and duty to stay informed about the condition of the sea.

USA, SAN FRANCISCO
A large proportion of the human race has settled by the sea. Today, 60 per cent of the world's population is concentrated on a coastal band just 60 km wide – a mere 15 per cent of the Earth's land surface. This settlement of the coasts continues to intensify, and in twenty years 75 per cent of the population will be crowding together on the shores. Added to this statistic is the seasonal influx of tourists. The inexorable drift towards urbanization of the coasts renders the oceans even more vulnerable, polluted as they already are by the agricultural, industrial and domestic waste that is dumped along their shores.

8 The Future of the Ocean

CHINA, SHANGHAI
A hive of activity, the new business district of Shanghai on the seafront reflects the hectic growth and modernization that has taken a grip on the city and the port. In 2004, China was responsible for two-thirds of the increase in world trade. It has become the planet's workshop, importing raw materials by bulk carrier, and exporting manufactured goods by container ship to all corners of the Earth. With 300 million tonnes of merchandise being handled every year, the port of Shanghai is second only to Singapore. It is ahead of Rotterdam, and by 2020 is expected to be in first place.

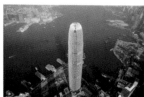

HONG KONG, THE TWO INTERNATIONAL FINANCE CENTER
The proliferation of skyscrapers in Hong Kong is even greater than in New York. The Two International Finance Center, which in 2003 climbed to a height of 415 m, dominates the forest of 7,200 towers spiking the seafront. Hong Kong is one of the most densely populated places in the world. Like Tokyo, Mumbai, New York, Shanghai, Lagos, Los Angeles, Calcutta and Buenos Aires – eight of the ten largest cities in the world – it has grown up on a coast. These sprawling cities, which have sprung up in just a century, have rapidly destroyed their coastal environments. Hong Kong's once rich coral reefs have not survived the urbanization of the coast.

GREECE, ATHENS, THE PARTHENON
Greece supplies a large proportion of the world's maritime labour force, and its sailors are among the best in the world. It is also the home base of an elite class of mega-rich ship-owners, who possess the largest fleet of merchant vessels in the world. Each of these billionaires has a fleet of at least 1 million tonnes, half of which fly a flag of convenience, often Cypriot, Maltese or Panamanian. But sometimes their fortunes stem from breaking sanctions or from exploiting international crises, such as the Iran–Iraq war.

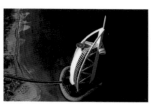
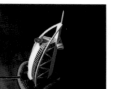

UNITED ARAB EMIRATES, DUBAI, BURJ AL-ARAB HOTEL
Situated on a man-made island 200 metres from the shore, the luxury Burj Al-Arab hotel has dominated the coast of Dubai since 1999. This architectural marvel, like a sail hoisted onto a 321-metre mast and billowing in the wind, accommodates within its 60 storeys a vertiginous atrium 180 m high, and more than 200 sumptuous duplex suites. For a cost of about $2 billion, Dubai – the home of superlatives – now has the tallest and most luxurious hotel in the world. Now a national symbol, Burj Al-Arab decorates all the number plates in the country. The underwater hotel Hydropolis, its submarine counterpart, is already being built.

GREAT BRITAIN, EDDYSTONE LIGHTHOUSE
The Eddystone lighthouse is in fact the fourth of that name to be built on the dangerous, isolated reef off the south-west coast of Plymouth. The original, built in 1698, was the first to be constructed on a rock in the open sea, and the present tower, 49 m high and in operation since 1892, launched the age of automation. The helicopter in the colours of Trinity House, the service responsible for Britain's 71 lighthouses, is landing on the platform that crowns the lantern. Providing such sea-based lighthouses with helipads allows technicians to repair faults at maximum speed, and is a key element of automation, which has taken over in all British lighthouses since November 1998.

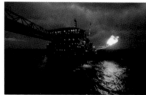

NORTH SEA, CLAYMORE RIG
The underground seams of black gold extend far beyond the continents. Exploiting the deposits offshore, some 3,000 oil rigs are currently supplying 30 per cent of world production. It can take twenty years to exhaust one deposit, and there are reserves in the seas off California, Venezuela and Alaska, in the Gulf of Mexico, the Caspian Sea, the North Sea and the Persian Gulf (which has 60 per cent of known underwater reserves). But just like the deposits on land, these offshore oilwells will not last for ever. In the North Sea they are already beginning to run dry.

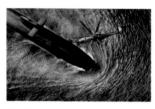

SEA OF IROISE, RETURN TO BASE
The latest generation of nuclear submarines is the jewel in the crown of the French deterrent force, which has been in operation since the launch of the *Redoutable* in 1967. The SNLE (*sous-marins nucléaires lanceurs d'engins*) patrol the high seas for ten weeks at a time, moving silently and indiscernibly at great depths, bearing a load of sixteen strategic ballistic missiles that can be launched at a moment's notice. These secret weapons, hidden from the eyes of the world, send out a permanent message of deterrence to any potential enemy of France and her allies. After every mission, the submarines return to their base at Île Longue, near Brest, for maintenance.

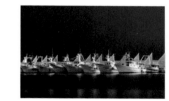

ITALY, VIAREGGIO
When you see Viareggio today, it is difficult to imagine the modest little fishing village that nestled here in the 12th century. Now a major port, with several shipyards that have given birth to some highly prestigious yachts, Viareggio is an elegant and sophisticated seaside town on the coast of Versilia, in Tuscany. A high-class resort popular in both summer and winter, its busy seafront is filled with luxury Art Nouveau hotels. But it also has its avant-garde side, as can be seen from the futuristic contours of this simple fishing quay, which seems like the work of some brilliantly original architect.

GREECE, PIRAEUS
The ancient port of Athens is today a vast complex, consisting of a passenger port (the largest in the Mediterranean, and the third largest in the world with 12 million passengers a year), a commercial port (third among Mediterranean ports, after Valencia and Barcelona), and also a section for ship repairs. A major source of employment and revenue, Piraeus plays a vital role in the Athenian economy. However, the extreme demographic concentration of the city and its suburbs also illustrates the risk of saturation which threatens the future of the Mediterranean coasts. The population of these Mediterranean cities is expected to rise from 70 million in 2000 to 90 million by 2025.

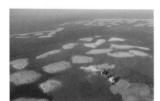

UNITED ARAB EMIRATES, DUBAI, THE WORLD
Everything is possible in Dubai – even owning a part of 'The World'. Outside the city, a man-made archipelago by this name has added to the Persian Gulf 300 islets of between 2 and 8 hectares, laid out as a map of the world. Wealthy investors are already squabbling over them even before the work is finished. In this kingdom of artifice, high security and upmarket development, any dream can come true: private villas, hotels of all kinds, golf courses, retirement homes. The World is just one of the many eccentric projects competing to transform Dubai – a square of desert trapped between sands and implacable heat – into a world tourist centre.

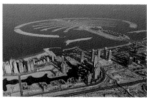

UNITED ARAB EMIRATES, DUBAI, THE PALM JUMEIRAH
Dubai, a showcase of land won from the sea, is planting a total of three immense palm trees in its shore and letting them grow out into the Persian Gulf. The man-made peninsulas of The Palms have created out of nothing hundreds of kilometres of new coast, all set for urbanization. These virgin territories will soon bear fruit: dozens of hotels, thousands of villas and apartments – all sold already – with restaurants, leisure parks, shopping malls, marinas and more. In order to stay rich when the oil runs out, Dubai is investing massively in tourism, and the aim is to attract 15 million visitors by 2010 – triple the figure for 2004.

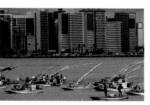

BRAZIL, FORTALEZA
Coastal areas represent only 10 per cent of the ocean, but they contain a mosaic of natural environments that are even richer and more productive than the relative desert of the high seas where 90 per cent of all marine species live. Of the 13,200 known species of fish, nearly 80 per cent live near the shores. Mangroves and coral reefs play a vital role in protecting the coast against erosion. The transformation of these regions, however, into apartments, second homes, resorts and tourist attractions places a heavy burden on the ecosystems that support marine life. In Fortaleza, scrabbling at the foot of the buildings, the impoverished sea can still dress itself up with a few picturesque *jangadas*.

FRANCE, THE ARCACHON BASIN
In the last thirty years, the evolution of the leisure industry and the arrival of moulded plastics, which have revolutionized the economics of shipbuilding, have brought about an extraordinary boom in the pleasure boat sector. Nearly 800,000 pleasure boats – 70 per cent of them motorized – fly the French flag. The unstoppable proliferation of such boats is now swamping the coasts. The 370 or so French marinas are already full to bursting point, and it is estimated that another 54,000 berths are needed – nearly a quarter of the number now in existence. And yet the majority of these boats spend the whole year at their moorings. One can scarcely imagine the chaos if all of them were to set sail at the same time.

INDIA, KERALA, HOTEL SURYA SAMURA
Tourism has become the leading industrial activity in the world: every year, 700 million travellers move around the world, and the number is expected to double by 2020. Airports, marinas, hotels and golf courses have sprung up on many tropical coasts during recent years, like this luxury hotel on the west coast of India. Sensitive marine ecosystems such as mangroves, coral reefs and the shores on which turtles lay their eggs have all been forced to give way to the infrastructures of tourism. Often accompanied by an increase in pollution and damaging impact on the fragile environment, such development frequently brings more losses than gains to the host country.

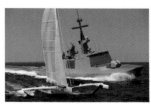

FRANCE, A HYDROFOIL AND THE STEALTH FRIGATE *SURCOUF*
Originating from totally different worlds, two 21st-century creations meet each other as they sail in convoy. The stealth frigate *Surcouf*, a warship that embarked on active service in 1997, has a reduced radar signature and a high degree of automation. Alain Thébault's hydrofoil ingeniously overcomes the resistance of the water by flying over it. This 5-tonne dragonfly lifts out of the water at 10 knots by rising on its foils, and it can easily cruise at an average speed of 30 knots. These are two visionary technical innovations that will take sea transport into the future.

FRANCE, LE HAVRE, PORT 2000
With the rise in sea trade, international container traffic is growing. In March 2006, Le Havre opened its new container port, Port 2000, which has cost over one billion euros to build. By tripling the capacity of Le Havre's own port, these infrastructures have allowed Le Havre to make up for the French delay in accommodating container traffic and to compete with Antwerp, Rotterdam and Hamburg, its European rivals. The future 'French container capital' was inaugurated by the arrival of the container freighter CMA-CGM *Tosca*, one of the largest in the world with a capacity of almost 8,500 container units.

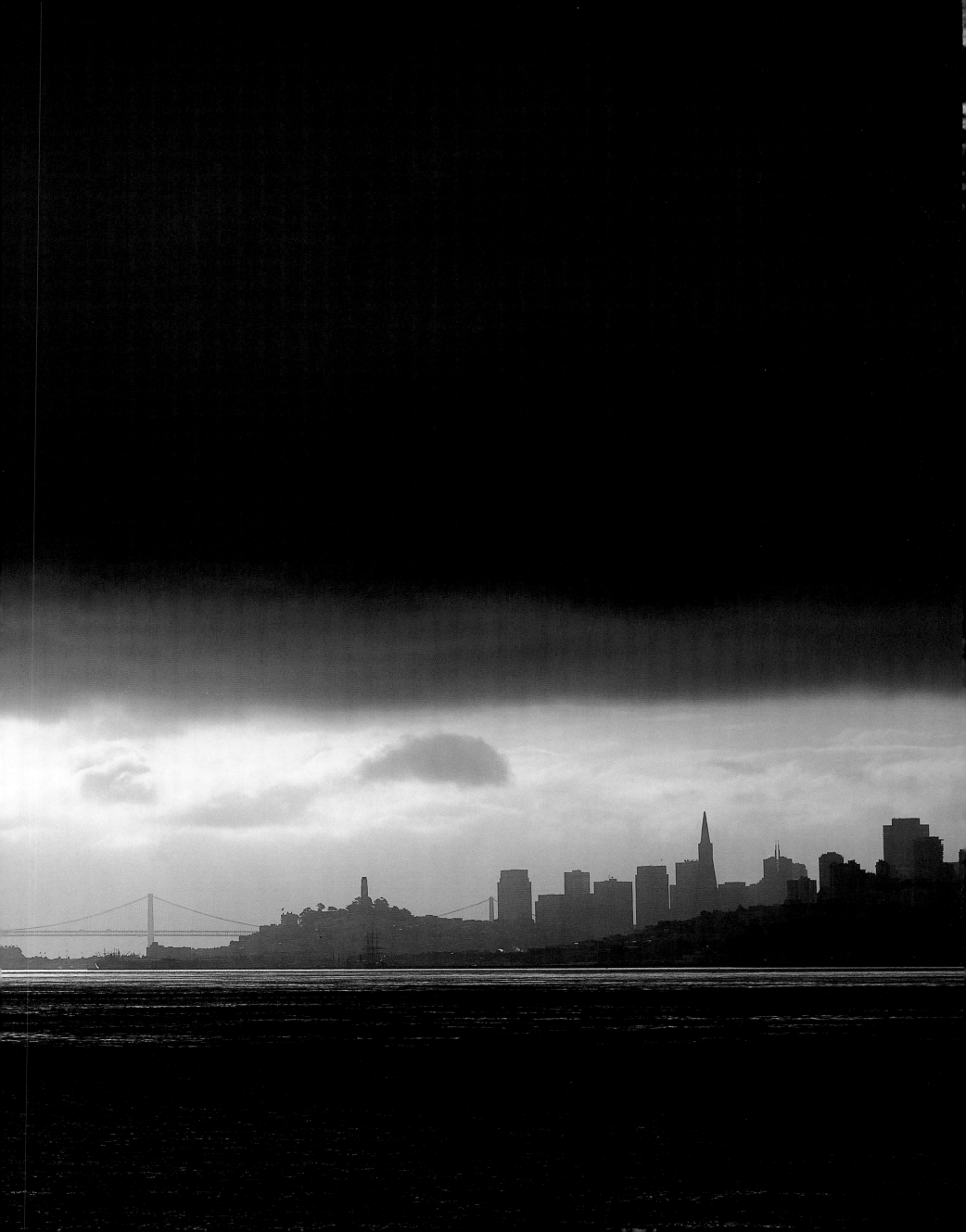

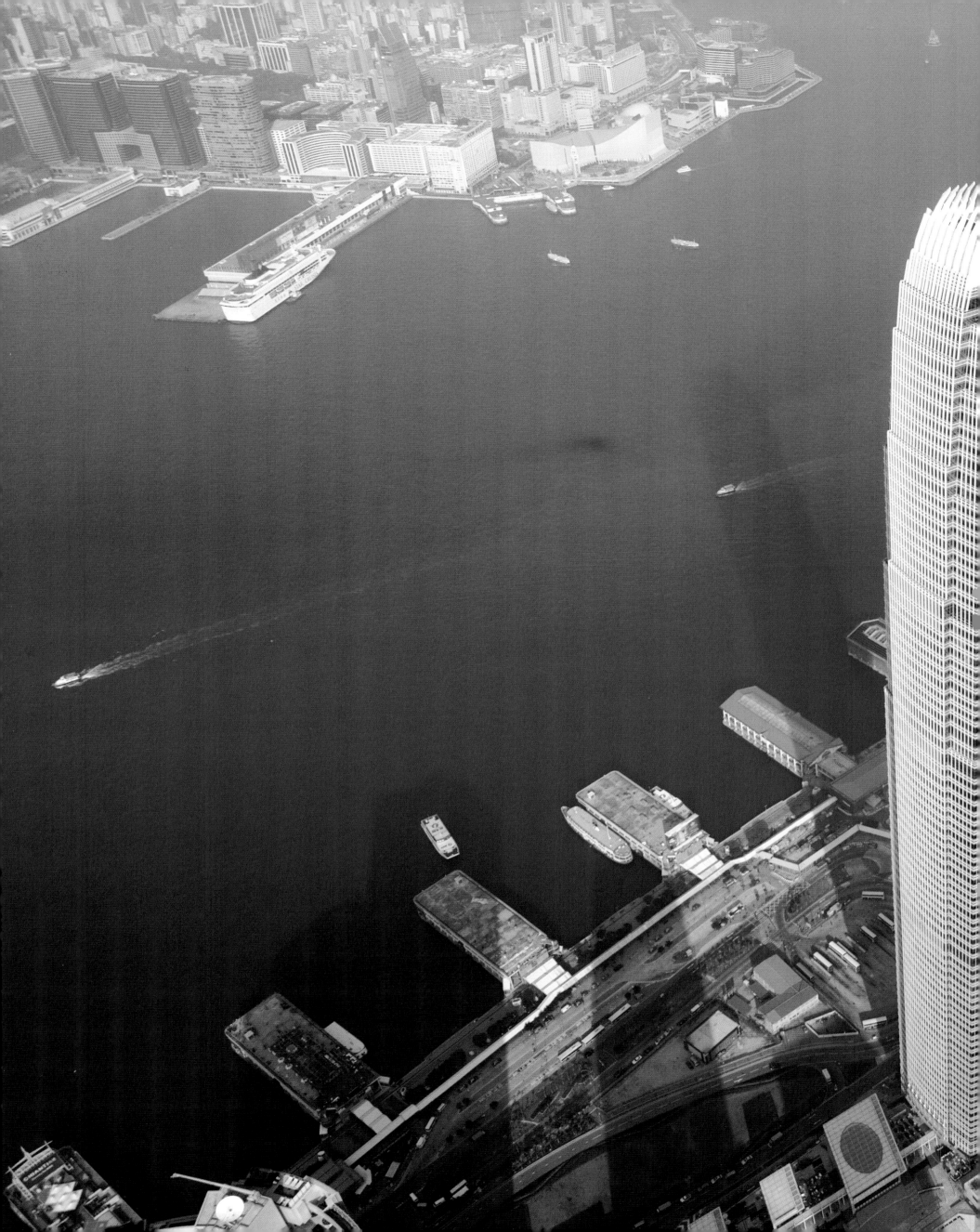

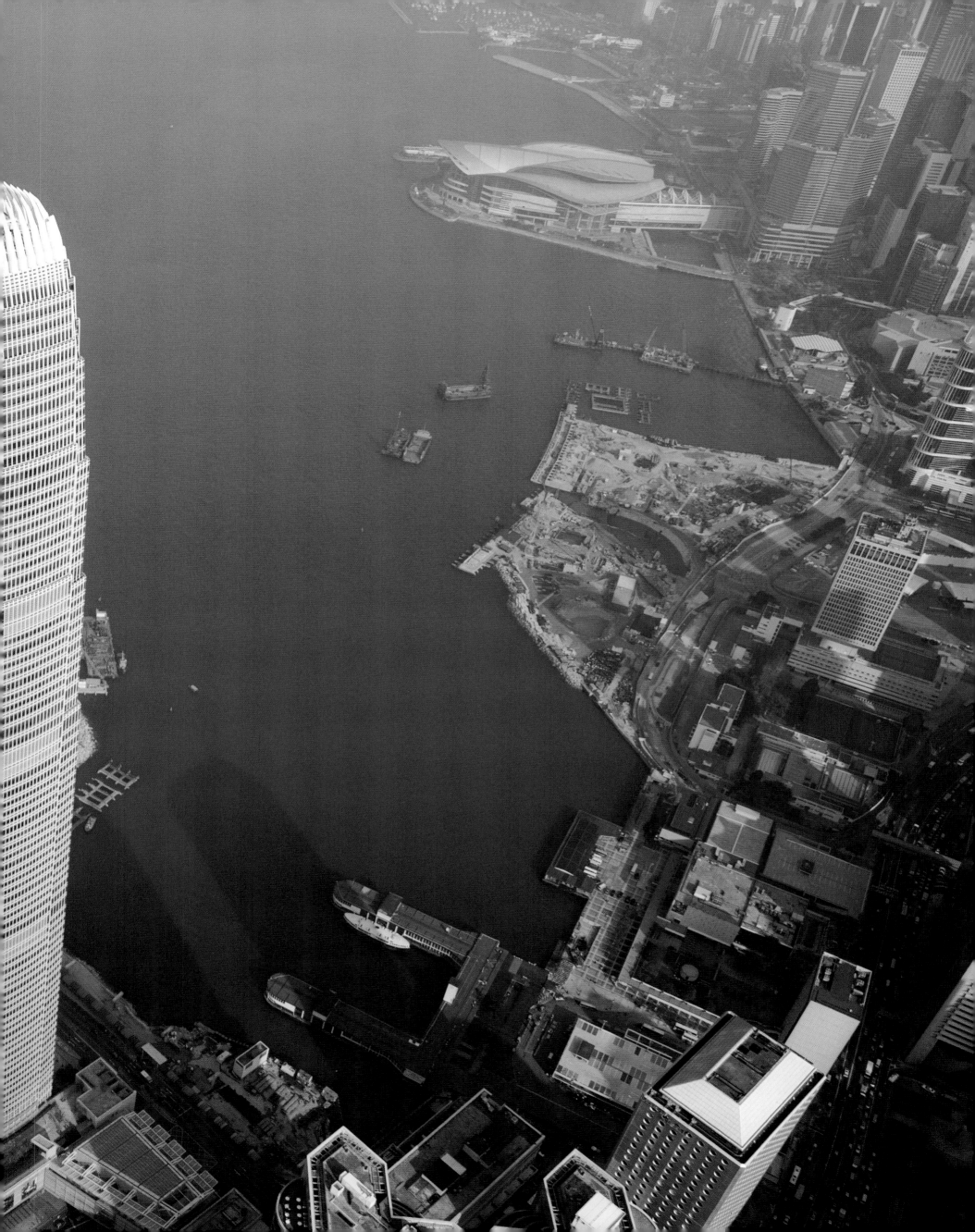

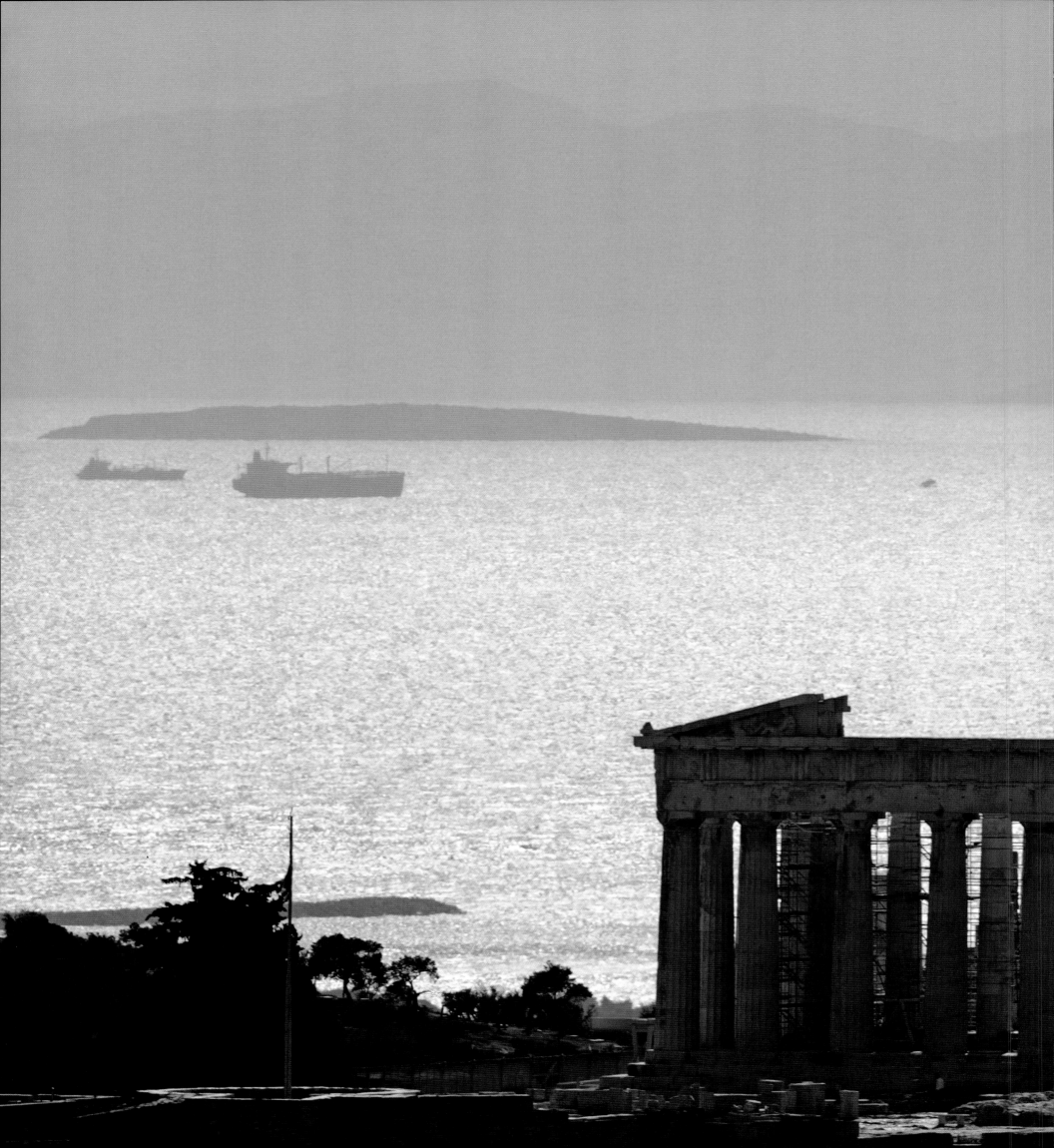

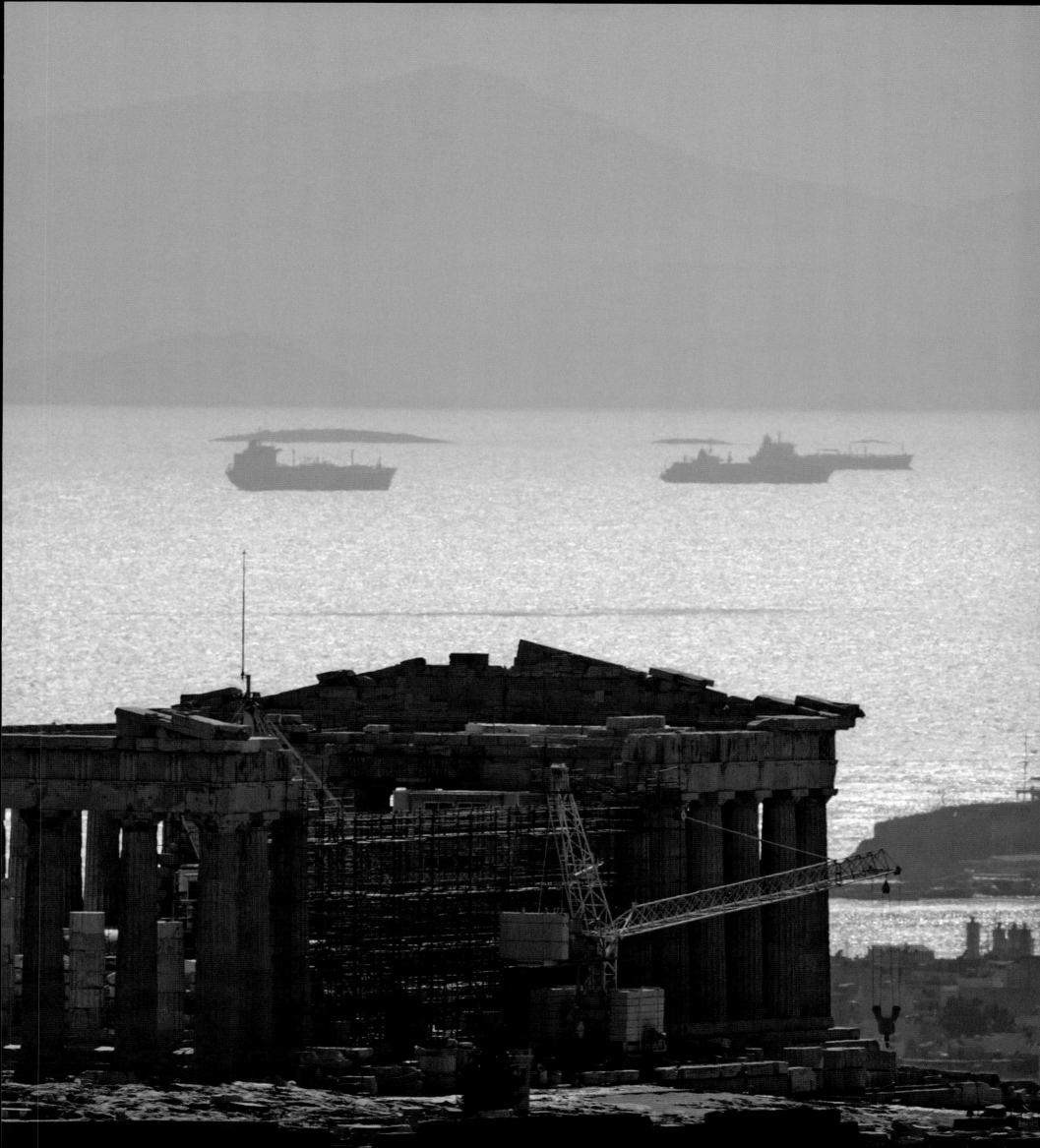

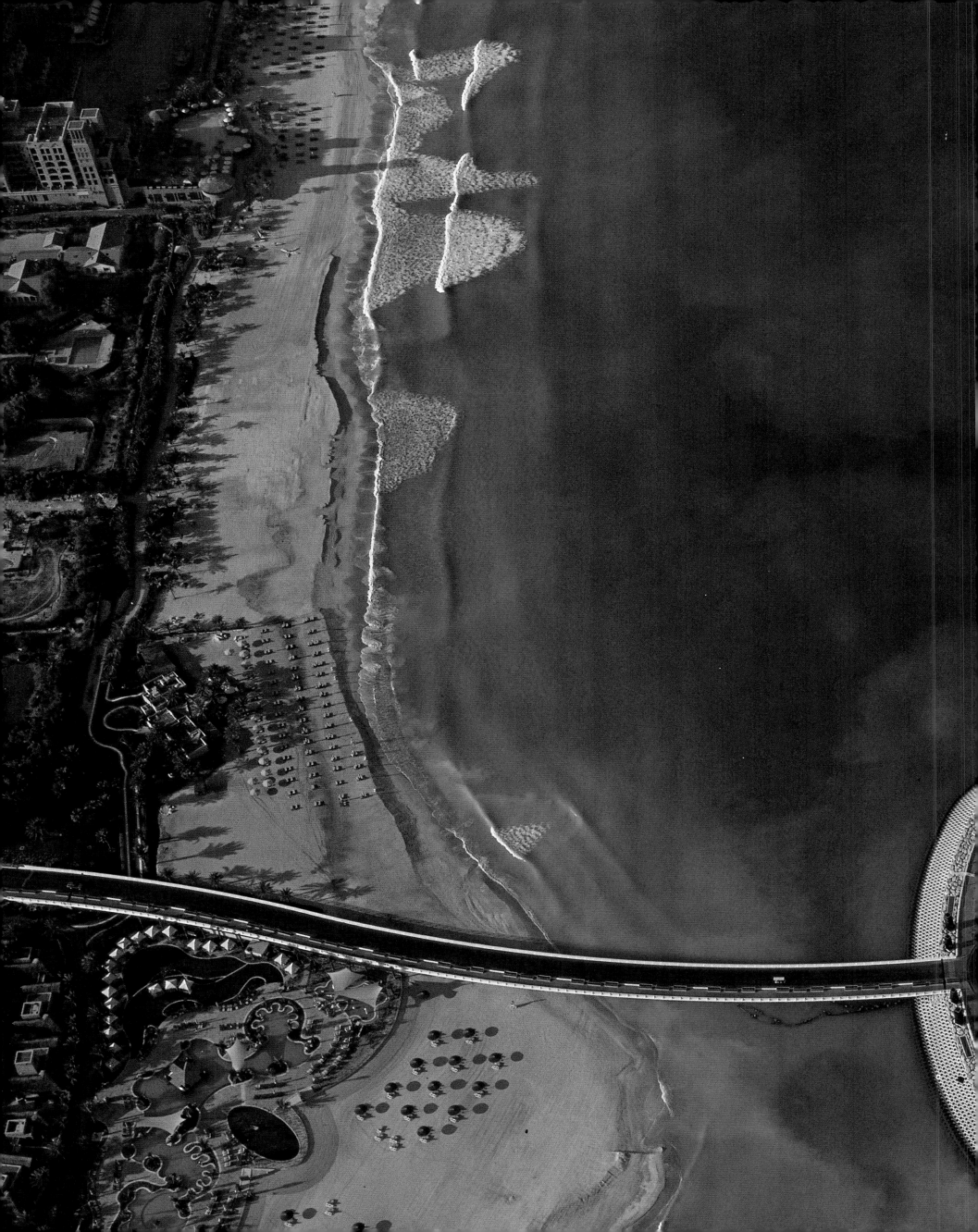

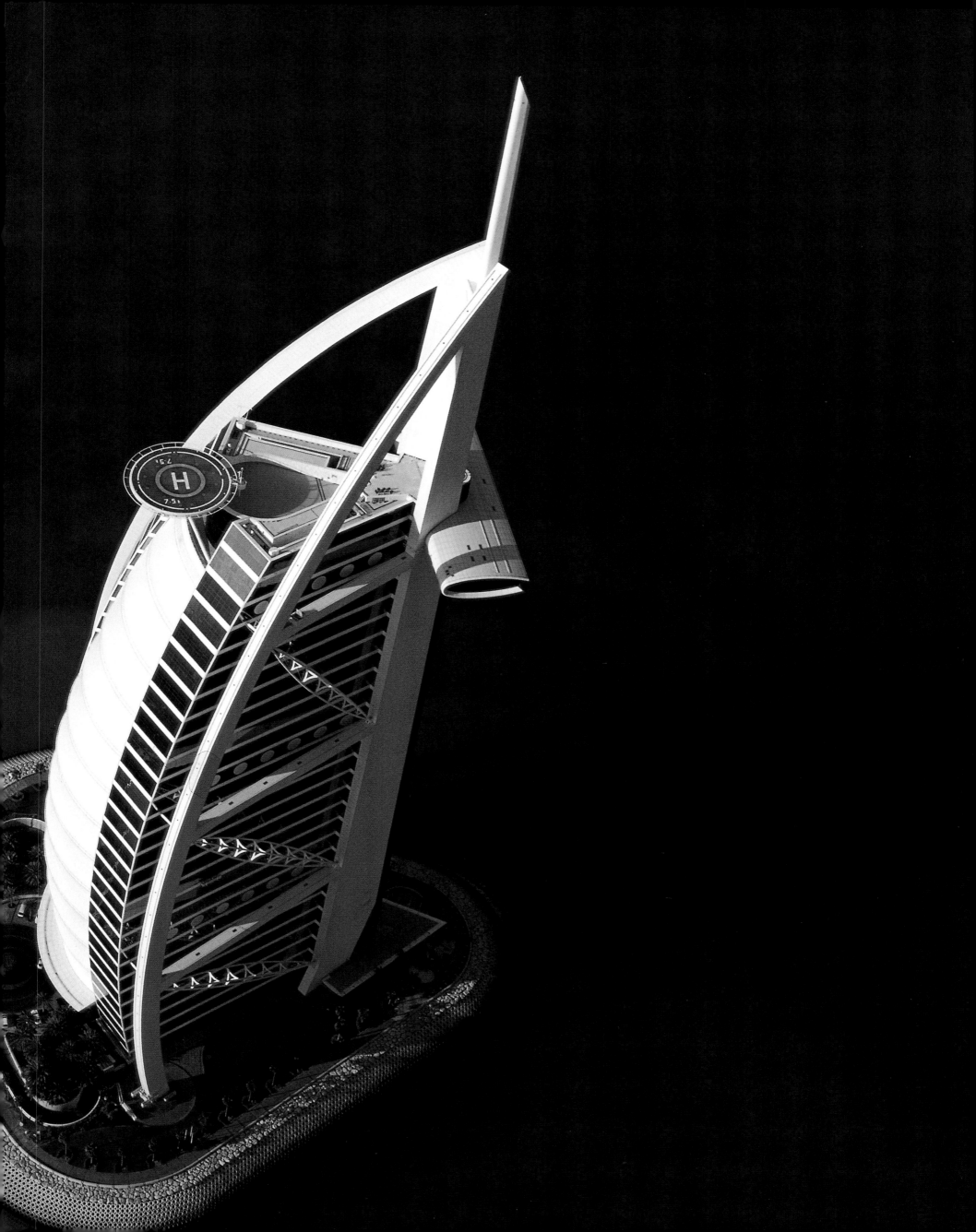

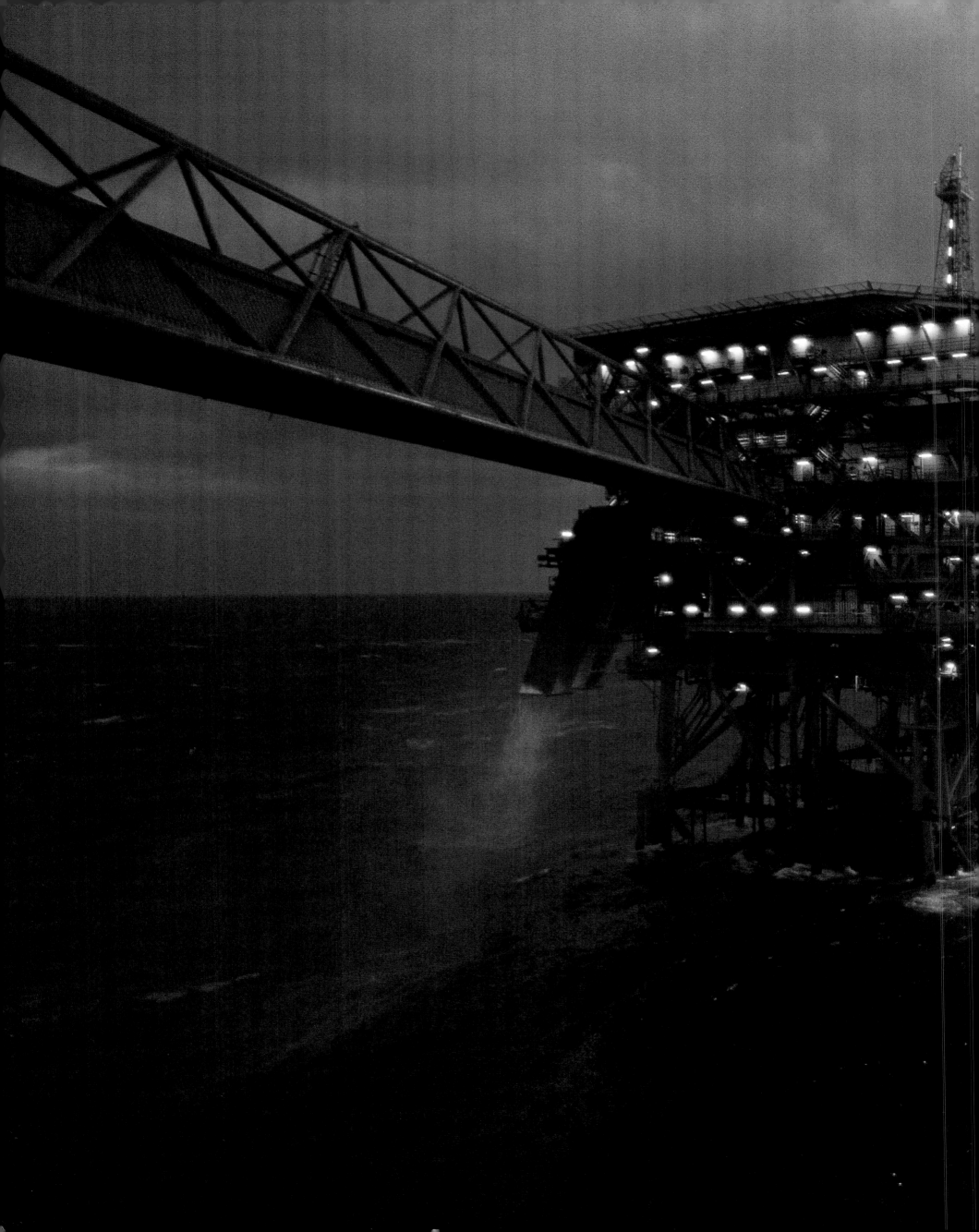

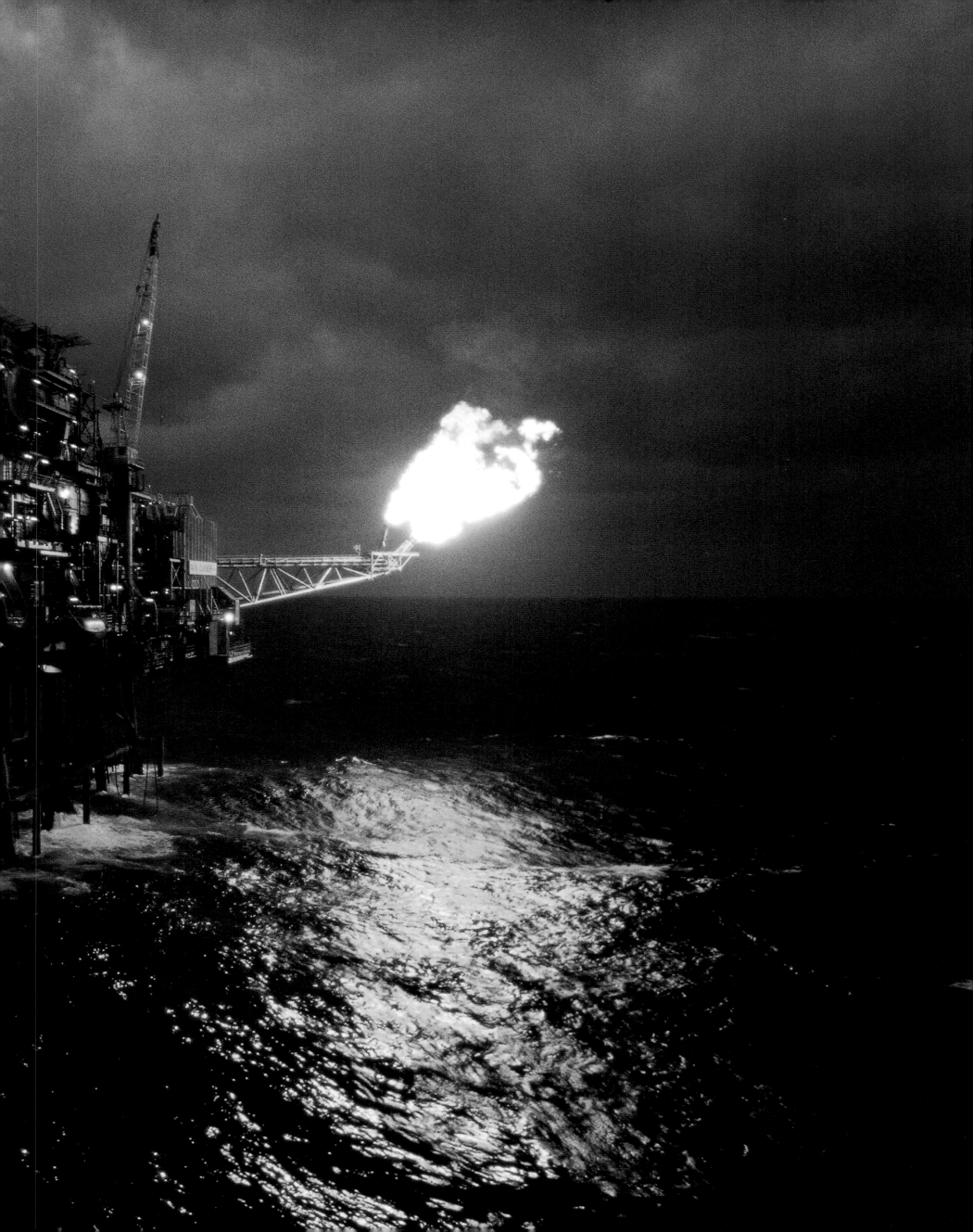

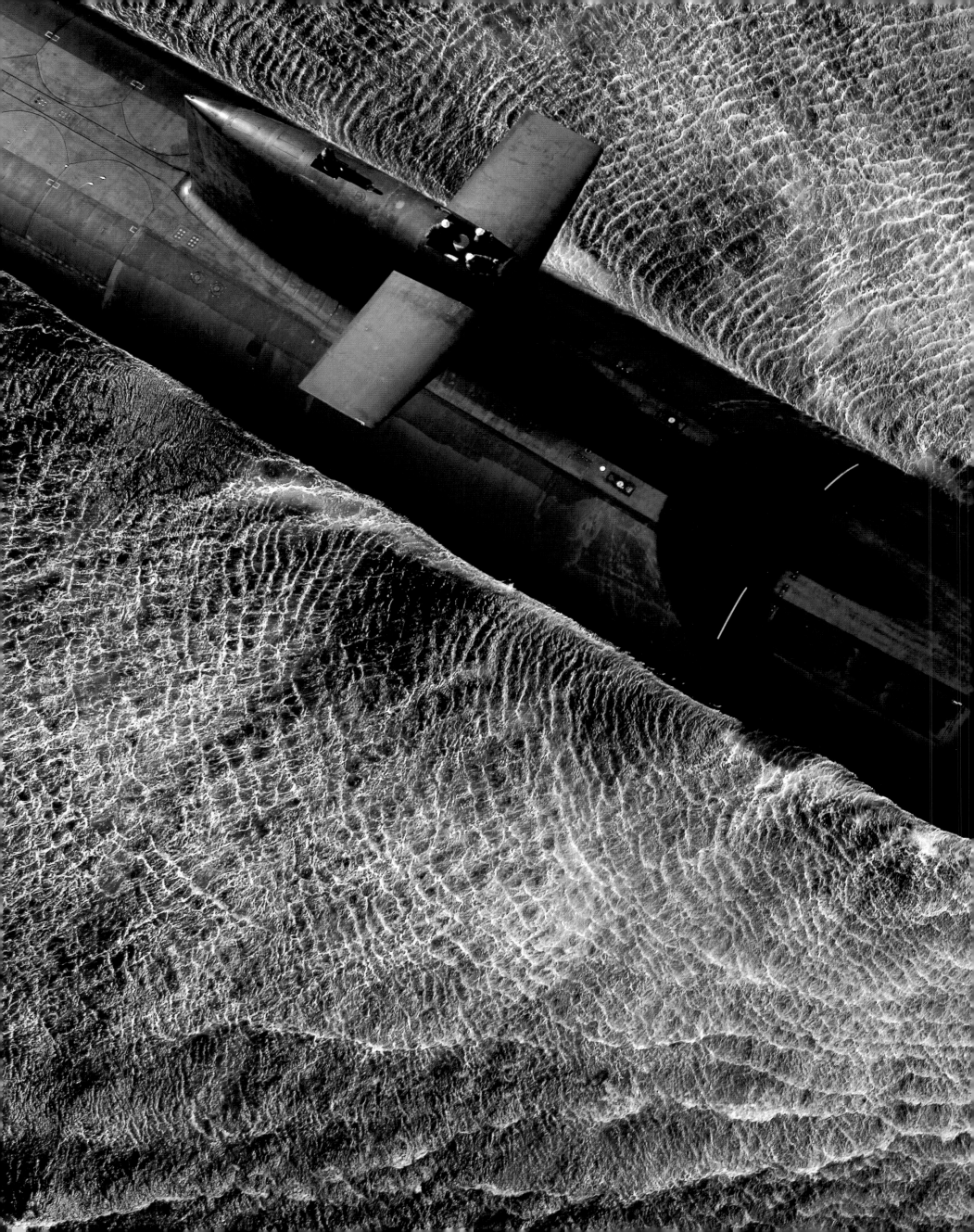

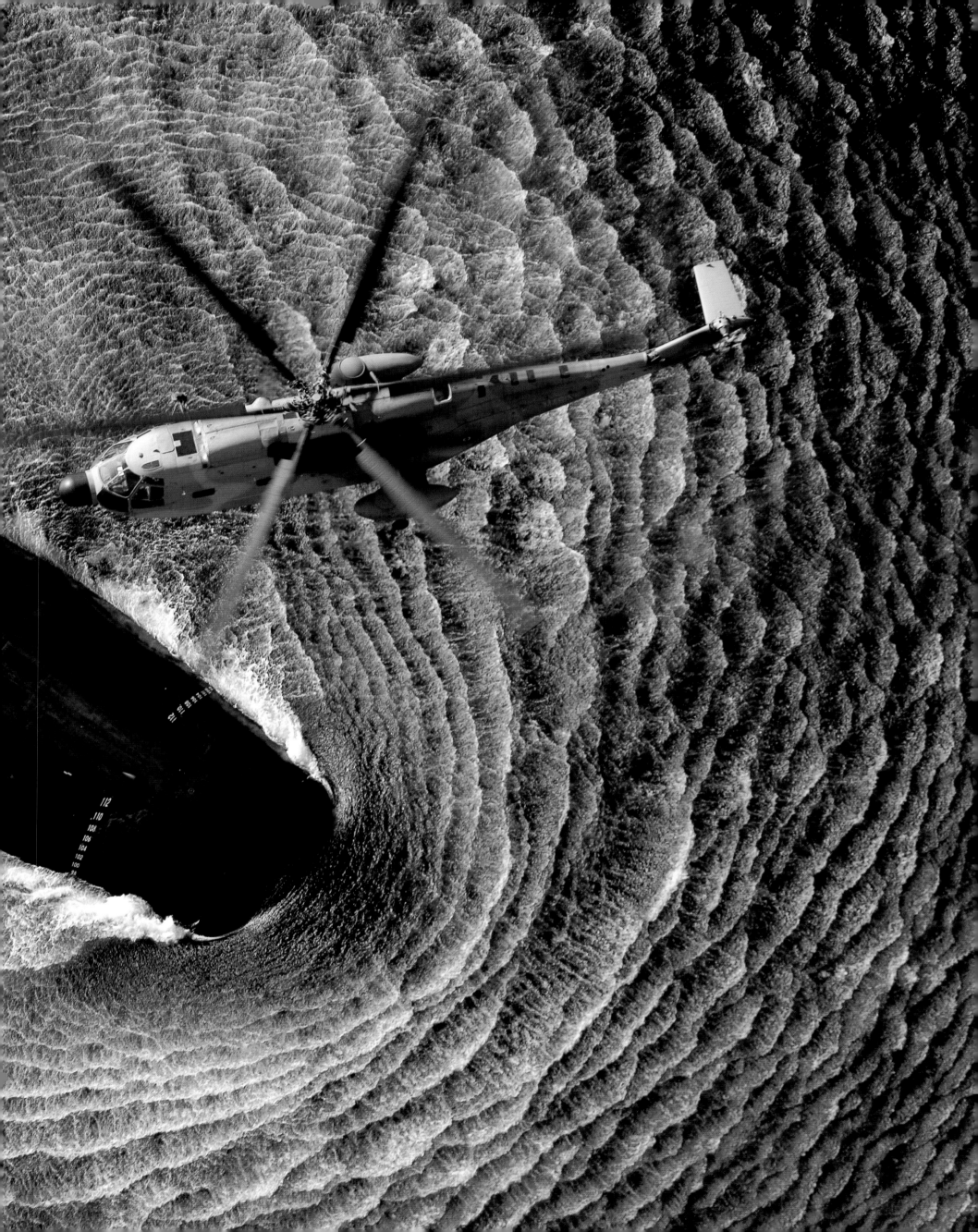

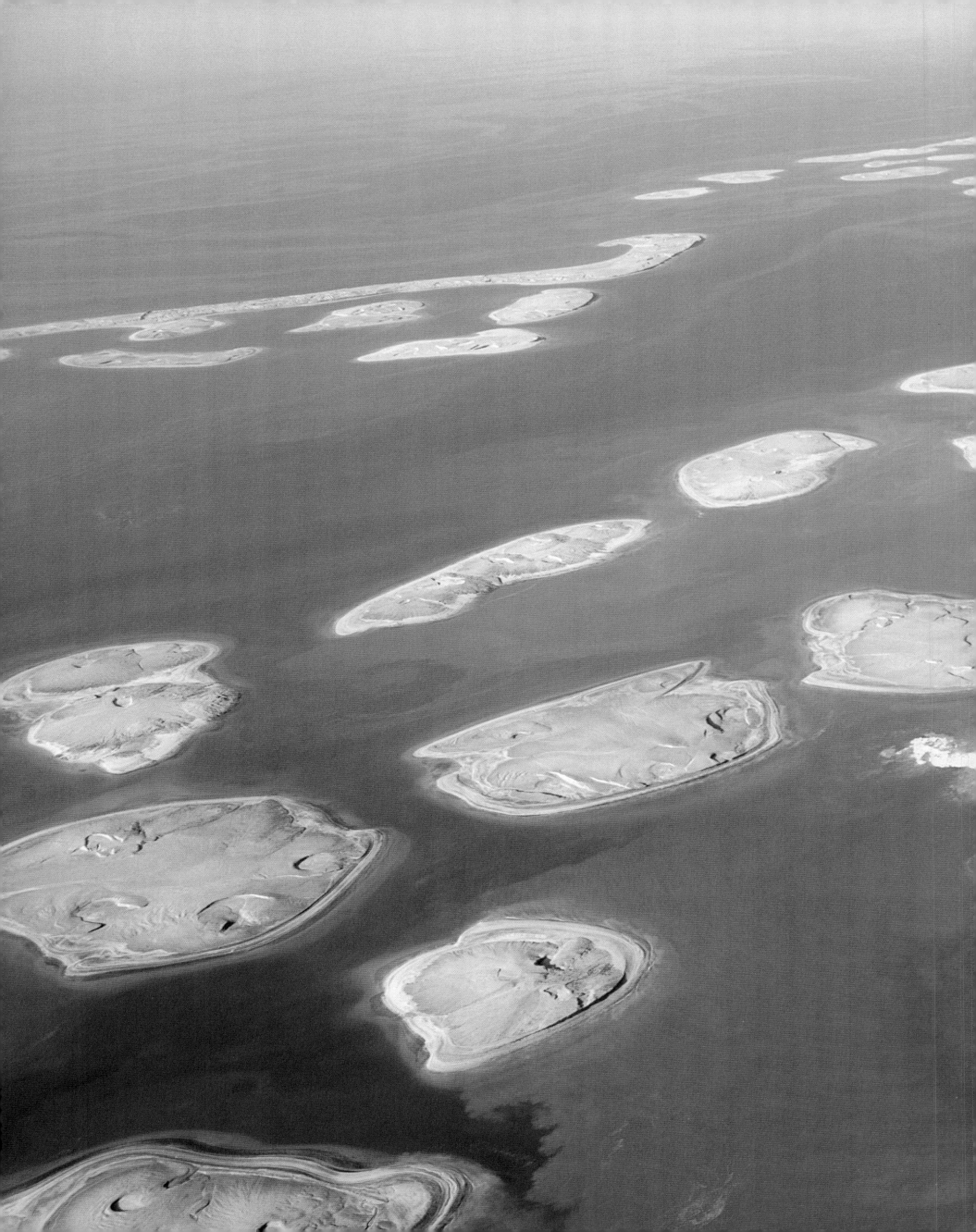

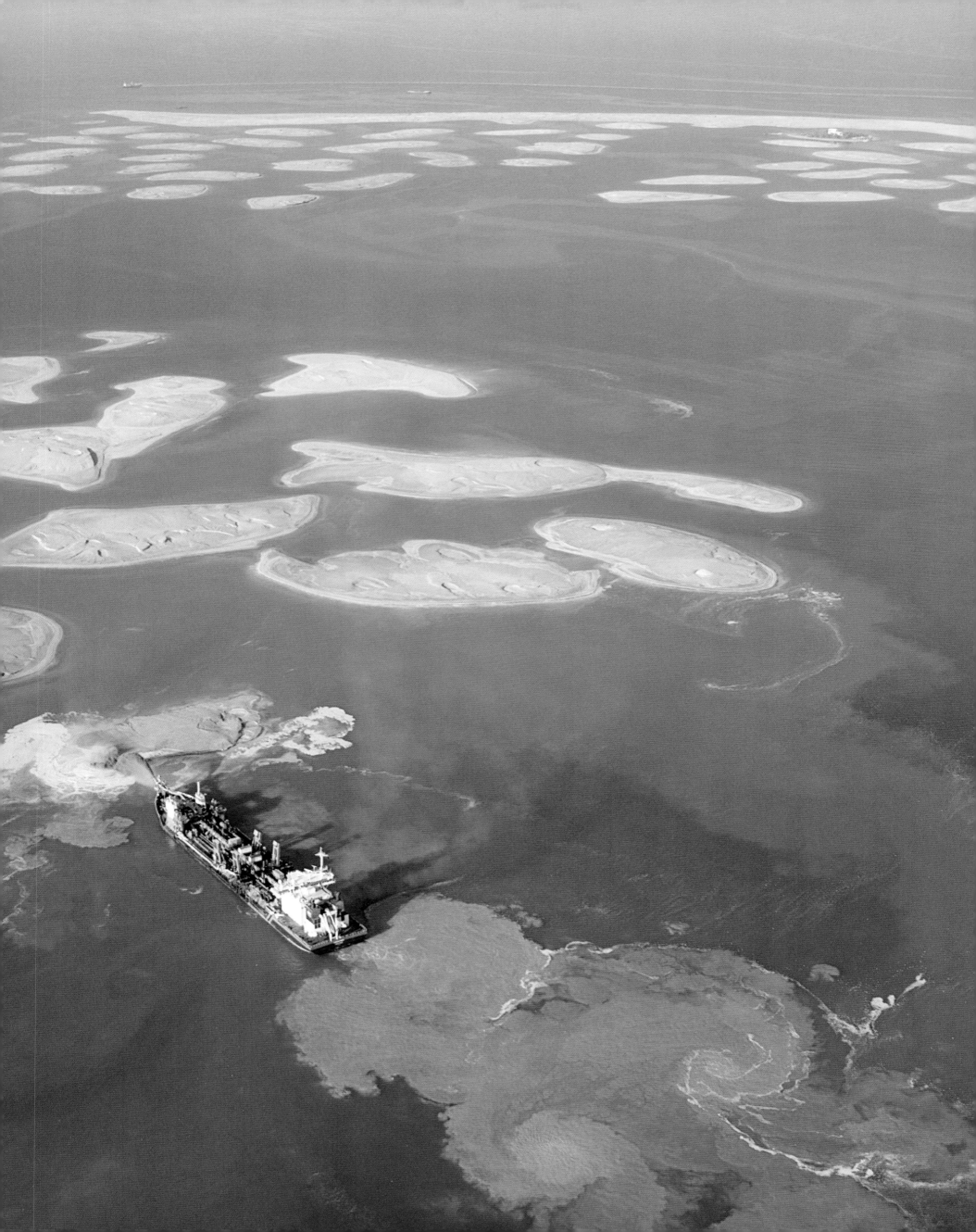

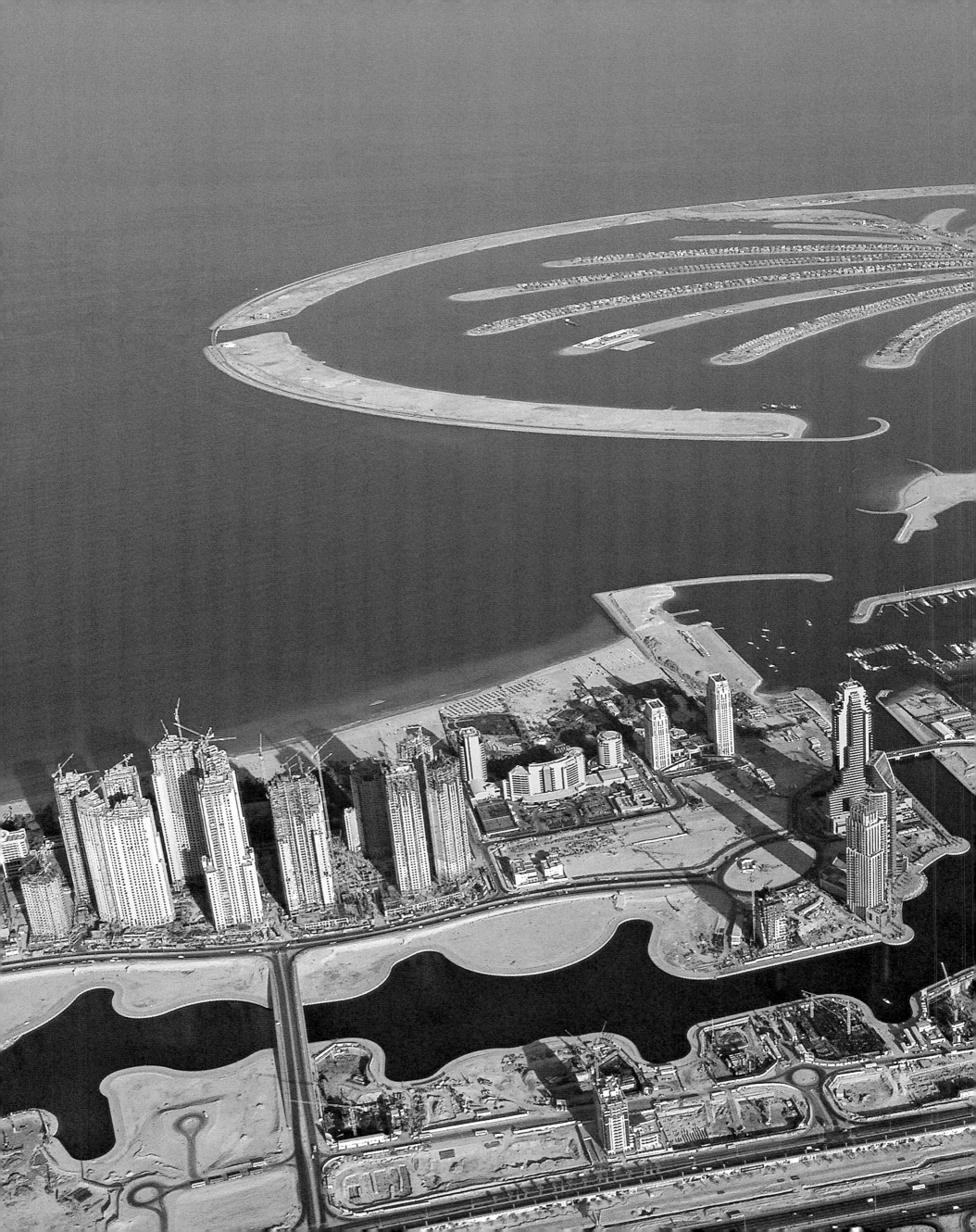

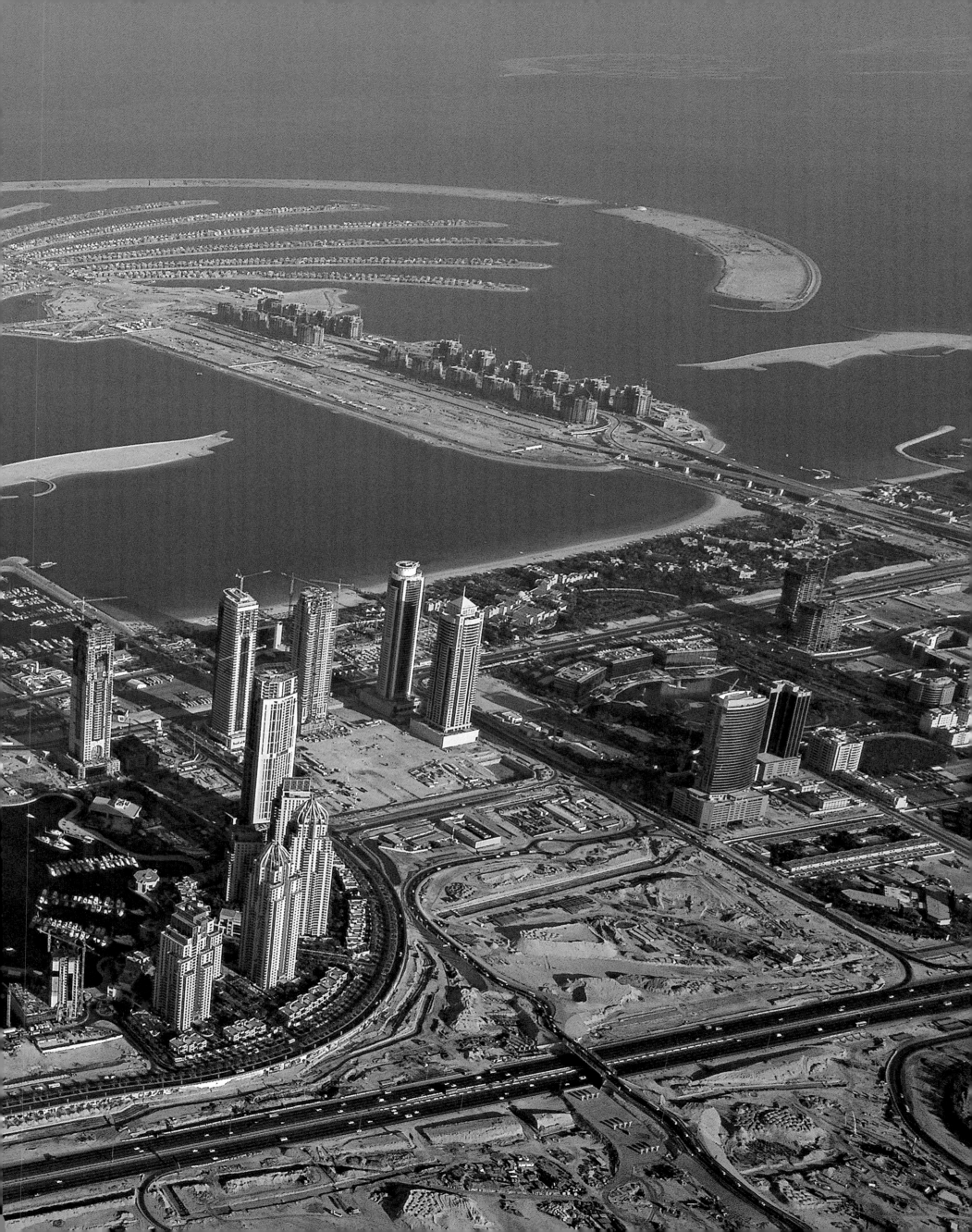

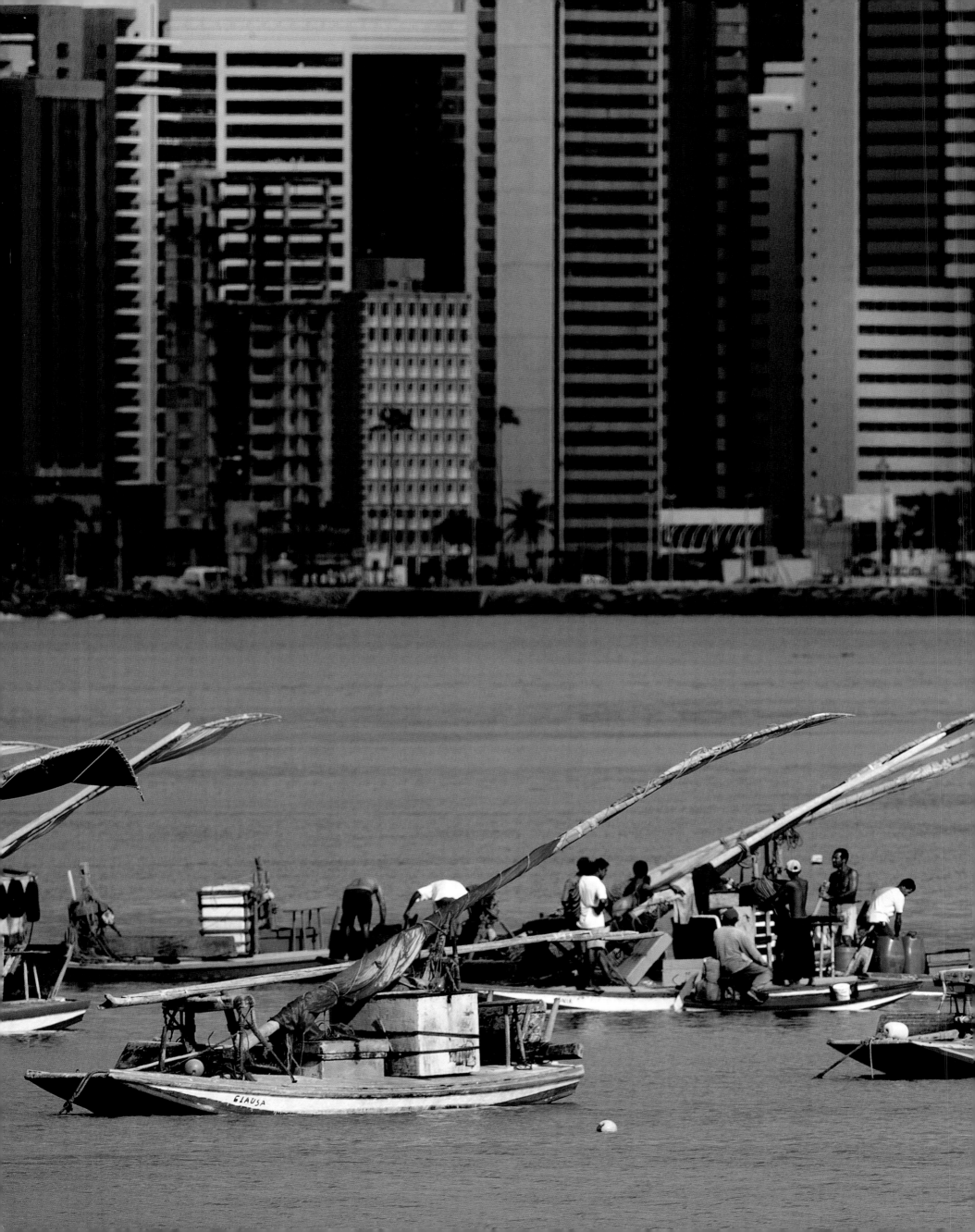

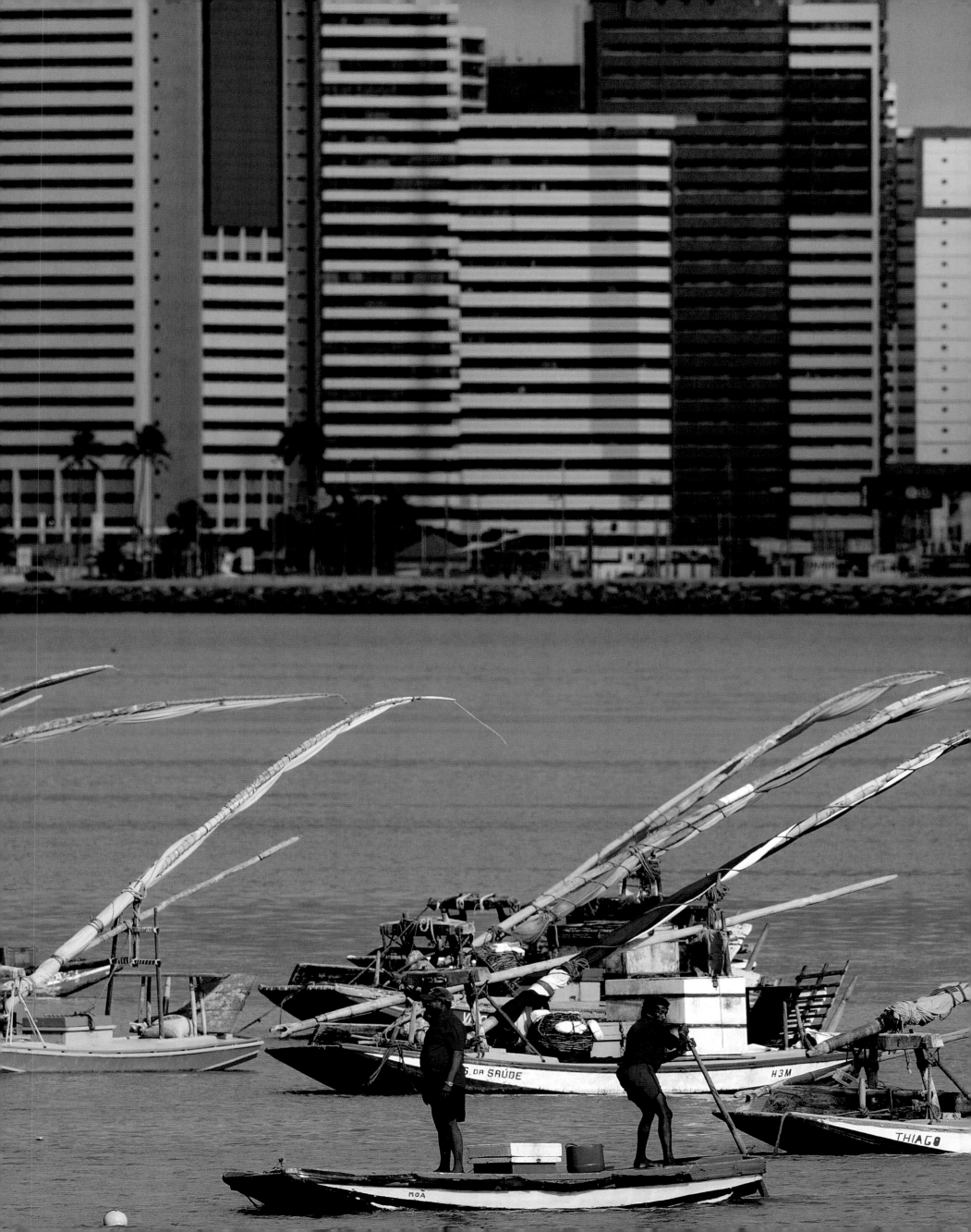

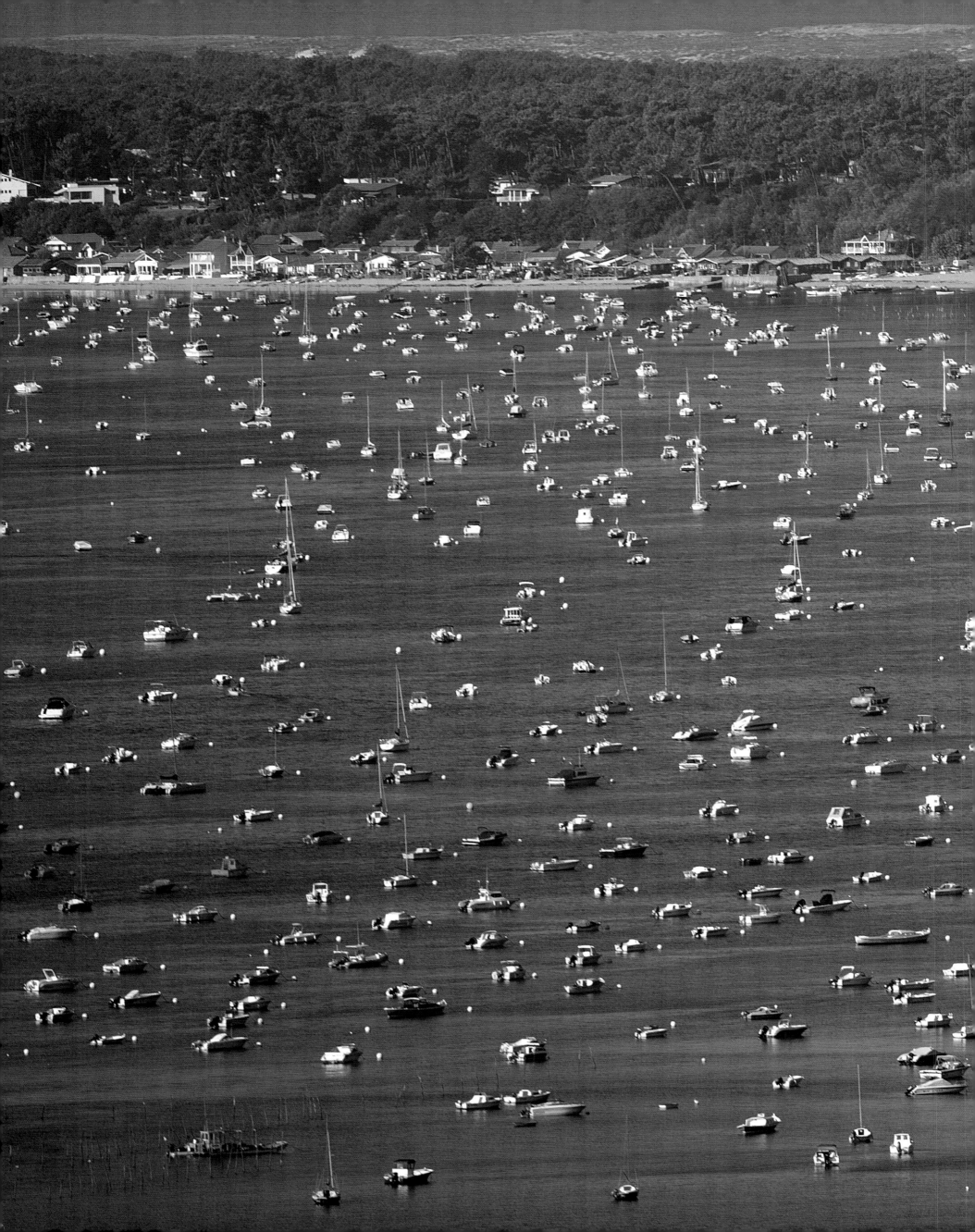

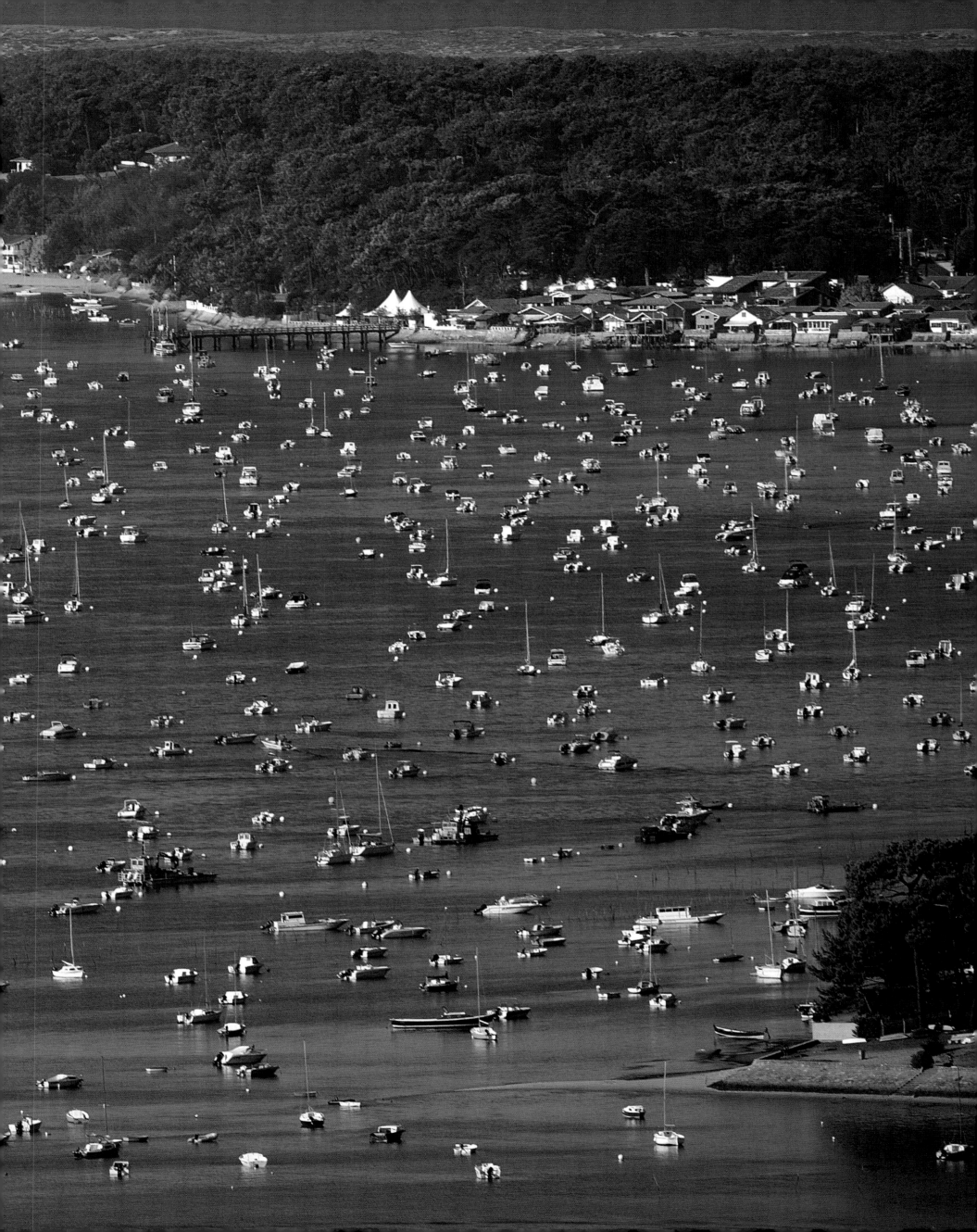

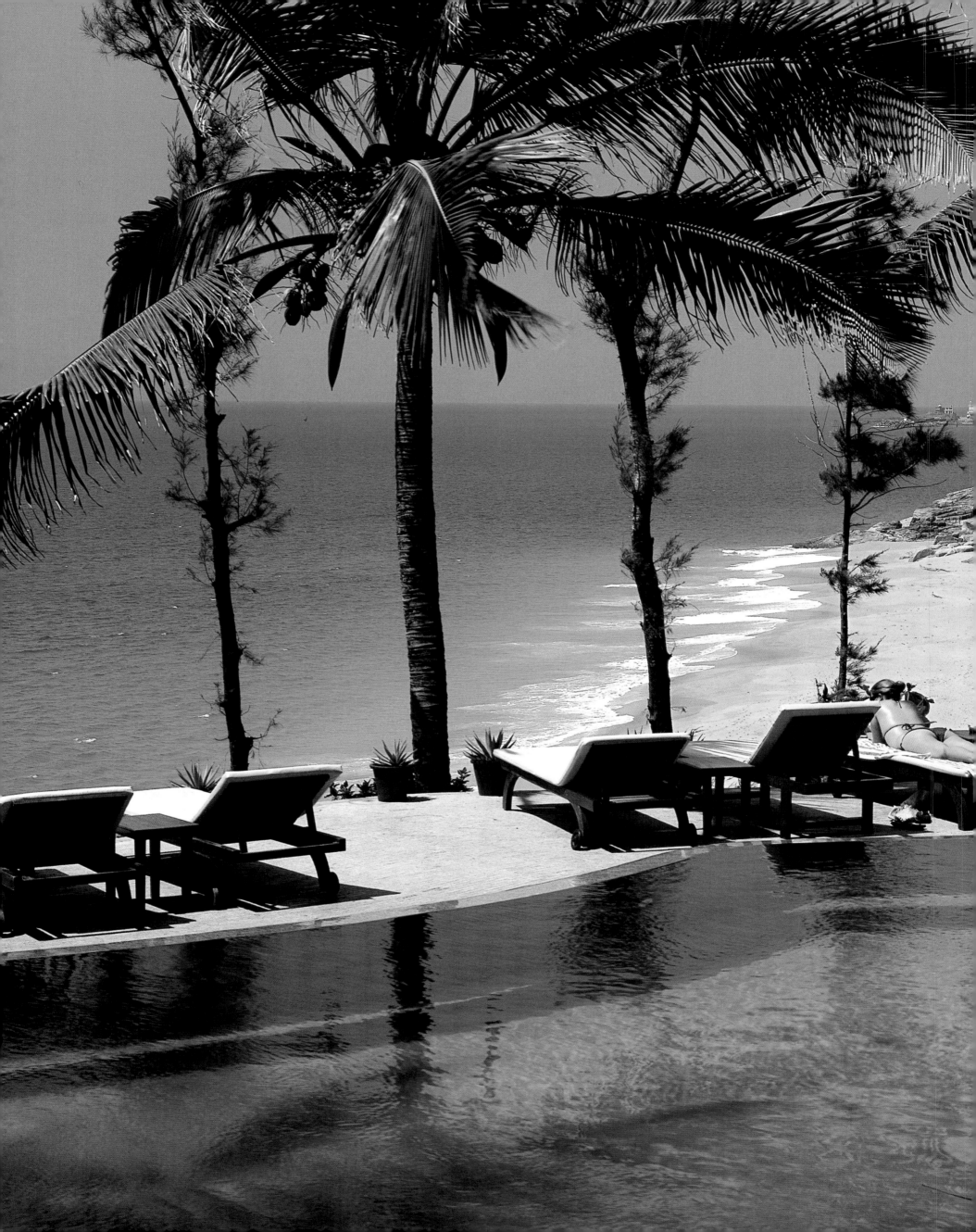

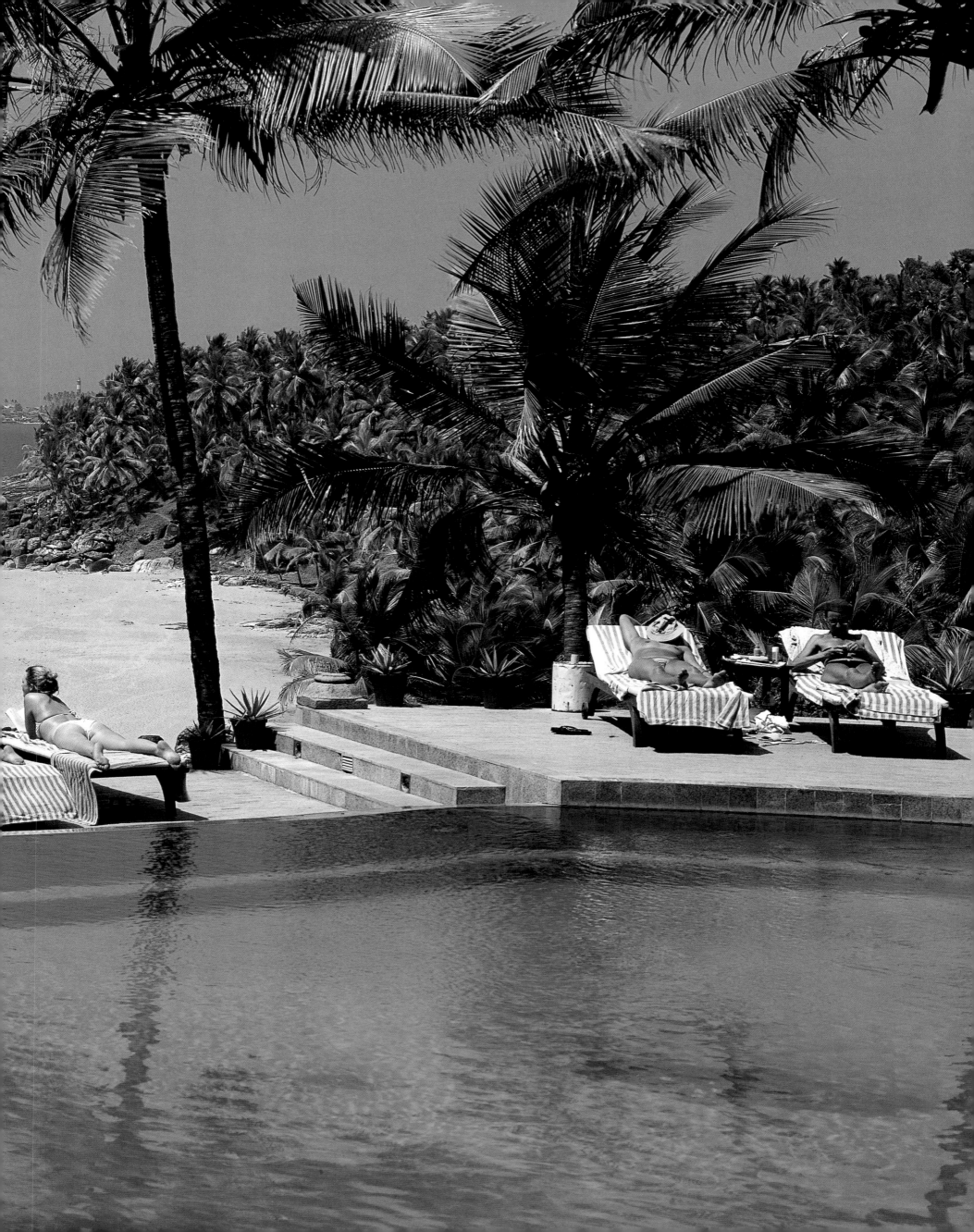

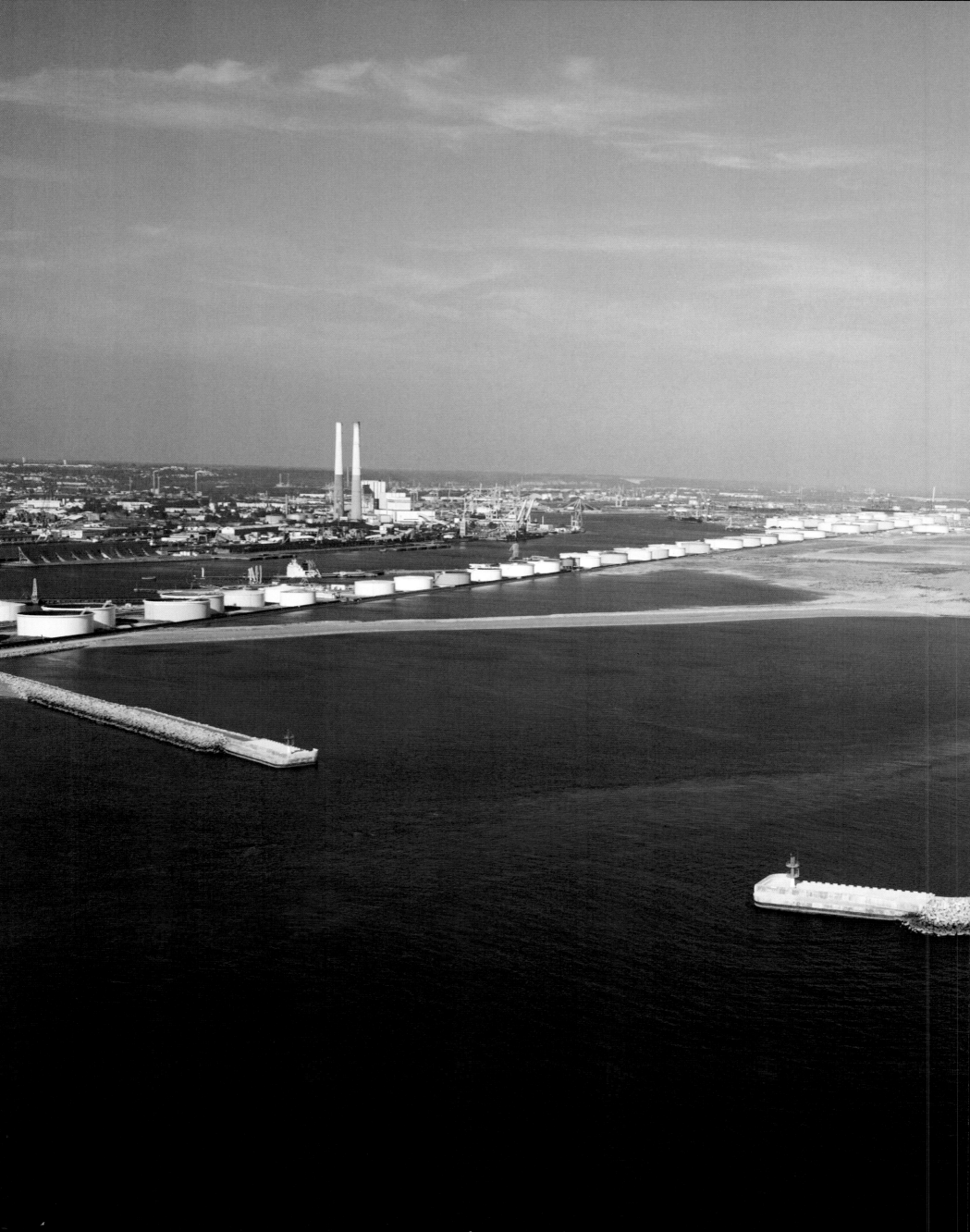

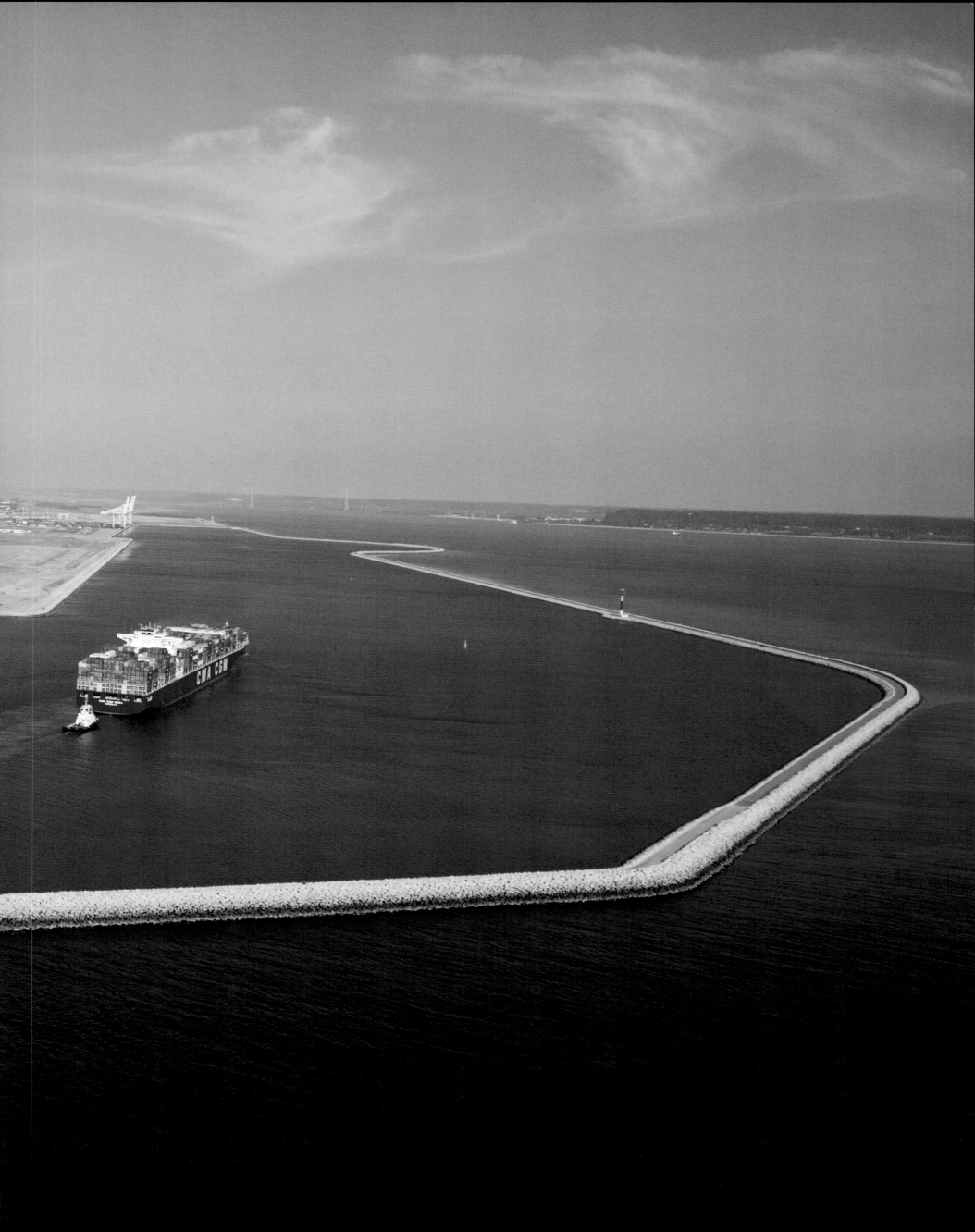

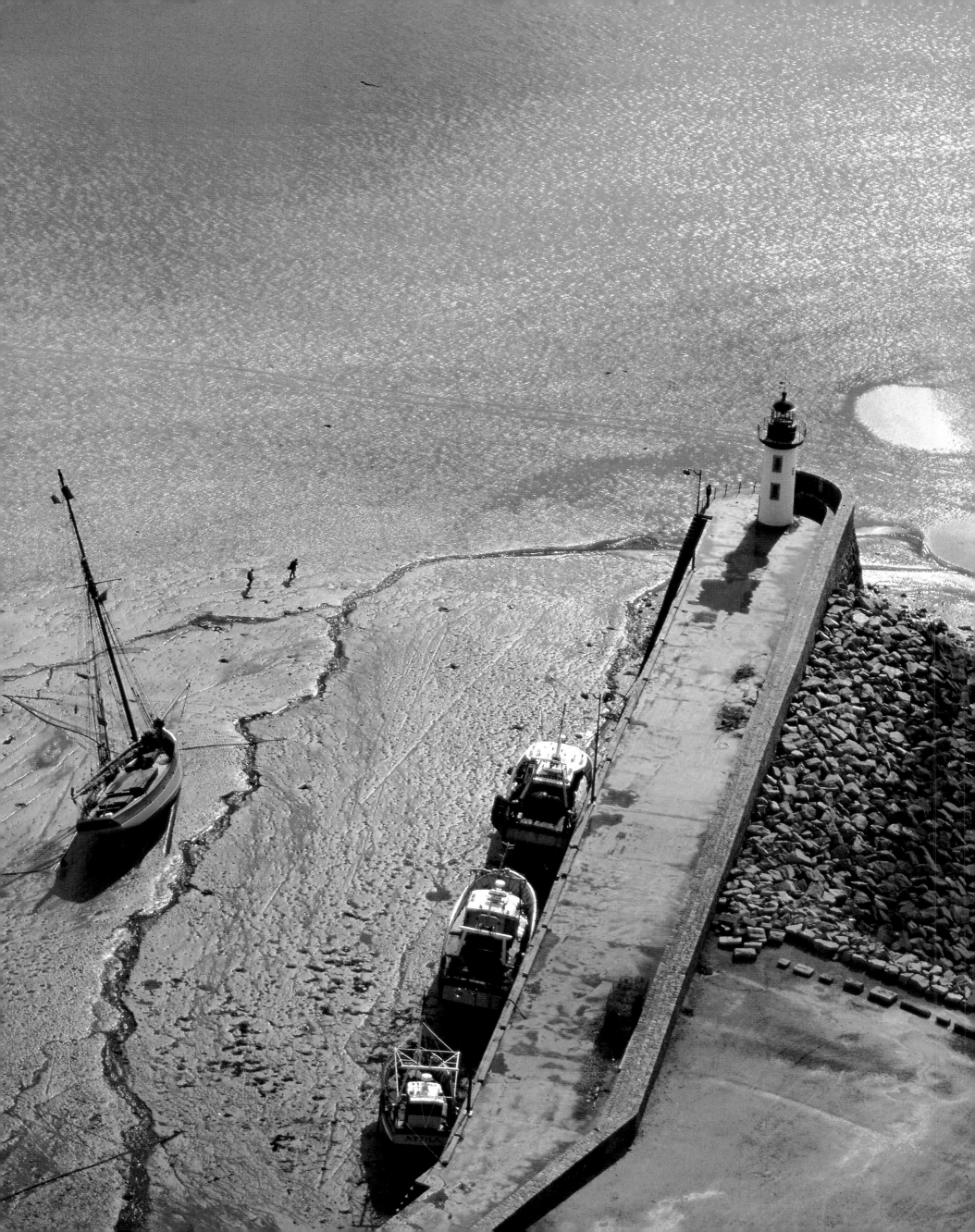

9 The Ocean in Figures

The oceans are too vast and too complex for us to comprehend.
We can only grasp a fact here or a detail there. But perhaps through
Philip Plisson's photographs, we can try to contemplate their nature,
and set sail amid their mysteries.

The Pacific Ocean covers an area of 181 million km^2 – the size of all the other oceans put together.

80% of the oxygen we breathe is produced by phytoplankton. Phytoplankton absorb 30% of the CO_2 we discharge, and help to limit global warming.

45% of the population of Britain live less than 50 km away from the coast. The figure is 8.2% in France.

On average, 1,000 g of sea water contains 35 g of salt.

Traffic on the seas has increased by 470% since 1970. It is likely to triple in the next twenty years.

The seas and oceans are a vast source of wealth: the UN estimates their worth at about $7,000 billion.

The Strait of Malacca is the longest in the world, at 780 km. In the last twenty years, more than 2,000 acts of piracy have taken place there.

On average, a ship of over 300 tonnes is wrecked every three days.

From five metres down, sea water absorbs 75% of solar radiation. Bearing in mind that only the sun is able to break down the macromolecules of plastic (which takes twenty years), it is a safe bet that the plastic bags and other plastic items of waste that line the seabed will remain there for a long time.

220,000 ships of more than 100 tonnes cross the Mediterranean every year, amounting to 30% of the world's commercial maritime traffic, and 20% of hydrocarbon transportation.

Indonesia consists of more than 17,500 islands. The Philippines contain around 7,000.

Acts of piracy on the high seas have risen by 400% in the last twenty years. 80% of piracy takes place inside territorial waters.

70% of coral reefs are endangered.

35 new species of marine life are discovered per week.

95% of the world's trade is carried out by sea.

One seal eats 2.5 tonnes of cod a year.

Two-thirds of the world's largest cities are coastal. Of the 23 cities with a population of more than 8 million, only five are not situated by the sea: Delhi, Mexico City, Paris, Beijing and Seoul.

The average depth of the Pacific Ocean is 4,280 m, Indian Ocean 3,890 m, and the Atlantic 3,330 m.

The world's fleet of container ships has increased tenfold in the last twenty years. More than two-thirds of manufactured goods are transported by container.

Flags of convenience are on the rise: from 9% in 1955 to 25% in 1985, to 37% in 1985, and to 51% in 2005.

Microalgae contain on average: 1% vitamins, 6% minerals, 13% lipids, 15% sugar, 60% protein, and 5% other substances.

In China, 80% of effluents are discharged into the sea without treatment.

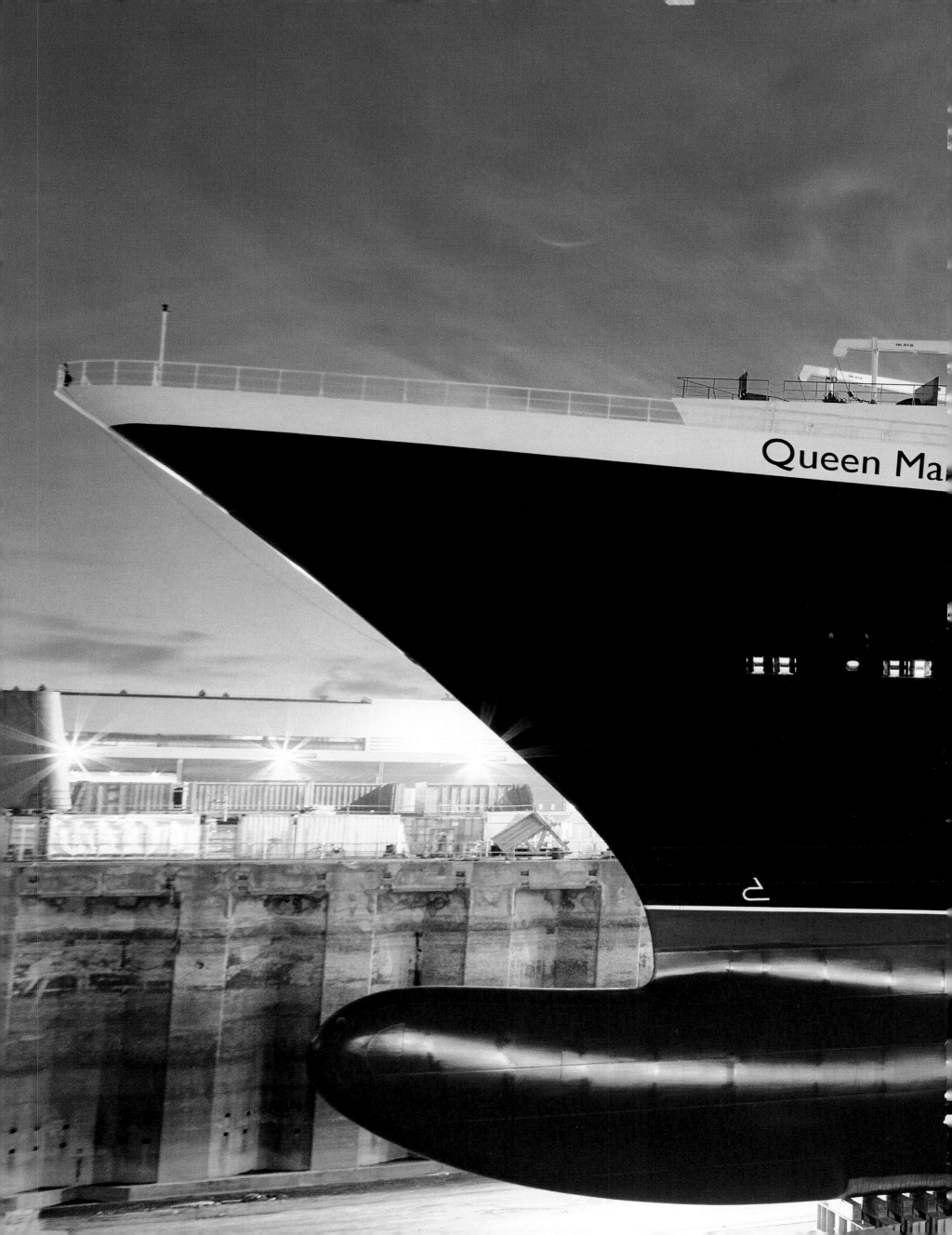

Every year, 135 million tourists descend on Mediterranean coastal resorts. By 2025, this will rise to between 235 and 253 million.

Half the Earth's mangrove forests have been destroyed.

Every year, the seas and oceans are polluted by 6 million tonnes of hydrocarbons and other waste products; 150,000 tonnes are caused by oil slicks; 1.8 million tonnes are caused by dumping; more than 4 million tonnes come from the land (agricultural, industrial and domestic waste).

Nearly 23,000 species of fish have now been classified.

Since 2002, traffic in Chinese ports has increased by about 30% a year.

On average, pleasure boats are used for only 38 hours a year.

The Atlantic Ocean is expanding by an average of 2 cm a year; South America is moving 4 cm a year further away from Africa.

Since 1800, approximately 120 billion (= million million) cubic metres of carbon monoxide have polluted the oceans. Every day, 20 to 25 million additional tonnes of carbon monoxide dissolve in the sea, acidifying the waters.

The extension to the port of Shanghai covers an area equivalent to the whole of Paris.

The volume of waste at the bottom of the north-west basin of the Mediterranean is estimated to be 175 million tonnes.

Maritime transport causes seven times less pollution than road transport from carbon dioxide – the main factor in the greenhouse effect.

40% of ships weighing more than 300 tonnes are over 15 years old. They represent 80% of the total number of shipwrecks.

Although they constitute 62% of the planet's total area, the bathyal zones (between 200 and 2,000 m deep) and abyssal zones (from 2,000 to 6,000 m) of the oceans are still practically unexplored.

80% of shipwrecks are caused by human error: 21% by the crew; 12% by the pilot; 21% by people on land; 3%

by the officer in charge of the engine room; 43% by the officer of the watch.

20% of the world's maritime traffic passes through the English Channel, with cargoes that include 275 million tonnes of hazardous materials.

The transport of crude oil and its derivatives constitutes half the total volume of trade. Other raw materials make up one quarter, and the remaining quarter comprises manufactured goods.

For 1,000 litres of beer carried over 1,000 km, CO_2 emissions are 6.9 kg per ship, and 58 kg per truck.

Two-thirds of the GNP worldwide is produced by half the world's population living and working less than 100 km away from the coast.

Spirulina, a form of blue algae, contains an amount of protein up to 60% of its dry weight.

The deepest known point in the ocean is at 11,034 metres, in the Mariana Trench.

Fewer than 10% of North Sea cod reach adulthood.

8,000 oil tankers are currently at sea.

The coasts of Great Britain are lit by 71 lighthouses, 11 light vessels and over 500 buoys and beacons.

The seas contain 97.54% of the Earth's water.

Dolphins can jump 6 metres above the water.

The three busiest ports in the world are, in descending order, Singapore, Shanghai, Rotterdam.

The mass of the sea is three hundred times greater than that of the Earth's atmosphere.

The visible portion of an iceberg represents 10% of its volume; the remaining 90% is submerged.

Based on the number of ships in excess of 1,000 tonnes, the five largest navies are those of Greece (20.3% of the world's fleet), Japan (14.2%), Norway (6.7%), Germany (6.3%) and China (6.1%).

The seas as we know them today are comparatively young (the oldest regions go back 180 million years). The continents, however, are old (several billion years).

HONG KONG, CONTAINER SHIP OTELLO
The giant container freighter *Otello*, built by the French shipyard CMA-CGM, is a colossus: 300 metres long, 40 metres wide, and 14 metres deep, with a capacity of 8,500 containers. The world fleet now includes some fifty ships that can hold more than 7,500 containers, while a further 165 are under construction. The trend towards such gigantism is a response to the massive growth worldwide in sea traffic: from 2,000 containers during the 1970s, the average capacity has risen to 6,000, and there is even talk of cargoes up to 10,000 containers. However, to exceed that figure would entail a massive reorganization of the world's ports and their facilities.

FRANCE, CAP ANTIFER, OIL TERMINAL
More than 100 million tonnes of hydrocarbons cross the Channel every year. All the oil that travels over the oceans in some 8,000 supertankers serves to supply us with energy. Invaluable for our comfort and for our daily movement from place to place, it is all too often used to excess. In order to prevent repetition of the catastrophic oil slicks of the past, the tankers will have to be equipped with double hulls from 2015 onwards. This measure is designed to phase out all the dilapidated and dangerous vessels, but perhaps it is also necessary to review the whole principle of flags of convenience and the laxity that goes with them.

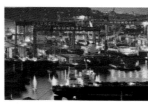

KOREA, ULSAN, HYUNDAI SHIPYARD
Until 1970, the biggest shipbuilders in the world were European, but they were then supplanted, first by Japan and then by Korea. In order to stay in business, Europe specialized in 'added value' ships such as liners, whereas the Asian countries made their fortunes with bulk carriers and oil tankers. Hyundai Heavy Industries (HHI) is now the largest shipyard in the world, and produces more than one ship every week. At the time when this photograph was taken, the site contained 17 ships of over 300 metres either under construction, receiving their finishing touches, or awaiting delivery: tankers for oil and gas, and giant container ships.

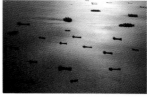

GREECE, GULF OF ELEFSINA
Astonishingly, one of the most damaging sources of sea pollution comes from sea water. When empty, cargo ships load up with water for ballast in order to stabilize themselves. In the port where they take on their cargo, they empty the water out. In one year, about 10 million tonnes of ballast water moves from one part of the world to another, and with it goes a vast quantity of other matter: plankton, algae, fish, jellyfish, and thousands of other invertebrates. Once they have been dumped, few survive, but some do adapt to their new environment, and may even thrive, to the detriment of local species of flora and fauna.

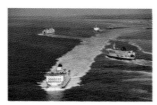

FRANCE, TRAFFIC BETWEEN DOVER AND CALAIS
Above the Channel Tunnel, the ferries continue to perform their endless ballet. Every day, 63,000 passengers embark on the 130 crossings from one shore to the other. With the growth of tourism during recent years, the transport of passengers by sea has enjoyed a real boom. It is a fast and safe way for people and their vehicles to move across the water to destinations like France or Ireland for the British, or England or Corsica for the French. The world market is estimated at 130 million passengers, of whom 24 million cross the Channel and 48 million cross the Baltic.

FINLAND, GULF OF BOTHNIA, ICEBREAKER
In northern Europe, the Baltic Sea divides up into the Gulf of Finland in the east and the Gulf of Bothnia in the north, between Sweden and Finland. Riddled with reefs, turbulent, narrow and not very deep, this almost land-locked sea can only connect with the exterior by way of constricted straits. Its waters, which renew themselves only slowly, contain a low level of salt (and are even fresh at the bottom of the Gulf of Bothnia), and so freeze over in winter. Despite these hostile conditions for navigation, maritime traffic here is dense. During the winter months, the ports of Finland are totally dependent on icebreakers.

FINLAND, GULF OF BOTHNIA, ICEBREAKER
Every winter the Gulf of Bothnia and the Gulf of Finland, on the western and southern coasts of Finland respectively, are frozen over. In the Gulf of Bothnia, *Otso*, a powerful Finnish icebreaker, comes to the aid of merchant vessels, using its reinforced bow to cut through the floes and carve out a passage of clear water through which the ships may follow it. Without these icebreakers, Finland's trade would grind to a halt in the frozen seas. During the long winter, they help some 14,000 ships to reach their destinations.

FRANCE, SAINT TROPEZ, 118 WALLY POWER
The ship-building firm of Wally creates luxury mega-yachts for wealthy enthusiasts, with a range of sailing boats over 50 m long and motorboats of over 40 m, beautifully streamlined and resolutely futuristic, while their interiors are comfortable and practical. The latest product of these visionary architects, the *118 Wally Power*, is a powerhouse of technology, aerodynamics and design. Its aggressively shaped hull is 36 m long, and is driven by a 16,800 horsepower engine. Luxury yachts nowadays can move at a speed of 60 knots – a new concept of cruising.

JAPAN, TOKYO, TUNA MARKET
The consumer has a vital role to play in reining back the overexploitation that is affecting all the oceans of the world. Today, labelling encourages good practice by showing that products have come from sustainable fishing where every effort is being made to conserve resources and to pay a decent wage to the fishermen. This sort of eco-labelling is beginning to make an impact in Europe, but when will it become commonplace in Tokyo, the largest fish market in the world? More than 2,500 tonnes of fish are eaten there every day except Sunday. With consumption this high, the Japanese may soon cause the permanent disappearance of the tuna.

USA, FLORIDA, MIAMI BOAT SHOW
Every year, Miami holds a huge trade show where more than 2,000 representatives of the boating industry come to display their latest yachts, launches, engines and equipment. The success of the show is clear evidence that this particular world market has the wind very much in its sails. Between 1997 and 2002, the annual growth rate was 7 per cent. France leads the world in sailing boats with 67 per cent of the world's production. But this rapid growth could easily stall through a critical shortage of berths on the coasts. Perhaps the only solution is to store them on land?

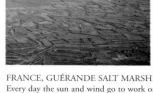

FRANCE, ARCACHON, MARINA
On a fine day in August, when conditions for sailing are ideal, the port is 80 per cent full. The figure is scarcely surprising when you take into account the fact that the average time people spend sailing their pleasure boats is 38 hours a year. Owning a boat is in no way the same thing as sailing. In many cases, the acquisition of a boat is simply a way of giving form to one's dreams of escape and freedom. But the faraway places envisaged in those dreams generally remain mirages. In all the world's yachting harbours, thousands of dreams simply bob up and down, attached to their mooring ropes.

FRANCE, GUÉRANDE SALT MARSHES
Every day the sun and wind go to work on the 2,000 hectares of salt marshes on the Guérande peninsula. Their task is to evaporate the seawater. Bustling about on the levees, a salt-marsh worker skilfully wields the long rod that collects the crystallized salt. He has a thousand years of experience behind him. In these saline pockets, the concentration of salt reaches 300 grams per litre, as opposed to 30 grams in seawater itself. A third of the world's salt production is extracted from sea water, and the rest is provided by rock salt, which also comes originally from the sea. The chemical industry and the de-icing of roads account for three-quarters of production.

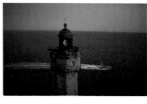

FRANCE, OUESSANT, LA JUMENT LIGHTHOUSE
Behind the La Jument lighthouse, a launch belonging to the Société Nationale de Sauvetage en Mer (the French National Sea Rescue Association) leaves its wake in a calm sea. Founded in 1967, the SNSM now has 3,500 volunteer lifesavers and 1,200 volunteer officials. Distributed among 231 rescue posts along all French coasts, including the French overseas territories, these men and women bring assistance to 10,000 people and 3,000 boats a year, and are never paid a penny. Every year, more than 600 people owe their lives to these guardian angels of the shore.

FRANCE, CORDOUAN LIGHTHOUSE
In 1360, a somewhat precarious tower was built to guide ships at shallow mouth of the Gironde river. The addition of a lighthouse in 1789 on the third floor, first built in 1611, raised the height of the tower to 68 m. Cordouan is a sumptuous baroque building that symbolized the authority of church and state; it contains royal apartments, decorated with magnificent inlays, and a chapel. It was at the top of this cylindrical palace, nicknamed the 'Versailles of the Sea', that Augustin Fresnel, inventor of the lens now used in all lighthouses, tested his prototype in 1823. This lighthouse of kings has been classed as an historic monument since 1862.

UNITED ARAB EMIRATES, DUBAI CREEK
A vast inlet that winds its way inland over more than 10 km into the very heart of Dubai, the creek has contributed a great deal to the development of the city. Its calm waters provide a natural port for the hundreds of dhows moored to its banks. Carrying all sorts of merchandise, they ply back and forth between the small ports of the Persian Gulf, and sometimes even go as far afield as India and East Africa. Made of wood, in a traditional shipyard, these unchanging vessels represent centuries of trading, and they seem unaffected by the hectic modernization of Dubai that is going on all around them.

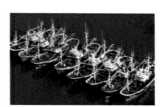

SPAIN, HARBOUR OF CASTRO-URDIALES
During the 20th century, technological progress and growing demand multiplied the world's fish production twenty times over. It has actually doubled since 1970. A third comes from aquaculture, which has enjoyed a spectacular boom over the last twenty years, whereas the catch at sea has more or less peaked, because most fishing zones and stocks have already been exploited to full capacity or beyond. Three-quarters of this production is for human consumption, and the rest is processed into flour and oil to be used as animal feed. The quantities consumed vary, of course, nation by nation, with Spaniards eating seven times more fish than the French.

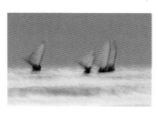

BRAZIL, JANGADAS IN THE EARLY MORNING
In the misty light of dawn, a fleet of *jangadas* heads out to sea, as if they have escaped from another era. The *jangada* is the traditional boat of the fishermen in north-eastern Brazil, and it already existed long before the Portuguese colonized the country in the 16th century. But there is nothing obsolete about these boats. Despite their crude appearance, they are fast and flexible. Adjusting the tension and the tack of the sails is as sophisticated as on the most modern sailing boats. When they wet the sails, the purpose is to close up the fibres and make them smoother and therefore more efficient as they harness the winds of Ceará.

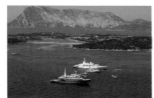 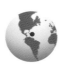

ITALY, SARDINIA, GOLDEN FLEET
Symbolizing the glamorous world of the multimillionaires, huge luxury yachts ply all the oceans, from the Caribbean to the Mediterranean, not to mention the Pacific. Often registered at George Town in the Cayman Islands, these sparkling gems cannot bear the least imperfection, and so from morning till night they are scrubbed and polished to satisfy owners who, in fact, are rarely on board anyway. All the same, these boats are not exactly white elephants. If you want to hire one, it will cost $400,000 a week, and apparently business is booming, which only goes to show that even in these parsimonious days, there is plenty of money about.

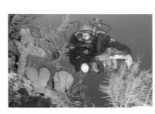

ALBERT FALCO IN MARTINIQUE, 2001
With the aqualung, invented in 1943 by the ocean explorer Jacques Cousteau and the engineer Emile Gagnan, the dream of breathing underwater became a reality. The bottle of compressed air and its regulator allow divers to wander freely round the underwater world. Having accompanied Cousteau for forty years on his adventures, Albert Falco, captain of the *Calypso* and leader of the diving team – pictured here in Martinique – has made a major contribution to our knowledge of the wonders to be found in our fragile oceans. As well as a means of exploration and a leisure pursuit, diving is also a profession, and often a difficult and dangerous one.

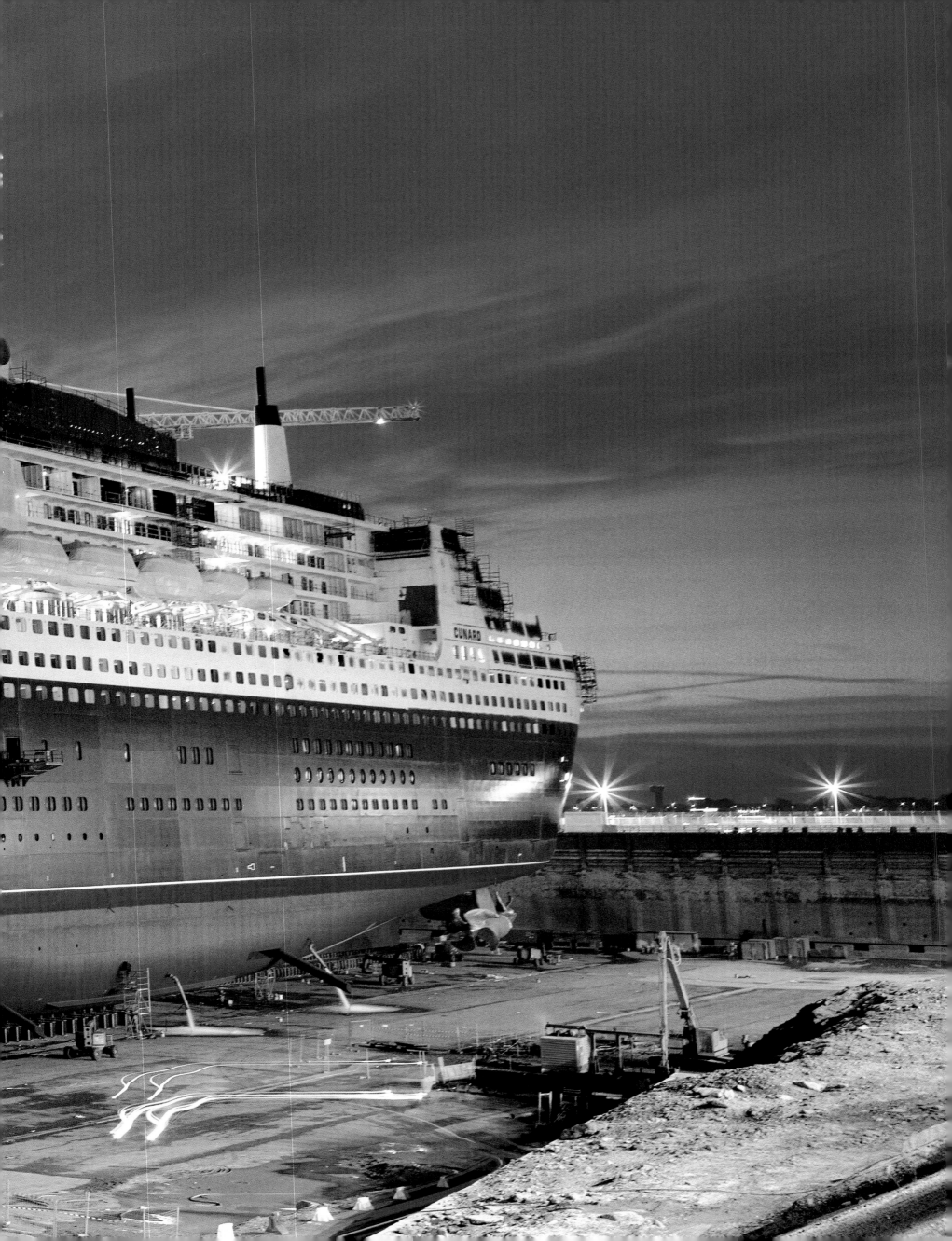

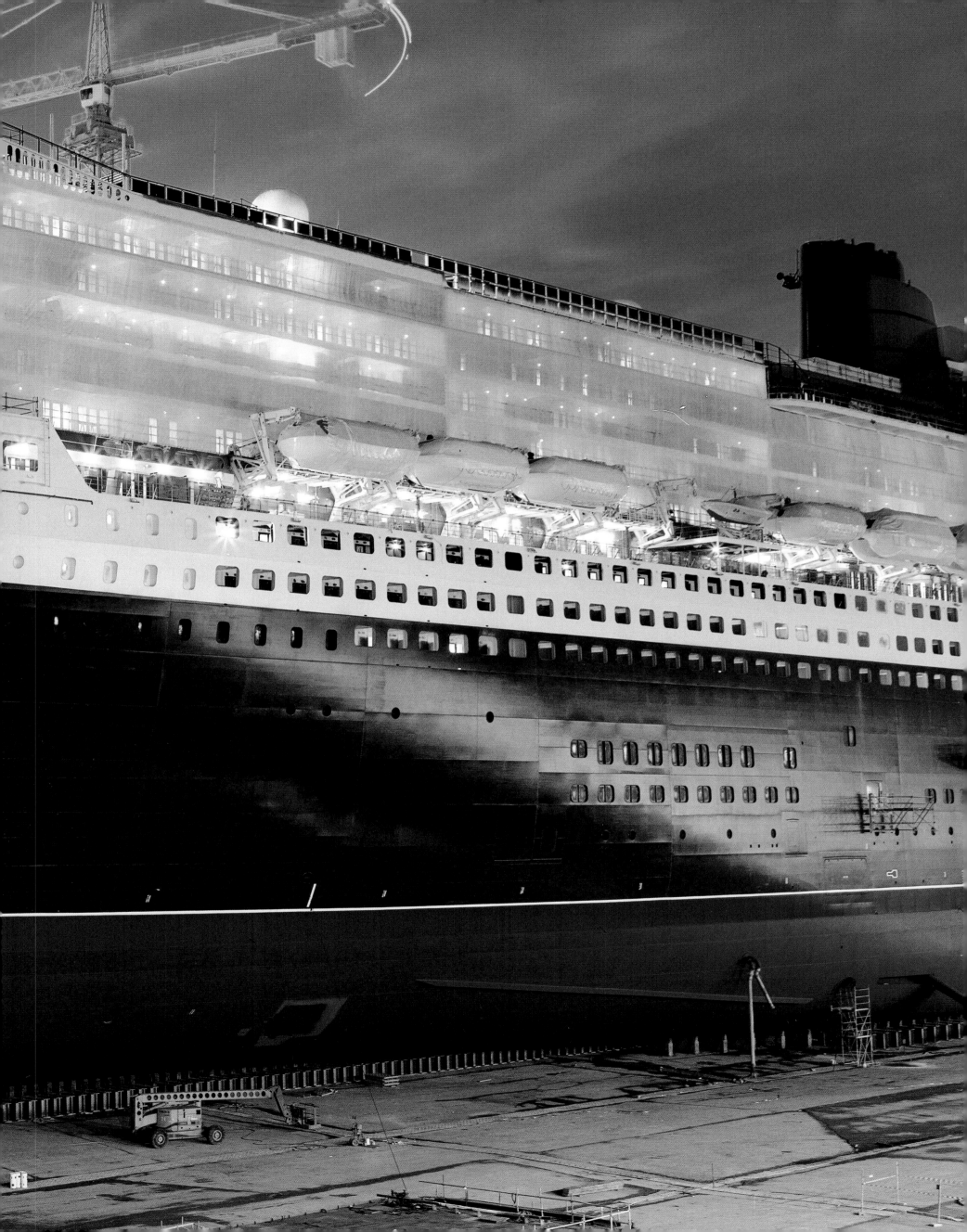

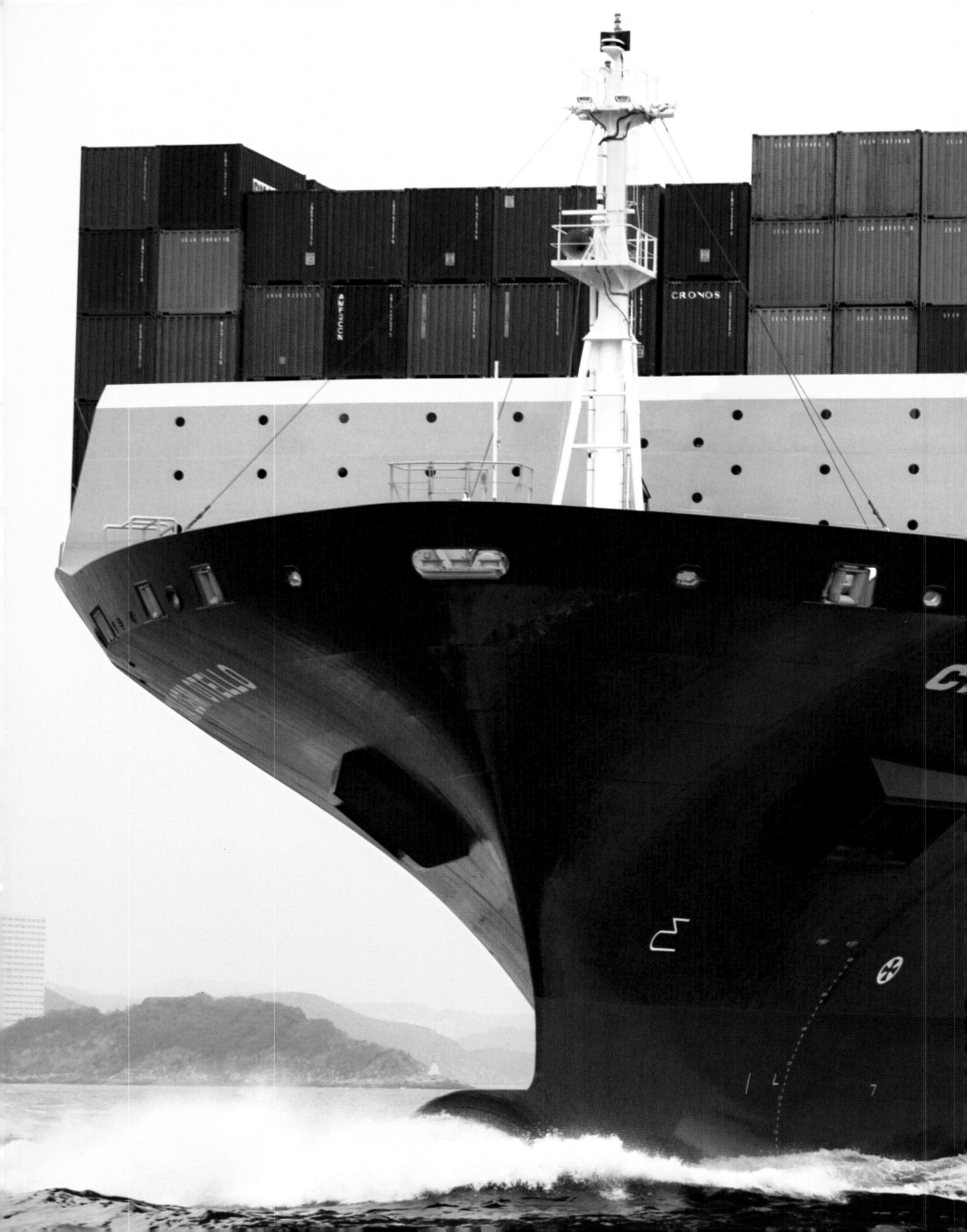

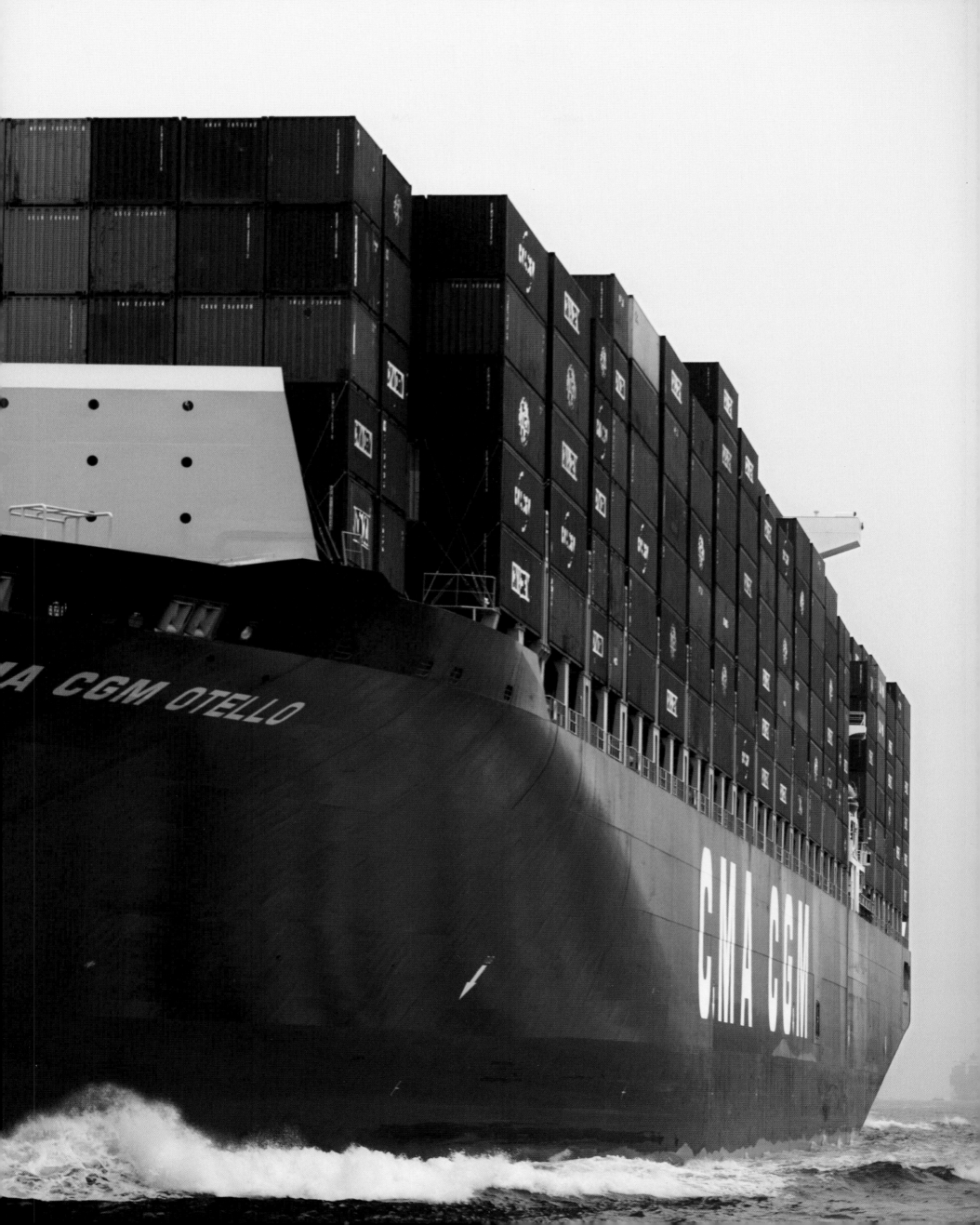

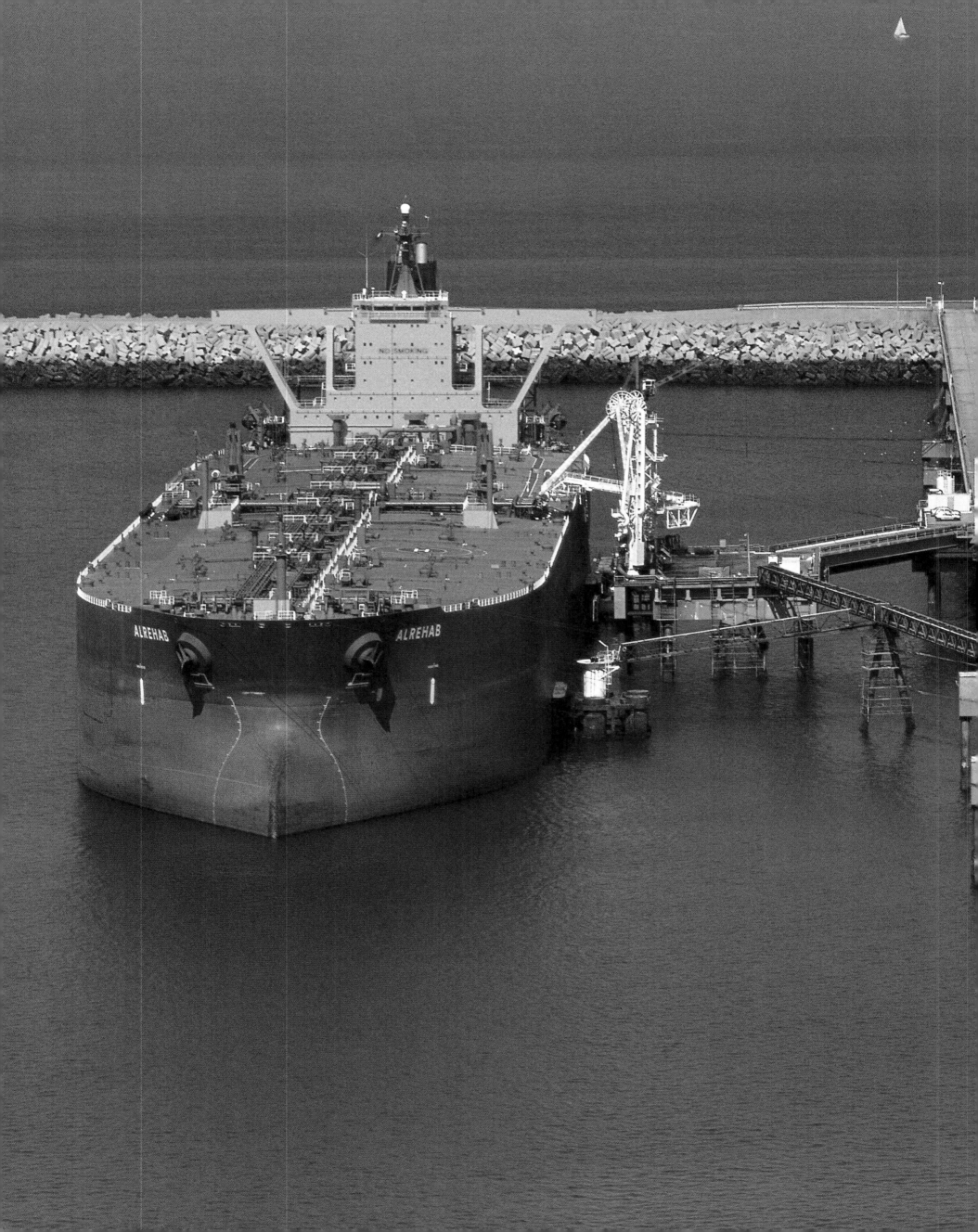

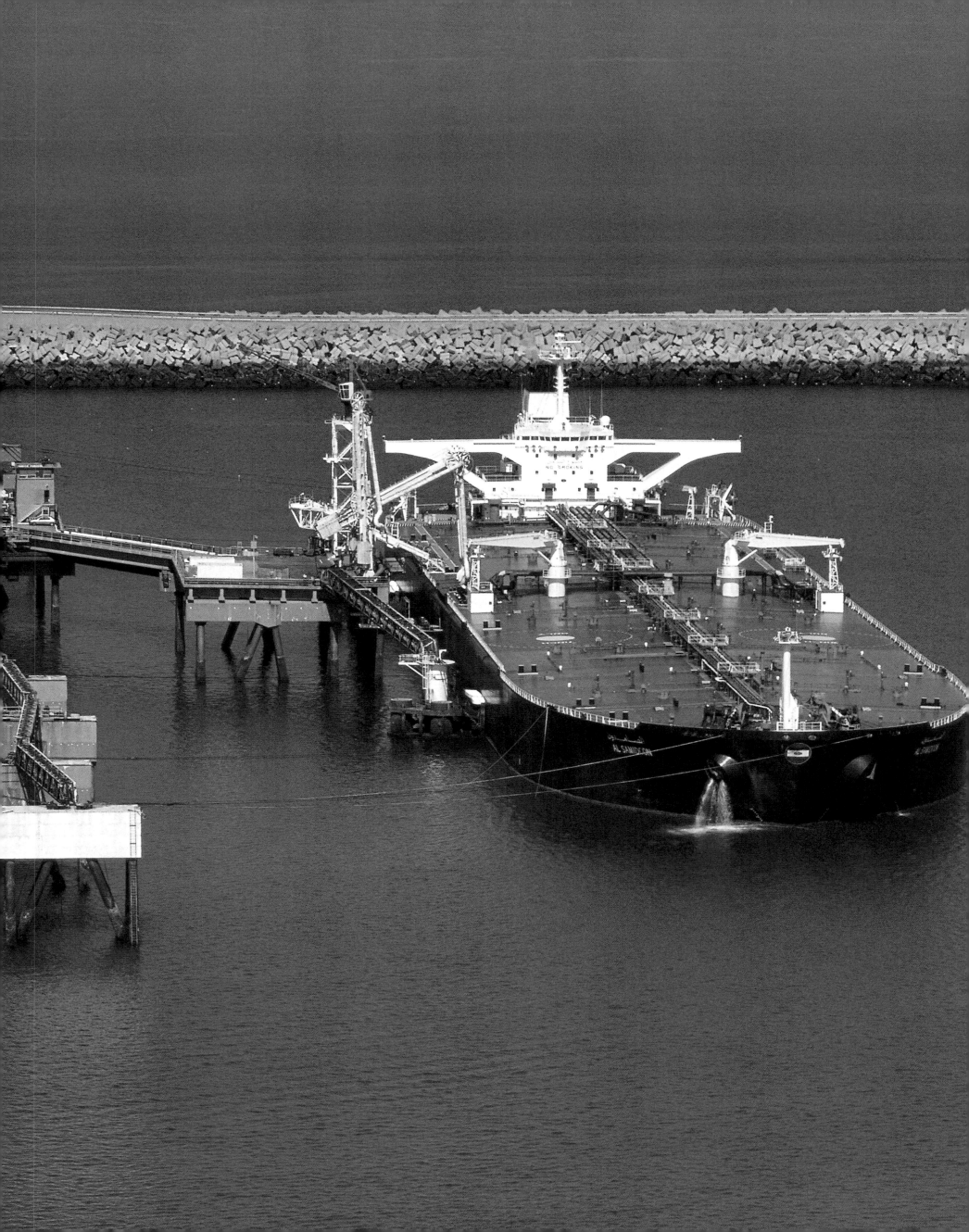

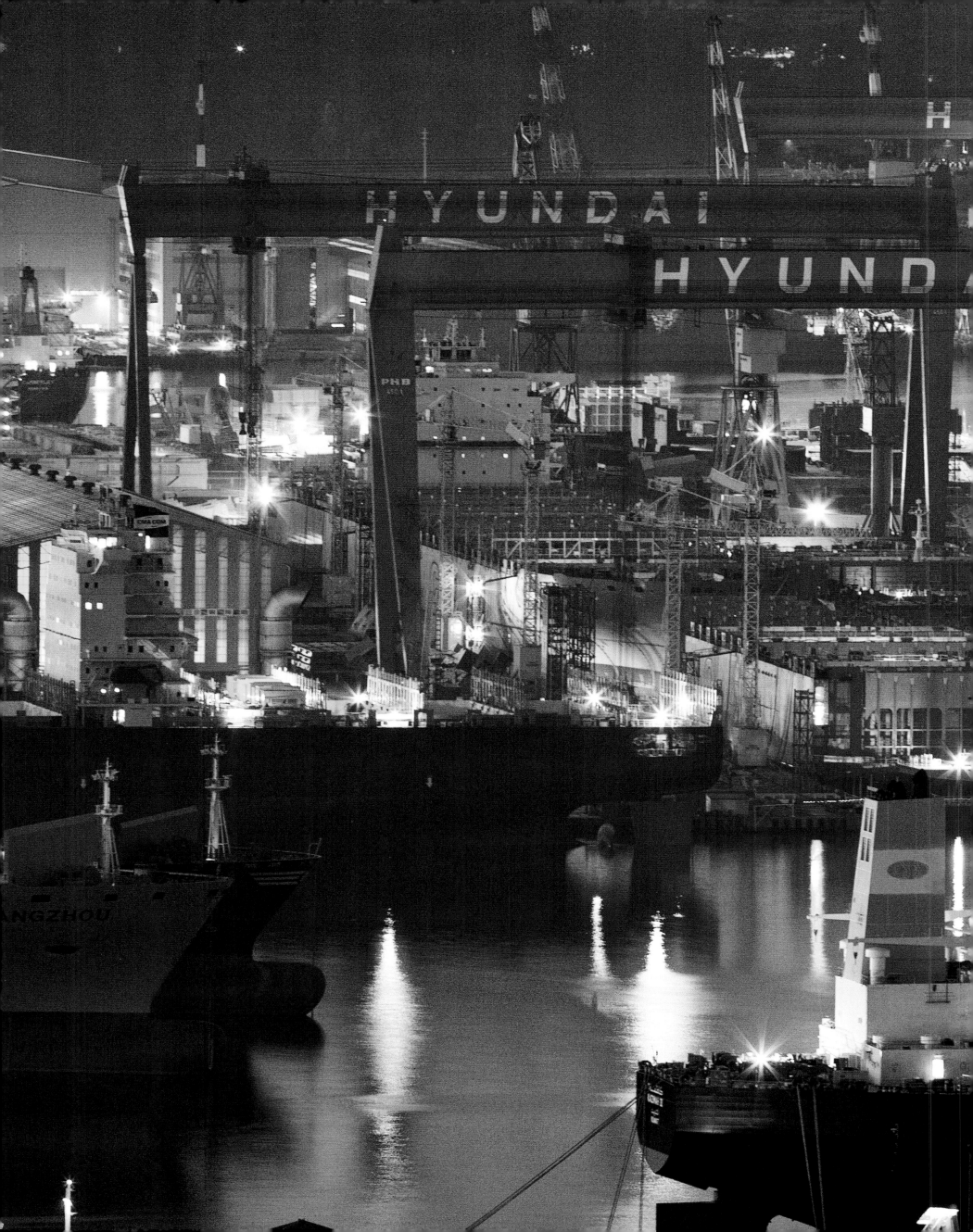

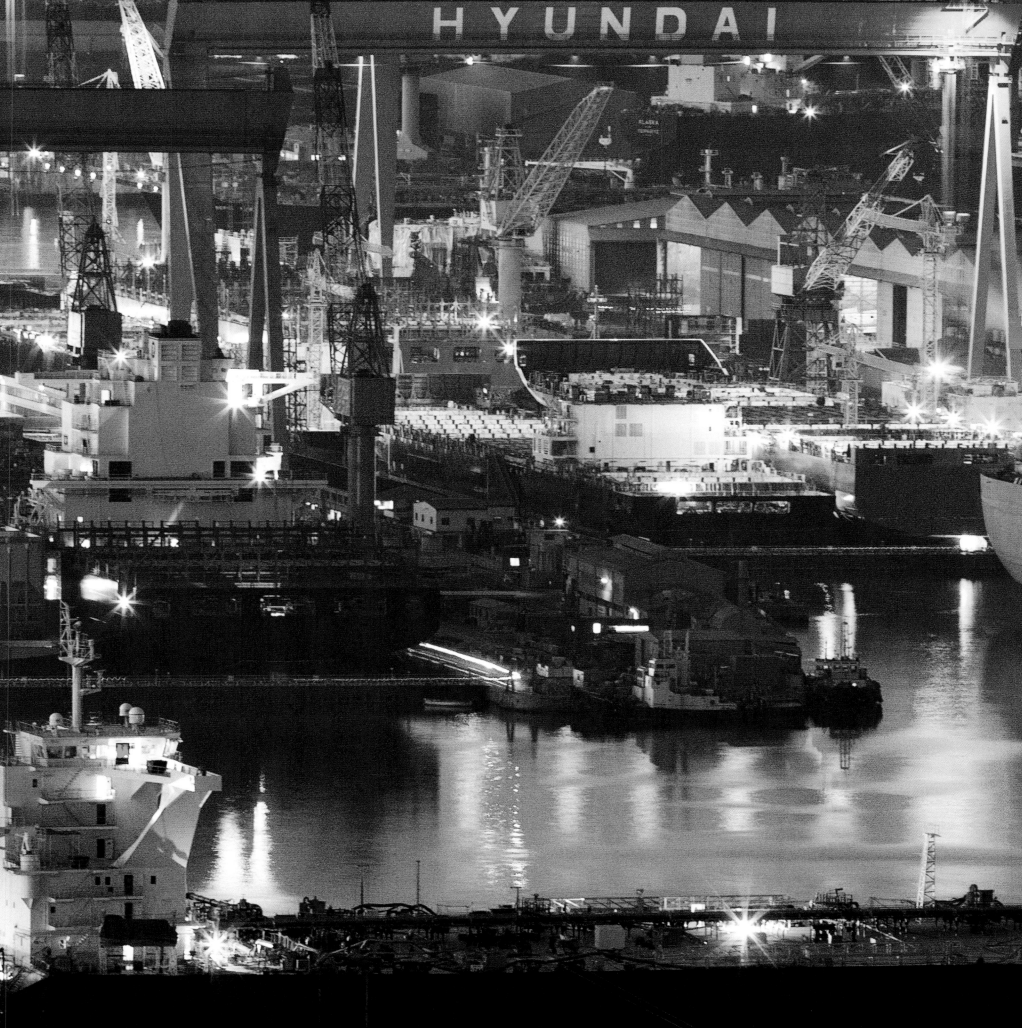

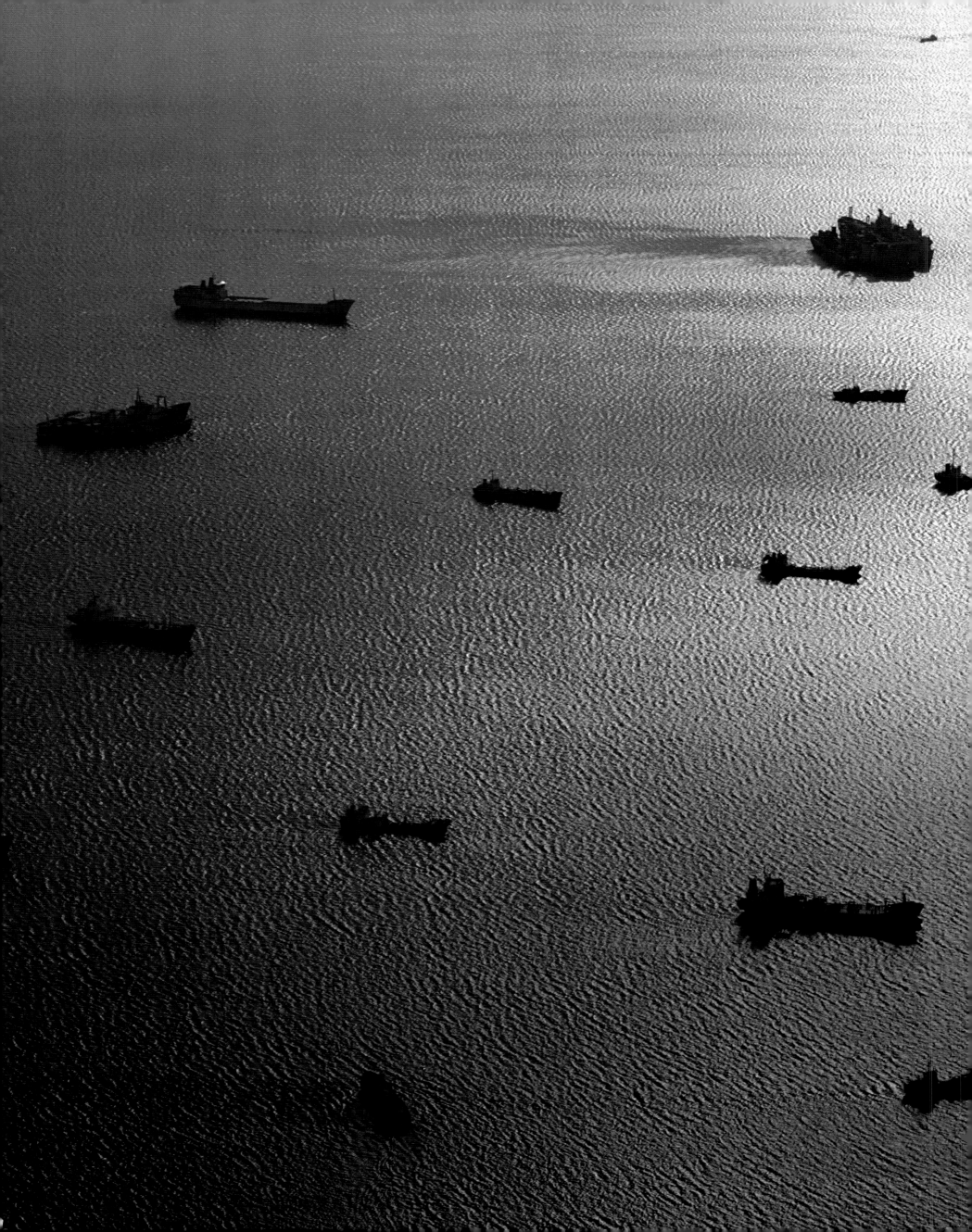

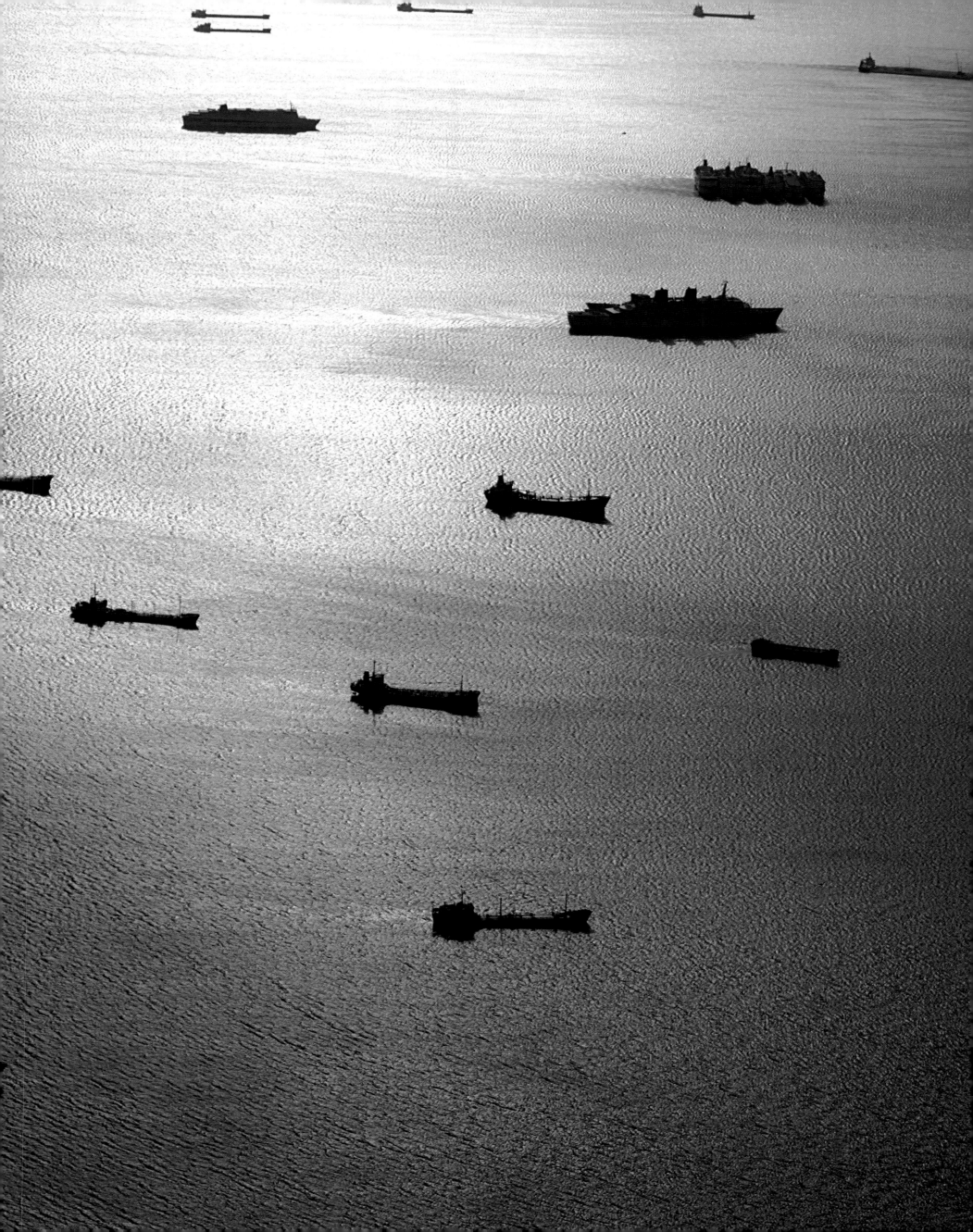

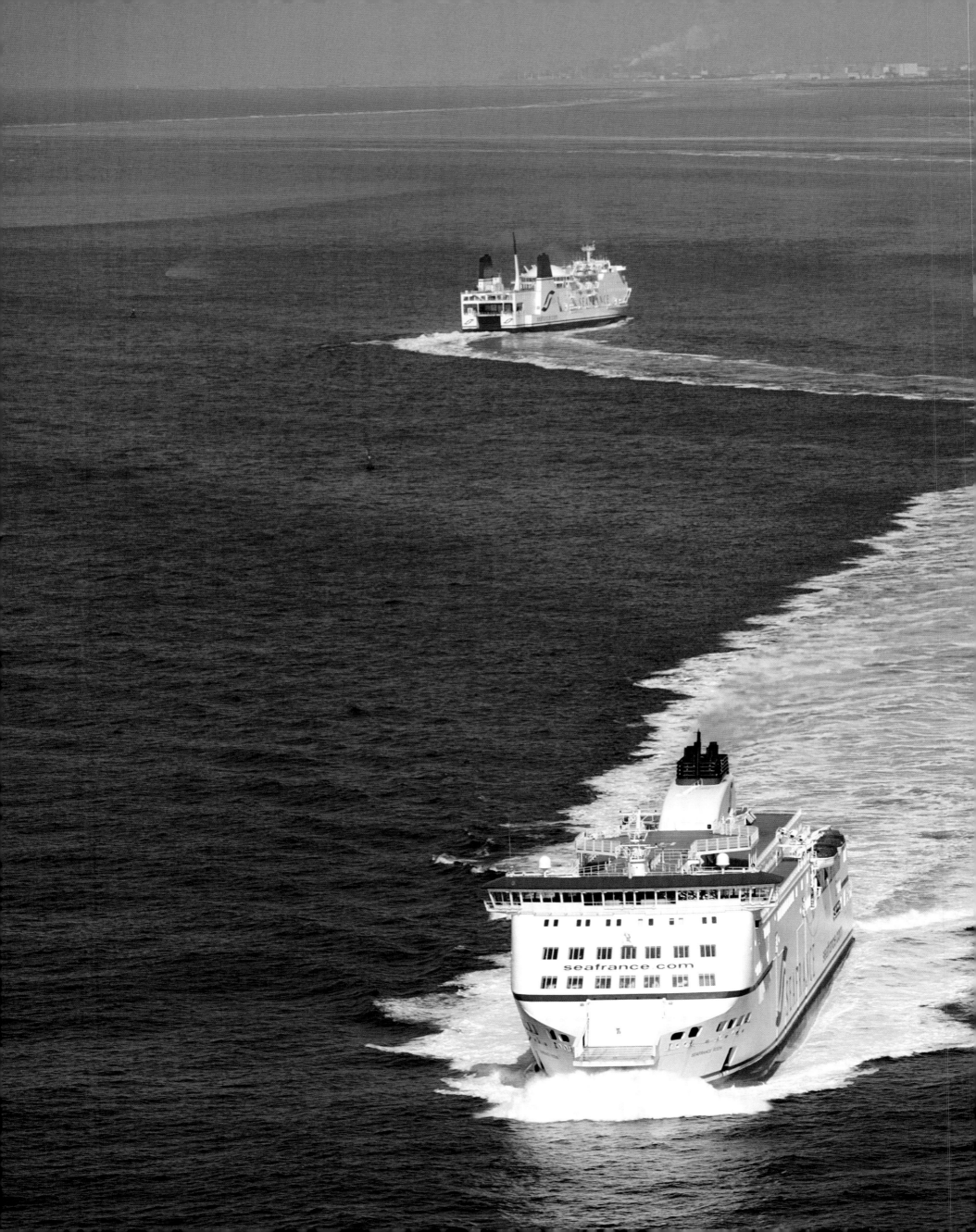

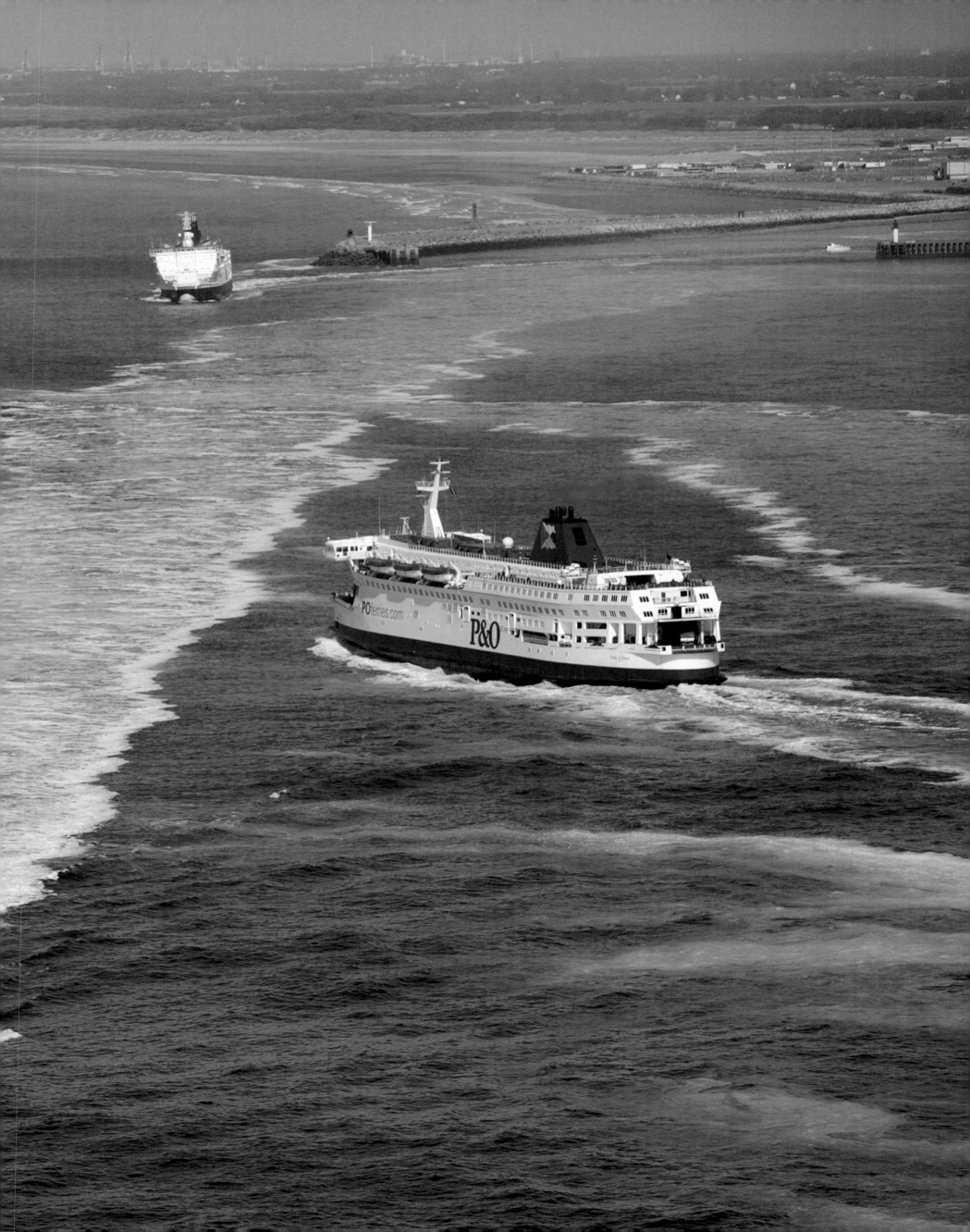

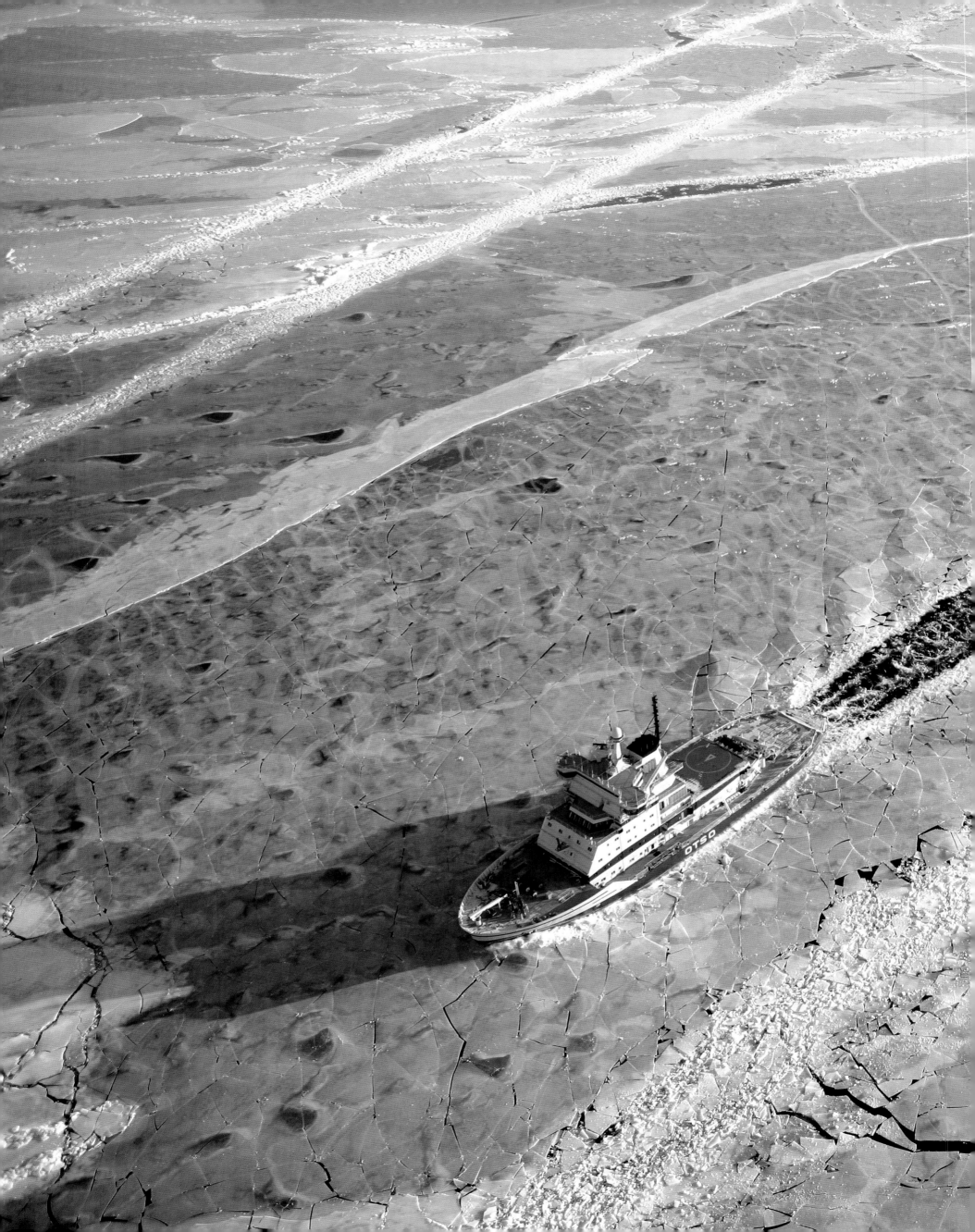

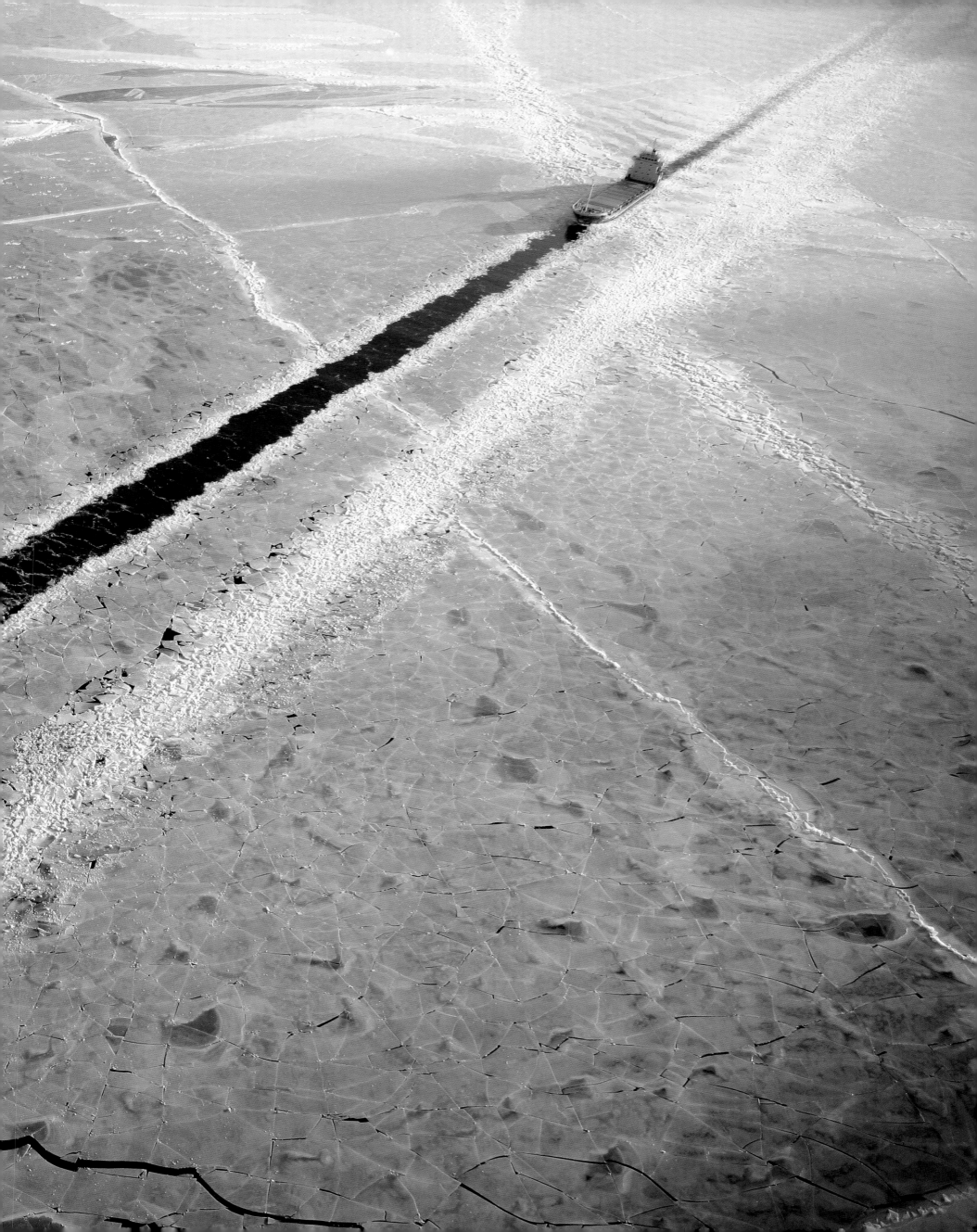

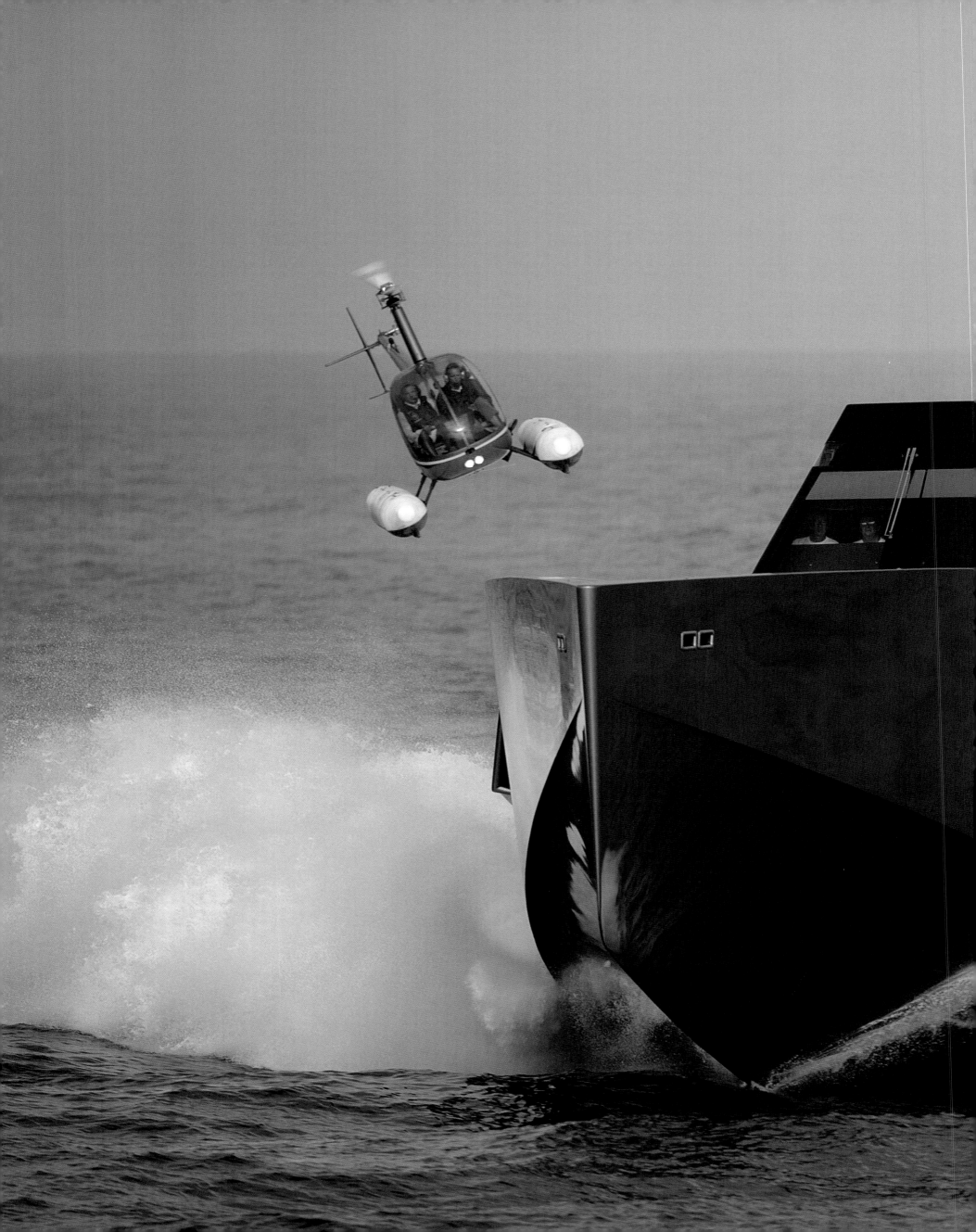

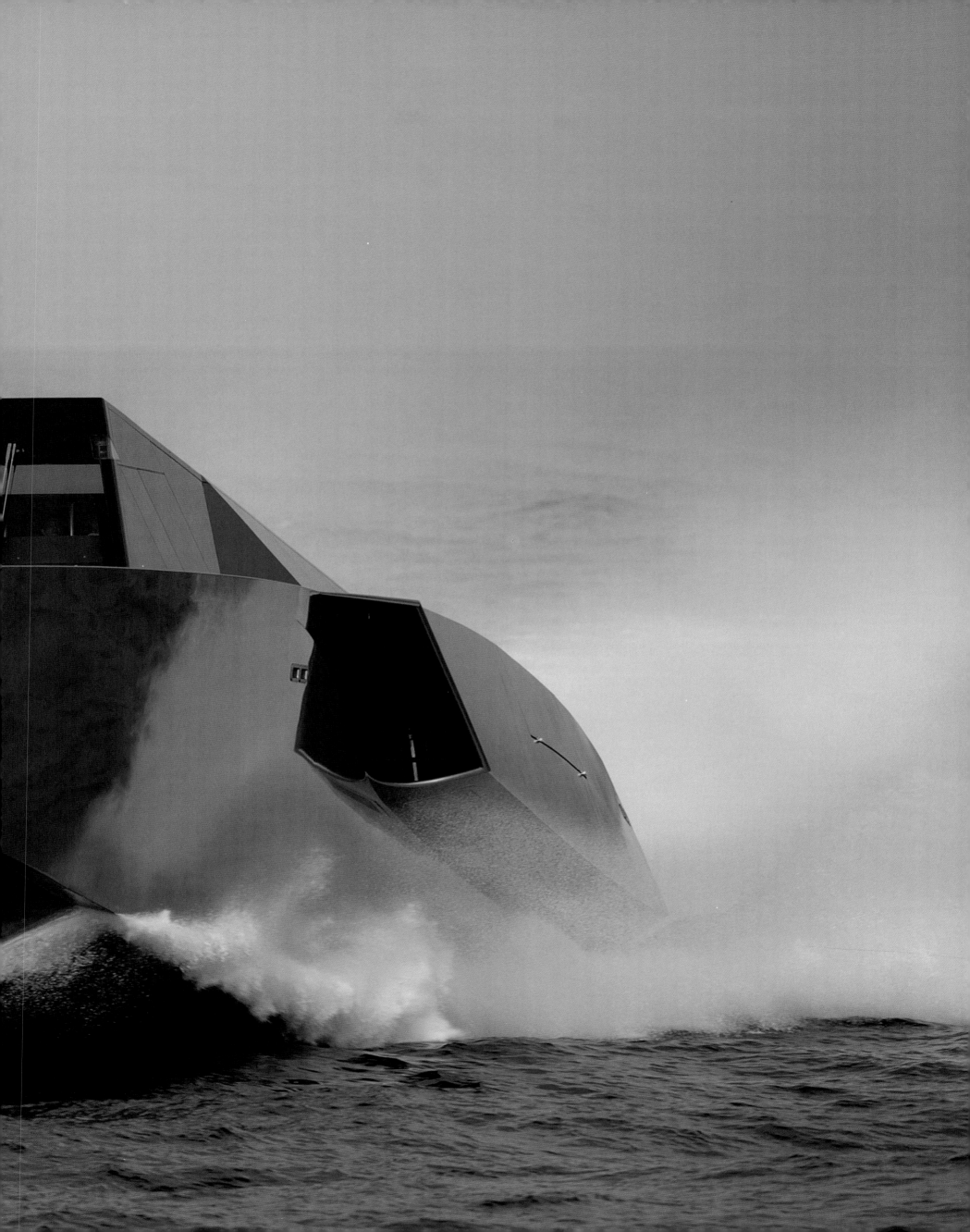

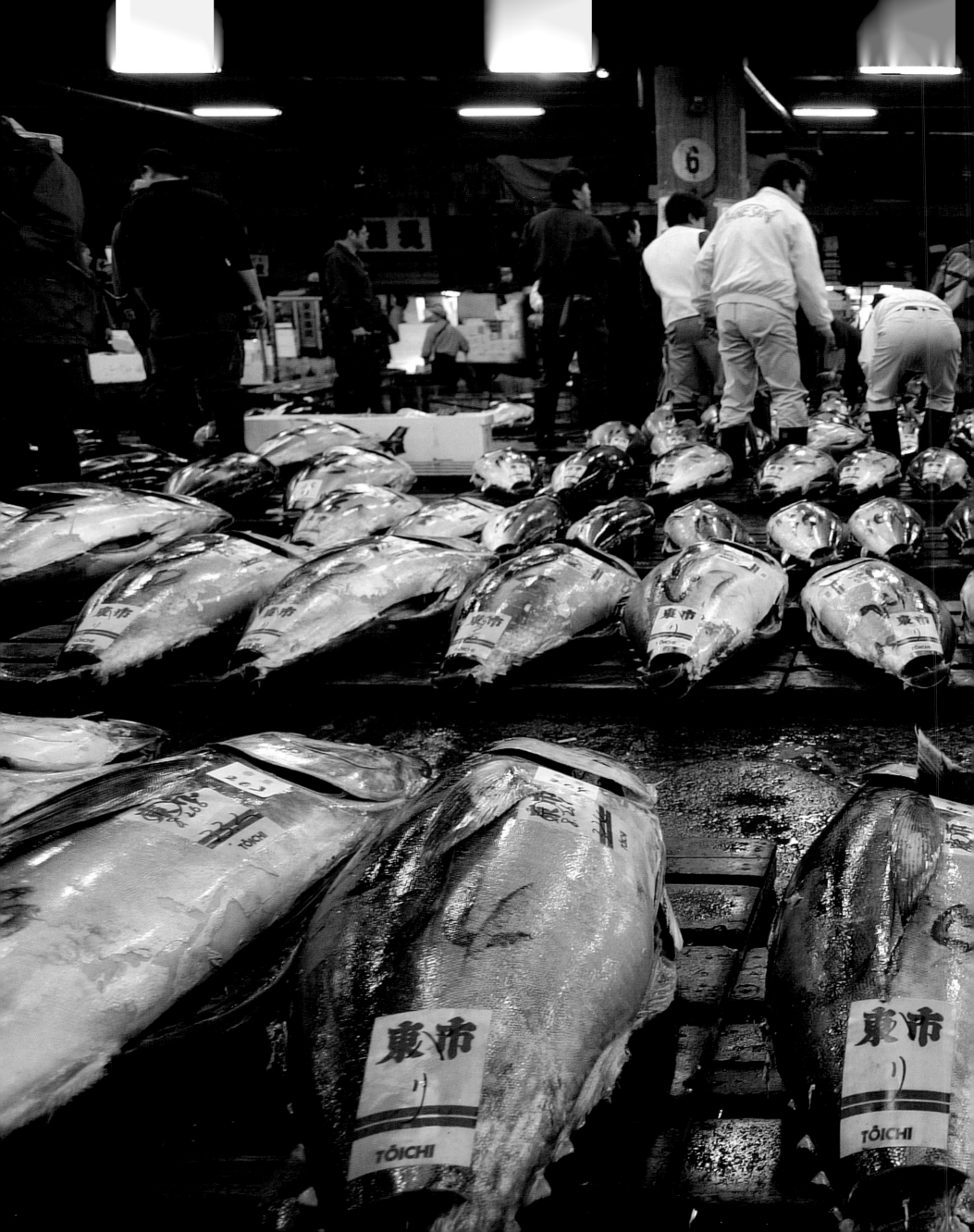

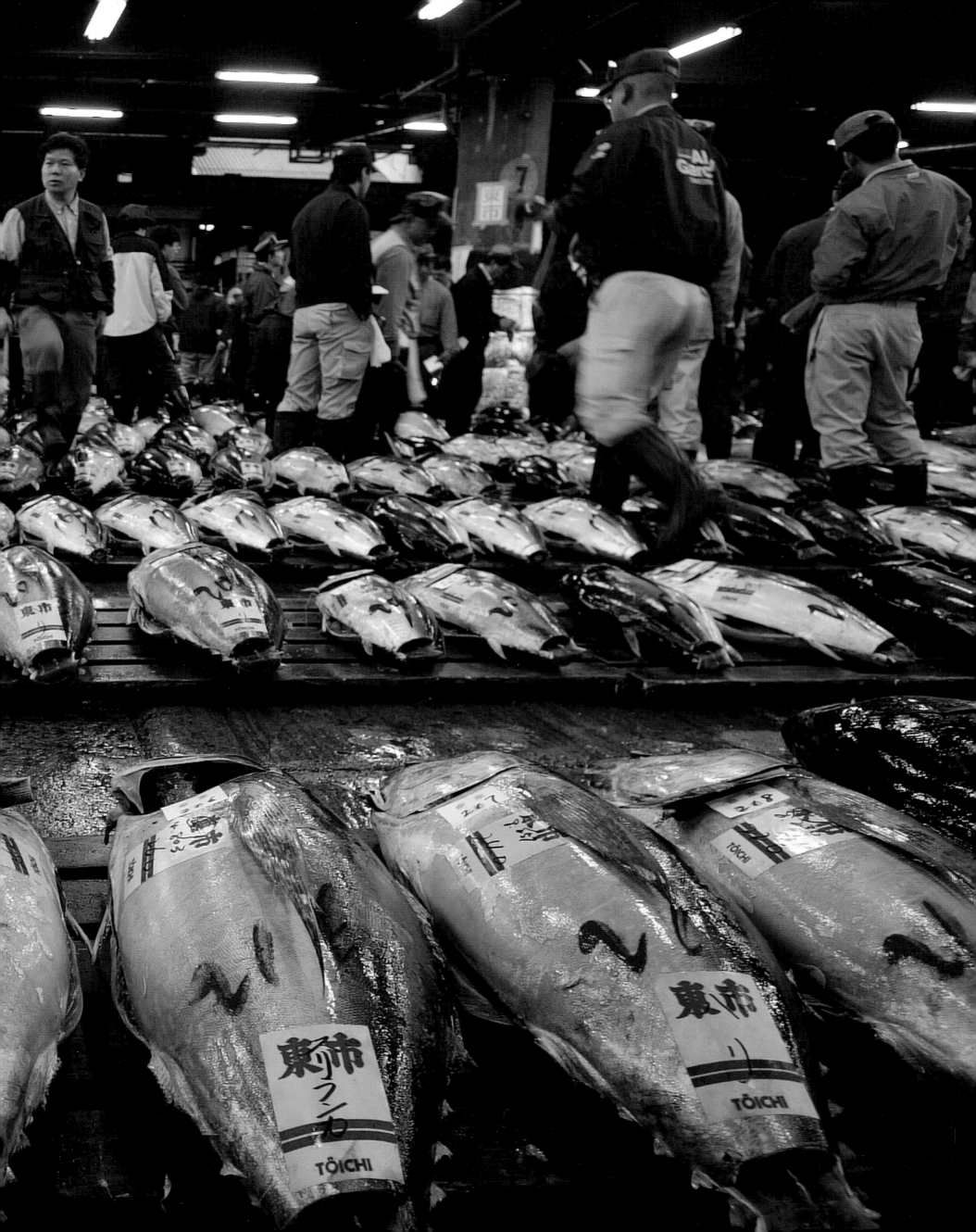

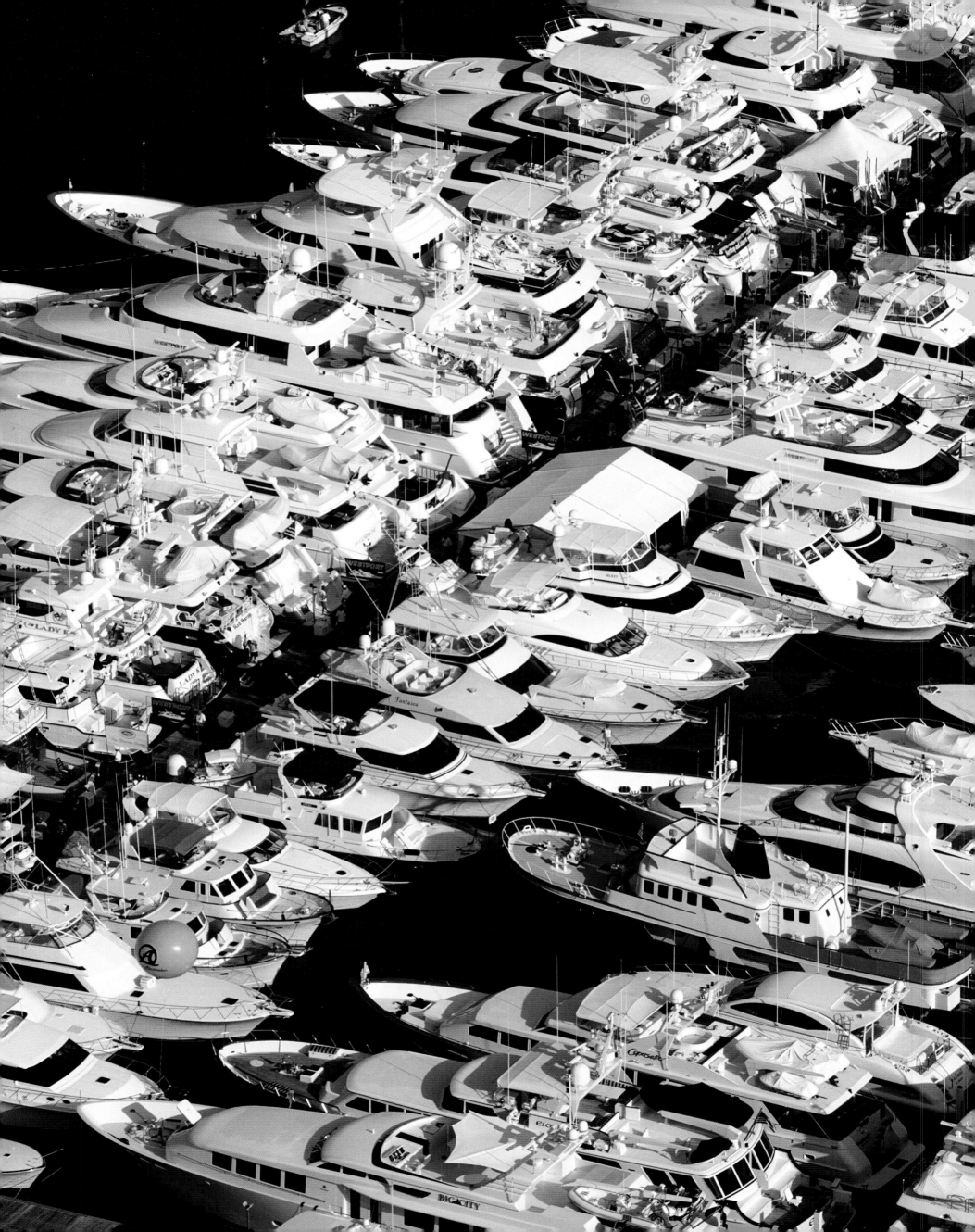

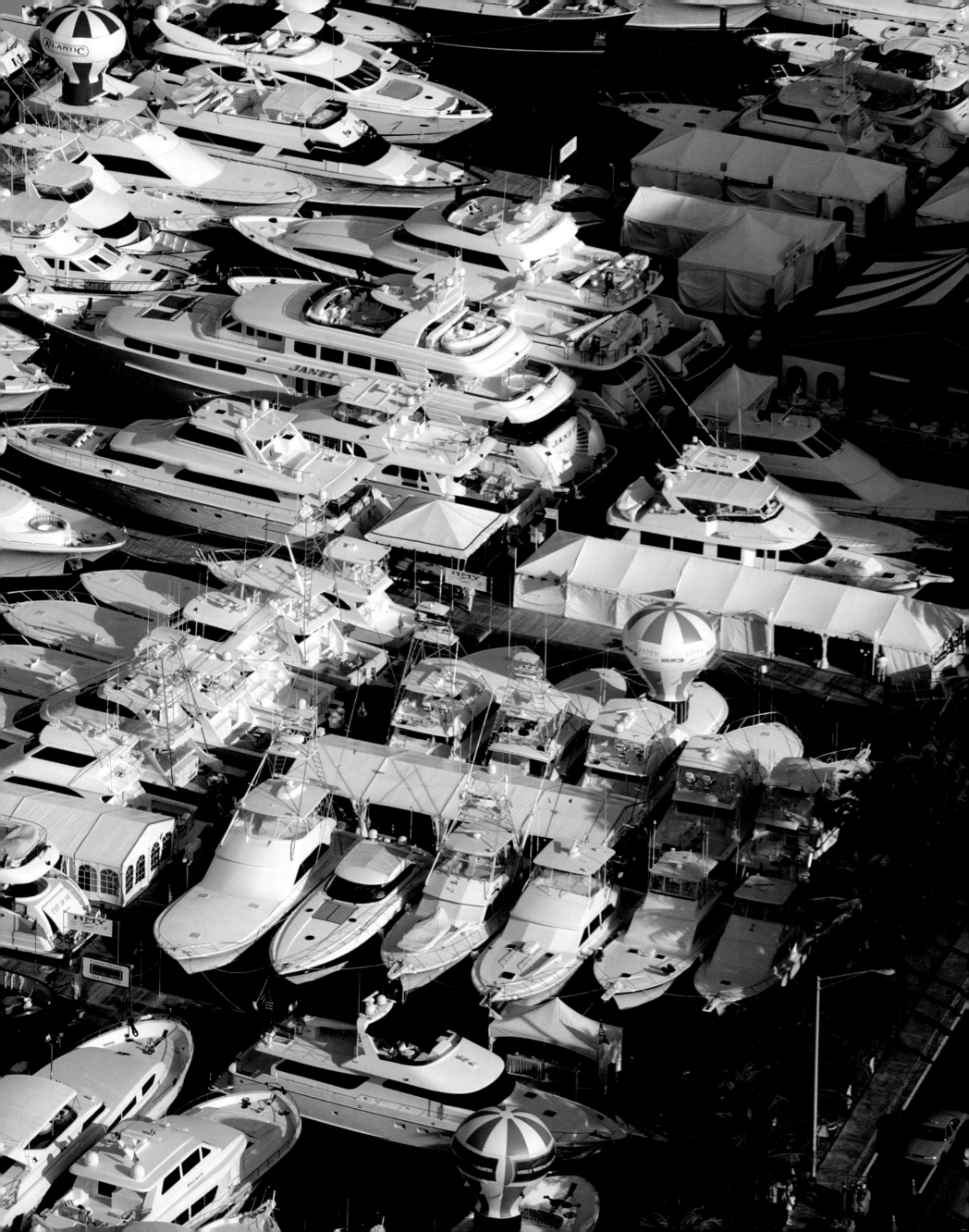

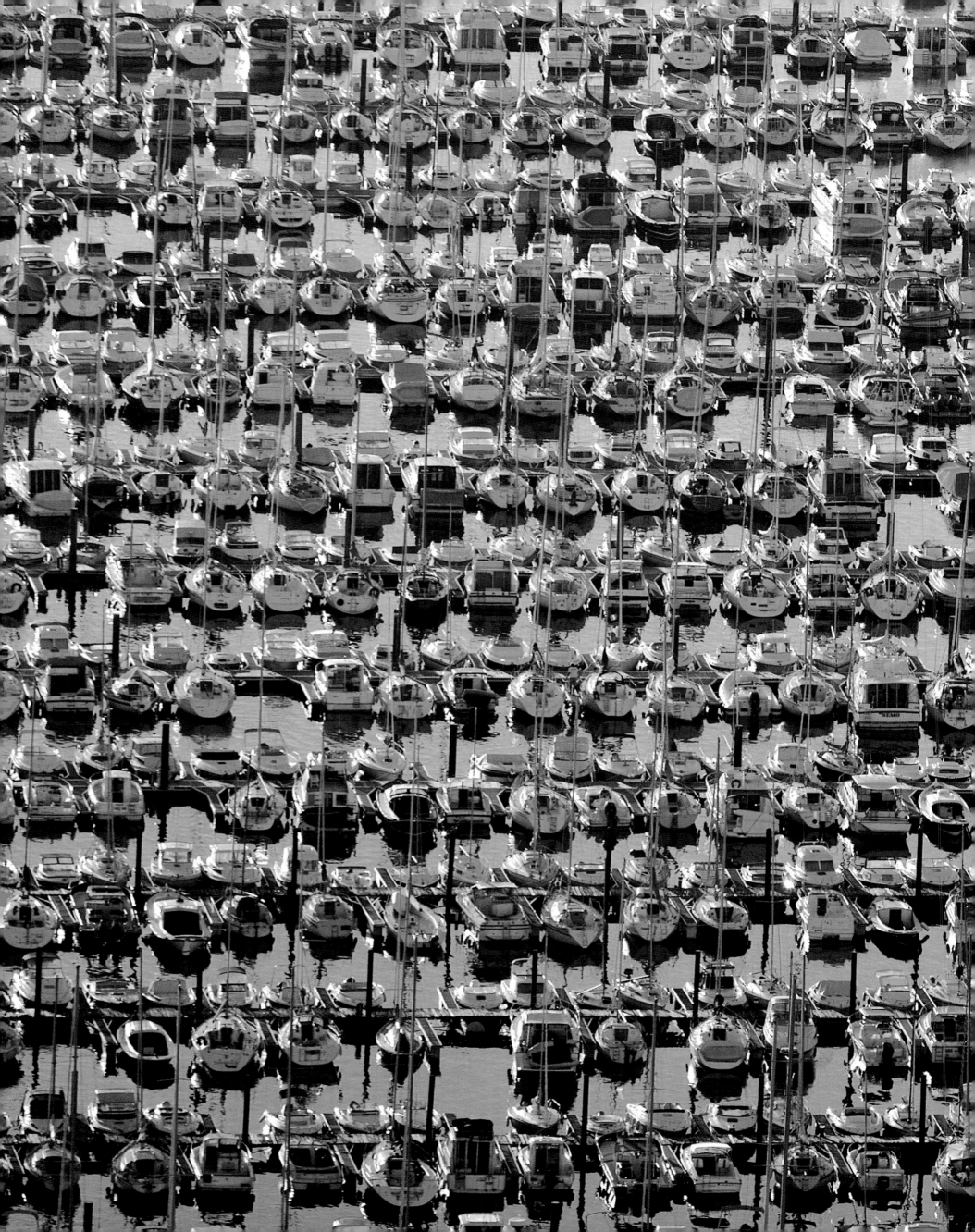

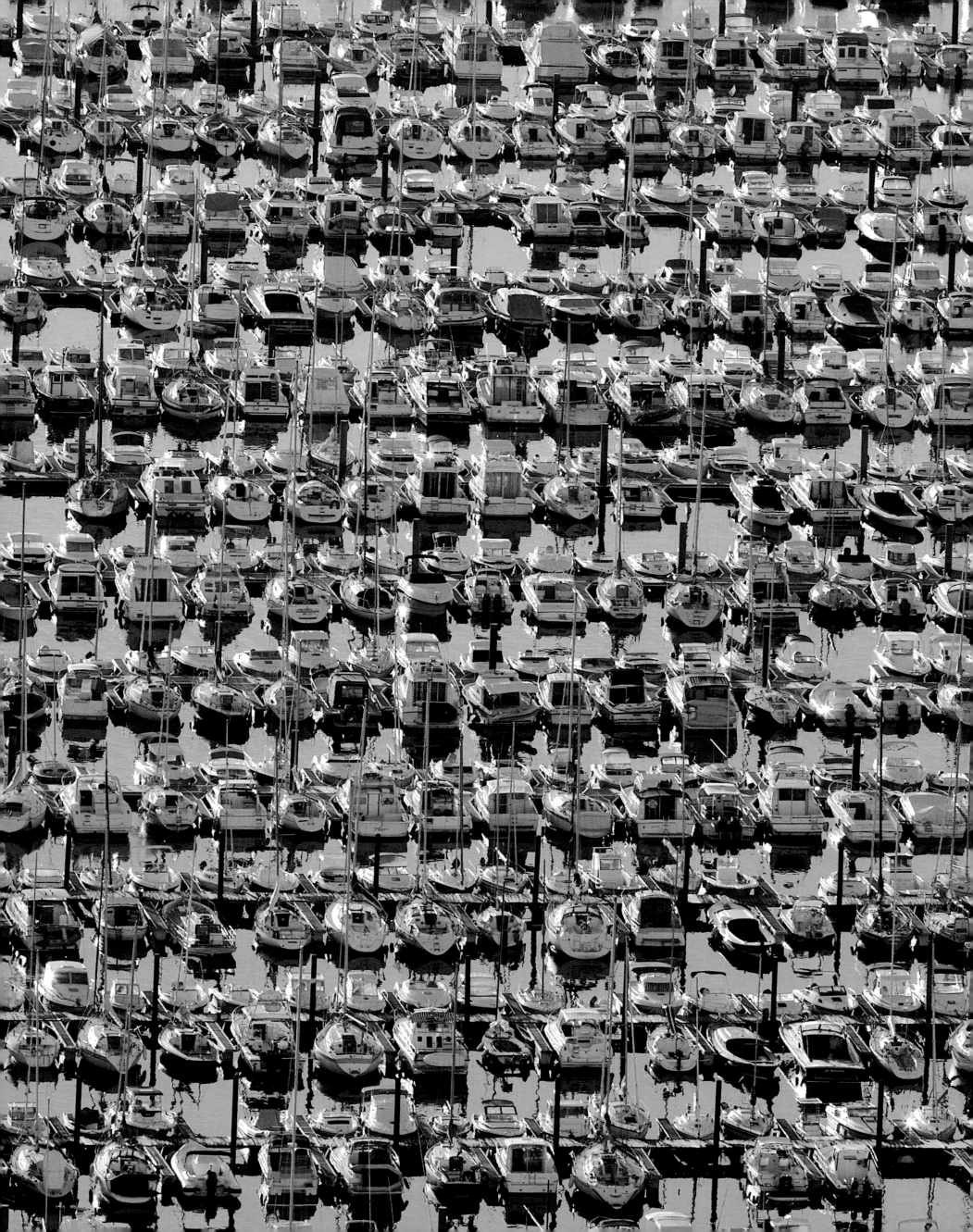

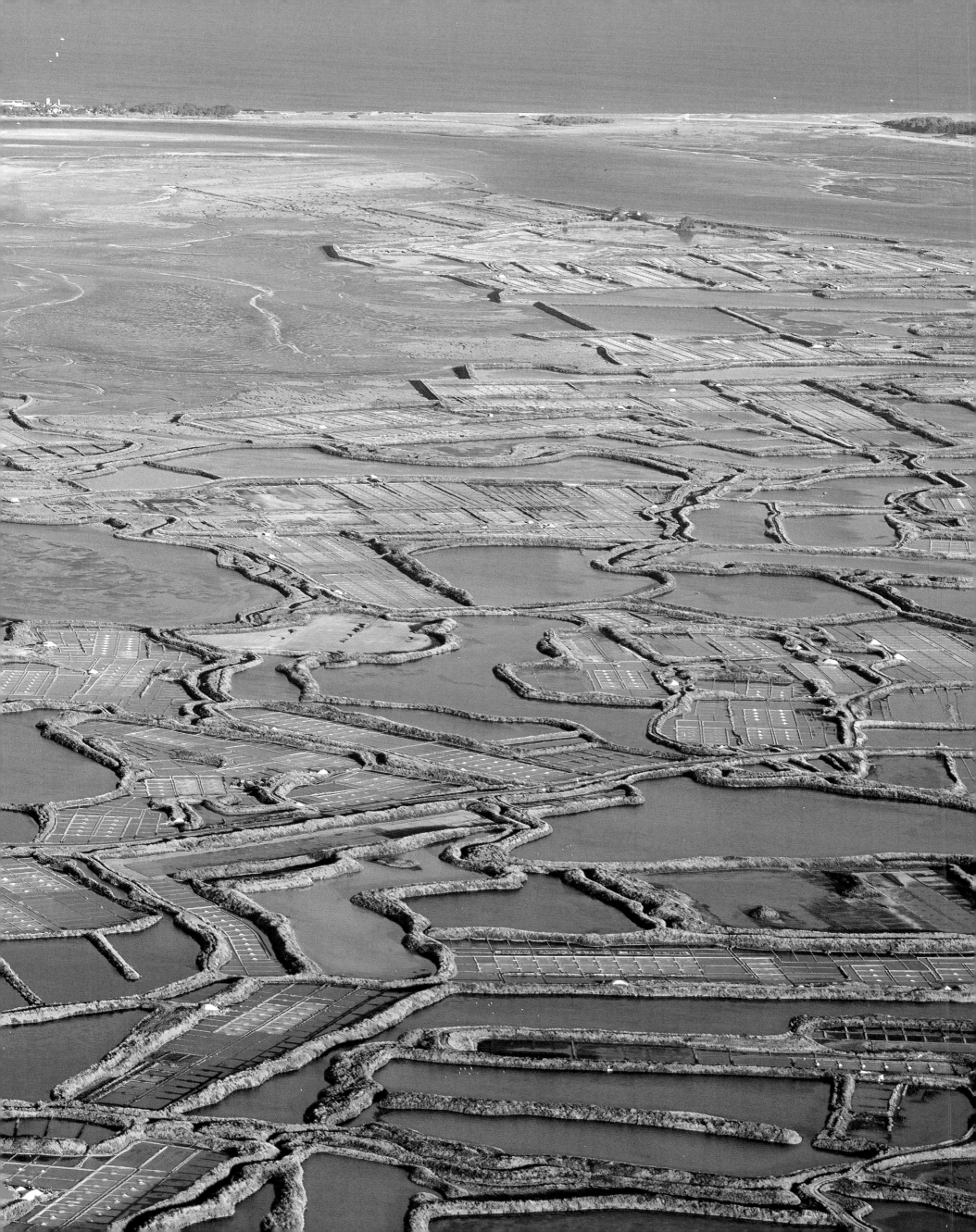

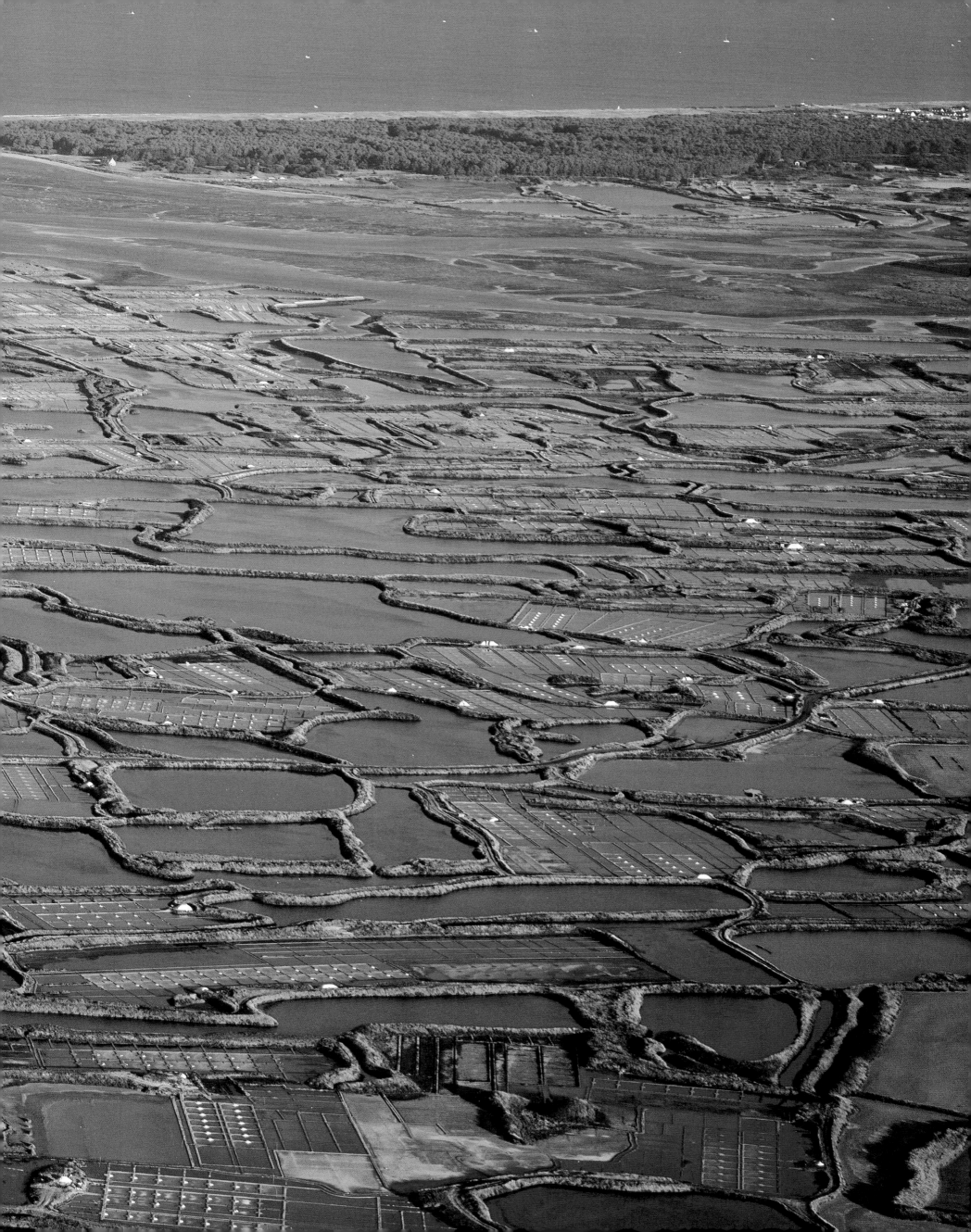

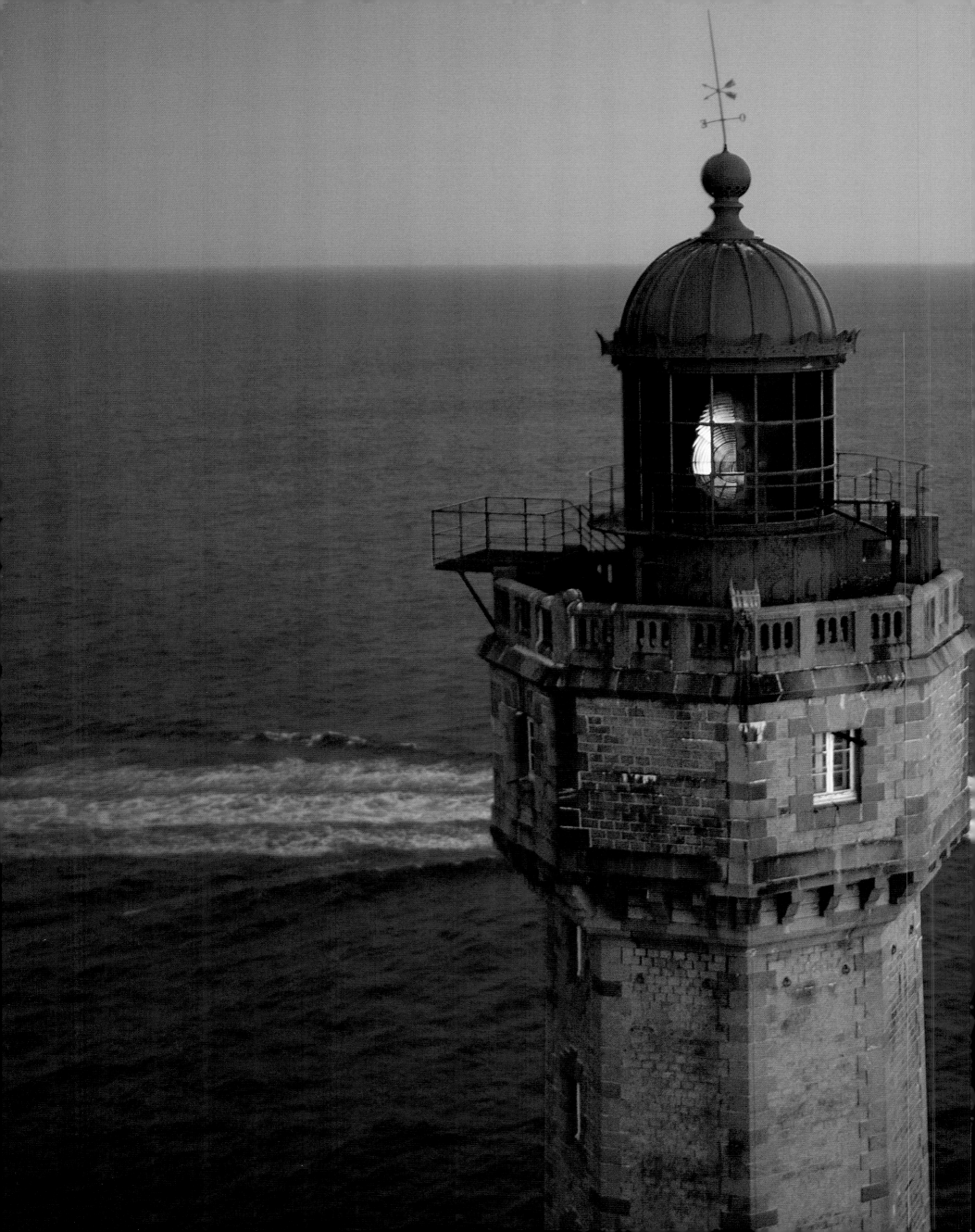

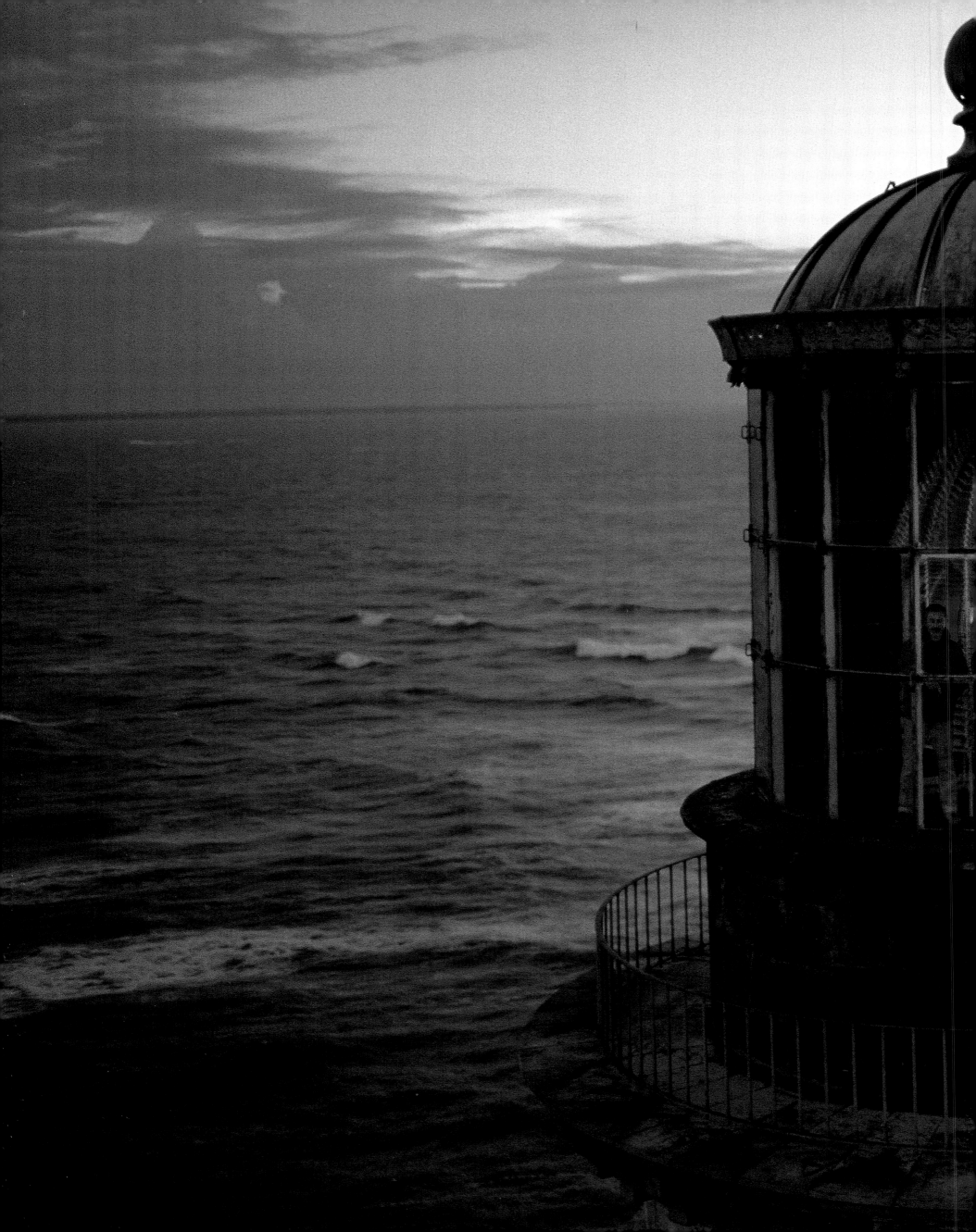

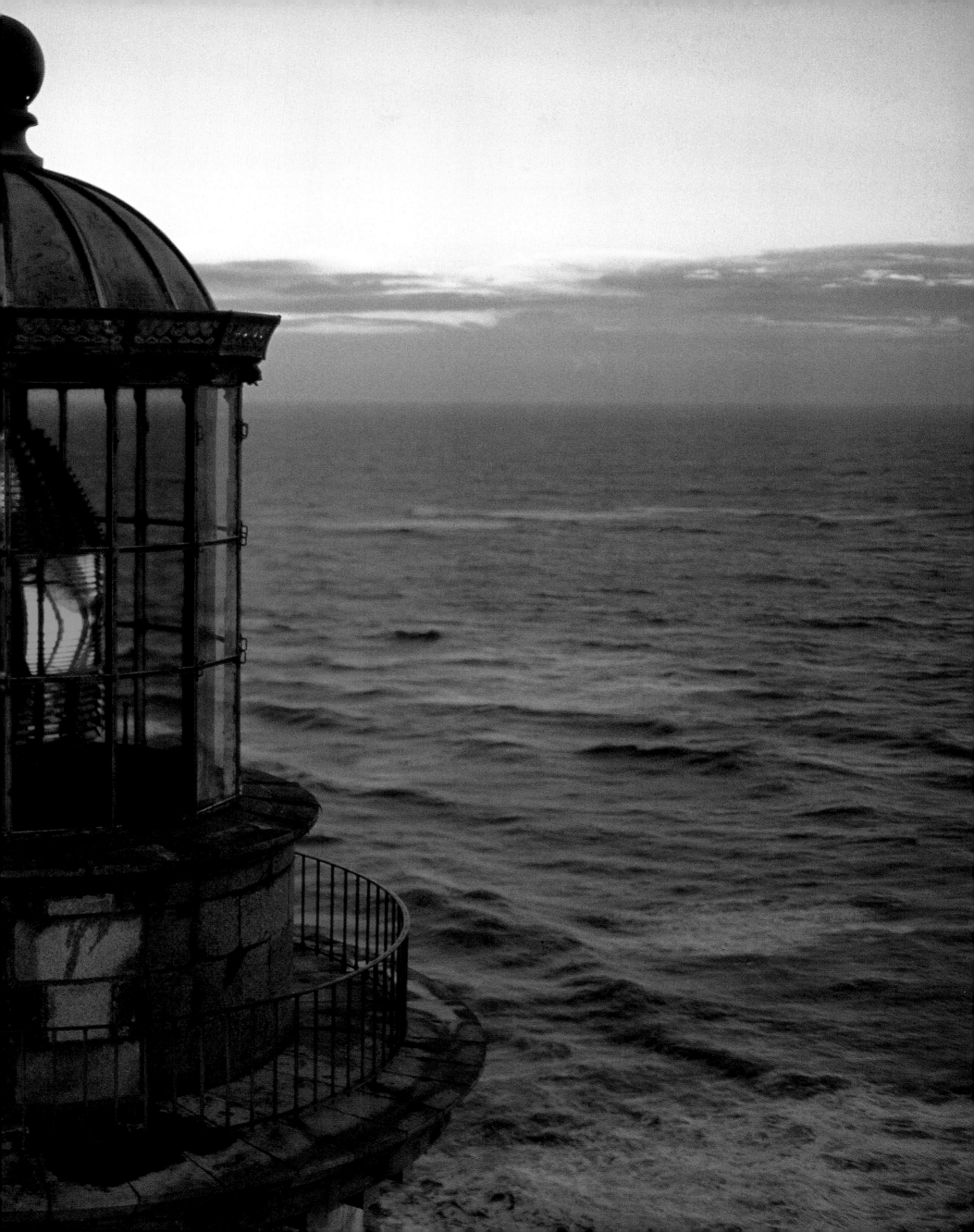

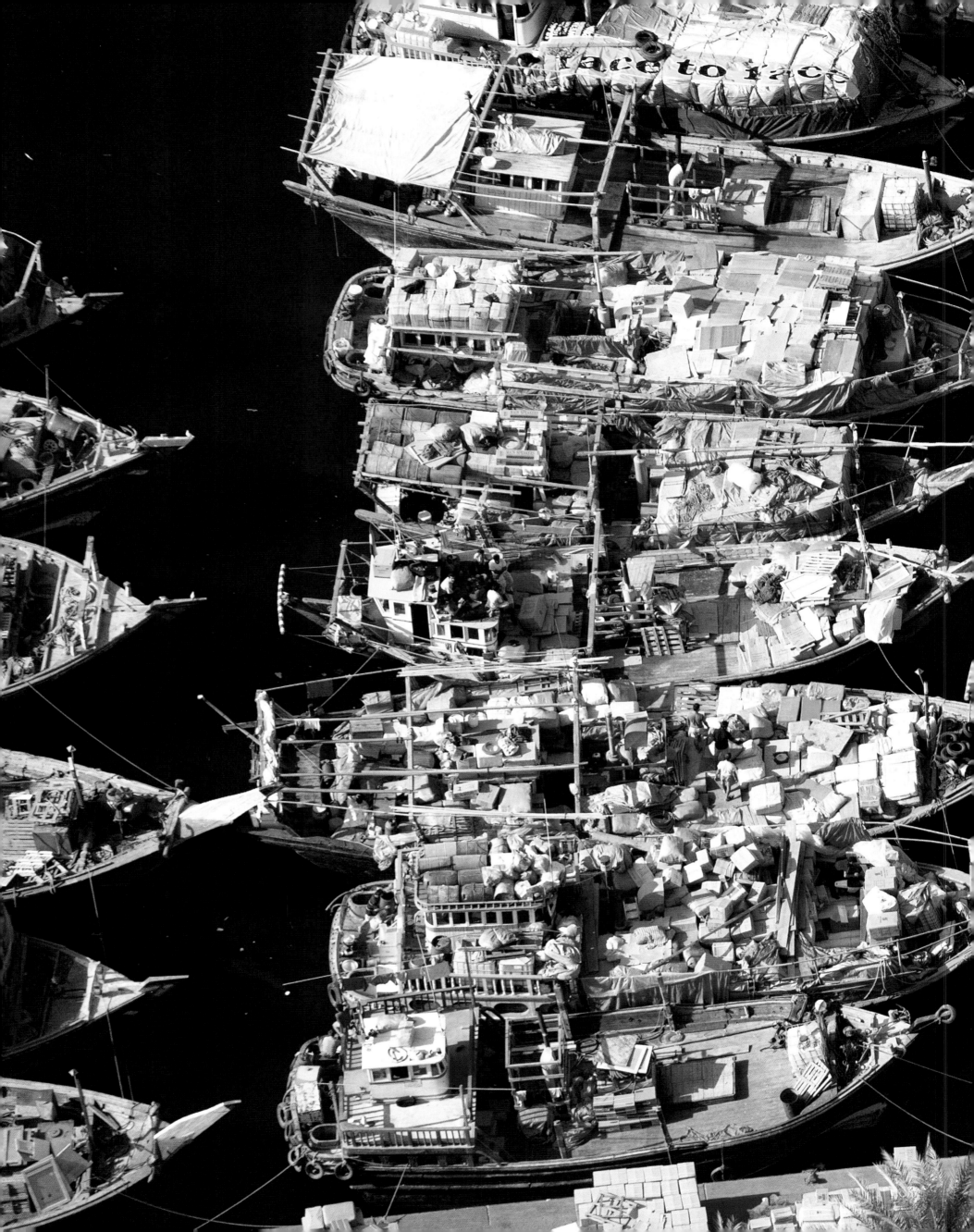

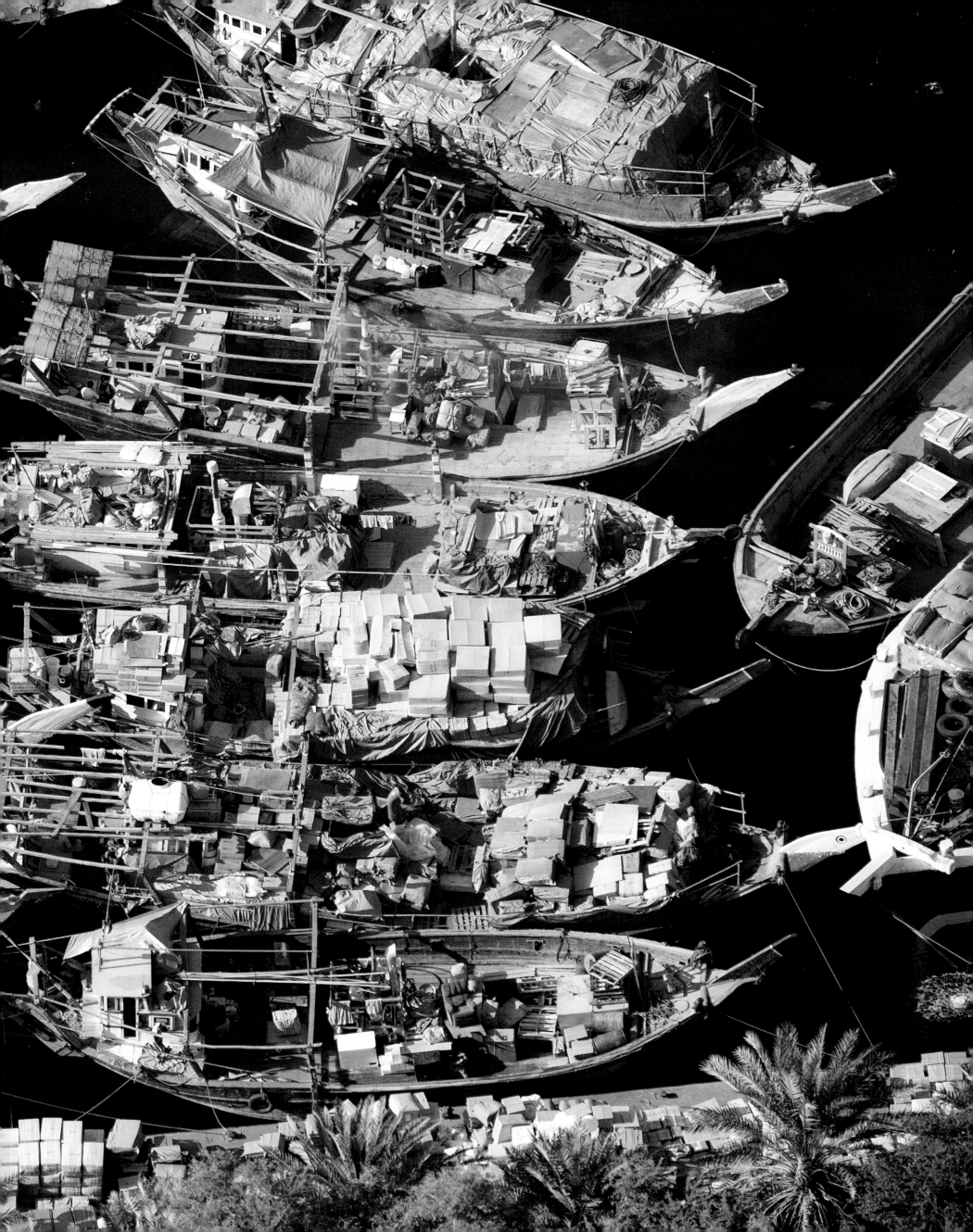

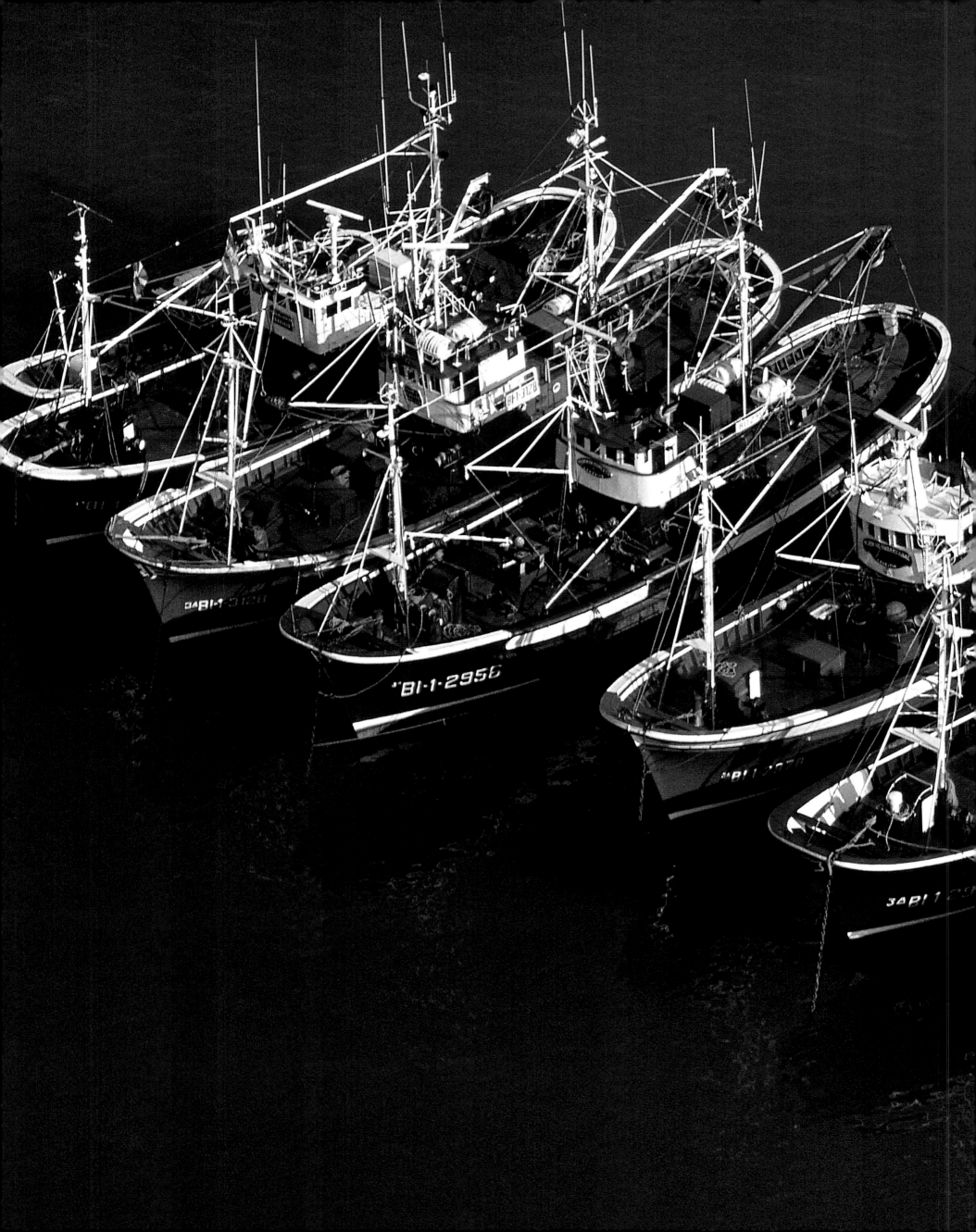

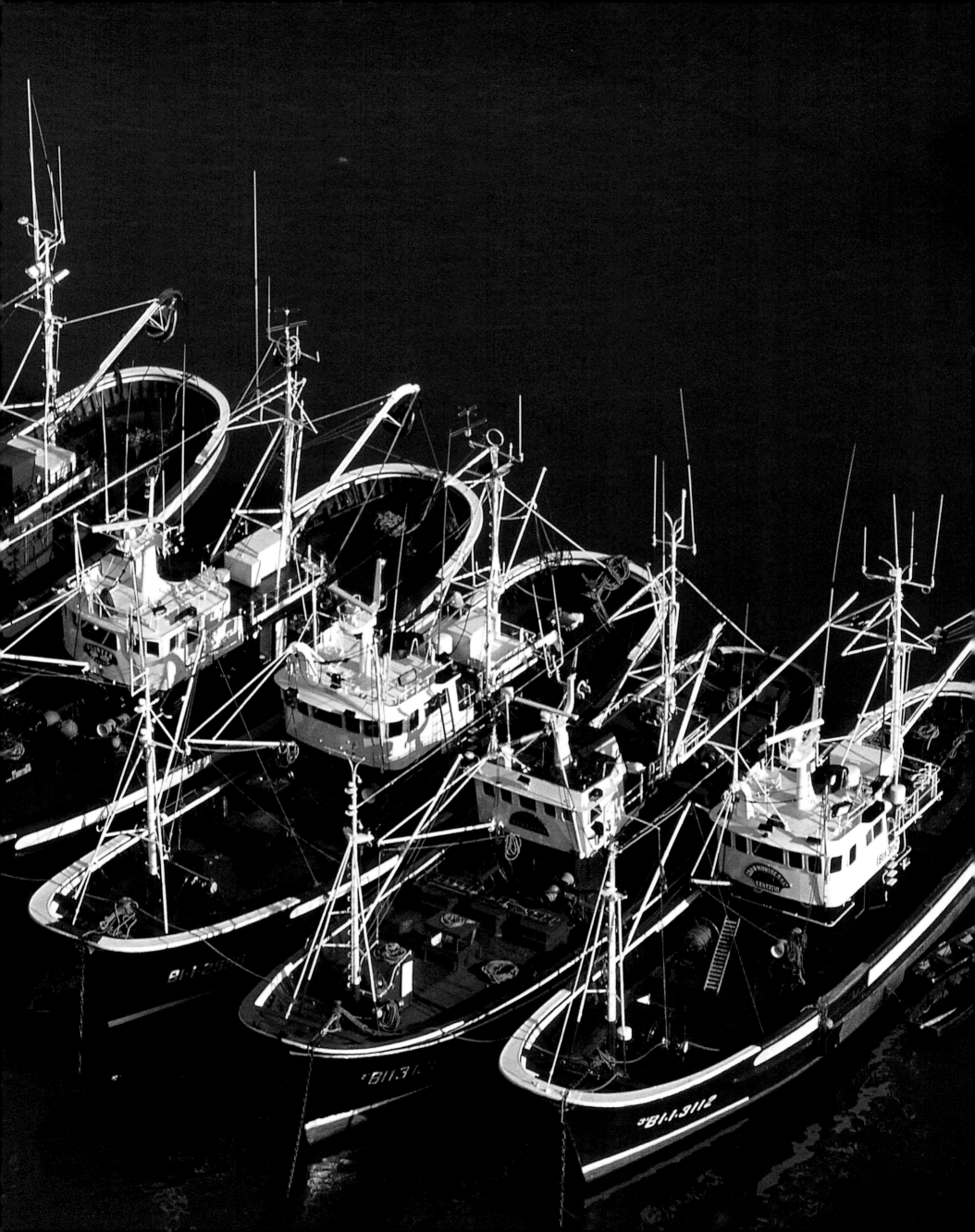

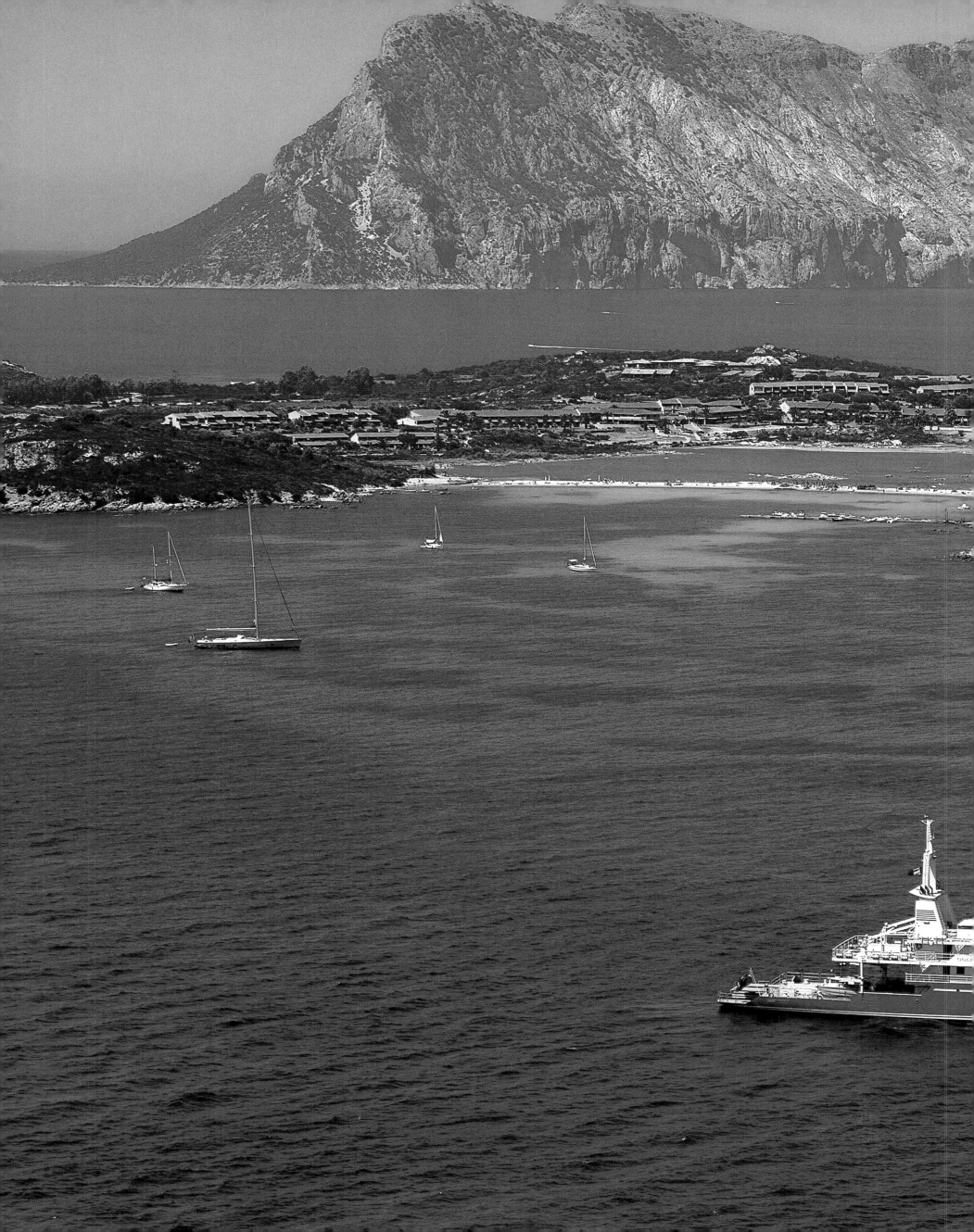

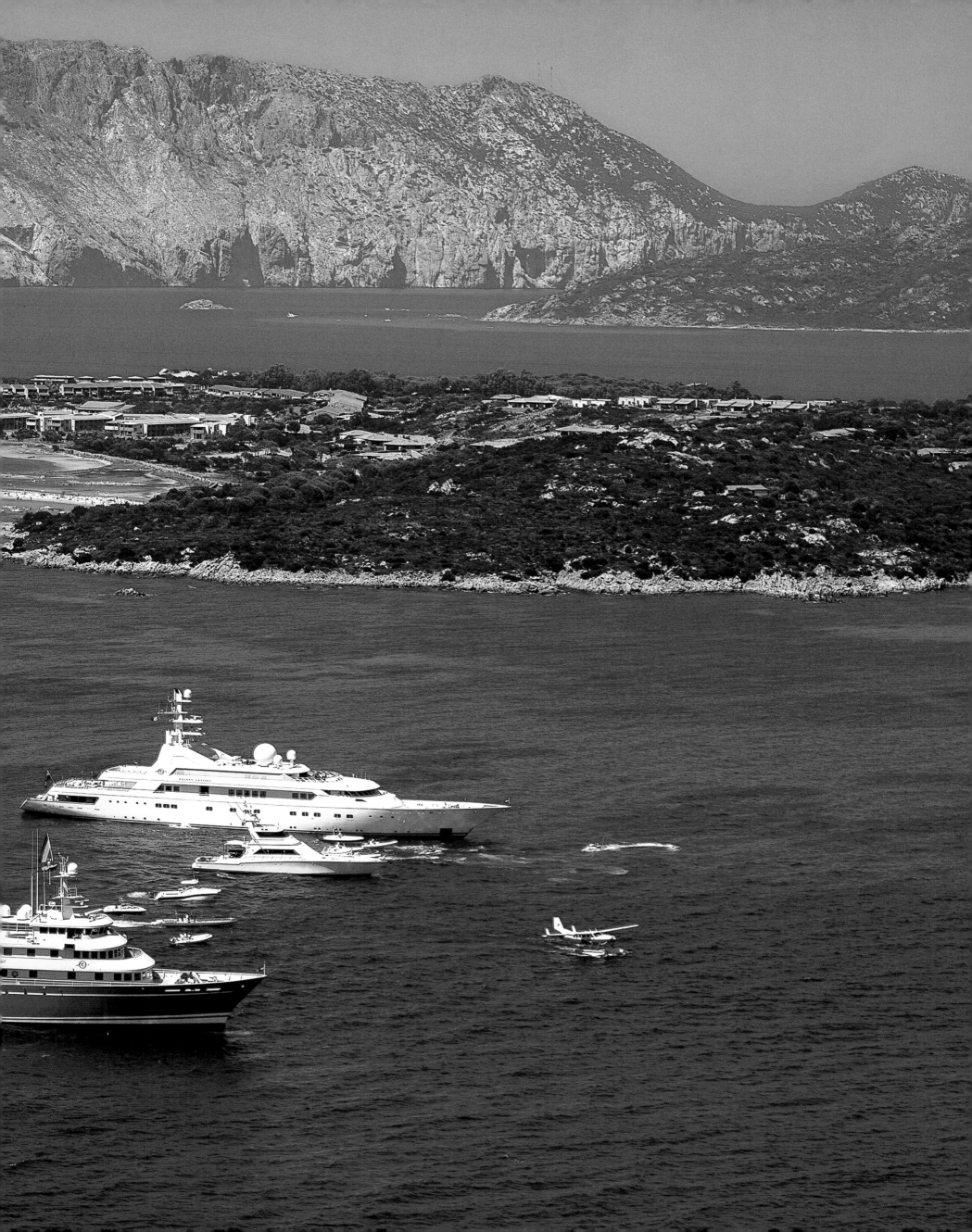

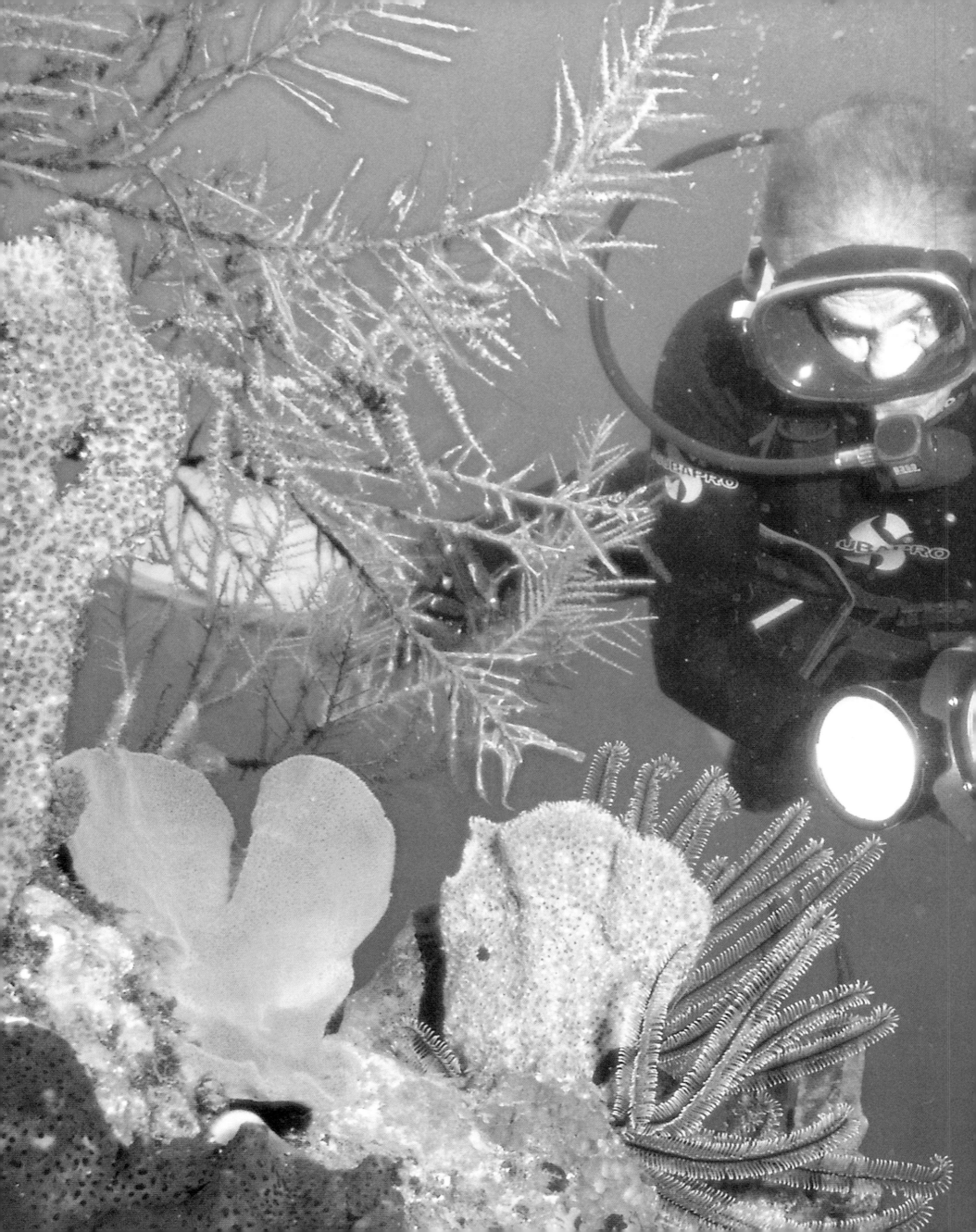

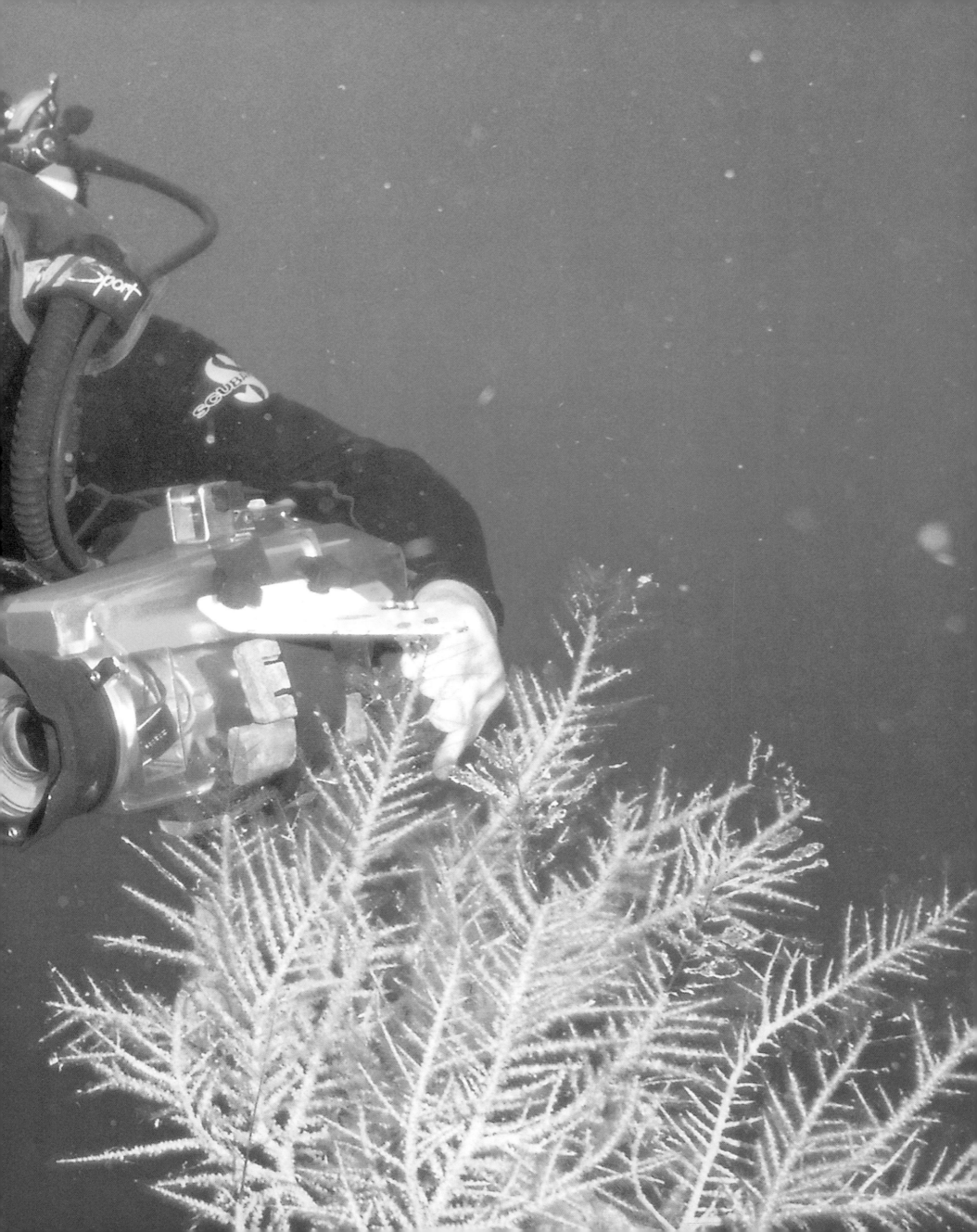

Acknowledgments

The success of any book relies on finding the right balance
between the skill of an artist and the know-how of a publisher.
So my special thanks go to Hervé de La Martinière, who has trusted
in me for so many years and has published my wildest dreams.

Thanks to Carole Daprey, my editor, who calmed my flights of fancy,
to Philippe Marchand, who designed these pages,
and all the team at Éditions de La Martinière who were a part of the making of this book:
Brigitte Govignon, Marie-Laure Garello, Agnès Poirson.

Thanks to Anne Jankéliowitch, who, from her Polynesian hideaway,
brought all her intelligence and sensitivity to the captions for this book.

Thanks to the team at Pêcheur d'Images, who did the picture research and
editing for this book and who look after the distribution of my photos and the running
of my picture library from their base at La Trinité, under the direction of Philippe Kerzerho.

All my thanks to the French Navy and their officers and crews who gave me such a warm
welcome aboard their vessels and who continue to uphold our naval traditions.

Thanks to Daniel Manoury, Éric Oger and Thierry Leygnac,
my pilots from Bretagne Hélicoptère, who took me flying so skilfully in all weathers.

Thanks to Météo France and their team of marine forecasters from Toulouse,
who helped me to be ready for every encounter with nature.

Thanks to Marie-Brigitte, Franck, Anne and Guillaume who all share my passion in this project.

All my thanks to Tania Saade, director of communications at CMA-CGM,
for her valuable partnership over all these long-haul voyages.

Thanks to Annette Roux, president of the Bénéteau group
and godmother of Pêcheur d'Images IV,
to the French Lighthouse and Beacon Services,
the French National Sea Rescue Association,
the Compagnie des Îles du Ponant, Chantiers de l'Atlantique,
Cunard, Brittany Ferries, the owners of the *Mariquita*,
the *Pirata* team at Fortaleza, and the Monaco Yacht Club.

Thanks also to my friends: Neil Corbasson for our stay in Dubai,
Lucas Basini, Jean-Yves le Norcy, Susan and Bill Hoehler,
Charles Claden, captain of the *Abeille Bourbon*,
Cyril Hofstein of *Figaro Magazine*,
Tonguc Bilguin for our stay in Turkey, Seppo Toivenen for our stay in Finland,
Angelos Kopitsas, Panos, Rala, Ariane and Catherine for our stay in Athens.

A special mention to my assistant, Christophe Le Potier,
who once more managed the unmanageable for the three years
that we spent visiting fifty countries to create this book.

Finally, thanks to Jean-Paul and Pierre Le Govic,
my printers and engravers for more than twenty years.

All my apologies to:
All those I've forgotten who deserve to be mentioned here.